The publisher gratefully acknowledges the generous contribution toward the publication of this book provided by the Blakemore Foundation and by the Art Book Endowment Fund of the Associates of the University of California Press, which is supported by a major gift from the Ahmanson Foundation.

AUSTERE LUMINOSITY

OF CHINESE CLASSICAL

FURNITURE

AUSTERE LUMINOSITY OF CHINESE CLASSICAL FURNITURE

Sarah Handler

UNIVERSITY OF CALIFORNIA PRESS BERKELEY LOS ANGELES LONDON

University of California Press
Berkeley and Los Angeles, California

University of California Press, Ltd.
London, England

Library of Congress Cataloging-in-Publication Data

Handler, Sarah.
 Austere luminosity of Chinese classical furniture /
Sarah Handler.
 p. cm.
 Includes bibliographical references and index.
 ISBN 0-520-21484-6 (cloth : alk. paper)
 1. Furniture—China—History—Ming-Ch'ing
dynasties, 1368–1912. 2. Furniture—Social aspects—
China. I. Title.
 NK2668.H36 2001
 749.2951—dc21 00-061992

Manufactured in Hong Kong

10 09 08 07 06 05 04 03 02 01
10 9 8 7 6 5 4 3 2 1

The paper used in this publication meets the minimum
requirements of ANSI/NISO Z39.48-1992 (R 1997)
(*Permanence of Paper*).♾

For Willis Barnstone

CONTENTS

ACKNOWLEDGMENTS

Research for this book was made possible by a CSCPRC (Committee on Scholarly Communication with the People's Republic of China) grant for research in China, 1983–85, and an NEA Senior Research Grant, 1991–92.

To Laurence Sickman, who first introduced me to Chinese furniture, I owe a scholarly approach that formed the basis for all my later work. To Wang Shixiang I am grateful for his deep knowledge of Chinese furniture and the good times we had working together in Beijing. I am indebted to the Museum of Chinese Classical Furniture for its collection and influence on the field; my special thanks go to Curtis Evarts, Jeanne Chapman, and James Kline. I also wish to thank all the many scholars, curators, collectors, and others who have helped me over the years in innumerable ways that have contributed to this book.

I thank, personally and intellectually, Audrey Spiro, James Cahill, and Sheila Keppel. I am grateful to Virginia Bower for her slides, to the poet-scholars Willis Barnstone and Chou Ping for their translations, to all those who have provided photographs, and to Jean Han and the staff of the East Asian Library, University of California, Berkeley. I thank Fergus Bordevich and Nathan Sivin for information about George Kates.

At the University of California Press I would like to thank my sponsor, Deborah Kirshman, whose belief in this project sustained it over the years; Jennifer Toleikis Abrams, for her multiple assistances; my wise editor, Rose Vekony; my copyeditor, Amy Klatzkin, whose knowledge of English breathed ease and coherence into the text and whose command of things Chinese saved me from error; and Steve Renick, who elegantly shaped page and picture.

To Willis Barnstone I owe special thanks for his constant inspiration, ideas, and encouragement.

CHRONOLOGY OF DYNASTIES

Shang	c. 1500–c. 1050 B.C.
Zhou	c. 1050–221 B.C.
Western Zhou	c. 1050–771 B.C.
Eastern Zhou	770–221 B.C.
Spring and Autumn Period	770–475 B.C.
Warring States Period	475–221 B.C.
Qin	221–207 B.C.
Han	206 B.C.–A.D. 220
Western Han	206 B.C.–A.D. 9
Xin	9–25
Eastern Han	25–220
Three Kingdoms Period	
(Wei, Shu, Wu)	221–265
Southern and Northern Dynasties	265–581
Southern (Six Dynasties)	
Western Jin	265–316
Eastern Jin	317–420
Liu Song	420–479
Southern Qi	479–502
Liang	502–557
Chen	557–589

Northern	
Northern Wei	386–535
Eastern Wei	534–550
Western Wei	535–557
Northern Qi	550–577
Northern Zhou	557–581
Sui	581–618
Tang	618–906
Five Dynasties	907–960
Liao	907–1125
Song	960–1279
Northern Song	960–1126
Southern Song	1127–1279
Jin	1115–1234
Yuan	1279–1368
Ming	1368–1644
Qing	1644–1911

INTRODUCTION
A Taste for Austere Luminosity

*T*he harmonious simplicity of form and the sheen of polished hardwood endow Chinese classical furniture with an austere luminosity. That light lies on the surface and in the wooden heart of the pieces and gives them their plain magnificence. The twentieth century discovered this furniture as art, and this revaluation commanded the attention of private collectors, museums, and scholars. These wood objects, which I perceive as functional sculptures, effectively generated a taste for austere luminosity.

Chinese classical furniture, also known as Ming-style furniture, is made from dense hardwoods valued for their grain patterns and natural beauty. The materials, design, and workmanship are of the highest quality. In the twentieth century this furniture was called classical because, as Laurence Sickman pointed out in a 1978 lecture before the Oriental Ceramic Society, its basic structure descends directly from antiquity and possesses the traits of restraint, balance, and grandeur that are associated with a classical style in any medium or culture.[1] Classical, in this sense, refers to a style and an aesthetic taste rather than necessarily to a particular period. Scholars and connoisseurs have appropriated the epithet *classical* to accord high esteem to plain hardwood (as opposed to ornate, lacquer, and softwood) furniture. Recently the word *vernacular* has been adopted to distinguish later softwood furniture from classical hardwood pieces.[2]

In China once a form was created it continued to exist as a viable artistic possibility for later imitation and development. So while the classical furniture style had its main origins in the Song dynasty (960–1279), it did not reach its apogee until the late Ming and early Qing dynasties (c. 1550–1735). Only in the mid sixteenth century did the Chinese begin to use hardwoods widely for furniture; this is the period when they lifted the ban on maritime trade and began importing large quantities of tropical hardwoods from Southeast Asia. The use of hardwoods permitted the creation of austere, slender-legged chairs and tables relying on the lustrous beauty of the precious wood for their decorative effect. This classical hardwood furniture was, however, only one of the furniture styles found in the cul-

tured homes of the rich. Plain lacquered pieces were especially prized, as were polychrome, carved, and inlaid lacquer pieces. In addition there was an abundance of ceramic stools, pieces fashioned from gnarled branches or roots, and even light bamboo furniture, which hardwood pieces sometimes imitated.

One associates classical furniture with the wealthy social elite, especially the literati or scholar-officials who, after passing rigorous examinations in the Confucian classics, obtained coveted government positions. The literati were the most educated and cultured members of society as well as the most respected artists, writers, and connoisseurs of refined taste. Of course, classical furniture was also found in the palace and in the houses of wealthy merchants who aspired to imitate the literati life and tastes. The rich typically lived in compounds with their wives, concubines, and extended family members. The compounds, surrounded by high windowless walls, had rooms opening onto interior courtyards. Directly inside the front entrance a screening wall prevented outsiders from seeing, through an open door, into the house. These walls enclosed and separated the inner world of the family from the public domain.

This spatial arrangement of the house reflected the Confucian family system, which prescribed rigid rules for gender segregation. These rules of conduct were expounded by eleventh-century Neo-Confucians, including Sima Guang, and later became the ideal way of life. Sima wrote: "The men are in charge of all affairs on the outside; the women manage the inside affairs. During the day, without good reason the men do not stay in their private rooms nor the women go beyond the inner door."[3]

The front courtyard was the male part of the compound, where male visitors were received. Behind were the women's quarters, into which no males, except for family members and servants, were supposed to venture. The house had a north-south orientation, with the most important rooms along the main axis facing south toward the sun. Long covered walkways connected the buildings and courtyards, and overhanging eaves formed covered verandas. Since it was usually necessary to go outside when going from room to room, these covered walkways and verandas provided protection from both the sun and bad weather.

While much of the furniture in these rooms could be used interchangeably in various parts of the compound, other pieces were designed to be used in a specific area. For instance, large canopy beds decorated with auspicious motifs for the birth of many sons belonged in a woman's bedroom, while washbasin stands were placed in a bedroom rather than the reception hall. The more decorated pieces were considered suitable for the women's quarters, while the more austere pieces were appropriate for a gentleman's study. Aesthetic and practical criteria determined the place of every piece of furniture in the house.

Great pieces of Chinese furniture are objects of stunning beauty whose measure places them not only among the so-called decorative arts but with the practical art of architecture as well. Indeed, many pieces of furniture—cabinets and canopy beds, for example—use not only some of the same design features as architecture but are also similar in joinery and engineering. In these aspects the cabinet or canopy bed is a microcosm of the house. Both furniture and architecture are fully functional. Clearly the patronizing and confining term *decorative art* is a misleading frame for classifying the functional art of Chinese classical furniture.

In daily life, furniture must fulfill the basic needs of supporting and containing. So a desk or dining table must be sturdy and provide ample leg room for those seated around it. And a bed should have a comfortable soft-mat seat with a firm yet yielding surface. Cabinets for storing large scrolls have removable central stiles so that a scroll can be easily inserted and will not fall out when the doors open. A single piece of furniture, depending on time and situation, can be used for many purposes. A long side table with everted flanges, for example, may stand under a painting in a reception room and hold an incense burner and a vase of flowers. But when there is a death in

the family, the same table may be used as an altar table for performing the funerary rites. And on occasion it is pulled out into the middle of the room to serve as a desk for scholars seated on either side.

When created by highly skilled craftsmen, this furniture is often infused with an artistic force that transcends the bounds of time and place. These functional sculptures in wood are thus as much at home in a contemporary American house as they were in the Chinese dwelling for which they were created. The finest pieces are imaginative and harmonious variations of a long tradition. They have an energy, unity, and beauty not found in routinely reproduced copies. In contrast to the place of furniture in the rest of the world, Chinese furniture distinctly incorporates other arts in addition to architecture. So a Chinese screen may contain a painting or poem, and at once we have calligraphy, poetry, and painting. In furniture the balance between the lines of the solid members and the spaces between them embodies the same aesthetic principles as calligraphy. And furniture shares with ceramics, metalwork, and textiles a decorative vocabulary of auspicious characters and pictorial motifs.

The concept of Chinese classical furniture is a twentieth-century phenomenon. Its international appreciation originated during the 1920s and '30s among foreign residents of Beijing who were influenced by the Bauhaus aesthetics of their time and bought this type of furniture for their own homes. Thus began a new appreciation of Chinese furniture that replaced the previous emphasis on lacquer and more ornately carved pieces. Collectors concentrated on the acquisition of classical furniture, which became the center of study, connoisseurship, and exhibition. At that time, though, only a few Chinese connoisseurs owned classical furniture, it was not a major field for collecting, and there was no Chinese research on the subject. The first books on classical furniture were written in English and based on the furniture in the Beijing homes of foreigners. These were Gustav Ecke's *Chinese Domestic Furniture,* published in a limited Shanghai edition in 1944, and George Kates's 1948

New York publication of *Chinese Household Furniture.* When events leading to the Communist takeover in 1949 forced foreigners to leave China, some of their furniture was brought to the West and set the standard for private and museum collections.

After returning to the United States in 1941, George Kates introduced Chinese hardwood furniture to interior decorators, furniture designers, and those interested in the arts through his lectures, magazine articles, book, and an exhibition of pieces from his own collection at the Brooklyn Museum in 1946. Gustav Ecke, who had become a professor at the University of Hawaii and a curator at the Honolulu Academy of Arts, was instrumental in promoting an interest in Chinese furniture on the islands and organized an exhibition there in 1952. Laurence Sickman, another former resident of Beijing, began a major collection at the Nelson-Atkins Museum in Kansas City, which soon became a mecca for those interested in Chinese furniture.

In the 1960s permanent furniture galleries were installed in the Nelson-Atkins Museum and the Philadelphia Museum of Art, whose collection was cataloged by Jean Gordon Lee. C. P. FitzGerald published *Barbarian Beds: The Origin of the Chair in China,* continuing the historical study of the Chinese chair begun over a decade earlier by Louise Hawley Stone in *The Chair in China.* The 1970s began with the appearance of *Chinese Furniture: Hardwood Examples of the Ming and Early Ch'ing Dynasties,* by Robert Ellsworth, the collector and dealer most responsible for establishing the *huanghuali* furniture market in the United States. In 1978 Sickman gave his influential lecture "Chinese Classic Furniture" when he was awarded the Hills Gold Medal in London. The following year the French connoisseur Michel Beurdeley published *Chinese Furniture,* which discusses furniture made from lacquer, enamel, porcelain, and bamboo as well as hardwood.

China's opening to the outside world in the 1980s led to a tremendous surge of interest in Chinese furniture. Wang Shixiang, who was the son of a Chinese diplomat and had been part of the Beijing in-

ternational community before the Revolution, began to reestablish contacts with foreign friends and in 1985 published *Classic Chinese Furniture,* which appeared the next year in English and then French and German translations. This book, the culmination of forty years of collecting and research, is the first written by a Chinese on classical furniture and the first to illustrate pieces from Chinese collections. It includes some pieces more ornate than what Westerners had come to regard as Ming-style furniture. Wang's book had a great impact on the field and the marketplace. Pieces began coming out of China through Hong Kong, and Chinese and foreign collectors became increasingly interested in classical furniture. In 1988 the Victoria and Albert Museum in London published Craig Clunas's enlightened *Chinese Furniture.* The decade ended with the publication of *Connoisseurship of Chinese Furniture: Ming and Early Qing Dynasties,* an expanded, more scholarly version of Wang Shixiang's book. An English edition appeared the following year.

In 1990 the Museum of Classical Chinese Furniture opened in Renaissance, California. Founded by the Fellowship of Friends in the Sierra Nevada foothills of northern California, this museum was the only one in the world devoted exclusively to Chinese furniture. To promote the study and appreciation of furniture, the fellowship also published the quarterly *Journal of the Classical Chinese Furniture Society.*

Meanwhile in Asia a growing interest in classical furniture led to exhibitions and the first international symposia. In the fall of 1991 the Art Gallery of the Chinese University of Hong Kong exhibited the Dr. S. Y. Yip collection, accompanied by a catalog and symposium, and there was the first display of Ming furniture in the Hong Kong Museum of Art, which had recently moved to new premises. In November the First International Symposium of Chinese Ming Domestic Furniture, organized by Chen Zengbi, was held in Beijing in memory of Gustav Ecke. In addition, five exhibitions were arranged by the China Arts and Crafts Museum, the Central Academy of Arts and Design, the Association of Classical Chinese Furniture, and the Beijing Arts and Crafts Association. For the first time the Palace Museum, in a recently opened section, displayed its classical furniture. Many scholars, collectors, dealers, and craftsmen from all over China attended these events, evidence of the new and rapidly expanding field. Furniture in China was at last accepted as part of the artistic tradition. The next year the private Tsui Museum added a room of *huanghuali* furniture when it opened in Hong Kong. When the new Shanghai Museum opened in 1996, special furniture galleries included pieces from the newly acquired Wang Shixiang collection.

In October 1992 the Second International Symposium on Chinese Ming Domestic Furniture was held in Suzhou in memory of Yang Yao, a collector and skilled draftsman who did the drawings for Ecke's book. A few weeks later the first American symposium, sponsored by the San Francisco Craft and Folk Art Museum, took place in San Francisco in conjunction with an exhibition of pieces from local collections.

San Francisco was again the site of a Chinese furniture exhibition in 1995–96, when the collection from the Museum of Classical Chinese Furniture was shown at the Pacific Heritage Museum and a catalog published. The *Journal of the Classical Chinese Furniture Society* ceased publication at the end of 1994, and in September 1996 the museum's entire collection was sold at Christie's in New York for unprecedented sums. The collection had been formed during the 1980s and '90s, when many excellent pieces of classical furniture were coming out of China.

Other private collections were also formed in various parts of the world, including Hong Kong, Taiwan, and Singapore. In late 1996 Robert Ellsworth published a catalog of the Hong Kong collection of Mimi and Ray Hung, and the Asian Art Museum in San Francisco exhibited many of the pieces in 1998. The Alice and Bob Piccus collection was sold at Christie's in New York in 1997.[4] There has been an obvious trend to make significant collections known through publication, exhibition, and sale.

As interest in classical furniture grows, there has re-

cently been an increasing interest in softwood, bamboo, and later Chinese furniture as well. In 1996 the Peabody-Essex Museum in Salem, Massachusetts, held the first exhibition of Chinese vernacular furniture, "Friends of the House: Furniture from China's Towns and Villages," with a catalog by Nancy Berliner and myself. Concurrently the Museum of Fine Arts in Boston opened with Nancy Berliner's "Beyond the Screen: Chinese Furniture of the Sixteenth and Seventeenth Centuries," which included lacquer, root, and other styles together with the classical. This exhibition was also accompanied by an affordable catalog. Then, in 1998, pieces from the Kai-Yin Lo collection were shown at the Asian Civilization Museum in Singapore and published in *Classical and Vernacular Chinese Furniture in the Living Environment*.[5] Classical furniture began to be seen as just one significant part of the Chinese furniture tradition, and the full richness and complexity of that tradition began to be explored.

This book had its origins in the high-spirited rediscovery of classical furniture in the 1990s and developed from a series of articles I wrote about pieces in the Museum of Classical Chinese Furniture. My intention is to give a sense of the world of which this furniture was a part as well as the art, craft, function, and historical precursors of these pieces. So with a New Historical nudge I hope to bring these pieces alive, dealing with them as intrinsic works of art as well as placing them in a social and historical context.

The first chapter deals with the most important event in the history of Chinese furniture: the adoption of the chair-level mode of seating. *Mat-level mode* and *chair-level mode* are terms I developed some years ago as a helpful way of understanding the historical revolution from mat to chair, which decisively changed the development of furniture as well as the lifestyle that the presence of high chairs and high tables permits.[6] The next chapters discuss the twentieth-century vogue for Chinese classical furniture and the life of an important early collector, George Kates. Each subsequent chapter elaborates one type of furniture,

tracing its historical antecedents and discussing its function, social significance, and cultural associations; I further examine the pieces' form, aesthetics, material, construction, and relation to similar examples. First, various types of seats are considered: the yoke-back chair, the folding armchair, the lowback armchair, and the stool. Then there are chapters on the platform, couchbed, and canopy bed, all of which serve as seats during the day and beds at night. Next are chapters on tables (the *kang* table, square table, desk, and side table), cabinets and shelves, and screens. The book concludes with separate chapters on the incense stand, lamp stand and lantern, braziers, and washstands.

In this book I make extensive use of sources, including excavated materials, literary texts, and visual representations in paintings, woodblock prints, stone engravings, and other media. I do so in part because the few extant examples of Chinese furniture dating before the mid sixteenth century were mostly excavated from tombs. Some tomb pieces were actually used by the deceased during their lifetime, but others, both full size and miniature models, were made expressly for burial. Because of the paucity of actual pieces from the early periods, I look at all these visual and textual sources for clues about the historical development and social role of furniture. Visual and textual sources also provide information about the contexts in which the many extant Ming and early Qing pieces of furniture were used, giving an idea of their function and placement, their relation to other objects in the interior, the meaning of their decoration, and their social significance. I concentrate on these matters as well as on artistic and technical aspects rather than on traditional dating, provenance, and stylistic development, which are problematic with so few firmly dated pieces and little information about regional characteristics. Even dated excavations and textual and visual sources all provide only *terminus ad quem* dates for the unearthed and depicted objects, since older objects were often used by later generations.

Objects excavated from tombs, visual sources, and

textual sources are not literal documents and cannot be used uncritically. Created in a particular context for a specific purpose, they were not mere transcriptions of reality. The creators had their own agenda. For instance, a couchbed found in a tomb may appear fine but have weak joints and be unable to withstand everyday use. This does not mean that beds used in daily life were actually made this way or that the carpenter who made the tomb bed was unskilled; rather, it means that this tomb bed was never intended to be used. Similarly, when we see exaggeratedly elevated canopied beds in the Dunhuang cave paintings, their height indicates status rather than the height of actual beds. Or when in a woodblock illustration depicting the reception hall of a house the only furnishings are two chairs in front of a screen, we cannot conclude that halls were sparsely furnished; perhaps only the significant elements of the scene are shown. Likewise, a literary account may refer to an ideal rather than an actual world, a past era rather than a contemporary one.

Chinese classical furniture touches on the arts of painting, poetry, calligraphy, and relief sculpture, and in its form and construction incorporates the principles of traditional wooden architecture. With a glance at the Bauhaus, we see that the furniture anticipates the plane-surfaced buildings of the twentieth century in Germany, France, and the United States. The range of Chinese furniture is unique and immense. The invention of a thoroughly distinctive way of supporting and containing people and things within the household is one of China's singular contributions. More revealing is the nature of that contribution, which I have placed in the sharp light of austere luminosity. The pieces create compelling spaces both around and within their forms. The magical totality of Chinese classical furniture, from its rich surfaces and shrewd proportions down to the austere soul of art that resides in the hardwood interiors, commands our eyes to witness each piece as a solitary work. Then we see a structure of fine wood sculptured by light.

REVOLUTION AND DISCOVERY

1 | RISING FROM MAT TO CHAIR
A Revolution in Chinese Furniture

China was the only nation in East Asia, indeed the only nation outside the West, to adopt the chair-level mode of living before the modern period. This fact has intrigued visitors to China since at least the early seventeenth century, when the Jesuit Nicolas Trigault noted this radical departure from non-Western habit.[1] From the earliest times until about the tenth century the Chinese commonly sat on mats or low platforms. Although from at least the Eastern Zhou period (770–221 B.C.) people occasionally sat on an elevated seat with their legs pendant, only in the Northern Song dynasty (960–1126) did sitting on a chair at a high table become the norm. The adoption of the chair-level mode of living wrought a revolution in Chinese furniture. Indeed, it profoundly transformed many aspects of Chinese life, for the way a people sit and how they hang their legs affect not only the shapes and sizes of chairs and tables, but also wall heights, architecture, and social and eating habits. Raising the height of furniture elevates the vision and has implications for the spirit as well. No longer was the high seat a privilege reserved for the emperor and a few priests and officials. As wealth in China dispersed, the adoption of the chair was both symbol and product of a new prosperity that entailed an entirely new mode of living.

Height and authority are often correlated. In English we speak of rising to power or being elevated to a position. We talk about the seat of authority. High judges sit on the bench. The chair and table, in particular, are among the oldest symbols of authority. For the Greeks the *catheídra,* meaning "seat," was the synonym of power, and for Christians it was the cathedral. In royal societies the name of the king or queen might change, but the symbol of authority remains the throne (from the Greek *thronos*).

In ancient China most people sat and slept on mats (*xi*), a custom reflected in the modern word for chairperson (*zhuxi*), which literally means "master of the mats." However, even in early times there was a minor distinction in level, since the wealthy and important also had low platforms. From as early as the Han dynasty (206 B.C.–A.D. 220) there are pictorial examples of what I call the mat-level mode of living. An Eastern Han (A.D. 25–220)

FIGURE 1.1 Lecture scene. Eastern Han dynasty. Rubbing from pottery relief from a tomb near Chengdu, Sichuan. Height 40 cm, length 46 cm. Chongqing Museum. Photo courtesy of the Chinese Culture Foundation, San Francisco.

pottery tomb tile unearthed near Chengdu in Sichuan province shows respectful, formally dressed students seated in the correct kneeling posture on long rectangular mats and a square single-person mat (fig. 1.1). The mats are made of woven rushes or bamboo, which might be lacquered red or black and bound with silk. The teacher, as befits his status, is elevated on a small low platform of simple box construction; he leans on an armrest (*ji*), which on each side has four curved legs attached to a runner. Seating is arranged according to a complex protocol reflecting social position and having symbolic, and sometimes even political, implications.[2]

During the Han dynasty, platforms could be small, like this one, or long enough to accommodate a num-

ber of people. Both large and small platforms often had screens on two sides, such as those depicted in the stone engravings at Anqiu, Shandong province (see fig. 9.1), and in the offering shrines of General Zhu Wei. Sometimes platforms are covered by canopies. For instance, a wall painting found in a tomb in Mi county, Henan province, shows a feast in progress, with the occupant of the tomb probably among those seated in the place of honor beneath a large canopy hung with patterned silk and bedecked with flags.[3] In front of him, level with his seat, is a long low table with curved legs, a larger model of the arm-rest in the lecture scene (see fig. 1.1), laden with sumptuous dishes. The guests are arranged on mats in a huge U shape before the table.

A rare early platform belonging to Chang Taiguan, a fourth-century B.C. ruler of the kingdom of Chu, was found at Xinyang, Henan province (fig. 1.2). It is an elegant and sophisticated piece consisting of a black-lacquered wooden frame, 218.2 centimeters long and 139 centimeters wide, decorated along the outer edge with a red carved key-fret design. The frame is supported by six short legs elaborately carved in the form of double scrolls or coiled snakes. The legs tenon into the frame, a method of construction basic to all Chinese furniture. A low bamboo railing, mounted in bronze and wound with silk, encloses all but a slightly off-center portion of each of the long sides. Transverse braces originally supported some kind of seat. This type of large low platform, called a *chuang* in contemporaneous literature, was a daytime seat, often ceremonial, as well as a bed at night. A bamboo pillow and lacquer armrest were found in the same tomb, suggesting that these objects were for nighttime and daytime use on the *chuang*.[4]

When the Chinese lived at mat level, they used numerous kinds of small low tables. A Han dynasty pottery tomb tile depicts a feast with music and dancing for entertainment (fig. 1.3). On the left a musician plays the zither (*se*) for a guest seated on the far right. In the background sits a woman, identified by her double hair knot. They are watching a slow dance performed by a dancer dressed in a trailing, long-sleeved

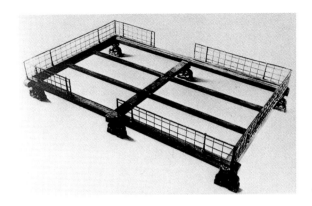

1.2

1.3

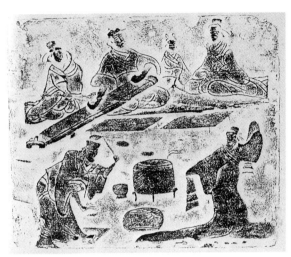

FIGURE 1.2　Reproduction of a bed. Fourth century B.C. Excavated in 1956 from tomb no. 1, Xinyang, Henan. Platform: lacquered wood; railing: bamboo, bronze, and silk. Length 218.2 cm, width 139 cm. From Henan Sheng Wenwu Yanjiusuo, *Xinyang Chumu*, pl. 30.1.

FIGURE 1.3　Feasting and dancing. Eastern Han dynasty. Rubbing from pottery relief from a tomb in Chengdu, Sichuan. Height 40 cm, length 48.5 cm. Chengdu Museum. Photo courtesy of the Chinese Culture Foundation, San Francisco.

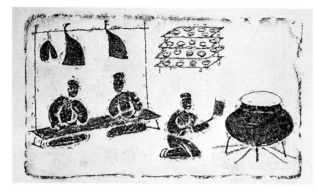

1.4

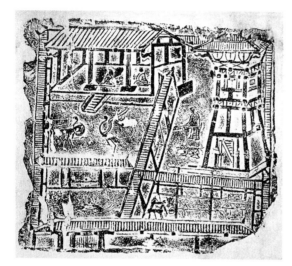

1.5

FIGURE 1.4 Kitchen preparations. Eastern Han dynasty. Rubbing from pottery relief from a tomb in Xindu county, Sichuan. Height 25.5 cm, length 44.5 cm. Xindu County Cultural Bureau. Photo courtesy of the Chinese Culture Foundation, San Francisco.

FIGURE 1.5 Estate, Eastern Han dynasty. Rubbing from pottery relief from a tomb in Chengdu, Sichuan. Height 39.5 cm, length 47 cm. Chengdu Museum. Photo courtesy of the Chinese Culture Foundation, San Francisco.

robe. A man beats out the rhythm on a drum. In front of each feaster is a small rectangular table for serving food. One common type is a low painted lacquer model with four wood or metal feet in the shape of stylized hooves. A luxurious example was excavated from the first- or early-second-century Tomb of the Painted Basket at Lelang, near modern Pyongyang, Korea.[5] Lelang was a Chinese commandery at the time, and this table, like other inscribed pieces from the same site, was probably made in Sichuan province in China. The top of the table is decorated with undulating patterns of clouds, animals, and immortals framed by geometric borders; all are delicately executed in gold, silver, and other colors against a red ground. The legs are shaped like stylized hooves and ornamented in red and yellow.

Dining tables were often small enough to be carried from the kitchen already set with dishes. A low rectangular rimmed model holding cups, an oval bowl with two handles for wine, chopsticks, and dishes with remains of food (see fig. 12.4) was excavated from the tomb of the Marquess of Dai, who died soon after 168 B.C. Both table and dishes were costly, being lacquered red and black with painted decoration.

Different sizes of low rectangular tables, often with curved legs, were used in the kitchen. A long model is shown in a rubbing from an Eastern Han pottery tomb relief unearthed in Xindu, Sichuan province (fig. 1.4). Here two cooks preparing a meal are seated on the ground in front of a rack from which joints of meat are hung. On the right a person is fanning the fire, and behind him the dishes are laid out on small tables identical to those before the feasters in the banquet scene in fig. 1.3. A large curved-leg table—the earliest example of the type known to exist—was excavated from the Tomb of the Painted Basket.[6] It uses the basic Chinese joinery that has persisted to the present day. On each short side of the table, five bent legs tenon into transverse braces beneath the top and a scalloped runner at the bottom. Exposed tenons are visible on the surface of the table as well as on the underside of the runner.

The mat-level mode of living clearly influenced the houses that people lived in at this time. The low furniture was neither abundant nor highly specialized, and it could be moved easily to serve several functions. It determined the proportions of the house, which might have one or more stories, and the lack of division into rooms. A pottery tomb relief depicting a Chengdu estate shows an entire compound surrounded by a wall with tiled eaves (fig. 1.5). The front gate (lower left) opens into a courtyard with fowl, and on the right is the kitchen with a well, stove, and rack similar to the one in fig. 1.4. In the courtyard behind the kitchen stands a tower that probably served as a watchtower and, according to contemporary literature, was also used for pleasure viewing.[7] Beneath the tower a servant and a dog face a roofed wall or corridor leading to the main courtyard. A visitor would enter the front gate and cross the barnyard, in which we see a fowl, and then cross into the main courtyard, with the reception room at the far end. Steps lead up to the three-bayed building with fluted columns where the master of the house and his guests are seated on mats watching the dancing cranes—symbols of immortality and longevity—in the courtyard.

The building has no interior divisions, but screens would have been used to divide the space, protect from drafts and sunlight, and serve as marks of honor behind distinguished persons. A screen found in the tomb of the Marquess of Dai (see fig. 16.2) consists of two feet supporting a lacquered wood panel. One side is painted with a red dragon intertwined with clouds on a black ground; the other has a jade disk in the center surrounded by a black geometric pattern on a red ground. Both sides have identical patterned borders.

The interiors of the houses of the rich had brick floors and textiles on the walls for warmth and decoration. Light and ventilation came through lattice windows that literary records suggest were sometimes covered with silk. A number of pottery tomb models of houses show the lattice extending down to the floor beside the main door so that the inhabitants seated on mats on the floor would have light and air.[8] Variations of the Han dynasty courtyard house are still found in parts of China today, and sitting on mats and using low tables remain the traditional way of living in Korea and Japan.

Even in ancient China people occasionally sat on elevated seats for ceremonial and practical reasons in a Buddhist context and at court. A fragment of a bronze vessel from the Eastern Zhou found at Liuhe in Jiangsu province shows a person seated on a high stool drinking from a horn-shaped cup (see fig. 7.1). Probably this is a ceremonial occasion. High tables too were not unknown. Another Eastern Zhou vessel fragment depicts a high offering table with upturned ends (see fig. 14.1), a predecessor of the everted flanges of later times. A pottery tomb model of a high table with a jar on top was found in a late Eastern Han tomb at Lingbao, Henan province.[9] This miniature table is a forerunner of the high square hardwood tables popular for dining in later times. It was made at a time when high seats were sometimes used for everyday household tasks, such as weaving. Sichuan was famous for its brocades and silk, and some of the stone tomb reliefs show ladies seated on high seats weaving at a loom and operating the treadles with their feet.[10]

Deities, like high dignitaries, are often elevated to indicate their status. The cave paintings at Dunhuang, Gansu province, depict many Buddhist deities and monks raised up on thrones, chairs, and stools, which are the precursors of later furniture. The most extreme examples of elevation are the canopied beds in illustrations to the *Vimalakīrti Sūtra* that, together with their accompanying curved-leg tables, are elevated beyond realistic possibilities (see fig. 10.4). Nonetheless their basic form is comparable to representations of canopied beds in a secular context. Various types of stools show seated deities with their legs pendant. In cave 275 a painting from the Northern Liang (421–439) shows a bodhisattva sitting, one leg pendant and the ankle of the other resting on his knee, on a cylin-

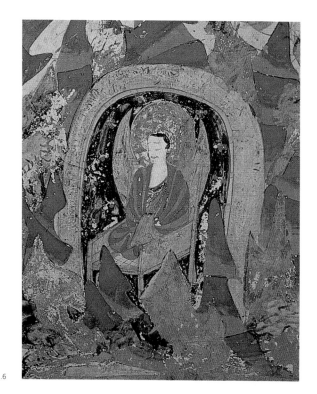

1.6

drical stool with rounded top, probably made of cane. Another painting in the cave depicts an hourglass-shaped stool. In cave 295 a pensive bodhisattva sits on a more fanciful stool with a lotus leaf–shaped seat, base, and matching footstool in a painting from the Sui dynasty (581–618) depicting Śākyamuni entering Parinirvana.[11] On a mid-sixth-century Buddhist stele in the Nelson-Atkins Museum of Art, a monk holding an incense burner sits on a low round stool.[12] Folding stools, still common today, are thought to have been imported into China during the late second century. Perhaps the earliest depiction is on a Buddhist stele dated to 543 found near Luoyang that shows the Nepalese seer Asita seated and holding the infant Buddha (see fig. 7.3).

By the Tang dynasty (618–906), the habit of sitting on stools with legs pendant was prevalent among the ladies at court, marking the beginnings of an elevated mode of sitting in the daily life of the elite. For example, three-color glazed pottery tomb figurines show women seated on hourglass-shaped models (see fig. 7.5). In paintings of life at court that are believed to be close copies of Tang dynasty works, such as *Ladies Playing Double Sixes,* the oval wooden stools have four legs with cut-off cloud-head feet, cloud-head motifs repeated halfway up the legs, arch-shaped cusped aprons, and continuous beading along the inside edges. Sometimes cushions are tied onto the stools.[13]

Before the tenth century there are isolated examples of honorific chairs used not for easy access to tables but as a means of giving stature to important people. The earliest representations of such chairs in China are all in a Buddhist context. A depiction in Dunhuang cave 285, dated 538, shows a monk meditating in a cave in the mountains. He is seated in a kneeling posture on a highback armchair, which clearly has a woven seat (fig. 1.6). At this time there were also chairs with high backs and no arms. A rubbing from a Buddhist stele in the collection of the late Laurence Sickman shows a monk seated with legs pendant on such a chair with a back consisting of two high side posts joined by a single low horizontal bar.

In the Tang dynasty, chairs are also occasionally

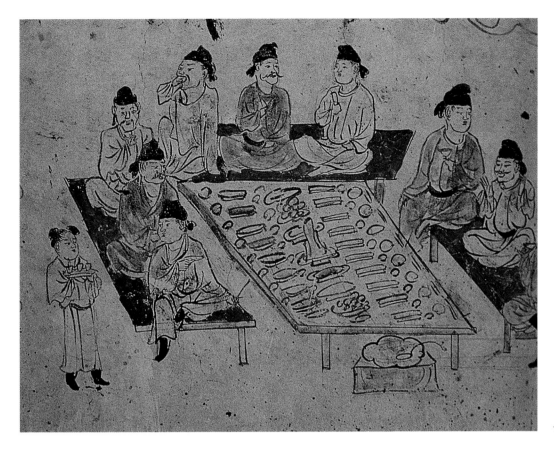

1.7

connected with high officials as well as priests. A wall painting in the tomb of Gao Yuangui, a general who died in 756, shows him seated with legs pendant on a large armchair. A century later the Japanese monk Ennin visited China, and his diary describes important officials as well as priests sitting on chairs which he calls by the modern Chinese term *yi*. That Ennin bothers to mention sitting on chairs indicates that the practice was unusual.[14]

Mid and late Tang depictions of banquets show parties of men or women gathered around large rectangular tables. They are seated on benches or stools that are the same height or only slightly lower than the tables. For instance, in a wall painting in a tomb in Nanliwang, Chang'an county, Shaanxi, men are seated on long benches around a table laden with food (fig. 1.7). They sit in various postures—cross-legged,

with one knee raised, or with one leg hanging over the edge of the bench. None of the diners has his legs stretched out or under the table. This table has recessed legs, but in other representations the tables are constructed like boxes, making it impossible for people to sit with their legs under the table.[15] Uncomfortable as these seating arrangements may be, they herald a transitional period between mat-level and true chair-level living in China, when it became the common practice to sit on chairs at high tables that were proportioned to provide sufficient leg room, rather than on mats or low platforms.

The radical change in how people lived becomes apparent in a painting generally considered to be a twelfth-century copy of *The Night Revels of Han Xizai* (fig. 1.8), a handscroll attributed to the tenth-century painter Gu Hongzhong. The painting and the

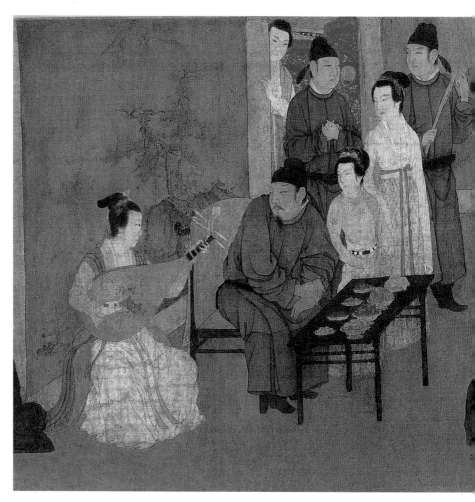

FIGURE 1.8 Attributed to Gu Hongzhong (tenth century). *The Night Revels of Han Xizai.* Early twelfth-century copy. Detail of a handscroll. Ink and color on silk. Height 29 cm, length 338.3 cm. Palace Museum, Beijing. Photo courtesy of Wango Weng.

story behind its creation were recorded in the early-twelfth-century catalog of the painting collection of the Song emperor Huizong (r. 1101–26).[16] Han Xizai was an accomplished and learned gentleman who, to avoid being appointed to an official government post, deliberately led a dissipated existence. The emperor was suspicious, however, and wanted to discover if there was any truth in the stories about Han's lavish and licentious parties. So he sent Gu Hongzhong to attend one of the banquets and paint what he saw, and what Gu saw was most improper according to Confucian standards. The result was not only this delightful painting, but also one of the first extant depictions of a Chinese interior showing in detail the chair-level

mode of living. Like all copies, this painting inevitably updates the original work and thus gives an idea of the tenth- to twelfth-century Chinese interior.[17]

Furniture in this dynamic period has become a much more important component of the interior than it was in the Han dynasty. It is larger and includes new types and forms. Screens, now decorated with ink paintings of landscapes, continue to divide up large interior spaces, but, because people are now elevated by sitting on chairs, the screens are also much larger than in the Han dynasty. Han Xizai, with a beard and tall hat, is seated on a couch in front of tables laden with food and wine. The U-shaped wooden couch appears to be lacquered black and has high

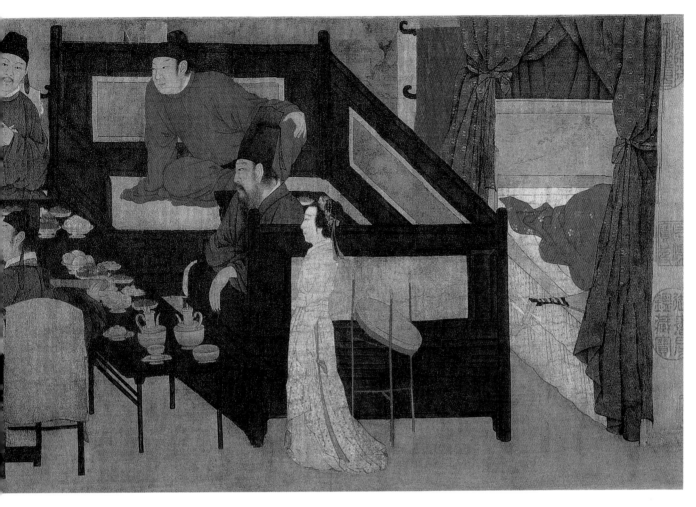

1.8

sides and a back inset with ink paintings. Its unusual shape, which seems to have occurred in furniture only at this period, derives from pedestals in Buddhist cave temples.[18]

Han and his red-robed friend are seated with their legs up. On the couch between them, only partially visible, is a low table. The feast is laid out on this low table and three high rectangular tables in front of the couch. Wine pots and cups on stands are arranged on one table; the other tables are each set with eight dishes of persimmons and other foods arranged in two rows.

The high tables have round recessed legs, simple curvilinear apron-head spandrels, and side stretchers. This shape, with slight variations, has been found in a full-size wooden tomb table, a miniature tomb model, and a tomb painting from the eleventh and twelfth centuries, and it has remained popular ever since.[19] The tables are still an awkward height, almost level with the seats, so that it is impossible to fit one's legs under the table; but with them there is, at last, a clear intention of chair and table.

The black-lacquer chairs have bow-shaped top rails with upturned ends to which silk covers are tied for this special occasion. To keep their mortise-and-tenon joints from overlapping, the stretchers on the bases of the chairs are stepped, with the front one lowest, the side ones higher, and the back one highest. In this scroll apparently only the more important

guests are seated on chairs. The women never sit on chairs but on low stools or couches. Behind Han Xizai is a suggestive glimpse of a canopied bed with the patterned curtains tied back to reveal humped brocade covers, the neck of a musical instrument, and a landscape painting ornamenting the side panel. Beside the bed are the curved ends of a clothes rack.

The adoption of the chair-level mode of living was undoubtedly connected with the fundamental changes taking place in China during the Song dynasty (960–1279). Technological improvements in the cultivation of wheat and rice greatly increased food production. Improved transportation along waterways led to economic interdependence among localities. Successive invasions along China's northern frontier cut off the overland trade routes to the west, and China developed the alternative of the sea, becoming a leading maritime nation. Cities grew into great commercial centers, with a new society based more on commercial ties and less on the old paternalistic hierarchy.

Specific monetary changes also affected the empire. The earlier barter system gave way to a widespread monetary economy, and at the end of the eleventh century the first paper money was printed. With unprecedented wealth came a great demand for luxury goods among a large part of the population, not just the residents of the imperial palace.

There were also important changes and refinements in all the arts, including the art of furniture making. For the first time "greater woodwork" (damuzuo) was distinguished from "lesser woodwork" (xiaomuzuo). "Greater woodwork" referred to buildings, "lesser woodwork" to furniture and the latticework of windows, doors, and partitions. They became two distinct branches of carpentry.[20]

At the same time, with the development of woodblock printing came the wide diffusion of all kinds of practical and literary knowledge and increased access to education. The first national newspapers were printed in the Song dynasty. On another level, storytelling became an important part of urban entertainment and led to the first popular secular literature. The examination system grew in importance, and scholar-

officials developed a culture and lifestyle that was emulated for centuries. It was an exciting period of economic and social revolution, great curiosity, the amassing of knowledge, and radical change and innovation. Among the primary innovations was the revolution in everyday life and the home that came with the popular advent of the chair and the mode of living it shaped.

During the Song dynasty even the common people came to use tables and chairs. The early-twelfth-century painting *Qingming Festival on the River,* by the court painter Zhang Zeduan depicts high tables and benches or chairs in all the restaurants, tea houses, and wine shops of the city. Traditionally this long handscroll was considered to be a depiction of the Northern Song capital, Bianjing (present-day Kaifeng, in Henan province), at the time of the Qingming Festival, when all the people go to the countryside to sweep the graves of their ancestors and admire the early spring foliage. However, recent scholarship suggests that the scroll portrays an idealized city that is a model of peace and order (qingming), and therefore the title should be translated *Peace Reigns over the River.*[21] The scroll begins in the suburbs, and the viewer "travels" along the river past simple country inns and teahouses where people sit together on benches at large rectangular tables. Nearer the city the scene bustles with townspeople, travelers, peddlers, and workers crowding streets lined with shops and restaurants.

Just outside the gates stands a large second-class restaurant called a *jiaodian,* according to the sign at the elaborate entrance (a bamboo superstructure hung with bunting and banners). Inside the compound is a two-story building with paper-covered lattice windows open to reveal several rooms (fig. 1.9). In one, guests are seated on benches around a large rectangular table, just as in modest establishments (see fig. 12.7). A man is leaning on the balustrade of the balcony surrounding a second story sheltered by bamboo awnings. He gazes into the courtyard below. His friends are feasting around a table laden with dishes brought from the kitchen on a large round tray. The

1.9

1.10

people sit together around one high table instead of on mats at low individual tables, the previous norm.

From such images we can infer fascinating new manners in Chinese life. As a result of chair-level living, people began to help themselves with their own chopsticks to food from a common dish, as we still see in China today, and new forms of tableware developed. Moreover, in the Song dynasty the first truly national Chinese cuisine emerged, free from conventions of ritual or region and incorporating a great variety of ingredients from all over the country. The best restaurants became meeting places for the cultured elite. Food was served on beautiful porcelain or silver dishes, and rooms were decorated with flowers and miniature trees. Rare antiques and paintings by famous artists were displayed. In effect, the restaurants were the art galleries of the time.[22]

Qingming Festival on the River shows some of the new forms of furniture for the elevated mode of living. Just inside the city gate an official appears to be collecting taxes from the merchants bringing in their goods (fig. 1.10).[23] He sits on an elevated version of the ancient folding stool to which a curved top rail and back have been added. The seats of Chinese chairs are almost always higher than those of Western chairs because the feet of a seated person are meant to rest on the front rung, as shown in the handscroll, or on a separate footstool to keep them off the cold brick floor.

FIGURES 1.9 and 1.10 Zhang Zeduan (early twelfth century). *Qingming Festival on the River.* Details of a handscroll. Ink and slight color on silk. Height 25.5 cm, length 525 cm. Palace Museum, Beijing.

In other sections of *Qingming Festival on the River* we see folding chairs with curved armrests and curved splats, a form that has been in use ever since. There were also rigid armchairs with curved rests. Fig. 1.11 shows an elegant seventeenth-century example fashioned from *huanghuali* wood. One of the most popular tropical hardwoods since the mid sixteenth century, its color ranges from golden yellow to reddish brown and when polished has a characteristic orange-gold sheen. The wood has a vigorous grain, sometimes forming eccentric abstractions that are especially prized. On this seventeenth-century chair, lighter-colored boxwood is subtly used to delineate both the raised dragons ornamenting the hand rests and a stylized *shou* longevity character on the splat. The chair has two side stretchers and a downward curving apron that continues in an unbroken line down to the footrest stretcher. The slight upward taper of all verticals lends a sense of lightness, and there is a perfect and subtle balance between the curved and straight

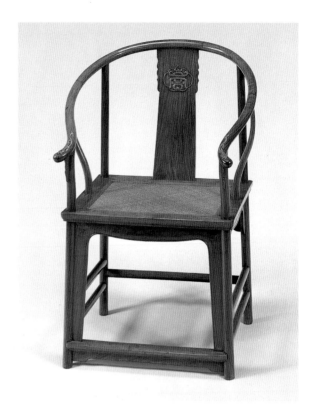

1.11

FIGURE 1.11 Roundback chair. Ming or Qing dynasty, seventeenth century. *Huanghuali* wood with boxwood inlay. Height 100 cm, width 59 cm, depth 46 cm. © Christie's Images, Ltd., 1999.

FIGURE 1.12 Attributed to Ma Yuan (active before 1189–after 1225). *Composing Poetry on a Spring Outing.* Southern Song dynasty. Detail of a handscroll. Ink and color on silk. Height 29.3 cm, length 302.3 cm. The Nelson-Atkins Museum of Art, Kansas City, Missouri. (Purchase: Nelson Trust.) © The Nelson Gallery Foundation.

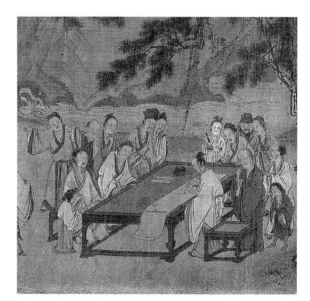

1.12

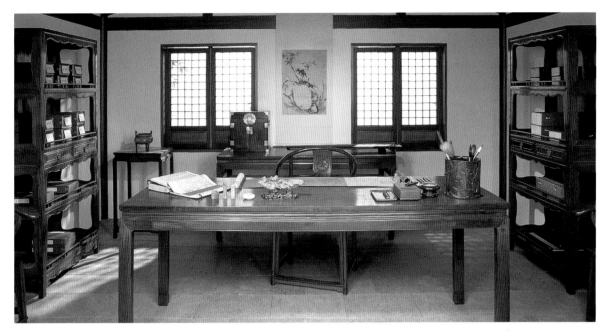

FIGURE 1.13 Reconstruction of
a seventeenth-century Chinese
scholar's studio. Courtesy of
the Arthur M. Sackler Gallery,
Smithsonian Institution,
Washington, D.C.

members. This chair curves to fit the human body. The same curved splat was later to bring greater comfort to Westerners when in the eighteenth century Queen Anne furniture incorporated this Chinese innovation.[24]

With chair-level living, furniture became higher and larger. Early depictions, such as a wall painting in the Northern Qi (550–577) tomb of Cui Fen,[25] show writers seated on a mat at a small low table with curved legs, similar to the tables used in the Han dynasty kitchen in fig. 1.4. By contrast, in the painting *Composing Poetry on a Spring Outing*, attributed to Ma Yuan (active before 1189–after 1225), a late-twelfth-century poet is standing at a large high table brushing a poem for his friends (fig. 1.12). Such large tables need strengthening to carry the weight of the top boards. Here strength is achieved with a continuous

floor stretcher on which the legs (terminating in typical Song dynasty cloud-head feet) rest. The poet could sit at the table on the matching stool, but the floor stretcher would get in the way of his feet.

High stretchers were also used to strengthen tables (see fig. 1.8), but they likewise interfere with the legs of a seated person. The best solution is the waisted table, with an inset panel between the top and the apron. This design allows tables to be very large: one in the Arthur M. Sackler Gallery is 178 centimeters wide yet relatively light and elegant in appearance. Fig. 1.13 shows this table as it might have been used in a seventeenth-century Chinese scholar's studio, laden with a partially unrolled handscroll, several books, a large brush holder, a fantastically shaped rock on a wooden stand, and seals. Large tables were the favored desks in China because they provided enough space

to brush large scrolls. Small objects were kept in chests, like the one on the table under the window, or in bookcases or cupboards. On the table beneath the hanging scroll is a Chinese zither that the scholar would have played while burning incense in the burner on the tall stand. The bookcases in this studio are especially beautiful and impressively large, about 190 centimeters high. The fronts and sides are fashioned from *huanghuali* wood; an interestingly patterned *jichi* wood burl is used for the backs, shelves, and tops. *Jichi,* literally "chicken-wing" wood, is a hard purplish brown wood with a streaked grain suggesting the feathers near the neck and wings of a chicken. Each bookshelf, with a low railing in front and a curvilinear inner frame above, would also be suitable for displaying a few choice antiques. In the middle are two drawers. Typically bookcases come in pairs, and all the pieces of furniture are arranged parallel to the walls and at right angles to one another.

These bookcases are but one of the new types of furniture that developed once the elevated mode of living became common. Several others may be seen in the Ming room in the Astor Court at the Metropolitan Museum of Art in New York (fig. 1.14). In 1980 craftsmen came from China to build this room and the adjoining garden. Using traditional tools, they followed traditional Ming dynasty designs and techniques that can still be seen today in the gardens of Suzhou. They brought with them fifty pillars of *nan* wood (an evergreen of the cedar family prized for building and coffin making because of its resistance to insects, deterioration, and warping), specially logged for the project in Sichuan province, and terra-cotta tiles made in the Lumu imperial kiln, which was reopened for the occasion. For the doors they used gingko wood lattice consisting of many small pieces carefully mitered and joined with mortise-and-tenon joints like those used in furniture. The completed room displays the museum's collection of hardwood furniture in a setting similar to those in which the pieces were originally used.

A pair of cupboards stand two and a half meters high, each consisting of a cabinet with a separate upper cupboard. Only one is visible in the photograph; the other is on the opposite side of the room. The design is simple and imposing, with the beauty of the wood enhanced by brass hardware that is both functional and decorative. Several kinds of high narrow tables would have been placed against the walls, their exact function depending on the room and the occasion. Here stands a long table with everted flanges and trestle legs in which are set openwork panels carved with coiling dragons. Next to the table is a three-drawer coffer with removable drawer runners to provide access to an additional storage area beneath. On the wall is a large hanging scroll, a format influenced by Buddhist banners and developed along with the chair-level mode so that paintings could ornament the walls for a special occasion and be viewed by several people at once. The older handscroll format (on the table in fig. 1.13) could be viewed only in small sections by one or two at a time.

Elevated furniture also demanded bigger houses, and consequently the architecture is loftier, with ceilings and windows higher than in mat-level times (compare with fig. 1.5). On the doors of the Astor Court the lattice does not extend all the way to the ground and would have been covered with oiled paper instead of the silk of earlier times.[26] Lattice doors, wooden room dividers, and openwork partitioning panels first began to be used in the late Tang dynasty.[27] With chair-level living, screens were inadequate as space dividers, and thereafter walls divided living spaces into rooms, their functions distinguished by their furnishings, as *Qingming Festival on the River* testifies. In effect, rooms came into being.

Another consequence of chair-level living was the new habit of keeping outdoor shoes on after entering a house. (When people sat on mats on the floor, they removed their shoes indoors.) The dirt that shoes tracked in inspired further changes: brick floors needed to be cleaned easily, and so new techniques were developed to make them smoother, stronger, and more level.[28] During the Han dynasty, platforms and mats for guests were arranged hierarchically, with the most important seat at one end, preferably facing

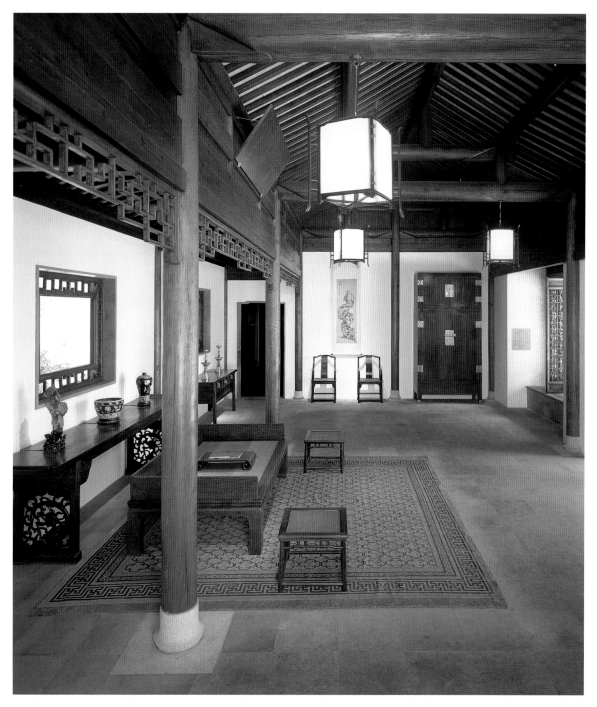

1.14

FIGURE 1.14 The Ming room,
the Metropolitan Museum of
Art, New York. Gift of the
Vincent Astor Foundation,
1980. Photo © 1982 The
Metropolitan Museum of Art,
New York.

south toward the sun, and lesser seats were in parallel rows in front (see fig. 1.1). By the Song dynasty chairs and stools had replaced mats, with stools placed farthest from the host for the less important guests. In place of the mat-level platform was a new chair-level type of furniture, the couchbed (*ta* or *luohan chuang*), which has a railing on three sides and, like the platform, is used for both sitting and sleeping.

The couchbed and other Ming dynasty furniture in the Astor Court are all made of hardwoods: the stools from *jichi* wood, the armchairs from *zitan* wood (the heaviest, densest, and most prized of Chinese cabinet woods), and the other pieces from *huanghuali* wood. Hardwoods were not widely used before the mid sixteenth century.[29] The furniture in *The Night Revels of Han Xizai* (see fig. 1.8) is black lacquer, and lacquer furniture continued to be popular, often used together with plain wood pieces in the same room.

The couchbed in the Astor Court has a small low table in the middle for holding books or tea utensils. That table is a smaller version of those used on *kang*s in north China. The *kang* is a high, hollow platform built against the wall of a room and heated—often by a kitchen stove in an adjoining chamber. In the late-Ming woodblock illustrations to the novel *The Plum in the Golden Vase* (*Jin ping mei,* chaps. 3, 4, 80, 81) and a painting by Shen Zhou (see fig. 11.5), the *kang* is shown against a side wall. In the Qing dynasty, *kang*s were commonly placed under the south windows.

They were usually made of brick or unbaked clay with a brick top. But in palaces such as the Forbidden City in Beijing, they were often made of wood, and the entire brick floor of the room was heated from underneath. In many places today *kang*s are still used for sleeping and daytime sitting. They are covered by a bamboo mat on which rugs and cushions may be placed, and they have their own low mat-level furniture consisting of small tables, cupboards, and shelves. People sit on *kang*s with their legs up (as in mat-level living) or pendant resting on a low stool (chair-level). Curiously, the *kang,* at the chair-level elevation, gave new life to the older mat-level practices. Only in China did the elevated form of living come together with the mat-level form—a poignant example of how in China even within revolution the continuity of tradition is strong.

As we have seen, the adoption of the chair-level mode of living marked a crucial point in Chinese history, with far-reaching causes and consequences. When people rose from the floor and began to sit in chairs around high tables, they introduced dramatic changes in the social customs of eating, working, and leisure. They sat in a room and a house that were likewise radically reshaped to accommodate the simple phenomenon of sitting high on a chair next to a table. Such elevation profoundly altered the lives of Chinese people, their surroundings, and, in both the physical and aesthetic sense, their vision of the world.

2 | A MING MEDITATION CHAIR IN BAUHAUS LIGHT

*I*n his famous essay "Kafka and His Precursors," Jorge Luis Borges proves that Kafka was not only influenced by his precursors, but was himself a defining influence on *them*. So too Borges, imbued with Franz Kafka's fantasy and magic realism, not only continues a Kafkaesque tradition but, because of his own eminence, also gives new definition and esteem to Kafka. In short, just as the past alters and affects us, so we alter and affect the past.

In good Borgesian manner, then, the Bauhaus gave us an aesthetic of plainness, austerity, minimalism, and geometric lines and spaces for understanding, judging, and even recognizing classical Chinese furniture. It is possible that the Bauhaus knew classical Chinese furniture and welcomed it, whereas it would have rejected ornate chinoiserie or Victorian bric-a-brac. Significant for our generation, however, is that the Bauhaus existed, that it dominated much of architecture and furniture design in Europe and America, and that it now provides us with a sympathetic eye for the magnificent plainness of the wooden household furniture sculpted by Chinese artists. By using the Bauhaus aesthetic—as opposed to that of postmodernism, which represents a return to complexity—the modern critic alters the traditional appreciation of this ancient Chinese tradition, putting Bauhaus and classical Chinese in vital harmony. Aiding the Bauhaus in altering our perception of Chinese pieces are the products of other artistic schools characterized by a similar geometric austerity— Spanish seventeenth-century domestic and monastic tables, chairs, benches, and chests; and American Shaker and contemporary Scandinavian designs.

The aesthetic resonance between Bauhaus and classical Chinese furniture is obvious when we compare Marcel Breuer's "Wassily" armchair (fig. 2.1) with a seventeenth-century Ming-style Chinese armchair (fig. 2.2). The chairs are similar in their basic form, minimalist use of materials, and geometric simplicity. The Chinese *huanghuali* wood chair was not revolutionary for its time; rather, it represented the perfection of a long tradition. Chairs of similar form had been used since the sixth century (see fig. 1.6), and the basic methods of wooden joinery were known before the fourth century B.C. (see fig. 1.2). Hardwoods such

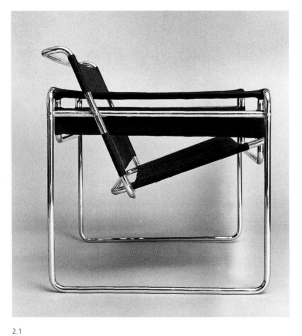

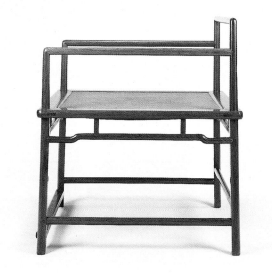

2.1

2.2

FIGURE 2.1 Marcel Breuer
(1902–81). "Wassily" armchair.
Late 1927 or early 1928.
Chrome-plated tubular steel
with canvas slings. Height
71.4 cm, width 76.8 cm,
depth 70.5 cm. The Museum
of Modern Art, New York.
Gift of Herbert Bayer.
Photo © 1999
The Museum of Modern
Art, New York.

FIGURE 2.2 Meditation chair.
Ming or Qing dynasty,
seventeenth-century. *Huanghuali*
wood. Height 84.5 cm, width
75.3 cm, depth 75 cm.
© Christie's Images,
Ltd., 1999.

as *huanghuali,* however, were widely used for furniture only after the mid sixteenth century. The use of hardwoods led to the construction of pieces with slender members and to other refinements in joinery and design. Each piece was individually made by hand, and each was expensive.

Breuer's chair was revolutionary because it was the first piece of furniture made from bent tubular steel, and soon after the creation of this prototype, steel-tube furniture became a popular mass-produced product. In both material and concept, Breuer's work exemplified a new idea of the chair as a comfortable, simply designed seat that could be mass-produced. Breuer was influenced by Gerrit Rietveld and other members of De Stijl, who saw furniture as "abstract-real sculptures" composed of simple geometric forms—cubic volume and interlocking planes in space. But unlike Rietveld, Breuer believed that seats should be comfortable and used elastic material to provide support without pressure.[1]

In China furniture making has always been treated as a craft, and until recently it was not collected as an art form. There is no theoretical literature connected

with furniture, a significant fact in a culture with a wealth of treatises on all sorts of things, from ink-stones to garden rocks to flower arranging to raising goldfish. Seen through Bauhaus eyes, however, classical Chinese furniture is an art. So the Borgesian principle of redefining and influencing our precursors prevails. The Bauhaus saw architecture, sculpture, painting, furniture, and domestic objects through the same aesthetic lens. Thus the Bauhaus empowers us to endow Chinese furniture with the aesthetic measures of art.

Although the Breuer and Chinese armchairs are made of different materials—steel and fabric, on the one hand; wood and cane, on the other—their frames are similar in shape, proportion, and slenderness. Both are practical chairs that are relatively light and easy to move. The construction—steel screws and wooden tenons—is clearly visible. There is no ornament, and the visual beauty of the furniture depends on the interaction between the plain geometric forms and the spaces between them. The designers did not think of solid masses but of space enclosed by lines and planes. In twentieth-century Europe this way of thinking was a radical concept derived from Japanese influences on architecture, but in China it appeared before the fourth century B.C. in the *Dao de jing*:

> Thirty spokes share the wheel's hub:
> It is the center hole that makes it useful.
> Shape clay into a vessel;
> It is the space within that makes it useful.
> Cut doors and windows for a room;
> It is the holes which make it useful.
> Therefore benefit comes from what is there;
> Usefulness from what is not there.[2]

In both chairs, the surfaces enclosing the spaces have their own linear beauty. Breuer described his chair as creating "pure, dazzling lines in the room,"[3] while the Chinese might have compared the slender wooden frame of their chair to forceful brush strokes in calligraphy. Both chairs are really three-dimensional sculptures meant to be seen from different angles. In the Chinese chair, the linearity of the form is light-

ened by the slight upward taper of the arms and legs and the restrained hump of the stretchers. At first glance all the members appear to be round, but on closer inspection the legs, top stretchers, and struts prove to be squared on the inside, and the base stretchers have a flattened elliptical cross-section. The austerity of the Bauhaus chair is relieved by the slant of the seat, which appears suspended in space within a network of lines and planes, yet is carefully designed so that the sitter never touches the steel framework. It reflects the relaxed but disciplined posture considered comfortable and proper at the time. As Walter Müller-Wulckow explained in 1932:

> The characteristic, ideal posture of any era can best be seen in how people sit. Whereas once it was the saddle or later the imposing attitude of the ruler that affected everyday life, nowadays it is the casual but tense position of a car driver, leaning back, with his legs stretched out, which unconsciously influences our imagination.[4]

In China, however, it was considered comfortable and proper to sit up straight with feet resting on the chair's front runner or on a separate footstool (see fig. 2.9), or with legs up in a kneeling position (see fig. 1.6), or in a meditation posture (see figs. 2.6, 2.7, 2.8). Sometimes this type of chair was used with a slanting wooden or mat backrest, which, despite its visual similarity to the back of the Wassily armchair, results in a different posture for the seated person, since the seat is flat rather than angled (see figs. 2.8, 2.9, 2.10).

The Wassily armchair was named after Wassily Kandinsky, for whose house in Dessau it was originally designed. The house was one of a group of Master's houses built by Walter Gropius in a pine wood near the Bauhaus building. Like the furniture, the houses were unornamented functional geometric forms (fig. 2.3). There was a perfect balance between the solid masses and the surrounding spaces. The exterior formed an incisive pattern with its flat roof, plain surfaces, and frameless doors and windows. This severity was relieved by the changing play of light and shadow created by the reflection of the surrounding

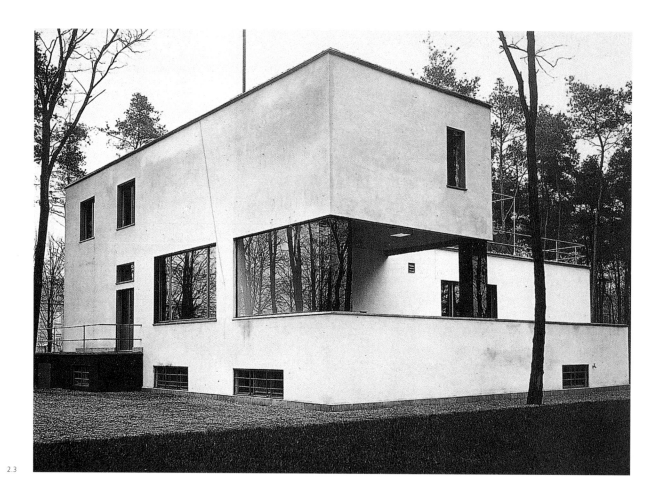

2.3

trees on the glass studio walls and white surfaces. When first built, these buildings seemed shockingly cold and stark, but their innovation prevailed. Now this aesthetic has become an accepted part of modern architectural design. Aesthetically, Bauhaus modernity is similar to the calm, meditative geometric clarity of the Chinese chair, which cast ever-changing shadows on the plain walls of the Ming interior (fig. 2.4).

The architecture and furniture of the Bauhaus was part of the twentieth-century modernist revolution. Bauhaus designers reacted against the fussy surfaces of the Victorian period by removing surface concealment to reveal underlying geometric forms. This return to elemental plainness began with the Postimpressionists Gauguin, Van Gogh, and Cézanne, who continued the use of natural light and color dis-

covered by the Impressionists while rejecting their soft, light-filled, fleeting surfaces. Influenced by the color planes of Japanese prints, the Postimpressionists saw elemental geometric volumes under nature's surface, and their obsession with unadorned structure led directly to the cubist analysis of Braque and Picasso.

By this time, the experimental modernist movements in all the arts were rejecting what they saw as the decorative frills of the nineteenth century in favor of primary forms. Hence, in poetry the intricate prosody and rhetoric of Swinburne and Rossetti had run its course. Using the model of Chinese and Japanese poetry introduced by the translations of Amy Lowell in America, Arthur Waley in England, and Judith Gauthier in France, the imagist poets Ezra Pound, H.D., and William Carlos Williams revolutionized

poetry in the West, producing a poetry of uncluttered images perfectly in keeping with the essentialism of modernist architecture and furniture. In part, the Bauhaus was successful because it captured the spirit of a world movement whose ancestry also included the early-twentieth-century enthusiasm for primitive art and ancient architecture. Moreover, the Bauhaus had an obvious coincidence of taste with the measured forms of classical Chinese furniture.

Classical Chinese furniture is now seen to anticipate Western furniture of the twentieth century; in the eighteenth and nineteenth centuries the West would have regarded it with a much less sympathetic eye. Ornate lacquered furniture and elaborately carved pieces first attracted European collectors, who were influenced by the *chinoiserie* taste for exoticism. For Odilon Roche, the author of the first book on Chinese furniture (*Les meubles de la Chine,* published in 1922), lacquered furniture was the furniture of China. Not until 1940 did John C. Ferguson, in his *Survey of Chinese Art,* discuss both plain and lacquered wood furniture. And only in 1944, with the publication of Gustav Ecke's *Chinese Domestic Furniture,* did simple hardwood furniture become equated with the whole of Chinese furniture. Ecke grew up in Germany when the Bauhaus and other modernist movements were flourishing, and he studied fine arts, literature, and philosophy at the universities of Bonn, Berlin, and Erlangen. Thus he was naturally attracted to the minimally decorated geometric forms and subtle beauty of what has become known as Ming-style furniture or classical Chinese furniture. These terms are not necessarily limited to pieces actually made in the Ming dynasty, and they refer to only one style of furniture used at that time, excluding the more ornate lacquer and carved wood pieces. George Kates, Laurence Sickman, and other foreigners living in Beijing in the 1930s and '40s also bought Ming-style furniture for their homes, and later many of those pieces were taken to the West, where they set the standard for private collectors and for collections in American museums such as the Nelson-Atkins Museum in Kansas City, the Philadelphia Museum of Art, the

2.4

FIGURE 2.3 Walter Gropius (1883–1969). Gropius's house, Dessau, 1925/26. Photograph by Photothek, Berlin. Bauhaus-Archiv Museum für Gestaltung. From Droste, *Bauhaus,* 126.

FIGURE 2.4 Three-quarter view of fig. 2.2. From Handler, "A Ming Meditation Chair," fig. 5.

2.5

FIGURE 2.5 Model showing the joinery of the arm of the meditation chair in fig. 2.2.

Metropolitan Museum of Art in New York, and the Museum of Classical Chinese Furniture in California. Since 1944 this furniture has been the focus of most Chinese and Western writings; Michel Beurdeley and Craig Clunas are among the few who remind us that lacquered furniture was equally, or even more highly, valued in Ming China.

Thus the Bauhaus aesthetic has significantly altered our perception of Chinese furniture, causing us to admire especially the most geometric and minimal pieces, such as the armchair in fig. 2.2. The exceptionally slender construction of this chair is possible because of an unusual joint (where the arms meet the front posts and the top rail meets the back stiles) consisting of a full-length mortise and tenon with half-lapped miters (fig. 2.5). This type of strong, sophisticated joinery was perfected in the Ming dynasty, when hardwoods were commonly used. The union of clever joinery and strong hardwood permitted the ultimate development of the meditation armchair.

The earliest known depictions of armchairs in China are all in a Buddhist context. In the far right of a scene on a mid-sixth-century stele in the Nelson-

Atkins Museum of Art, an abbot or high prelate is shown seated on his knees (*weizuo*) on an armchair.[5] The armchair is similar in design and proportions to the seventeenth-century chair in fig. 2.2, except that the long arms extend beyond the front posts, and there are no high stretchers. A depiction in Dunhuang cave 285, dated 538, shows a meditating monk in the same posture on a chair with a high back, solid panels beneath the arms, and a woven seat (see fig. 1.6). Thus as early as the sixth century there were both low- and highback meditation chairs.

Sixth-century Buddhist texts indicate that these meditation chairs were called "woven seats" (*shengchuang* or *shengzuo*). The term first appears in the biography of Fotudeng in Huijiao's *Lives of Eminent Monks* (*Gaoseng zhuan*), written between 519 and 554. Here we read that the Central Asian monk sat down on a *shengchuang,* burned incense, and chanted an invocation to exorcise an evil dragon.[6] Meditating monks sat in the lotus position (*jiejia* or *jiejia fu*) on woven seats in peaceful natural settings removed from the noise and bustle of the world. Yang Xuanzhi, in his *Record of Buddhist Monasteries in Luoyang* (*Luoyang qielan ji*), completed in 547, describes the meditation building in a beautiful garden beside the Jinglin monastery in the bustling city of Luoyang:

> To the west of the monastery was a garden rich with exotic fruit-trees where was unbroken song from the birds in spring and the cicadas in autumn. In the garden was a meditation building containing Jetavana cells which although tiny were exquisitely built. The stillness of the meditation room, the remote calm of the cells, the splendid trees framing the windows and the fragrant azaleas around the steps gave the feeling of being in a mountain valley rather than a city. Monks practiced stillness on rope seats [*shengzuo*], eating the wind and submitting to the Way as they sat cross-legged and counted their breaths.[7]

By the ninth century scholars and important officials as well as priests and monks used chairs. The great Tang poet Bo Juyi (772–846), a Buddhist layman, writes of lounging on his meditation chair, called a "woven seat":

I've talked out a thousand poems.
My heart's life is in the Buddhist carriage.
I sit lounging on a woven seat, chanting to myself.
In my previous life I was a monk poet.[8]

Bo's lines suggest that by this time meditation chairs might have been used in some homes. The Japanese Buddhist monk Ennin, who traveled in China between 838 and 847, repeatedly refers in his diary to priests and high officials sitting on chairs.[9]

Deities also sat on large armchairs, and one was made in 1087 as a seat for the statue of Yi Jiang in the Hall of the Sage Mother (Shengmudian) in the Jinci temple, Taiyuan, Shanxi province (fig. 2.6). Yi Jiang was the wife of King Wu, founder of the Zhou dynasty, and the mother of the first lord of the state of Jin, hence her name Sage Mother and her worship in this Jin memorial temple. Her almost-life-size painted clay statue, together with those of forty-two attendants dressed in the Song fashion, is believed to have been commissioned by the dowager empress Liu (969–1033), who wished to identify herself with this virtuous female ruler of antiquity. Since the Shengmudian is built over one of the springs that are the source of the Jin River, Yi Jiang was also popularly worshiped as a rain deity.

An inscription discovered in the 1950s on the base of this statue of Yi Jiang says that in 1087 the Golden Dragon Society of Taiyuan prefecture provided the Sage Mother with a seat (*zuowu*) as an offering from its members.[10] The lower part of the seat is the typical waisted, painted platform that forms the base for many Buddhist statues. The upper structure is exactly like the top of a large wooden armchair. The wide back has a high central section with a curving top rail ending in phoenix heads, which often adorn objects used by the empress. Phoenix heads, painted green and gold, are also found at the ends of the curving lower back rails and the arms. The front posts are shaped and fluted. Compared to the Ming armchair, with its stark geometries, this chair is more complex and curvilinear in design and has more intri-

cate, delicate profiles. Yet both chairs have a sense of spaciousness.

This same spaciousness is also found in armchairs depicted in Song dynasty portraits of Buddhist monks, such as the long handscroll of Buddhist images by Zhang Shengwen, a devotional painting created between 1173 and 1176 at the court of the kingdom of Dali (in present-day Yunnan province). This painting, exquisitely drawn in subtle colors, sensitively depicts the faces of the monks and details of the furniture and landscape. About 470 Bodhidharma, the first patriarch of the Chinese Chan (Zen) Buddhist sect, is said to have brought the teachings from India to China. He is shown reading a sutra while seated on a rustic yokeback armchair fashioned from gnarled branches (fig. 2.7). This simple, natural material creates a fitting seat for an otherworldly monk. The design of the chair is exactly like that of sophisticated lacquered or hardwood pieces. Elsewhere in the painting monks are shown seated on similar chairs made from bamboo or plain wood cut into straight square-cut members.

It is impossible to lean back comfortably in these large armchairs because of their deep seats and horizontal back rails, so they are often used with separate backrests, which are sloping and higher than the back of the chair. An example can clearly be seen in an illustrated edition of Buddhist moral stories (fig. 2.8). This chair is similar to classical Ming furniture in its minimal geometries. Its arms are short and supported by a pair of parallel front posts and side stretchers with one central strut. Like the chair in fig. 2.7, it is used with a separate rectangular footstool. The meditating monk sits in the lotus position.

Sometimes the backrests are composed of wooden frames with headrests and paneled slats like Ming yokeback chairs, as can be seen in a painting attributed to the Song dynasty painter Liu Songnian but which was probably executed in the mid fifteenth century (fig. 2.9). The chair resembles the seventeenth-century armchair in figs. 2.2 and 2.4 except that it has only one high straight stretcher on each side and no struts. It is possible that the seventeenth-

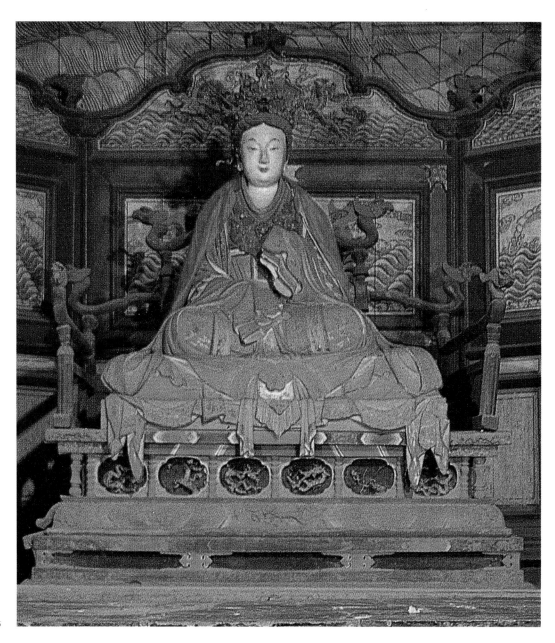

2.6

century chair also was made more comfortable by the addition of an elegant *huanghuali* backrest. A chair of similar proportions, but somewhat less minimalist in style, is illustrated in an advertisement in the September 1994 issue of *Orientations*. The chair has a removable cane backrest, in a *huanghuali* frame, which hooks onto the back rail. Since the back rail on the chair in figs. 2.2 and 2.4 has been replaced, the traces of wear indicating the use of a similar backrest can no longer be found.

In the Ming painting (see fig. 2.9), a gentleman is sitting on the chair, with his feet resting on the foot rail, enjoying the peaceful beauty of his garden. The setting suggests that this type of large simple armchair was used in a secular as well as a religious context and could be sat on with legs up or down. On

2.7

2.8

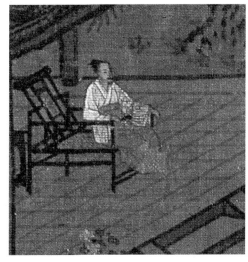

2.9

FIGURE 2.6 Yi Jiang seated on a chair. Northern Song. Statue: Tiansheng era (1023–32). Painted clay. Chair: 1087. Wood. Shengmudian, Jinci, Shanxi. From *ZGMSQJ, Diaosu bian 5: Wudai Song diaosu bian*, 92.

FIGURE 2.7 Zhang Shengwen. Bodhidharma. 1173–76. Detail of a long handscroll of Buddhist images. Ink and color on paper. Height 31 cm. National Palace Museum, Taipei.

FIGURE 2.8 Woodblock illustration to *Efficacious Charms from the Tianzhu* (*Tianzhu lingqian*), Jiading reign period (1208–24). From Zheng Zhenduo, *Zhongguo gudai banhua congkan* 1: 296a.

FIGURE 2.9 Attributed to Liu Songnian (c. 1150–after 1225). *Four Landscape Scenes*. Ming copy or imitation. Detail of a handscroll. Ink and color on silk. Palace Museum, Beijing. From *ZGLDHH, Gugong Bowuyuan canghuaji* 3: 74.

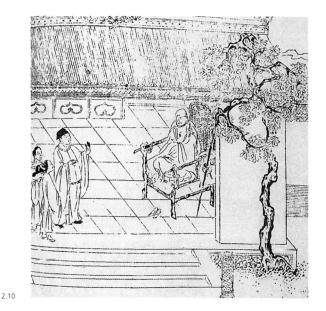

FIGURE 2.10 *Ximen Encounters a Barbarian Monk.* Ming dynasty. Detail of a woodblock illustration to *The Plum in the Golden Vase* (*Jin ping mei*), Chongzhen reign period (1628–44), chap. 49.

other occasions this same gentleman might have sat here in his garden pavilion meditating in the lotus position, or when slightly drunk on a hot summer day he might have sat with his legs up, wearing loose informal dress and cooling himself with a fan, in a manner comparable to Han Xizai toward the end of a night of revelry. At the beginning of the famous twelfth-century handscroll *Night Revels of Han Xizai* (see fig. 1.8), we see Han seated on a couch, properly dressed in gown and hat. But later in the scroll Han is shown without his outer robe, his chest exposed, and he is sitting with his legs up on a large yokeback side chair surrounded by alluring young women. Chinese furniture is commonly used in different milieus on different occasions—for contemplating the garden, for religious meditation, and for loafing and flirting.

Armchairs with low backs are known today as "rose chairs" (*meiguiyi*) in north China and "writing chairs" (*wenyi*) in the south. Usually they are small and rather delicate and so are considered suitable for ladies. But in woodblock illustrations we also see men using them. The rose chair in figs. 2.2 and 2.4 is unusual because of its large dimensions. It is certainly suitable for meditating in the lotus position, as is the large "abbot's chair," with its round back above solid panels, in the Philadelphia Museum of Art.

Large chairs are called "meditation chairs" (*chanyi*) in Ming dynasty writings, such as the *Classic of Lu Ban* (*Lu Ban jing*) and Gao Lian's *Eight Discourses on the Art of Living* (*Zun sheng ba jian*). However, as Gao explicitly states, the term refers to a highback chair:

> A meditation chair is half as big again as an ordinary chair. Only the "water polish" ones are fine, though speckled bamboo is also possible. In this style the horizontal rail for pillowing the head at the top of the back needs to be broad and thick before they are acceptable for use.[11]

Wen Zhenheng, in the section on meditation chairs in his *Treatise on Superfluous Things* (*Zhang wu zhi*), does not write about the form but says that they are made of cane from Mt. Tiantai (Zhejiang province) or of naturally gnarled timbers. There are no extant early examples of these chairs, but they are depicted in illustrated books such as *The Plum in the Golden Vase* (*Jin ping mei*), in which Ximen Qing meets a foreign monk seated in the lotus position on a gnarled wood armchair with a mat backrest (fig. 2.10). *The Plum in the Golden Vase,* also known in English as *The Golden Lotus,* is a renowned erotic novel first published in 1618. It is a cautionary tale recounting the excessively luxurious and debauched life of Ximen Qing, a corrupt wealthy merchant, and his wives and concubines. Full of detailed descriptions, it is a wonderful source for information about sixteenth-century life. In the late Ming it was illustrated with woodblock prints and in the late seventeenth century with a series of paintings.[12]

In connection with gnarled wood and rattan furniture we find a rare recorded name of a Ming furniture maker, Wu Popiao. The only other name that has

so far come to light is Liu Jingzhi, who is listed under the heading "Skilled Hand in Small Wood" (i.e., the making of such things as furniture, partitions, windows, and screens), in Zhou Hui's *Details of Nanjing* (*Jinling suo shi*), published in 1610.[13] Wu Popiao is the *hao* (pseudonym) of the Daoist painter Wu Ruzi (died c. 1572), a man respected by the Jiangnan literati, who recorded incidents from his life and appreciated the furniture he made from rustic and natural materials.[14] Tu Long, in his 1607 *Desultory Remarks on Furnishing the Abode of the Retired Scholar* (*Kao pan yu shi*), writes about the famous craftsman's cane meditation chairs:

> I have often seen meditation chairs made by Wu Popiao. He fashioned them of cane from Mt. Tiantai and used Dali marble for the backs. When the person sitting in one is a priest, the luster of his subtle art is incomparable.[15]

Gao Lian describes a gnarled wood armrest, made by his friend Wu Popiao, in which the wood is naturally twisted so that it forms a semicircle and has three protuberances, growing at right angles, which form the legs.[16] Both Buddhist monks and the literati appreciated the use of materials left in their natural state; in creating such a rustic piece the craftsman has truly matched his innate nature with that of the tree. Those who sit or lean on it are closer to the Dao of the tree and thus to all nature.

As the Bauhaus reflects a unifying aesthetic of minimal geometries, so the Chinese meditation chair becomes an example remarkably similar in form to the aesthetic that in the twentieth century has dominated the arts in America and Europe. The Chinese chair's historical connection with meditating Buddhist monks permits us to call it a meditation chair, and, indeed, in its calmness and profundity it, like the Breuer chair, appears to be a meditating structure. The quiet geometries of the Chinese and Breuer chairs resonate in harmony. It is entirely appropriate that these two masterpieces of furniture sculpture should be seen historically in one aesthetic light and that they come to life together, meditating before the eyes of contemporary viewers.

3 | GEORGE KATES DISCOVERING CHINESE FURNITURE DURING THE YEARS THAT WERE FAT

*S*tudents and connoisseurs of Chinese hardwood furniture are indebted to George Kates both for his scholarly work and for his sensitive understanding of China and Chinese culture. His modest yet penetrating book, *Chinese Household Furniture,* his pioneering exhibitions, and his widely read magazine articles introduced classical Chinese furniture to the West. Because of his intimate knowledge of China, he could present this furniture not only as a series of beautiful objects, but as the product of one of the world's great civilizations as well. More than anyone else, he placed the furniture in its context and saw it as part of a way of life.

Kates's study of Chinese furniture was only one of many interests that flowered as a result of his seven-year sojourn in pre-Communist Beijing. Years of travel and study prepared him for that experience, which, as he later wrote in his memoir, *The Years That Were Fat,* "granted to me the very meaning of my life."[1]

George Norbert Kates was born in 1895 in Cincinnati, Ohio. His father, a successful industrialist, was a Polish Jew; his mother was of German ancestry. During his youth Kates traveled extensively in Latin America, Europe, Australia, and South Africa; with the help of a succession of European governesses, he easily learned French, German, and Spanish. He attended private schools in Mexico City and New York and served in the U.S. Army in France and Germany during World War I. Thanks to these varied experiences, Kates became cultured and cosmopolitan, a frequent visitor at the great houses in Newport and the favorite of elderly society ladies. But Kates was also, by bent and training, a preeminent scholar.

He began by studying architecture at Columbia and then, after the war, transferred to Harvard. There he first became interested in China, meeting the famous French Sinologue Paul Pelliot, who was teaching at the Fogg Museum. In 1922 he graduated summa cum laude and went on to Queen's College, Oxford, to take a Doctor of Philosophy degree in European History and Fine Arts. It took him almost eight years to complete, because in

1927 he began to divide his time between the traditional intellectual world of Oxford and the film studios of Hollywood, where he was a cultural consultant for Paramount.

For a time he was stimulated by the piquant contrast between these two spheres, but eventually he became disenchanted, feeling that he was losing his integrity between the "snobbery" of Europe and the "vulgarity and greed" of Hollywood. In the spring of 1932, as the stock market crash began to affect Hollywood, he moved to Rhode Island, where he bought and restored a mid-eighteenth-century house. Here he spent the winter alone, reflecting and reading. His reading included some of Pearl Buck's novels and Arthur Waley's translations of Chinese poetry. The poetry was a revelation to him, bringing him what he called "a pure new joy" and giving a different direction to his life. He began to teach himself Chinese and, encouraged by Langdon Warner, the well-known Harvard professor of East Asian art history, by the end of the year had booked passage on a ship to China. Thus in 1933 began seven years of tranquility and abundance.

At first he stayed in the Beijing Language School, studying Chinese with a group of earnest missionaries. Before long, however, he realized that he wanted to experience the essence of old China by living in the traditional manner of the Chinese gentleman-scholar. "I would treat Peking as Paris," he wrote. "There, in time gone by, I had once lived very simply, much nearer to the heart of Gallic France than my friends of passage, perched during their short journeys in more fashionable parts of the city. Peking as Paris it would be for me, for speech and daily communication, for food and shelter as well, and even—if self-consciousness did not interpose—for dress and other matters of local custom."[2]

At that time China attracted many cultured foreigners—political idealists, writers, and aesthetes—who found they could live well on little, enjoying the refined existence perfected over the centuries by the Chinese upper class. The English aesthete Sir Harold Acton remained for some time and learned Chinese, describing his stay in *Memories of an Aesthete* (1948). In 1939 the English author Osbert Sitwell published *Escape with Me! An Oriental Sketch-book,* and later the Greek novelist Nikos Kazantzakis recorded his impressions of China, which he had visited in 1935. But it was Kates, perhaps more than any other Westerner, who deliberately and single-mindedly became Chinese. In the Legation Quarter his ways were dismissed as "going native," and because he began to avoid the expatriate dinners at which he was in great demand, he was dubbed "the Oyster."

His Chinese idyll began in earnest when he moved into a dignified three-courtyard dwelling within the Imperial City. It was old-fashioned, without running water and electricity, but its beautiful tracery windows were intact. Here he installed himself with his two Chinese servants (who spoke no English) and ran the household in the traditional manner. Gradually he furnished the house in an unpretentious, elegant manner with hardwood furniture, fabrics that changed according to the season, metalwork, red lacquer, finely colored rugs, calligraphy, and paintings. His taste, as his teachers and servants made clear, accorded perfectly with that of the old scholar class.

Kates had lost nearly all his Hollywood earnings when the brokerage firm in which they were invested went bankrupt, but in inexpensive Beijing he could nonetheless live a leisured life "composed of hours that were tranquil rather than agitated, made of peaceful enrichment rather than the excitement of adventure."[3] He hired private tutors and, by cultivating the Confucian teacher-student relationships, learned a great deal about traditional culture. He soon became proficient enough to attend classes in Chinese and history at Beijing University and to do original research using Chinese sources.

He was particularly fascinated by the harmonious regularity of the layout of Beijing and its palaces, lakes, and gardens. He passed so much time in the Forbidden City—savoring its changing times and seasons—that he was given a special pass and allowed to see many sections normally closed to visitors. He searched the palace archives and museum library for informa-

tion about the history of the city and its buildings. One result of these studies was the article "Prince Kung's Palace and Its Adjoining Garden in Peking," which he wrote with H.-S. Ch'ên and published in *Monumenta Serica* in 1940. This scholarly yet beautifully written article is still unsurpassed in its blending of architectural and social history to present a vivid picture of a uniquely Chinese world and way of life.

For seven years Kates was able to live in his house in old Beijing, adhering to a vanishing way of life and ignoring the political conflicts of modern China. Those years passed in the growing and delighted mastery of the Chinese language, in the discriminate acquisition of beautiful objects, and in an ever increasing appreciation of the Chinese people and of traditional Chinese values. But at last he was forced to succumb to the great turbulence that surrounded him. Threatened both by Japanese aggression and by the domestic struggle between the Communists and the Nationalists, Beijing became so unstable that in early 1941 the United States Embassy requested its nationals to leave the city. Thus ended for Kates "the years that were fat."

On his return to America, Kates continued to work out all the professional and personal aspects of his life in China. He was a Guggenheim Fellow at the Library of Congress from 1942 to 1943 and supervised the archives sent from the Chinese National Library in Beijing. His research resulted in the article "A New Date for the Origins of the Forbidden City," which was published in the *Harvard Journal of Asiatic Studies* in 1943. This detailed and scholarly article, written in his usual lively style, proves that the Forbidden City is on the site of a Jin (1115–1234) palace that was the summer residence of the court, not as previously thought on a new site selected by Kublai Khan (1215–94). In the spring of 1945 he returned to China to replace John Fairbank as director of the American Publications Service in the U.S. Embassy in Chongqing. Returning to America, he attended the San Francisco Conference, which established the United Nations, and did linguistic research for the United Nations Secretariat.

For the next five years Kates was involved with Chinese art. He organized an exhibition of Chinese furniture that opened at the Brooklyn Museum of Art on February 21, 1946. One of the purposes was to dispel the prevalent notion that all Chinese furniture was of the ornate palace type. Some thirty-five pieces from Kates's own collection were displayed to show the sort of plain polished furniture, usually of hardwood, that would have been used in private homes where, as he later wrote, "means were ample and taste was good."[4] To demonstrate how seat coverings changed according to the seasons, some cane seats were left uncovered and others had brocade or red wool cushions. Photostatic enlargements of contemporary dated sixteenth- and seventeenth-century woodblock illustrations (from the Spencer Collection in the New York Public Library) were displayed beside the pieces to show how they would have been used and help establish the chronology.

In early 1947 Kates became curator of Oriental art at the Brooklyn Museum, a position he held for two years. He also lectured widely and gave two series of talks at Parson's School of Design in New York City: "Chinese Household Furniture" and "Chinese Household Furniture and Its Suggestions for Modern American Houses." On February 11, 1949, his exhibition "Chinese Metalwork" opened at the museum. Here he showed a selection of small objects, mostly from his own collection, "commonly used in traditional Chinese life to minister to the purposes of daily living"; included were metal fittings and mountings for furniture. Both exhibitions were original and imaginative, presenting Chinese art in the context of daily life. This approach has only recently begun to attract the attention of Chinese art historians.

Kates's furniture exhibition led to the publication in 1948 of his book *Chinese Household Furniture*. The book began in Beijing in the winter of 1937–38, when Kates's sister Beatrice, a New York interior decorator, and Caroline Bieber, an Englishwoman who was adapting Chinese jewelry and metalwork to make Western costume jewelry, selected and measured the best examples of furniture in the homes of the for-

eign community. Hedda Hammer Morrison, a professional photographer, joined them. The furniture they investigated, of simple elegant design, appealed to the Bauhaus-influenced taste of the time, and many foreigners were buying and restoring old pieces for their own use.

Four years earlier in Beijing Gustav Ecke had published *Chinese Domestic Furniture* in a limited portfolio edition with excellent large photographs. This was the first book in any language on Chinese hardwood furniture. But Kates's *Chinese Household Furniture* was the first widely accessible, popularly priced book on the subject and had as its "primary object to make clear how these pieces were designed, how they fitted into traditional Chinese life, and how today they can fit into our own."[5] Using book illustrations and his own experience, Kates describes how the different pieces were used. He discusses the history of Western interest in Chinese furniture, noting that the Chinese considered furniture a craft and hardly mentioned it in their writings. He reviews the furniture types and their histories. He clearly summarizes all that was known at the time about the furniture and raises the basic issues and problems in the field, many of which remain unanswered today. More than anyone before or since, he was interested in the use of furniture in daily life. The pieces he illustrates are for the most part different from those in Ecke's books, although both Ecke's *Chinese Domestic Furniture* and Kates's *Chinese Household Furniture* are based on the collections of foreigners in Beijing. It is significant that foreigners living in China in the 1930s and 1940s were the first to collect and write about domestic furniture, and only as a result of their interest did the Chinese begin to write on the subject.

In 1949 and 1950 Kates published a series of eight articles on Chinese hardwood furniture in the London magazine *The Antique Dealer and Collectors' Guide.* Kates discusses the furniture by type, and the series includes material from *Chinese Household Furniture* combined with some interesting new observations and previously unpublished woodblock illustrations. He contributed an article on Chinese household furniture to the April 1949 issue of *House & Garden,* which is devoted to the Far Eastern influence in contemporary interior decoration and also includes articles on Chinese furniture in contemporary rooms, contemporary furniture influenced by the Far East, and Ming furniture used in modern groupings in Robert Drummond's residence in Beijing. Throughout this issue are reproductions of Chinese woodblock illustrations and pictures of Chinese metalwork taken from Kates's Brooklyn Museum exhibitions. The very existence of such an issue of *House and Garden* suggests that Kates's publications, exhibitions, and lectures had far-reaching influence on the furniture design and interior decoration of the day. He was the main source of their China orientation.

For Kates the first years after his return from China were lean and bleak. But gradually he turned his loss into gain, writing about his life in China in *The Years That Were Fat: The Last of the Old China.* Here he describes his servants and teachers, the streets and shops of Beijing, and his own unmodernized courtyard house. He records the impressions he gathered during his long wanderings through the city, painstakingly reconstructing the history and original aspect of the Forbidden City, the imperial lakes, the Summer Palace, and the Western Hills on the basis of his research in the Chinese archives. Immediate and particular in reference, this account conveys the overriding warmth and affection he felt for those "fat years." The writing of this extraordinary memoir seems to have released him from a sense of deprivation; only after he had gathered the wealth of those years in book form could he leave China and life there behind him. China had been a universe, not merely an object of study. He movingly comes to terms with his two worlds, China and the West, in the eloquent last pages of his book:

> Yet my admiration for the Chinese system, which in so many ways had enlarged and helped to free me, was never absolute. I had learned, not from China as it actually was, but from what it had been in its great past; from simple souls, the children of its soil, eager in pleasure and enduring sorrow—who today were only passive material in the hands of stronger and

far less admirable characters. There was thus no call to continue back in the West to "Sinify" myself, to evade responsibility in the pretended interest of some spiritual custodianship, while actually fleeing from reality.

Nor had I ever felt tempted to jettison the values of earlier years, spent in contemplation of worlds other than Chinese, worlds to which I was now by destiny returned. I was of the West, of the one global civilization of our time. I had no thought to struggle against this, and silently took facts as I found them. Unlike those about me, however, I was aware that across the seas I had stumbled across a true discovery; and in happy years there I too had known bliss as from "Another Cave of Heaven."[6]

Thereafter, as his finances became "lean," he sold his Chinese furniture and returned to his Western heritage, pursuing varied aesthetic, historical, and literary interests in Europe, the Middle East, and America. He lived for a time in Russia and became proficient in yet another language. He edited and wrote studies for collections of the works of Willa Cather and also wrote an unpublished study of Elizabeth (1837–98), the tragic empress of Austria and Queen of Hungary who was assassinated by an Italian anarchist. Thereafter, moving from country to country, city to city, room to rented room, he read, studied, wrote away, and persisted in a slow, largely undocumented three-decade retreat from public life as he disappeared, quietly and elegantly, in the West.

Kates faded so completely that he was generally assumed to be dead. We have a final glimpse of him, however, in Fergus Bordewich's *Cathay: A Journey in Search of Old China*. In the early 1980s Bordewich had taught journalism in Beijing, but he found China disappointing, feeling that "something crucial had been lost, or at least hidden." Later he determined to discover how much of Old China had survived. Quite by accident he came across a copy of *The Years That Were Fat* in a secondhand bookstore and was so enchanted that he became "almost obsessed" with Kates. After discovering that Kates was alive, Bordewich went to see him in a Connecticut nursing home a few years before Kates's death in 1990. "The portly man I found inside was confined to a wheel chair," observed Bordewich. "What must once have been a rather austere face had collapsed into waves of loose flesh. Nevertheless, his heavy-lidded gaze was acute and intelligent. His grace of manner was recognizably more Asian than Western and immediately made me think of his description of the literary Chinese upon whom he had modeled himself, whose personalities had been 'rubbed' to remove the 'rasping edges of speech and manners.'"[7]

Kates talked lovingly and in detail about China, taking from a drawer the few small objects, lustrous with much handling, that were all that was physically left to him from those years. Although China occupied his thoughts, Kates was not nostalgic. The composure and patience he had learned in the East are evident in these words to his visitor: "Don't think of me as being desirous of going back to China, Mr. Bordewich. The China I knew is no longer there. But the West I knew is no longer there either. The Harvard I knew is no longer there. Nor is the Hollywood I knew. I have no longing or homesickness for a world that's gone. It's gone for everybody. I could make a life of nostalgia for myself, but I regard that with distrust. We have a duty to live in the present, and I want to live on pleasant terms with it."[8]

CHAIRS

4 | A YOKEBACK CHAIR
FOR SITTING TALL

*T*he Chinese yokeback chair is the stately seat of Buddhists, deities, royalty, and important people. Surmounted by a long horizontal rail extending beyond the back posts, its high back forces the occupant to sit up tall in a dignified and commanding posture. Moreover, because its form has a strong vertical emphasis, it elevates and empowers the person seated on it. The yokeback is either an armchair or, without arms, a side chair. One of the earliest types of Chinese chairs, this seat became the most popular model in the Middle Kingdom.

The first depictions of yokeback chairs occur in Buddhist contexts. A painting in Dunhuang cave 285, dated 538, shows a meditating monk seated in a kneeling posture on a chair with a high back and straight yoke (see fig. 1.6). There are solid panels beneath the arms and a woven seat. The vertical members appear to be square with a slight upward taper, as in the chairs in later Chan paintings. Although this type of chair appears suddenly in the sixth century in this highly developed form, with no earlier models, it most likely evolved over time.

The early history of the yokeback chair is still clouded in documentary mist. Many writers have discussed the origins of the chair in China and point out that early terms relating to seats and sitting suggest a foreign reference.[1] There is insufficient textual and visual evidence, however, to prove that the earliest Chinese chairs were imported or based on foreign prototypes. All we can be sure of is that the first known depictions of chairs in China are all connected with the imported Buddhist religion. In addition, we know that by at least the fourth century B.C. the Chinese had contact with chair-using peoples, such as the nomads living in the Altai Mountains in southwestern Siberia.

In 1948 Sergei Rudenko began excavating *kurgan* (tumulus) 5 in the small trading town of Pazyryk. As with other tombs in the area, water seeped into the stone mound shortly after burial and turned to ice, thus preserving the corpses as well as the wooden, leather, and cloth grave goods. Among Rudenko's extraordinary finds was a large felt hanging with appliquéd ornament (about 4.5 by 6.5 meters). John F. Haskins has conclusively shown

FIGURE 4.1 Detail of a felt yurt
screen. C. 350 B.C. Excavated
from *kurgan* 5, Pazyryk, Siberia.
Approximately 450 cm ×
650 cm. Permission of
Willis Barnstone.

that this felt served as a windscreen for a yurt.[2] It
was supported by long poles thrust through loops
on the back of the screen and topped by extraordi-
narily beautiful three-dimensional felt sculptures of
yellow and black swans. The screen is decorated with
a repeated scene of a mounted horseman facing a
seated figure holding a blossoming branch (fig. 4.1).
Rudenko believes that the figure is a goddess,[3] but
Haskins has doubts because it is bald. The seat is a side
chair with turned legs and a back that curves back-
ward at the top and ends in a pointed ornament. In
the same *kurgan* was found a rare piece of Chinese
silk embroidered with a bird-and-flower motif typi-
cal of the southern state of Chu.[4] Mounted on felt,
it was used as a saddle blanket. Thus we know that
the people of this region possessed Chinese luxury
goods; objects from other *kurgan* also show Chinese
influence. The Chinese in turn might have had some
knowledge of this nomadic culture.

The feet of the figure seated on the chair on the
Pazyryk felt screen rest on the ground. In China,
however, early representations of Buddhists sitting on
yokeback chairs show them with their feet resting on
the front stretcher of the chair or in a kneeling or lo-
tus position with their feet up. Both positions appear
in a late Tang painting in cave 196 at Dunhuang (fig.
4.2). In this iconic depiction of Śāriputra, the Bud-
dha is surrounded by adoring monks from many
different nations who, like the believer viewing the
mural, are worshiping his wisdom and learning. Two
of the monks, clearly important ones, are seated on
armchairs with curved yokebacks, the chair's arms
protruding beyond the front posts, tapering legs, and
low stretchers. During this period yokeback chairs
were probably called by the modern Chinese term *yi,*
since this is the word Ennin uses repeatedly in his di-
ary when referring to priests and high officials sitting
on chairs.[5] Earlier sixth-century Buddhist texts speak
of the chairs as "woven seats" (*shengchuang, shengzuo*).

Buddhist monks continued to favor yokeback
chairs, and there are many detailed depictions of them
in later Chinese and Japanese portraits of Chan and
Tendai priests. Zhang Shengwen, in his long hand-

scroll of Buddhist images painted between 1173 and 1176, portrays nine monks each seated on a different version of the yokeback armchair (see fig. 2.7). The chairs are made of wood, bamboo, or gnarled branches and vary in their proportions, structural details, and decoration. Some of them have thronelike characteristics; the Great Master Hongren's chair, for example, has a high back embellished with an ink landscape painting and surmounted by a bejeweled curved yoke ending in dragon heads. Often these chairs with exaggeratedly high backs are draped with a brocade cloth (covering the back, arms, and seat), as may be seen in the early-fourteenth-century portrait of the Chan priest Zhongfeng Mingben in the Senbutsuji, Kyoto.[6] The extreme verticality of these imposing chairs emphasizes the soaring authority of the two great Buddhist teachers.

Song dynasty representations also show yokeback chairs used as thrones for deities and royalty. For example, a Song statue of the goddess Yi Jiang sits on a wide wooden yokeback seat, dated 1087 (see fig. 2.6). Today in the Forbidden City we can still see thrones of the same basic design as Yi Jiang's seat, exemplified by the ornate gilt dragon throne in the Hall of Supreme Harmony.[7] Recently a wide yokeback armchair—attributed to the early Yuan dynasty (late thirteenth century) and related to Yi Jiang's chair—was found in one of the pagodas at Baisikou in Helan, Ningxia.[8] It has a wooden seat only slightly elevated on low legs and cloud heads ornamenting the upturned ends of the yoke and arms. Perhaps it too was a throne elevated on a platform for a deity.

Deities were also enthroned on yokeback chairs without arms, as may be seen, for instance, in the Southern Song (1127–1279) stone carvings in the Dazu cave temples in Sichuan province. In fig. 4.3 we find the Jade Emperor—a Daoist god in charge of the worlds of the past, present, and future—sitting in a formal, dignified posture with knees apart and feet resting firmly on a stool. The emperor wears a crown and holds his scepter of office. The wide chair, with its vigorously curved top rail with upturned ends, is a forerunner of the Ming yokeback chair. The solid

4.2

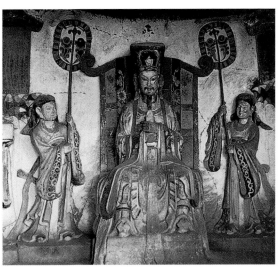

4.3

FIGURE 4.2 *Śariputra*. Late Tang dynasty (848–906). Detail of a wall painting illustrating the conversion of the heretic Raudrāka. Dunhuang cave 196. From Dunhuang Wenwu Yanjiu, *Zhongguo shiku Dunhuang Moyao ku,* vol. 4, pl. 184.

FIGURE 4.3 The Jade Emperor. Southern Song (1127–1279). Rock carving. No. 15, Suchengyan, Dazu, Sichuan. From Dazu Rock Carvings Museum in Chongqing, *Dazu Rock Carvings of China,* 173.

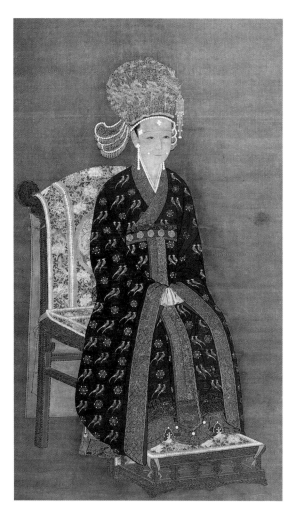

4.4

back has framed panels, and the emperor leans against a runner with floral decorations. Chair runners, even in later times, were used only on ceremonial and formal occasions. They are held in place by the upturned ends of the yokeback and hang over the top rail, back, and seat. George Kates aptly called them the "dress clothes" of Chinese furniture.[9]

In a series of portraits in the National Palace Museum, Taipei, similar yokeback side chairs serve as the thrones for the Song dynasty emperors and empresses. A charming portrait of Gaozong's empress (Gaozong r. 1127–62) shows what appears to be a lacquer chair embellished with finely detailed dragon and cloud patterns (fig. 4.4). The apron has cloud-shaped spandrels, and the curved yoke ends in upturned cloud heads, or *ruyi* motifs. The *ruyi* is a wish-granting scepter terminating in a cloud-head motif, which resembles the *lingzhi* fungus of immortality. The cloud head is a common decorative motif on furniture. Fashioned from square members decorated with beaded edges, the empress's chair has high stretchers. Ornate flower-patterned chair runners are tied to the back stiles and hang almost to the floor in front and in back. The chair has an elaborate separate footstool with its own brocade cover.

The high, narrow chair emphasizes the empress's elevated position. She appears tall and dignified, with her clasped hands resting on her lap and hidden by long sleeves. The demure, meditative, commanding figure is ramrod straight, but sits with a relaxed yet firm authority. Rather than leaning back, she perches on the edge of the chair with her feet elevated on the separate footstool. When the roundback chair and folding roundback chair replaced the yokeback chair as the seat in court portraits in the Ming and Qing dynasties (1369–1644, 1644–1911), the posture of courtly authority changed in accordance with the chair's structure. In fig. 4.5, for example, the wife of an eighteenth-century imperial nobleman rests her raised elbows on the chair's arms, which form one continuous curve with the top rail. Breadth has replaced verticality. Moreover, the court lady leans on her chair and rests her feet on the back edge of the

FIGURE 4.4 *Gaozong's Empress.* One of a series of portraits of Song dynasty emperors and empresses. Hanging scroll. Ink and color on silk. National Palace Museum, Taipei.

front stretcher, sitting into the chair rather than alighting on its edge. These two portraits not only demonstrate how the shape of a chair determines posture, but also tell us about changes in ideals of feminine beauty, makeup, dress, and ornament.

In addition to serving as seats for deities and Buddhists, yokeback chairs have been used by laymen since the Tang dynasty. A wall painting in the tomb of Gao Yuangui, a general who died in 756, shows him seated on a large yokeback armchair with his feet on the floor.[10] The chair is fashioned from square-cut members with a horizontal bar beneath the yoke and small blocks at the top of the back posts, a style familiar from Buddhist portrait paintings. Chairs at this time would only have been used by the well-to-do— someone like Gao who had a relatively high rank and belonged to an important family. To depict him sitting on a chair symbolized his status and prestige. Like special clothing and precious objects, the chair conveyed honor and signified rank.

By the Northern Song dynasty (960–1126), everyone sat on high seats with their legs pendant, and chairs were much more widely used. We even find wooden models of chairs included among the spirit goods placed in tombs to provide the deceased with all the comforts of life. A funerary chair was found in a tomb dating from the Liao dynasty (907–1125) in Jiefangyingzi, Inner Mongolia (fig. 4.6). Fashioned from square members, the chair's slightly splayed back legs pass through the seat to form the stiles and are joined by two horizontal rails and a curved, backward bending yoke. The inside edges of the stiles are chamfered. Three boards form the seat within a frame whose members project where the front and sides intersect. A wide straight apron has large ornamental cutouts, and there are low side stretchers.

Chairs similar to the Liao pieces are depicted in tomb paintings and reliefs showing a couple seated on either side of a table laden with food and drink. In the 1099 tomb no. 1 at Baisha, Henan, each chair has a separate footstool and stands in front of a ceremonial screen.[11] Indeed, this type of chair was probably

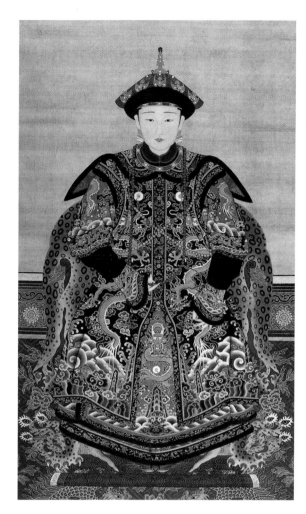

4.5

FIGURE 4.5 *Wife of an Imperial Nobleman.* Eighteenth century. Hanging scroll. Ink and color on silk. 190.9 cm × 100.4 cm. Courtesy of the Arthur M. Sackler Gallery, Smithsonian Institution, Washington, D.C.

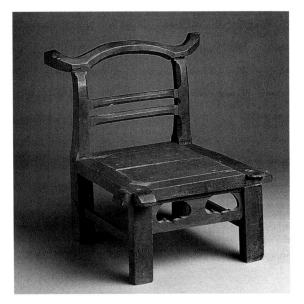

4.6

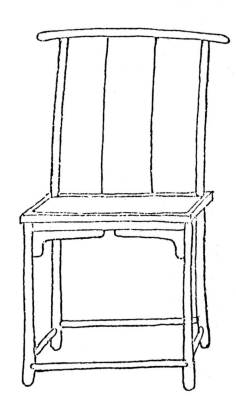

4.7

FIGURE 4.6 Funerary yokeback chair. Excavated from an early eleventh-century Liao dynasty tomb at Jiefangyingzi, Inner Mongolia. Wood. Height 50 cm, length 41 cm, width 40 cm. Collection of Chifeng Municipal Museum. From Kessler, *Empires Beyond the Great Wall*, 112.

FIGURE 4.7 Wooden chair found in a house flooded in 1108 at Julu county, Hebei. Wood. Nanjing Museum. Drawing from Yang Yao, *Shinei zhuangshi he jiaju*, 6.

FIGURE 4.8 Miniature wooden chair. Jin dynasty. Excavated from the 1190 tomb of Yan Deyuan, Datong, Shanxi. Height 20.5 cm, seat 10.5 cm × 10.5 cm, arm length 17.4 cm. Redrawn from Datong Shi Bowuguan, "Yeh Deyuan mu," pl. 1.1.

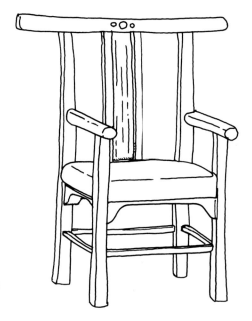

4.8

common. In 1995 a piece almost identical to fig. 4.6 showed up in a San Francisco antique store. The San Francisco chair is made of "Chinese coffin wood" (*Taiwania cryptomerioides*) and appears sturdy enough to sit on. Equally small seats are still used in China today.

All these chairs—the miniature models and those depicted in paintings—are heavy in appearance. The earliest extant actual chair, however, is a more elegant and comfortable seat (fig. 4.7). Found in a house in Julu county, Hebei, that Japanese archaeologists excavated about 1920, it was in use in 1108 when the site was flooded. Compared to the Liao chair, it is a more slender and elongated structure with round instead of square main members. The legs are splayed and are thicker toward the base. A curved splat replaces the uncomfortable horizontal rails used in the Liao chair. The yoke of the early twelfth-century chair curves upward toward the center and is rounded at the ends. Beneath the seat, curved spandrels extend almost to the center of the chair. There is a low stretcher between the front legs, and there were probably once similar stretchers on the other three sides. Originally some of the mortise-and-tenon joints were reinforced with pins.[12] The refined design of the chair foreshadows Ming dynasty hardwood furniture.

Yokeback chairs were probably common by the twelfth century, since they are frequently depicted in Jin dynasty tombs, as in the early Jin tomb of the Yin family in Jishan, Shanxi. On the north wall of the entrance hall are pottery representations of the fourteen male and female occupants of the tomb, each seated on a high yokeback side chair. The chairs have ceremonial runners, footstools, and curved yokes with *ruyi* motifs on their upturned ends.[13] Yokeback side chairs also appear on the brick tiles decorating the interior walls. The chairs depicted in the tiles serve as formal seats, seats for feasting couples, and a seat for a meditating monk.[14]

None of these yokeback chairs has arms, suggesting that the side chair was the most common model at the time. A miniature wooden yokeback armchair

was found at Datong, Shanxi, however, in the Jin dynasty tomb of Yan Deyuan, who died in 1190 (fig. 4.8). It is sturdier than the chair in fig. 4.7, thanks to a long, straight yoke and arms, a straight apron with curved spandrels, and high stretchers.

Among extant examples of later yokeback chairs, armchairs are much more common than side chairs, probably because the armchair—with its front posts and armrests supporting the back—is a stronger construction that is better able to withstand hard use. Yokeback side chairs, however, continued to be more popular in daily life and are more frequently depicted in paintings and books. A typical *huanghuali* side chair is classical in its simplicity of design and elegance of proportions (fig. 4.9). Characteristic of Ming furniture is the inward slope of all vertical members, creating a light and graceful appearance. The high, backward-bending back posts and top rails are round in cross-section; the rails have subdued curves and teardrop ends. Beautifully figured wood forms the plain C-curved splat. A hard-mat seat replaces the original soft-mat construction. (Hard-mat seats have boards beneath the mat, whereas soft-mat seats have only a curved transverse brace.) The legs are rounded on the outside and squared on the inside, forming a small shelf to support the frame of the seat. Stepped stretchers, oval in shape with flattened tops and bottoms, strengthen the legs. Between the front legs is an arched inner frame with beaded edge. The aprons on the sides, back, and beneath the footrest are of standard form.

Twentieth-century Beijing craftsmen call yokeback side chairs "lamphanger chairs" (*dengguayi*). The term originated in Suzhou, where the high yokebacks were similar in shape to a kind of bamboo wall lamp commonly hung near the kitchen stove.[15] Because these chairs are fairly light, they are easy to carry out into the garden. They are useful, too, in the study, bedroom, and main hall for receiving visitors and for seating guests at banquets. Usually one sits up straight in them, but the yokes are also good for pillowing the head for naps. In a Yuan dynasty painting by Liu Yuan, we see Sima Caizhong in this casual posture, dream-

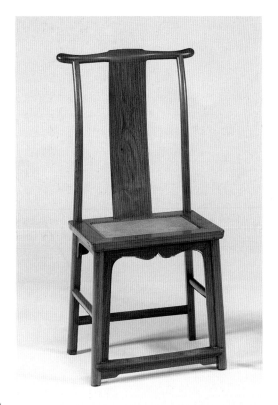

4.9

FIGURE 4.9 Side chair, one of a
pair. Ming dynasty, late
sixteenth/early seventeenth
century. *Huanghuali* wood.
Height 109 cm, width 49.5 cm,
depth 39 cm. © Christie's
Images, Ltd., 1999.

FIGURE 4.10 Liu Yuan. *Sima
Caizhong Dreaming of the Singing
Girl Su Xiaoxiao*. Yuan dynasty,
c. thirteenth to fourteenth
century. Handscroll. Ink and
color on silk. Height 29.2 cm,
width 73.6 cm. Cincinnati Art
Museum, J. J. Emery Endow-
ment and Fanny Bryce Lehmer
Endowment.

FIGURE 4.11 Banquet scene.
Ming dynasty. Woodblock
illustration to *The Plum in the
Golden Vase* (*Jin ping mei*),
Chongzhen reign period
(1628–44), chap. 63.

ing that the beautiful fifth-century courtesan poet Su
Xiaoxiao is reciting a poem predicting their future
union (fig. 4.10). Su Xiaoxiao is the ideal of the sen-
suous and spiritual woman as well as the harbinger of
Sima Caizhong's death, the moment at which their
two spirits will unite for eternity.[16]

When yokeback chairs were used for formal oc-
casions, patterned silk runners made them festive and
gave them status. A good example is fig. 4.11, a mid
seventeenth-century woodblock illustration to *The
Plum in the Golden Vase* (*Jin ping mei*) depicting the
banquet given in honor of two eunuchs who have
come to pay their respects before the coffin of the
Sixth Lady. Chair runners are long rectangular pieces
of cloth, often with designs that conform to the shape
of the chair (fig. 4.12). Many of the surviving ex-
amples are silk tapestries, called *kesi* ("slit tapestry")
because of the vertical slits where one color ends and
the next begins.

Kesi chair runners have brightly colored auspicious
designs on grounds of gold-wrapped threads. The
runner makes an attractive continuous vertical com-
position, but is actually divided into four sections
reflecting the shape of the chair. The top of the run-
ner is decorated with upside-down motifs, since it is
meant to hang over the chair's yoke and thus would
appear right side up when the viewer stands behind
the chair. On the runner in fig. 4.12 the top section
has an upside-down *shou* character and two peaches.
These symbols of longevity are encircled by five bats,
representing the five blessings (long life, riches, health,
love of virtue, and a natural death). The section that
covers the back of the chair has a garden scene with
a Taihu rock and *lingzhi* fungus of immortality sprout-
ing from the ground on the left. The white magno-
lias signify purity and the lush peonies, wealth and
rank. The seat of the chair is delineated by a bat in
the center of a flower medallion surrounded by flow-
ers, clouds, and four bats. The bottom part of the run-
ner, which would hang from the seat of the chair, has
a charming and unusual asymmetrically placed de-
piction of the Isle of the Immortals rising from styl-
ized wave patterns. This chair runner is one of a pair

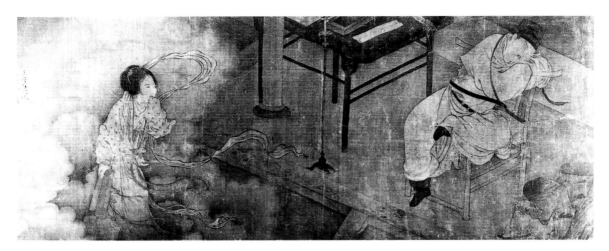

that, together with the matching table frontal, would have transformed ordinary chairs and a table into festive furniture conveying wishes for long life, good fortune, and prosperity.

The Plum in the Golden Vase banquet scene (see fig. 4.11) shows how frontals hang along the long front sides of dining tables. The feasters sit next to each other along one side of the table facing the guests across the room. Their chairs have double side stretchers and are equipped with separate footstools. Other illustrations of intimate suppers show identical arrangements with chairs and table in their "dress clothes" and the lovers seated next to each other. Note that, in the banquet scene, the ladies watching the proceedings from behind a screen sit on stools. There is a definite hierarchy of seats in China: armchairs are reserved for the most important persons, side chairs for those of lesser rank, and stools for the least significant. The ladies are watching a performance, which takes place on a carpet spread between the tables, while a group visible on the right plays a musical accompaniment. Carpets, like chair and table frontals, were brought out only for special occasions to create a stage for theater and dance or a setting for ceremonial meetings.

At banquets the feasters sometimes sat on yoke-back armchairs. Today in China these are commonly known as "official's hat chairs" (*guanmaoyi*) because of their supposed resemblance to the winged hats

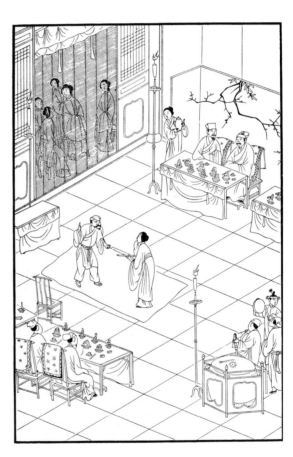

FIGURE 4.12 Chair runner.
C. 1700. *Kesi* with metallic
gold ground. Height
161.62 cm, width 48.58 cm.
Santa Barbara Museum
of Art. Gift of Ralph E.
and Mary V. Hays.

FIGURE 4.13 A pair of yokeback
armchairs. Ming dynasty.
Huanghuali wood. Height
120.6 cm, width 58.4 cm,
depth 44.4 cm. The Nelson–
Atkins Museum of Art,
Kansas City, Missouri.
(Purchase: Nelson Trust.)

4.12

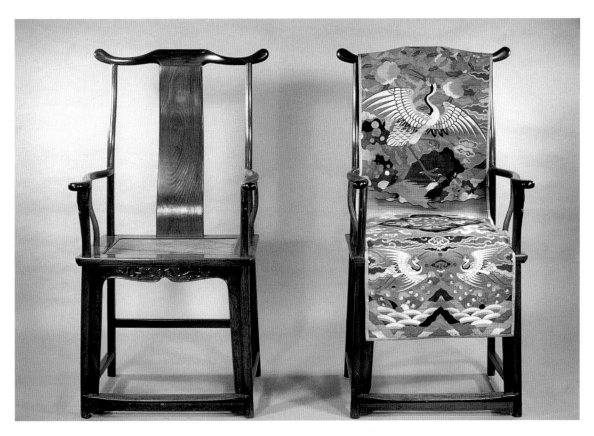

4.13

Ming officials wore (see fig. 6.2). They are also called "official's hat armchairs with four protruding ends" (*sichutou guanmaoyi*).[17] One of the late-Ming illustrations to *The Plum in the Golden Vase* shows Pang Chunmei, on a visit to a monastery, sitting in the place of honor on a yokeback armchair, referred to in the text as a *gongzuoyi* ("lordly seat chair").[18]

There are two types of yokeback armchairs: those with the front legs and posts fashioned from a single piece of wood and those with recessed front posts. The continuous-leg-and-post construction is of course stronger. Each type can be subdivided according to whether the yokes and arms have teardrop or flat ends.

A pair of *huanghuali* chairs in the Nelson-Atkins Museum of Art provides striking examples of the teardrop-end, continuous-leg-and-post model (fig. 4.13). These chairs differ in spirit from the side chair in fig. 4.9, which also has a yoke with teardrop ends. The armchair's yoke is vigorously upturned and flat

rather than backward curving. Back posts, splats, arms, and side and front posts are all S-curved. The S-curved splat was popular in Ming times and undoubtedly developed in the interests of greater comfort as well as aesthetics. It seems to have existed by at least the first half of the twelfth century, since Fan Long's painting *The Eighteen Arhats* in the Freer Gallery depicts an armchair with its back covered by a cloth that follows the S-shaped form of the splat underneath.[19] In the chairs in fig. 4.13, the S curves of the top resonate with the curves of the arched inner frames on the front and sides below; a raised tendril ornament emphasizes the curves of the front frame. Those flowing curves and the vigorous grace of the design give these chairs their vitality.

The basic chair design with a tall back and S-curved splat was so pleasing and functional that it was repeated many times with variations, giving each chair its own special character. A pair that John W. Gru-

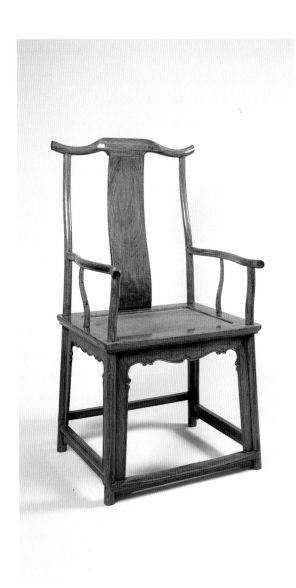

4.14

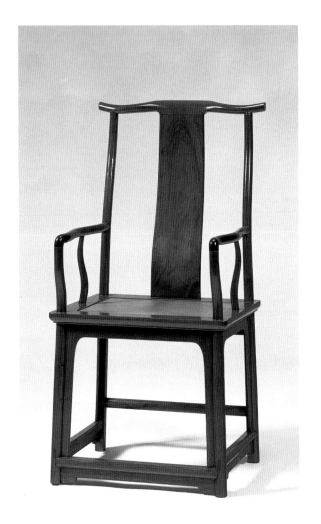

4.15

FIGURE 4.14 Yokeback armchair, one of a pair. C. 1600. *Huanghuali* wood. Height 113 cm, height of seat 49.5 cm, width 59.7 cm, depth 48.3 cm. Collection of John W. Gruber.

FIGURE 4.15 Yokeback armchair with continuous arms. Ming dynasty, late sixteenth/early seventeenth century. *Huanghuali* wood. Height 120.6 cm, width 60.3 cm, depth 45.2 cm. © Christie's Images, Ltd., 1999.

ber acquired from Alice Boney in 1978 have a more monumental, stately presence; fig. 4.14 shows one of them. In keeping with the cutoff (or flat) ends of yokes and arms,[20] the curves are less flamboyant yet full of inner strength. The proportions, which are less elongated than those in fig. 4.13, are particularly beautiful and are enhanced by the more complex silhouettes of the inner frames with their rounded cusps. The aprons are attached to the legs with a half-lap miter and dovetail join, which is stronger than the more common simple half-lap miter or mitered tongue-and-groove joins. A similar chair in another private American collection suggests that these chairs were part of a larger set, as was often the case.

In another variation, yokeback armchairs have the continuous arms usually associated with the "southern official's hat armchair" (*nanguan maoyi*, a pair of which stand next to the compound wardrobe in fig. 1.14). Fig. 4.15 shows an example of this rare hybrid form. Although it is fashioned from thick pieces of *huanghuali* wood, its elegant proportions prevent a heavy appearance. Nicely figured wood forms the S-curved splat, and a plain inner frame with straight beaded edges is placed between the legs. A similar chair made of bamboo with recessed, rather than continuous, front posts is illustrated in the 1609 encyclopedia *Pictorial Encyclopedia of Heaven, Earth, and Man* (*Sancai tuhui*).[21] This depiction suggests that the continuous arms might have evolved from the bent bamboo construction.

Woodblock illustrations frequently show yokeback chairs in front of a screen in the main hall for receiving guests. Sometimes the chairs have continuous arms, as in a Wanli period illustration to *Records of the Red Pear* (*Hongli ji*; fig. 4.16). Here two officials exchange polite salutations. They elevate their joined hands, which are concealed in their long sleeves, and bow slightly. A servant emerges from behind the screen with refreshments. Guests are greeted with great politeness, and a strict etiquette is observed. The famous Jesuit Matteo Ricci, who lived in China from 1583 to 1610, describes this ceremony of salutation and reception in detail:

4.16

4.17

FIGURE 4.16 Woodblock illustration to *Records of the Red Pear* (*Hongli ji*). Ming dynasty, Wanli reign period (1573–1620).

FIGURE 4.17 Woodblock illustration to the drama *The Love Letter* (*Qingyou ji*). 1630. Detail.

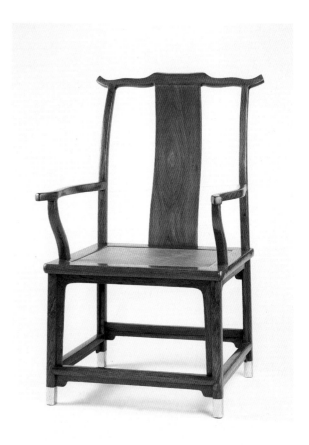

FIGURE 4.18 Large yokeback armchair. Ming or Qing dynasty, seventeenth century. *Huanghuali* wood. Height 121 cm, width 68.5 cm, depth 54.4 cm. © Christie's Images, Ltd., 1999.

FIGURE 4.19 A pair of yokeback armchairs. Ming or Qing dynasty, seventeenth century. *Jichi* wood. Height 111.8 cm, width 57.5 cm, depth 46.8 cm. © Christie's Images, Ltd., 1999.

4.18

4.19

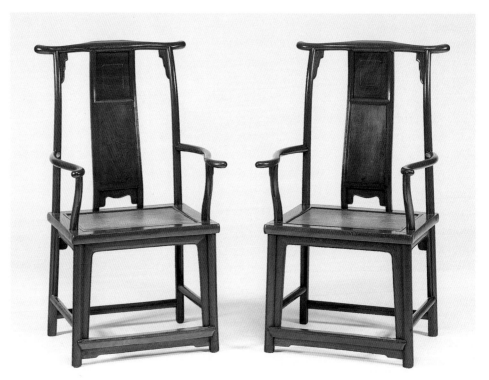

When a family is receiving at home, the one in charge takes a chair in both hands, and places it in the position of honor for the visitor. Then he dusts it off with his hand, though there will be no sign of dust on it at all. If there are several visitors, he arranges the chairs according to dignity of position in the reception room and then touches each of them with his hands, as it were, to see that they are properly aligned. This gesture is then repeated by all of those who are being visited. The next step in the ceremony is for the principal visitor to take the chair of the host and place it opposite his own, repeating the pretended gesture of dusting it off with his hand. This placing of chairs is then repeated by the other visitors, if there be more, in order of age or of dignity. While this is being done, the one to whom special honor is to be paid on the occasion stands a little aside and with his hands joined and concealed in his sleeve continues to raise and to lower them slightly and slowly, while returning thanks and modestly refusing the proffered compliment. Undoubtedly they waste a lot of time in ceremonies connected with the principal seat of honor, concerning which definite regulations are to be observed. Age takes precedence among citizens of equal rank. In the courts, priority is determined by dignity of office. The place of honor is always granted to a welcome foreigner, and such visitors rank according to the greater distance from which they come. . . . When the guests are seated, the best-trained servant in the house, clad in a flowing robe reaching down to his ankles, sets out a decorated table on which there are as many saucers as there are people present. These saucers are filled with the drink called ch'a, in which there are small pieces of sweet fruit. This is considered to be a dessert and it is eaten with a silver spoon.[22]

Yokeback armchairs were used not only for receiving guests in the main hall, but also by the scholar at his desk. In a 1630 woodblock illustration to the drama *The Love Letter* (*Qingyou ji*), we see a literati's study with a zither hanging on the wall and a book on a wide table (fig. 4.17). The large yokeback armchair has a curving yoke and arms, an S-shaped splat, and a mat seat. This chair, with its recessed front posts, is probably fashioned from hardwood and beautifully crafted.

Ordinary people used similar chairs, but made of softwood. In an illustration to the 1637 edition of Song Yingxing's *Exploitation of the Works of Nature*

(*Tiangong kaiwu*), a craftsman painting the decoration on a ceramic bowl sits on a yokeback armchair.[23] Large yokeback armchairs were called meditation chairs (*chanyi*) in the fifteenth-century carpenter's manual *Classic of Lu Ban* (*Lu Ban jing*) because their size is suitable for meditating in the lotus position.[24] In 1591 Gao Lian gave this description: "A meditation chair is half as big again as an ordinary chair. Only the 'water polish' ones are fine, though speckled bamboo is also possible. In this style the horizontal rail for pillowing the head at the top of the back needs to be broad and thick before they are acceptable for use."[25]

One rare example of such a large meditation chair has recessed front posts and flat ends (fig. 4.18). It is fashioned from strong square members, their angularity balanced by the curves of the upturned yoke, back posts, S-shaped splat, arms, and front posts. This play of forms, together with the relative thinness of the members and upward taper of the verticals, gives liveliness and grace to this monumental chair. There is considerable variation in the angle of the yoke on this type of seat. Here the yoke is almost upright, whereas on the side chair in fig. 4.9 it is more horizontal. Although all the surfaces on the meditation chair are plain, without beading or other ornament, the figures of the wood create lively patterns. The feet of this chair are covered with metal casings. Beneath them is evidence of an old repair that restored the worn-down feet to their original height by adding a piece of new wood and then a small piece of old wood. When the casings are in place, the legs appear to be intact.

The vertical splats of chairs are the ideal place for displaying the lively and abstract figures of the wood. This is especially evident on a pair of *jichi* wood yokeback armchairs with recessed front posts (fig. 4.19). *Jichi*, or "chicken-wing," wood is purplish-brown with a streaked grain suggesting the feathers near the neck and wings of a chicken. On the yokeback armchairs different cuts of *jichi* wood have been used to create a playful relationship between the two chairs. On one splat the top panel is fashioned from radially cut wood with fine parallel lines; the bottom panel,

4.20

FIGURE 4.20 Yokeback armchair, one of a pair. Ming dynasty, probably sixteenth century. *Huanghuali* wood. Height 112.2 cm, width 60 cm, depth 46.4 cm. Private collection. Drawing from Handler, "A Yokeback Chair for Sitting Tall," fig. 26.

made from tangentially cut wood, exhibits the characteristic *jichi* wood feathered pattern.[26] On the other splat the woods are reversed, with the tangential cut used for the top panel and the radial cut for the bottom panel. This delight in reversed symmetry has a long tradition in China, where it gives order to the complex motifs on ritual bronze vessels from the Shang (c. 1500–c. 1050 B.C.) and Zhou (c. 1050–221 B.C.) dynasties.

The *jichi* wood armchairs are a little smaller than the standard size. They have round members, although the framing members of the splats have sharp central ridges. The arms and almost horizontal yokes have teardrop ends. Each chair has a simple beaded-edge inner frame and stepped stretchers, those on the side being flattened ellipses in cross-section. Beneath the handrests and the yokes, shaped flanges give an

interesting form to the spaces between posts and splats, which are complemented by the spaces created by the decorative openings in the panels at the bottom of the splats.

A unique variation on this type of yokeback chair (with recessed front posts and teardrop ends) may be seen in a striking *huanghuali* chair illustrated in fig. 4.20).[27] The back of the chair is considerably narrower than the seat, and thus the S-shaped arms curve around the corners of the seat. The back is covered by a large mat panel and separated from the vigorously curved yoke by inset panels with cutout, beaded-edged cartouches. There are shaped spandrels beneath the yoke. Like the back, the seat has a hard-mat panel replacing the original soft-mat construction. The base of the chair is waisted and has horse-hoof feet; these features, as well as the mat-panel back and curved arms, are rarely found on extant pieces. This powerful design is related to depictions in Ming dynasty paintings and woodblock illustrations. No other examples appear to have survived, probably because the recessed-post construction is more fragile than the continuous-leg-and-post construction.

The origins of this form trace back to at least the twelfth and thirteenth centuries, when versions appear in Buddhist paintings. A group of paintings from Ningbo, Zhejiang, for example, show the Kings of Hell sitting on yokeback chairs, and a hanging scroll in the Museum of Fine Arts, Boston, depicts the tenth King of Hell seated behind his desk on a yokeback armchair.[28] The tenth king's chair has a more elaborate top than the *huanghuali* chair in fig. 4.20, and the waisted base resembles the pedestal of Buddhist statues. This tenth king's chair is analogous to the 1087 chair on which the goddess Yi Jiang sits (see fig. 2.6). In both cases the top of the chair is probably related in its basic form to actual pieces of furniture used in daily life at the time.

By the Ming dynasty the type of arms and back seen on the chair in the Ningbo painting are found on domestic chairs. We see it in *Playing the Flute to Attract Phoenixes* (fig. 4.21), by Qiu Ying (c. 1495–c. 1552). A man sits on a chair that has horse-hoof feet, arms,

4.21

and a back like those in fig. 4.20. The hierarchy of seats prevails: only the man sits in an armchair, while the lady, playing a flute, sits on a stool. Hardwood chairs with horse-hoof feet are unusual, and the few published examples include a set of four horseshoe armchairs and two pairs of "southern official's hat" armchairs.[29] It is unclear whether the chair in Qiu Ying's painting has a waist. Waisted yokeback chairs appear in woodblocks, as in an illustration to Jin Xiangbiao's *The Lute* (*Pipa ji*) from the Wanli period (1573–1620).[30] Wang Shixiang illustrates two waisted horseshoe armchairs—a *huanghuali* one in the Summer Palace, to which he gives a Ming date, and an early Qing *zitan* model in the Palace Museum.[31] Since the back of the chair in Qiu Ying's painting is concealed by a runner, we do not know if it has a mat panel. However, an album leaf by Tang Yin (1470–1523) depicts a folding armchair with a large mat panel beneath inset panels (see fig. 5.10). A rare extant example of this type of folding armchair (see fig. 5.9) has a back resembling that on the chair in fig. 4.20. The folding armchair, however, has three panels with marble insets in the openings, and it is not a yokeback chair.

The yokeback chair is the most vertical of Chinese chairs. Because it forces the body into a position of upright rectitude, it readily imparts honor, dignity, and power. In both the ancient and modern worlds, verticality—in tower, cathedral, and skyscraper—asserts soaring authority. It is ironic that we use the word *yokeback* to designate this chair, when the yoke signifies horizontal suppression—the opposite of the vertical aspiration and authority these chairs convey.

In the sociology of chairs, the yokeback occupies an odd place in the class structure. Its political alliance is both with the aristocracy (religious and secular), who first used it, and the ordinary chair-owning, somewhat affluent classes, who adopted the yokeback, made it their own, and spread its popularity throughout China. Thus the hardwood yokeback chair, symbol of power and prestige, crossed over class boundaries and spread widely and elegantly into ordinary households. Unlike most privileged objects, it penetrated the social ranks of Chinese society as thoroughly as chopsticks and rice. The yokeback is the chair of China. Prince and princess, merchants high and low, all sat comfortably erect on its seat.

5 | THE FOLDING ARMCHAIR
An Elegant Vagabond

*T*he traditional folding armchair leads a double existence: it folds away into transportable luggage and sets up with all the stability and grandeur needed to comfort an emperor. It is a protean object, momentarily beautiful and practical, but constructed for imminent metamorphosis. Throughout its long life it is an elegant vagabond.

The folding armchair, which appeared with the advent of the chair-level mode of living in the Song dynasty, evolved from the ancient folding stool that had been used in China since the second century. By the Ming dynasty it was so common that it is the only chair to appear in the 1436 illustrated children's primer *Newly Compiled Illustrated Four-Word Glossary* (*Xinbian duixiang siyan*), where it is listed under its modern name, *jiaoyi* ("folding chair").[1] Since the folding chair was more fragile and subjected to greater wear than other chairs, few Ming examples survive. Among the extant examples are three so similar that they appear to have been made in the same workshop.

The first (fig. 5.1), which belonged to the former Museum of Classical Chinese Furniture in Renaissance, California, was acquired in China about 1920 by the British fur trader George Crofts and later entered the Royal Ontario Museum's collection. It is said to have once belonged to a temple in Beijing. The Nelson-Atkins Museum of Art in Kansas City, Missouri, owns a second chair (fig. 5.2), and the third is the property of Zhao Luorui of Beijing (fig. 5.3). (The Beijing chair is one of a pair whose mate the Minneapolis Institute of Arts acquired in 1996.) All of these chairs are made from *huanghuali* wood, and every join is reinforced with iron ornamented with silver.

The chairs are almost identical in form, dimensions, and proportions, although their similarity may not be immediately evident because the replacement mats or rope seats have changed the heights and angles of the frames. The powerful, continuous sweep of the downward-curving horseshoe-shaped arms is balanced by the C-curve of the splats and the horizontality of the seat frames, footrests, and stretchers. The front legs cross over the back legs and soar upward, widening and bending backward in a strong curve, then narrowing and

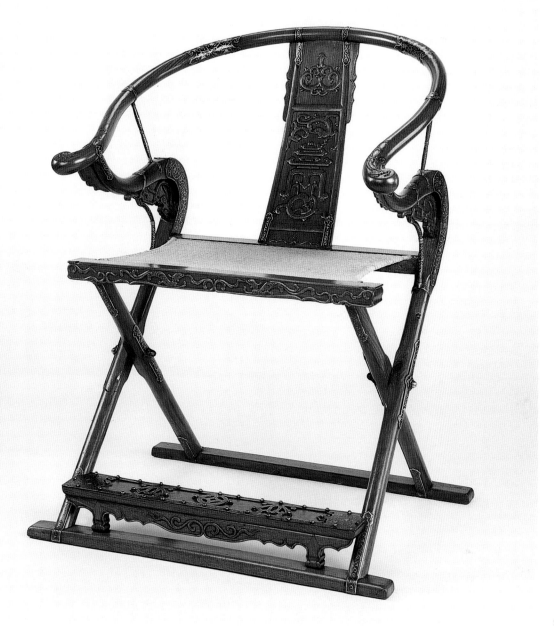

FIGURE 5.1 Folding armchair.
Ming dynasty, late sixteenth/
early seventeenth century.
Huanghuali wood, iron, and
silver. Height 97.5 cm, width
69.3 cm, depth 45.5 cm.
© Christie's Images, Ltd., 1999.

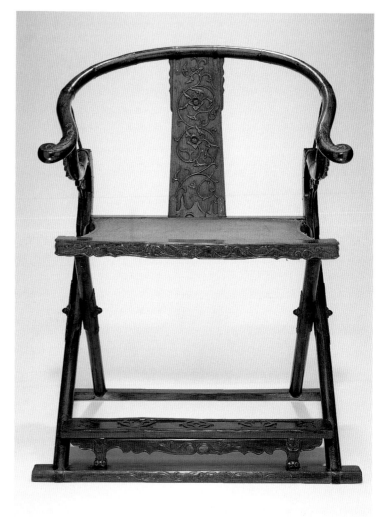

FIGURE 5.2 Folding armchair. Ming dynasty. *Huanghuali* wood, iron, and silver. Height 101.5 cm, width 68.8 cm, depth 45 cm. The Nelson-Atkins Museum of Art, Kansas City, Missouri. (Purchase: Nelson Trust.) © The Nelson Gallery Foundation.

FIGURE 5.3 Folding armchair. Ming dynasty. *Huanghuali* wood, iron, and silver. Height 94.8 cm, width 69.5 cm, depth 53 cm. Collection of Zhao Luorui, Beijing. From Wang Shixiang, *Classic Chinese Furniture*, 104.

5.2

dipping before rising to meet the arms. Metal pivots, inserted where the legs cross, enable the chairs to fold upward. Since wood cut in a curve loses strength, it must be reinforced with metal at each join. The backward curves of the legs and the tops of the footrests are also reinforced with metal.

The splats and the curving arms of the three chairs show a slight difference in dimensions, undoubtedly as a result of the varying sizes of available wood. The arms of the Renaissance and Kansas City chairs are each formed from three pieces of wood fastened together by half-lapped pressure-peg joins strengthened with metal. The arms of the Beijing

chair, by contrast, each have five segments and four decorative rather than functional metal strips that do not correspond with the joins. A smaller piece of wood was used to make the arms of this chair, and the outward-curving handrests are plain, without the downward swooping snub-nosed *chi* dragons carved on the other examples. (*Chi* are immature dragons who have not yet grown horns.)

Beneath the handrests of the Beijing chair are small openwork dragon-and-cloud-shaped spandrels; the other chairs have solid spandrels with beaded curvilinear edges. All are strengthened beneath the backward curve of the leg by large spandrels decorated

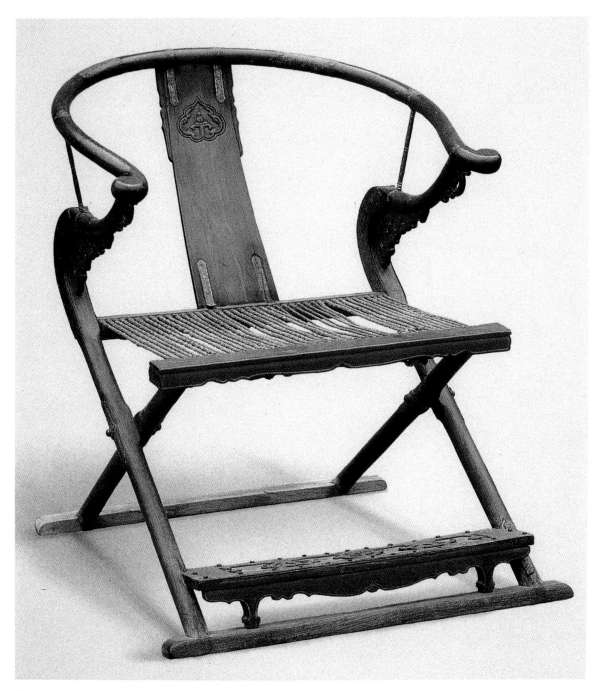

5.3

with curling dragons. The Renaissance spandrels are recent copies of those on the Beijing chair. However, the spandrels on the Beijing chair also appear to be replacements, since they bear no mark of the metal bands that must have wrapped around them to secure the curved metal braces.

The splats of all three chairs have the same flanges and the same lively, flowing quality to their ornamentation, although the motifs differ. The splat of the Beijing chair is embellished with confronting dragons within a *ruyi*-shaped medallion. On the Kansas City chair, flowering vines scroll upward in alternate directions from one side of a miniature triple-peaked mountain. The splat on the Renaissance chair is wider than the others and made from a single piece of wood carved to imitate a common type consisting of a frame with three inset panels. The central panel has a large longevity character (*shou*) in relief, whose vertical strokes and sequence of horizontal lines create the impression of a tower of tables. Above and below the *shou* character are long-nosed *chi* dragons, their bodies curiously fragmented. Parts of these dragons overlap the *shou* character, recalling the interaction between the tendrils and the main stem of the vine in the Kansas City chair. At the top of the Renaissance splat, the curves of the dragons echo in a stylized *ruyi* motif, the base of which appears to be formed of simplified dragons.

Running dragons and scrolls also decorate the front seat stretcher on the Renaissance chair, which has the same profile and bottom edge as the Kansas City chair. The latter is decorated with a curling vine and flower motif. In contrast, the front seat stretcher of the Beijing chair is plain. Each chair has an attached footrest with curvilinear apron, small feet, and protective metal plates. The inevitable question of replacement arises in regard to the wooden portion of the footrest in the Kansas City chair—the ornamentation is incised rather than raised, different in character and not aligned with the carving on the stretcher and splat. Thus, the apron and feet of the footrest would appear to be replacements like those on the Renaissance chair, which are known to be recent.

On each chair the iron bands that protectively encase and emphasize the larger curve of the legs are embellished with silver scrolling lotus designs, a popular decorative motif derived from fifth-century Buddhist art. The ornamentation is of the same basic type but was clearly executed by different hands. Originally all the chairs had curved braces to strengthen the bend of the legs and prevent the folded seats from hitting the wooden spandrels; these braces are missing from the Beijing chair. The curved braces and the struts between legs and arms are bamboo-shaped and adorned with scrolls and geometric patterns. The wooden footrests are protected by iron plates cut out in designs of two rhinoceros horns flanking a coin, symbols of happiness and wealth. The plates are attached with metal pins ending in raised bosses that are both functional and decorative. Most of the bosses on the Renaissance footrest, unlike those on the other chairs, are original. The entire surface of the metal, wherever it is used to strengthen the joins, is finely ornamented with geometric designs and stylized lotus and curling, leafy tendrils. The delicately detailed silver patterns against the dark iron complement the sheen of the *huanghuali* wood and give the chairs a luxurious appearance.

The silver inlay does not lie in grooves cut into the iron, but rather the entire ground has been crosshatched to make a rough surface capable of holding the silver wire hammered into it. As early as the Shang dynasty, bronze chariot fittings were inlaid with silver, and in the fourth century B.C. iron belt hooks were inlaid with both silver and gold. However, the technique of crosshatching the iron surface to attach the silver ornamentation does not appear until much later. One example is a Sino-Tibetan ritual iron basin (now in the Avery Brundage Collection at the Asian Art Museum of San Francisco) with an inscribed date corresponding to 1298. The technique also appears on later Ming bronzes as well as on iron *ruyi* scepters with delicate gold and silver decoration, bearing the signature of Zhang Aochun and a date equivalent to 1622.[2]

With the Song dynasty vogue for archaism, the an-

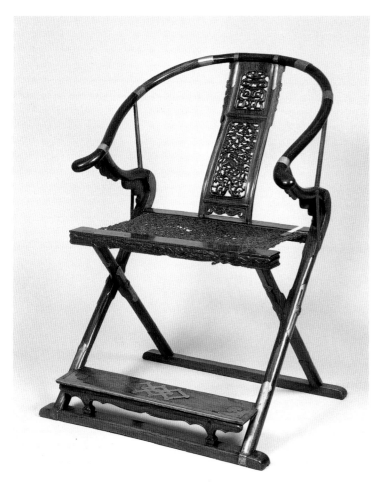

FIGURE 5.4 Folding armchair.
Ming dynasty. *Huanghuali* wood
and brass. Height 100.3 cm,
width 63.5 cm, depth 40 cm.
Collection of John W. Gruber,
New York.

5.4

cient practice of embellishing iron with gold and silver was revived and became increasingly popular in the Ming dynasty. The earliest extant examples of this revival all point to a Tibetan origin for this form of decoration. For example, the Asian Art Museum of San Francisco recently acquired a unique "Jeweled Buddha" plaque (c. tenth to eleventh century) made in the Central Asian Uighur Kingdom of Qocho (c. 850–c. 1250), near modern Turfan; the plaque is made from the same materials as a corn measure decorated with a Nestorian cross obtained near Lhasa.[3] The Nestorian cross connects the corn measure to Turfan, the tenth-century center of Nestorian Christianity.[4] Iron decorated with gold was also used for a Tibetan iron mask illustrated on the cover of the July 1987 is-

sue of *Orientations* (and now in the Kronos Collections, New York) and on a fifteenth-century Chinese helmet with Tibetan *lantsha* characters and stylized lotus and curling tendril motifs (collection of Michael Goedhuis)—a combination of designs similar to those on the folding armchairs and seen in the background of many Tibetan *thangkas*. It is conceivable that artisans from Tibet, headed by the young Nepalese Anige, introduced the technique into China when they visited the Mongol court in 1260.[5]

The similarity between the Renaissance, Kansas City, and Beijing folding armchairs is even more pronounced when they are compared with the intricate chair in the collection of John W. Gruber, New York (fig. 5.4). This chair is also made from *huanghuali* but

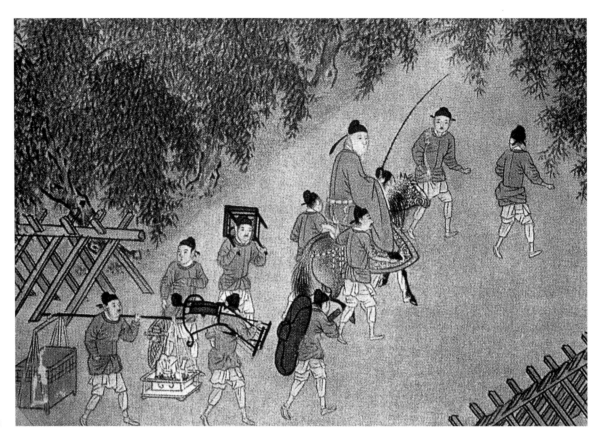

has more elaborate carvings and plain brass rein-
forcements. It has plain wooden struts and spandrels
beneath the bend of the legs that differ from the bam-
boo-shaped metal struts and dragon-carved stretch-
ers of the other three chairs. The splat has an S rather
than a C curve, and the frame contains three inset pan-
els instead of being made from a single piece of wood.
The splat is also decorated with openwork rather than
relief carving, and the *shou* character on the top panel
and the cloud patterns in the center have the same
intertwining quality. The large central panel is magni-
ficently carved with a lively *qilin* standing on a rock
of the Taihu type commonly used to represent moun-
tains in gardens. The *qilin* is a mythical beast, said to
bring about the birth of sons, that appears when the
ruler is wise and judicious. Clouds swirl above the
qilin, and a *lingzhi,* the sacred fungus of immortality
and a wish-fulfilling symbol, appears in the right-hand
corner.

The lowest panel of the splat has an arched open-
ing at the bottom, and the scroll carving is more elab-
orate than that on the other chairs—a feature also
evident in the running dragons and scrolls on the front
seat stretcher. The metal on the footrest consists of
a strip along the front, ending in cloud-head shapes
at the corners, and a separate, interlocking triple-
lozenge-shaped piece in the center. Although the
complex and beautifully executed carving and the
rich tone and interesting grain of the wood, offset by
gleaming brass mounts, create a wonderfully decora-
tive effect as fine as that of the Renaissance, Kansas
City, and Beijing chairs, clearly the New York chair
is the product of a different workshop.

Light and easy to move, the folding armchair was
practical for traveling; emperors and commoners used
it for both formal and informal occasions. In fig. 5.5
a servant carries a folding armchair across his shoul-
ders as he walks behind his master, mounted on horse-

back, in the twelfth-century album leaf *Returning from a Spring Outing*. The headrest of the chair has the shape of a lotus leaf, a style that first became fashionable in the 1130s.[6] Ming and early Qing paintings and woodblock illustrations indicate that the popularity of the folding armchair continued. Jin Nong (1687–after 1764), one of the eight eccentric painters of Yangzhou, had a folding armchair carried out into his garden on a hot summer day so that he could enjoy the shade of the banana trees. His disciple, Luo Ping, painted him napping there with his chest exposed (fig. 5.6). The informality of dress and occasion—most unusual for such a portrait—gives us a rare glimpse of an intimate moment.

The head of the family would also use folding armchairs inside the house when writing at his desk, dining alone or with friends, or formally receiving visitors (with a screen placed behind the chairs for the occasion). Ladies, too, often sat on this type of chair when receiving guests. In any gathering, the folding armchair was a status symbol used by the most important persons, while others sat on side chairs or stools. As another indication of its importance, it is the chair most commonly found among miniature pottery tomb furniture, conferring on the deceased a status in the tomb perhaps beyond what he or she had known in life. In one example a large representation of the metal pivot on the legs makes clear that the chair can fold.[7] Often these miniature folding chairs were draped ceremonially with cloth or had long rectangular chair covers and were placed in front of screens or next to cloth-draped tables laden with wine and food vessels. Ancestral portraits often show deceased emperors, officials, and other people sitting on folding chairs. Frequently, as in the portrait of the wife of an imperial nobleman in fig. 4.5, the person in formal dress sits on a carved lacquer folding armchair, a magnificent cloth or animal-skin drape further enhancing the subject's status.

On the battlefield, generals gave orders while seated on folding armchairs covered with tiger skins to indicate martial valor and rank. Both emperors and empresses used them as portable thrones, often with

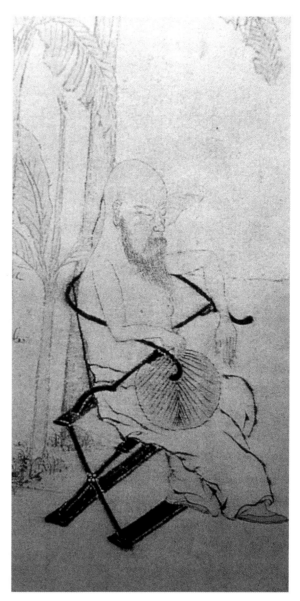

5.6

FIGURE 5.5 *Returning from a Spring Outing.* Southern Song. Detail of an album leaf. Ink and color on silk. Palace Museum, Beijing. From *Songren huace* 5: pl. 6.

FIGURE 5.6 Luo Ping (1773–99). *Portrait of Jin Nong's Noon Nap beneath Banana Palms.* 1760. Detail of a hanging scroll. Ink and color on paper.

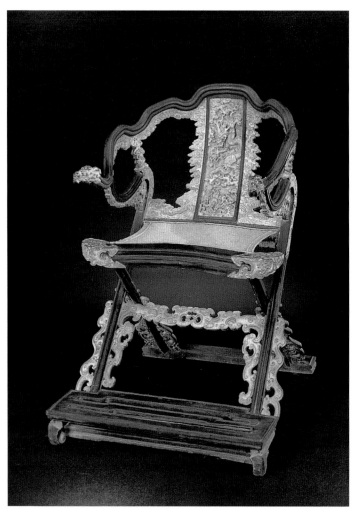

FIGURE 5.7 Folding armchair. Eighteenth century. Black and gold lacquered wood. Height 99 cm, width 92.5 cm, depth 74.5 cm. Palace Museum, Beijing. From *ZGMSQJ, Gongyi meishu bian* 11: 128.

5.7

matching rectangular footstools, when traveling or taking the air in the gardens and on the verandas of the palace. They also served as important gifts of state: among the presents the Yongle emperor (r. 1403–24) gave the Tibetan lama De-bzhin-gshegs-pa in 1406 was a silver folding chair and a silver footstool.[8] The Qing imperial emblematic objects include a gilded folding armchair that originally had been used daily by the emperor.

Like other palace furniture, imperial folding armchairs were usually more ornate than those used by officials and wealthy commoners. For example, fig. 5.7 shows one of a striking set of twelve black-lacquered wooden chairs in the Forbidden City, Beijing,

that are profusely decorated with gold-lacquered carvings. These chairs have undulating horseshoe arms and thick, inward-curving front seat stretchers with cloud-shaped brackets. The unusual form of the arms evolved from Southern Song prototypes, such as the chair depicted in the stone relief of a tomb excavated in Guangyuan, Sichuan, which has three rather than six undulating segments.[9] The handrests of the Forbidden City chairs are in the form of gold dragonheads, making the black arms resemble dragon bodies weaving through the golden clouds beneath them. The clouds frame the spaces between splats, arms, legs, and side posts with rich uneven-edged forms and continue into the splats, which are deeply

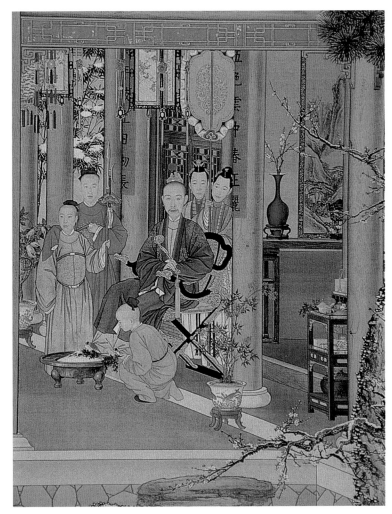

FIGURE 5.8 Giuseppe Castiglione (1688–1766), Tang Dai, et al. *Emperor Qianlong Enjoying the Snow*. Eighteenth century. Detail of a painting. Palace Museum, Beijing. From Wan, Wang, and Lu, *Daily Life in the Forbidden City*, 278.

carved with five-clawed dragons. Fluid openwork gold patterns of *chi* dragons and clouds form wide stretchers and spandrels on the legs. The backs of the chairs are beautifully finished, and the splats are embellished with the symbols of the five sacred Daoist mountains amid waves—motifs common on protective amulets. Presumably the entire decorative scheme of these chairs, with their sacred mountains, dragons, and clouds, has specific Daoist ritualistic connotations, suggesting that the chairs may originally have had a ceremonial function.

Thanks to a New Year's painting by the Italian Jesuit Giuseppe Castiglione (1688–1766) in collaboration with Chinese court painters, we know that the Qianlong emperor (r. 1736–95) used one of these chairs in his leisure moments (fig. 5.8). In a rare depiction of an actual extant piece of furniture, we see the emperor seated on a veranda watching his children build snow lions and set off firecrackers in the courtyard. Relaxed and dressed informally, he warms his feet on a low metal brazier. Behind the chair two concubines watch their children play. A pair of incense burners perfume the air, and a plum tree flowering in the snow tells us that it is early spring.

Folding horseshoe armchairs were only one form of folding armchair used for informal occasions. Wang Qi illustrates a Ming variation called the "drunken lord's chair" (*zuiwengyi*) in his 1609 *Pictorial Encyclopedia of*

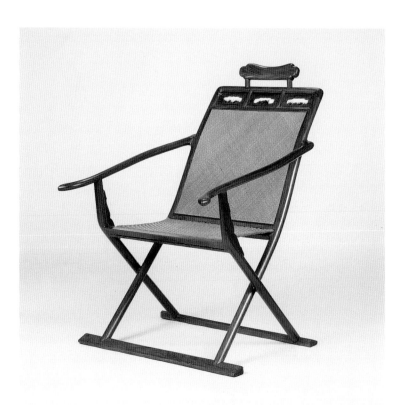

5.9

FIGURE 5.9 "Drunken lord's chair." Ming or Qing dynasty, seventeenth century. *Huanghuali* wood. Height 101.3 cm, width 72 cm, depth 91.5 cm. © Christie's Images, Ltd., 1999.

FIGURE 5.10 Tang Yin (1470–1524). *Landscapes and Figures*. Detail of one album leaf from a set of ten. Ink on paper. Height 38.2 cm, width 63.6 cm. National Palace Museum, Taipei.

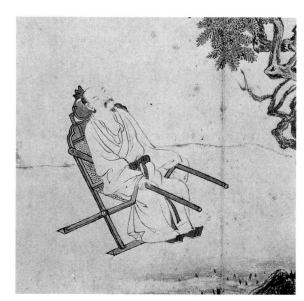

5.10

Heaven, Earth, and Man (Sancai tuhui).[10] Its most distinctive feature is the long straight arms extending well beyond the footrest stretcher. It has a splat with inset panels, curved top rail with upturned ends, a headrest, and a separate footstool.

A rare early example of this type of chair is illustrated in fig. 5.9. Unlike the sumptuous horseshoe-back folding armchairs, the "drunken lord's chair" is minimally ornamented with clear-cut geometric lines. The curved part of the leg and the simple curvilinear spandrel are carved from the same piece of wood. The rectangular back of the chair has a large hard-mat panel, above which three wooden panels inset with marble plaques form three miniature mountain landscape scenes. Great attention has been paid to subtle details, such as the soft beading around the plaques and the restrained inward-facing hooks at the juncture of top and side frame members. Since each of the legs has a single tenon fitting into a mortise on the arm, the chair folds easily when one lifts the arms and pushes back the top of the leg. The blind pivot hinge that joins the legs is sophisticated and is not found on other early chairs, suggesting that this chair might be a later piece in the classical style. The headrest and seat are recent replacements.

Erotic paintings and book illustrations often show a "drunken lord's chair" in interior scenes because the chairs were comfortable for relaxing. In a painting of a scholar by Tang Yin (1470–1524) we see that they were used outside as well (fig. 5.10). The back of the chair Tang painted is almost identical to that in fig. 5.9, with its large hard-mat panel, headrest, and three wooden panels inset with marble.

Beauty and function in art sometimes achieve a rare harmony. The folding armchair—with its beautiful form, intricate decoration, and practical, movable comfort—represents the commingling of beauty and function in Chinese art. This elegant vagabond of early furniture has two states of existence: when folded up for transportation and temporary oblivion, it is pure potential; when unfolded and realized, it brings both physical comfort and visual pleasure.

6 | THE LOWBACK ARMCHAIR WITH CARVINGS OF BAMBOO, MAGIC FUNGI, OR THE THREE FRIENDS OF WINTER

The puzzling and provocative name "rose chair" (*meiguiyi*) refers to a common type of Chinese armchair. This small, angular chair has a low back only slightly higher than the arms, which, like the back, are straight and placed at right angles to the front posts. The essential form of the chair is light and delicate, but it may have elaborate carved decoration. Although in Beijing it is known as a rose chair, it is called a "writing chair" (*wenyi*) in Jiangsu and Zhejiang provinces, according to Wang Shixiang.[1] Neither of these names appears in pre–twentieth century writings. That the so-called rose chair has no apparent connection to a rose in its decoration, form, or use has led to the speculation that there is some mistake in the characters. William Drummond, a collector and art dealer in Beijing during the 1930s, called it "beauty's chair" (*meirenyi*), and Craig Clunas suggests that it may have been intended for women.[2] In the West the rose is a popular symbol of love, with strong feminine associations and suggestions of delicacy, sensuality, and transience. In China, however, although the rose is a symbol of youth and is the plant that can stand for all four seasons, it does not have much prestige and is rarely depicted or referred to. Thus the name "rose chair" remains a mystery.

The rose chair, or "lowback armchair," as it is called in some English publications, is thought to have been based on a popular Song type in which the back and arms are of the same height.[3] This theory may be true, but Western scholars regard all the paintings depicting these chairs, despite their Song attributions (960–1279), to be Ming copies (1368–1644).[4] A related chair, however, appears in a painting that is accepted as a genuine twelfth-century work by the Southern Song Academy painter Ma Gongxian (active Shaoxing era, 1131–62; fig. 6.1). The picture belongs to the category of Chan painting known as "pictures of Chan encounters" (*chanhuitu*). It depicts the Confucian official Li Ao (d. c. 844)—a friend of Han Yu (786–824), who fervently opposed Buddhism—seeking instruction from the Chan master Yaoshan Weiyan (751–834). In the traditional story, Yaoshan ignored his distinguished visitor until Li Ao, impatient and cross, said:

"Seeing your face is less impressive than hearing your name," to which the wise *chan* master calmly replied, "How is it that you value the ear more than the eye?" Impressed by this answer, Li Ao bowed in reverence and asked, "Which is the right way (to enlightenment)?" Yaoshan Weiyan's answer was to point with one finger upwards, and downwards with the other hand, a strange gesture which Li Ao failed to understand. Finally the master added, "The clouds are in the sky; the water in the vase." Now Li Ao understood, and spontaneously recited the following verse:

> His ascetic body is dry like a crane.
> Below a pine grove are two boxes of sutras.
> I came to ask the way of enlightenment
> and heard:
> "The clouds are in the sky, the water in the
> vase."[5]

In the painting, Li Ao stands straight and still on one side of a large stone table, his hands raised in reverence. Long even lines delineate his robe, and his face is conventionally calm. On the other side, Yaoshan sits on a bamboo chair under a towering pine. He is pointing upward, his body's taut energy emphasized by the restless angular lines of his garments and his gleeful expression. The direction of his movement is reinforced by the overhanging pine branch above and the angular, downward-bending plum branch in a vase on the table. The vase is elevated on a small stand. Beside it are an oval inkstone with its cover removed, a small bowl, and two sutra boxes. His bamboo seat resembles a lowback armchair, with arms and back of the same height, to which a backrest has been added. The seat, top rail, and aprons of the chair are made from wooden boards.

Although there are no known extant Ming examples of lowback chairs with arms and back of the same height, they are frequently depicted in paintings and book illustrations. In 1437 Xie Huan painted *A Literary Gathering in the Apricot Garden,* which contains both bamboo and hardwood lowback armchairs (fig. 6.2). The bamboo chair (*left*), fashioned from thick pieces of speckled bamboo, has a splat and double stretchers on each side. The front legs, arms, and back are made from a single stalk of bamboo, which bends around the back posts and around small horizontally

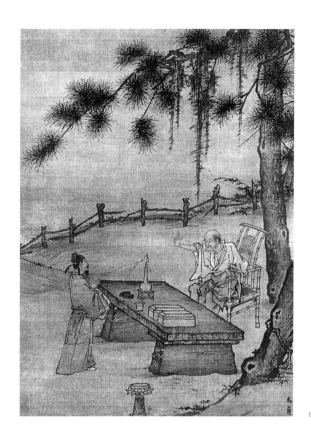

6.1

FIGURE 6.1 Ma Gongxian (active Shaoxing era, 1131–62). *The Meeting between Li Ao and the Chan Master Yaoshan Weiyan.* Southern Song, twelfth century. Detail of a hanging scroll. Ink and slight color on silk. Height 115.9 cm, width 48.5 cm. Nanzenji, Kyoto. Tokyo National Museum, *Sōgen no Kaiga,* 41.

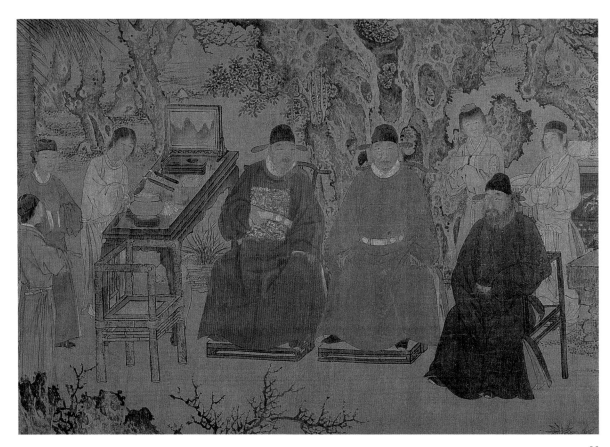

FIGURE 6.2 Xie Huan (active
1426–52). *A Literary Gathering
in the Apricot Garden.* 1437.
Detail of a handscroll. Ink and
color on silk. Height 37.5 cm,
length 240.7 cm. The Metro-
politan Museum of Art, New
York. Purchase, The Dillon
Fund Gift, 1989 (1989.141.3).
Photo © 1995 The Metropolitan
Museum of Art, New York.

FIGURE 6.3 Woodblock
illustration from *The Phoenix
Seeks a Mate* (*Huang qiu feng*).
Early Qing edition.

FIGURE 6.4 Dai Jin
(1388–1462). *A Nocturnal
Outing of the Demon Queller
Zhong Kui.* C. 1450. Detail
of a hanging scroll. Ink and
color on silk. Height 189.7 cm,
width 120.2 cm. Palace
Museum, Beijing. From
Wen C. Fong et al.,
Images of the Mind, 140.

placed pieces of bamboo at the front ends of the arms. The stocky rusticity of the bamboo chair contrasts with the slender elegance of the hardwood model (*right*). The hardwood chair is depicted twice, here as a seat for Yang Shiqi and, in the preceding section of the handscroll, as an empty chair on one side of a square table set up for a game of *weiqi*. It is made from square, rather than round, members and has a splat with a large solid panel beneath a small opening. On each side are high stretchers with shaped spandrels. The detail of the painting illustrated here shows the "Three Yangs," scholars in the Hanlin Academy who were appointed grand secretaries and became famous for their exemplary service as advisers to the emperors. Yang Pu and Yang Rong, wearing official robes indicating their rank, are seated in a manner appropriate to their high status in imposing frontal postures on large yokeback chairs with footstools. Yang Shiqi sits more informally on a small lowback armchair with no footstool. The Yangs are conventionally depicted in a famous Beijing garden surrounded by various objects indicating their learning and refined taste. A bamboo chair, a reed stool, and lacquered tables appear together with the hardwood furniture, indicating that hardwood furniture was not the only kind used by the famous arbiters of taste.

Lowback armchairs also served as informal seats for women. In an early Qing illustration to the drama *The Phoenix Seeks a Mate* (*Huang qiu feng*), three ladies sit in the center of the room, each in the middle of her seat with her feet on the floor, rather than on the front stretchers or on stools (fig. 6.3). Unlike highback chairs with curved splats, the lowback chair is not designed to fit the body and digs uncomfortably into the sitter's back. The chairs in this woodblock print have leg-encircling base stretchers, a feature derived from bamboo furniture, which is often strengthened by the use of two or more such stretchers (see fig. 6.8).

Since small lowback armchairs are lighter than other seats, they make good sedan chairs, especially when made from lightweight bamboo. Dai Jin depicted a speckled bamboo model in his painting *A*

6.4

Nocturnal Outing of the Demon Queller Zhong Kui (c. 1450; fig. 6.4). This elegant seat is carefully constructed, with cane bent into ovals to decorate the open panels and strengthen the construction. Cords bind the ovals to the frame and are also used for reinforcement and decoration on other parts of the chair. A footrest is attached by metal rods to the carrying poles. Similar chairs are shown in Ming Academy copies of Song paintings, such as *The Eighteen Scholars*.[6] Here the arms extend beyond the seat to join posts supporting the front of the footrest. There are inset panels with begonia-shaped openings beneath the seat and the stretchers. The slender, minimal construction of the chair indicates that it is made from hardwood. There are no known extant Ming examples of this type of lowback armchair with extended footrest. The minimal aesthetic of the chair in the painting, however, is reminiscent of the meditation chair in fig. 2.2. In its basic form, the meditation chair is a much larger version of the small rose chair, with the back slightly higher than the arms. Extant large meditation chairs are rare, but there are many small lowback armchairs.

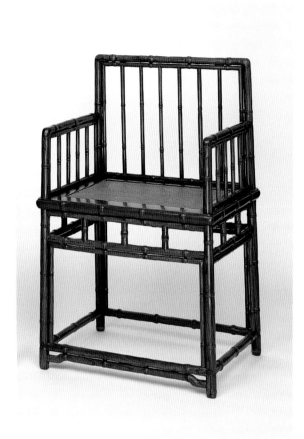

FIGURE 6.5 Bamboo-style lowback armchair, one of a pair. Qing dynasty, late seventeenth/early eighteenth century. *Huanghuali* wood. Height 88 cm, width 56 cm, depth 45.5 cm. The Minneapolis Institute of Arts. Photo courtesy of Ming Furniture, Ltd.

Because bamboo furniture has influenced the design and construction of many small lowback armchairs fashioned from hardwood, it is tempting to speculate that the form was first made in bamboo. Only from the Ming dynasty is there reliable evidence that this form was also made in wood, and wooden lowback armchairs seem to have become popular when hardwood began to be widely used for furniture. Characteristic of small lowback armchairs is the manner in which the top rail and arms curve smoothly into the posts, imitating by means of complex mortise-and-tenon joints the flexibility of bamboo, which can be bent around corners (see, e.g., fig. 6.2). Some *huanghuali* chairs are even carefully carved to resemble round stalks of bamboo, with the round jointed stalks clearly delineated, a fascinating paradox in which a precious material imitates a plebian one. Fig. 6.5 shows one of a pair of lowback chairs of this type, with spindles on the back and sides that copy a technique used to strengthen more fragile bamboo pieces; here the spindles were fitted into a rectangular frame, which was then attached to the arms and seat frame. Since bamboo cannot be cut into large flat boards, there are straight stretchers separated by struts beneath the seat instead of the usual apron. Similarly, a simple rectangular frame replaces the typical arch-shaped frame above the base stretcher.

Imitating common bamboo in rare and costly materials is an ancient tradition in China. An early example is found on a Western Han (206 B.C.–A.D. 9) censer excavated from a pit near the tomb of Emperor Wu (r. 140–86 B.C.) in Xianyang county, Shaanxi (fig. 6.6). This exquisite "mountain censer," made of bronze decorated with gold and silver, is unusual because it stands on a long post carefully fashioned to resemble a segmented stalk of bamboo. The post rises from the mouths of two dragons coiled around the circular openwork base. At the top of the post three rearing dragons support the mountain-shaped censer on their heads. Bands of dragons encircle the bottom of the bowl; above them layered peaks rise from waves or swirling clouds.

Censers such as this are the earliest three-dimen-

sional depictions of mountains in China; they represent "spirit mountains," which are intermediary between heaven and earth and are the source of sacred rivers and mysterious clouds. On their peaks live immortals, animals, and men engaged in various activities. The dragons symbolize the active power of water. When incense or grasses burn in the bowl, the fragrant smoke emerges from holes hidden behind the peaks, enveloping the mountain in magical clouds. These mountain censers might have perfumed the chambers of the nobility, but they were probably also associated with the cult of immortality and used in state rituals and funerals. By the end of the Han, they were known as "Mt. Bo censers" (*boshanlu*).[7] Inscriptions around the base and bowl of this censer, however, refer to it as a "gilded bamboo-stemmed censer" (*jinhuang tu zhujie xunlu*). The inscription also tells us that it was made in 145 B.C. and presented in 144 B.C. to the Weiyang imperial palace. Remarkably, it records the official titles of the two craftsmen responsible for its manufacture. Other inscribed artifacts excavated from the same pit indicate that the censer was later given to Emperor Wu's elder sister.[8]

It is indeed curious that bamboo was reproduced, faithfully and with considerable effort, in precious metals and luxurious hardwood. It shows a delight in making permanent the impermanent and transforming the shape of the cheapest and most common material into the rarest and most costly. The bamboo form enhanced the sculptural qualities of the pieces and made them look lighter than they were. It also carried symbolic meanings. By the Ming dynasty, bamboo symbolized the perfect gentleman, the superior man (*junzi*) who, like the pliant but resilient bamboo, bends with adversity but remains morally upright within. The bamboo's hollow stem represents the Daoist or Chan Buddhist whose mind is free of desire; its empty heart also symbolizes modesty, fidelity, and virtue. Always green, bamboo stands for longevity as well.

Few chairs are carved to imitate bamboo, but many borrow design and construction elements from bamboo furniture. One of the most popular styles has

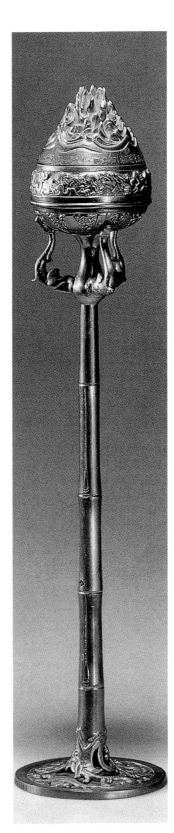

FIGURE 6.6 Mountain censer (*boshanlu*). Western Han, 145 B.C. Excavated from a pit near Maoling, Xianyang county, Shaanxi. Bronze, gilded and silvered. Height 58 cm. Maoling Museum. From Pirazzoli-t'Serstevens, *La Cina*, 1: 177.

6.6

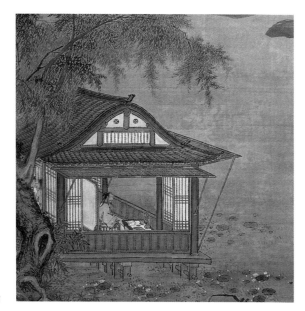

6.7

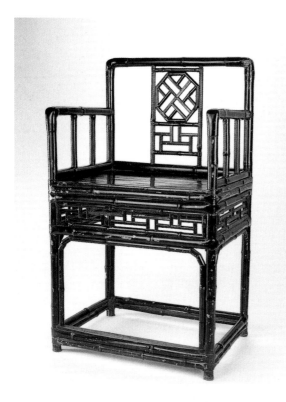

6.8

spindles on the back and sides. It appears in many paintings and is the model for lowback armchairs illustrated in the late seventeenth-century *Painting Manual of the Mustard Seed Garden* (*Jieziyuan huazhuan*).[9] The late fifteenth-century court painter Liu Jun (active c. 1475–c. 1505) depicts a spindle chair in his *Mi Yuanzheng Listening to a Fisherman's Flute* (fig. 6.7). The scholar, seated before a large standing screen in a pavilion over the water, has laid down his book and leans back in his chair absorbed in the sound of the flute. The chair, a variation of the standard spindle type, has an open panel beneath the arm.

Small lowback armchairs tend to have more elaborate decoration than most other types of chairs. On the bamboo-style chair in fig. 6.5, narrow inlaid metal strips terminating in *ruyi* shapes originally wrapped the joints of the top rail, arms, and stretchers. The remains of nails on the footrest stretcher indicate that it too was once covered with metal. (The mate of this chair has a footrest stretcher on which the indentations from the metal mounts lack the *ruyi* terminations, indicating that the footrest is a replacement.) Creating an elegant decorative effect, the metal also protected and strengthened the chair. This functional and ornamental use of metal appears on some of the earliest known pieces of Chinese furniture, such as the carved lacquer bed excavated at Xinyang in Henan province, which has bamboo railings with bronze mounts (see fig. 1.2). On Ming and early Qing hardwood furniture, metal mounts are usually made from a copper-nickel-zinc alloy known as *paktong* ("white copper"); occasionally yellow brass or iron was used.

So beautiful were the metal mounts on wood that they inspired a variation on bamboo furniture—a fascinating example of the complex and continuous cycles of imitation and re-creation. On a small nineteenth-century lowback bamboo armchair, strips of lacquered cloth bind the joints of the top rail and arms (fig. 6.8). The smooth, lustrous black lacquer against the rugged bamboo creates an effect analogous to the gleam of paktong on the bamboo-shaped hardwood. The chair has two spindles beneath each arm. The

splat is divided into two; the top panel has a crisscross lattice within an octagonal frame, and the bottom panel, a straight lattice. Lattice within a rectangular frame decorates the space between the seat and stretcher, in an arrangement like that found on the *huanghuali* bamboo-style chair (see fig. 6.5). Many of the small sections of bamboo that make up the latticework have vertical indentations, a natural formation of the plant that is cleverly used here for ornamental effect. This same formation was carefully indicated on the post of the Western Han mountain censer (see fig. 6.6). The stretcher and a double stretcher beneath the seat wrap around the outside of the legs. The three-sided frame has small pieces of bamboo placed diagonally at the corners. Cane bindings strengthen the joints. Wood forms the seat and the footrest board on top of the front stretcher. Both wood and bamboo have a lacquer coating.

Some lowback armchairs have open back and side panels with decorative frames and stretchers, echoing the basic form of the lower portion of the chair. The ornamentation of the lower part of the chair, however, is often conventional, in contrast to the freer style of the top. The base of the *huanghuali* chair in the Central Academy of Arts and Crafts in Beijing (fig. 6.9) has a standard arch-shaped frame with a curling tendril motif. The frame on the back is more complex in its silhouette and more elaborately embellished, with delicate angular spirals and perky *chi* dragons swooping down the sides. A humpback stretcher echoes the curve of the top rail, with its butterflied corners. The struts beneath are carved to represent magic *lingzhi,* the fungi of immortality. The arm panels are simplified versions of the back. This chair is more highly decorated than many of the open-panel type, but the carving and design are exceptionally fine.

The most ornate lowback armchairs have elaborately carved openwork panels, as in the chair in fig. 6.10, one of a pair with the "three friends of winter" motif. The chair is fashioned from nicely figured *huanghuali* and has a conventional base with arched frames and scrolling tendril designs. A hard mat has replaced the original cane seat. The back and sides

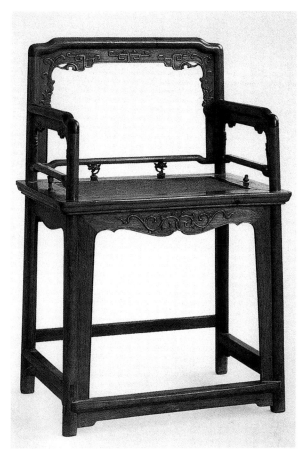

6.9

FIGURE 6.7 Liu Jun (active c. 1475–c. 1505). *Mi Yuanzheng Listening to a Fisherman's Flute.* Detail of a hanging scroll. Ink and color on silk. Image height 355.6 cm, width 156.2 cm. The Minneapolis Institute of Arts. Photo courtesy of Harrie and Tom Schloss.

FIGURE 6.8 Lowback armchair. Nineteenth century. Bamboo and wood. Height 85 cm, width 54 cm, depth 42 cm. Evelyn's Antique Chinese Furniture, Inc., San Francisco.

FIGURE 6.9 Lowback armchair, one of a pair. Ming dynasty. *Huanghuali* wood. Height 69 cm, width 58 cm, depth 45 cm. Central Academy of Arts and Crafts, Beijing. From Wang Shixiang, *Classic Chinese Furniture,* 81.

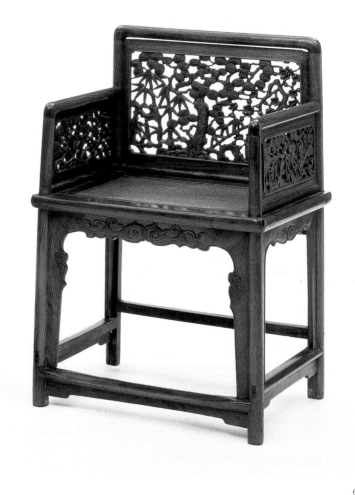

FIGURE 6.10 Lowback armchair, one of a pair with "three friends of winter" panels. Ming or Qing dynasty, seventeenth century. *Huanghuali* wood. Height 83 cm, width 57.7 cm, depth 46 cm. Collection of Edward C. Johnson 3d. Courtesy Museum of Fine Arts, Boston.

6.10

comprise beautifully carved panels, each made from a single piece of wood. On each panel a unified pictorial composition depicts a central pine flanked by a plum tree and bamboo, with the setting indicated by garden rocks and a suggestion of the ground. The front surface of the central panel is carved with great detail in three dimensions. On the reverse of the panel, however, only the main outlines are delineated, and there is no beading. On the side panels, the plum blossoms and bamboo face outward, with the more simply carved, and less visible, inner face of the panels forming the reverse side. Most likely this chair stood

against a wall, allowing the beauty of the carving to be fully displayed.

When this pair of chairs are placed back to back, it is evident that the back panels are identical, indicating that they were made from the same board. First the design was marked and roughly cut out; then the plank was cut in two. This was probably a common technique for other pieces of furniture as well, such as the large single-panel screen in Chap. 16 (see fig. 16.12).

The "three friends of winter" (*suihan sanyou*) are the pine (*song*), bamboo (*zhu*), and prunus (*mei*). The pine and bamboo are always green, and the prunus is the first to bloom in early spring. The pine symbolizes nobility, venerability, and longevity. The bamboo exemplifies integrity, fidelity, and humility; and the prunus, purity, perseverance, and transient female beauty. Because the prunus has five petals and five is a sacred number, it is an auspicious blossom; the petals represent the "five blessings": old age, health, wealth, love of virtue, and a natural death. "Early Plum," a ninth-century poem by Zhu Qingyu, groups the three plants together. By the thirteenth century they represented the moral virtues of the Confucian scholar. Hu Han (1307–81) clearly expressed this symbolism in an inscription on a painting of the three friends of winter: "The gentleman takes from the pine its incorruptibility, from the bamboo its straightness,

and from the flowering plum its purity."[10] A painting by Zhao Mengjian (1199–1264), a member of the Song imperial clan at the end of the dynasty, gives a poignant rendition of this theme, with branches of the exquisitely drawn plants floating against the empty silk. By the seventeenth century the motif had become a conventionalized auspicious design in ceramics, wood carvings, and paintings.[11]

The motif of the three friends of winter and the sturdy proportions of the chair made it an appropriate seat for a scholar in his study or garden. Among existing pieces and representations in paintings and woodblock prints, there is no support for the theory that the lowback armchair was primarily a seat for women. Rather, it was an informal seat used by both sexes in everyday domestic settings.

The lowback armchair, then, is small, light, informal, and moveable, serving both men and women, indoors and outdoors. This playful and imaginative form reveals an interplay between hardwood and bamboo in which a more precious material imitates a humbler one, thereby confusing hierarchical value systems and contributing to the chair's whimsical qualities. Although the modern term "rose chair" remains inexplicable, in its most elaborate and finest incarnations this common armchair acquires the enduring beauty of the rose.

7 | A UBIQUITOUS STOOL

*T*he ubiquitous stool, a multishaped seat without walls, roams indoors and outdoors as the modest wanderer of Chinese furniture. And, like a wanderer ready to journey anywhere, it normally faces all directions at once. Always ready to move and never fussy about its orientation, the stool is one of the most convenient surfaces for supporting people and objects. Often it is a poor person's seat—purely utilitarian, at home or on the street. But when it is made of hardwood, lacquer, or ceramics, it can be both costly and elegant.

A universal and basic type of furniture, stools have been in continuous use since ancient times. In China an early depiction of a stool appears in what is probably a ceremonial context on a fragment of an Eastern Zhou (770–221 B.C.) incised bronze vessel (fig. 7.1). The stool has a high curved seat and a base that widens at the bottom. There are no known remaining ancient Chinese stools, but we begin to see representations in other media in the fourth and fifth centuries A.D., when several types are depicted in Buddhist art.

An early form, which probably originated in India and became known in China through Buddhist art, is frequently shown as the seat for a meditating bodhisattva, who sits with one leg drawn up and the ankle resting on the opposite knee. In a Northern Liang (A.D. 421–439) relief sculpture in cave 275 at Dunhuang, the stool is bulbous and made of bent reeds or cane secured by a horizontal band. The bodhisattva sits in a niche framed by a pair of trees, and he is flanked by two attendants painted on the wall behind him.[1] Often the meditating bodhisattva's stool is shaped like an hourglass, with a band tightened around the cane in the middle to create a waisted effect. This shape of cane stool has long been used in Southeast Asia, where it can still be seen today. There are many charming Chinese Northern Wei (386–535) depictions of hourglass-shaped cane stools, such as that on the back of a small bronze image of a standing Guanyin, with an inscription dated 489, in the Hebei Provincial Museum (fig. 7.2). On this exquisite bronze, the tree beneath which the bodhisattva meditates is represented by a leafy branch in a vase, its curve following the edge of the plaque and echoing the outline of the figure. The cane stool, depicted in flowing parallel

lines like those of the garments and leaves, has an organic vitality that unites all these natural materials that sprang from the earth.

A bodhisattva is one who renounces Buddhahood until everyone on earth is saved. He or she is therefore depicted as a more accessible divinity than the Buddha, who normally sits stiffly upright on a throne. The bodhisattva, however, sits on a stool with limbs bent and body twisted in a manner not possible on a chair with confining armrests and back. The comfort and support of the chair induces a ready-made posture, while the stool allows one to assume innovative and imaginatively significant postures. In a Western equivalent, entertainers on the stage rarely sit on chairs, but rather on round stools, which permit them a great range of postures to convey their many moods. In a practical sense, the stool allows freedom of movement, inviting the sitter to take on postures that satisfy the needs of deity, artist, worker, and even entertainer. The stool, then, implies activity and diversity, while the chair invites immobility and frontality. Unlike other types of seating, such as an armchair or a bed, a stool rarely provides pure relaxation because it does not offer total support. The stool always requires an infusion of energy on the part of the sitter just to maintain balance.

On a stool one sits in the center in a balanced posture, leaning slightly forward, as we observe in early representations of monks and sages seated on rectangular, round, or folding stools. In a Northern Wei painting in cave 257 at Dunhuang, a monk sits on a simple rectangular stool with straight corner legs; the monk's outstretched legs are balanced by his forward lean.[2] Elsewhere we find a monk seated on a low round stool. He has adopted a bowed posture as he holds an incense burner and worships an image of the Buddha. The scene is on the sixth-century stele from Ruicheng *xian*, Shanxi, in the Nelson-Atkins Museum of Art in Kansas City, Missouri.[3] On another stone stele dated 543, the Nepalese seer Asita sits on a folding stool and holds the infant Buddha (fig. 7.3). He has drawn up one knee to form a T, and his body is bent to cradle the child in his arms. The stool's

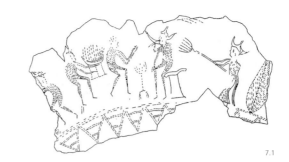

7.1

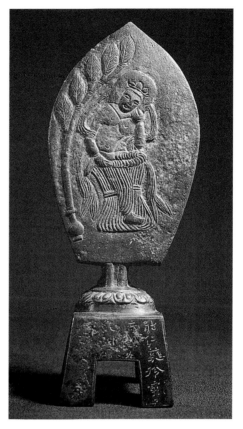

7.2

FIGURE 7.1 Bronze fragment of Eastern Zhou (770–221 B.C.) vessel. Drawing from CPAM, Jiangsu Province and the Nanjing Museum, "Jiangsu Liuhe Chengqiao Dong Zhou mu," 114.

FIGURE 7.2 Meditating bodhisattva. Northern Wei dynasty, dated 489. Bronze. Height 21.7 cm. Hebei Provincial Museum. From *ZGMSQJ, Diaosu bian* 3: 113.

7.3

7.4

FIGURE 7.3 *Asita Holding the Infant Buddha.* 543. Detail of a rubbing from a Buddhist stone stele found near Luoyang, Henan. From Chavannes, *Mission archéologique dans la Chine septentrionale,* 1: 284.

FIGURE 7.4 Pottery models from the tomb of Zhang Sheng, Anyang. Sui dynasty. From Anyang Archaeological Team, "Anyang Sui Zhang Sheng mu fajui ji," 543, figs. 2–4.

crossed legs are joined by a metal rod that acts as a pivot, allowing them to fold together. Stretchers on the top and bottom connect the legs. As usual in China, Asita sits on the side of the stool with the stretchers. The artist has beautifully rendered the image of Asita sitting in an energetic posture on a small and precarious stool. Since the straight lines of the stool parallel the dominant lines of the sitter, the folding stool appears to gain stability.

On the basis of textual evidence, most scholars consider that folding stools, called *hu chuang* in ancient China, were imported into China during the late second century A.D. More has been written about them than about any other topic in the history of Chinese furniture.[4] In ancient China—as in ancient Egypt, Greece, and Rome—the folding stool was a prestigious seat and a symbol of dignity.[5] The first folding stools were used in Egypt during the second millennium B.C. Made of wood, they were adorned with carved duck's heads or lion's legs, gold mounts, and inlays of ivory, ebony, and semiprecious stones. Tomb reliefs and paintings show men of authority using them in both official and domestic contexts. In ancient Greece they were the seats of gods and heroes. The folding stool attained its exalted and clearly defined position as the Roman *sella curulis* (curule stool), which was the most important seat of office for emperors and magistrates. An empty *sella curulis* is a common symbol on Roman tomb reliefs.

Likewise, in China by the late sixth century the wealthy and important had depictions of stools in their tombs to provide comfort and status in the afterlife. An engraving on the stone walls of the tomb of a Shandong merchant who died in 573 shows the deceased seated on an hourglass-shaped stool in the same one-leg-up posture as the meditating bodhisattvas. He is receiving goods from a curly haired, big-nosed foreigner.[6] In a Sui dynasty (581–618) tomb belonging to Zhang Sheng were found pottery models of two stools and a table (fig. 7.4). The rectangular stools have solid board sides and exposed tenons on their tops. The table has everted flanges and on each side multiple legs attached to a base stretcher.

Noble ladies of the Tang dynasty (618–906) are frequently depicted sitting on stools, which must have been common items of furniture in their homes. In a painting in cave 445 at Dunhuang, hourglass-shaped stools provide seating for female heretics receiving the tonsure after their defeat in the contest with Śāriputra. The stools are quite high, since one monk stands on a low footstool to better perform his task.[7]

Three-color glazed pottery models of beautiful women seated on hourglass-shaped stools have been found in Tang tombs. An especially fine one excavated from a noblewoman's tomb near Xi'an (fig. 7.5) is believed to represent the occupant of the tomb because it was found in the most honorific position: by the north wall facing south, surrounded by the other burial objects. The figure is thought to have originally held a mirror in her left hand and is thus an early example of the "beauty gazing in a mirror" theme that became popular in later paintings. She sits straight, as befits her dignity, so that she, the stool, and the entire pottery figurine will not topple over. She is exquisitely dressed in a long-sleeved undergarment, short low-necked vest, and long green brocade skirt decorated with flower patterns and tied under the bosom with flowing ribbons. The tips of her fashionably upturned shoes peak out from beneath the skirt. Her hair is piled in a soaring bun, and between her brows is a floral decoration (*hua dian*) that was painted or made of tiny pieces of metal. Pious ladies may have placed similar models, representing themselves, before Buddha images in the hope of increasing their blessings.[8]

Tang ladies also sat on square and round stools. A tomb in the village of Nanliwang, Xi'an, Shaanxi, yielded an unusual painting representing a six-panel screen of beauties in a garden.[9] One of the ladies sits on a plain square recessed-leg stool with base stretchers. She is playing the *pipa,* an instrument of central Asian origin associated with lovers, courtesans, and popular songs. A small servant stands nearby, and a tree towers overhead. Stools were ideal for displaying the graceful curves of a woman's back. In *Tuning the Lute and Drinking Tea,* a handscroll in the Nelson-

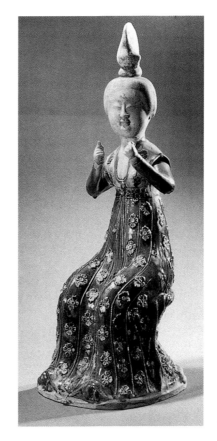

7.5

FIGURE 7.5 Beautiful woman. Tang dynasty, eighth century. Three-color glazed pottery model. Unearthed in 1955 from tomb 90, Wangjiawen, Xi'an, Shaanxi. Height 47.5 cm. From Chang Wan-li, *Three-Colours Glaze Pottery,* fig. 1.

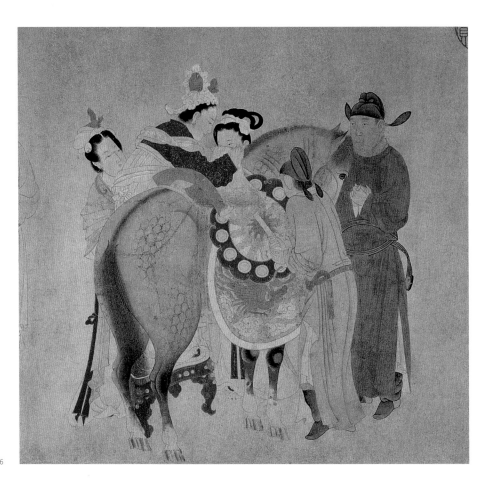

7.6

Atkins Museum of Art that is attributed to the eighth-century painter Zhou Fang, we see the back of a lady who sips tea as she listens to her friend playing the zither (*qin*).[10] Her elaborate wide, low stool has rounded corners, cloud-head feet, scrolling decorations, bows hanging from rings, and a cushion. Similar wooden stools serve as seats for ladies in another painting attributed to Zhou Fang, *Ladies Playing Double Sixes,* in the Freer Gallery of Art, Washington, D.C.

Tang ladies were fond of riding and probably used similar stools when mounting their horses. In the provocative depiction *Yang Guifei Mounting a Horse,* by the Yuan dynasty (1279–1368) painter Qian Xuan, the plump favorite of Emperor Minghuang (r. 713–756) climbs from an ornate stool with her maids' help (fig. 7.6). The stool has cabriole legs with cloud-head feet and spandrels. Since the Song dynasty (960–1279),

stools for mounting horses have been called *xiama wuzi,* or simply *mawu.*[11] Paintings of outings to the countryside show a man on horseback accompanied by servants carrying sturdy square stools that could have been used for mounting the horse as well as for sitting (see fig. 5.5). Moreover, Yuan and Ming tombs often contain pottery models of large processions in which servants carry stools for their masters, who are on horseback.[12] Undoubtedly stools have always been multifunctional, used not only for seating but also for reaching high places or holding small objects.

Although by the Song dynasty chairs had become common and were the more prestigious seat, stools remained in wide use and were considered perfectly comfortable. In China, unlike in the West, people usually sit up straight, not relying on a chair's arms

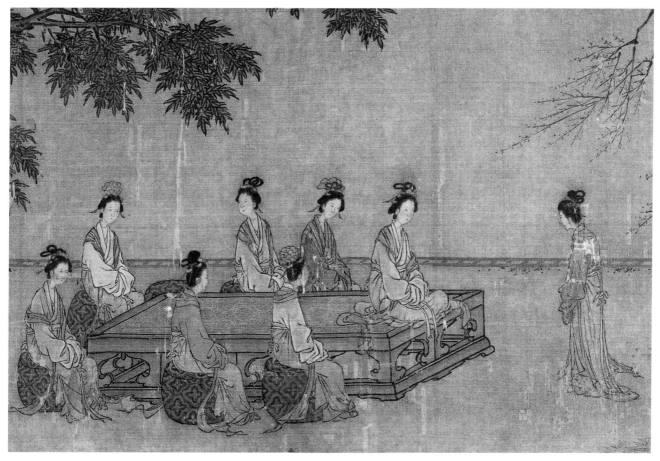

7.7

or back for support. In effect they use the chair as if it were a stool. Chairs were more prestigious, however, because they were larger, more imposing, and costlier and because their armrests enabled sitters to assume positions of grandeur.

Because stools are small, people could easily acquire a few extra ones for unexpected situations. Moreover, for their own pleasure or to accommodate guests, they could move the stools or carry them outside. In scenes of aristocratic life we see both men and women seated on large round stools. In a twelfth-century illustration to chapter 1 of the *Ladies' Classic of Filial Piety* (*Nü xiaojing*), said to have been written by Lady Zheng in the mid Tang dynasty, young women sit decorously on this type of stool around a large platform (fig. 7.7). They are listening to a moral lesson delivered by the renowned Han dynasty female

FIGURE 7.6 Qian Xuan (c. 1235–after 1300). *Yang Guifei Mounting a Horse*. Detail of a handscroll. Ink and color on paper. Height 29.5 cm, length 117 cm. Courtesy of the Freer Gallery of Art, Smithsonian Institution, Washington, D.C.

FIGURE 7.7 Attributed to Ma Hezhi (twelfth century). *The Starting Point and Basic Principle*. Illustration to *Ladies' Classic of Filial Piety* (*Nü xiaojing*), chap. 1. Detail of a handscroll. Ink and color on silk. Height 26.4 cm, length 63.7 cm. National Palace Museum, Taipei.

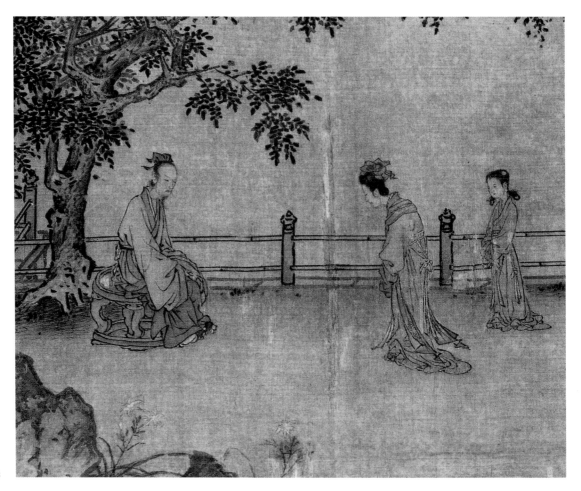

7.8

scholar Ban Zhao (c. 45–c. 115). As befits her high status, Ban sits on the platform. She begins her discourse with a summation of the importance of the filial way, which has been passed down from the wives of the sage emperor Yu: "Filiality broadens heaven and earth, deepens human relationships, moves ghosts and spirits, and affects the birds and beasts."[13] This statement sets the tone for the rest of the text, which—unlike the earlier *Biographies of Eminent Women* (*Lie nü zhuan*) and *Admonitions of the Court Instructress* (*Nüshi zhen tu*)—teaches that a woman's observance of filiality influences not only her family, but also the order of the whole society and the cosmos. Although Ban Zhao lived in the Han dynasty (206 B.C.–A.D. 220), the painter depicts a contemporary twelfth-

century scene, with ladies dressed in the Southern Song style seated on large, boldly patterned round stools.

The illustration to chapter 7 of the *Ladies' Classic of Filial Piety* depicts another type of round stool (fig. 7.8). It has cabriole legs with cloud-head feet standing on a round base stretcher. The stretcher itself stands on low cloud-head feet, and the same motif ornaments the aprons. This stool is clearly made of wood, while the one illustrating chapter 1 might be ceramic. *The Three Powers* (heaven, earth, and man) is the title of chapter 7, and the painting illustrates the idea that a woman's husband is her heaven.[14] The husband sits on the stool under a tree, and his wife bows respectfully before him while a maid stands discreetly be-

FIGURE 7.8 Attributed to Ma Hezhi (twelfth century). *The Three Powers*. Illustration to *Ladies' Classic of Filial Piety* (*Nü xiaojing*), chap. 7. Detail of a handscroll. Ink and color on silk. Height 26.4 cm, length 63.7 cm. National Palace Museum, Taipei.

FIGURE 7.9 *Moonlit Night*. Southern Song (1127–1279). Fan painting. Ink and color on silk. Palace Museum, Beijing. From *Songren huace*, 8: 6.

7.9

hind her. Here, to sit on a stool conveys more honor than standing. But in other depictions it is evident that sitting on a chair is even more prestigious. In a Yuan tomb painting from the Yuanbao Shan Tomb, Chifeng county, Inner Mongolia, the wife sits on a stool similar to the one in *The Three Powers* illustration, while her husband, whose position in society is more important, sits on a folding armchair.[15]

A popular type of round stool has oval openings in the sides that derive from cane stool construction, in which the sides are made of circles or ovals of cane bound together. Stools with oval openings first appear in paintings from the Song dynasty. In *Moonlit Night* (fig. 7.9), a Southern Song fan painting in the Palace Museum, Beijing, a pair of these stools stand

before a screen in an open pavilion. They appear to be made of wood and have five openings, round base stretchers, and low feet. A lady stands nearby, waiting for her lover to sit down with her on the stools for a drink and chat before going to the bedroom. The bed, with a long pillow, invites the eye through the open doors on the left. In pots before the doors bloom huge lotus blossoms, symbols of sexual love, fertility, and summer. Moonlight illumines the scene, revealing a garden with a pair of tall trees, rocks, and lush vegetation in the distance.

Stools can easily be carried out to the garden to serve as seats or low tables. Sometimes they are lacquered and wonderfully decorated, like the one in *Children Playing in a Garden in Autumn*, by the twelfth-

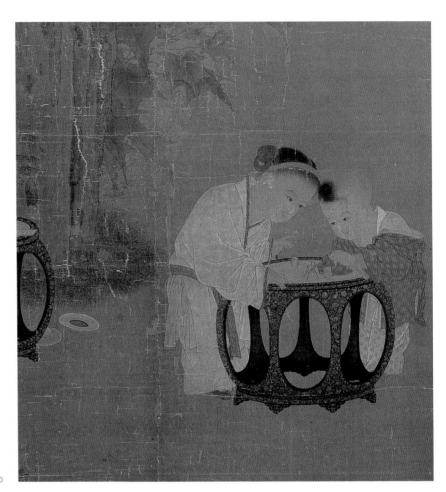

7.10

FIGURE 7.10 Su Hanchen (active c. 1110–65). *Children Playing in a Garden in Autumn*. Detail of a hanging scroll. Ink and color on silk. Height 197.5 cm, width 108.7 cm. National Palace Museum, Taipei.

FIGURE 7.11 Stool with double stretchers, one of a pair. Ming dynasty, late sixteenth/early seventeenth century. *Huanghuali* wood. Height 51 cm, width 52 cm, depth 41 cm. © Christie's Images, Ltd., 1999.

century artist Su Hanchen (fig. 7.10). In this hanging scroll, two children play under a tall, thin rock standing among flowering plants. The princely children are dressed in garments decorated with gold and wear gold and pearl ornaments. They are completely absorbed in playing with a toy balance made of jujube fruits, which sits on the mat top of a round stool with five bold oval openings. The stool is an exquisite piece of furniture, well proportioned and decorated with stylized silver chrysanthemum and vine patterns against a black lacquer ground. This painting is remarkable for its delicate detail and the animated expressions of the children.

Stools and large tables were also carried to the gar-

den for scholarly gatherings where friends painted and composed poetry. A large square stool with mat seat, legs ending in cloud-head feet, and a base stretcher is depicted in the Southern Song painting *Composing Poetry on a Spring Outing,* attributed to Ma Yuan (see fig. 1.12). The stool stands by a large rectangular table of similar design. In the fan painting *Returning from a Spring Outing* (see fig. 5.5), a scholar rides home accompanied by servants carrying necessities, including a square corner-leg stool with high stretchers. The mat seat of the stool has been removed for easy transport, revealing the crossed supporting braces. Because it is easy to move, the stool—like its counterpart, the folding chair—brings both elegance and practicality to a day's outing.

Perfected in the Ming dynasty, the design and construction of the type of stool seen in *Returning from a Spring Outing* is exemplified by a pair of rectangular *huanghuali* stools, one of which appears in fig. 7.11. The stool is fashioned from thick timbers and is exceptionally strong in both appearance and construction. Its slightly splayed legs are square on the inside and rounded on the outside, with bold beading at the juncture of the two surfaces. The stretchers joining the legs—one on each long side and two on each short side—have a flattened elliptical cross-section. This shape echoes the form of the legs and produces a lighter effect than would be the case if the stretchers were perfectly round or square. All the stretchers, except for the upper side stretchers, are wood-pinned for extra strength. The apron-head spandrels above the stretchers are plain except for their beaded edges and butterflied corners, which relieve the severity of the design. The beading continues along the bottom and top edges of the rounded seat frame, which is noticeably worn on the long sides, indicating the direction in which people sat. In addition to the double side stretchers, there are two curved transverse braces beneath the mat and the palm-fiber seat, with an additional rectangular support in the center. This overbuilding suggests that the stool is an early hardwood piece copying earlier softwood construction.

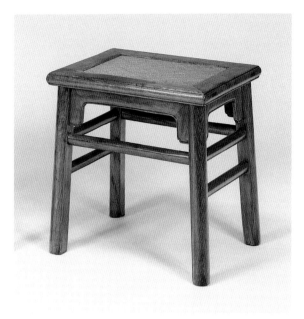

7.11

The general term for "stool" in north China today is *wudeng.* Under the heading "stool" (*wu*) in the annotated *Treatise on Superfluous Things* (*Zhang wu zu jiao zhu*), the Ming connoisseur Wen Zhenheng distinguishes between square stools (*fangwu*), rectangular benches (*changwu*), and round stools (*yuanwu*). In the *Classic of Lu Ban* (*Lu Ban jing*), a rectangular stool with recessed splayed legs is called *wuzi. The Pictorial Encyclopedia of Heaven, Earth, and Man* (*Sancai tuhui*) names stools according to the material they are made of: wooden stools are *muwu;* bamboo are *zhuwu.*[16]

Ming tombs frequently contain pottery models of servants carrying stools, often as part of a long procession. Some of these figurines demonstrate how large square stools were carried on the back, small stools placed over one shoulder, drum stools held with both hands, and folding stools slung over the shoulder. The figurines also show the variety of sizes in which stools were made, from large to very small.[17]

Large stools were, of course, the more imposing and important seats; peasants and workers used diminutive models. Ming illustrations to *Exploitation of the Works of Nature* (*Tiangong kaiwu*) depict some of the workers sitting on stools only slightly raised from the ground. In fig. 7.12, for instance, a potter

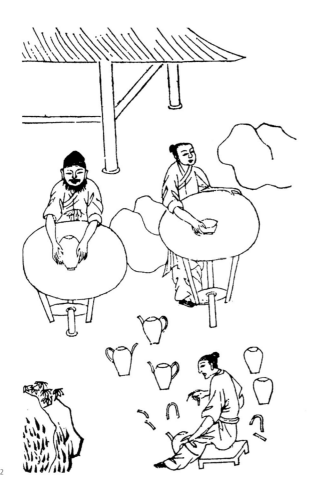

FIGURE 7.12 Making pottery jars. Woodblock illustration to the 1637 edition of *Exploitation of the Works of Nature*.

seated on such a stool is putting handles and spouts on earthenware jars while his coworkers stand behind revolving potter's wheels shaping the bodies of the vessels. Only on a stool, unimpeded by back or arms, does one have the freedom of movement necessary for this practical task. Chinese have long regarded these low stools as comfortable, and today in the countryside and back streets of China one still sees people sitting on them.

The finest pieces of Ming furniture have great aesthetic beauty, even when their form follows a standard type. Thus, although waisted stools with horse-hoof feet are common, the stool in fig. 7.13 is noteworthy for its wonderful proportions, solidity, and grace. Fashioned from thick timbers of light-colored *huanghuali,* the stool has a soft-mat seat with two curved transverse braces. The seat frame, with its deep inward curve ending in a wide bead, is balanced by the outward curve of the leg. The stool is strongly constructed, with humpback stretchers and a recessed waist and apron made from a single piece of wood. The edge of the apron has a wide bead that continues down the legs and high horse-hoof feet. The outer surfaces are slightly convex and the edges somewhat rounded. Such stools had many different uses. In an illustration of a schoolroom in the 1681 edition of *Imperial Edicts, Illustrated* (*Sheng yu xiang jie*), a boy sits on a similar stool while his classmates sit on round stools.[18] The pupils sit at long tables facing each other under the watchful gaze of the teacher, who is seated in front of a screen on a yokeback chair with a footstool. Here we see again that stools are lower than chairs in the hierarchy of seats.

A different aesthetic derived from bamboo furniture is seen in a large square *zitan* stool (fig. 7.14). *Zitan,* the densest and most prized of Chinese hardwoods, has a dark purplish-black color and a fine, sometimes almost invisible, grain. The frame of the top, with its thick double-molded edge, the rounded leg-encircling stretcher, the rounded struts, and the round legs—all reflect the construction of a bamboo stool. It is not an imitation but a transformation in which elements of light, fragile bamboo furniture ap-

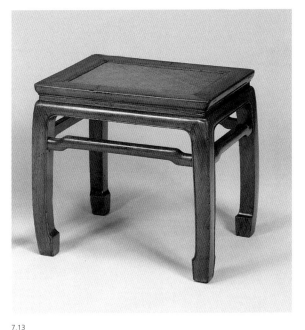

7.13

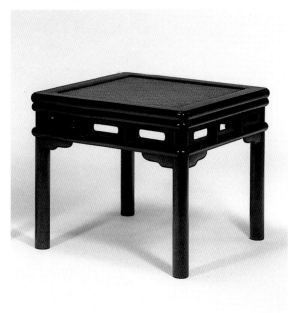

7.14

pear in a piece made from the hardest and densest of Chinese furniture woods. The dark wood has a jade-like luster and soft rounded edges. On each side, three flat panels with beaded-edged oval openings are inset between the top and the stretcher. There are curving beaded-edged spandrels below the stretcher. The soft palm-fiber seat is supported by two long, curved transverse braces connected to the sides of the frame by two short braces. This kind of bracing, also found on a small platform (see fig. 8.21), relieves pressure from the caning of the seat, which can cause the frame to warp.

The decorative effect of the *zitan* stool depends on the shape and placement of its members. It is the carving, however, that gives ornamental beauty to a pair of square *huanghuali* stools with cabriole legs and humpback stretchers (fig. 7.15). The carving is profuse and delicate, with unusual variations on standard motifs. The graceful cabriole legs end in stylized claw feet with floral details. The hump of the stretcher emerges from a pair of open-mouthed dragons whose abstract bodies, each with one three-clawed leg, are carved on the legs of the stool. At the top of each leg is the head of a benign-featured animal with a hoofed

FIGURE 7.13 Stool with humpback stretcher, one of a pair. Ming dynasty, late sixteenth/early seventeenth century. *Huanghuali* wood. Height 51 cm, width 56 cm, depth 47 cm. © Christie's Images, Ltd., 1999.

FIGURE 7.14 Large stool, one of a pair. Qing dynasty, late seventeenth/early eighteenth century. *Zitan* wood. Height 52 cm, width 63 cm, depth 63 cm. © Christie's Images, Ltd., 1999.

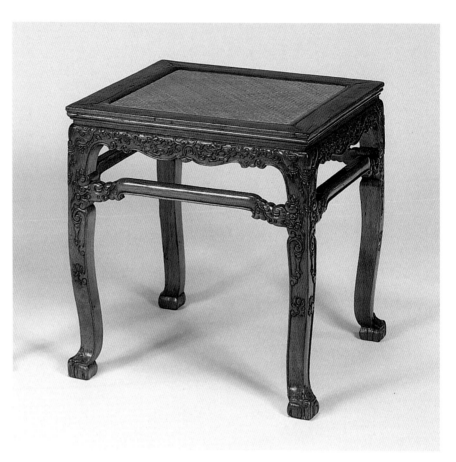

7.15

FIGURE 7.15 Square cabriole-leg stool, one of a pair, with detail. Qing dynasty, seventeenth or eighteenth century. *Huang-huali* wood. Height 54 cm, width 52 cm, depth 52 cm. © Christie's Images, Ltd., 1999.

FIGURE 7.16 Dai Jin (1388–1462). *The Puppet Show.* Leaf from the album *Happy Events in Peaceful Times.* Ming dynasty. National Palace Museum, Taipei.

leg dangling from its mouth. On the aprons two dragons face a vine motif. The beading that edges the curves of apron and legs flows into the relief carving. The complexity of the carving and edges echoes in the profile of the top molding and recessed waist. Although elaborate, the ornamentation seems to be an integral part of the structure, not simply added to the surface.

Sotheby's New York sold a similar stool in October 1987 as lot 409. There are three other examples of these stools, all with replaced feet and added base stretchers. One, belonging to the Beijing Hardwood Furniture Factory, is illustrated in Wang Shixiang's *Classic Chinese Furniture,*[19] and the other two are in a private collection. The carving was so highly valued that, even though the feet had been destroyed, all three stools were saved, restored, and published.

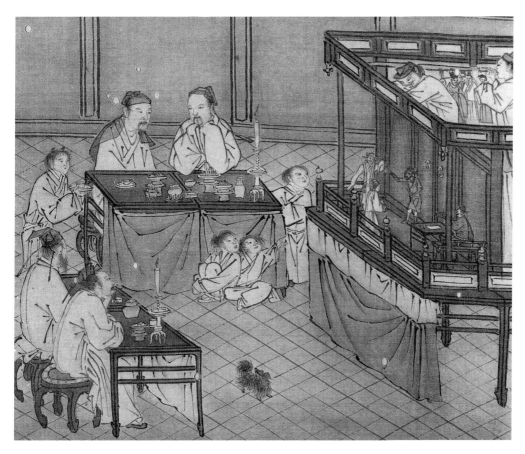

7.16

Among extant Chinese stools, square and rectangular models are more common than round ones. Yet round stools (which Beijing craftsmen call *yuandeng*) appear more often in paintings, woodblock illustrations, and specific literary references. The stool most frequently depicted is round with four usually slightly convex legs ending in horse-hoof or cloud-head feet. This is the model type for painters, according to the 1680 *Painting Manual of the Mustard Seed Garden* (*Jieziyuan huazhuan*),[20] and is seen in many paintings, such as a leaf from Dai Jin's album *Happy Events in Peaceful Times* (fig. 7.16), depicting a puppet show in a well-to-do household. Four men and three boys, attended by a servant, are watching puppets perform on a portable stage. A small dog barks at the entertainment. The men sit on round stools with cloud-head feet at rectangular tables spread with refreshments and

illumined by candlelight. Each table consists of two smaller square tables placed side by side and hung with table frontals for the occasion. A frontal also adorns the tables holding the stage. We see the puppeteers behind the stage. On stage stands a miniature table just like the ones the audience is using, indicating that these tiny pieces were not only tomb objects but had uses in everyday life as well.

Both women and men used round stools. Ladies sit on them around a banquet table in a woodblock illustration depicting Meng Yulou's birthday celebration in the novel *The Plum in the Golden Vase* (*Jin ping mei;* fig. 7.17). The artist shows the square table festively bedecked with a frontal and laden with delicacies. A fire burns in the brazier underneath. A folding screen stands behind the table, and incense smoke emanates from the mouth of a lion-shaped burner on

a stand. Two musicians entertain the company. Xi-men Qing, master of the house, and his principal wife, the Moon Lady, are seated in the position of honor on chairs at one end of the table with the screen behind them. Meng Yulou and the other wives sit on stools on either side, as befits their lesser rank on this occasion.

The hierarchy of seating was of great importance in all social situations, and stools were the lowliest seats. In 1661 the Italian Jesuit missionary Daniello Bartoli described the funeral rites for a deceased Chinese father, noting that the humble stool was the only seat allowed to a son after his father died:

> On the first night he lies outstretched at the foot of the coffin, not for a long time thereafter does he use any other bed for sleeping but a simple straw pallet. He does not listen to music, nor attend cheerful spectacles. Any dish either delicate itself or tastily seasoned, and especially all meat, remains far from his table. He does not write on paper decorated with some bright color, as is customary there, but either plain or marked by a particular tincture of bereavement, and instead of chairs, which are there large, sumptuous, and prettily carved, he avails himself of a small and uncomfortable stool, and other such penances, which, after a few months, little by little begin to slacken.[21]

7.17

FIGURE 7.17 *Meng Yulou's Birthday*. Ming dynasty. Woodblock illustration to *The Plum in the Golden Vase* (*Jin ping mei*), Chongzhen reign period (1628–44), chap. 73.

Chinese novels show that the type of seat people used varied by their social status and age in relation to the other people present. In the eighteenth-century novel *The Story of the Stone* (*Shitou ji,* also known as *Honglou meng,* or *A Dream of Red Mansions*), Grandmother Jia, the matriarch of the family, reclines on a couchbed while the young people sit around on low stools (*aideng*). When Baoyu visits the Prince and is asked to stay behind for a chat, he "made his kotow of thanks for this honor, and perching delicately on a covered porcelain tabouret [*xiudun*] near the door, talked for a while of his studies and compositions and other things." If maids dared to sit at all, they would only use stools, the lower the better: "Having handed over the box, Silver plumped herself down on a small stool [*wuzi*]; but Oriole was less bold; and even when

Aroma offered her a foot-stool [*jiaota*] to sit on, she still refused to be seated."[22]

As Laurence Sickman pointed out in his 1978 lecture to the Oriental Ceramic Society, the age-old hierarchy of seating is as evident today at official gatherings in the People's Republic of China as it was in the arrangement of furniture in the reception room of the twentieth-century porcelain collector Guo Baochang: "The large *k'ang* [couchbed] is placed against the end wall, facing south. Here only the guest of honor and the host would be seated. The entire arrangement is perfectly symmetrical, and the guests are seated in descending order of precedence gauged by the distance from the *k'ang*. Of first consequence are the chairs nearest it on each side and so on down to the porcelain stools in the foreground destined for the younger generation or for indigent relatives. Exactly this same hierarchy of seating is rigorously followed in the People's Republic of China today."[23]

Extant round hardwood stools exist in several models. One model is waisted with cabriole legs. An example of this type in a private collection in Hong Kong is fashioned from *huanghuali* and has a marble top.[24] The recessed waist is embellished with large beaded-edged cutouts with floral centers flanked by teardrop cutouts. The aprons are adorned with spirited running dragons facing a vine motif, which flows into the bead outlining the edge of the apron and continues down the cabriole legs to end in a fleur-de-lis-like motif on the foot. There is a pleasing grace and vitality to the form and decoration of this piece.

A fanciful variation of the round stool has a top shaped like a plum blossom. These lobed stools appear in woodblock illustrations and paintings, such as those illustrating *The Plum in the Golden Vase* in the Nelson-Atkins Museum (see fig. 10.10). The only known extant Ming hardwood example, however, is in the Dr. S. Y. Yip Collection, Hong Kong.[25] This graceful stool has cabriole legs attached to the aprons and top with flush bridle joints. The top is solid and the waist recessed. The curved aprons are carved with wide, flat curling-tendril patterns. Cloud-head motifs cleverly mask the joined pieces of wood at the top of

7.18

FIGURE 7.18 *Oriole Orders the Lute Boy to Eat While She Writes a Letter.* Woodblock illustration to *The Story of the Western Wing,* 1498 Hongzhi ed., vol. 5, act 1.

each leg, and curls accentuate the backs of the upturned feet. Five intersecting stretchers (like those on the five-legged washbasin stand in fig. 20.7) strengthen the legs.

A round stool in the Beijing Hardwood Furniture Factory has convex legs resting on a circular base stretcher.[26] Similar stools, sometimes with cloud-head feet and cushions, appear frequently in the 1498 illustrations to *The Story of the Western Wing (Xixiang ji).* In one scene, Oriole sits on this type of stool writing a letter to her lover, who has just passed the examinations with the highest honors (fig. 7.18). The young messenger waiting to deliver her letter uses an identical stool as his table while he eats a quick meal. Stools served not only as temporary tables, but also as more permanent stands for objects, such as a washbasin in the kitchen (see fig. 20.4). And like step stools, they were also useful for reaching high places. Jiao Bingzhen, a court artist of the Yongzheng period (1723–35), depicts a lady standing on a drum stool to roll up a blind.[27]

Drum stools were made from both wood and porcelain. Fig. 7.19 shows one of a pair of drum stools fashioned from *huanghuali* wood that are especially sat-

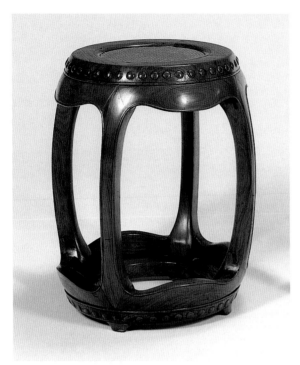

7.19

FIGURE 7.19 Drum stool, one of a pair. Ming or Qing dynasty, seventeenth century. *Huanghuali* wood. Height 38 cm, diameter 47 cm. © Christie's Images, Ltd., 1999.

isfying in their form and proportions. In shape these small round stools resemble a typical Chinese drum: along the edge of the seat frame and circular base stretcher, rounded bosses imitate the nails used to hold the drum skin in place; raised beads suggest the edges of the skin. On the far left of the Ming woodblock illustration in fig. 7.20 we see a drum upright in a wooden stand and a drummer about to strike the top with a stick. This type of drum existed well before the Shang dynasty (c. 1500–c. 1050 B.C.). In 1977 a bronze drum from the fifteenth or fourteenth century B.C. was discovered at Chongyang *xian,* Hubei, that has excellent resonance and retains all the elements, including the bosses, of a wood and skin drum.[28]

The drum stool in fig. 7.19 is made from thick timbers, and the four vertical members have a strong outward curve. The downward curving aprons at the bottom mirror those at the top. Legs and aprons are outlined by a beaded edge, accentuating the large rounded openings. The openings in the sides of these stools give the structures a pleasing lightness and were probably inspired by the type of cane stool we see in Ming paintings such as *Evaluating Antiques in the Bamboo Courtyard,* by Qiu Ying (c. 1495–1552; see fig. 13.14). The drum stools have soft-mat seats, and the base stretcher rests on low feet. Loose tenons join the legs and lower aprons, instead of the usual long tenons on the ends of the legs fitting into long mortises in the aprons. The stool in fig. 7.19 and its mate were not purchased together and exhibit different signs of wear. When one was acquired it had no feet, and the bottom of the base stretcher was rough. On the other, the bosses on the base stretcher are not centered, indicating that the bottom has worn down with use.

Drum stools are called *gudun, zuodun,* or *xiudun. Xiudun* literally means "embroidery stool" and apparently refers to the old practice of covering the seat of the stool with an embroidered panel.[29] The term occurs in Ming writings and is often used for drum stools made of porcelain, which may be decorated on the top with representations of square pieces of embroidery weighted with coins at the corners. From

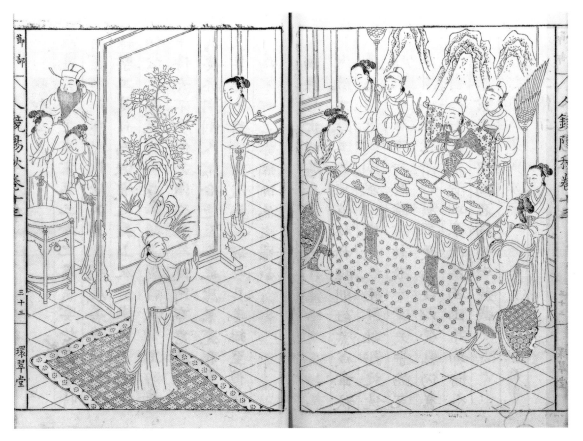

The Plum in the Golden Vase we learn that porcelain drum stools were among the furnishings of a lady's apartments and were part of her dowry. When Ximen Qing was conspiring to marry Pan Jinlian he "laid out sixteen taels of silver to buy her a black lacquer bedstead, elaborately adorned with gold tracery, bed curtains of scarlet silk with gold roundels, a dressing case ornamented with floral rosettes, and a complete complement of tables, chairs, and porcelain taborets [*xiudun*] embossed with patterns of ornamental brocade." The novel explicitly states that because porcelain stools are cold, they are not always the most suitable seats for ladies.[30]

The right-hand panel of the woodblock illustration in fig. 7.20 shows two porcelain drum stools ornamented with an overall geometric pattern; decorated cloths cover their seats. Ladies sit on the stools at either end of the table, while a man sits in the place

FIGURE 7.20 Design by Wang Geng; carving by Huang Yingzu. Woodblock illustration to Wang Tingna, *Biographies of Exemplary People* (*Renjing yangqiu*). 1610. Bibliothèque nationale, Paris.

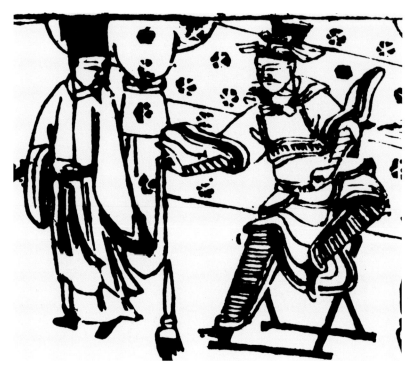

FIGURE 7.21 *Song Jiang.* 1588–94. Woodblock illustration to *Water Margin* (*Shuihuzhuan*), chap. 21. Bibliothèque nationale, Paris.

7.21

of honor on an armchair. Because of the festive occasion, a length of patterned cloth adorns the chair's yoke. A performance is taking place on a carpet spread on the floor in front of the table. A large standing screen partially conceals the musicians and an actor as well as a maid who is bringing refreshments on a dish covered by a protective net.

Porcelain stools were used not only in wealthy households, but also by craftsmen. In the illustrations to *Exploitation of the Works of Nature,* porcelain drum stools with cloud patterns serve as seats for a woman weaver, a jade cutter, and a man painting blue lines around the rim of a Jingdezhen bowl.[31] Porcelain stools were especially popular for outdoor use, since they withstand the elements better than their wooden counterparts. In Qiu Ying's *Evaluating Antiques in the Bamboo Courtyard* (see fig. 13.14), porcelain stools stand in a bamboo grove around a stone table, which a servant is preparing for a game of *weiqi.* Garden stools made of stone were even sturdier; they can still

be seen today, together with stone tables, in many old gardens.

Among wooden stools, folding models were most popular for use outside because they were light and could easily be reduced to a compact size and slung over the shoulder. Even after chairs had gained wide acceptance and higher status, the folding stool retained its prestige in certain settings; it was still used by commanders on the battlefield, for example, and was symbolic of their rank. In a late-sixteenth-century woodblock illustration to chapter 21 of the novel *Water Margin* (*Shuihuzhuan*), the brigand leader Song Jiang sits outside his tent on a folding stool, one foot raised, the other resting on the stool's front stretcher (fig. 7.21).

Folding furniture of all types is especially practical for the military and was also widely used in the West. An exhibition held in Memphis, Tennessee, in September 1993 displayed some of Napolean's folding

FIGURE 7.22 *Zitan* folding stool. Qing dynasty, seventeenth or eighteenth century. Height 48 cm, width 59 cm, depth 39 cm. © Christie's Images, Ltd., 1999.

7.22

stools, tables, and beds, all made by ironsmiths who followed him on his campaigns. In Beijing today one still sees groups of soldiers sitting on folding stools.

Traditional Confucian scholars, however, do not consider folding stools dignified. According to Wu Tung, when a group of distinguished Chinese scholars and connoisseurs unrolled the eleventh-century painting *Scholars of the Northern Qi Dynasty Collating Classical Texts* and saw the depiction of the scholar Fan Zun seated on a folding stool, they thought it most unsuitable.[32] Yet this negative judgment was anachronistic: Fan Xun lived in the Northern Qi (550–577), when chairs were uncommon and folding stools were seats of honor.

The Great Mosque in Xi'an has a rare pair of folding stools (called *jiaowu* or *mazha*) that are made from *huanghuali* wood with decorative metal plates protecting and strengthening the leg pivots, the footrests, and the joints of the legs and front stretchers. The footrest resembles those commonly found on folding armchairs, with metal *ruyi* motifs in the front corners and a triple lozenge design in the center, all secured by nails with raised heads. A curling tendril design and beaded edge decorate the apron of the footrest. Boldly carved running dragons adorn both sides of the seats. The dragons are original, but the cord seats are modern replacements.

A different spirit pervades the *zitan* folding stool in fig. 7.22. It is made from thicker members with rounded edges, which produce an effect of softness even though *zitan* is the hardest and densest of furniture woods. There are no carved decorations and no metal mounts apart from a small rondel accentuating the leg pivots. The lines are straight except for the curvilinear edge of the footrest's apron. Thus the beauty of the piece depends on the deep luster of the wood and the simplicity of the design. This stool is unusual because of the footrest, which causes the sitter always to face one direction—a limitation usually characteristic of chairs rather than stools.

As an essential form, the stool can accommodate both human beings and objects. It has no vertical walls for support or containment above its horizontal flat top, so it holds its human beings or objects by gravity alone. The stool embodies the essential block structure for supporting weights. In a formal sense, every chair or table has a stool in it, even though additional elements may disguise the essential underlying form. Adding armrests conclusively changes a stool into a chair; expanding the dimensions of the stool's top produces a table. The stool's principle of support remains the same. The modest stool is ubiquitous and practical, and the Chinese imagination has also made it beautiful in shape and surface.

BEDS

8 | LIFE ON A PLATFORM

The platform is the elemental form in Chinese furniture. At its simplest, with an absolutely horizontal surface devoid of protective or comforting side structures, only gravity holds the sitter or sleeper in place. Platforms may be large enough to accommodate a group of people or just the right size for one. There is always space for a few books and an armrest. Sometimes there is enough room for a backrest, a vase of flowers, a small table for informal meals, some treasured antiques—all the small objects that contribute to the comforts and pleasures of leisure moments. Elevated above the draughts and dampness of the floor, the platform can be a living space for both sleeping and waking hours. One of the earliest forms of seating furniture, platforms remained fashionable for this purpose until modern times.

The oldest archeological evidence of platforms is the marble and bronze pedestals from the Anyang period of the Shang dynasty (thirteenth to eleventh century B.C.). One of the most impressive pedestals is a fragmentary rectangular marble stand decorated with incised tigers (fig. 8.1) found in tomb HPKM 1001 at Houjiazhuang, near Anyang, Henan province. The top, measuring about 45 cm by 18 cm, is supported by recessed legs whose form resembles the legs joined by arched and cusped aprons found some thirty centuries later in hardwood furniture. Square bronze stands were also used to give ritual vessels greater height and, consequently, greater status; one is shown supporting a covered wine container (*you*) on the left-hand side of a bronze platform (fig. 8.2). By the early Western Zhou (eleventh to tenth century B.C.), bronze *gui* (ritual food vessels) and their square bases were cast together in one piece, making the vessel and pedestal an integrated unity (see, for example, fig. 12.1).

In this period, ritual vessels also stood on large rectangular bronze platforms (*jin*). Two of these—one in Tianjin and one in the Metropolitan Museum of Art in New York—are said to have been excavated in 1901 at Baoji, Shaanxi. The one in the Metropolitan (see fig. 8.2), together with its thirteen ritual wine vessels, is called the "Tuan Fang altar set" after the Manchu governor of Shaanxi who once owned it and in whose province it

FIGURE 8.1 Fragment of marble stand. Thirteenth to eleventh century B.C. Found at tomb HPKM 1001, Houjiazhuang, Anyang, Henan. Height 12.5 cm, top c. 45 cm × 18 cm. From Kao Ch'u-hsün, *Hou Chia Chuang,* pl. 85. Courtesy of the Institute of History and Philology, Academia Sinica.

FIGURE 8.2 Bronze altar table. Early Western Zhou, late eleventh century B.C. Reportedly excavated in 1901 at Baoji, Shaanxi. Platform height 18.1 cm. The Metropolitan Museum of Art, New York. Munsey Bequest, 1924 (24.72.1-14)

8.1

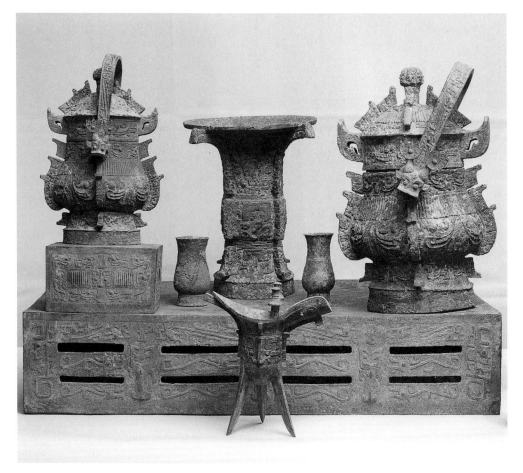

8.2

was found. The platform has narrow rectangular side openings and is ornamented with attenuated dragons in relief. Joseph Needham believes that the platform is a hot plate for warming sacrificial wine. Smoldering charcoal burned inside, and the slits functioned as vents.[1] Such platforms, fashioned from costly bronze, were probably based on more common wooden prototypes. Although no wooden objects have survived from the Shang dynasty, impressions on the earth in Anyang tombs show that there were beautifully carved wooden implements and sculptures embellished with colors and inlays.[2]

Platforms served as honorific seats in the Han dynasty (206 B.C.–A.D. 220). A pottery tomb tile from Sichuan shows a teacher elevated on a plain dais above his students, who sit on mats below (see fig. 1.1). He kneels—a posture common at the time—and leans on an armrest. Above is a latticelike structure, suggesting that the lecture is taking place inside or against the outer wall of a building. The scene was probably inspired by the introduction of a system of formal education in Sichuan under the enlightened governor Wen Weng.[3]

Besides boxlike platforms, there were also platforms with legs. Both types existed together throughout Chinese history. Several stone and pottery examples have been excavated from early tombs, such as the rare inscribed stone piece (87.5 cm long, 72 cm wide, and 19 cm high), supported by legs, that was found in 1964 in Dancheng, Henan. From the front its form resembles the Anyang stand in fig. 8.1, except that the cusp does not meet in the center. The inscription reads: "Sitting platform [zuota] of the deceased Han ruler Erudite Assistant Grand Tutor of Changshan."[4] Thus we know that such platforms were called ta and were used for sitting. That this ta was inscribed with the prince's titles and buried in his tomb suggests that ta were status symbols used only by high officials. In *Popular Literature* (*Tongsu wen,* A.D. 180), the Later Han writer Fu Qian distinguishes between ta, which are around 84 cm long (about the size of the Dancheng platform), ping boards for one person to sit on, and chuang, which are 192 cm.[5]

There are many depictions of people seated on single-person platforms that were either rectangular or square. A wall painting excavated from a third- to fourth-century tomb in Liaoyang, Liaoning, shows the two occupants of the tomb seated on individual square platforms, each of which has four legs and scalloped spandrels. Servants are serving food from a small rectangular table between the two seats. A canopy hangs overhead.[6] Fu Qian called these seats ping. They are also called duta, "single platforms," in fifth-century texts such as Liu Yiqing's *New Discourses on the Talk of the Times* (*Shishuo xinyu*): "When Liu Yuanzhi was young he was recognized by Yin Hao, who praised him to Yu Liang. Yu Liang was extremely pleased and proceeded to take him on as an assistant. After he had greeted him, he had him sit on a single couch [duta] while he conversed with him."[7]

Long platforms (chuang) were used for large banquets. On the engraved stone slabs in the shrine of Zhu Wei at Jinxiang, Shandong, as many as four feasters kneel on each of the long platforms, which are protected by screens. A wall painting found in an early-third-century tomb at Mixian, Henan, shows a platform beneath a canopy bedecked with patterned silks and flags.[8]

Any platform of sufficient length could be used as a bed as well as for sitting. A rare early depiction of someone asleep on a bed—which stands on four recessed legs and is just big enough for one person—appears on a stone relief in the A.D. 151 shrine of the Confucian scholar Wu Liang in southwestern Shandong province (fig. 8.3). A virtuous wife lying in bed is about to be killed by an assassin, who mistakenly believes she is her husband.

Behold the Virtuous Woman of the Capital,
Whose husband's enemies kidnapped her father.
They coerced her into acting as a go-between,
But she did not dare to promise.
She arranged the date for the enemies' revenge,
But changed sleeping places with her husband.
She died for a completely benevolent cause,
And in righteousness ranks first in the world.[9]

8.3

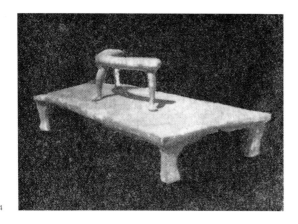

8.4

FIGURE 8.3 *Story of the Virtuous Woman of the Capital.* Later Han, A.D. 151. Rubbing of stone carving in Wu Liang shrine, Shandong. From Wu Hung, *Wu Liang Shrine*, 268.

FIGURE 8.4 Pottery platform and armrest. Eastern Jin (317–420). Excavated from tomb no. 7, Xiangshan, Nanjing. Height 21.4 cm, length 112 cm, width 65 cm. From Chen Zengbi, "Han, Wei, Jin," 67.

Rectangular sitting platforms were frequently big enough to hold an armrest and other small objects. An Eastern Jin (317–420) pottery tomb model excavated from tomb no. 7 in Xiangshan, Nanjing, was found with a pottery armrest, plate, eared wine cup, ceramic ink slab, incense burner, and spittoon (fig. 8.4). These objects would have made the deceased comfortable and content as he sat on his platform, which has four legs connected by cusped aprons that break in the center. The model is carefully fashioned to resemble a real piece of furniture and has transverse braces clearly depicted on the underside. Similar pottery models from other Eastern Jin tombs still have traces of lacquer, suggesting that they are replicas of wooden furniture with painted lacquer decoration. The excavation reports call the models "pottery tables," but Chen Zengbi shows that they must be sitting platforms for one person, measuring 75–130 cm long, 60–100 cm wide, and 12–28 cm high.[10]

In a depiction of Guo Ru carved about 525 on a limestone sarcophagus, we see how such a platform was used (fig. 8.5). Guo Ru was so poor that he could not feed his mother, wife, and small son. One day he said to his wife: "The boy eats too much; there is nothing left for our old mother. Let us bury the child. We may have other sons but we can never have another mother." He began digging a hole in the ground, but soon found a gold ingot inscribed with the words "God's gift to Guo Ru; let no one deprive him of it." He and his wife happily took the ingot and bought food for the old mother.[11] The scene illustrated here shows them presenting food to the mother, who is seated in an informal posture on a platform with corner legs; various food dishes are arranged beside her. That she is elevated on a platform is an indication of her status as revered head of the family. The nearby tree with a double trunk—a natural phenomenon representing human virtue—marks the auspiciousness of the occasion. Although this is a Northern Wei sarcophagus, in other parts of the engraving large bamboo shoots, a banana tree, and a gibbon appear, suggesting that the composition is based on a handscroll originating in the southern

Yangzi valley rather than around Luoyang, the North-ern Wei capital in northern Henan.[12]

Larger platforms could seat several people. In the Sui and Tang dynasties (581–618, 618–906, respec-tively), they were often rectangular boxlike construc-tions with ornamental oval cutouts that had cusped or scalloped upper edges. As Gustav Ecke pointed out in 1944, the form evolved from early platforms (see fig. 8.2).[13] In a wall painting found in a 584 tomb in Jiaxiang, Shandong, we see the Xus seated on a large wooden platform watching a dancer on the floor be-low perform the Dance with Meteor, or some simi-lar ball dance.[14] The mural is badly damaged, but it is still possible to see that the lady is resting against a bolster while her husband leans on a small rectangu-lar table with multiple straight legs on each side. They are holding wine cups, and dishes laden with food are arranged on the platform in front of them. A mat with a patterned border covers the top of the platform.

Tang dynasty paintings from Dunhuang depict similar box-construction platforms serving as beds, seats, and tables.[15] Large images of paradise are often flanked by small narrative scenes telling a Buddhist story set in contemporary China and providing valu-able information about the life of the time. Along-side a painting of the paradise of Bhaisajyaguru, the Buddha of Healing, are illustrations of the Nine Forms of Violent Death. In one we see a dying man in bed supported by his wife.[16] The bed is a red box-construction platform covered by a black-bordered mat. Monks and laymen seated on benches beside the bed are reciting sutras. An identical platform serves as the seat for the Buddha when he was still a boy prince (fig. 8.6). Sitting on the left, he is engaged in a discussion with the doctor of literature, who holds a symbolic scroll and is seated on the right. The doc-tor of military science, holding an official tablet, stands below the platform on the right.

A special type of greatly elevated platform appears in some of the Tang dynasty wall paintings at Dun-huang. In cave 112 a monk sitting on a high elegant box-construction seat preaches to a group of lay fol-lowers kneeling below (fig. 8.7). No doubt this is a

8.5

FIGURE 8.5 *The Filial Son Guo Ru*. Northern Wei, c. 525. Rubbing of a detail of an engraved limestone sarcopha-gus. The Nelson-Atkins Museum of Art, Kansas City, Missouri. (Purchase: Nelson Trust.)

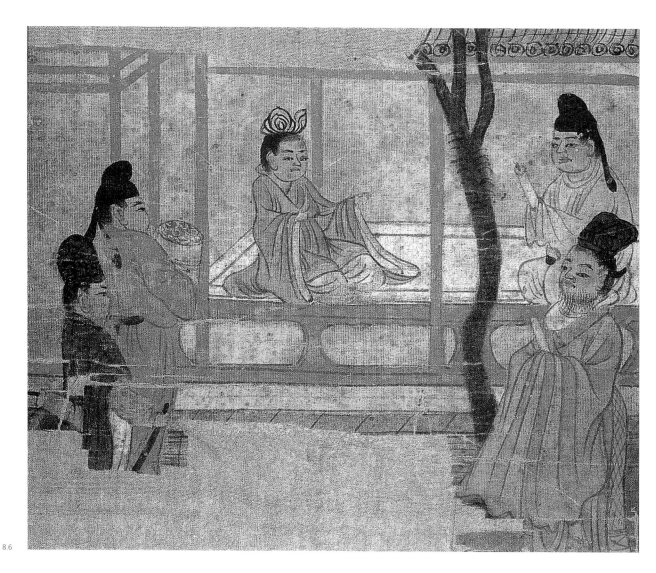

8.6

FIGURE 8.6 *Scenes from the Life of the Buddha: Śākyamuni in Discussion*. Eighth or early ninth century. Detail of a banner found at Dunhuang. Ink and color on silk. Stein painting no. 90. © The British Museum, London.

FIGURE 8.7 High platform for lecturing on the sutras. Mid Tang (781–848). Detail of a wall painting in Dunhuang cave 112. From Dunhuang Wenwu Yanjiu, *Zhongguo shiku Dunhuang Moyao ku,* vol. 4, pl. 55.

FIGURE 8.8 Wooden platform. Five Dynasties, 927–929. Excavated in 1980 from the tomb of Cai Zhuang, Qianjiang, Jiangsu. Height 57 cm, length 188 cm, width 94 cm. Yangzhou Museum. Drawing from Chen Zengbi, "Qian nian gu ta," 67–68.

platform for lecturing on the sutras (*jiangzuo*), like those Emperor Yizong presented to the monks of Anguo temple in 871, which stood 6.2 meters high and were fashioned from a wood called *chentan*. Edward Schafer, following the commentary that identifies *chen* as *chenxiang* and *tan* as *tanxiang,* interprets the passage to mean "framed in aloeswood and sandalwood," since these aromatic woods are unsuitable for making furniture. However, according to Camille Fung and Alan Fung, *chentan* is another name for *huanghuali*.[17] Ennin describes in detail the scripture-lecturing rite conducted from a high platform at the Mt. Chi cloister in 839:

> At the moment the bell sounded for the congregation to settle down, the lecturer entered the hall and mounted to a high seat, while the congregation in unison called on the name of the Buddha. . . . After the lecturer had mounted to his seat, the invocation of the name of the Buddha stopped. A monk seated below him chanted in Sanskrit, entirely in the Chinese manner, the one-line hymn, "How through this scripture," etc. When he reached the phrase, "We desire the Buddha to open to us the subtle mystery," the crowd chanted together, "The fragrance of the rules, the fragrance of meditation, the fragrance of deliverance." . . . After the singing of the Sanskrit hymn had ended, the lecturer chanted the headings of the scripture and, dividing them into the three parts, explained the headings.[18]

Portraits of famous Tang monks frequently show them seated on small low platforms. Elevation emphasized their importance and sanctity in a manner analogous to placing ritual bronze vessels and images of Buddhist deities on stands. In 805 the Japanese priest Kukai, returning from a trip to China, brought with him portraits of the five patriarchs of the True Word Sect of Tantric Buddhism, painted by Li Zhen. The Fourth Patriarch Śubhakarasimha (Shanwuwei) is portrayed kneeling on a rectangular dais with horse-hoof feet. The strong wood grain is clearly visible, as is the pattern of the brocade mat on which the patriarch sits.[19]

A rare example of a wooden platform was excavated from the Five Dynasties (907–960) tomb of Cai

8.7

8.8

Zhuang in Qianjiang, Jiangsu (fig. 8.8). Its dimensions, material, and design resemble those of furniture used in daily life. Only certain aspects of the joinery (the use of two pieces of wood for the short frame members and metal nails to secure a miter, instead of a mortise-and-tenon join, at the corners of the top frame) indicate that the piece was made expressly for the tomb and is not strong enough to be used in a household. Since Cai died in 927 and was not buried until 929, we know that the burial piece was made between those dates. The gridlike seat consists of nine horizontal boards supported by seven vertical boards. The legs, connected by a single side stretcher, have curving profiles ornamented with *ruyi* heads. The *ruyi* motif continues on the apron.[20]

Large platforms provided the ideal surface for

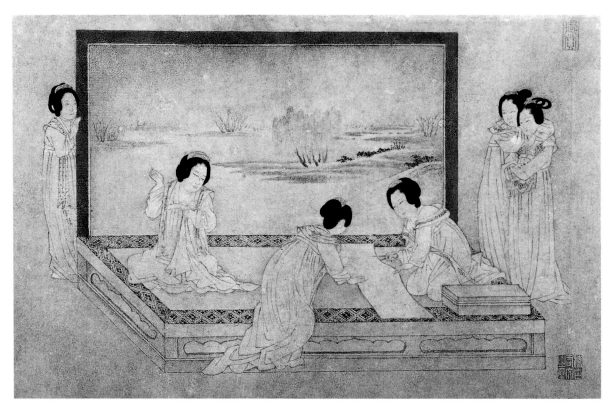

8.9

FIGURE 8.9 Mou Yi (1178–after 1242). *Clothes for the Warriors.* Southern Song, 1238–40. Detail of a handscroll. Ink on paper. Height 27.1 cm, length 266.4 cm. National Palace Museum, Taipei.

FIGURE 8.10 *Scholars of the Northern Qi Dynasty Collating Classical Texts.* Northern Song, eleventh century. Detail of a handscroll. Ink and color on silk. Height 27.6 cm, length 114 cm. Denman Waldo Ross Collection. Courtesy Museum of Fine Arts, Boston.

many kinds of everyday activities in both the men's and women's quarters. As winter approaches in Mou Yi's *Clothes for the Warriors* (fig. 8.9, painted between 1238 and 1240), we see women on a platform making clothes for their absent husbands. Two ladies cut the cloth, while another lady sews. The finished garments will be placed in the box standing at the corner of the platform. The low box-construction platform has a mat seat with brocade border. A large screen with a painting of a river landscape stands behind the platform to protect the diligent ladies. *Clothes for the Warriors* is delicately painted in tones of black ink that capture the sad and gentle melancholy of a poem by Xie Huilian (397–433), which it illustrates:

> My cloth of glossy silk is done;
> my lord is wandering and does not return.
> I cut it with scissors drawn from this sheath,
> sew it to make a robe you'll wear ten thousand miles.
> With my own hands I lay it in the box,
> fix the seal that waits for you to break.

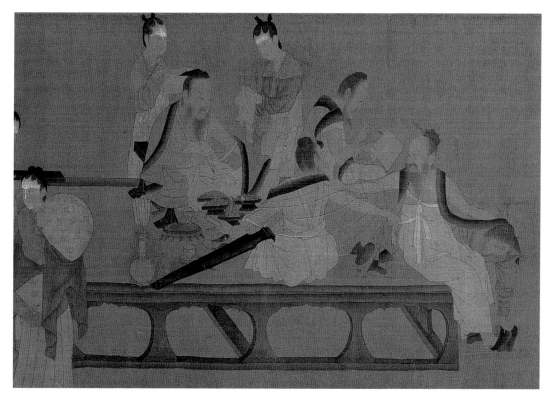

8.10

Waist and belt I made to the old measure,
uncertain if they will fit you now or not.[21]

In the eleventh-century painting *Scholars of the
Northern Qi Dynasty Collating Classical Texts* (fig.
8.10), we see a large platform on which four learned
men collate the texts of the classics for the heir ap-
parent of the Northern Qi dynasty (550–577). This
important event in the history of Chinese bibli-
ography was a favorite subject for pictorial repre-
sentation. One scholar, sitting on the edge of the
platform with his feet on the floor, is absorbed in
writing. His colleague, leaning against an armrest and
holding a brush, is deep in thought. On the other
side of the platform two scholars rest from their
labors. One interrupts his zither playing to tug on
the sash of his departing friend, whom a boy servant
is helping with his boots. In his efforts to prevent his
friend from leaving, he knocks over a dish of food.
Scattered about the platform are other food dishes,

wine cups on stands, a round inkstone with many
feet, and a vase for the game of throwing arrows.
Maidservants stand around the platform prepared to
clean a wine cup or provide a large cushion.

The box-construction platform in *Scholars of the
Northern Qi Dynasty Collating Classical Texts* is spacious
enough to accommodate a group of people. Other
platforms that are smaller and narrower are suitable
for one or two people. In *Playing Weiqi in the Bamboo
Pavilion,* painted in 1566 by the Suzhou artist Qian
Gu, one of the players sits on a narrow platform (fig.
8.11) that has rectangular openings with inset frames
instead of the oval openings with scalloped upper
edges found in Song paintings. His opponent sits on
a stool on the opposite side of the game table. The
open pavilion overlooks the water and is set in a bam-
boo grove with banana and pine trees nearby. A small
platform of this type was easy to bring out to a cool
summer retreat.

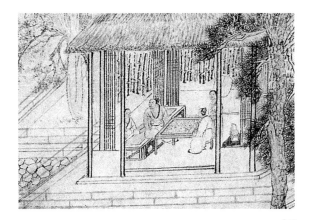

FIGURE 8.11 Qian Gu (1508–72). *Playing Weiqi in the Bamboo Pavilion.* Ming dynasty, 1566. Detail of a hanging scroll. Ink and color on paper. Liaoning Provincial Museum. From *ZGMSQJ, Huihua bian* 7: pl. 152.

8.11

8.12

FIGURE 8.12 Box-construction platform. Ming or Qing dynasty, seventeenth century. *Jichi* wood, *nan* wood seat panels. Height 44 cm, length 184.7 cm, width 89.2 cm. From Handler, "Life on a Platform," fig. 18.

FIGURE 8.13 Couchbed. Ming dynasty. *Huanghuali* wood inlaid with ivory, mother-of-pearl, and soapstone. Height 97 cm, length 198 cm, width 103 cm. The Nelson-Atkins Museum of Art, Kansas City, Missouri. Gift of Laurence Sickman in memory of Inez Grant Parker.

A rare extant example of a similar platform is fashioned from *jichi* wood and has three rectangular openings on each long side and two on each short side (fig. 8.12). The openings are separated by double-mitered struts and inset with narrow beaded-edged panels. The struts tenon through the continuous base stretcher to form small feet, and separate feet have been added at each corner of the platform. The strut tenons have been recently carved into feet and probably originally tenoned into some kind of additional base stretcher. The frame of the top, narrow waist, and apron are fashioned from a single piece of wood. The top of the platform consists of four *nan* wood panels set into mitered mortise-and-tenon frames supported by six transverse braces. The platform seems

to have been designed for convenient dismantling: easily removable slide-lock dovetail joints attach three of the braces to the frame. Once these joints are released, the entire frame comes apart.

When the *nan* wood panels are removed, symbols engraved on the inner surfaces of the frame and stretchers make it easy to assemble the piece. The symbols, occurring singly or interlocked, include coins, ingots, rhinoceros horns, and rhombuses—signifying wealth, good fortune, and victory. They are the unlimited treasures that, in Buddhist art, stream forth in magic vapors rising from a gourd or fall like toys from a bag of riches emptied in the clouds.[22] The owner of a platform with such auspicious symbols would surely himself attain great riches. It is unusual to find treasure emblems used as carpenter's marks, which are more often characters or numbers. Numbers are used on an early-eleventh-century wooden tomb model of a couchbed excavated from a Liao tomb in Jiefangyingzi, Inner Mongolia (see fig. 9.4). A pair of display cabinets have directional characters for left,

right, above, middle, and below (*zuo, you, shang, zhong, xia*) as well as *he* (join) and its homonym *he* (peace) (see fig. 15.24). H. A. Giles wrote in 1885 that artisans usually preferred to use characters from the beginning of the popular children's primer *Thousand Character Essay* (*Qianzi wen*) rather than numerals; and *tian* (heaven) and *di* (earth) were more common than *shang* (top) and *xia* (bottom).[23]

The *jichi* wood platform is one of the earliest known intact examples of this type. In the Nelson-Atkins Museum of Art in Kansas City there is a *huanghuali* couchbed that is believed to be an early platform to which railings were added later (fig. 8.13). The railings are fashioned from different wood and are different in style and decoration from the base. Moreover, the side rails have been lengthened to fit the base by the addition of an upright at each end. The platform is higher, wider, and more slender than the *jichi* wood platform. The design is simple, flat, and unwaisted. The four removable seat panels are similar to those on the *jichi* wood platform. It is not really a box

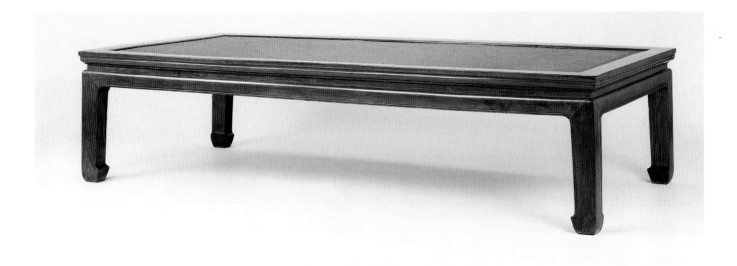

8.14

construction because the legs have horse-hoof feet that rest on a continuous base stretcher. A lower *huanghuali* platform, acquired by the Minneapolis Institute of Arts in 1999, has eight instead of six horse-hoof feet and a soft-mat seat.[24]

Box-construction platforms were popular in the Tang dynasty, but by the Ming, platforms with four legs had come into favor. Like the box-construction model, the four-legged platforms came in various sizes. Modern Beijing craftsmen called the long narrow ones "single sleep" (*dushui*)—a term close to the expression "single sleep bed" (*dumianchuang*), which the Ming connoisseur Wen Zhenheng mentions in his *Treatise on Superfluous Things.*[25] Westerners refer to these single beds as daybeds, which is misleading because all Chinese beds (couchbeds, canopy beds, *kangs*) are used both for daytime sitting and nighttime sleeping. A classic example of a *huanghuali* single bed is waisted and has horse-hoof feet (fig. 8.14). Its lines are straight and its surfaces plain; the only ornamentation is the molded frame of the top and the wide concave beading along the inner edge of the legs and apron.

Single beds and light platforms were easily moved into the garden and were perfect for daytime reclin-

ing, as we see in an evocative painting by Chen Hong-shou (1599–1652), *Reclining on the Incense Fumigator* (fig. 8.15). Here a lonely, lovesick young mother reclines on a platform with slender horse-hoof feet, simple curving spandrels, and a blue mat. She leans against a wire cage enclosing an incense burner, a device used for perfuming and drying clothes, and appears in her loneliness to be conversing with a parrot looking down from his elegant metal perch. Her small son, under the watchful gaze of a maid, is trying to catch a butterfly (symbolizing a lover) painted on a round fan.

Platforms with four legs could also be larger, heavier structures that were not so easily moved. Although frequently depicted in paintings and book illustrations, few pieces of this type have survived. We are fortunate to find two *huanghuali* examples. One is a wide sixteenth-century platform with high waist and cabriole legs resting on small triangular pads that protected them from damp floors (fig. 8.16). Bold and simple in design, it has restrained curves and no beading or relief decoration. It is fashioned from thick pieces of wood, yet does not have a heavy appearance because its strong construction allows the legs to be relatively slender. The upper part of each leg forms a high corner post—into which the recessed waist is mortised and tenoned—and tenons into the frame of the top. The tenon at the top of the leg, which passes through the seat frame, is unusually long, increasing the stability of the joint.[26] This construction is found on tables and stands and probably predates the continuous waist construction.[27] The only other known occurrence of this join on seat furniture is on a miniature wooden model of a platform excavated from the 1589 tomb of Pan Yunzheng in the Luwan district of Shanghai (fig. 8.17). The model—fashioned from southern elm (*ju, Zelkova sheneideriana*), a local softwood—is not quite eight centimeters high, yet it is nicely made with horse-hoof feet and a fine mat seat with patterned borders and palm-fiber underwebbing. The large *huanghuali* platform probably had a similar seat once, but it has been replaced over the years.

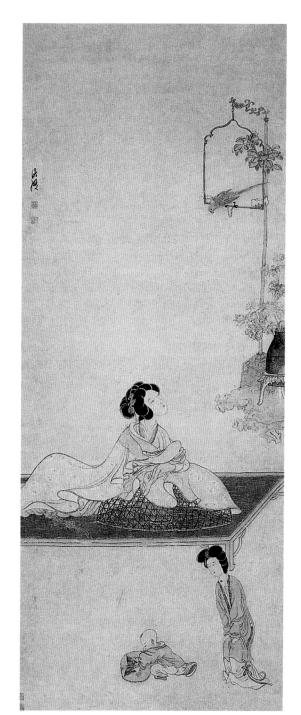

8.15

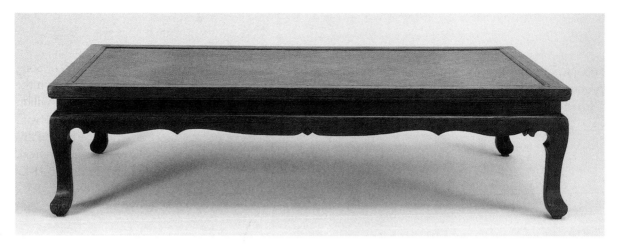

8.16

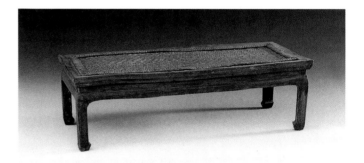

8.17

This high-waisted platform is a majestic piece of furniture that would have dominated any room and provided a commodious living space. It could have been used, for instance, in the library to provide a comfortable working space for a scholar. In a woodblock illustration designed by the famous Ming painter Ding Yunpeng (1547–c. 1621), we see a scholar happily ensconced with his books and scrolls on a large platform (fig. 8.18). Leaning on a semicircular armrest, he appears to be awaiting the refreshments his servant is carrying in on the right. Of course this and any other wide platform could also be used as a double bed; see, for example, an early Qing woodblock illustration to "An Official, Patronizing a Prostitute, Hears the Complaint of Her Former Customer" ("Ren su ji qionggui su piaoyuan"), a story in *Silent Operas* (*Wusheng xi*), by Li Yu (c. 1610–80; fig. 8.19). The couple lie on a wide platform with mat seat,

curvilinear apron, and inward-curving legs ending in cloud motifs, an appropriate symbol of wish fulfillment and longevity. The platform is equipped with a cylindrical pillow and patterned coverlet for sleeping. Above, we glimpse garments that have been thrown over a clothes rack. For greater privacy, platforms were sometimes surrounded by folding screens or occasionally placed within a large free-standing canopied structure (see fig. 10.6).

Clouds also decorate the apron of the *huanghuali* platform in fig. 8.20. The curves of this motif echo in the undulating apron, corner reliefs, and cabriole legs, lending a subtle suggestion that the seat of the platform is floating on clouds. This platform is more flamboyant in its form and decoration than the high-waisted piece. Its waist is not so high, is continuous without corner posts, and is separate from the apron. A bold bead along the inner edge of the legs and

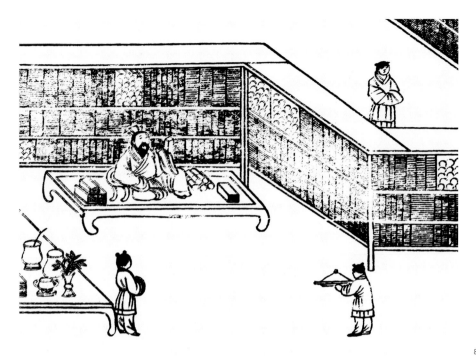

8.18

FIGURE 8.16 High-waisted platform. Sixteenth century. *Huanghuali* wood. Height 52 cm, length 212 cm, width 114 cm. Piper Tseng collection. Courtesy Peter Lai Antiques, Hong Kong.

FIGURE 8.17 Miniature wooden model of a platform. Ming dynasty. Excavated from the 1589 tomb of Pan Yunzheng, Luwan district, Shanghai. Southern elm (*ju*), rattan mat seat over palm fiber. Height 7.94 cm, length 26.68 cm, width 4.94 cm. Shanghai Museum.

FIGURE 8.18 Ding Yunpeng (1547–c. 1621). *A Scholar in His Library*. Woodblock-printed design for ink cake. From Cheng Dayue, *Chengshi moyuan,* 8: 30b. Courtesy the East Asian Library, University of California, Berkeley.

FIGURE 8.19 Woodblock illustration to Li Yu's *Silent Operas* (*Wusheng xi*). From Li Yu, *Li Yu quanji,* early Qing, c. 1735, 12: 5063.

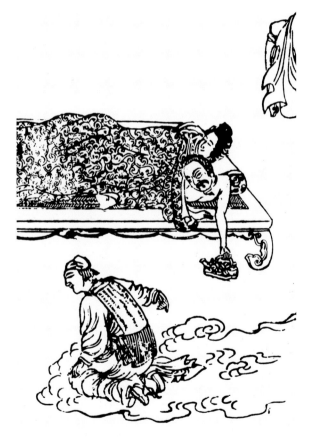

8.19

8.20

8.21

FIGURE 8.20 Platform. Ming dynasty, late sixteenth/early seventeenth century. *Huanghuali* wood. Height 53.6 cm, length 221.3 cm, width 98.5 cm. © Christie's Images, Ltd., 1999.

FIGURE 8.21 Small platform. Ming or Qing dynasty, seventeenth century. *Huanghuali* wood. Height 48 cm, length 112 cm, width 87 cm. From Handler, "Life on a Platform," fig. 27.

8.22

FIGURE 8.22 Shen Zhou
(1427–1509). *Waves on the Bank*
(*An bo tu*). Detail of a
handscroll. Ink and color on
paper. Length 185 cm. Suzhou
Municipal Museum. From
ZGMSQJ, Huihua bian
7: pl. 11.

apron ends in a spiral at each foot. There is a pleasing unity in the undulating form and ornament of this platform, which imparts a sense of lightness to a basically solid, heavy piece.

In addition to platforms large enough for reclining, there are also small models suitable for one person. The *huanghuali* example in fig. 8.21 has round legs that double-tenon directly into the frame of the top and are strengthened by round stretchers. It has three transverse braces, one in the center and two close to the sides. Two small struts join the side braces to the side frames. This same strengthening device is also found on a pair of large *zitan* stools (see fig. 7.14). The small platform's top frame has a beautifully rounded edge and straight apron with a beaded edge extending into a scrolling motif at each corner. This platform is a later chair-level form of the early square single-person seats seen in Han dynasty depictions. In fig. 8.22 a contemplating scholar sits on a similar small platform in *Waves on the Bank* (*An bo tu*), by Shen Zhou (1427–1509). He sits in front of a large single-panel screen before the open door of his country re-

treat. Piles of books are visible in an adjoining room; bamboo and trees shade the building, which overlooks a stream.

Platforms—whether small single-person seats or large living spaces for a number of people to sit and sleep on—are a highly versatile type of furniture. Unlike chairs, they are spacious enough to hold a few useful objects, and they are lighter and easier to move outside than couchbeds. They may be as large as *kang*s but have the advantage of being portable rather than built in. Platforms are a type of furniture unknown in the West even today, yet they are the earliest seating furniture in China. They were low honorific seats when the mat-level mode of living prevailed. When chair-level living became common, platforms became every-day elevated living spaces for the activities that had previously taken place on mats on the floor. Unencumbered by railings, canopies, and immobility, platforms—rather than couchbeds, canopy beds, or *kang*s—are the best example of the elemental form of Chinese furniture. On their plain elevated surfaces all kinds of daily activities took place.

9 | A COUCHBED DAY AND NIGHT FOR COMFORT AND JOY

*M*ore ingenious and beautiful than any equivalent in the West, the Chinese couchbed served as a couch during the day and a bed at night. Unlike the Western sofa bed, which requires elaborate restructuring into another shape, the Chinese couchbed is immediately ready, with a minimum of housekeeping changes, for pleasant sitting, erotic pastime, or rejuvenating sleep. The concept of using one piece of furniture for both sitting and sleeping is very old in China. At different periods distinct structures had this same dual function: the platform, canopy bed, couchbed, daybed, and *kang.*

The couchbed has a railing on three sides of the seat; this is the feature that distinguishes it from other Chinese beds. The origins of the couchbed's form can be traced back to the Han dynasty, when a related structure was used only as a seat. A number of stone engravings in tombs show the deceased sitting on a small low platform with a high screen or railing on two sides. One found in Anqiu, Shandong, is clearly a seat of honor on which the warrior occupant of the tomb sits leaning on an armrest with his weapons in a rack behind him (fig. 9.1). According to Liu Xi's *Explanation of Names* (*Shiming*), a dictionary compiled during the Eastern Han (A.D. 25–220) or Three Kingdoms period (221–265), this kind of low seat, suitable for one person, was called a *ta. Ta* also referred to a seat used for many guests at a banquet; it was longer, narrower, and lower than the *chuang,* which was a daytime seat and, unlike the *ta,* also a nighttime bed.[1] Sometimes tomb depictions show canopies above both short and long *ta* to enhance the status of those seated on them.[2]

The low couch in fig. 9.1 has four short legs and curvilinear spandrels. This form with legs is distinct from the contemporary low, boxlike seating platforms (see fig. 1.1). Prototypes for both forms are found in Shang dynasty bronze "hot plate" tables for warming sacrificial wine.[3] The hot plate with legs is the antecedent of the Ming and early Qing couchbeds discussed in this chapter.

The small low couch continued to be the honorific seat for one person and gradually became higher and more refined. On a wooden screen excavated from the 484 tomb of

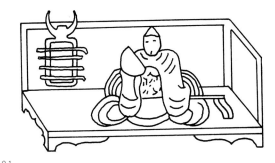

9.1

9.2

Sima Jinlong in Datong, Shanxi, one of the virtuous women from antiquity, a model of Confucian morality, sits on a couch with high railings on three sides (fig. 9.2). Each railing consists of a wooden frame with an inset crosshatched panel. The edges of the aprons are cut out in wavelike patterns.

When the chair-level mode of living became prevalent in China, the chair began to replace the couch as the seat of honor, and the couch assumed new forms, culminating in the couchbed. An unusual U-shaped couch is depicted in *The Night Revels of Han Xizai* (see fig. 1.8). The elegant wooden couch appears to be lacquered black and has a high chair-level seat with high railings on three sides inset with ink paintings. The legs extend to form the corner posts, which protrude above the railings. The sides of the base are covered by wooden panels with a straight apron and simple spandrels at the bottom. Further on in the handscroll we see Han Xizai comfortably seated with four beautiful courtesans on a couch similar in design but with a square seat, instead of a U-shaped seat, and low railings at both of the front corners (fig. 9.3). The curving edges of the low railings offset the stiffly rectilinear high ones and invite one to enter and sit. Because of their shapes and proportions, both couches appear to have been for sitting or reclining, not for sleeping.

FIGURE 9.1 Detail of a stone engraving from the tomb at Anqiu, Shandong. Second century. Drawing from Wang Zhongzhu, "Handai wuzhi wenhua lueshuo," 70.

FIGURE 9.2 Detail of a wooden screen painted in lacquer. Northern Wei dynasty. Excavated from the 484 tomb of Sima Jinlong, Datong, Shanxi. From *Wenhua dageming qijian chudu wenwu*, 144.

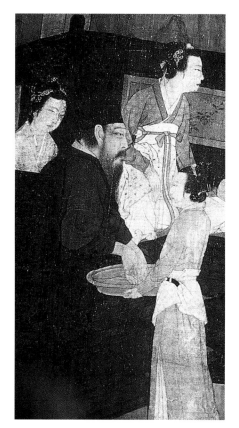

FIGURE 9.3 Attributed to Gu Hongzhong (tenth century). *The Night Revels of Han Xizai.* Early twelfth-century copy. Detail of a handscroll. Ink and color on silk. Height 29 cm, length 338.3 cm. Palace Museum, Beijing.

9.3

During the Liao (907–1125), Song (960–1279), and Jin (1115–1234) dynasties, there were also couches with legs terminating in cloud-head feet and with dimensions making them suitable for both daytime sitting and nighttime sleeping. A full-size wooden couchbed made expressly for a Liao dynasty tomb was found at Jiefangyingzi in Inner Mongolia (fig. 9.4). The top has a railing on three sides composed of solid lower panels and narrower open upper panels separated by vertical posts and horizontal bars; the base consists of a solid rectangular block with a painted or carved indication of front legs and apron. This couchbed is clearly not for actual use because it lacks real legs and the seat is not fastened to the base. Between the cloud-head feet is an apron with, according to the excavation report, eight inset peach-shaped ornaments daubed with red,[4] which are clearly derived from Tang dynasty box-construction platforms with ornamental openings.

We can get an idea of how side stretchers stabilized the legs on an actual piece of furniture by examining a comparable miniature wooden model found at Datong, Shanxi, in the Jin dynasty tomb of Yan Deyuan, who died in 1190 (fig. 9.5). The side and back railings were originally the same height with two horizontal bars at the top. In both the Liao and Jin couchbeds, the top and base are two distinct parts with no real unity of design. The upper section appears stiff, with straight members meeting at right angles and no curving lines except in the restrained modeling of the struts and, in the case of the Liao couch, of the finials of the corner posts. Contrasting with this rigidity are the complex, delicately curved edges on the straight flat legs, ending in cloud-head feet.

Cloud-head feet were popular during the Song dynasty, but thereafter lost their popularity, probably because they are unstable and fragile. They do not appear on later extant hardwood furniture, although

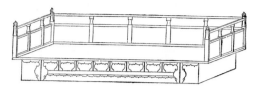

9.4

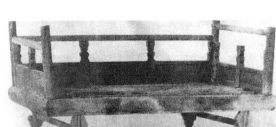

9.5

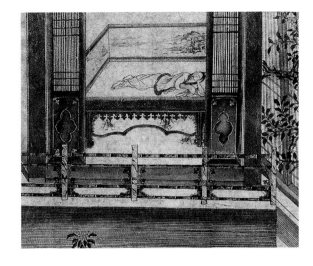

9.6

FIGURE 9.4 Full-size wooden couchbed model. Liao dynasty. Excavated from an early eleventh-century tomb at Jiefangyingzi, Inner Mongolia. Height 72 cm, length 237 cm, width 112 cm. Drawing from Wengniute Qi Wenhuaguan, "Nei Menggu Jiefangyingzi Liao mu fajue jianbao," 332.

FIGURE 9.5 Miniature wooden couchbed. Jin dynasty. Excavated from the 1190 tomb of Yan Deyuan, Datong, Shanxi. Height 20 cm, length 40.4 cm, width 25.2 cm. From Datongshi Bowuguan, "Datong Jindai Yeh Deyuan mu fajue jianbao," 5.

FIGURE 9.6 "In the tenth month the cricket goes under my bed." Southern Song dynasty, thirteenth century. Detail of the handscroll *Odes of Bin*. Ink on paper. Height 29.7 cm, length 137.6 cm. The Metropolitan Museum of Art, New York. John M. Crawford Jr. Collection. Gift of The Dillon Fund, 1982 (1982.459).

they are occasionally found on softwood pieces and are depicted in paintings and woodblock illustrations, maybe as an archaism. Cloud-head feet have a rigidity, flatness, and delicate grace characteristic of the Song, exemplified beautifully in a thirteenth-century ink painting in the Metropolitan Museum of Art called the *Odes of Bin*. This handscroll illustrates a section of the ancient *Book of Songs* (*Shi jing*) that describes the cricket's seasonal migrations. For the line "In the tenth month the cricket goes under my bed,"[5] the artist has painted a man happily dreaming on a couchbed as crickets cavort underneath (fig. 9.6). The landscape paintings on the high railings provide a peaceful setting for his slumbers. The base is elaborately decorated (perhaps with artistic license) with scrolling patterns along the edge, a row of cutout cloud-head motifs edging the apron, an exaggeratedly curving stretcher, and scalloped edges along the inside of the legs.

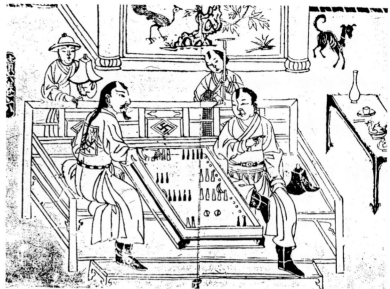

9.7

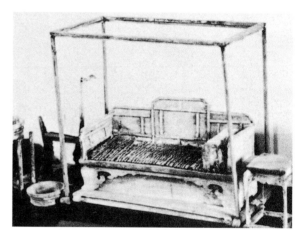

FIGURE 9.7 *Playing Double Sixes*. Yuan dynasty. Woodblock illustration to Chen Yuanjin's *Compendium of a Forest of Affairs* (*Shilin guangji*).

FIGURE 9.8 Miniature wooden couchbed. Ming dynasty. Excavated from the 1389 tomb of Zhu Tan, Zhouxian, Shandong. Shandong Provincial Museum, Jinan. From Addis, *Chinese Ceramics from Datable Tombs*, 65.

9.8

A similar stiffness and lack of unity between the parts persists beyond the Song in, for example, a couchbed depicted in a Yuan dynasty (1279–1368) woodblock illustration to Chen Yuanjin's *Compendium of a Forest of Affairs* (*Shilin guangji*) (fig. 9.7). Here we find a new form of couchbed: the side railings are lower than the back, and cylindrical legs strengthened by low stretchers have replaced the fragile, unstable cloud-head feet. The long footstool, however, retains the cloud-head feet, and remnants of this shape ap-

pear in the spandrels. The back, consisting of various open and patterned panels awkwardly combined, does not unite harmoniously with the rest of the structure. In this charming depiction of a moment of leisure, we see two men, engaged in a game of double sixes, sitting at ease on either side of an unusually long game table. Refreshments are ready on a nearby side table, and a dog wags its tail as it enters the room from behind a wall decorated with a painted garden scene.

Double sixes was popular with both commoners and courtiers during the Tang dynasty. According to the manual by the Song player Hong Zun, the game originated in the western regions of China. It is played with dice and two sets of clothes beater–shaped pieces, one white and one black, called "horses." The horses move according to the throw of the dice, and the first one to get all his horses out wins.[6]

Not until the Ming dynasty (1368–1644)—the great age of classical furniture—was the design of the couchbed perfected so that it became a truly harmonious form. This new harmony can be seen as early as 1389 in a wooden model excavated from the tomb of Zhu Tan, the tenth son of the first Ming emperor, Taizu (fig. 9.8). The tomb is famous among art historians because it contained an important painting of lotuses signed by the early Yuan artist Qian Xuan (c. 1235–after 1301), a rare example of an excavated painting by a known artist. The couchbed from that tomb has a solid back consisting of three panels, the highest in the center. Each of these panels is in turn composed of seven small symmetrically arranged recessed panels. The side railings are slightly lower than the back and consist of one panel. Careful attention guided the harmonious arrangement of the panels, which follow the basic structure of the couchbed. For instance, the bottom of the narrow rectangular panel at the top of the center back aligns with the top edge of the side panels. All panels have rounded butterflied corners, leading the eye down to the smooth outer curves of the cabriole legs. These decorative and unifying butterflied corners were used at least as early as the Southern Song dynasty (1127–1279), when they appear on the edge of the large wave screen in *A Lady at Her Dressing Table,* a fan painting by Su Hanchen (active c. 1124–63) in the Museum of Fine Arts, Boston (see fig. 16.8). The base of the waisted couchbed has cabriole legs with interior flanges continuing the line of the curvilinear apron. A long, low footstool extends the length of the couchbed. The whole is surrounded by a wooden frame, undoubtedly designed to support a

curtain that would be lowered at night for privacy and hooked back during the day, when the bed was used for sitting. The frame is similar to those placed over ceremonial platforms in the Han dynasty (206 B.C.–A.D. 220). Perhaps this arrangement is what Wen Zhenheng, the late-Ming connoisseur of material culture, referred to when he wrote: "Then there are some particularly large curtains, known as 'sky-covering curtains.' To sit or lie inside them in the summer months, with tables, couches [*ta*], cupboards or shelves, is rather suitable, although not in the antique style."[7]

Wen uses the word *ta* for couchbed, and this seems to be the usual Ming term. The term Wang Shixiang uses—Luohan bed (Luohan *chuang*)—is a much later craftsman's designation. In *Eight Discourses on the Art of Living* (*Zun sheng ba jian*), with a preface dated 1591, Gao Lian discusses a bamboo couchbed (*zhuta*) that has screens on three sides without the posts used to support the canopy of a canopy bed.[8] Tu Long, in his *Desultory Remarks on Furnishing the Abode of the Retired Scholar* (*Kao pan yu shi*), says in his section on the low couchbed (*duanta*): "Along three sides there are uprights, the one on the back being slightly higher than those on the sides."[9]

The model with a slightly higher back is the most common style and is especially beautiful in its proportions. The 1609 *Pictorial Encyclopedia of Heaven, Earth, and Man* depicts one such couchbed (labeled *ta*) with butterflied corners, a branch of bamboo painted along the back, a mat seat, and low horsehoof feet.[10] Ming paintings often show scholars sitting on couchbeds in their garden retreats, and the famous *Painting Manual of the Mustard Seed Garden* (*Jieziyuan huazhuan*) names and illustrates one, together with its long footstool.[11] In these texts *ta* clearly designates a couchbed with railings on three sides. However, the *Newly Compiled Illustrated Four-Word Glossary* of 1436 uses the term *chuang* for a platform that has ornamental openings with cusped upper edges, railings on three sides, and a back divided into three with a higher center panel.[12]

Wen Zhenheng tells us that in the late Ming,

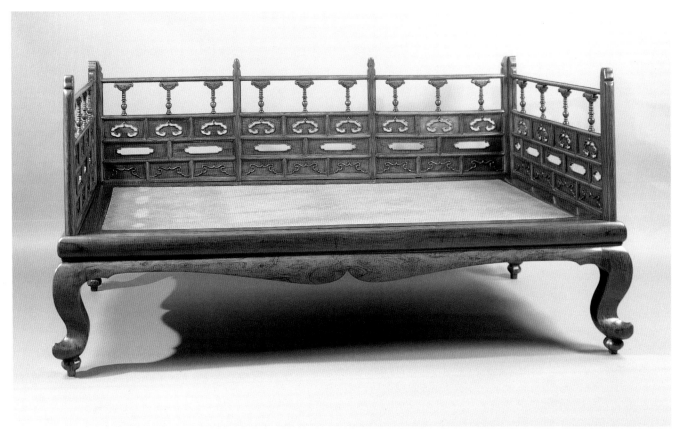

9.9

FIGURE 9.9 Couchbed. Ming
dynasty. *Huanghuali* wood;
inner frame of seat, elm wood.
Height 48.26 cm, length
208.28 cm, depth 120.65 cm.
Photo courtesy of Ming
Furniture, Ltd.

FIGURE 9.10 Panel under a
window. Fifteenth to sixteenth
century. Fang Wentai's house,
Qiankou, Anhui. Drawing
from Zhang Zhongyi, *Huizhou
Mingdai zhuzhai*, 90.

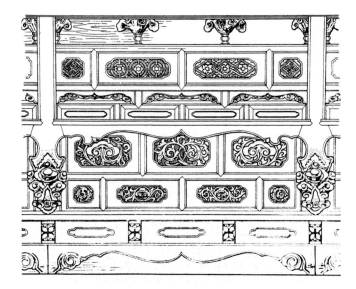

9.10

couchbeds (*ta*) were made of various materials: "Recently there have been vulgar pieces inset with Dali stone, having burnished red and black lacquer, incised with bamboo motifs which were then filled in, or with new mother-of-pearl inlays. Pieces made from *huanan, zitan, wumu,* or *huali* woods are appropriate."[13] Among the extant hardwood couchbeds are a number of fine examples, including a unique *huanghuali* piece with a high railing and corner posts (fig. 9.9). The railing is similar in overall form to those found on Five Dynasties (907–960), Song, Liao, and Jin couches (see figs. 9.3, 9.4, and 9.5). However, the decorative panels are related to the wooden carvings found in fifteenth- and sixteenth-century houses built for minor officials and prosperous merchants enriched by the salt monopoly in Huizhou (modern Shexian) in southeast Anhui. Some of these houses were moved from nearby small towns and the surrounding countryside to Qiankou, where today one can see Fang Wentai's home, with its beautiful carved panels (fig. 9.10). The panels are beneath the second-floor windows, which overlook the pond in the narrow courtyard below; inside, a built-in window seat runs the length of the wall. The house panels and the panels of the couchbed in fig. 9.9 are similar in plan and motifs, although the couchbed is made of precious hardwood, rather than softwood, and is more finely carved. The panels in both house and bed are arranged in horizontal bands separated by double-mitered struts, with proportions and motifs carefully adjusted to fit the spaces. At the top are stylized high-relief or three-dimensional lotus leaf designs; the bottom has three-dimensional or relief forms reminiscent of the aprons on a piece of furniture. Both have bands of panels with begonia-shaped (*qiuhaitang shi*) cartouches.

The couchbed has a soft-mat seat with a removable elm wood frame. The base, formed from thick timbers, has a separate narrow waist. Marks at the outer corners of the seat frame indicate that at one time metal mounts were added. Similar marks are found on other pieces, such as a pair of *huanghuali* rose chairs carved to resemble bamboo furniture (see

fig. 6.5) and seem to be a later strengthening or decorative addition rather than part of the original design. Balls and small pads elevate the boldly curving cabriole legs.

Fig. 9.11 shows a different style of *huanghuali* cabriole-leg couchbed with a restrained profile and elaborate interior carving. The low railings, slightly higher along the back, have butterflied corners, and lines of decorative beading elegantly frame the pierced panels, which are intricately carved with patterns of paired birds against intertwining foliage. In the central panel a phoenix flies toward its mate, who has just alighted on the ground; twisting branches, curling leaves, and stylized flowers create a dense background. The almost straight legs rest firmly on the ground and end in outward-pointing feet with scrolls and a leaf design, which turns into a bead running up the outer edge of the leg; their form and decoration are similar to those on a canopy bed in the Palace Museum, Beijing.[14] In contrast to the plain sweeping curves on the previous couchbed, the apron on this one has an elaborate beaded edge, and relief carvings of dragons and scrolling vine patterns cover its surface. The carving on this piece is beautifully done and is an integral part of the design, giving the surface a rich decorative interest. The ornate bird-and-flower decoration and the numerous pairs of birds (including phoenixes, mandarin ducks, and magpies) symbolic of marital bliss suggest that this couchbed was part of a bride's dowry.

Horse-hoof feet are more common on couchbeds than are cabriole legs. One *huanghuali* example has straight legs ending in low, crisp horse-hoof feet (fig. 9.12). This piece is much plainer than the preceding cabriole-leg models and is distinguished by its clean lines, perfect proportions, subtle ornament, and beautifully grained wood. The straight beaded-edged apron and low railings emphasize its horizontality. The railings are unusual: they are each made from a single piece of wood with rounded corners and are carved on both sides to give the effect of long inset panels. On the outside the panels are slightly recessed in the center with thumb-molded borders, while on

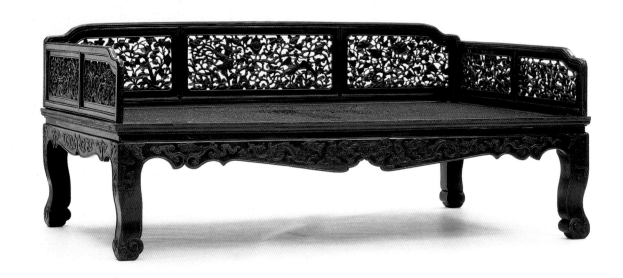

9.11

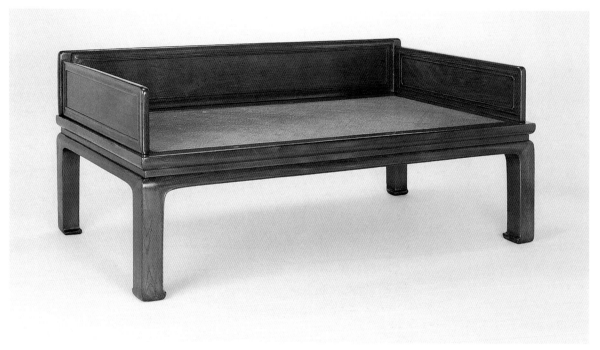

9.12

the inside the thumb molding is sharper, and its out-
lines echo in the beading with butterflied corners. It
is typical of Chinese furniture makers to pay special
attention to this interior decoration, because the
couchbed was meant to be seen from the front. Since
the railings are made from one piece of wood, with-
out breadboard ends, the end grains are weak, and
there has been some repair in the back corners.

This type of couchbed—with a straight apron, low
horse-hoof feet, and restrained decorations—must
have been popular in the late Ming dynasty, for it ap-
pears frequently in woodblock illustrations. In a late-
Ming illustration to the novel *The Plum in the Golden
Vase,* Pan Jinlian, reclining suggestively on such a
couchbed, casts a love hexagram with her red em-
broidered shoes to see if Ximen will visit her (fig.
9.13). She rests on a thin mattress with patterned bor-
ders and leans against a pillow. At night a quilt would
have been added for warmth. The doors are open, and
beside the couchbed are a stool and a long table with
a vase of flowers, a teapot, and a cup. Couchbeds were
a major piece of furniture in the women's apartments,
and in illustrations we see them used as the locus for
all kinds of everyday activities—chatting with friends,
playing with children, and conducting amorous dal-
liances. They were probably a kind of secondary bed,
smaller and simpler than the large canopy bed that was
an important symbol of a woman's status in the
household.

In the north people slept on a *kang,* or built-in
heated platform, which often had curtains that could
be drawn at night.[15] But couchbeds were also used,
sometimes placed opposite the *kang,* as we learn from
this incident in the mid-eighteenth century novel *The
Story of the Stone:* After a drinking party, "Aroma could
see that Parfumée was extremely drunk. Fearing that
any but the slightest movement might make her sick,
she lifted her up, very, very, gently, and laid her down
beside Bao-yu on the kang. She herself lay down on
the couchbed [*ta*] opposite. A gentle oblivion then
descended upon all of them and they slept like tops
until morning."[16]

9.13

FIGURE 9.11 Couchbed. Ming
or Qing dynasty, seventeenth
century. *Huanghuali* wood.
Length 213.4 cm, depth
125.7 cm. Collection of
Edward C. Johnson 3d.
Courtesy Museum of Fine
Arts, Boston.

FIGURE 9.12 Couchbed. Ming
or Qing dynasty, seventeenth
century. *Huanghuali* wood.
Height 79 cm, length 192 cm,
depth 100 cm. © Christie's
Images, Ltd., 1999.

FIGURE 9.13 *Pan Jinlian Casting
a Love Hexagram.* Ming dynasty.
Woodblock illustration to *The
Plum in the Golden Vase (Jin ping
mei),* Chongzhen reign period
(1628–44), chap. 8.

FIGURE 9.14 Detail of a
woodblock illustration to
*Heavenly Horses Matchmaker
(Tian ma mei).* Ming dynasty,
Chongzhen reign period
(1628–44).

We get a more detailed description of a couchbed
when a stage is set up for theatricals during New Year's
celebrations:

> Towards the east side of the hall, there was a large,
> low wooden couchbed [*ta*] with a carved pierced-
> work back of interlacing dragons, which had been
> put there for Grandmother Jia to lie on. It was
> furnished with a back-rest and bolsters and was large
> enough to have a fur rug spread out on it and still
> leave room at one end for a small, exquisitely gilded
> table [*ji*] of foreign make on which had been placed
> a teapot, a teacup, a spittoon, a napkin and, among
> various other small objects, an eyeglass-case. Grand-
> mother Jia rested with her feet up on the couchbed
> and, after talking for a while with the company, took
> out the eyeglasses from their case and looked through
> them at the stage.[17]

Grandmother Jia is often described as reclining on a
couchbed or *kang*. Her seat indicates her age as well
as her rank as the clan matriarch. For special occa-
sions, other ladies of high status might also be pro-
vided with couchbeds while everyone else sat on
chairs. From these descriptions we know that the
couchbeds were made comfortable with small tables,
bolsters, backrests, and furs. Sometimes one or two
high tables were placed in front of them for dishes and
incense burners, or a footstool was set on the ground
in case Grandmother Jia wished to sit upright.[18]

A couchbed also furnished the studio (*zhai*) of the
master of the household (fig. 9.14). The studio was
where the learned and cultured gentleman worked.
It contained his books, a large table on which were
all the utensils needed for painting and calligraphy, an
incense burner, a zither, a few scrolls and other works
of art, and a couchbed. The studio could be part of
the house or a separate structure and ideally was a
retreat in a pleasing natural setting. According to Li
Rihua (1565–1635):

> The studio should be situated where the brook twists
> and bends between the hills. The total structure should
> not exceed two or three buildings, with an upper
> story to observe the clouds and mists. On the four
> sides there should be a hundred slender bamboo
> plants—to welcome the fresh wind. To the south a
> tall pine tree [on which] to hang my bright moon.

A gnarled old prunus with low, twisting branches to come in through the window. Fragrant herbs and thick moss surround the stone foundation. The east building houses the Daoist and Buddhist sutras, and the west building the Confucian classics. In the center, a couchbed [*ta*] and desk [*ji*] with a scattering of fine calligraphy and paintings. In the morning and evenings, white rice and fish stew, fine wine and tea, a strong man at the gate to reject social callers.[19]

Here, sitting or lying on the couchbed, one could meditate, study, entertain friends, or sleep. A small table might be set on the couchbed or a large table placed in front of it for dining or looking at scrolls and texts.

"There was no way in which they were not convenient," Wen Zhenheng wrote of couchbeds, "whether for sitting up, lying down or reclining. In moments of pleasant relaxation they [gentleman-scholars] would spread out classical or historical texts, examine works of calligraphy or painting, display ancient bronze vessels, dine or take a nap, as the furniture was suitable for all these things."[20] Couchbeds, then, were for informal, intimate moments. For formally receiving visitors, however, chairs were the appropriately honorific seat, according to Ming dynasty pictorial representations.

While texts and paintings make it clear that the couchbed was an important piece of furniture in the studio, they provide little information about a gentleman's bedroom. Literati painters and connoisseurs, who wrote about the surroundings of a cultured gentleman, were much more interested in the studio than other areas of the house. Nonetheless, in an entry on bedrooms in the chapter "Placing and Arrangement," Wen Zhenheng describes a gentleman's bedroom containing a bed (*wota*) that might be a couchbed: "Place a bed [*wota*] facing south. The half of the room behind the bed [*ta*] is where people do not go and should be used for such things as a brazier, clothes rack, washbasin, dressing case, and reading lamp. In front of the bed [*ta*] place only a small table with nothing on it, two small square stools, and a small cupboard containing incense, medicine, and delightful

vessels. The room should be refined, elegant, and not too cluttered. If too gorgeous, it will be like a ladies' room and unsuitable for a recluse sleeping in the clouds and dreaming of the moon."[21]

Ming society strictly segregated the sexes. In large wealthy households the front courtyards were reserved for men and the back courtyards for women. Only the master was allowed free access to the women's apartments. On rare occasions the women visited the front part of the house for a family celebration or performance, which they observed from behind screens when males who were not family members were present. Sexual encounters usually took place in the women's private quarters. Thus novels and their illustrations, as well as erotic paintings, tend to depict the women's part of the house.

In his studio a gentleman might sit with his books on a plain couchbed with C-curved legs. A *huanghuali* example of this type demonstrates how fine woods fashioned into bold, massive forms can produce furniture that is really functional sculpture (fig. 9.15). The natural richness of the wood, with its vigorous swirling grain patterns, is strikingly displayed in the low plain railings with butterflied corners, which lead the eye down the simply molded seat frame and recessed waist to the great curves of the legs ending in high horse-hoof feet. A hard-mat seat replaces the original soft-mat seat. Continuous beading along the inner edge of the straight apron and strongly bowed legs accentuates this powerful line. The piece is superbly proportioned, with a balance between the linearity of the railings, the sweeping bow of the legs, and the spaces underneath. Here the rigidity, flatness, and delicate grace of earlier pieces have become a flowing, three-dimensional, powerful form.

Sometimes couchbeds with strongly curved legs and high horse-hoof feet have lattice railings. One has what Wang Shixiang calls a carpenter's square lattice (fig. 9.16).[22] When we look at the wood of the lattice, we see only a complex geometric pattern. But when we look at the spaces in between, L and T shapes are clearly visible. Latticework is especially

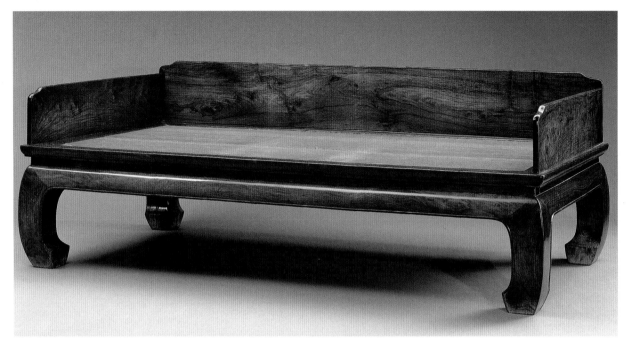

9.15

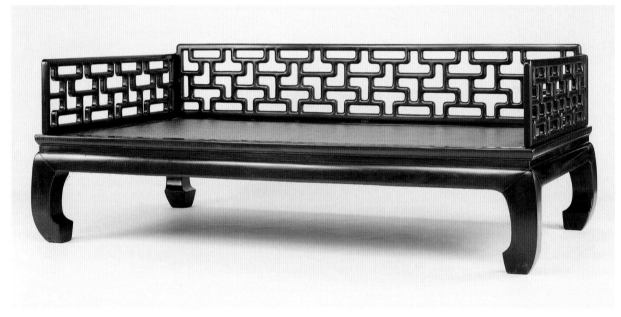

9.16

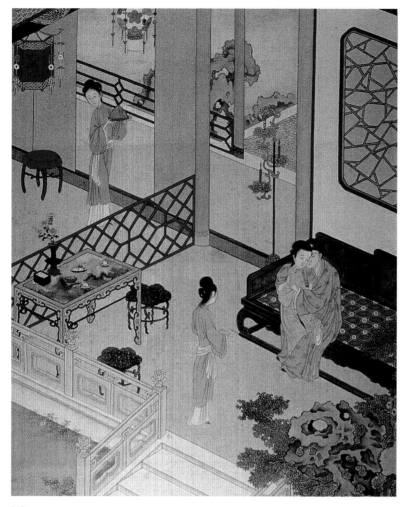

9.17

FIGURE 9.15 Couchbed. Ming dynasty, sixteenth or seventeenth century. *Huanghuali* wood. Height 75.5 cm, length 211 cm, depth 112 cm. The Nelson-Atkins Museum of Art, Kansas City, Missouri. (Purchase: The Kenneth A. and Helen F. Spencer Foundation Acquisition Fund.)

FIGURE 9.16 Couchbed. Ming or Qing dynasty, seventeenth century. *Zitan* wood. Height 83 cm, length 234 cm, depth 128 cm. © Christie's Images, Ltd., 1999.

FIGURE 9.17 Attributed to Gu Jianlong (1606–c. 1694). *Ximen Selects a Lucky Day to Make Mistress Ping His Sixth Wife.* Qing dynasty, c. 1662–c. late 1670s. Illustration to *The Plum in the Golden Vase* (*Jin ping mei*). Ink and color on silk. Height 39 cm, width 31.5 cm. The Nelson-Atkins Museum of Art, Kansas City, Missouri. (Acquired through the Mrs. Kenneth A. Spencer Fund.)

delightful because there are two ways to view it. Furthermore, it casts pleasing, ever-changing shadows on the wall behind. The *zitan* wood of this piece is especially fine, possessing a jadelike luster. Since the couch is exceptionally large and *zitan* timbers are relatively small, the long waists in the front and back are each made from two pieces of wood. On one back leg the pith of the wood has been filled. This is not a defect; *zitan* wood often has a hollow center that has to be filled when large pieces of thick wood are required.

Other variations of this model of couchbed have a back divided in three with a higher central panel and continuous base stretcher. In *Ximen Selects a Lucky Day to Make Mistress Ping His Sixth Wife,* a painting illustrating *The Plum in the Golden Vase,* the loving couple sit together on a luxurious black lacquer couchbed with gold edgings and paintings on the railings (fig. 9.17).[23] Under them is a thin mattress of patterned brocade. Exquisite furnishings have been provided for the new bride. A pair of gold-flecked plum blossom–shaped lacquer stools accompany an ornate marble-topped table, which has markings evoking a cloud-filled sky before rain. Wine cups and snacks wait on the table, and a maid brings additional refreshments protected by a cover with silk netting. Chrysanthemums in a vase indicate that it is autumn, and the burning red candles in the gilded candelabra

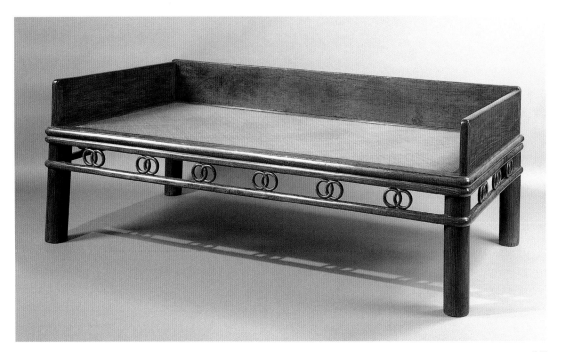

FIGURE 9.18 Couchbed. Ming dynasty. *Huanghuali* wood. Height 53.34 cm, length 207.01 cm, depth 103.5 cm. Photo courtesy of Ming Furniture, Ltd.

FIGURE 9.19 Couchbed. Ming or Qing dynasty, seventeenth century. *Huanghuali* wood. Height 129.54 cm, length 213.36 cm, depth 78.79 cm. © Christie's Images, Ltd., 1999.

show that it is nighttime. A maid approaches the couchbed carrying a book, perhaps containing erotic illustrations.

The low back, which we have seen combined with either cabriole legs or legs terminating in horse-hoof feet, was also used with straight round legs during the Ming dynasty. In a superbly designed *huanghuali* example (fig. 9.18), the cylindrical form of the legs echoes in smaller diameters in the double molding of the seat, the stretcher, and the interlocking double-circle struts. The continuous stretcher goes around the outside of the legs repeating in half-scale the form of the seat molding. The style derives from bamboo furniture construction and is found in identical forms on stools.[24] The lively grain patterns of the wood show to full advantage in the solid railings, which have breadboard ends concealing and strengthening the end grains of the planks. There is a soft-mat seat. The back of the bed is finished with the same care and detail as the front.

The influence of bamboo furniture is even more pronounced in an elaborate version of the round-leg

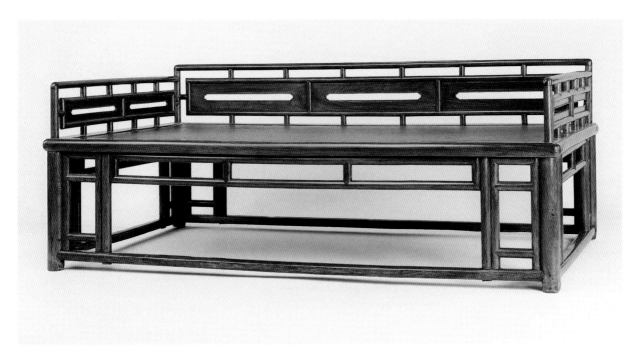

9.19

couchbed (fig. 9.19). This is a later version of the one in the Yuan dynasty illustration to *Compendium of a Forest of Affairs* (see fig. 9.7), with a low stretcher on all sides and open panels decorating the low back. In the later piece all awkwardness has disappeared, and the parts integrate into a harmonious unity. The rectangular lines of the basic structure repeat in the interior frames, which are imitations in precious hardwood of more impermanent bamboo furniture construction. Three other versions of this design are known. Robert Ellsworth has a *hong* wood example. Another, formerly in the Robert and William Drummond Collection, is made from *jichi* wood and has beaded-edged, firecracker-shaped (rather than begonia-shaped) openings on the panels and a small matching table that sits on it when the couchbed is used as a seat during the day.[25] The third is *zitan* with a softer golden-hued wood used for the inner frames and panels.[26] The panels have more elaborate fire-cracker-shaped openings with interior interlocked circles and double-rope patterns. Legs and posts are made from single pieces of wood, while in the

huanghuali example two pieces of wood are used for each.

The *huanghuali* couchbed has a thick seat frame with a soft-mat seat. Below the seat on all sides are inner vertical members that pass through and support the base stretchers; this construction is especially important for the front stretcher because it served as a footrest. The inset frames between these vertical members and the legs all have a sliding dovetail tenon joining them to the legs. The back legs have both lost quite a bit of height. The Drummond piece must have lost height too and was repaired with high brass feet.

According to the Ming arbiters of taste, couchbeds could vary in dimensions, but they had to be aesthetically pleasing both in their appearance and in their use in the interior. They should be elegant (*ya*), restrained, and harmonious, rather than vulgar (*su*) and ornate. They should both delight the eye and give pleasure (*ke'ai*) to those who sit and sleep on them. Above all they must be classical—that is, in keeping with the good standards of the old. Classical, not

chronologically old, is what *antique* (*gu*) really means in a Chinese context. Craig Clunas explains: "For Wen Zhenheng and his contemporaries, artefacts were an integral part of a continuum of moral and aesthetic discourse, where *gu* does not simply mean 'chronologically old', but implies 'morally ennobling'. The evidence of numerous entries in the *Treatise on Superfluous Things* is that an object made the previous day could be deemed 'antique' if it met certain criteria in a fitting manner."[27]

We must keep this definition in mind, then, when we read Wen Zhenheng's entry on tables and couches: "When the men of old made tables and couchbeds [*ta*], although the length and width were not standardized, the pieces were invariably antique [*gu*], elegant [*ya*] and delightful [*ke'ai*] when placed in a stu-

dio or room. . . . The men of today make them in a manner which merely prefers carved and painted decoration to delight the vulgar [*su*] eye, while the antique pieces are cast aside, causing one to sigh in deep regret."[28]

Thus the couchbed delighted the eye of the beholder and was a practical and comfortable piece of furniture. Through its development it acquired the most diverse functions, serving for sitting and eventually also for sleeping. In addition to these uses, the couchbed was a place where all the activities of the master and mistress of the household occurred—chatting with friends, reading, playing double sixes, eating, flirting, and lovemaking. In short, the Chinese couchbed provided a platform for all the richness and complexity of their comforts and joys.

10 | THE CANOPY BED
A Little World Made Cunningly

I am a little world
made cunningly
Of Elements, and an
Angelike spright

John Donne

*V*isually and symbolically the canopy bed was the major piece of furniture in a traditional Chinese home. Considered essential for setting up basic housekeeping, it was typically part of a bride's dowry. In a Confucian society the significance of the bed resides in its associations with birth and death and consequently with one's ancestors. Thus it was an important status symbol, the object of rivalry among wives and concubines. By its very size, the canopy bed dominates the room, and the intricacy of its decoration attracts the eye. A most versatile piece of furniture, it is a bed at night and a seat where friends may be entertained during the day when the curtains are drawn back, the quilts are folded against the back railing, and a small table is placed on the mattress. At night the curtains come down and the canopy bed transforms into a private enclosure for pleasure and rest. Thus the bed becomes a unique form of furniture, a room within a room.

The beautiful hardwood canopy beds of the Ming and Qing dynasties that we see today are the culmination of a tradition already sophisticated in the fourth century B.C. From this period survive two remarkable beds from the southern kingdom of Chu. One (see fig. 1.2), excavated in 1956 at Xinyang, Henan, was found near a bamboo pillow and a carved lacquer armrest. The armrest, which the owner probably used while sitting on the bed during the day, has on each side four legs ending in a curved foot base, a design that was later adopted and modified to produce the low table or bench placed in front of the canopy bed.

Thirty years after the Xinyang excavation, a similar bed was discovered in the 316 B.C. tomb no. 2 at Baoshan in Jingmen, Hubei province (fig. 10.1). The bed, found disassembled and folded against the southern end of the west chamber, is an early example of knocked-down folding furniture. The base is fashioned from wood lacquered black, and the railing is of bamboo and wood. The bed consists of two identical square sections, each standing on four legs consisting of spindles fastened to a straight base. The railing has small rectangular open panels and, unlike the Xinyang bed, is stepped at the openings in the center of each long side. This form resembles later Korean beds, except that the railing has two

10.1

openings rather than one. The seat of the Baoshan bed has braces along the width and was spread with a silk-wadded quilt over bamboo and grass mats.

To dismantle the bed, one must first remove the braces and separate the two square frames. Since the fronts and backs of the frames are hinged just before they join the short sides, they can then be folded against the sides. The whole bed then becomes a bundle 135.6 cm long, which was easy to carry into the tomb and took up less space than the fully assembled bed. A few centuries later a folding table was buried in the tomb of Liu Sheng, who died in 113 B.C.[1] Folding stools are believed to have come to China from the West during the late second century A.D. Centuries later folding stools, chairs, and tables were still part of the furniture repertoire (see, e.g., figs. 7.22, 5.1–5.4, 11.12).

The Baoshan bed is also an early example of knockdown furniture: before folding it up one first had to dismantle it by removing the braces. This concept of constructing furniture so that it can be easily disassembled also persisted, and there are certain pieces, such as the four-part wardrobes and display cabinets in figs. 15.21 and 15.24, that are specially constructed to facilitate disassembly. The large alcove bed can be disassembled in about twenty minutes. Today in Hong Kong antique stores Chinese furniture still arrives and is stored in its knocked-down state.

These elegant and refined pieces of furniture were

called *chuang*. According to an early definition in the *Explanation of Names* (*Shiming*), a lexicon compiled during the Eastern Han dynasty (A.D. 25–220) or Three Kingdoms period (221–265), the *chuang* is for sleeping and sitting and may be used by more than one person.[2] In literature of the Warring States period (475–221 B.C.)—an era to which both the Chu beds belong—we find references to *chuang* used as beds and *chuang* used as seats. Ode 189 of the *Book of Songs* (*Shi jing*) says:

> When a son is born
> He is cradled on the bed (*chuang*).
>
>
>
> When a daughter is born
> She is cradled on the floor.[3]

Here we see blatant and unembarrassed gender distinction in the use of furniture in Chinese society. The son is given a protective, and presumably comfortable, bed, while the less-valued daughter is cradled unceremoniously on the floor.

In *Mengzi* Book 5 we find reference to the bed as a daytime seat: "Xiang then went away into Shun's palace, and there was Shun on his bed [*chuang*] playing on his lute."[4] The bed also had a ceremonial function at this time, as is obvious from statements such as this aphorism from *The Book of Shang Jun* (*Shang Jun shu*): "When the Lord is on his square bed (*guang chuang*), the Empire is governed."[5] Such statements—relating furniture to its symbolic function and sug-

gesting traditional patrimonial powers even with regard to beds—are ubiquitous in China. The lord on his bed, a metonym for authority and power, is clearly a rhetorical equivalent to the later metonym of the emperor on his throne.

The Chu beds were luxury items of a type probably used only by the ruling family, and it is likely that they originally had canopies. Long bed curtains are mentioned in "Summons of the Soul" ("Zhao hun"), a contemporaneous poem from the kingdom of Chu. In the poem the wandering soul is called back to all the good things of life, including the canopy bed, which is, by implication, a private paradise for intimate joys.

> Beauty and elegance grace the inner chambers:
> Mothlike eyebrows and lustrous eyes that dart out
> beams of brightness,
> delicate colouring, soft round flesh, flashing, seductive
> glances.
> In your garden pavilion, by the long bed-curtains,
> they wait your royal pleasure . . .[6]

Remains of canopy frames have been found in a number of early tombs, some dating from the Warring States period.[7] In the tomb of Liu Sheng, the pleasure-loving prince who died in 113 B.C. and was ostentatiously buried in a suit of glittering jade, there were bronze-hinged sockets, hub connectors, and splice connectors that originally joined bamboo or wooden poles to form a canopy frame (fig. 10.2). The frame is about 250 cm long and 150 cm wide, just right for containing within it a bed the size of those found at Xinyang and Baoshan. The frame would have been hung with silk curtains, which were let down at night and drawn back for daytime sitting.

A larger version of such a canopy is depicted in a Han dynasty wall painting from an early third-century B.C. tomb at Mixian, Henan.[8] The canopy is hung with patterned silk and bedecked with flags. The painting shows the bed in ceremonial use for a banquet, and among those seated in the place of honor beneath the canopy is probably the occupant of the tomb. In front of him, level with his seat, is a long low table with curved legs at each end set into a base

10.2

FIGURE 10.1 Reproduction of a folding bed. Excavated from the 316 B.C. tomb no. 2, Baoshan, Jingmen, Hubei. Bed: lacquered wood; railing: bamboo and wood. Height 38.4 cm, height of seat 23.6 cm, length 220.8 cm, width 135.6 cm. From Zhang Yinwu, "A Survey of Chu-Style Furniture," fig. 34.

FIGURE 10.2 Reconstructed bed canopy frame. Han dynasty. Excavated from the 113 B.C. tomb of Prince Liu Sheng, Mancheng, Hebei. Drawing from Zhongguo Shehui Kexueyuan Kaogu Yanjiusuo and Hebei Sheng Wenwu Guanlichu, *Mancheng Hanmu fajui baogu*, 1: 177.

10.3

FIGURE 10.3 After Gu Kaizhi
(c. 344–c. 406). *The Admonitions
of the Instructress to the Court
Ladies.* Detail of a handscroll.
Ink and color on silk. © The
British Museum, London.

love poetry we find more elaborate descriptions of the bed and its furnishings. In the love *fu* "On a Beautiful Woman" ("Meiren fu"), Sima Xiangru (?–117 B.C.) details the furnishings of a bedstead: "A lovely girl alone in her room, reclining on a bed [*chuang*], a strange flower of unsurpassed elegance, of gentle nature but of luscious appearance. . . . Then she made the bedstead ready, provided with the rarest luxuries, including a bronze censer for scenting the quilts. She let down the bed curtains to the floor. The mattresses and coverlets were piled up, the pointed pillows lay across them."[11]

The bed was both scented and warmed by the censer (*za*), which consisted of a bronze box with glowing coals in the lower compartment and powdered incense in the upper tier beneath an openwork lid. The pillows (*juezhen,* literally "horned pillows"), which were hard and placed under the neck, were probably crescent-shaped with ends pointed like cow horns. The bed had a sleeping mat under a silk quilt. Above was a silk canopy.

Zhang Heng (78–139) talks of a square bed in his poem "Like Sounds" ("Tongsheng ge"), in which a bride addresses her husband:

In my thought I long to be changed into your
 bedmat [*xi*],
So as to act as a cover for your square bed [*guang
 chuang*].
I wish to be changed into a silken coverlet [*qin*]
 and canopy [*chou*],
So as to protect you from draughts and cold.
I have swept clean the pillow and the bedmat,
And I have filled the burner with rare incense.
Let us now lock the double door with its golden lock,
And light the lamp to fill our room with its
 brilliance.[12]

The first pictorial representation of a canopy bed in a domestic rather than a ceremonial context appears in the painting *The Admonitions of the Instructress to the Court Ladies,* generally considered to be based on a fourth- or fifth-century composition by Gu Kaizhi (c. 344–c. 406; fig. 10.3). The scroll illustrates a moral treatise on the proper conduct for ladies. The bed scene accompanies the text:

stretcher, a variant form of the Xinyang armrest. The table is laden with sumptuous dishes, indicating that a feast is in progress. Those seated on mats, arranged in a huge U shape before the table, are the guests. At that time it was common practice to sit on mats on the floor, since low beds and platforms were honorific seats used on ceremonial occasions by the elite. On this raised furniture they sat with their legs tucked up rather than hanging over the edge.

For further information on the canopy bed in the Han dynasty we must turn to the writings of the time. Xie Cheng's *History of the Later Han* informs us that in summer months the Prefect of Dongjun in Hebei province sat on a bed made from elm (*yumu*) boards.[9] From the *Private History of Queen Feiyan* (first century B.C.), we discover that lady Zhao had a bed decorated with eagle wood (*chenshuixiang*) made especially for her when she accompanied the emperor to Yizhou.[10] In

If the words you speak are good
Men for a thousand miles will respond to you.
Should you depart from this precept,
Even your bedfellow will doubt you.[13]

A distrustful-looking gentleman sits on a long bench that is of exactly the same form and in the same position as the tables in front of long platforms in Han tomb depictions (see fig. 13.1). In the adjoining canopy bed, a lady leans on one of the hinged screens paneled with matting on the inside. The bed has a rectangular boxlike base in which side panels have oval cutouts with cusped upper edges. This type of base, like the Xinyang type with legs (see fig. 1.2), can be traced back to Shang and Western Zhou prototypes.[14] Both types became a permanent part of the furniture tradition. The wooden canopy is no longer a separate structure but is supported by four corner posts arising from the base and is hung with diaphanous curtains tied up with ribbons. Now we see clearly how such bedsteads formed a room within a room. The curtains were raised and screens opened for daytime sitting. At night the bed was completely enclosed, providing privacy in living quarters where extended families and their servants all lived together in open halls divided into smaller apartments by screens.

Bed curtains, and probably the bedstead itself, were part of a bride's trousseau, as we learn from a moving poem that Wang Song (third century) wrote after her husband of some twenty years, General Liu Xun, left her for a younger wife.

> Your curtain is flapping before the bed!
> I strung you there to screen us from daylight.
> When I left my father's house I took you with me.
> Now I take you back.
> I will fold you neatly and lay you flat in your box.
> Curtain, will I ever take you out again?[15]

The curtains were made of silk and often embroidered or figured with flying immortals and other auspicious patterns.[16] Prized and coveted possessions, canopy beds were still used only by the wealthy. Some of these beds must have been extremely extravagant.

The annals of the first emperor of Qi (r. 479–483) state that a petition was sent to the throne prohibiting excesses among the people, such as using tamarisk (*cheng*) and cedar (*bo*) beds with curved legs.[17] Two and a half centuries later the Tang emperor Xuanzong and his favorite consort, Yang Guifei, gave away magnificent beds. They bestowed a paneled bed of painted hardwood on a scholar who was nominated to the academy. They presented the minister An Lushan with beds of veneered sandalwood inlaid with ivory, complete with coverlets of plaited reeds bordered with green silk and lined with white silk.[18] Another account tells of a Tang dynasty official of the salt and iron monopoly in Fujian who had a golden bed and a pillow encrusted with lapis lazuli.[19] Besides such ostentatious materials, we know from Chen Cangqi's *Materia medica* of 739 that at this time beds were also made from the *huanghuali* wood (Chen calls it *lü mu*) so prized by later craftsmen.[20]

During the Tang dynasty the ceremonial function of the canopy bed reached its apogee—not in daily life but in Buddhist art, where it often appears in depictions of the *Vimalakīrti Sūtra*. Vimalakīrti, a renowned retired scholar and a rich respected householder, was a faithful follower of Buddha. Once when Vimalakīrti was ill the Buddha sent Mañjuśrī, the bodhisattva of wisdom, to inquire after his health. The two then engaged in a famous debate, which Mañjuśrī lost. This episode was a favorite with the Chinese because Vimalakīrti reminded them of their own virtuous Confucian scholar and the debate was similar to their *qingtan*, the art of conversation. Since the story was not popular in Indian art, the Chinese had no pictorial prototypes. They therefore turned to their own furniture tradition and showed Vimalakīrti seated on a canopy bed. To enhance the thronelike quality, the bed is usually greatly elevated, as in a representation from the first half of the eighth century in cave 103 at Dunhuang (fig. 10.4). This bed, with its box-construction base and oval cutouts, is similar to the one in the *Admonitions* scroll (see fig. 10.3). The screens behind Vimalakīrti are decorated with a checkered pattern of light and dark rectangles in-

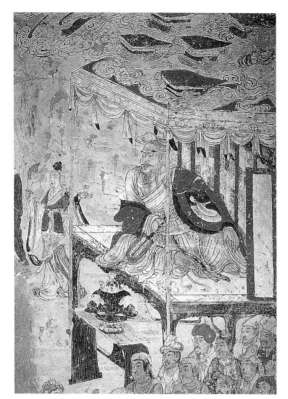

10.4

10.5

FIGURE 10.4 Detail of an illustration to the *Vimalakīrti Sūtra*. First half of the eighth century. Wall painting in Dunhuang cave 103. From Dunhuang Wenwu Yanjiu, *Zhongguo shiku Dunhuang Moyao ku,* vol. 3, pl. 155.

FIGURE 10.5 Wooden bed. Ming dynasty, Hongwu era (1368–98). Excavated from a tomb at Xiangfen county, Shanxi. Length 198 cm, width 82 cm. Drawing from Dao Fuhai, "Shanxi Xiangfen xian chutu de Hongwu shiqi de lin chuang," 25.

scribed with appropriate texts. The canopy has assumed crownlike embellishments. In front of the bed is a tall version of the curved-leg table. Such markedly elevated canopy beds are unlikely ever to have existed. However, by about the tenth century it became the practice of the Chinese to sit on chairs at high tables rather than on mats or low platforms. As a result, all furniture was made higher and became a more important component of the interior, taking on a greater variety of forms.

We see an early depiction of these changes in the handscroll *The Night Revels of Han Xizai* (see fig. 1.8), which gives suggestive glimpses of canopy beds with cloth-draped bases and opaque patterned curtains tied back. Ink paintings of landscape scenes ornament the low side panels of the beds. Beside the beds we see the curved ends of clothes racks. The furniture is probably lacquered black. At this time there were surely also red lacquer beds, because in 1029 an imperial edict decreed that such beds could be used only by the emperor.[21]

By the Ming dynasty (1368–1644) the chair-level mode of living had fully developed, and the classical age of Chinese furniture had arrived. From this period date the earliest extant complete examples of canopy beds, as well as a bed from the Hongwu era (1368–98; fig.10.5) that is strikingly similar to the early Xinyang and Baoshan beds (see figs. 1.2, 10.1). The Hongwu bed is unusual because it is not a miniature model but an actual piece of furniture excavated from a Ming tomb. Beds of similar form are not found among known Ming and early Qing hardwood pieces, although they occur in later vernacular softwood furniture.[22] It has cloud-head feet and stylized floral-patterned spandrels. The railing is continuous, with an opening in the center of one of the long sides, and is supported by six square posts with bottle gourd–shaped finials. The railing has solid inset boards along the bottom and lotus-shaped struts between parallel horizontal bars. If the posts were extended and supported a top framework, it would be a six-post canopy bed.

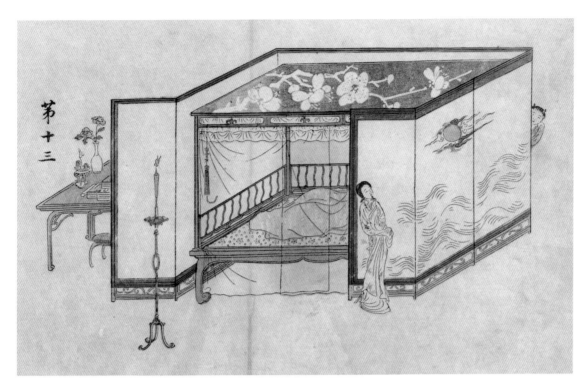

第十三

10.6

Canopy beds have either six or four posts. Today in north China both types are called *jiazichuang*. In the Ming dynasty *Classic of Lu Ban* they are referred to as *tengchuang* ("bed with cane webbing").[23] Extant canopy beds from the Ming and early Qing have six, rather than four, posts, although four-post examples appear in woodblock illustrations. For example, an illustration to the play *The Story of the Western Wing* (*Xixiang ji*) shows a four-post canopy bed with inward curving feet and a low railing with undulating spindles like those found on lowback chairs (fig. 10.6).[24] In front of the bed a burning candle indicates that it is night. The transparent bed curtains have been let down from the brass hook that dangles on its elaborately knotted and tasseled silk cord. Inside, the bed is equipped with a thin brocade-covered mattress and a silk quilt. The canopy is decorated with branches of flowering plum, a symbol of fertility and creative power. The bed stands in the middle of the room surrounded by a high folding screen for privacy. On the

FIGURE 10.6 *The Canopy Bed.* Woodblock illustration to Min Qiji's 1640 edition of *The Story of the Western Wing* (*Xixiang ji*), leaf 13. Museum für Ostasiatische Kunst, Cologne. Photo: Rheinisches Bildarchiv, Cologne.

screen are painted waves below a moon encircled by scudding clouds. The moon is the celestial embodiment of womankind and governs the tides, while water is the terrestrial image of the female principle. Peonies in a vase on the table symbolize feminine erotic charm and were also thought to keep sickness and evil influences at bay. Next to them, a vessel filled with burning incense pleasantly scents the air.

On this four-post bedstead, the curtains hang outside the wooden framework. When there are six posts, the curtains would hang inside. Curtains could be

transparent or opaque and patterned. Writers such as Wen Zhenheng had definite ideas about what was appropriate and inappropriate for bed curtains:

> Bed curtains for the winter months should be of pongee silk or of thick cotton with purple patterns. Curtains of paper or of plain-weave, spun-silk cloth are both vulgar, while gold brocaded silk curtains and those of *bo* silk are for the women's quarters. Summer curtains can be of banana fibre, only these are not easy to obtain. Curtains of blue fine gauze from Suzhou, or curtains of patterned towelling are also acceptable. There are those which are made of silk for painting, with landscapes or monochrome ink paintings of plum blossom on them, but these all achieve vulgarity while striving for elegance.[25]

The lucky inhabitants of the canopy bed lay within the closed curtains as in their own private world whose special aura was created by the fabric, which ranged from diaphanous gauze to heavy patterned brocade. The illusion broke when they arose and hooked back the curtains during the day. Curtain hooks hung from knotted silk cords, and the best were exquisitely made of metal with engraved, openwork, and inlaid ornamentation.

According to the *Classic of Lu Ban,* there are only certain days each month when it is auspicious to place the bed in a room and hang the bed curtains. Of all the furniture discussed in this carpenter's manual, superstitious directives mention only the bed. This is not surprising, since the bed was meant ultimately for the procreation of sons to maintain the family altar and eventually become influential ancestors themselves.[26]

In old China the bed was the most frequently used piece of furniture in a household. Li Yu (1611–c. 1680) pointed out that men spent more time with their beds than with anything or anyone else:

> Of the hundred years in a man's life, half are spent in the daytime and half at night. Our days are spent in a variety of places—in this room or that, on a boat, in a carriage—but our nights are spent in only one place, in bed. Thus, beds are our constant companions for half of our lifetimes—they surpass even our wives in that respect—and we ought to treat them more generously than anything else. I fault my contemporaries for throwing themselves heart and soul into finding a house and yet studiously neglecting the sleeping quarters. The reason they do so is that their beds are not seen by anyone else, only by themselves. But by that reasoning, since wives, concubines, and maids, the human counterparts of beds, are also seen only by us, would these men allow them to go about like hags, with unkempt hair and dirty faces, and not do anything about it?
>
> I am quite different. Every time we move, I plan the sleeping quarters first, before seeing to anything else, because if wives and concubines are the human counterparts of beds, beds are the inanimate counterparts of wives and concubines. If I were to make a new design for a bed, I would have trouble paying the carpenter, but I have always done my best to decorate the bed and bed-curtains and to arrange the sleeping quarters. It is like a poor man's taking a wife. He cannot change her rustic look into that of a classic beauty; he merely sees that she is conscientious about washing and combing and that she makes liberal use of oils and creams. What are my methods? The first is to Make the Bed Bloom with Flowers; the second is to Provide a Frame for the Bed-curtain; the third is to Supply a Lock for the Bed-curtain; and the fourth is to Put Skirts on the Bed.[27]

Li Yu then goes on to describe in detail how he makes the bed bloom with flowers by growing real flowers up the posts. Or he builds a narrow wooden shelf for flower pots and wraps them in embroidered silk so that they resemble fantastic rocks or floating clouds. Then lying within the bed curtains he feels, "My body is no longer a body, but a butterfly flitting about, sleeping, and eating among the flowers. Man is no longer a man but an immortal, strolling about and reclining in paradise."

Another connoisseur of the art of living suggested hanging within the curtains vases with seasonal flowers and bottle gourds filled with incense.[28] And in *The Story of the Western Wing* there is reference to an incense censer used to perfume the bedding when the maid Crimson tries to cheer up her lovesick mistress: "Sister, you're not feeling well. I will infuse your covers until they are, oh, so fragrant so that you may sleep a little."[29] Thus the canopy bed becomes a fragrant, flower-filled world, a retreat for lovers and dreamers.

This world is full of auspicious symbols. One of the most common is the *wanzi,* or ten-thousand-

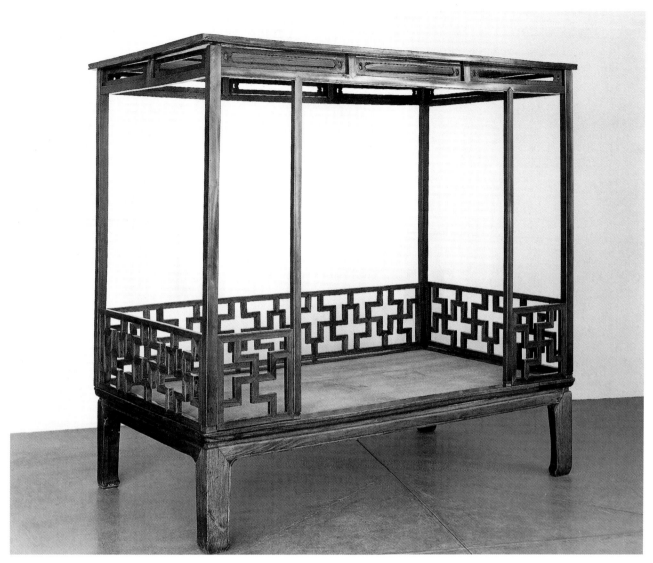

10.7

character pattern, an ancient symbol for immortality and infinity that was considered especially suitable for the bedchamber, where it appears both on the lattice of the bed and on other furnishings. Along the back and side railings of a six-post canopy bed in the Philadelphia Museum of Art is a continuous pattern of repeated *wanzi* motifs, standing for an unending multiplication of happiness, wealth, and years of life (fig. 10.7). The front panels each contain a single *wanzi*. The members of the lattice are mitered, mortised, and tenoned together; each double-mitered join

FIGURE 10.7 Canopy bed. Ming dynasty, sixteenth century. *Huanghuali* wood with red pine canopy panels. Height 183.5 cm, width 209.3 cm. Philadelphia Museum of Art.

10.8

FIGURE 10.8 Canopy bed.
Woodblock illustration to Wang
Qi's 1609 *Pictorial Encyclopedia
of Heaven, Earth, and Man*
(*Sancai tuhui*), Qi Yong,
juan 12, 17a.

is also wood-pinned on the back. As with all canopy beds, the piece is meant to be viewed from the front, and therefore greater attention is paid to the detail and finish of the members visible from this vantage. Thus in the Philadelphia bed, surfaces visible from the front are slightly convex, creating a beautiful play of light on the lustrous surface of the wood. Under the canopy are inset panels with beaded-edged, fire-cracker-shaped openings. The posts of canopy beds often flare outward at the base or end in pads, like the stone bases supporting wooden columns in Chinese architecture. This bed has uncharacteristic concave pads, low horse-hoof feet, and beading along the inner edge of the legs and straight aprons. The miter at the join of leg and apron continues through the waist. This variation of the usual join appears on a number of other pieces, mostly large couchbeds and canopy beds.[30]

The Philadelphia canopy bed seems to have been a standard Ming dynasty type. An almost identical piece is illustrated in the 1609 *Pictorial Encyclopedia of Heaven, Earth, and Man* (fig. 10.8). The curtains, hung inside the frame of the six-post bed, have a valance along the front and are decorated with branches of budding plum blossoms; a pair of curtain hooks hang down beneath the tasseled cords.

Other types of canopy beds are more elaborately decorated. One especially elegant model has front panels with curling spandrels connected to a motif with four cloud-heads in the center (fig. 10.9). A variation of this pattern using straight and curved lines repeats continuously on the back and side railings. The front of the bed is the most profusely ornamented, with six openwork panels beneath the canopy. Along the top is a center panel containing a scrolling peony design with two magnolia flowers in the middle; plum blossoms adorn the right panel, and peaches and peach blossoms ornament the left one. Underneath is a long central panel containing magnificent confronting dragons entwined with scrolling floral motifs. The same flowers repeat on the side panels. Each side of the bed has two panels with slanting *wanzi* patterns, and along the back are three panels with delicate

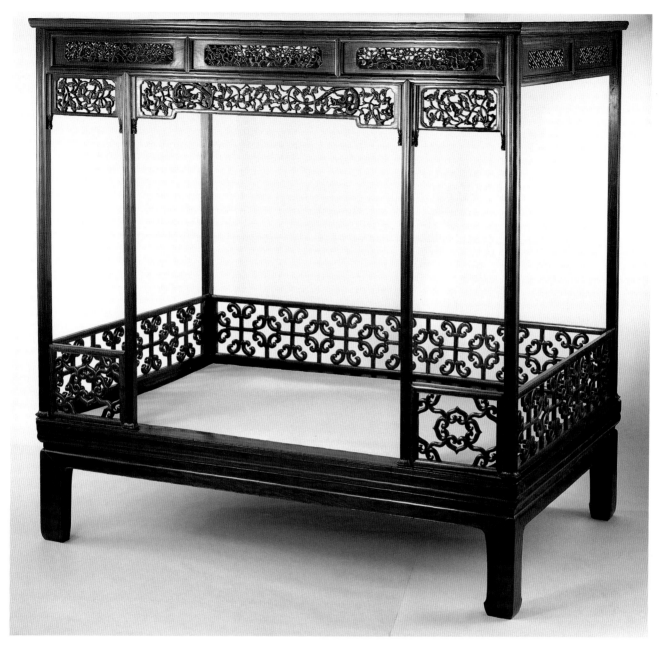

10.9

FIGURE 10.9 Canopy bed. Qing
dynasty, late seventeenth/early
eighteenth century. *Huanghuali*
wood with elm panels on top.
Height 224 cm, length 223 cm,
depth 145 cm. © Christie's
Images, Ltd., 1999.

THE CANOPY BED **149**

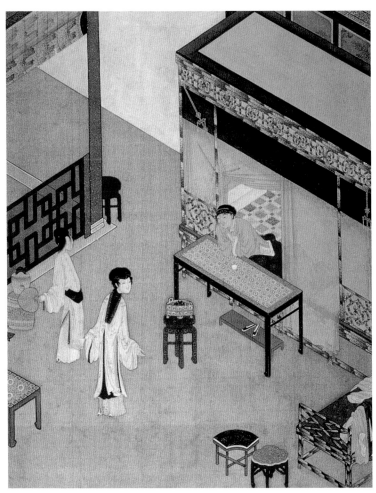

FIGURE 10.10 Attributed to Gu
Jianlong (1606–c. 1694). *Hua
Zixu Lies Dying of Mortification
and Chagrin*. Qing dynasty,
1662–c. late 1670s. Detail from
an illustration to *The Plum in
the Golden Vase* (*Jin ping mei*),
chap. 14. Ink and color on
silk. Height 39.4 cm, width
31.8 cm. The Nelson-Atkins
Museum of Art, Kansas City,
Missouri. (Acquired through
the Mrs. Kenneth A.
Spencer Fund.)

10.10

cloud-head motifs. The decorative motifs on the bed
all contain symbolic connotations appropriate to the
bedchamber: clouds suggest "clouds and rain" (*yun
yu*), a euphemism for sexual union; the dragon is a
symbol of male vigor and fertility; plum blossoms de-
note pretty women and sexual pleasure; peonies with
magnolias symbolize wealth and high rank; the peach
indicates longevity; and *wanzi* means good luck and
fertility. The carving of the panels is refined, as is the
carving on the posts, which have beaded edges, bead-
ing in the center (double beading on the four front
posts), and an elegant flare at the bottom where a sep-
arate piece of wood has been added.

The panels in the front railing of the bed resem-
ble those on the bamboo canopy bed in fig. 10.10, a

painting illustrating the episode in *The Plum in the Golden Vase* where the cuckold Hua Zixu dies of chagrin. Transparent curtains hang behind and offset the openwork designs. One side of the curtain has been hooked back and the blue blind rolled up to allow the young man to lean on a narrow table placed in front of the bed for daytime use. He is wrapped in a quilt, which would normally be folded neatly against the back railing of the bed during the day. Low footstools, such as the one depicted here, are always used with beds. The furniture is certainly not a matching set but is fashioned from a variety of materials: the bed and armchair are made of speckled bamboo; the footstool, bench, and fan-shaped stool are of hardwood; and other pieces are of lacquered wood. Colorful brocades cover the tops of the table, chair seat, and stools. Even though this informal scene takes place in a garden pavilion, each piece of furniture is carefully arranged parallel to the walls and at right angles to one another; the central area is left empty. Diagonal and haphazard groups in the center of a room are unseemly to Chinese eyes. From depictions such as this, we know that canopy beds were used in both men's and women's bedrooms. Tasteful men's bedrooms, however, would have a certain simplicity and plainness; more ornate furnishings, such as gold-brocaded silk curtains, were considered inappropriate.

Sometimes canopy beds are highly decorated with detailed openwork designs on both railings and panels as well as relief carving on the base. A complex yet harmonious example of this is the cabriole-leg bed in fig. 10.11. Here we find a veritable bestiary of diverse dragons. Each of the lower panels of the railing contains a pair of dragons, either facing each other or with one turning back to look at the other running behind him. The large panels above, on the back and side railings, have multiple large *shou* ("long life") characters encircled by a ring and separated by a pair of cavorting dragons, one with a single long horn, the other with a stubby hornlike protuberance on the top of its head. Above each *shou* roundel is a round strut in the form of a coiled dragon. A variation of the decorative schemes of the railings appears in the

openwork panels beneath the canopy, where a pair of horned dragons face an abbreviated form of the *shou* character and cloud scrolls end in *chi* dragon heads. Below, intertwined *chi* dragons form the continuous openwork spandrel fitted into a slot in the posts; consequently the posts are shaped at the top rather than double mitered or straight.

The front railing is distinguished by a slightly different form of dragon roundel and by a pictorial central panel with a landscape scene containing mountains, fantastic rocks, the *lingzhi* fungus of immortality, clouds, a sun or moon, and a mythical beast resembling a hooved dragon or a supernatural *qilin* without its usual horns. The scene is carved in varying levels of relief to give it depth. The dragon theme continues in the relief carvings on the base of the bed, where confronting *chi* dragons adorn the waist panels. The curvilinear front apron has in the center intertwined *lingzhi* fungi flanked by spirited two-horned dragons, with simpler single-horned dragons riding the crest of the beads on the sides. A slightly simplified version decorates the side aprons. The high waist has bamboo-shaped struts tenoning into a separate lower molding. The cabriole legs extend from a ferocious animal mask and end in massive claw feet. All the carving on this bed has great vigor enhanced by small variations that add to the visual interest. Although the decoration is profuse, its total effect has the controlled detail of a Persian rug, imposing its clarity through orderly planes of rich elaboration.

Another canopy bed identical in form and spirit was exhibited in the fall of 1991 at the China Arts and Crafts Museum, Beijing. Rather than dragons, its principle decorative motifs are birds and flowers. A related bed in the Palace Museum, Beijing, has the same form except for its full-moon opening. The base is covered with dragons and scenes of birds and flowers. The carving is delicate, and there is an elaboration of detail and motifs distinct from the bold vigor of the carving on the bed in fig. 10.11. The surroundings of the full-moon opening, railings, and lattices beneath the canopy are ornamented with a repeating pattern of four cloud-head motifs linked by

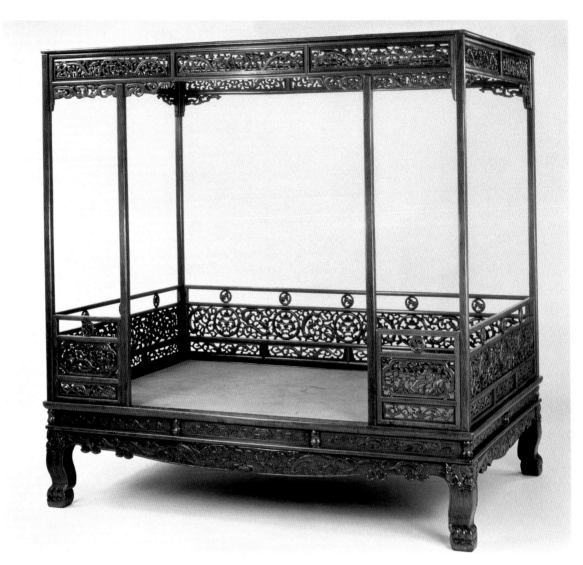

10.11

FIGURE 10.11 Canopy bed.
Ming or Qing dynasty,
seventeenth century.
Huanghuali wood. Height
225.1 cm, length 226.1 cm,
width 225.1 cm.
© Christie's Images, Ltd.,
1999.

FIGURE 10.12 Canopy bed.
Ming–Qing dynasties,
1600–1700. *Huanghuali*
wood. Height 206 cm.
Victoria and Albert
Museum, London. Photo
courtesy V & A Picture
Library; Ian Thomas,
photographer.

crosses. This repetition gives unity to the considerable expanse of openwork panels forming the canopy frame.[31] With their lush detail of decorative motifs, such beds place those sitting and lying within them in a wondrous imaginary world.

Wholly different is the world created within the canopy bed in the Victoria and Albert Museum, London (fig. 10.12). Here is a design of stark geometries that would please the most refined connoisseur. The bed is fashioned from slender members, round in cross-section, in a manner derived from bamboo fur-

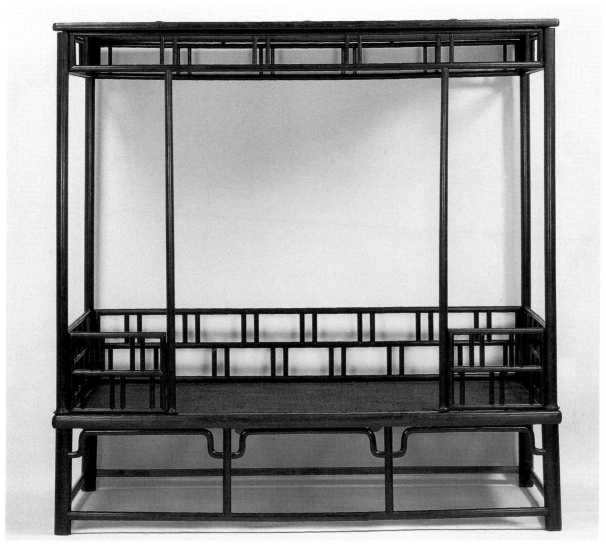

10.12

niture. The railing has two horizontal sections with twin struts staggered at regular intervals, creating space rectangles that relate to one another in multiple patterns. This twin-strut arrangement repeats in a single band beneath the canopy. The four posts flare outward at the bottom. The lower part of the bed has a humpback stretcher and a continuous base stretcher. This bed is a beautifully proportioned piece of furniture. Its visual interest depends on the spaces between the members as much as on the members themselves.

Besides open canopy beds with lattice railings, there were also those with solid board sides and back. The tops of these beds are outstandingly architectural, often resembling the superstructure above an entranceway, as may be seen in the 1623 woodblock illustration to *The Life of Han Xiangzi* (fig. 10.13). This print clearly shows the soft-mat seat that was originally found on all canopy beds. In summer the seat was pleasantly cool; in cold weather it was covered with a thin brocade mattress. The long rectangular pillow was hard and could be made of porcelain, bam-

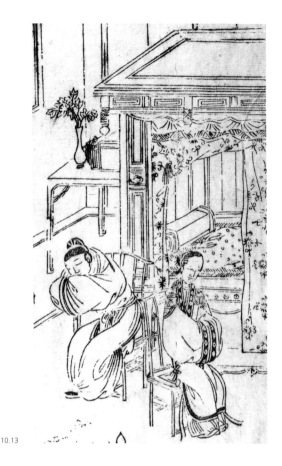

FIGURE 10.13 Woodblock
illustration to *The Life
of Han Xiangzi*, 1623.

ally, as in this case, they are carefully fashioned to suggest something of the detail and elegance found in actual pieces. Since few full-size dated pieces of furniture have survived, the models unearthed from tombs are important for the study of Chinese furniture. The alcove bed from Pan Yunzheng's tomb has the same *wanzi*-patterned railings as the Philadelphia canopy bed (see fig. 10.7) and similar cutout openings in the panels beneath the canopy. The soft-mat seat has a rattan mat with under-webbing of palm fiber. In front of the bed four additional posts and railings create an alcove. The alcove's front railings consist of two panels, the upper having a single *wanzi* lattice panel and the lower a simple frame. The whole structure rests on a platform supported by low feet. A pair of silver curtain hooks was found on the bed.[32] Such an alcove bedstead is a more highly developed form of the Gu Kaizhi canopy bed with a bench in front. The alcove is fitted with a footstool and two stools for entertaining companions or holding books, tea utensils, and candles. At night, drawn curtains would have provided privacy and protection from insects.

Sometimes only the alcove has a platform, and the feet of the bed itself rest directly on the floor, as in a wooden model from the 1613 tomb of the high official Wang Xijue on Tiger Hill, Suzhou (fig. 10.15). Here, too, the railings have *wanzi*-patterned lattices. The front posts rest on separate oval pieces of wood, and there is a curvilinear apron along the front of the platform. Beneath the canopy are panels with firecracker-shaped openings (like those on the Philadelphia bed), horizontal members with protruding exposed tenons, and shaped aprons between the front posts. The miniature bed was found fully equipped with a small pillow in a peony patterned satin cover, two yellow silk quilts decorated with intertwined peony branches, and yellow silk curtains ornamented with the hundred-butterflies design that signifies wishes for long life.[33]

A rare example of an actual alcove bed is in the Nelson-Atkins Museum of Art in Kansas City, Missouri (fig. 10.16). It is similar to the model found in Pan Yunzheng's tomb (see fig. 10.14). The canopy and

boo, rattan, or leather. Often the pillow had a cloth cover with auspicious patterns embroidered on the ends.

All these canopy beds are clearly in the same tradition as those in the earlier paintings attributed to Gu Hongzhong and Gu Kaizhi (see figs. 1.8 and 10.3). In the Ming dynasty a new type of bed appeared, one with a small alcove in front. A miniature wooden model of this type was excavated from the 1589 tomb of Pan Yunzheng and his wives in the Luwan district of Shanghai (fig. 10.14). Such models of furniture from the private apartments of the deceased were thought to provide a congenial atmosphere in the tomb to prevent the soul from wandering. Occasion-

platform, made of painted softwood, were periodically replaced, most recently in the eighteenth century. The rest of the bed dates from the Ming dynasty and is fashioned from *huanghuali* wood. This bed is exceptional for the superb quality of its wood, design, and joinery. The slightly concave surfaces subtly enhance the orange-gold shimmer of the wood. The continuous *wanzi* patterns on the railings slant as though cut at random from a larger block, producing a more interesting and less static effect than when the design is straight. The mortise-and-tenon construction of the bed allows the entire structure to be dismantled in twenty minutes for easy moving. An elaborate and refined version of the mortise-and-tenon joint is found on the bed's railings. Here each member of the fret is double mortised and tenoned to the adjoining member, with the tenon ends exposed. Looking at the inside of the fret, one can see that the member carrying the tenons has a thin extension mitered into the abutting member. This design conceals the end grain of the wood. On the outside of the fret, this join is mitered. Where members of the fret cross each other on the outside, the topmost member is cut out in a double double-miter shape—a striking example of sophisticated joinery intentionally exposed to exploit its decorative as well as its functional values.

The alcove bed is known today as a *babuchuang*. In the *Classic of Lu Ban* it is called a "cool bed" (*liangchuang*) if the sides are open. Those with solid walls are called "great beds" (*dachuang*).³⁴ There are no early examples of *dachuang*, but we can see one in a Chongzhen period illustration to the *Classic of Lu Ban* that clearly shows the double side walls (fig. 10.17). Probably an outer case was constructed around a canopy bed, resulting in a double ceiling and double walls on the back and sides. This is similar to the large freestanding case containing a daybed depicted in a woodblock illustration to *The Plum in the Golden Vase* (fig. 10.18). Here solid doors along the front allow the bed to be completely enclosed, and we have the most perfect example of a room within a room. Lanterns hang from the ceiling, and paintings or

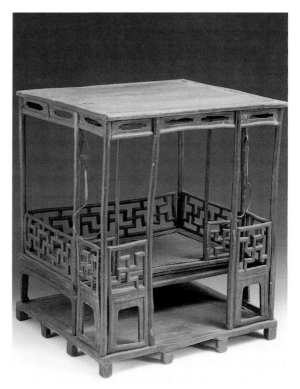

10.14

10.15

FIGURE 10.14 Miniature wooden alcove bed. Ming dynasty, sixteenth century. Excavated from the 1589 tomb of Pan Yunzheng, Luwan district, Shanghai. Southern elm (*ju*). Height 36 cm, length 31 cm, depth 28 cm. Shanghai Museum.

FIGURE 10.15 Miniature wooden alcove bed. Ming dynasty. Excavated from the 1613 tomb of Wang Xijue, Tiger Hill, Suzhou. Height 4 cm, length 39.5 cm, width 28.2 cm. Drawing from Museum of the City of Suzhou, "Suzhou Huqiu Wang Xijue mu qingli lue," 53.

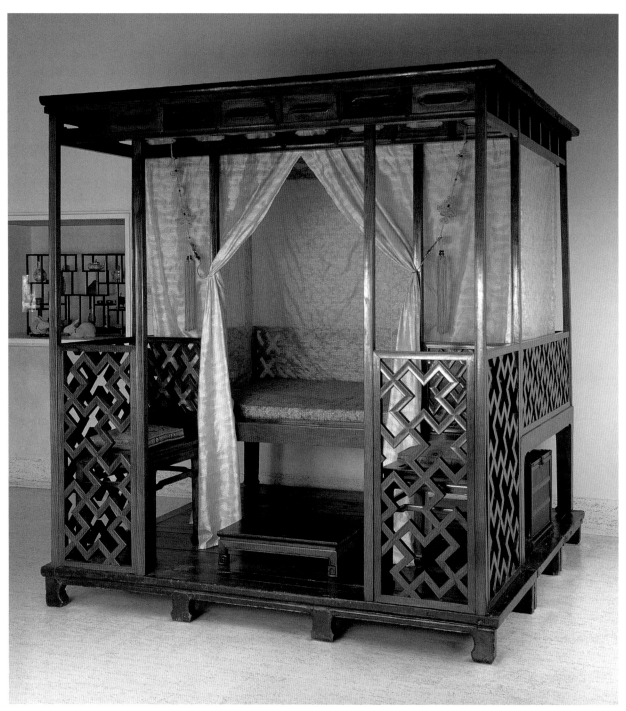

10.16

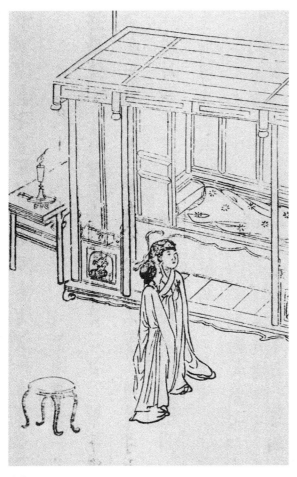

10.17

10.18

embroideries adorn the inside of the doors and interior walls. Outside we see the typical furnishings of a bedroom. Clothes hang from the clothes rack by the side of the bed and the rim of a wicker hamper. Garments are stored in chests stacked on low square-cornered cabinets. There is a stool and a large table with drawers on which stand a teapot and cups, a mirror, and a tiered box.

In *The Plum in the Golden Vase* we can see how important beds were for the ladies of Ximen's household. The bed dominated a woman's room, and the greater part of her life was spent on it, sleeping or sitting. Beds were part of a bride's dowry and an indication of her status within the family. For instance, Pan Jinlian insisted that Ximen buy her a bed similar to that of her rival Li Ping'er. It was expensive and

FIGURE 10.16 Alcove bed. Ming dynasty, sixteenth century. *Huanghuali* wood with painted softwood canopy and platform. Height 234.3 cm, width 219 cm. The Nelson-Atkins Museum of Art, Kansas City, Missouri. (Purchase: Nelson Trust.)

FIGURE 10.17 Woodblock illustration to the *Classic of Lu Ban* (*Lu Ban jing*). Ming dynasty, c. 1600.

FIGURE 10.18 *The True Couple Anticipating the Marvels of the Wedding Night.* Ming dynasty. Woodblock illustration to *The Plum in the Golden Vase* (*Jin ping mei*), Chongzhen reign period (1628–44), chap. 97.

elaborately decorated with mother-of-pearl birds and flowers, palaces and pavilions, and the "three friends of winter" (pine, prunus, and bamboo). Perfume balls hung within the purple gauze curtains, which were held back with silver hooks suspended from brocaded silk ties. Much later in the novel, when a former maid returns to the deserted mansion where the once prosperous family had lived, she grieves over the disappearance of this bed that had meant so much to her mistress.[35]

The canopy bed was until modern times the center of a woman's world from which she ruled her domain. A revealing description from the China memoir of Grace Service, who lived in Chengdu, Sichuan province, at the beginning of the twentieth century, tells of the difficulties of persuading a Chinese lady to leave her bed and enter the hospital. The bed contained her jewels and the money for running her household. Its railings and curtains gave her security and protection.

> Her bed was a mammoth wooden structure enclosed by curtains fastened tightly down on three sides and drawn apart in front. Chinese beds are placed with one side, not the headboard, against a wall, so these drawn curtains were on the front of the bed. At the rear and about two feet higher than the bed there was a long shelf with small drawers below. On the shelf were medicines, food, tea, and a great collection of oddments. In the drawers, some of them half open, were more eatables, rolls of silver dollars, jewels, and a heterogeneous lot of treasured possessions. . . .
>
> . . . she could not go [to the hospital]. Everything depended on her: she gave out all the money; her hands, weak as they were, controlled every detail of the establishment. . . .
>
> . . . [In the hospital] for one thing, she hated the comfortable iron hospital bed. It seemed so open and exposed! I asked that the bed be moved into a corner.

This was done, but she told me the next day that she had been unable to sleep. In the dead of night, when left alone by the nurse, she had dragged her mattress off onto the floor and slept there! As she expressed it, "I've had eight children, but I've never slept in a bed without sides."[36]

With the Nelson-Atkins Museum of Art's Ming dynasty alcove bedstead we reach the final stage in the evolution of the Chu bed. During this period the bed is still used for both sleeping and daytime sitting, but it is part of the furnishings of a bedroom and never a couch of state. The low structure has been elevated to a height suitable for sitting with the legs pendant. The bed forms a completely self-contained unit in which superb wood is subtly fashioned into a piece both functional and beautiful, achieving perfection of proportion, detail, and design. As such the bed has become true interior architecture.

Over the centuries Chinese craftsmen developed the canopy bed into an elaborate structure for living. By night it preserved bodily heat, renewed physical and spiritual energy, enhanced the private hours of love, and was a means of inspiring dream in the sleeping mind. By day it was a spacious seat with room for a few useful objects, treasured possessions, and favored friends. Without the canopy bed, the Chinese house would have forfeited a social center as well as a major object of beauty. Close to essential things in their poetry, in their practical philosophies, and in their interior wooden sculptures known to the world as classical furniture, the Chinese also invented, cunningly, the complete world contained in the canopy bed—a small room of wood and silks that is at once a court within the house and, with curtains drawn, a private kingdom of one's own.

TABLES

11 | ON A NEW WORLD AROSE
A *KANG* TABLE

The most significant event in the history of Chinese furniture was the adoption of the chair-level mode of living in about the tenth century. As we have seen, this ascension from the floor profoundly changed not only furniture but also architecture, other furnishings, and social customs. Before this time Chinese people commonly sat on mats or low platforms and used a variety of low tables. When the custom of sitting high on chairs became prevalent, tables also became high, and many new types of furniture developed. Yet in this new, higher, world the old low tables continued to be used, now placed up on the bed, couchbed, or heated *kang*. These so-called *kang* tables often reflected forms found in the earliest tables. Alongside the new types of high furniture, new types and designs of low furniture developed for use on the new high seats. The mat-level way of living simply moved up to the level of the *kang,* so that the old mat-level and new chair-level modes of living existed side by side. This is an impressive example of the strong continuity within the Chinese tradition—once something is invented, it never disappears. Rather, it adapts and persists in new circumstances.

The earliest extant pieces of Chinese furniture are bronze offering tables from the Anyang period of the Shang dynasty (thirteenth to eleventh century B.C.). At that time ancestor worship dominated the life of the king, and his primary duty was to perform the correct sacrificial rites. It was believed that after death people continued to exist, to need food, and to have power over the living. Thus the mediating king, whose position was fixed between heaven and earth, had to appease his own ancestors to maintain the health and prosperity of his people. His ancestors needed wine, grain, animals, and human beings. These sacrifices were placed in bronze ritual vessels and on small tables that are astonishing in their artistic and technical quality. Sacrificial wine was warmed in vessels set into round openings in long bronze tables. Two types of warming tables have been found. One, from Fu Hao's tomb at Anyang, has six legs that permit it to be set among hot coals.[1] The other is a platform with rows of rectangular openings that served as vents for the fire inside (see fig. 8.2).

One of the few small tables for food offerings that survived from the Shang dynasty (c. 1500–c. 1050 B.C.) was found in 1979 in a storage pit in Huaerlou, Yi county, Liaoning province (fig. 11.1). The legs of this early table slant slightly inward toward the top, a construction that derives from wooden architecture and is characteristic of later yokeback chairs and tapered cabinets (see figs. 4.9, 4.13–15, and 15.9). The arched and cusped opening between the legs of the Shang table is a feature commonly found, often with decorative elaborations, on hardwood tables and seats (see, e.g., figs. 11.11–16, 4.9, 9.9). The top of the bronze table, shaped like a shallow basin, later evolved into the water-stopping molding seen on the table in fig. 12.10. Thus three thousand years later the form persists, appropriately transformed, but energetically alive and well. This essential Chinese form may be much older than the three millennia we can document. Indeed, it is doubtful that those late Shang bronzes represent the genesis of the form.

The base of the bronze table is covered with various animal faces (taotie) and dragon designs. These imaginary beasts ensure that the ancestors will receive the sacrifices in the other realm.[2] The motifs are arranged in reverse symmetry along a central axis, a design principle that dominated later furniture decoration (see, e.g., fig. 7.15). A small bell hangs at each end between the legs. Given that similar bells hung within the integral bases of early Zhou bronze gui vessels, it is possible that the Huaerlou table functioned as a stand supporting a ritual food vessel rather than as a table.[3] Although the Huaerlou piece—made from costly, superbly crafted bronze and decorated with powerful mythical beasts—was used to serve food to the dead, it is probably similar in form to simpler wooden tables used at banquets for the living. Thus it is the predecessor of the low tables placed on kangs or beds for informal dining during the Ming (1368–1644) and Qing (1644–1912) dynasties.

Excavations from the Spring and Autumn Period (770–475 B.C.) have yielded several small wooden offering tables. A particularly interesting lacquered example from the state of Chu, with upturned ends

and paintings covering all sides, was found in tomb 4 at Zhaoxiang in Dangyang, Hubei province (fig. 11.2). Its resemblance to classical Ming forms is startling. The top is red lacquer, and the sides and legs have a black lacquer background covered with vigorous red lacquer paintings of imaginary beasts skillfully arranged to fill all the outer surfaces. The strongly upturned ends of the top are clearly predecessors of later everted flanges (see figs. 14.2–5, 14.16–17). They appear to give status to the table and so reinforce its ritual function. The raised ends might also have helped prevent the offerings from sliding off. Rectangular spandrels at the top of each leg forecast those commonly found on tables and chairs beginning in the Song dynasty (960–1279; see fig. 1.8). According to early texts, these sacrificial tables were called zu and were used for meat offerings. The Book of Songs (Shi jing), for example, describes sacrifices to the ancestors in detail:

> We mind the furnaces, treading softly;
> Attend to the food-stands [zu] so tall,
> For roast meat, for broiled meat.
> Our lord's lady hard at work
> Sees to the dishes, so many,
> Needed for guests, for strangers.
> Healths and pledges go the round,
> Every custom and rite is observed,
> Every smile, every work is in place.
> The Spirits and Protectors will surely come
> And requite us with great blessings,
> Countless years of life as our reward.[4]

Various other forms of small wooden tables have been excavated from tombs around Changsha, Hunan, near the site where the Chu capital was built in the fifth century B.C. In tomb 1 at Liuchengqiao, a table (length 44.7 cm, width 27.7 cm, height 12 cm) was found with four legs on each side standing on a curved runner.[5] The tombs at Yutaishan contained a liubo game table with three legs shaped like hoofed animal legs (fig. 11.3). In the center of the top is a sunken covered box for the game pieces. The table is lacquered black, with the rim, box, and board markings in red. Liubo, or the game of the "six learned scholars," is first mentioned in "Zhao hun"

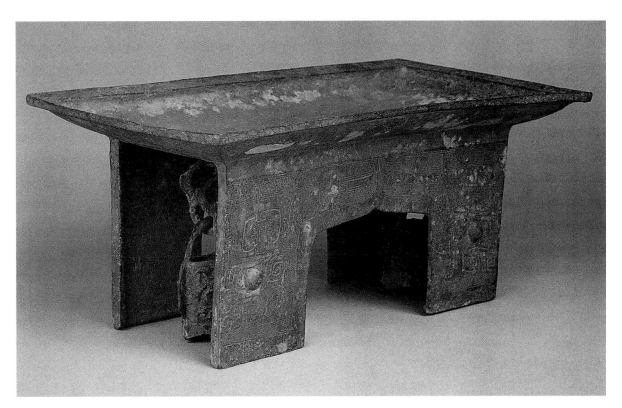

11.1

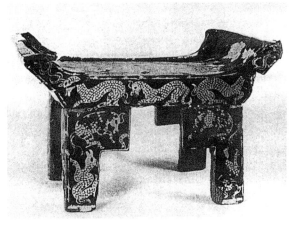

11.2

11.3

FIGURE 11.1 Small sacrificial
table. Shang dynasty, Yinxu
period (thirteenth–eleventh
century B.C.). Found at
Huaerlou, Yi county, Liaoning.
Bronze. Height 14.3 cm,
length 33.6 cm, width 17.7 cm.
Liaoning Provincial Museum.
From Liaoning Sheng
Bowuguan, *Liaoning Sheng
Bowuguan*, pl. 16.

FIGURE 11.2 Small sacrificial
table. Spring and Autumn
period. Found in tomb 4,
Zhaoxiang, Dangyang, Hubei.
Lacquered wood. Height
14.5 cm, length 24.5 cm, width
19 cm. From Yichang Area
Museum, "Hubei Dangyang
Zhaoxiang," pl. 1.

FIGURE 11.3 Reproduction of
liubo game table. Mid Warring
States period. Found in tomb
314 at Yutaishan, Jiangling,
Hubei. Lacquered wood.
Height 24 cm, length 39 cm,
width 32.7 cm. From Jingzhou
Museum, *Jiangling Yutaishan
Chu mu*, pl. 18.4.

("Summons of the soul"), a poem by Song Yu from the third century B.C.:

> Then with bamboo dice and ivory pieces the game
> of Liu Bo is begun;
> Sides are taken; they advance together; keenly they
> threaten each other.
> Pieces are kinged and the scoring doubled. Shouts
> of "five white!" arise.[6]

At least in early times, when there was no distinction between games purely for pleasure and those for determining the will of the spirits, *liubo* was a game of divination. So at this time even game tables, like other tables, were primarily ritual objects. The board is similar in design to ancient Chinese sundials (and to patterns on the backs of bronze mirrors), and so the moves have astrological significance. Two players used twelve pieces, each marked with one of the animals of the four directions, and moves were decided by the throwing of six sticks.[7] There are many depictions of *liubo* players from the Han dynasty (206 B.C.–A.D. 220). A second-century A.D. pottery tomb model discovered at Lingbao, Henan, shows the players kneeling on a low platform with a board, rather than a table, between them. In China, play and games, essential in the life of every culture, pervade both secular and religious activity. Even in tombs the play goes on.

Scenes of feasting and entertainment often appear on tomb walls and show low tables used for serving food. In one such scene, on a pottery tomb tile from Sichuan, low rectangular tables stand in front of the figures, who sit on mats (see fig. 1.3). A large wine pot stands in the center, but food has not yet been set out on the tables. From contemporary texts we know that banquets were formal affairs with many guests seated in a complex arrangement determined by ritual and political considerations. Therefore this is a symbolic, rather than a realistic, depiction of a banquet. It evokes a scene of daily life and thus allows the deceased to go on enjoying his banquets, with their accompanying music and dance, in the afterlife. As Kenneth J. DeWoskin aptly remarks: "the tomb was not a silent vault but a chamber in which many

of life's sensual pleasures, including the pleasures of music and dance, could continue to be enjoyed."[8]

Han dynasty tables for serving food were usually rectangular or round, and sometimes square. Their legs were straight, or paw-shaped, modeled like those of a hoofed animal, or there were several curved legs on each side ending in a continuous runner. Small rectangular tables were stacked in the kitchen when not in use. These tables were sometimes elegant works of art, like the rectangular one found in the fourth-century B.C. tomb at Xinyang that contained the spectacular carved lacquer bed (see fig. 1.2). The table is beautifully decorated with a roundel pattern and has bronze hoof-shaped legs, bronze corner mounts, and bronze rings suspended from stylized animal faces.[9] Here, as in later furniture (see figs. 5.1, 15.21), the bronze is both decorative and functional.

Several beautifully ornamented metal table legs and corners were found at Mancheng, Hebei, in the tomb of the pleasure-loving prince Liu Sheng (d. 113 B.C.). One lacquered wooden table had gilt bronze panels engraved with cloud motifs covering the front of each leg and inset into the corners. This is a rare example of an early folding table. As Wang Shixiang describes it, "Hinge plates attached to the underside of the table allow the legs to fold inwards. As the legs are unfolded, a bronze support attached to each hinge plate by a pin is placed perpendicular to the hinge to hold the leg in place. When the leg is folded these supports lie parallel to the hinges, fitting into sockets on the side of each leg."[10] This table was thus both a practical piece of furniture, easily folded for storage and transport, and an elegant luxury item made of costly lacquer embellished with gilt bronze.

Tables used to serve food were called *an,* wooden trays for presenting food were *pan,* and round tables, *qiong.*[11] *An* could be quite small, as we know from an account of the virtuous lady Meng Guang who "raised the table as high as her eyebrows" whenever she served her husband, Liang Hong, a meal.[12] Perhaps the table Meng Guang raised so high resembled the rectangular rimmed table on low feet that

was found in the tomb of the Marquess of Dai (d. c. 168 B.C.) at Mawangdui, Hunan province (see fig. 12.4). It is lacquered red and black with swirling cloud patterns. On it were found cups and dishes with the remains of food.

There were also large curved-leg *an* tables, which were placed in front of the platforms on which many people sat for the formal banquets so frequently depicted in the Wu Liang shrine and other Han tombs. Food or cups of wine were set out on the tables on round trays. The curved-leg *an* table had other purposes as well. A mural painting from a tomb in Sandaohao village, near Liaoyang in southern Manchuria, clearly shows such a table with a sheet of paper and a writing brush sticking up from one corner (see fig. 13.1). A man sits behind on the platform facing another man seated on a similar platform with a long table. A servant stands between them offering refreshments, and dishes are set out on a round serving tray. Large curved-leg tables were also used as chopping boards in the kitchen (see fig. 1.4). So the curved-leg table served as a desk, a chopping board, and a serving table.

An actual large curved-leg table excavated from the Tomb of the Painted Basket at Lelang, Korea, shows that constructions basic to later furniture had already developed (fig. 11.4). On each short side of this table, five bent uprights tenon into a transverse brace beneath the top and into a scalloped runner at the bottom. Exposed tenons are visible on the surface of the table as well as on the underside of the runner.

During the Han dynasty, low tables appear to have been used only on the floor. Only armrests (see fig. 1.1) and game boards without legs are shown actually placed on a low platform. In a later period small low tables began to be used on platforms, as in a 584 wall painting excavated from tomb 1 at Yingshan in Jiaxiang county, Shandong province.[13] In a banquet scene Xu Shilang, the occupant of the tomb, and his wife sit on a box-construction platform with oval openings while they watch a whirling dancer. The wife leans against a bolster. In front of the husband is

11.4

FIGURE 11.4 Curved-leg table. First or early second century A.D. Excavated from the Tomb of the Painted Basket, Lelang, Korea. Wood, partially lacquered. From Koidzumi and Sawa, *Tomb of Painted Basket,* pl. 71.

a small table, which is a straight-leg variant of the Lelang curved-leg table (see fig. 11.4). Here we have a rare early depiction of a table elevated from the floor onto another piece of furniture. Later, when the mat-level mode of living was abandoned and people commonly sat on chairs at high tables, small tables were frequently elevated on other pieces of furniture, and the *kang* table came into being.

Today low tables are generally referred to as *kang* tables. The term is misleading, however, because these tables were used not only on the *kang,* but also on other large seats and on the floor or ground as well. Nonetheless, as Craig Clunas observes, "the name kang table now adheres so firmly that it would be pedantic to alter it." Wang Shixiang distinguishes three types of *kang* tables: *kangzhuo,* or wide *kang* tables; *kangji,* or narrow *kang* tables; and *kang'an,* or narrow *kang* tables with recessed legs.[14]

None of these terms appears in the writings of the Ming dynasty connoisseurs or in the *Classic of Lu Ban.* However, in the late Ming novel *The Plum in the Golden Vase* (*Jin ping mei*) the term *kangzhuo* refers to a table placed on the kang for a game of *weiqi.* Elsewhere in the novel a table used for an informal supper on the *kang* is called simply a "little table" (*xiaozhuo*).[15] In *The Story of the Stone,* written around 1760, two maids carry out a *fanzhuo* (dining table) and place it

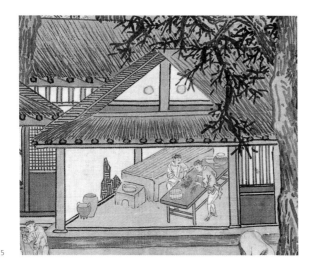

11.5

FIGURE 11.5 Shen Zhou
(1427–1509). *Village Scenes.*
Detail of a handscroll. National
Palace Museum, Taipei.

the Ming woodblock illustrations to *The Plum in the Golden Vase, kang*s are sometimes depicted in the women's quarters along a side wall, and the text specifically states that Ximen Qing's fourth wife had two bedrooms, one with a *kang* and the other with a wooden bed.[18] Usually the stove, which is also used for cooking, is in an adjoining room, but in a rare depiction of a *kang* in a painting ascribed to Shen Zhou (1427–1509), the stove is right next to the *kang* (fig. 11.5). The room appears to be a kitchen, with cooks standing at a long high table chopping vegetables; one wall is badly in need of repair. Although the cooks work standing on the floor, they undoubtedly sat and slept on the *kang*.

*Kang*s were fueled with straw or crop stalks in the countryside and coal or charcoal in the towns. As early as the Song dynasty, a poem by Zhu Bian (d. 1154) refers to coal used to heat a bed in the famous coal-producing city of Datong, Shanxi province.[19] The use of coal for radiant heating impressed the Jesuit Gabriel de Magalhães, who in about 1660 wrote of its efficiency and dangers:

> This coal is brought from certain Mountains two Leagues distant from the City (Peking), and it is a wonderful thing that the Mine has never fail'd, notwithstanding that for above these four Thousand Years not only this City so large and populous, but also the greatest part of the Province, has consum'd such an incredible quantity, ther'e not being any one Family, tho' never so poor, which has not a Stove heated with this Coal that lasts and preserves a Heat much more violent than Charcoal. These Stoves are made of Brick like a Bed or Couch three or four Hands breadth high, and broader or narrower according to the number of the Family. Here they lie and sleep upon Matts or Carpets; and in the day time sit together, without which it would be impossible to endure the great Cold of the Climate. On the side of the Stove there is a little Oven wherein they put the Coal, of which the Flame, the Smoak and Heat spread themselves to all the sides of the Stove, through Pipes made on purpose, and have a passage forth through a little opening, and the Mouth of the Oven, in the which they bake their Victuals, heat their Wine, and prepare their Cha or The; for that they always drink their Drink hot. . . . The Cooks of the Grandees and Mandarins, as also the Tradesmen that deal in Fire, as Smiths, Bakers, Dyers, and the like, both Summer

on a wooden bed. *Kangzhuo* can also designate small tables when they are not used on the *kang*. For instance, in *The Story of the Stone, kangzhuo* set on the floor in the center of the hall are heaped with coins for the actors who performed in the New Year's celebrations.[16]

The *kang* is nonetheless crucial to an understanding of the low tables that so often adorned it. It also played an important role in the Chinese household. This raised heated platform provided a warm, comfortable living area on which the family, rich or poor, could sit, sleep, dine, or converse during the bitterly cold winters of north China. The word for this heated built-in platform is the *kang* written with the fire radical. It should not be confused with the word *kang* written with the box radical, which was used in the south in the early twentieth century to denote a movable wooden or bamboo couchbed with railings on three sides.[17] In this book, *kang* refers to the built-in heated platform of the north. These *kang*s, which are about ninety centimeters high, are made of brick and heated by hot air running through a system of flues connected to an external stove and chimney. In

and Winter make use of this Coal; the Heat and Smoak of which are so violent, that several Persons have been smother'd therewith; and sometimes it happens that the Stove takes Fire, and all that are asleep upon it are burnt to Death.[20]

The top of the *kang* was covered with mats, and often there would also be rugs or thin mattresses as well as low tables, cupboards, and shelves. The *kang* in an eighteenth-century household might have been framed in a deep, handsomely carved recess,[21] or there might have been "a smaller kang in an alcove-room to the side of the main kang and discreetly separated from it by an openwork wooden screen." Sometimes there were curtains that could be let down at night to provide the cozy privacy of a canopy bed.[22] The *kang* was a warm, intimate living space raised above the floor to table height. When not leaky and smoky (and when the accompanying stove and oven did not spread fire and death), the *kang* warmed life in China and made winter tolerable.

This heated platform became popular in north China when northerners took up the habit of sitting on chairs at tables. By at least the twelfth century, *kang*s are mentioned in literature. Archeological finds show that early ones ran along two or three sides of a room. Later they were usually placed under the south window and were thus further warmed by the winter sun. The most common type was heated by an external stove, but some *kang*s were warmed by a portable stove brought in when the coals were already glowing and placed in an opening in the front of the hollow *kang*. Such a *kang* appears in a set of eighteenth-century watercolors painted, it is believed, by a Chinese working under European direction. The *kang* is narrow and extends around three sides of the side room near the front entrance, where visitors were received.[23]

The *kang* has an ancient origin. It is actually an elevated, above-ground version of an old underground heating system consisting of an external underground stoke hole, a series of ducts, and a smoke vent. The earliest mention of this system is from the late fifth or early sixth century in *Commentary on the Waterways Classic (Shui jing zhu)*.[24] Even after the *kang* became com-

mon, underground heating was still used in palaces and the homes of the wealthy. In the eighteenth-century novel *The Story of the Stone*, Snowy Rushes Retreat is described as having underground heating (*di kang*) that pleasantly warmed the entire floor.[25] Often in rooms with underground heating a wooden platform would stand next to a screen or wall. Fig. 11.6 depicts one in the reception hall of a wealthy eighteenth-century household. According to Ecke this type of platform is called *dipingchuang*.[26]

The Forbidden City has both underground heating and *kang*s with their own aboveground heating.[27] Rooms with underground heating have built-in wooden platforms for sitting and sleeping that, depending on the size of the room, may be many meters long or small and intimate. These platforms and *kang*s have their own low furniture—tables, coffers, cabinets, and screens—and when in a bedroom might have curtains hanging from carved wooden frames (fig. 11.7). During the day low tables placed in the center served as desks, dining tables, and tea tables and held books, vases, incense burners, and other objects. Similarly, small low tables were placed on canopy beds, daybeds, and couchbeds (fig. 11.8).

In chair-level China people still sat on the floor or ground for some informal occasions and needed a low table. Many paintings of literary gatherings in gardens show a servant squatting off to one side to fan a stove, with a small table nearby for the cups and dishes (see fig. 13.14). Sometimes on these occasions connoisseurs used both low and high tables for studying antiques (see fig. 14.15). Paintings and woodblock illustrations show that small tables were also useful when traveling by boat. Seated in their boat around a low table holding food and drink, friends could enjoy a moonlit night on the water, their wine cups constantly refilled from the pot warming on a stove in the stern (fig. 11.9).

It is not uncommon to find depictions of this mat-level use of tables in Ming and Qing paintings, but it is unusual to see a table elevated on a seat. One of the earliest paintings to show an elevated low table is *The Night Revels of Han Xizai*, a twelfth-century

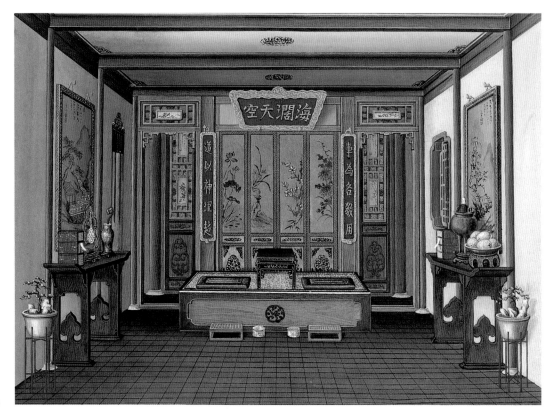

11.6

11.7

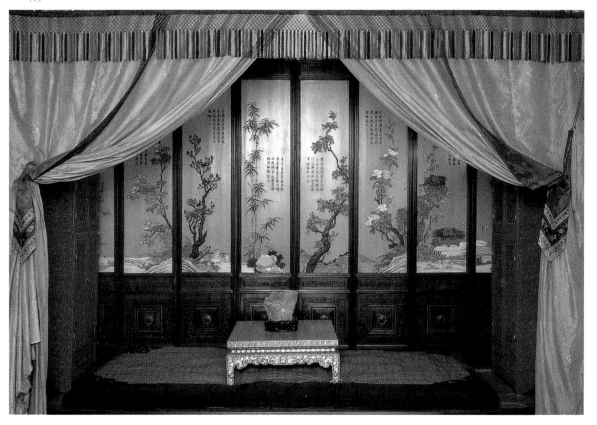

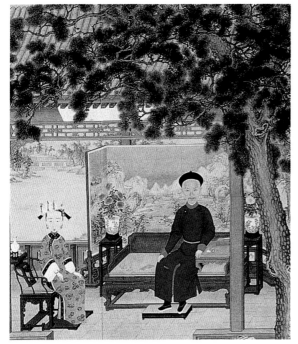

11.8

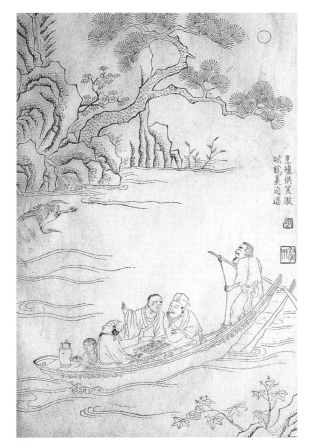

11.9

copy of a work attributed to the tenth-century painter Gu Hongzhong. In it a *kang* table with food and drink is partially visible on a U-shaped wooden couch (see fig. 1.8). Sometimes *kang* tables were really game tables, such as the double-sixes game table in the middle of a couchbed in a Yuan dynasty woodblock illustration (see fig. 9.7). In chair-level China the players sat with one leg resting on a footstool, rather than kneeling, as was the custom in the Han dynasty. The rectangular table, awkwardly long for the couchbed, has corner legs and a continuous base stretcher. A variant of this *kang* table appears in another Yuan work, Liu Guandao's *Whiling Away the Summer* (fig. 11.10). This so-called double-screen picture depicts a scholar reclining on a movable platform placed among bamboo and banana plants. Behind him is a screen on which a similar indoor scene is painted, and that scene contains a screen ornamented with a landscape painting. The indoor scene depicts a scholar seated on a platform with a low table holding an ink slab, a brush rack, painting albums, and a vase. The table's corner legs, spandrels, and continuous floor stretcher echo the design of the platform.

Many more actual *kang* tables survive than the few representations of them in paintings and woodblock prints would suggest. Large ones of a size suitable for use on the heated *kang* have been popular with West-

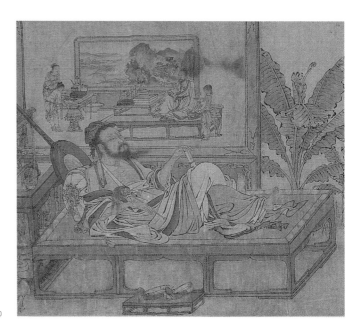

11.10

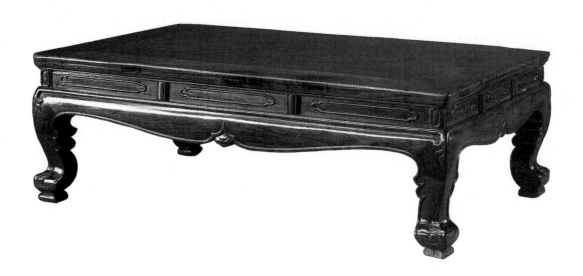

11.11

FIGURE 11.10 Liu Guandao (active c. 1279–1300). *Whiling Away the Summer*. Detail of a handscroll. Ink and color on silk. Height 30.5 cm, length 71.1 cm. The Nelson-Atkins Museum of Art, Kansas City, Missouri. (Purchase: Nelson Trust.)

FIGURE 11.11 Small *kang* table. Ming dynasty. *Huanghuali* wood. Height 36 cm, length 77.2 cm, width 52.7 cm. The Nelson-Atkins Museum of Art, Kansas City, Missouri. (Purchase: The Kenneth A. and Helen F. Spencer Foundation Acquisition Fund.)

FIGURE 11.12 Small *kang* table with folding legs. Ming dynasty, late sixteenth/early seventeenth century. *Huanghuali* wood. Height 22.8 cm, length 75.9 cm, width 51.5 cm. © Christie's Images, Ltd., 1999.

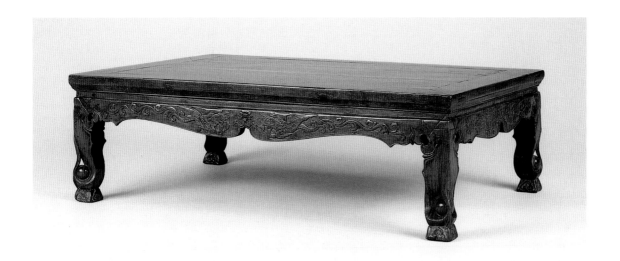

11.12

ern collectors. It is rarer to find a small table appropriate for the couchbed, canopy bed, or daybed. Rectangular tables are the most common, but there are also square models.[28] The majority of *kang* tables are rectangular and waisted with cabriole legs, which the Chinese call "praying mantis legs" (*tanglang tui*) or "elephant trunk legs" (*xiangbi tui*).[29] Small pads beneath the feet stabilized the tables and prevented the feet from sinking into the rug or thin mattress placed on the *kang*.

A small rectangular table in the Nelson-Atkins Museum of Art is made from rich, golden-hued *huanghuali* wood with beautiful grain patterns (fig. 11.11). On each side of the high waist are three inset panels with beaded begonia-shaped motifs, a variation of which appears at the corners. A beaded molding along the top of the apron turns into a raised-leaf pattern at the upper part of the legs and echoes in reverse on the upturned feet, which stand on small pads. The beading along the flanged inner edge of the leg ends in a point above a seed motif in the cusp of the apron.

A number of *kang* tables have foldable or easily removable legs for convenient moving and storage,[30] like the second-century B.C. table found in the tomb of Liu Sheng. The small *huanghuali* example in fig. 11.12 is richly ornamented, with cabriole legs ending in leaf motifs holding small balls, pads carved with *ruyi,* and on the apron a central flower motif flanked by winged dragons (a type of dragon rarely found on furniture). Originally the table had metal hinges that allowed the legs to fold upward into spaces carved on the insides of the long aprons. Now the folding mechanism is missing, and one leg has been replaced.

Kang tables are often elaborate and imaginatively designed—surely because they are small and their elevated position brings their details into full view. For instance, the top of one *zitan* table has gilt-bronze corner mounts and is beautifully inlaid with coconut shell separated by silver wire in the "cracked ice and plum blossom" design popular during the Kangxi period (1662–1722). This exquisite piece belongs to the China Arts and Crafts Museum, Beijing, which exhibited it in the autumn of 1991.[31]

Small lacquer tables were common and would have created a delightful contrast with a more sober hardwood couchbed. In *The Story of the Stone* we read of a "small, exquisitely gilded table [*ji*] of foreign make" that was probably a Japanese lacquer table with gold designs. It holds various small objects (including a

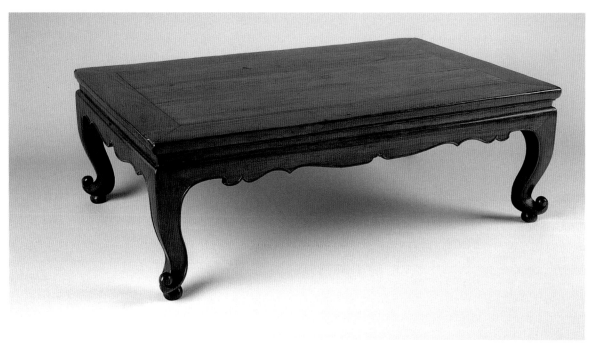

11.13

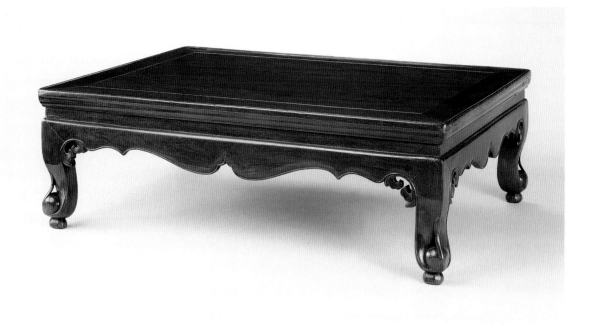

11.14

FIGURE 11.13 *Kang* table. Ming dynasty. *Huanghuali* wood. Height 30.5 cm, length 93.4 cm, width 61.5 cm. The Nelson-Atkins Museum of Art, Kansas City, Missouri. (Bequest of Laurence Sickman.)

FIGURE 11.14 *Kang* table. Ming or Qing dynasty, seventeenth century. *Huanghuali* wood. Height 30 cm, length 96 cm, width 68 cm. © Christie's Images, Ltd., 1999.

teapot, teacup, spittoon, napkin, and eyeglass case) and sits at one end of the couchbed from which Grandmother Jia watches the New Year's theatricals through her spectacles. In her elevated mat-level world, Grandmother Jia sits with her feet up, reclining comfortably against furs, backrest, and bolsters, while a lovely imported lacquer table holds small necessities within easy reach.[32]

On a large heated *kang* one could, by using bigger tables, create a similarly cozy sphere with room for several people. The late Laurence Sickman owned a large *kang* table that is particularly graceful in its simple lines and proportions (fig. 11.13). The craftsman who created this piece emphasized the beauty of the vigorously grained, reddish-gold *huanghuali* wood by carving the waist and apron from a single piece of wood. The upward-curling leg ends in a ball whose shape echoes in the semicircular pad on which it stands. This type of leg is called "curled pearl" (*juanzhu*) or "pearl on the end of an elephant's trunk" (*xiangbijuanzhu*).[33] Beading leads the eye from the scrolling foot along the smooth curve of the leg to the undulating cusped apron.

Fig. 11.14 shows an elaboration of this basic cabriole-leg-and-ball form. The ball at the tip of the feet is held in place by a leaflike form that repeats in the more complex double-leaf motif at the juncture of leg and apron. The aprons have deep cusps, especially on the shorter sides. A close examination reveals a slight unevenness in the apron's boldly curving edge. Such pleasant imperfections often contribute to the charm of handmade furniture. The table is made of *huanghuali* wood and has a beautifully figured top. Three dovetailed transverse braces support the top, and dovetail-shaped peg tenons pin the waists and aprons to the top. The aprons and waists are made from two pieces of wood, except for one of the short aprons, which together with its waist is carved from a single piece of wood. This interesting variation is most likely the original construction, since all the wood is of uniform quality and patina and appears to be carved by the same hand. Such inconsistencies are common in construction details and reflect the unavailability of materials rather than an alteration or restoration. The large size of the wood used for the leg, which is carved from the same piece as its leaf motif, shows that where it was important the craftsman did not stint on materials. The top of the table has a small raised edge, called a "water-stopping molding" (*lanshuixian*) in Chinese because it was supposed to contain spilled wine or water. The origin of the water-stopping molding traces back to the rims on Shang and Han dynasty tables (see figs. 11.1, 12.4). As in the Han dynasty, these low tables were frequently used for dining. In the Ming, however, low tables were usually placed on seats rather than on the floor. The diners could sit with their feet up, as in mat-level times, or with their legs pendant. In the Ming the low tables were used for informal meals, while banquets were always served to guests seated on chairs at high tables.

In *The Story of the Stone* many meals in the women's quarters were served on *kang* tables. It was a more relaxed and comfortable way of eating than sitting on chairs or stools around a high table. You could lounge in cool informal attire against the pillows and flower-petal-filled poufs. And it was convenient as well, because the women could accommodate a large group both on the *kang* itself and on chairs placed beside it.

"Let's not sit up at the big table[," said Aroma]. "We can put the round pear-wood table on the kang [*huali yuan kangzhuozi*]. It will be much more relaxed and comfortable on the kang. . . . "

"It's so hot," Bao-yu said to the maids. "Let's take our outer clothes off." . . .

And so, before taking their places on the kang, they went off to remove their hair-ornaments and make themselves more comfortable. They returned wearing only tunics and trousers, with their unadorned hair loosely knotted or coiled. . . . [Bao-yu was] already ensconced on the kang. He was leaning back, one elbow resting on a newly-made turquoise-coloured pouffe stuffed with rose and peony petals, playing guess-fingers with Parfumée. . . . they proceeded to arrange themselves around the table. . . .

One by one the new guests started to arrive. . . . To accommodate the greater numbers, Aroma and the other girls put another table alongside the one

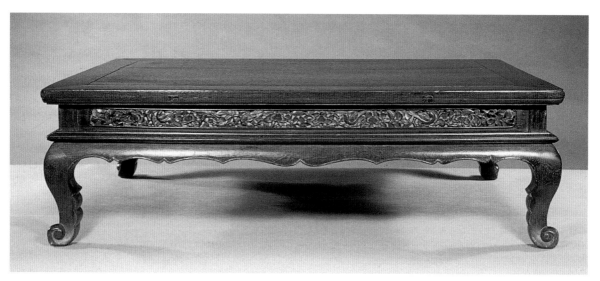

11.15

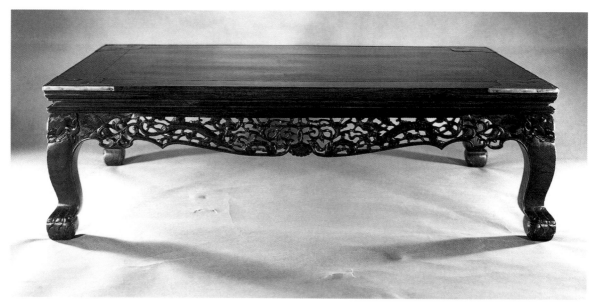

11.16

FIGURE 11.15 *Kang* table. Ming dynasty. *Jichi* wood. Height 29.2 cm, length 95.3 cm, width 65.7 cm. The Nelson–Atkins Museum of Art, Kansas City, Missouri. (Bequest of Laurence Sickman.)

FIGURE 11.16 Low *kang* table with dragons in clouds. Ming dynasty, fifteenth century. Carved *huanghuali* wood with inlaid metal corner fittings. Length 97.2 cm. © The Cleveland Museum of Art, 1998. Severance and Greta Millikin Collection.

already on the kang and a row of chairs facing them on the floor below. Bao-yu and the other guests arranged themselves on the kang, while the seven maids and Parfumée, as hosts, sat on the row of chairs below, within reach of one or other of the tables. . . .

"Cousin Lin can sit there, against the partition," said Bao-yu. . . . He made her a little nest of pillows there, into which, though it was somewhat inconveniently distant from the table, she settled herself very comfortably.[34]

In the old China—as described, for instance, in *The Story of the Stone*—there was no regular time or place for meals. Food was brought in from the kitchen when requested and served wherever the diners happened to be. Maids might carry in low dining tables, place them on the *kang,* and set them with wine cups, soupspoons, and chopsticks. Then maids would serve food from dishes brought from the kitchen in large lacquer carrying boxes. When the meal was finished and the food cleared away, they would bring in washbasins and spittoons for rinsing the mouth. After this tea was served.[35] The *kang*—the highest, warmest, and most comfortable seat—was the place of honor where the family matriarch, Grandmother Jia, and senior family members sat. Others sat on chairs or stools on the floor below. The rules of propriety were strictly hierarchical, and servants, even when invited, generally refused to get up on the *kang.* When Patience wanted to keep her ailing mistress company at lunch, she dared only perch in a half-standing posture on the edge of the *kang.*

> Felicity and three or four junior maids came in at this point carrying a short-legged table [*xiao kangzhuo*] between them which they set down on the kang. Xi-feng's lunch consisted of no more than some bird's nest soup and a couple of small, light dishes suitable for an invalid palate. Unable to eat more, she had cancelled the portion that under normal catering arrangements would have been her due. Felicity put the four dishes to which Patience was entitled on Xi-feng's table and filled her a bowlful of rice. Patience then half sat, half stood with one foot curled underneath her on the edge of the kang and the other one resting on the floor, and in that position kept Xi-feng company while she ate her lunch.[36]

The table at which Xi-feng and Patience ate might have had enchanting pierced carvings of birds and flowers along its waist, as does a *jichi* wood piece formerly in the collection of Laurence Sickman (fig. 11.15). The dense rounded carving has a bold vigor in keeping with the spirit of the scrolled feet, flanged cabriole leg, and repeatedly cusped apron. The recessed panel tongue-and-grooves into the corner posts, which are extensions of the legs. Like the small *huanghuali kang* table in fig. 11.11, this one has a molding along the top of the apron, but here it is more pronounced and made from a separate piece of wood.

Cabriole legs with animal heads and claw feet occur on a number of *kang* tables. An elaborately carved table of this type belongs to the Cleveland Museum of Art (fig. 11.16). The table is fashioned from pleasingly figured *huanghuali* wood and has a raised rim. *Ruyi*-shaped bronze plates decorate and protect the corners of the tabletop, just as in the Han dynasty folding table found in Liu Sheng's tomb. The powerful legs extend from open-mouthed animal heads and end in massive claws grasping balls, creating an effect similar to the cabriole legs with small pads (see figs. 11.11–14). The ornamentation continues along the wide curvilinear apron with openwork carving in a complex design of dragons and intertwining cloud scrolls.

Cabriole legs have a long history in China. Their prototypes are found on ritual bronze vessels from the Shang and Western Zhou (c. 1050–771 B.C.) dynasties. A *ding* found in Jiangxi province, for example, has flat legs in the form of tigers or perhaps dragons. The beasts stand on their outward-curling tails and hold the body of the vessel in their open jaws. Sometimes open-mouthed animal heads hold the legs in their mouths. The Yi Gong *gui,* excavated in Beijing and dating from the late eleventh or early tenth century B.C., stands on four legs composed of elephant heads holding their outward curling tusks in their mouths (fig. 11.17). Using realistic animal parts in unrealistic ways is typical of ancient Chinese bronze-age art and was no doubt meant to enhance the efficacy of the sacrifices made in these vessels. This *gui* gets its

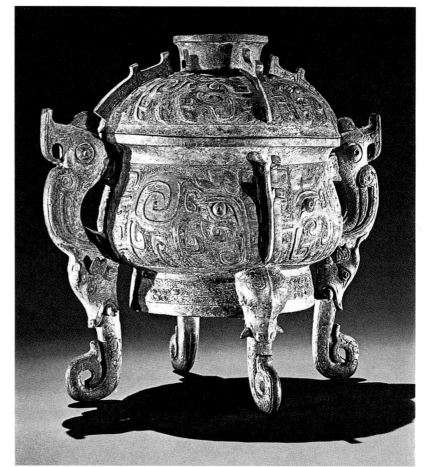

FIGURE 11.17 Yi Gong *gui*. Western Zhou, late eleventh/early tenth century B.C. Bronze ritual vessel. Excavated in 1974 from M209, Huangtupocun, Liulihe, Fangshan. Beijing Cultural Relics Bureau. From Fong, *Great Bronze Age,* 231.

FIGURE 11.18 Three-drawer *kang* table. Ming dynasty, late sixteenth/early seventeenth century. *Huanghuali* wood. Height 29.21 cm, length 96.53 cm, width 25 cm. © Christie's Images, Ltd., 1999.

11.17

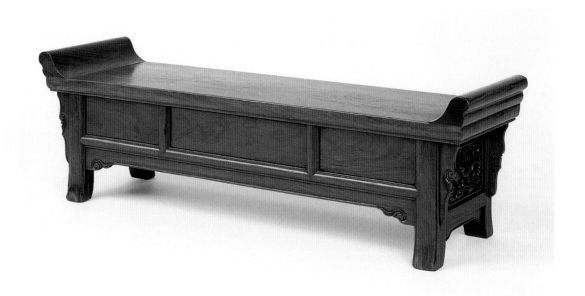

11.18

name from the inscription cast in the center of its lid: "Bo made this *jiu* [*gui*] for Yi Gong."[37] Later, in the fourth century A.D., cabriole legs ending in paw feet appear on pottery tomb models of semicircular armrests. By the Tang dynasty many incense burners have cabriole legs that look like an animal head holding in its mouth a leg ending in a claw foot. A ferocious example of this leg appears on a luxurious incense burner with gilt ornamentation that was part of the spectacular hoard of treasures and Buddhist relics found in 1987 beneath the Famensi pagoda in Fufeng, near Xi'an, Shaanxi province.[38]

The animal world has always been a major source of artistic inspiration and designs. Cabriole legs with paw feet appeared independently in different parts of the ancient world. In Egypt in the Old Kingdom period (2686–2181 B.C.) lion legs replaced bull legs as the favored support for furniture. The famous armchair of Queen Hetepheres (Fourth Dynasty, c. 2613–2494 B.C.), considered the oldest extant chair in the world, stands on four legs shaped like a lion's. The legs stand on short ridged copper-covered cylinders to protect the delicate paws. The wood of the rest of the chair was originally sheathed in gold. Such legs were elegant and at the same time conveyed the powerful strength of a living beast, all clearly seen in a single wooden leg now in the British Museum. Shortly after the reign of King Cheops (Fourth Dynasty), the decoration on thrones became more elaborate, and lion heads were added to the top of the legs. Unlike Chinese furniture, the head stares straight ahead and does not hold the leg in its mouth.[39]

Tables placed on the *kang* or bed served not only as dining tables but also as holders for various objects and as desks. In *The Story of the Stone* Baoyu lost his wits after losing his precious jade; when he came in to change, he took it off, left it on the *kang* table, and forgot to put it on again when he went out.[40] In the Forbidden City there is a low desk made expressly for the Kangxi emperor's mathematical studies (see fig. 13.16).

Large wide tables used in the center of the *kang* have corner legs; twentieth-century Beijing craftsmen call them *kangzhuo*. The long narrow tables placed along the sides of the *kang* are called *kang'an* when their legs are recessed and *kang ji* when they have corner legs.[41] They held, among other objects, the folded bedding during the day. Since these tables were used for storage, they might also have drawers. One three-drawer model has massive everted flanges (fig. 11.18), a later variation of those found on the small Spring and Autumn Period sacrificial table in fig. 11.2. The three-drawer *kang* table is made from *huanghuali* wood with attractive grain patterns on the solid top and drawer panels. The drawers resemble trays that slide when raised and pulled from underneath, as is evident from signs of wear along the bottom edge of the apron. Beneath the drawers is a horizontal stretcher carved from the same piece of wood as the apron. The apron has a beaded edge extending to the leaflike flourishes at each corner, but the edge between the flourish and the leg has no beading. This unusual design repeats in the spandrels, whose curvilinear edge combines with the everted flange, the molded edge of the top, and the forward curving leg to create a dynamic profile. The back of the table is as beautifully finished as the front, with a solid panel instead of the three drawers separated by double-mitered struts. Each side has an inset panel and horizontal stretcher and apron made from separate pieces of wood; the right apron is a replacement. The delightful panels are carved with different auspicious openwork designs of a bird on a branch with pomegranates, magnolias, and a fantastic *taihu* rock. The pomegranate with its many seeds is a symbol of fertility, and the magnolia suggests a beautiful woman.

Besides low tables with drawers, small cabinets were also placed in pairs along the sides of the *kang* for storage. Often these were miniature versions of large pairs of cabinets standing on the floor. Professor Zhao Luorui owns an elegant pair of miniature round-cornered *jichi* wood cabinets (*kanggui*) that are pleasingly proportioned, with gracefully curving cusped aprons and *ruyi*-shaped spandrels (fig. 11.19). There is a round lock plate, removable central stile, and considerable upward taper. Unlike larger cabinets,

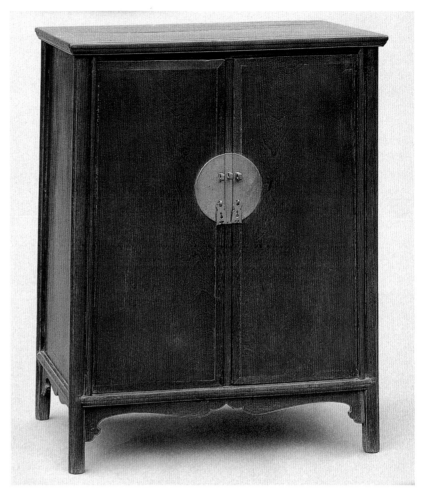

FIGURE 11.19 *Kang* cabinet, one of a pair. Ming dynasty. *Jichi* wood. Height 64 cm, top 65.5 cm × 39.5 cm. Professor Zhao Luorui Collection, Beijing. From Wang Shixiang, *Classic Chinese Furniture,* 210.

11.19

the tops of this pair are beautifully finished, each with a mitered frame and floating panel, because these surfaces would have been visible and used for small objects. Furnished with small cabinets, tables, shelves, and screens (see fig. 11.7),[42] the *kang* was a complete living space—a mat-level realm raised up to a chair-level world.

Occasionally objects were designed so that they could be transformed and used in both the mat- and chair-level parts of the house. Some metal braziers had two stands: a high one for the floor, a low one for the *kang*.[43] Similarly, square *kang* tables might easily tenon into separate high legs. In summer, for example, when no one wanted to dine on the warm *kang,* the

low *kang* table could transform into a high dining table for use with chairs or stools in the cool garden. Zhu Jiajin calls such tables "eight immortals *kang* tables" (*kang baxian*) and "eight immortals floor tables" (*di baxian*).[44] In English they are sometimes called "winter-summer tables."

One *huanghuali* example easily dismantles into three main parts: a low table with cabriole legs and two side leg units (fig. 11.20). Each side unit consists of two round legs connected by double stretchers and a horizontal top member. The top member has two openings into which sliding tenons can be fitted to attach it to a transverse brace beneath the frame of the tabletop. Two dovetail tenons lock the shoulder of each leg into the cabriole leg of the *kang* table. The

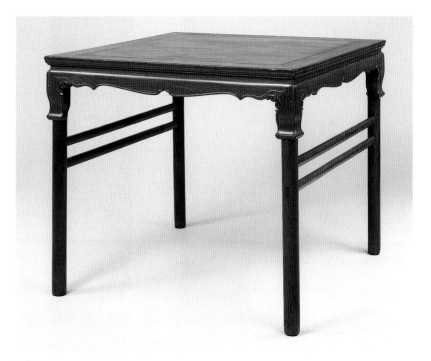

11.20

kang table has a recessed waist made from the same piece of wood as the apron. A wide bead lines the inner and outer edges of the legs and the cusped curving apron. The bead subtly changes in width as it follows the curves and forms abstract leaflike motifs at the inner corners and outer edges. Given that two identical tables are in private collections, this was probably a standard type made in sets.

Removing the legs also makes these tables easy to store, and a group of similar tables can be conveniently stacked, like the stacks of tables in the Han dynasty kitchen in fig. 1.4. Likewise, one of the twelve handscrolls recording the Kangxi emperor's second tour to the south in 1689 depicts stacks of low square tables.[45] In one detail we see servants bringing food and drink on carrying poles for the emperor's banquet. They unpack the containers onto a low square table and then carry the food up the steps to the kitchens. Two stacks of tables stand nearby. Paintings of imperial processions often depict red lacquer tables of this type lining the roadway, each table standing on a square carpet and laden with dishes of fruit.[46]

The winter-summer table, which can be both a low *kang* table and a high dining table, is a remarkable example of multifunctional furniture and has a unique place in the history of Chinese furniture. Only the winter-summer table, by the addition or subtraction of legs, was both a mat-level and a chair-level piece. Yet in reality most Chinese furniture had multiple uses. A supreme example is the *kang* table, which stood on seats and on the ground and served as a dining table, a tea table, a desk, and a surface for objects.

In the history of the Chinese household, there were two ascensions: mat level to chair level and low table to *kang* table. Indeed, the existence of the *kang* in the Chinese household gave a new purpose to the ancient low table—so much so that we scarcely speak of the low table as anything but a *kang* table. Just as the change from mat-level to chair-level living revolutionized Chinese furniture, architecture, and social customs, so the *kang* revitalized low furniture and once again altered everyday life.

12 | A SQUARE TABLE WHERE
THE IMMORTALS DINE

*I*n China today a square table, with four long benches or stools, is usually the central piece of furniture in the home. Here domestic gatherings take place, and food and conviviality are enjoyed. The presumed happiness of these occasions is expressed in the common name for a square table, "eight immortals table" (*baxian zhuo*). In a vast and populous country like China, which repeatedly endures catastrophic famines, floods, and other natural disasters, having enough to eat is a major preoccupation. Indeed, the common form of greeting is, "Have you eaten?" Food is an essential means of communication with ancestors, gods, family members, friends, and business associates. No family event or business deal is complete without a dinner. Food is also a source of health, long life, and sensory delight.

Square tables have a long history and ancient associations with food and games. The earliest extant square tables are small Western Zhou (c. 1050–771 B.C.) bronze stands supporting ritual vessels used in sacrifices to the ancestors. The bronze altar table from the late eleventh century B.C. that is in the Metropolitan Museum of Art in New York supports a stand that elevates a wine vessel (*you*; see fig. 8.2). A rare example of a separate stand, it has solid sides ornamented with long sinuous dragons and ribbing. More common at this time were stands cast in one piece with *gui* (ritual food vessels). The permanent elevation made these *gui* imposing and important ritual objects. The integral stands were either cube shaped or were cut out to form four legs. A four-legged example in the Arthur M. Sackler Gallery, Smithsonian Institution, Washington, D.C., has arched and cusped openings resembling those commonly found on Ming chairs and tables. The base, in contrast to the elaborately decorated vessel, is simply embellished with relief animal heads at the points of the arches, raised eyes on the legs, and a ridge outlining the contours of each side.[1] These ridges are the predecessors of the beading that accentuates the edges of Ming furniture.

Another striking similarity to Ming furniture is found on the *Ling gui* in the Musée Guimet in Paris (fig. 12.1). The legs of its integral stand are connected by a high horizontal bar with short verticals attaching it to the top. This is exactly like the stretcher-and-struts construc-

tion used to strengthen later tables and stools (see fig. 12.13). As Fu Xinian points out, this construction imitates the "column, beam, and strut" system of an ancient wooden architectural framework.[2] Although there is no clear evidence, it is conceivable that Western Zhou square bronze stands developed from wooden prototypes. Their Shang predecessors were separate stands and sacrificial tables made of stone and bronze. It is astonishing that sophisticated features of classical furniture—arched and cusped openings, beading, and transverse stretchers and struts—appear already on square bronze stands from the Western Zhou.

One of the most exquisite examples of Chinese metallurgy is a square bronze table or stand found in a fourth-century B.C. royal tomb belonging to the kingdom of Zhongshan in Pingshan county, Hebei (fig. 12.2). This extraordinary object is inlaid with gold and silver decorations and consists of a square frame (the top is missing) supported by a complex arrangement of three-dimensional dragons, phoenixes, and deer. Four deer sit around a ring that supports four dragons intertwined with four phoenixes. On top of the dragons' heads, columns and brackets support the table top in a manner derived from wooden architectural construction. The beasts have the vitality of real creatures: the deer are on the point of rising, the dragons crane their necks, and the phoenixes spread their wings as if about to burst into song. The casting and inlay are superb. This bronze is unique, and we have no clues about its actual function.

Among the objects found in the Zhongshan tombs is a stone board for the game of *liubo* that has unusually complex and skillful decoration. It is not quite square, but there are other early boards and game tables that are true squares. One of the most interesting of those is a black lacquer *liubo* table found in a Western Han tomb in Sanjiaowei, Tianchang county, Anhui (fig. 12.3). Red cloud patterns surround the T, L, and V markings characteristic of a *liubo* board. At each corner a pair of kneeling men, one young and one old, flank a small square. In the two drawers at opposite sides of the table were found eighteen rectangular silvery game pieces. The table is thus an early

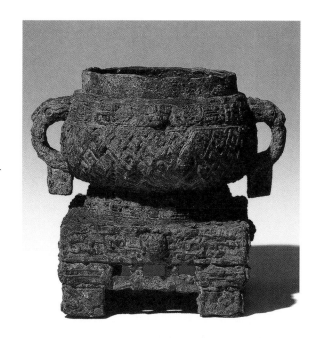

12.1

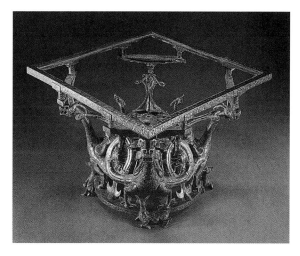

12.2

FIGURE 12.1 *Ling gui*, one of a pair. Second half of early Western Zhou, tenth–ninth century B.C. Height 25 cm. Musée des arts asiatiques–Guimet, Paris. © Photo RMN.

FIGURE 12.2 Square table. Warring States period, fourth century B.C. Discovered in the former kingdom of Zhongshan, Pingshan, Hebei, tomb 1. Bronze inlaid with gold and silver. Height 36.2 cm, length 47.5 cm. Hebei Provincial Museum. From *ZGMSQJ, diaosu bian* 1: pl. 169.

12.3

12.4

FIGURE 12.3 Lacquer *liubo* table. Western Han dynasty. Excavated from a tomb in Sanjiaowei, Tianchang county, Anhui. Top 42 cm × 42 cm. Drawing from Anhui Sheng Wenwu Kaogu Yanjiusuo and Tianchang Xian Wenwu Guanlisuo, "Sanjiaowei Zhanguo Xi Han mu chutu," 24.

FIGURE 12.4 Dining table. Western Han dynasty. Excavated from the c. 168 B.C. tomb I at Mawangdui, Changsha, Hunan. Lacquered and painted wood. Table length 60.2 cm, width 40 cm. From Hunan Sheng Bowuguan, *Changsha Mawangdui yihao Han mu*, 2: pl. 160.

mat-level version of the high Ming game tables with drawers and removable tops concealing multiple game boards (see figs. 12.19 and 12.20).

Liubo was a popular game of divination. In Han depictions we see both mortals and immortals playing it. A famous bronze mirror shows four excited immortals kneeling around a game table, above which is a four-character inscription: "Immortals Playing the Game *Liubo*" (*xianren liubo*).[3] There is, therefore, an early association between square tables and immortals. Two people or two teams played the game. A pottery tomb relief from the Eastern Han dynasty (A.D. 25–220) shows two players kneeling on either side of a small mat with weights at the four corners. The player on the left sits upright, waving his arms in excitement because he has just successfully thrown the six sticks (*zhu*) that determine how he will move the game pieces on the board; his opponent bends glumly over the board, staring at the sticks. The board, with the TLV marks clearly visible, stands beside the mat. In the foreground, two men seated on mats are drinking and chatting; a small rectangular table holds wine cups and food dishes.[4]

Small rectangular (and occasionally square) tables were the common dining tables of the Han dynasty (206 B.C.–A.D. 220). At meals each person ate from a small individual table in front of the seating mat. A low table of this type set with dishes, some of which still contained food, was found in the tomb of the Marquess of Dai, who died shortly after 168 B.C. in the southern region of Chu (fig. 12.4). The north compartment of the tomb evokes a room in the Marquess's house, complete with silk hangings on the walls and mats on the floor. The Marquess, represented by her gown, is supposedly seated on a rush mat in front of a lacquer screen. Various objects surround her, including lacquer toilet boxes and an armrest, a pottery censer, and painted figurines of servants. In front of her is the small table (*an*) with its matched set of dishes, all made of red and black lacquered wood decorated with geometric and cloud patterns.

The table is inscribed "Household of the Marquis

of Dai" (*Dai hou jia*) and rests on four short feet, only two centimeters high. It has a rim to contain spills, comparable to the "water-stopping molding" on Ming wine tables and square dining tables. On it were found five small food dishes inscribed, "May the Lord eat" (*jun xing shi*). They contained remains of food, mostly meat dishes, and a set of bamboo skewers. A pair of bamboo chopsticks rested on an oval winged cup inscribed, "May the Lord drink beer" (*jun xing jiu*). There were also two cups, the smaller one with a lid and the larger with an inscription stating its capacity of two *sheng* (around four hundred milliliters). That so many of the vessels found in this tomb are inscribed with their capacity, function, or ownership shows that tableware was sophisticated and specific.[5]

Michèle Pirazzoli-t'Serstevens notes that the remains of food on the Marquess's table are mainly meat, and there are no dishes for *geng* stew (made of meat and/or vegetables) or grain, indicating that this is a drinking party rather than a meal. The tomb grouping seems intended to represent a party that the Marquess enjoyed while alive, since the armrest is on her left, rather than on her right, where it should be, according to the *Book of Rites* (*Zhouli*), if she were a spirit. Although *jiu,* the alcoholic drink consumed by the Marquess, is usually translated as "wine," its composition and preparation make it more like modern beer. According to written records on bamboo slips found at Mawangdui, there were several kinds of beer: an unfermented beer or wort (*li, lao*), which was a malt drink of low alcoholic content, and a much stronger beer (*jiu, yijiu*) fermented with yeast. The Marquess also appears to have drunk tea, since "one basket of tea leaves" is written on one of the wooden plaques found in her tomb. Tea, at this time, was probably drunk for medicinal purposes rather than as a pleasing beverage.[6]

Ying-shih Yü suggests that the scene in the Marquess's tomb depicts only the beginning of a feast when wine was served; after the wine they would have had *geng* stew and other dishes, cooked grain, and fruit.[7] At formal banquets, the diners might sit on long platforms with the food placed level with the platforms on long curved-leg tables. Some form of entertainment—music, dance, acrobatics—usually accompanied Han feasts and drinking parties; for the Marquess of Dai there were five musicians, four dancers, and four singers. The poem "Summons of the Soul" (*Zhao hun*), written for a deceased Chu king to summon his soul back to the good things of life, vividly describes the food and music at a banquet:

> All your household have come to do you honor;
> all kinds of good food are ready:
> Rice, broom-corn, early wheat, mixed with yellow
> millet;
> Bitter, salt, sour, hot and sweet—there are dishes
> of all flavours:
> Ribs of the fatted ox, tender and succulent;
> Sour and bitter blended in the soup of Wu;
> Stewed turtle and roast kid, served up with yam
> sauce;
> Geese cooked in sour sauce, casseroled duck, fried
> flesh of the great crane;
> Braised chicken, seethed terrapin, high-seasoned,
> but not to spoil the taste;
> Fried honey-cakes of rice flour and malt-sugar
> sweetmeats;
> Jade-like wine, honey-flavoured, fills the winged
> cups;
> Ice-cooled liquor, strained of impurities, clear wine,
> cool and refreshing;
> Here are laid out patterned ladles, and here is
> sparkling wine.
> O soul, come back! Here you shall have respect
> and nothing shall harm you.
>
> Before the dainties have left the tables, girl musicians
> take up their places.
> They set up the bells and fasten the drums and sing
> the latest songs:
> "Crossing the River," "Gathering Caltrops"
> and "The Sunny Bank."[8]

The small, low tables at which the feasters dined were stacked in the kitchen when not in use, according to scenes in Han tomb murals (see fig. 1.4). One pottery tomb relief even shows an acrobat doing a handstand on top of a stack of twelve tables. Such activity is seen as well in a Ming painting of the Lantern Festival in the imperial palace, in which Emperor Xianzong (r. 1465–1487) watches various acrobatic feats performed on high square tables.[9] The practice

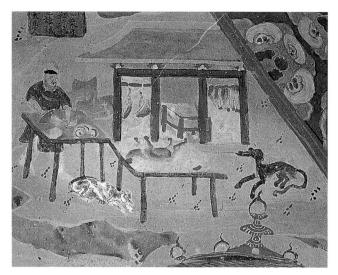

12.5

FIGURE 12.5 Butcher at work.
Late Tang dynasty, 848–906.
Dunhuang cave 85. Detail
of a wall painting illustrating
the *Lankāvatāra Sūtra*. From
Dunhuang Wenwu Yanjiu,
*Zhongguo shiku Dunhuang
Moyao ku,* vol. 4, pl. 157.

FIGURE 12.6 *Go* game board.
Eighth century. *Zitan* (red
sandalwood) with marquetry.
Board surface 49 cm ×
48.7 cm. Courtesy of the
Shōsōin Treasure House,
Nara, Japan.

of using tables in acrobatic performances has continued until today.

High square tables appear to have been used occasionally in the Han dynasty. A green-glazed pottery model (12 cm high, 14 cm square) was found in a tomb at Lingbao, Henan. This corner-leg table has a small pot on top, which was fired together with the table.[10]

High square tables continued to be used for food preparation in the Tang dynasty (618–906). A painting of a butcher at work in cave 85 at Dunhuang shows two large square tables with recessed splayed legs, each table used for a different stage of the process (fig. 12.5). This is an early illustration of how a pair of tables were used together. Meat hangs in the background, and two dogs wait expectantly for scraps. The flesh of wild animals was the most commonly eaten meat, since domestic beasts were considered more valuable for other purposes and were viewed as food for the gods rather than for men. Other meats, such as pork, veal, lamb, dog, beef, and camel, were mainly delicacies of the rich. Millet and rice were the dietary staples.[11]

In the Tang, people began to eat while sitting on benches or stools around large, low rectangular tables. In a wall painting found in a tomb in Nanliwang, Chang'an county, Shaanxi, most of the feasters sit cross-legged on the benches, which are almost the same height as the table and, like it, have four recessed legs (see fig. 1.7). This uncomfortable relationship between the heights of table and seat is characteristic of the transitional period between the mat-level and chair-level modes of living. At one end of the table, a small stand supports a large bowl of wine, probably made from glutinous millet or rice. Rows of wine cups, dishes, and platters of food cover the table. The dishes might have included dumplings (*jiaozi*), fried dough twists (*mahua*), and various fancy flower-shaped pastries (*dianxin*). Well-preserved examples of all these dishes were found at Astana, near Turfan, Xinjiang, and in 1974–75 some were exhibited in Washington, D.C., and Kansas City. Painted pottery figurines of

12.6

cooks found at Astana show how these dishes were prepared.[12]

In the Tang, spinach, sugar beets, lettuce, almonds, and figs were imported from the Near East. The imported "mare teat" grape was cultivated and made into wine. Dairy products—yogurt, cream, koumiss, curds, cheese, and butter—were more popular than at any other time in Chinese history. The passion for drinking tea led to the creation of the tea cult and the publication of Lu Yu's *The Classic of Tea* (*Cha jing*). Tea became associated with Buddhism, especially the Chan (Zen) sect. Although there do not appear to have been any cookbooks, dietary guides such as the *Food Canons* (*Shi jing*) and pharmacopoeias (*bencao*) must have had considerable influence on cooking.[13]

During the Tang dynasty the game of *weiqi* (Japanese *go*) was popular, and some magnificent square game tables have survived. The most spectacular of

these is in the Shōsōin Treasure House in Nara, Japan, and once belonged to the Japanese emperor Shōmu (r. 724–749; fig. 12.6). Made of *zitan* wood decorated with exquisite marquetry, it is in the form of a small platform with oval cutouts. The gridlines of the board are made of ivory, and the eyes are flower-shaped with ivory petals and boxwood centers. An inlaid pattern of tiny diamonds made of boxwood, ebony, and metal ornaments the edges of the table. On the sides of the table, ivory painted in delicate colors creates lively representations of birds, flowers, mountains, and camels and other animals. Painted floral designs decorate the base stretcher, and the inner edges of the openings are inlaid with ivory. The two drawers have gilt-bronze pulls and contain tortoise-shaped receptacles to hold the game pieces. X-ray photographs of the hollow interior of the table reveal that each drawer had an arm that pivoted

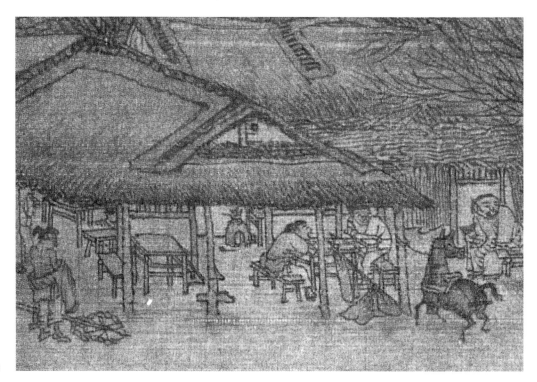

FIGURE 12.7 Zhang Zeduan
(early twelfth century).
Qingming Festival on the River.
Detail of a handscroll. Ink and
slight color on silk. Height
24.7 cm, length 528.3 cm.
Palace Museum, Beijing.

around a central axis. Therefore, when one drawer was pulled out the other automatically opened. The ingenuity, craftsmanship, design, and materials of this game table are superb.

The game table has its own wooden box decorated with a hexagonal pattern outlined with deer antlers. Within the hexagonals are flowers made from gold and silver foil with ink detailing. The flat-topped round wooden box for the game pieces is lacquered and decorated with inlaid silver designs of flowers and a tree with two birds holding flowers in their beaks. The circular game pieces are made from white quartz, black serpentine, and ivory stained red or navy and engraved with patterns of flying birds with flowers in their beaks.[14]

The game of *weiqi* spread from China to Japan, and by the eighth century it was popular in both countries. It was played at court and in the households of noble families. Tales from the court of Emperor Xuanzong (r. 847–859) tell of a famous match between a visiting Japanese prince and the greatest Chinese

player, Gu Shiyan, who barely won the match at the last moment with a spectacular move. Emperor Xuanzong himself enjoyed playing the game. Once, when the Precious Consort saw that he was losing, she untied one of her miniature dogs, which promptly jumped onto the board and disarranged the pieces, to the emperor's delight.[15]

Women also played *weiqi,* as may be seen in a detail from a painting on silk found at Astana in the tomb of a member of the rich and powerful Zhang family.[16] Although the painting was in fragments when it was discovered, it is nonetheless an important find, since it is rare to find such an early datable painting on silk. One section of the painting shows a lady, absorbed in moving her game piece, seated on a box-construction platform before a game table, which is similar in its basic form to the one in the Shōsōin. Her dress and demeanor suggest that she is a younger relative of the lady buried in the tomb. Another part of the painting depicts the occupant of the tomb dressed in a purple skirt, indicating that her husband was an official above the fifth rank.

Weiqi is a war game. The object is to gain as much territory as possible by occupying the points where the lines on the board intersect and by surrounding and capturing the enemy's men. It is a game of subtle strategy that can have cosmic and symbolic nuances. In writings of the Three Kingdoms period (A.D. 221–265) it is recorded by name and may have been known as early as the seventh century B.C. A square stone *weiqi* game table from the Eastern Han was found in a tomb in Wangdu, Hebei.[17]

High square tables came into common use for dining during the Song. In Zhang Zeduan's early-twelfth-century painting *Qingming Festival on the River,* we see them in fancy restaurants (see fig. 1.9) and simple eateries (fig. 12.7). As Michael Freeman points out, food is a central narrative theme of this handscroll,[18] which begins with scenes of early spring in the countryside, where the fields are ready for the new planting. We then see the river crowded with boats carrying grain to the capital, Bianjing (present-day Kaifeng). Restaurants and teahouses line the banks, becoming more elaborate and more numerous as we near the city. Within the city walls, the bustling streets are filled with vendors and food stalls as well as all sorts of restaurants, wine shops, and teahouses.

Humble eateries were open thatched structures with crudely made square or rectangular tables and benches (see fig. 12.7). Here a traveler would tie his donkey to a pillar and stop for a quick meal of noodles or soup. Fancier establishments at the water's edge stood on stilts and had enclosed rooms where chairs as well as benches were provided. These restaurants might specialize in a particular food or style of cooking; one might serve only vegetarian food, another only steamed buns with various fillings, and a third only Sichuan-style dishes. The most fashionable teahouses and wine houses were, like homes, enclosed by walls and consisted of various buildings opening onto interior courtyards. They were sumptuously decorated and furnished with scrolls by celebrated painters and calligraphers, floral displays, and fine porcelain and silver tableware.

The menus were extensive, reflecting the great variety of available ingredients and recipes. Some of the items on the menu came from vendors who also provided rich and poor with food on the streets. A single banquet might feature more than two hundred dishes. A thirteenth-century book lists dishes eaten at a grand banquet in Hangzhou, the capital of the Southern Song dynasty (1127–1279), in the order in which they were served:

> 41 dishes of fish, shrimps, snails, pork, goose, duck, mutton, pigeon, fried, sautéed, grilled, roast on the spit, roast in the oven, or boiled; 42 dishes based on fruits and sweetmeats; 20 dishes of vegetables: 9 of boiled rice served with different ingredients (sugar, sweet soya, cakes cut in thin slices, beans . . .); 29 dishes of dried fish; 17 refreshments (li-chee juice, honey or ginger drinks, paw-paw juice, pear-juice . . .); 19 kinds of pie and 57 desserts (cakes and dishes of vegetables and meat that could be served as dessert).[19]

A small cup of warm rice wine accompanied each dish. In Hangzhou some fifty-four different kinds of

wine, mostly local, were available for banquets and for drinking in the taverns, where they always accompanied food. Fruit was a much more important item in the diet than it is today; many varieties were available and were eaten throughout the meal as well as for dessert. Beancurd was invented in the late Tang or early Song and quickly became popular, especially among Buddhists.[20]

During the Song the Chinese developed the world's first grand cuisine, and it has persisted up to the present day. Thanks to revolutions in agriculture and commerce, cities received an unprecedented abundance and variety of foods from all over the country. A cook might open a restaurant in one region that specialized in food from a different region, so that homesick officials and travelers could enjoy their native dishes. A large and sophisticated clientele, both adventurous and critical, took real pleasure in eating and trying the unfamiliar. Restaurants were an integral part of city life and were important meeting places and social centers.

Concurrent with the development of a distinctive style of cooking was the adoption of the chair-level mode of living and the custom of eating together seated around a single table, instead of at small individual tables. This new way of eating made meals intimate, shared occasions in which everyone sat close together and helped themselves with their chopsticks from common dishes placed in the center of the table. For this custom, square tables were a particularly appropriate form.

Square tables, therefore, are often depicted in tombs. One of the scenes from the daily life of Yu Yin, who died in 1197 in Gaotang, Shandong, shows a meal laid out on a square table standing in front of a large single-panel screen decorated with calligraphy. The diner sits on a yokeback chair made festive with patterned fabric on the back and seat. Despite the presence of two servants, the chair is empty, perhaps an indication that this was Yu's seat. The table has stretchers—single on two sides, double on the other two—and spandrels. A large vase of flowers stands in the center surrounded by dishes of food, bowls, a

wine cup on a stand, and a wine ewer in a bowl of hot water.[21]

Many other tombs, such as the 1099 tomb at Baisha, Henan, have paintings or brick reliefs showing a couple seated on either side of a table. Although only one side of the table is depicted, they are probably small square tables similar to the miniature wooden square table found, together with a yokeback chair, in the tomb of Princess Ruichang, who died in 1050 at Jiangyin, Jiangsu. The princess's recessed-leg table has cusped aprons and stretchers on two sides. Small figurines of standing men are attached to the inside of each of the legs, complementing the figurines of women affixed to the chair.[22]

High square tables were also used for preparing and serving food. In one of a set of Northern Song (960–1126) carved pottery tomb tiles vividly depicting domestic activities, a woman stands beside a kitchen table (fig. 12.8). She is rolling up her sleeve before cutting up fish with the knife lying on the table. A large fish rests on a chopping block next to three small fish joined by a willow twig. A basin of water stands by her feet, and in front of the table a pot of water boils on a square stove. The table has recessed legs, stepped stretchers, and standard spandrels; the mitered frame of the top is clearly depicted. Fish, both fresh and salted, was a favorite food. In the Southern Song, the well-to-do ate many kinds of freshwater fish and shellfish, and there were exotic dishes such as fish cooked with plums and scented shellfish cooked in rice wine. Fish, pork, and rice comprised the main diet of the lower classes. The popularity of fish was even reflected in poetry, where it replaced chicken as a metaphor for special fare.[23]

High square tables used for serving wine and tea appear in northern tomb paintings of the Liao, Jin, and Yuan dynasties. An elegant one is depicted in the tomb of the Daoist Feng Daozhen (d. 1265) at Datong, Shanxi (fig. 12.9). It has corner legs ending in cloud-shaped feet, stretchers on all sides, and beading outlining the sides of the top. On the table is a jar labeled "tea powder," a tea whisk, and ceramic bowls and stands. A servant carries a stand with a bowl

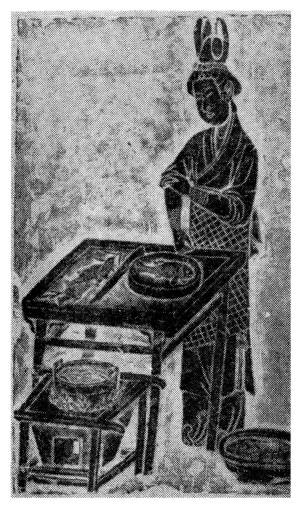

12.8

12.9

FIGURE 12.8 Preparing fish. Northern Song dynasty. Carved pottery tomb tile unearthed at Yanshi county, Henan. Height 34.1 cm, width 24.1 cm, depth 2.2 cm. Museum of Chinese History, Beijing. From *Chūgoku no hakubutsukan,* 5: pl. 168.

FIGURE 12.9 Serving tea. Yuan dynasty, 1265. Detail from a wall painting in the tomb of Feng Daozhen, Datong, Shanxi. From *Wenwu,* no. 10 (1962): cover.

of tea. At this time tea was usually prepared in a bowl by adding hot water to powdered tea and whisking until white froth appeared on the surface. Black-glazed Jian ware bowls were considered especially good for displaying the froth. Tea, which had been something of a luxury at the beginning of the Song, was a common everyday drink for rich and poor by the end of the dynasty. Indeed, it was one of the "seven necessities": firewood, rice, oil, salt, soysauce, vinegar, and tea.[24]

The cuisine and eating habits developed during the Song continued in the Ming dynasty, when the Chinese made beautiful hardwood square tables, many of which have survived until today. One type has a waist,

corner legs, horse-hoof feet, and curved braces. A *huanghuali* example of this type has a classical simplicity and grace (fig. 12.10). Its flat surfaces are unadorned except for double lines of beading at the lower edge of the top's molding and along the inner edges of the legs and aprons. Apron and waist are made from a single piece of wood. The S-curved braces, called "giant's arm braces" (*bawangcheng*), provide stability without disturbing the clean slender lines of the piece. They mortise and tenon into the legs and are pinned to the transverse braces. The rim of the low lacquer table found at Mawangdui (see fig. 12.4) has here transformed into an elegant water-stopping molding.

Illustrations to *The Plum in the Golden Vase* show

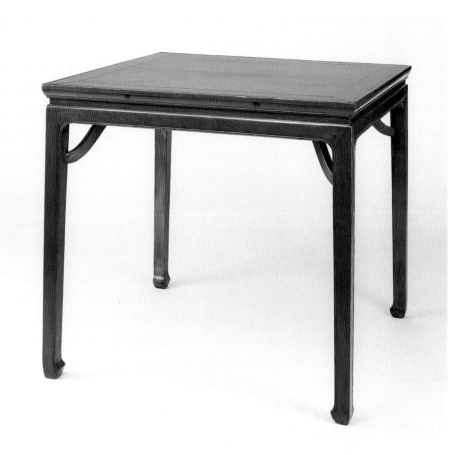

12.10

FIGURE 12.10 Square table with curved braces. Ming dynasty, late sixteenth/early seventeenth century. *Huanghuali* wood. Height 86 cm, top 96 cm × 96 cm. © Christie's Images, Ltd., 1999.

FIGURE 12.11 Attributed to Gu Jianlong (1606–c. 1694). *Ximen Decides to Deflower Li Guijie*. Qing dynasty, c. 1662–c. late 1670s. Illustration to *The Plum in the Golden Vase* (*Jin ping mei*), chap. 11. Ink and color on silk. Height 39 cm, width 31.2 cm. The Nelson-Atkins Museum of Art, Kansas City, Missouri. (Acquired through the Uhlmann Family Fund.)

similar square tables used for informal meals; for formal banquets rectangular tables were bedecked with frontals (see fig. 4.11). When Ximen Qing and his cronies visit the Verdant Spring Bordello, a square table with curved braces is brought in, the candles are lit, and the group feasts on an abundance of wine and food (fig. 12.11). Ximen is about to make the courtesan Li Guijie his mistress and is sitting with her on his lap urging her to drink a cup of wine. The others are inebriated and boisterous. One, holding out his rhinoceros-horn cup for a refill, has his chest bared in a most informal manner. Another seems about to fall off his stool as he wildly gesticulates toward his neighbor. The leisurely enjoyment of wine and food is the prelude to amorous encounters, and all three

12.11

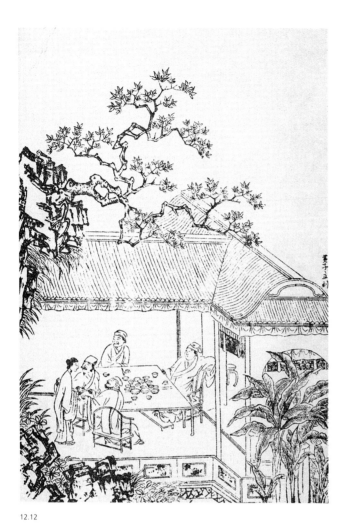

12.12

FIGURE 12.12 *Charming the Guests.* Ming dynasty. Woodblock illustration to *The Plum in the Golden Vase* (*Jin ping mei*), Chongzhen reign period (1628–44), chap. 35.

constitute the main sensual pleasures that are the focus of the novel. The table is elegantly set with delicate blue and white porcelain cups on red lacquer saucers.

On another occasion, when Ximen Qing entertains his good-for-nothing cronies on the veranda outside the Hall of the Kingfishers, they again sit casually around a corner-leg table (fig. 12.12). Ximen sits in the host's seat on a yokeback armchair with a footstool. On his right and left are the guests of honor Ying Boujue and Xie Xida, and opposite him is Han Daoguo, the manager of his silk shop. The guests all sit on roundback chairs with no footstools. Many dishes have been placed in the center of the table, and each diner has his own bowl, wine cup, and chopsticks. Ximen's pageboy Shuting, dressed as a girl, provides entertainment; here he offers a cup of wine to Ying Bojue. The text calls the table *baxian zhuoer*, an "eight immortals table."[25]

The term "eight immortals table" also occurs elsewhere in the novel. For instance, when Pang Chunmei returns to her old home and pays her respects to Ximen Qing's tablet, she is served tea, cakes, and fruits on a large eight immortals table set up in front of the altar.[26] For formal family gatherings, such as Meng Yulou's birthday, the eight immortals table is bedecked with a silk frontal, and the chairs are provided with runners (see fig. 7.17). Table frontals usually cover only the front of the table when it is used for dining, although occasionally there are depictions where the sides are also covered.[27] On officials' tables both sides and front are covered.

Square tables are also called "spring platforms" (*chuntai*) in, for example, the brothel scene (see fig. 12.11). The term *tai* accompanies illustrations of recessed-leg square tables in the fifteenth-century *Newly Compiled Illustrated Four-Word Glossary* and the seventeenth-century *Pictorial Encyclopedia of Heaven, Earth, and Man*. The one in the glossary has a single stretcher on two sides, while that in the encyclopedia has double stretchers on two sides and spandrels. "Square chess table" (*qipan fangzhuo*) is the term used in the *Classic of Lu Ban* for a square table with inset

panels in the recessed waist and a "four-toothed swallowing head" ornament on the top of each leg.[28]

In *The Plum in the Golden Vase,* an eight immortals table clearly refers to a square dining table, shown with six, four, or two people seated around it. In the *Classic of Lu Ban,* however, the term refers to a rectangular table with a lower shelf meant for a brazier. The association of a brazier with an eight immortals table is found in an illustration to chapter 73 of *The Plum in the Golden Vase,* where a separate brazier is placed on the floor under the table (see fig. 7.17). Twentieth-century Beijing furniture makers and dealers use the terms "eight immortals table," "six immortals table," and "four immortals table" to distinguish between the different sizes of square tables.[29]

There is, however, some confusion about these terms, and their respective dimensions are unclear. Because of the names, these tables are thought to have been intended to seat eight, six, and four people. However, six people do not fit comfortably around a square six immortals table. In the illustration of an eight immortals table in *The Plum in the Golden Vase* (see fig. 12.12), only four people sit around it, and there is no room for four additional diners. According to André Lévy, the table is big enough for four humans and four immortals, because the immortals take up little space (presumably because their diet makes them thin).[30] Another possible explanation is that the name refers to these beloved and auspicious immortals as a group, that is, as a single entity rather than as eight separate entities.

Legends concerning the eight immortals as a group seem to have first appeared in the Song dynasty.[31] Their portraits are hung up for celebrations, and their images and emblems appear frequently in the decorations of temples, homes, and clothing. Their exploits inspired numerous stories and short pieces preceding theatrical performances. They are a gay, fun-loving bunch, fond of food and drink and often inebriated. Invisible, they eat no grain, only breathing wind and drinking dew. Unlike gods, they are not connected to a particular place or lineage. They are unapproachable and unreachable by sacrifice or prayer. Although they cannot be forced, they will spontaneously benefit humanity.[32] Dining at an eight immortals table increases the simple happiness of eating by the comparison to immortals dining and enhances the enjoyment of food by having the immortals join in.

One of the strongest, most satisfying eight immortals tables is a waistless model with round recessed legs (fig. 12.13). It is fashioned from thick timbers of honey-colored *huanghuali,* and all the edges and corners are rounded. The humpback stretcher and two struts on each side recall the stretchers and struts on the Western Zhou *Ling gui* (see fig. 12.1). The top panel, made from boards with a pleasing curly grain, is supported underneath by two sets of dovetailed transverse braces placed at right angles to each other, their tenons exposed.

Such tables were used not only for meals for the living, but also for offerings to the deceased. At the elaborate memorial services for Ximen Qing's Sixth Lady, Li Ping'er, two household tables serve as an altar (fig. 12.14). A massive side table with everted flanges stands against the wall with a square table in front of it. The U-shaped textile hanging above the tables (between the pillars and pairs of banners on either side) define the ritual space. The square table, adorned with a gorgeous dragon-decorated frontal, holds an incense burner, a pair of red candles, food offerings, and various ritual objects. More offerings in porcelain bowls are placed one next to the other on the table behind. The Daoist master Huang, wearing a "nine thunders" hat and a magnificent scarlet robe embroidered with one hundred cranes against golden clouds, stands on the carpet in front of the altar offering a libation. Monks play musical instruments and recite prayers on either side. Similar altar tables, consisting of a square table in front of a side table, are still found in Chinese communities today.[33]

Upper-middle-class homes in the early part of the twentieth century used the same arrangement of tables against the back wall of the main hall.[34] The long narrow table was higher than the eight immortals table

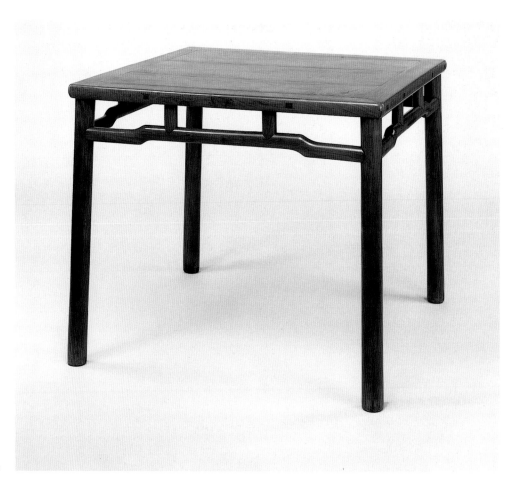

12.13

FIGURE 12.13 Square table with humpback stretchers. Ming or Qing dynasty, seventeenth century. *Huanghuali* wood. Height 84 cm, top 100 cm × 99 cm. The Minneapolis Institute of Arts. Gift of Ruth and Bruce Drayton. Photo © Christie's Images, Ltd., 1999.

FIGURE 12.14 Attributed to Gu Jianlong (1606–c. 1694). *Memorial Service for the Sixth Lady*. Qing dynasty, c. 1662– c. late 1670s. Illustration to *The Plum in the Golden Vase* (*Jin ping mei*), chap. 66. Ink and color on silk. Height 39 cm, width 31.2 cm. The Nelson-Atkins Museum of Art, Kansas City, Missouri. (Acquired through the Uhlmann Family Fund.)

and might have held a choice antique or a vase of flowers. A large pictorial hanging scroll usually hung on the wall above, flanked by a pair of narrow calligraphic scrolls. The family would display different scrolls for different seasons or domestic ceremonies. A pair of armchairs for entertaining an honored guest sometimes flanked the square table, which could be pulled into the middle of the room for meals or a game of chess.

Since square tables moved frequently and were in constant use, they had to be strong. Therefore, a form of square table with humpback stretchers and corner spandrels was popular. Tables of this type have clear architectural origins. In Chinese buildings, round pillars, which are connected at the top by beams, slant inward—a structure reflected in the recessed, rounded

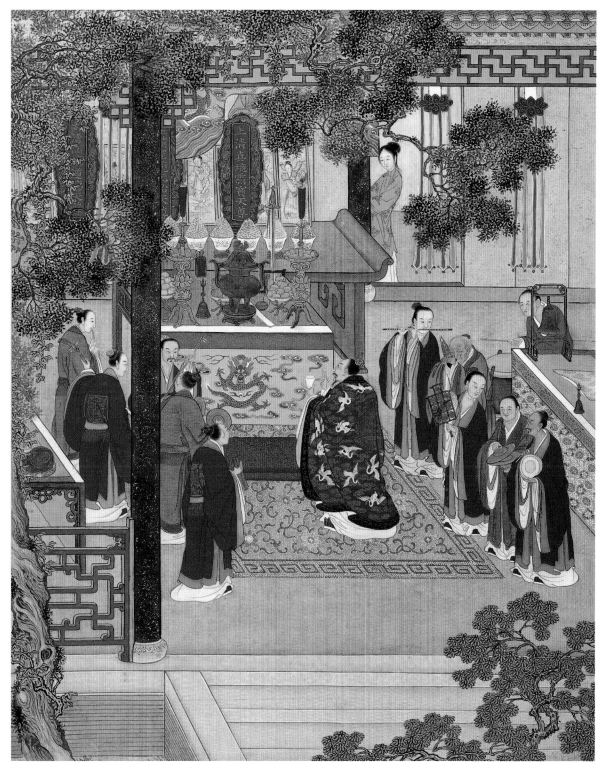

12.14

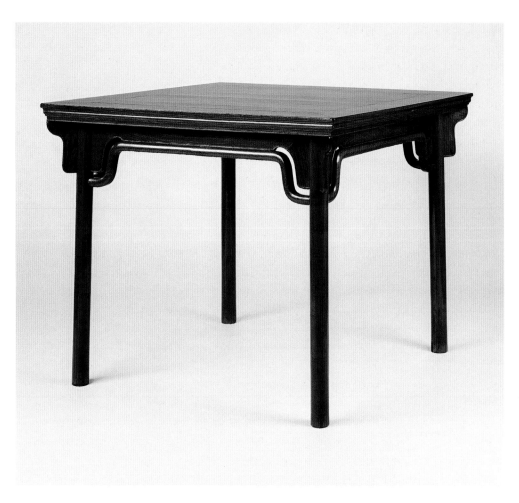

12.15

FIGURE 12.15 Square table with corner spandrels. Ming dynasty, late sixteenth/early seventeenth century. *Huanghuali* wood. Height 88 cm, top 106 cm × 106 cm. © Christie's Images, Ltd., 1999.

FIGURE 12.15 Square table with corner spandrels. Ming dynasty, late sixteenth/early seventeenth century. *Huanghuali* wood. Height 88 cm, top 106 cm × 106 cm. © Christie's Images, Ltd., 1999.

splayed legs and high stretcher of the table in fig. 12.15. The three-spandrel construction that supports the corners of the tabletop evolved from the brackets supporting the roofs of buildings. The use of corner spandrels is necessary to support the unusually wide frame of the top. To make the top of the table proportional to the rest of the structure, an extra molded edge has been added along the lower outer edge of the frame to give the illusion of a thicker board. Consequently, the deep complex molding of the top balances the heaviness of the deeply recessed high humpback stretcher, which is attached, with nails, to the central portion of the apron that dips down to meet it. The graceful gooseneck-shaped

openings on the sides lighten the appearance of this joined stretcher and apron. A bead edges aprons and spandrels and widens on the corner spandrels. The complex construction of this table strengthens its structure and provides maximum leg room for those seated around it. The deep tones of the *huanghuali* wood reinforce the bold design.

Among square tables with humpback stretchers and three spandrels, variations in form create different effects. A more delicate ornamental appearance marks a pair of square tables in a private collection in Taipei.[35] A lighter *huanghuali* wood offsets their unusual, highly figured, green serpentine panels. Fluted legs echo the moldings of the top frame. The cusped edges of the curving sides of the humpback stretcher are elaborated on the spandrels, with their curling leaf motifs. Two cloud-shaped decorative struts join the stretcher and apron.

It is rare today to find a pair of square tables, although they were probably made in sets and often used together. In the Tang painting from Dunhuang (see fig. 12.1) we saw a pair on which the butcher cuts his meat. Two tables might be placed together for formal occasions and large gatherings to enable diners to sit along one side and watch a performance or view the other guests. In his album leaf *The Puppet Show,* Dai Jin (1388–1462) depicts side-by-side square tables hung with frontals to create rectangular tables, two of which stand at right angles to each other so that everyone can watch the show (see fig. 7.16). In woodblock illustrations to *The Plum in the Golden Vase,* square tables are used only for informal and family gatherings (see figs. 7.17, 12.12). For a formal banquet rectangular tables, dressed with frontals in honor of the occasion, are set up around the walls of the hall (see, e.g., fig. 4.11).

According to Gu Qiyuan (1565–1628), banqueting customs in fifteenth-century Nanjing were simple. A servant invited the guests early on the morning of the banquet, everyone sat around an eight immortals table, and the party was over in the afternoon.

By the hour *si* [9:00 to 11:00 A.M.] the guests would have gathered. When there were six guests or eight, a large eight immortals table would be used. The main dishes would number only four, on large platters, with four minor accessory dishes at the four corners of the table. There would be no [preliminary] sweetmeats. The wine would be drunk from two large wine cups, used in turn by the guests. At the center of the table there would be a large bowl filled with water; one would rinse the wine cup, refill it, and pass it on to the next person. That was called the "rinsing bowl." The dinner party would disperse following the *wu* hour [after 1:00 P.M.].[36]

By the mid sixteenth century customs were more lavish, and servants distributed accordion-folded invitations to guests the day before the banquet. Instead of a single square table, there were separate small tables for two. The host provided seven or eight preliminary sweetmeats and dishes, and musicians played. The festivities continued until five in the evening. Ximen Qing entertained the eunuchs in this manner.

Banqueting customs, however, varied according to era, place, social rank, and personal taste. Wen Zhenheng, writing around 1620, considers eight immortals tables vulgar, suitable only for feasting; his comments imply that they were commonly used for banquets. Johan Nieuhof traveled in China from 1655 to 1657. In his book, which contains his original official report with additional information from other missionary sources, he describes a banquet at which the guests eat at individual square tables seated on chairs with runners: "they are conducted into the principal Room of Entertainment, which is richly adorn'd and furnish'd, not with Carpets, as among those of the East, (for they are not in use here) but with Pictures, Flowers, Dishes, and the like Household-stuff: Each Guest is seated apart at a four-square Table, well furnish'd with Dishes upon chairs."[37]

A number of missionaries wrote accounts of the banquets they attended in China. These are fascinating because of the things they noticed, things too ordinary for Chinese to mention in their writings. They were intrigued by such practices as the lack of table-

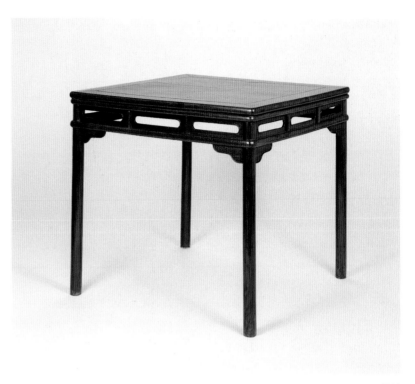

FIGURE 12.16 Double-molded square table. Qing dynasty, late seventeenth/early eighteenth century. *Huanghuali* wood. Height 87 cm, top 92 cm × 92 cm. © Christie's Images, Ltd., 1999.

12.16

cloths and napkins, the chopsticks, the way all food was cut into small pieces, and the beautiful manner in which fruits were served. The Portuguese Friar Gaspar da Cruz describes a banquet given by a rich Cantonese merchant in the winter of 1556:

> The tables were set in three places of the house, for every guest invited there was a table and a chair very fair and gilt, or with silver, and every table had before it a cloth of damask down to the ground. On the tables was neither cloth nor napkins, as well because the tables were very fine, as because they eat so cleanly that they need none of these things. The fruit was set along the edges of every table, all set in order, which was, roasted chestnuts and peeled, and nuts cracked and shelled, and sugar-canes clean and cut in slices, and the fruit we spoke of before called Lichias, great and small, but they were dried. All the fruit was set in small heaps like turrets very well made, crossed between with certain small sticks very clean, whereby all the tables in a circle were very fairly adorned with these little turrets. Presently after the fruit, all the services were placed in fine porcelain dishes, all very well dressed and neatly carved, and every thing set in good order; and although the

sets of dishes were set on top of the other, all were beautifully set; in such sort that he who sat at the table might eat what he would without any need of stirring or removing any of them. And presently there were two small sticks, very fine and gilt, for to eat with, holding them between the fingers; they use them like a pair of pincers, so that they touch nothing of that which is on board with their hand. Yea, though they eat a dish of rice, they do it with those sticks, without any grain of the rice falling.[38]

One of the standard types of square tables has a double-molded top edge, leg-encircling stretchers, and inset panels. A *huanghuali* example (fig. 12.16) is identical in form to the square *zitan* stool in fig. 7.14. The top panel is made from two wide boards, unlike the square tables in figs. 12.10, 12.13, and 12.15, which use a number of boards. The thick double-molded edge of the frame echoes in the single molding of the leg-encircling stretcher. These and the round legs all derive from bamboo furniture construction. On each side between the stretcher and top are three inset panels with oval beaded-edged open-

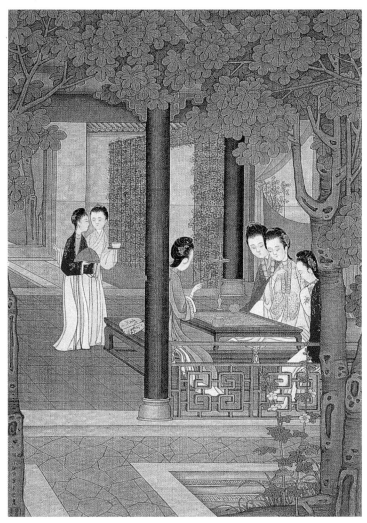

FIGURE 12.17 Jiao Bingzhen (late seventeenth/early eighteenth century). *Playing Weiqi*. Qing dynasty, Yongzheng period (1723–35). One of twelve leaves from the album *Pictures of Gentlewomen*. Color on silk. Height 30 cm, width 21.2 cm. Palace Museum, Beijing. From Palace Museum, *Court Painting of the Qing Dynasty*, 31, pl. 8.

12.17

ings. Beading also edges the shaped spandrels. In fig. 12.16 construction techniques for light, fragile bamboo furniture create a sturdy hardwood table.

As we have seen, square tables served many purposes. Paintings and book illustrations show people using them for writing, looking at antiques, and playing games. In woodblock illustrations to *The Plum in the Golden Vase,* for example, we see people playing *weiqi* on a bamboo table in the garden and Zhengji playing dominoes with the ladies on a table spread with a madder-red strip of felt.[39]

Indeed, a board and game pieces can be used on any square table. In fig. 12.17 Jiao Bingzhen depicts eighteenth-century palace ladies seated on a platform around a low table playing *weiqi*. On a hot summer night they sit on a veranda with a candle to illumine the game. Maids bring refreshments. On either side of the board is a bowl-like container for the game pieces. These containers were often wonderful examples of the woodworker's art. Each container consists of a bowl, carved from a single piece of wood, and a raised lid, which is indented in the center with upturned lips so that it is easy to grasp and remove. The container fits well in the hand and is pleasing to touch. For the pair of *huanghuali* game bowls in fig. 12.18, the craftsman selected wood from

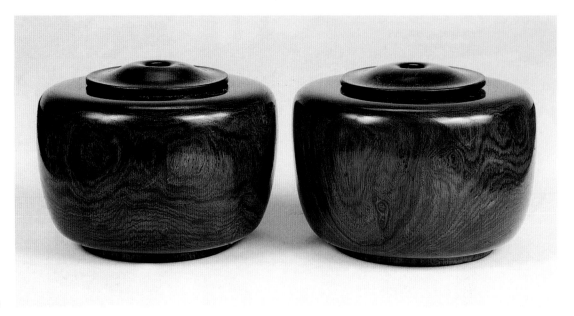

12.18

FIGURE 12.18 Pair of game bowls. Qing dynasty, late seventeenth/early eighteenth century. *Huanghuali* wood. Height 11 cm, diameter 15 cm. © Christie's Images, Ltd., 1999.

FIGURE 12.19 Square game table. Qing dynasty, seventeenth or eighteenth century. *Zitan* wood with silver inlay. Height 88 cm, top 90 cm × 90 cm. The Tsui Museum of Art, Hong Kong.

FIGURE 12.20 Detail of fig. 12.19 with the top and first game board removed, revealing a game board for double sixes.

a part of the tree where a branch begins to create interesting figures in the grain—markings the imagination can transform into a variety of images. Turning the bowl can resemble unrolling a horizontal landscape scroll. There are mountains, torrents, flat plateaus, and vast waters with descending geese. You boat beneath towering cliffs, enter caverns with bizarre formations, and view in the distance tiny peaks rising from swirling clouds. The bowl holding your game pieces is thus an endless source of delight.

In the Ming and Qing dynasties special game tables were fitted with various boards and containers for game pieces. An elegant *zitan* one in the Tsui Museum of Art in Hong Kong (fig. 12.19) has the same basic form as the *huanghuali* table in fig. 12.16 and, like it, can also be used for eating and other activities. When the top, with its floating panel within a mitered mortise-and-tenon frame, is removed, however, it becomes a game table. Between the stretcher and the top are seemingly solid recessed panels, but the center panel on each side conceals a small drawer. Beneath the removable top is a second tabletop, with two square containers for game pieces sunk into the frame and a reversible chess and *weiqi* board in the center. This two-sided game board can be removed

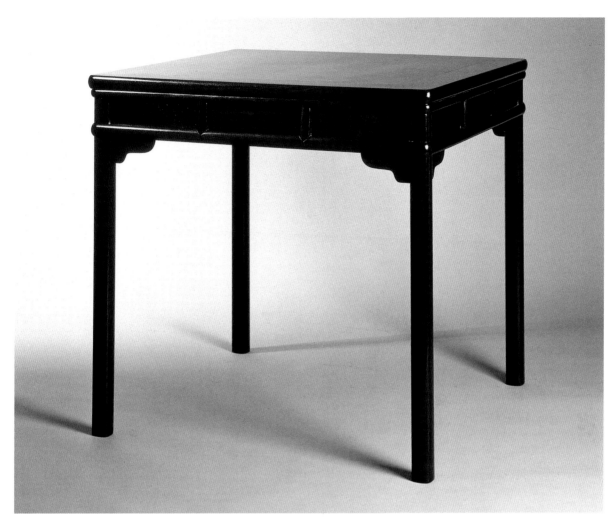

12.19

12.20

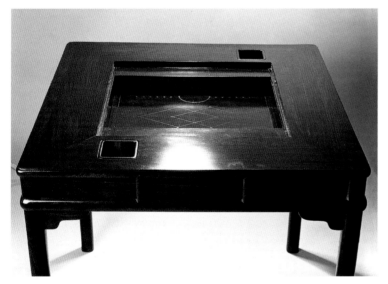

in turn to reveal a double sixes game board flanked by two long covered compartments for the game pieces (fig. 12.20). Fine silver inlay defines the divisions on all the boards.

Since double sixes, chess, and *weiqi* were all popular Ming and Qing board games, it was convenient to have all the equipment needed to play them in one table. The high square table in the Tsui Museum represents the ultimate development of the low Western Han and Tang game tables (see figs. 12.3, 12.6). Its austere classical exterior conceals a compact, intricate arrangement of the boards and containers for game pieces that is both aesthetically pleasing and practical. Useful both for dining and after-dinner games, it is a complete entertainment center.

While Westerners today may occasionally use foldable square card tables for games, they do not find square tables particularly useful for other purposes. Yet in China square tables have long been popular for the communal activity of eating as well as playing games. At a square table everyone can communicate easily with everyone else, whereas the typical large Western rectangular or oval dining table permits easy communication only with one's immediate neighbors, and then only with one neighbor at a time. In China, the activity of eating, like playing board games, focuses on the center of the table, where the food (or the game board) sits. At the square Chinese table, eating is a shared social experience.

In China the rectangular table is most often the workplace for calligraphy, painting, and composing poems. The square table, by contrast, is not normally devoted to such solitary visual or verbal creations. Rather, it is made for life's common but convivial pleasures, and it invites others to participate in the sensual enjoyment of eating and the fun of playing games.

13 | A CLEAN TABLE
BY A BRIGHT WINDOW

*C*alligraphy and painting were the most venerated art forms in China. All educated Chinese men and women had some proficiency in these arts, which were a symbol of their cultivation and their social and official status. Both painting and calligraphy involved brushing ink onto paper or silk laid flat on a table. Both arts employed the same basic materials, utensils, and techniques, and for both the individual brushstroke was of prime importance. To make Chinese ink, one must grind a solid ink stick or ink cake with water, a slow process providing time for contemplation and concentration. Only after calming his thoughts, concentrating his energies, and envisioning the finished piece did the artist lift the brush and, in a moment of intense creation, complete the work. The eleventh-century master Guo Xi gives a clear picture of the method and atmosphere—physical and spiritual—for painting: "On days when he was going to paint, he would seat himself at a clean table, by a bright window [*ming chuang jing ji*], burning incense to right and left. He would choose the finest brushes, the most exquisite ink; wash his hands, and clean the inkstone, as though he were expecting a visitor of rank. He waited till his mind was calm and undisturbed, and then began."[1]

The artist grasped the brush firmly in a more or less upright position and moved from the unsupported arm. Thus, it was often advantageous to be standing, especially when working on a big piece of paper or silk. For miniature work, however, one had to sit because the brush movement originated in the wrist or fingers. The ideal work surface was a large flat table. These so-called painting tables permitted unrestricted movement and were unencumbered by drawers. Although these may be considered the traditional desks of China, in practice many kinds of tables were used for painting and calligraphy, and painting tables also had other uses.

The earliest depiction of a Chinese desk is in a wall painting found in a tomb in Sandaohao village, near Liaoyang in southern Manchuria (fig. 13.1). A man sits on a low platform in front of a long low table with curved legs ending in a straight runner, identical to

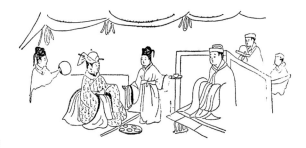

13.1

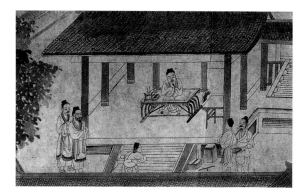

13.2

the table excavated in Lelang, Korea (see fig. 11.4). On the table depicted in the wall painting there is a piece of paper, and a writing brush sticks up from one corner. Since the table is level with the platform, the man would have sat on the floor to write, as shown in a wall painting in the Northern Qi tomb of Cui Fen excavated in Yeyuan in Lingqu county, Shandong province. The painting depicts an eight-paneled screen, one panel of which shows a man sitting beneath a tree on a mat at a low table. His brush is poised above the paper; on the table near at hand are a three-legged round ink slab and a mountain-shaped brush rest. A maid approaches carrying a small lamp stand with three oil receptacles.[2]

By the Song dynasty (960–1279) the curved-leg desk had risen to chair height. Fig. 13.2 shows a landlord leaning on one as he collects rent from his tenant farmers. This scene is in a thirteenth-century handscroll illustrating the *Odes of Bin,* songs about the occupations of the different seasons in the *Book of Songs.* The Confucians—who believed that these ancient songs revealed essential characteristics of the founders of Chinese society—gave the *Odes of Bin* moral and didactic interpretations. In fig. 13.2 the artist has illustrated the following lines with a scene from thirteenth-century life:

In the tenth month we bring in the harvest,
Millet for wine, millet for cooking, the early
 and the late,
Paddy and hemp, beans and wheat.[3]

The landlord, seated in the main hall of his house in front of a screen, collects rent from his tenants. Brushes in an upright brush rest, an ink stick, and an inkstone stand ready on the desk so that he can record the transactions in the ledger before him. The imposing desk has *ruyi*-shaped clouds on its aprons and is strengthened by braces and a central base stretcher.

This type of high curved-leg desk does not appear to have been used after the Song, perhaps because the design was not really appropriate for large tables. The form did, however, influence pieces such as the magnificent waisted *zitan* painting table in the

13.3

Palace Museum, Beijing, which has C-shaped legs joined by a base stretcher (fig. 13.3). The entire surface of the table, except for the top, is covered with dense relief carvings of *lingzhi*, the fungus of immortality. The rounded, tactile quality of the carving gives a sense of the fleshy plant, and the deep luster of the *zitan* wood reflects the dark sheen of this fungus, which grows in clusters on the roots of trees. In the early part of the twentieth century the table belonged to Guan Mianjun, a well-known collector and compiler of a painting catalog. His friend Guo Bao, who had a distinguished ceramics collection, coveted the table, but Guan refused to part with it. Finally Guo had a copy made that, although not nearly as fine as the original, is now also in the Palace Museum.[4]

In Song paintings we see other forms of desks besides the curved-leg model. Judges, in this world and in hell, sit behind large tables ceremoniously draped with fabric.[5] In *Composing Poetry on a Spring Outing* a poet brushes a poem on a large corner-leg table with cloud-head feet resting on a continuous floor stretcher (see fig. 1.12). The painting is thought to depict a scholarly gathering in a famous Hangzhou garden belonging to Chang Zi (1147–after 1201).[6] The poet is standing to brush his poem on a long handscroll held down by paperweights. Incense is probably burning in the pot on the table, creating a mood conducive to inspiration. A group of scholars, monks, and young girls gathered around the table watch intently. The poet could sit on the square stool, identical in design to the table, but the table's stretchers would get in the way of his feet. The table is an elevated version of the old Tang-style box-construction platform (see fig. 8.6), a form that was probably adopted to

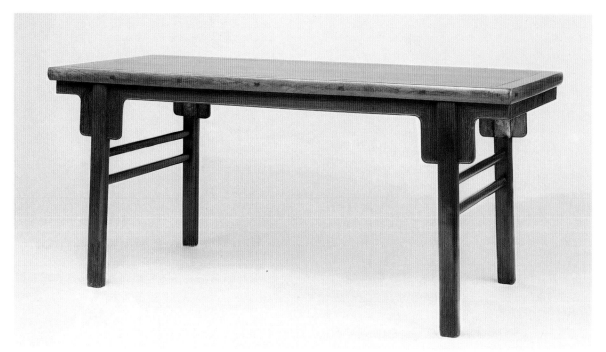

13.4

13.5

FIGURE 13.4 Painting table. Ming dynasty, late sixteenth/early seventeenth century. *Huanghuali* wood. Height 80.2 cm, length 186.2 cm, width 76 cm. The Metropolitan Museum of Art, New York. Purchase, The Vincent Astor Foundation and The Dillon Fund Gifts, 1996 (1996.338). Photo © Christie's Images, Ltd., 1999.

FIGURE 13.5 *Oriole Writes a Letter.* Late Ming dynasty. Woodblock illustration to Min Qiji's 1640 edition of *The Story of the Western Wing (Xixiang ji)*, leaf 18. Museum für Ostasiatische Kunst, Cologne. Photo: Rheinisches Bildarchiv, Cologne.

support the weight of the large top board. Later, ways were found to strengthen the construction without floor stretchers.

Small desks could be made with only a pair of high stretchers on each short side, so that nothing interfered with the writer's legs. Already in the Song a small high table was used for writing. In the early twelfth-century handscroll *Qingming Festival on the River,* a glimpse into one of the open shop fronts lining the bustling streets of the capital reveals a scribe seated on a folding chair at this kind of table (see fig. 1.10). This form of plain recessed-leg table—with unmitered bridle joints, simply shaped spandrels, straight or slightly shaped aprons, and high double side stretchers—was common in the Song. It is depicted in many paintings, and part of one is visible next to the landlord in the *Odes of Bin* (see fig. 13.2). Here, as in many early examples, a stretcher on the long side provides additional support. Japanese archaeologists excavated an actual table of this type about 1920 in Julu county, Hebei province, that was in use when the site was flooded in 1108.[7] This form of table has remained the most popular ever since and so may be called the "standard table."

The standard table was the most popular model for painting tables in the Ming and Qing. Subtle variations in proportion and design give each of these seemingly identical pieces its distinctive character. Some have an elongated elegance and delicacy, while others are much bolder in proportion and design. An example of the latter (fig. 13.4) exhibits a decisive vigor in its form and execution. It is fashioned from honey-gold *huanghuali* wood and has an exceptionally thick top frame with boldly rounded edges. The edges of the substantial rectangular legs are similarly rounded. A crisp bead edges the long flat aprons and angular spandrels. The tenons of the top frame and five dovetailed transverse braces are exposed. The spandrels consist of two pieces, each joined with a dovetail tenon to the apron.

Both men and women used this type of painting table. In a woodblock illustration to Wang Shifu's *The*

Story of the Western Wing, Oriole sits on a stool before a large standard table by a bright window; she spreads out paper to write a letter to Student Zhang, who has just attained the highest honors in the imperial examinations (fig. 13.5). Through the delicate bamboo blinds we see a porcelain brush pot, water dropper, ink, inkstone, and three-mountain-peak brush rest lined up on the table. Behind Oriole, on a smaller table of identical design, we see the end of a zither. The smaller table, set against a deeper background to suggest the back of the room, is visible again through a round window. The maid Crimson waits nearby to give the letter to the messenger, who stands outside by a splendid garden rock. The address on his saddlebag, which lies on the ground in front of him, indicates that he is from the imperial Hanlin Academy. The whole picture is framed as though it were mounted on a partially unrolled hanging scroll with patterned borders of cranes and clouds, symbols of long life and good fortune. The illustration is extraordinary for its inventiveness, sophisticated beauty, and superb technique.

Because women spent much of their time in their bedrooms, large painting tables are often depicted near canopy beds, which provided convenient seats. In a 1617 illustration to the play *The Peony Pavilion (Mudan ting),* the sixteen-year-old Du Liniang paints her self-portrait from her reflection in a mirror (fig. 13.6). Painted after a dream encounter with a lover, this portrait is itself a kind of dream reflection rather than a realistic depiction. Soon she dies of lovesickness, but after three years her desire is so strong that she returns to the world of the living as a ghost and finds the lover of her dream.[8] In the illustration, the pensive Du Liniang leans on a large corner-leg painting table with horse-hoof feet. On the table are an incense burner, a brush pot, a water pot, an inkstone, and inks. Behind them the bed curtains have been drawn back for daytime sitting, but the bedclothes remain in a suggestive heap.

Large painting tables with corner legs, such as Du Liniang's, are called *huazhuo,* while those with recessed legs are known as *hua'an.* Wide tables are best

for brushing large pieces of paper and silk. Wang Shixiang used an exceptionally wide (102.5 cm) Ming dynasty recessed-leg painting table when writing his monumental books on classical Chinese furniture (fig. 13.7). Fashioned from massive pieces of dark *zitan*, it easily disassembles into eleven separate elements.[9] The size and weight of the members stabilize the table's mitered bridle joint construction. The legs are ten centimeters wide and have a deep slot in the top into which the thick *ruyi*-shaped cloud spandrels and high apron are inserted. The joint's strength comes from the spandrels, which are unusually wide and moreover are separate from the apron and tenon into it. The spandrels and archaistic feet are bold in design and are united by a continuous bead that runs along the edge of the straight apron and ends in an angular scroll in its upper corner.

Painting tables were prized possessions of the literati, who sometimes wrote inscriptions on them, just as they did on paintings and calligraphy, recounting their history and extolling their virtues. The table in fig. 13.7 has engraved on one of its long aprons an inscription written by Prince Pu Tong in 1907. He tells us that the table once belonged to the famous collector and connoisseur Song Xipi (Song Luo, 1634–1713). Following the example of Zhang Shuwei (Zhang Ting, 1768–1848), who engraved poems on a table that had once belonged to the famous Ming dynasty collector Xiang Molin (Xiang Yuanbian, 1525–90) and a *zitan* chair that had been owned by the Ming calligrapher and painter Zhou Gongxia (Zhou Tianqiu, 1514–95), Prince Pu Tong now inscribes his own treasured table:

> Formerly Zhang Shuwei had in his possession a table that once belonged to Xiang Molin and a *zitan* chair that once belonged to Zhou Gongxia. Zhang composed poems and had them engraved on the table and chair; the poems can be found in his collected works, *Qingyige ji*. This painting table I acquired from the Song family of Shangqiu [Henan]. Originally it belonged to Xipi. Since it is bequeathed by former scholars and is still in good condition, it should be treasured just like Xiang Molin's table and Zhou Gongxia's chair. I caress it and dust it with loving

13.6

FIGURE 13.6 Huang Yifeng (b. 1583). *Painting a Self-Portrait.* Woodblock illustration to the 1617 edition of Tang Xianzu's *Peony Pavilion* (*Mudan ting*). Height 20.7 cm, width 13.1 cm.

FIGURE 13.7 Painting table. Ming dynasty. *Zitan* wood. Height 83 cm, length 192.8 cm, width 102.5 cm. From Wang Shixiang, *Classic Chinese Furniture*, 174–75.

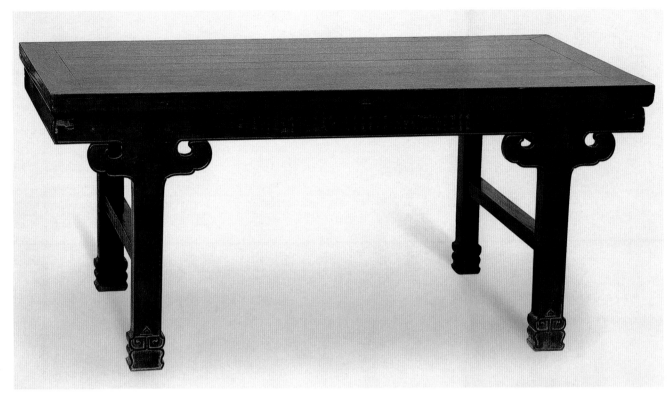

13.7

care, secretly delighted to be destined to own it. Therefore I write a few sentences to express my respect for the former scholars. Inscribed by Xiyuan, Lazy Tong, on an autumn day in the year *ding wei* [1907].[10]

Painting tables were especially prized by the scholar-artist because he created his masterpieces on them. It is not surprising, then, to find that most of the known pieces of inscribed furniture are painting tables. These inscriptions, like the colophons on paintings, record the provenance of the table and praise its excellence. A small standard recessed-leg painting table in the Nanjing Provincial Museum, made of *huanghuali* with a *tieli* wood top, has a laudatory poem that was engraved on the leg in 1595:

> The material is beautiful and strong, the workmanship pure and graceful. I will lean on you and you will comfort me for 100 years.
> Written by Old Chongan in the first month of 1595 in the reign of Wanli.[11]

An inscription is also found on an unusual small painting table made of red lacquered softwood in the Yangzhou Museum. It is a recessed-leg table with mitered bridle joints. The legs have a bead down their centers and end in a shape derived from the Song cloud-head foot. High humpback stretchers touch the apron, and the center of each curved part is ornamented with a *lingzhi* fungus. There are double stretchers on both sides. On one long side of the table the top overhangs the apron by ten centimeters more than on the other side. This unique feature gives more leg room to the person seated on that side. The top has a beaded rim and an inscription on the left written by the owner, Wang Tingzhang, in 1745:

> The decoration was inspired by an ancient cart, the construction by the jade table. As you lean on it, the surface exudes a misty glow. Day after day and night after night it stays the same, with a painting on its left and a history on its right and sometimes with a *qin* on its surface as I sip my wine. I esteem and prize it for

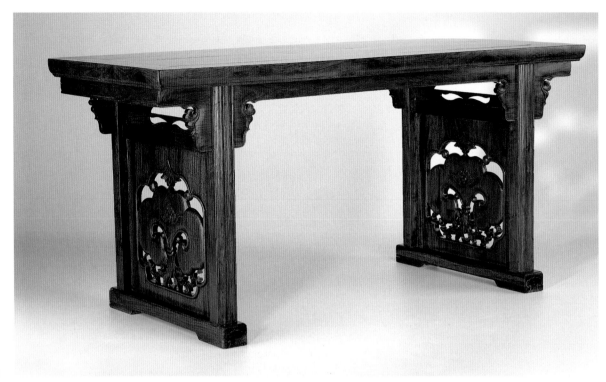

13.8

it represents the best of civilized life. I bequeath it to my descendents forever and ever. In the summer of the 10th year of Yichou written by Wang Tingzhang.[12]

This inscription is important because it states that the table was specially designed by the owner, rather than being a standard shop model, which accounts for its unconventional overhang. Moreover, the date is unexpected because, as Wang Shixiang points out, we would tend to assign a table of this form to the mid Ming or earlier, and the decorated high humpback stretchers are related to those on an early table excavated from the tomb of Zhu Tan (d. 1389).

Finally, in the Palace Museum, Beijing, there is a *zitan* writing table with eight drawers that has the names of many Qing dynasty painters and calligraphers engraved on the legs and frame. Although the inscription does not include a date, we know that one of those listed, Tang Yifen, died in 1853.[13]

Wang Shixiang's inscribed *zitan* painting table has unmitered bridle joints and a single stretcher on each

side. Painting tables with unmitered bridle joints can also have large carved side panels set into a foot base. One, in the Nelson-Atkins Museum of Art, is fashioned from *huanghuali* wood of a mellow golden color with broad, irregular grain patterns (fig. 13.8). The top consists of four long butt-joined boards supported by a long horizontal brace and four short dovetailed transverse braces. The apron and curvilinear spandrels, decorated with a leaf motif, are made from a single plank of wood and edged with double beading. The front face of each leg has double-beaded edges and a slightly convex profile depressed in the center by two vertical lines of beading. Small *ruyi* shapes ornament the short sides of each foot base. This motif repeats on a much larger scale in each of the openwork side panels, where a slightly convex *ruyi* is decorated with an upside-down bat, a rebus meaning "happiness has arrived." There are curling leaves at the base of the *ruyi,* and the carving is framed by a beaded-edged cartouche. The panel is inset between the feet and a high horizontal stretcher, above which is a narrow panel with a curving cutout decoration. The side panels enable this type of table to have more decoration than is usually found on recessed-leg tables. In this example the ornamentation is especially effective, with bold motifs united by the lilting curves of their edges. A similar table, but with everted flanges, was called *tianranji* in the early sixteenth century, according to a labeled illustration in the *Pictorial Encyclopedia of Heaven, Earth, and Man* and a written description by Wen Zhenheng. The term *tianranji* is still used in south China for recessed-leg painting tables.[14]

Among extant painting tables, recessed-leg models are more common than those with corner legs. The corner-leg construction permits a slender minimal design with a great deal of leg room, as shown in a large *zitan* painting table in the Zhejiang Provincial Museum. Wang Shixiang traces the ownership of the table back to the famous Manchu scholar and *qin* player Foniyingbu, who bought it from the Manchu bannerman Zhu, a descendant of the Duke of Cheng of the Ming dynasty.[15] It is fashioned from slender members with flush surfaces and is profusely deco-

rated with *chi* dragons beautifully carved in relief. The graceful movement of the dragons, which are different in form and expression from those usually found on furniture, creates an undulating surface pattern: a pair of dragons rush toward each other in the center of the apron; small twisted dragons cover the corner miters; a dragon soars up each leg and another swoops down so that its head becomes the horse-hoof foot. The contours of the dragons' bodies form the unusually complex outlines of the inner edges of the table. This complexity of the inner edges contrasts with the table's straight, right-angled outer edges to create a lively decorative variation on the basic straight-form table.

Such large straight-form tables are, however, rather unstable because the mortise-and-tenon joints between the legs and tabletop are not strong. To provide stability without interfering with the legs of someone seated at the desk, curved corner braces were often used. Although few straight-form tables without corner braces survive, they have a pleasing simplicity of form and frequently appear in paintings and woodblock illustrations. For instance, in one of the illustrations in *The Cheng Family's Ink Catalog* (*Chengshi moyuan*), a dreaming scholar rests his head on a plain corner-leg desk with horse-hoof feet and flush surfaces (fig. 13.9). The illustration is a design for an ink cake, which, together with the inkstone, brush, and paper, is one of the "four treasures of the library" (*wenfang sibao*). These four utensils—all essential for painting and writing—are often valued art objects in themselves. There is an extensive literature about their history, characteristics, and connoisseurship. Shexian, in Huizhou prefecture, southern Anhui province, was the center for ink manufacture in the late Ming, and Cheng Dayue (1541–c. 1616), who in 1606 published *The Cheng Family's Ink Catalog,* was one of the region's three leading ink makers. To make ink they burned resinous pinewood to obtain carbon and then added vegetable, animal, or mineral oil and glue; they sometimes also mixed in exotic substances according to secret formulas—adding fragrant musk, for example, or ground pearls, jade, or gold. They then

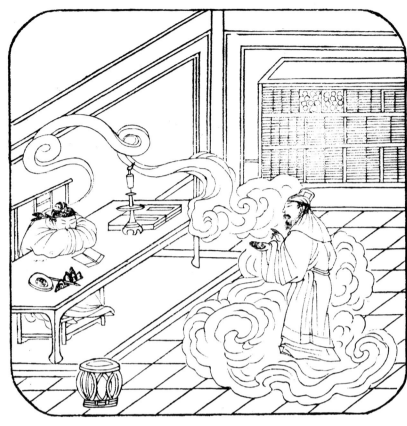

FIGURE 13.9 *Dreaming Man Abandons His Ink*. Woodblock-printed design for ink cake. From Cheng Dayue, *Chengshi moyuan* (The Cheng family's ink catalog) (1606), 8: 21b. Courtesy the East Asian Library, University of California, Berkeley.

13.9

placed the mixture in carved wooden molds to dry. Ink cakes with elaborate shapes and designs, like those illustrated in *The Cheng Family's Ink Catalog,* were collector's items not intended for use. Today, therefore, we still occasionally find Ming ink cakes made by Cheng Dayue.

The Cheng Family's Ink Catalog is famous not only for the beauty of its ink-cake designs but also as an example of superb woodblock printing. Cheng was one of the first to experiment with printing in four or five colors. The book also contains four woodcuts of Biblical pictures, which are the earliest examples of Western graphics in a Chinese publication. Moreover, in this book we find the oldest major romanization system for Chinese, devised by the Italian Jesuit missionary Matteo Ricci (1552–1610), who wrote the phonetic Portuguese spelling next to the Chinese text of his three essays. The well-known painter Ding

Yunpeng (active 1584–1618) drew most of the illustrations in *The Cheng Family's Ink Catalog*. Huang Lin (b. 1564), Huang Yingtai (1583–1642), and Huang Dao—members of the renowned Huang family from Qiucun village in Huizhou district—carved the woodblocks. Both sides of each ink cake appear in the catalog; one side had a picture and the other usually had an inscription or seal. In addition the book contains poems, essays, and eulogies from contemporary artists and scholars.[16]

The ink-cake design in fig. 13.9 depicts a dreaming scholar who has fallen asleep over a book and temporarily abandoned his ink. It undoubtedly refers to the story that Cheng Dayue found his special ink-cake formula for mixing oil and lacquer in a dream.[17] The painting table bears a brush rest and brush, inkstone, books, and a burning candle to indicate that it is night. The scholar sits on a yokeback chair with his

feet resting on the front stretcher. Both the chair and the table are elevated on a low wooden platform. Although no examples of these platforms have survived, they appear in several illustrations. For instance, a woodblock in the 1681 edition of *Imperial Edicts, Illustrated* (*Shengyu xiang jie*), in the Spencer Collection in the New York Public Library, shows a magistrate seated at his desk, which is elevated on a platform. They were also used beneath other types of furniture, such as the single bed, table, and stool in a painting illustrating *The Story of the Western Wing,* which is part of an album attributed to Qiu Ying (c. 1494–c. 1552) in the Rare Book Room of the East Asian Library, University of California, Berkeley.[18]

In the study depicted on the ink cake, there is a round stool next to the platform, and a bookcase filled with scrolls and books stands against the wall. Usually scholars would have used a footstool when sitting at their painting tables. In a woodblock illustration to the section on footstools in the *Classic of Lu Ban,* a scholar is reading at a corner-leg painting table with "giant's arm" braces (fig. 13.10). His feet rest on a footstool with corner legs and horse-hoof feet. Two other recessed-leg models with side stretchers appear in the foreground. One is what Gao Lian (active 1580–1600) calls a *gundeng,* "roller stool." Since the *Classic of Lu Ban* does not discuss the different models, we have to turn to the writings of Wen Zhenheng (1585–1645) and Gao Lian for information about this curious type of footstool. The top of the stool is divided into two open sections, each fitted with a cylindrical roller. The scholar sat before the footstool and placed each foot on a roller, rotating it to stimulate the acupuncture points on the bottom of the feet, thereby improving his circulation and sense of well-being. Roller stools sometimes have four rollers instead of two.[19]

One *huanghuali* example of the four-roller model is waisted and has horse-hoof feet with beaded inner edges extending along the straight apron (fig. 13.11). The rollers taper toward the sides and pivot freely. This type of pivot is clearly visible in the woodblock illustration in fig. 13.10 as well. In the Ming, roller

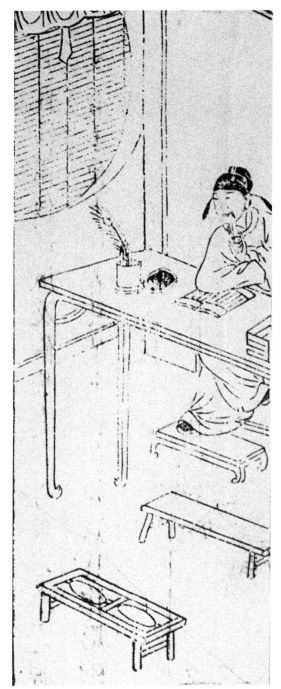

13.10

FIGURE 13.10 Woodblock illustration to the *Classic of Lu Ban* (*Lu Ban jing*). Ming dynasty, c. 1600.

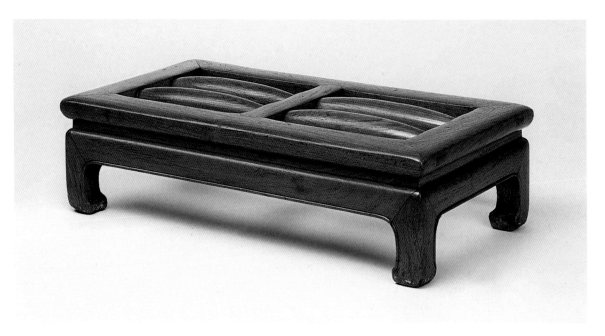

13.11

stools were always separate pieces of furniture, but later, in the Qing, they were sometimes built into the desk between the drawer pedestals.[20]

In fig. 13.10 the desk is near a round window and its surface is clean and orderly, with neatly arranged books, an inkstone, and a pot containing a peacock feather (a symbol of dignity, beauty, and official rank). This arrangement is a visual depiction of the phrase "a clean table by a bright window" (*ming chuang jing ji*), which suggests the ideal environment of the cultivated gentleman. The Northern Song literati were the first to use this four-character expression. The calligrapher Su Shunqin (1008–48) said that "one of the joys of life is having a clean table by a bright window, brush, inkstone, and paper."[21] Here the painting table has achieved an importance equal to that of the four treasures of the library. It is part of the setting in which the literati worked and, with like-minded friends, enjoyed their collections of calligraphy, painting, and ancient bronzes. It is the surface on which they wrote, painted, and played the zither. In *Paltry Earnings in the Immortals' Service* (*Dongtian qinglu ji*)—the predecessor of the Ming

treatises about the objects surrounding a cultivated gentleman—the thirteenth-century connoisseur Zhao Xigu wrote: "When the clean table by a bright window is set in order, seals and incense laid out, and fine friends stand reflecting one another like jade, then take the wondrous works of the masters of past time to contemplate the bird, seal, and snail scripts, the singular peaks and distant waters. Stroking the bells and tripods, personally gaze on the Shang and Zhou. When the spring of water flows in the Duan stone ink slab and a zither of scorched *tong* wood gives forth the sound of jade pendants, one is no longer aware of dwelling among men. This may be termed the pure blessing of the utensils of the leisured. What can go beyond this?"[22]

The words "a clean table by a bright window" evoke the refined implements used in writing and painting, the enjoyment of art objects, and the act of creating. They also connote the simple pleasures of the literati life, as the painter Bada Shanren (1626–1705) wrote when he was sixty-eight years old: "I have a clean table under a bright window. My book closed, I burn some incense. When I feel that I understand something, I am happy and smile to myself. The guest arrives, but we do not stand on formality. I brew cups of bitter tea, and together we enjoy some wonderful literature. After a long while, the rays of the setting sun light up the room, and I can see the moon rising above the pillars of my hall. The guest departs, crossing the brook in front of my house. I then call my boy servant to close the door and put down my rush cushion. I sit there quietly for a while, feeling carefree and content, my mind carried far away."[23]

Bada Shanren's studio is a retreat where he can meditate or entertain friends. Ideally, the studio should be surrounded by hills and overlooking a stream, with bamboo, pines, prunus, and fragrant herbs growing all around.[24] As soon as you enter the room, you are delighted by a sense of lofty elegance without a trace of vulgarity, writes Wen Zhenheng in his *Treatise on Superfluous Things*. The table is carefully positioned near the window to avoid the wind and the sun. On the table it is best to place the inkstone under the lamp or on the left side so that the reflection from the ink will not irritate the eyes. It is appropriate to put a fantastic stone or maybe a tray landscape on the painting table, but avoid anything made of red lacquer. Flowers should never be put on a painting table; small vases of flowers, however, may be set elsewhere in the studio. In the spring and summer the vases should be porcelain, while bronze is used in the fall and winter. In winter cotton should be hung over the window frames, but use only blue or purple.[25]

Wen was a member of the cultural elite, a cultivated connoisseur with refined taste who delighted in his material surroundings. His studio (*zhai*), or study (*shufang*), was at the center of this world, a retreat where he read, wrote, painted, and entertained close friends. A studio was separated from the women's quarters and was often furnished with a bed so that the master of the house could spend a night apart from his wives and concubines. Until the late sixteenth century such studios were found only in the homes of the literati. Then, as Fan Lian noted in 1593, petty officials began to add a study to their homes and to equip it with expensive hardwood furniture. "They called it the study," wrote Fan. "However, I really do not know what books they studied!"[26]

The Plum in the Golden Vase (*Jin ping mei*), which depicts life in sixteenth-century China when the Ming dynasty was disintegrating, contains a wonderfully ironic description of Ximen Qing's study. Ximen Qing, the hero of the novel, is a corrupt upwardly mobile merchant living in a small provincial town. He is portrayed as virtually illiterate, yet his study has all the trappings of high culture. There are landscape paintings by famous artists, a black lacquered zither, antique incense burners, and bookcases lining the walls. But everything is wrong. The paintings in gaudy mountings hang opposite each other, a practice that Wen Zhenheng considered especially vulgar. The furniture, such as the canopy bed in the center of the room made of black lacquer inlaid with gold and embellished with marble panels, is elaborate and ostentatious.[27]

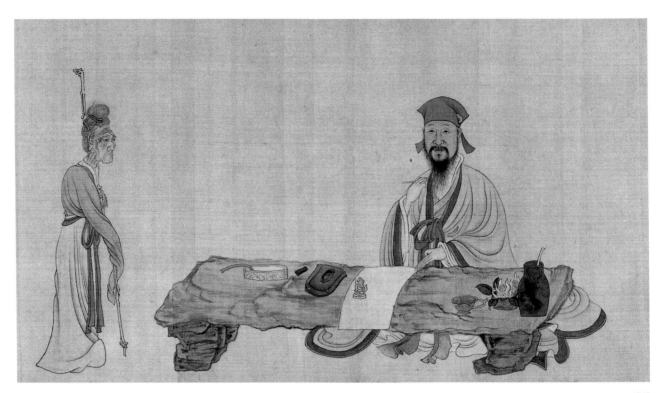

13.12

FIGURE 13.12 Chen Hongshou (1599–1652). *The Knowledgeable Old Crone*. 1649. Detail of the handscroll *The Four Pleasures of Nan Shenglu*. Ink and color on silk. Height 31 cm, length 289.5 cm. Drenowatz Collection, Rietberg Museum, Zurich. Photograph by Wettstein & Kauf.

In China gardens are considered the ideal setting for artistic endeavors. The garden is a microcosm of the natural world where one can partake in the delights of wandering among streams and mountains. It nourishes the spirit and provides a retreat, even in the middle of a city, from the bustle of daily life. It is the perfect spot for quiet contemplation, writing, painting, or elegant literary gatherings.

A desk made from natural stone is especially appropriate for outdoor use because it harmonizes naturally with the surroundings and can be left permanently outdoors. Moreover, it echoes the fantastic rocks that are a prominent feature of Chinese garden design. Chen Hongshou (1599–1652) shows such a desk in his *Knowledgeable Old Crone*, a scene in his 1649 handscroll *The Four Pleasures of Nan Shenglu* (fig. 13.12). Chen made the painting for his friend Nan Shenglu, whom he depicts in the guise of the famous Tang poet Bo Juyi. Both men, Chen writes in an inscription at the end of the scroll, were officials

in Hangzhou and had "a spiritual correspondence spanning a thousand years" in their refinement, simplicity, and understanding of Daoism and Buddhism. The style is archaistic in its fine outlines and absence of background, both characteristic of Tang painting. Yet the realism of the faces and the shading and brushwork of the table, the dress, and the objects on the desk are all typical of the mid seventeenth century. Chen Hongshou wrote the title and a poem to the right of the scene:

> When the poet tries too hard, racking his brain,
> His work will lack a natural grace.
> Thus the monk who is a connoisseur of lute music
> Must yield to this old crone.[28]

Here Chen refers to both poets, Nan Shenglu and Bo Juyi. The old crone is an allusion to a legend about Bo Juyi. Bo was a popular poet because he wrote about the sorrows of his time in plain colloquial language that everyone could comprehend. It was said, therefore, that whenever he finished a poem he read it to an old woman, and if she could not understand something he would rewrite it in simpler language. After finishing his poem, Chen asked his friend Tang Jiujing to write a companion poem, using the same subject, rhymes, and form of four lines of five characters each. Later he asked the monk Miyin to write a third poem.

The Knowledgeable Old Crone is concerned with poetry, while the other three scenes of the handscroll deal with wine, music, and Buddhist meditation. The whole subject derives from an autobiographical essay, "Life of the Master of Wine and Song" ("Zuiyin xiansheng zhuan"), that Bo Juyi wrote when he was sixty-seven and living in retirement. Bo's essay is itself modeled after "Life of the Master of the Five Willows" ("Wuliu xiansheng zhuan"), by Dao Qian (365–427).[29] Chen Hongshou's painting is, therefore, full of complex allusions to the past that combine with purely seventeenth-century references and techniques to create a great original work of art. Such handscrolls were a form of communication between the members of an elite group who were the scholars, writ-

ers, artists, and officials of China. Each was created on a wooden desk or, like Chen's painting, on a stone table in the garden.

Not all stone garden tables are as rustic as those Chen Hongshou liked to paint. Often they comprise three rectangular blocks of carved stone. In one of the ink-cake designs in *The Cheng Family's Ink Catalog,* this type of stone table stands beneath a willow tree by a balustrade overlooking a pond (fig. 13.13). A man sits deep in thought, preparing to make the first brushstroke on the paper spread before him. Two weights keep the paper in place; a triple-mountain-peak brush rest, an ink stick, and an inkstone are nearby. The design has the title "ink pond" (*mochi*), which refers to the pond by the desk as well as the ink pond of the inkstone. The depression filled with water, called "inkstone pond" (*yanchi*) or "water pond" (*shuichi*), is distinct from the flat surface of the inkstone where the ink is rubbed.[30]

Chinese paintings often show wooden furniture that has been moved out into the garden for parties or solitary enjoyment. Many elegant gardens were famous because of the celebrated social gatherings that took place in them, and such gatherings became a favorite subject of painting. On these occasions the cultured elite painted, wrote poetry, and displayed their art collections. In Qiu Ying's album leaf *Evaluating Antiques in the Bamboo Courtyard,* the Song dynasty literary and artistic luminaries Su Shi (1036–1101) and Mi Fu (1052–1107) study an album of fan paintings (fig. 13.14). The large corner-leg painting table with Song-style cloud-head feet has been spread with a brocade cloth in honor of the occasion. Three other large tables—two standard recessed-leg models and one corner-leg table with "giant's arm" braces—are covered with ancient bronzes, a zither, and other antiquities. Su and Mi sit on slender lowback armchairs fashioned from speckled bamboo, and their friend sits on a round cane stool. Large screens decorated with landscape paintings separate their space from the rest of the garden. On the other side of the screen a servant tends the stove, and in the distance another sets up a stone table for a game of *weiqi.* Still more serve

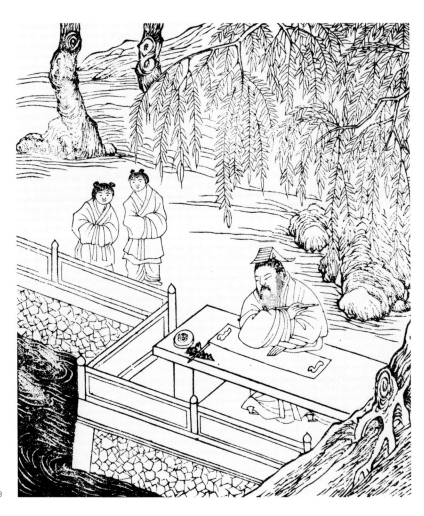

13.13

FIGURE 13.13 *Ink Pond.*
Woodblock-printed design
for ink cake. From Cheng
Dayue, *Chengshi moyuan*
(The Cheng family's ink
catalog) (1606), 9:15b.
Courtesy the East Asian
Library, University of
California, Berkeley.

FIGURE 13.14 Qiu Ying
(c. 1494–c. 1552). *Evaluating
Antiques in the Bamboo
Courtyard.* One of ten leaves
in *A Painted Album of Figures
and Stories.* Ink and color on
silk. Height 41.1 cm, width
33.8 cm. Palace Museum,
Beijing. From *ZGLDHH,
Gugong* 6: 49.

the company refreshments and bring in bundles of
scrolls.

Emperors and commoners alike used small painting
tables as well as large ones. Emperors often favored
more ornate models. An informal portrait of the
Kangxi emperor (r. 1662–1722) when he was about
thirty shows him seated at an elaborate black lac-
quered corner-leg table elegantly decorated with gold
dragon, plant, and geometric patterns (fig. 13.15). The
table gains strength from a humpback stretcher placed
high enough to avoid the emperor's knees. On the
top and aprons are Dali marble panels with natural
figurations resembling mountain landscapes. This lux-
urious table is just large enough to hold a sheet of pa-

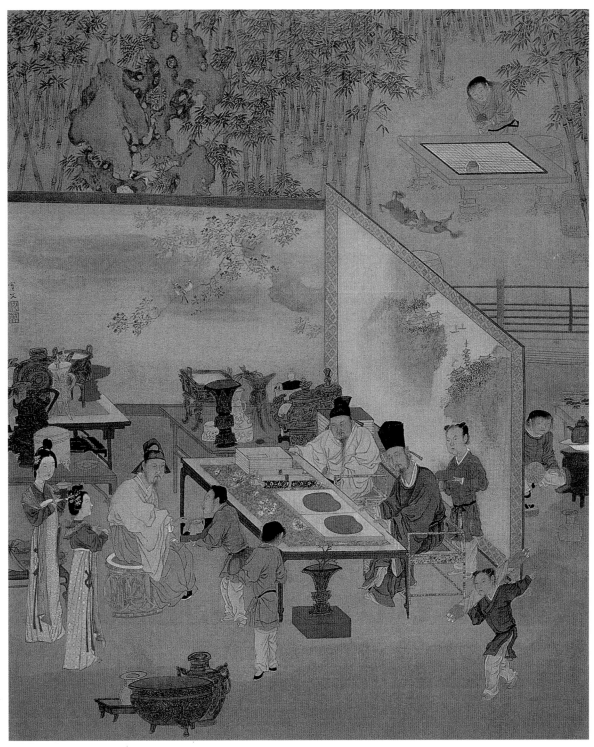

13.14

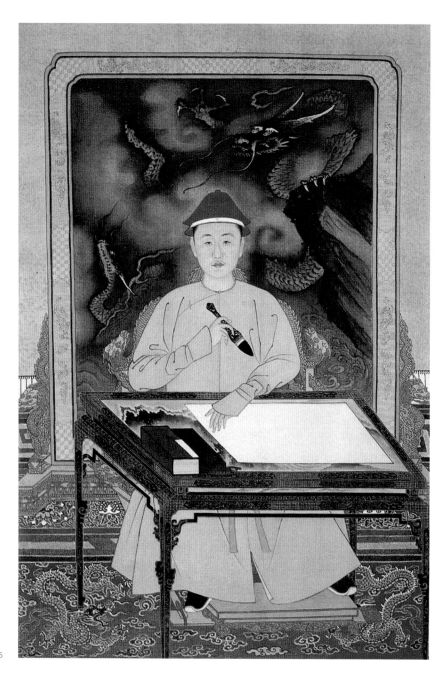

13.15

FIGURE 13.15 *Portrait of the Kangxi Emperor Writing.* Qing dynasty, r. 1662–1722. Hanging scroll. Color on silk. Height 50.5 cm, width 31.9 cm. Palace Museum, Beijing. From Wan Yi, *Daily Life in the Forbidden City,* 207.

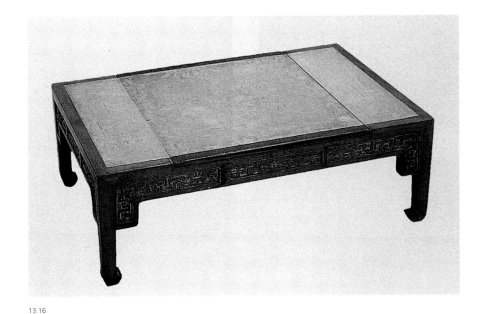

FIGURE 13.16 The mathematics desk of the Kangxi emperor. Qing dynasty, r. 1662–1722. Cedar with silver top. Height 32 cm, length 96 cm, width 64 cm. Palace Museum, Beijing. From Wan Yi, *Daily Life in the Forbidden City,* 214.

13.16

per, an inkstone, a water dropper, and a book. The emperor grasps a large brush with a porcelain handle. He was a proficient calligrapher who wrote his own edicts and regularly practiced calligraphy by copying the ancient styles.[31] Here he sits on a gilt folding armchair placed on a carpet in front of a standing screen. The dragons decorating his chair, carpet, and screen symbolize imperial power.

The Kangxi emperor was interested in Western mathematics, which he learned from Verbiest and other Jesuits who had official positions in his court. Today in the Forbidden City visitors can still see the emperor's mathematics desk (fig. 13.16). It is a cedar corner-leg *kang* table with horse-hoof feet and an archaistic angular pattern carved on the aprons. The top is inlaid with silver engraved with about a dozen arithmetical and scientific charts and tables. The top lifts off to reveal several small removable compartments for holding implements such as compasses and rulers. This *kang* table is a desk with a specific function, but any large *kang* table could be used for writing. In the bitter northern winters it was certainly more pleasant to write sitting snugly on the heated *kang* than standing on the cold brick floor before a table.

The Chinese did not consider drawers necessary in painting tables or desks. They kept small frequently used objects in boxes or trays nearby; things used less often they stored in large cabinets. In collections of classical Chinese furniture there are some small tables with drawers, but they were not necessarily used for writing. In the West drawers are an essential component of a desk, but we must be careful not to assume that any Chinese table with a drawer is a desk.

According to paintings and woodblock illustrations, small tables with drawers were often used as side tables. An illustration to *The Plum in the Golden Vase,* for example, shows one standing against a wall in the women's quarters holding a small domestic shrine (see fig. 14.12). They were also used as dressing tables. The illustration accompanying a description of a three-drawer model in the *Classic of Lu Ban* shows a woman using it as a dressing table while fixing her hair in front of a mirror. Tables of these dimensions did not make ideal desks for the Chinese scholar-artist and were only occasionally used as such. In an illustration of a silk shop in chapter 60 of *The Plum in the Golden Vase* we see the back of what must be, because of its construction, a table with drawers used as a desk by the shopkeeper. A book lies on it, and a small table screen provides some privacy in this pub-

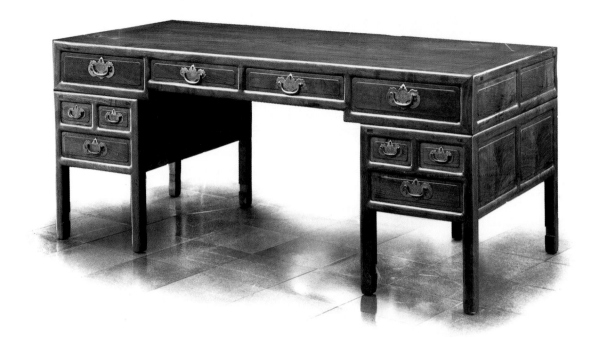

13.17

FIGURE 13.17 Laurence
Sickman's desk. Qing dynasty,
eighteenth century. Wood.
Height 85 cm, length 175.7 cm,
width 76.8 cm. The Nelson-
Atkins Museum of Art,
Kansas City, Missouri.
(Gift of Elizabeth Hay Bechtel.)

lic setting. The unconventional Li Yu was obsessed
with the usefulness of drawers and advocated having
them in writing tables. There is a clear reference to a
table with drawers used as a desk in chapter 81 of the
mid-eighteenth-century novel *The Story of the Stone*
(also known as *A Dream of Red Mansions, Hong lou
meng*): Bao-yu sits near the window at a small *huali*
desk (*xiaozhuo*) with a drawer into which Tealeaf puts
paper, ink, brush, and inkstone.[32]

Desks with drawers became common only in the
late Qing, possibly as a result of Western influence.
There were kneehole desks, such as the *hongmu* four-
drawer one with a cracked-ice patterned footrest in
the collection of Mr. and Mrs. John Bunker.[33] And
there were pedestal desks like the one Laurence Sick-
man used in his office in the Nelson–Atkins Museum
of Art (fig. 13.17). Sickman's has two drawers in each
pedestal and a row of four drawers beneath the top,

which is tenoned into the pedestals and lifts off for easy moving. Originally there was a lattice panel at the bottom of each pedestal. These eighteenth- and nineteenth-century pieces are desks in the Western sense rather than traditional Chinese painting tables.

In the West desks are for writing and have drawers for storing such things as pens, paper, and address books. Easels are used for painting. As we have seen, the Chinese used a large table for both painting and writing. This "clean table by a bright window" also symbolized creation. As a *tabula rasa* it suggests a spiritual purging, a necessary clearing away of earthly trivia to focus on the unknown and the new—a meditation or an epiphany. When that spiritual, intellectual, and emotional revelation assumes a material aesthetic form—appropriate to the table of creation—the result is a poem or a painting.

14 | THE SIDE TABLE
A Surface for Treasures and Gods

Among the most formal pieces of Chinese furniture is the so-called altar table, a long and narrow table with carved side panels and everted flanges. Since the late 1960s Western writers and dealers have called this imposing side table an "altar table," thereby distinguishing it from smaller types of side tables. The name is misleading, however. Pictorial depictions indicate that, although on occasion these tables might serve as altars, they were usually simply side tables. Placed in the center of the back wall in a main hall, one of these extraordinary side tables dominated the room. Above it hung a single scroll, or a scroll flanked by narrow calligraphic scrolls, and a few treasured possessions were placed on its surface. Thus the table, like the mounting of the scrolls, served to support and display. The three-dimensional objects elevated on the table and the pictures or writing elevated by their mountings became accessible for contemplation and evaluation and were prominent indicators of the taste, status, and wealth of their owners. These side tables, unlike other tables, have more to do with human contemplation than human activity. Painting tables hold ink, silk, brush, and inkstone for the act of painting or writing. Square tables hold food, and when the meal is finished the dishes are taken away. But the treasures on a side table remain even when the eye no longer contemplates them.

Certain features of the so-called altar tables have long been associated with ritual furniture. Decorations on bronze *yi* vessels of the Eastern Zhou (770–221 B.C.) depict high tables with wine jars. Some altar tables have upturned ends, precursors of the later everted flanges. An illustration found on a fragment of an Eastern Zhou *yi* vessel shows one such table in the center of the top floor of a two-story building (fig. 14.1). With three recessed legs, the table supports three large wine jars, two of which have long ladles lying over their mouths. A man turns away from the table to welcome a visitor entering the building. This scene depicts one of the many rituals crucial to all political and social interchanges at the time. It is a schematic, symbolic representation that repeated with some variations for sacrifices, laudatory banquets, and other ritual occasions. The large high table gives status

and dignity to the ceremony, especially because at the time people commonly sat on mats on the floor and used low tables.

Although no early high tables have been found, excavations have uncovered a number of low tables, including a small lacquer table with large upturned ends (see fig. 11.2). The creatures decorating its surface are magical symbols that facilitate communication with the spirits and are typical of the Chu shamanist tradition, which, unlike the sedate rituals of the Zhou, used ecstatic performances and wild imagery.[1] From texts describing Zhou ancestor worship, however, we can identify this type of table as a *zu* used to hold meat offerings. The funerary ritual involving the *zu* represented a communication between the living members of a kin group and their ancestors and took the form of a banquet to which the ancestral spirits were invited. A prescribed ritual verbal exchange took place between the descendants and an impersonator (one of the descendants who hosted the spirit of a deceased ancestor) in which the offerings were presented and received.[2] Since the ancestors consumed only the essence of the offerings the living enjoyed the rest at a lively banquet where a good deal of wine was consumed.

Among the Buddhist cave paintings at Dunhuang are many images of deities and sages with tables placed in front of them. Some of these high tables have upturned ends and on each side a number of curved legs set into base stretchers. Cave 103, for example, contains an eighth-century depiction of the sage Vimalakīrti's famous debate with the bodhisattva of wisdom, Mañjuśrī; one carefully delineated table in front of the sage has boards between each of the five recessed legs, giving the effect of a single ribbed panel at either end of the table (see fig. 10.4). The top comprises four boards with clearly visible grain patterns, and small rectangular blocks create the flanged effect at each end. In the center of the table is a large and elaborate incense burner. The Buddhist world is suffused with clouds of wondrously fragrant incense, creating magical realms that uplift and purify the spirit. Incense carries the piety and desires of wor-

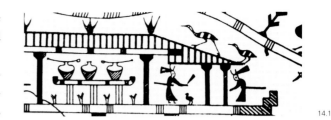

FIGURE 14.1 Engraved fragment of bronze *yi* vessel. Eastern Zhou (770–221 B.C.). Excavated from Changzhi, Shanxi. Drawing from Shanxi Sheng Wenwu guanli weiyuan hui, "Shanxi Changzhi Fengsuiling gu mu de qingli," p. 109, fig. 2.

shipers to the gods and brings down the deities' purifying breath. It creates the mood necessary for the great debate between the bodhisattva and the learned layman and spreads their wisdom throughout the world.

The table in the Dunhuang painting, the excavated piece (see fig. 11.2), and the one engraved on the bronze vessel (see fig. 14.1) are but three examples of the various types of tables used in ancient rituals. These tables are the precursors of later so-called altar tables. A typical Ming altar table, such as a *huanghuali* example in the Mimi and Raymond Hung collection, exhibits the high narrow form of the table on the bronze *yi*, side panels evolved from the table in the Dunhuang mural, and the upturned ends seen in all three ancient examples (fig. 14.2). The top of this magnificent table is fashioned from a single piece of wood more than three meters long. (Few of these long solid-board tops remain intact today because of the practice of cutting them down to a size considered more useful in the modern world.) Separate upward and outward curving pieces of wood conceal the ugly end grains of the top board. These everted flanges give definition and presence to the table and are a sophisticated refinement of the upturned ends first seen on the table depicted on the Eastern Zhou bronze. A concave molding delineates the lower edge of the tabletop, extends down the center of each recessed leg, and runs along the top edge of each foot base. The stan-

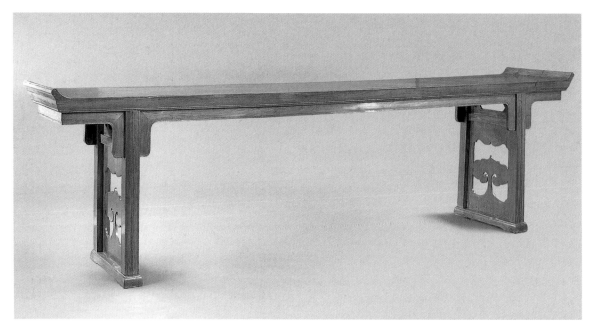

FIGURE 14.2 Side table. Ming dynasty, 1550–1600. *Huanghuali* wood. Height 92.1 cm, length 325.2 cm, width 52.1 cm. Mimi and Raymond Hung collection.

FIGURE 14.3 Detail of a side table. Late Ming dynasty, 1640. *Tieli* wood. Height 89 cm, length 343.5 cm, width 50 cm. Palace Museum, Beijing. From Ecke, *Zhongguo huali jiaju tukao*, 123.

FIGURE 14.4 *Auntie Xue Proposes a Match with Meng Yulou*. Ming dynasty. Woodblock illustration to *The Plum in the Golden Vase* (*Jin ping mei*), Chongzhen reign period (1628–44), chap. 7.

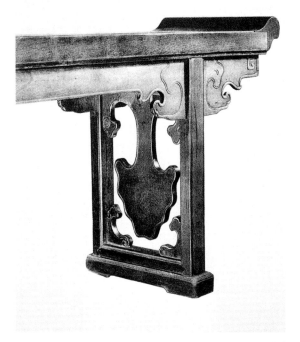

dard spandrels and aprons are fashioned from separate pieces of wood. Bold side panels—each carved with a single large upright *lingzhi* fungus of immortality within an arched openwork frame—emphasizes the great length of the table, with the *lingzhi* silhouetted dramatically against the open space.

A variation of the single *lingzhi* fungus motif is found on a rare dated table in the Palace Museum, Beijing (fig. 14.3). Under the tabletop an incised inscription reads: "Made in the midwinter of the Gengchen year of Chongzhen at the Kang District Government Office [*Chongzhen gengchen zhongdong zhi yu Kang shu*]." Thus we know that it was made in 1640 in Deqing county, Guangdong province. In 1944 Gustav Ecke published the table in *Chinese Domestic Furniture*. At that time it belonged to Lun Gu Zhai, an antique shop owned by the Xiao family on Liulichang, the Beijing street famous for its antique dealers and bookshops. The Palace Museum bought it in 1950.[3]

This exceptionally large table is fashioned from massive pieces of *tieli* wood and has large rounded everted flanges. *Tieli* is the tallest Chinese hardwood tree and its wood the least expensive. *Tieli* wood is durable with a coarse texture and a distinctive open thick-lined grain. Because the long top of the Beijing table is a solid piece of wood over eight centimeters thick, a concave section has been removed from underneath to lessen the weight without changing the outward appearance. Cloud motifs in low relief decorate the spandrels, and a wide bead runs along the edge of apron and spandrels, ending in an angular curl. On each side of the table is a large pendant cloud, a motif based on the *lingzhi* and resembling the *ruyi* wish-granting scepter. The cloud is suspended between two cloud-shaped spandrels and framed by the legs and a low stretcher, which rests on the foot base and double-tenons into the legs. There are also cloud-shaped spandrels at the juncture of the legs and low stretcher. This construction is different from that on the Hungs' table, where a panel has been carved out in a *lingzhi* shape and inserted between the legs and the foot base.

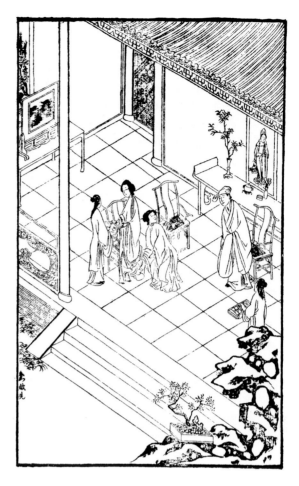

14.4

The type of table in figs. 14.2 and 14.3 served primarily as a side table, although it could also be a domestic altar table. Illustrations to *The Plum in the Golden Vase* (*Jin ping mei*), which show tables similar to the one in the Hung collection, depict both functions. In the woodblock illustration to chapter 7, one such table stands against the back wall of a reception hall (fig. 14.4). In the foreground the matchmaker, Auntie Xue, introduces Ximen Qing to Meng Yulou, the young widow of a wealthy textile merchant. Meng Yulou has stood up to give her visitor a cup of tea flavored with candied kumquats. Taking advantage of the moment, Auntie Xue raises the lady's skirt to reveal to Ximen's delighted gaze her tiny feet clad in scarlet shoes with high white satin heels. A servant brings in a tray with the betrothal gifts—six gold

rings, a pair of jeweled hairpins, and ten embroidered handkerchiefs. The text describes the furnishings of the well-appointed hall:

> Auntie Xue pushed open the red latticework doors of the eighteen-foot-wide, south-facing reception hall, on the center of the back wall of which there hung in the place of honor a scroll depicting the Bodhisattva Guanyin of the Water Moon, accompanied by her attendant, Sudhana. Landscape paintings by well-known artists hung on the other walls. There was also a marble standing screen, to either side of which stood tall, narrow-necked, bronze vases of the kind used in the game "pitch-pot." All in all:
>
>> The chairs and tables were shiny, and
>> The screens and lattices were posh.[4]

The woodblock artist has captured the essentials of this setting, although he has made some changes. A table screen replaces the standing screen, and the bronze pitch-pot vases are not shown. The painting does not depict the Water Moon Guanyin, who sits on a rocky ledge above a swirling pool and has a large halo symbolic of the moon, but it does illustrate another manifestation of the bodhisattva known as Yulan Guanyin (Guanyin with a fish basket). Yulan Guanyin—young, beautiful, and alluring—is especially appropriate for the occasion.[5]

The painting hangs above a long formal side table that holds a few tastefully arranged treasures, including a large vase of flowers, an incense burner, a vase holding incense tools, and a small box for incense powder. The appropriateness and quality of these treasures reflects Meng Yulou's taste and wealth. Arbiters of taste, such as the Ming connoisseur Wen Zhenheng and the eighteenth-century collector Lu Shihua, warn that vulgarity must be avoided:

> On the table beneath the painting one may place such things as fantastic rocks, seasonal flowers, or miniature tray-landscapes; but avoid garish objects such as red lacquerware.[6]

> If one places on the table underneath artificially-aged bronze vessels, fans of peacock feathers or foreign-made striking clocks—then such surroundings must be pronounced a grievous locality for a good scroll to find itself in.[7]

The table beneath the painting occupies the central position in Meng Yulou's reception hall and is therefore more imposing in form than the simple corner-leg side table standing under the landscape painting hanging on the side wall. It is not surprising, therefore, that this form of table, with its bold *ruyi* side panels and everted flanges, serves as a temporary altar for the Sixth Lady's memorial services (see fig. 12.14).

Although formal side tables could be used as altar tables in the home, temples used a distinctive type of table for this purpose. These are the true altar tables of China, which twentieth-century Beijing craftsmen call *gongan* or *gongzhuo,* depending on whether they have recessed or corner legs. The fifteenth-century *Classic of Lu Ban,* under the heading "Buddhist and Taoist Temples and Monasteries," refers to them as *baozhuo* and says that they should be three *chi* six *cun* high, four *chi* deep, and their length equal to the height of the corner column of the hall in which they stand. They are considerably larger than other tables described in the *Classic of Lu Ban;* assuming that *chi* here indicates the carpenter's foot (in which 1 *chi* equals 30 cm), Lu Ban's standard *baozhuo* would measure 96 cm high and 120 cm deep. The text says, "Sometimes *tuojiao* legs with sculptured lions and elephants are made, sometimes floor-stretchers are fitted."[8] *Tuojiao* probably refers to cabriole legs that appear to emerge from animals' mouths, as on the *zitan kang* table in fig. 11.16. Altar tables are usually ornate with high waists and cabriole legs that often stand on a base or base stretcher. They are large and massive, with long drawers extending along the length of the table for storing incense sticks.

In temples altar tables stand in front of representations of the deity, as in a Qing painting illustrating *The Story of the Western Wing* (fig. 14.5). The scene takes place in the Monastery of Universal Salvation, where Oriole and her mother are resting on their way to bury Oriole's father. Student Zhang, journeying to take the imperial examinations in the capital, is also staying in the monastery and has fallen deeply in love with Oriole. The monks are performing the mass for Oriole's father and have invited Student Zhang to burn

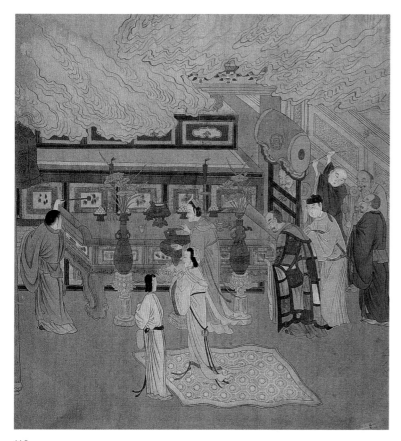

FIGURE 14.5 Attributed to Qiu Ying (c. 1494–c. 1552). *The Old Lady and Oriole Perform the Mass*. Illustration to *The Story of the Western Wing* (*Xixiang ji*). Album leaf. Ink and color on silk. Height 37 cm, width 33 cm. Courtesy the East Asian Library, University of California, Berkeley.

14.5

incense for his deceased parents. The ceremony takes place at a large red altar table placed at the foot of a Buddhist statue hidden by swirling clouds of incense.

> The incense smoke forms a canopy of clouds;
> The chanted incantations swell into ocean billows.[9]

The table has big everted flanges, a high waist inset with marble panels in turquoise frames, and massive cabriole legs ending in cloud heads. *Ruyi* cloud heads decorate the apron. In front of the table Oriole's mother places a lighted incense stick in a large burner on a marble stand as the grieving Oriole stands ceremonially on a rug beside her maid, Crimson. The abbot shakes his bell and reads sacrificial prayers while the monks play various dharma instruments. Student Zhang, gazing longingly at Oriole from behind the abbot, imagines that even the monks share his passion:

> It makes me wild and crazy;
> My itching heart cannot be scratched.
> Her weeping is like the warbling
> of an oriole in tall trees;
> Her teardrops are like dew falling
> on flower tips.
> That grand master is hard to copy,
> Covering up with a face of compassion.
> The monks who strike the cymbals are
> sorely vexed;
> The acolytes who keep the incense going
> simmer inside.
> The lamps' reflections shimmer
> in the wind;
> The haze of incense wafts like clouds.
> Greedily watching Oriole—
> The lamps die out, the incense disappears.[10]

Although the altar table in the Monastery of Universal Salvation is colorful and ornate, there were also refined hardwood models. An elegant *huanghuali* ex-

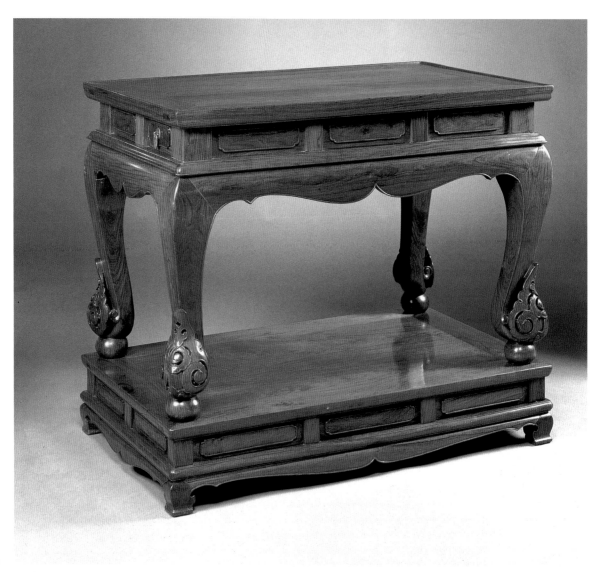

14.6

FIGURE 14.6 Altar table. Ming
dynasty, sixteenth century.
Huanghuali wood. Height
97.2 cm, table height 76 cm,
length 115 cm, width 69.8 cm.
The Tsui Museum of Art,
Hong Kong.

FIGURE 14.7 *Du Liniang's
Ghost Scattering Sacrificial Plum
Blossoms.* Ming dynasty.
Woodblock illustration to
Zang Maoxun's *Linchuan's Four
Dreams* (*Linchuan simeng*), Wanli
reign period (1573–1620).

ample in the Tsui Museum of Art stands on its own raised platform (fig. 14.6). Its cabriole legs rest on ball feet and are fashioned from massive timbers, yet have grace and delicacy because of their sweeping curves and the unusual pierced carving of their upturned ends. The ends curve up in a stylized leaf form full of cloudlike scrolls, while the simple, strong curves of the apron offset the complexity of this decoration. The top part of the leg is exposed, creating a corner-post effect on the high recessed waist, and a molding has been added between waist and apron. The waist has inset panels with raised begonia-shaped centers. On each short side is a long drawer extending almost the length of the table. The tabletop has a mitered mortise-and-tenon frame with a raised rim. The platform supporting this table has a recessed waist with smaller versions of the table's panels and an apron echoing that on the table. It stands on short flanged cabriole legs.

Such a harmonious and tasteful piece, which is aesthetically closer to domestic hardwood furniture than most altar tables, might have been used in a family shrine, such as Red Plum Shrine, where Du Liniang was buried. Du Liniang, the famous heroine of the romantic comedy *The Peony Pavilion* (*Mudan ting*), was ravished by a handsome young scholar in a dream and dies of unrequited passion. Her desire is so strong, however, that she returns to the world of the living as a ghost. A late Ming woodblock illustration to Zang Maoxun's revised edition of the play, *Linchuan's Four Dreams* (*Linchuan simeng*), shows Du's ghost in her own burial shrine (fig. 14.7). Sister Stone, the nun-custodian of Red Plum Shrine, had placed a flowering plum branch in a vase to appease the deceased's spirit, explaining that this offering symbolized Du Liniang's plight: "Within the hollow of this vase is held the mortal world, while her poor self just like this fading plum, watered but rootless, still brings a fragrance to our senses."[11]

The flowering plum, the first flower to bloom in the snow, symbolizes transient feminine beauty and youth. It is associated with coldness, solitude, loss, and the corpse or ghost of a beautiful young woman. Du

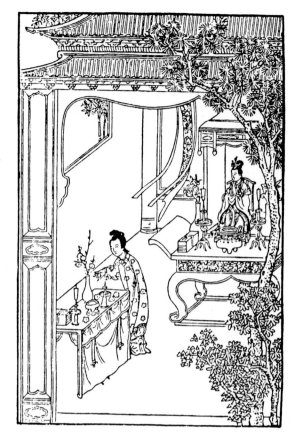

14.7

Liniang was so moved by this offering that she indicated her presence by scattering some of the petals.[12] In fig. 14.7 Du, clad in a robe decorated with plum blossoms, reaches toward a vase of living blossoms that stands on a small rectangular table with curved braces and a ceremonial frontal. Beside the vase are small candlesticks, a small incense burner, and devotional scriptures.

The shrine is a separate building, its roof and outer panels clearly visible. In the center of the back wall stands an altar table with big everted flanges, a high carved waist, and cabriole legs terminating in cloud-head feet standing on a continuous base stretcher. The altar table holds large versions of the same ritual implements found on the side table as well as two vases of *lingzhi* fungi. Behind the altar table is a small shrine with the statue of a goddess seated on a yokeback side

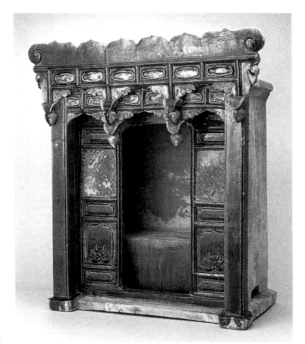

14.8

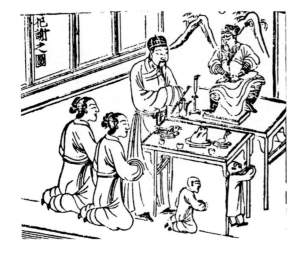

14.9

FIGURE 14.8 Miniature shrine. Ming dynasty. Earthenware with three-color glaze. Height 49 cm, length 43 cm. Keppel, "The Well-Furnished Tomb," fig. 6.

FIGURE 14.9 *Thanks Offering to the First Sericulturalist*. Ming dynasty. Woodblock illustration to Wu Wei Zi, ed., *Seas of Knowledge and Mines of Jade: Encyclopedia for Convenient Use* (*Bian yong xue hai qun yu*), 1607, p. 20.

chair. The canopied structure of this shrine—with its inset panels and hanging finials in the shape of lotus buds or peaches, symbolizing Buddhist rebirth or Daoist long life—is similar to a puzzling set of miniature pottery tomb furniture variously interpreted to represent beds, shrines, or sacrificial altars (fig. 14.8).[13] In the woodblock print in fig. 14.7, at least, such a structure is clearly a shrine.

As we have seen, while temples and shrines commonly used special altar tables, in the home or workplace almost any table could serve ritual purposes. Most Chinese worshiped numerous gods to get protection from evil spirits and to gain some benefit. There were official and communal rituals as well as private ones for personal reasons. A temporary altar was frequently set up on the most common of tables, a rectangular recessed-leg model with simply curved spandrels, straight aprons, and side stretchers. Often two such tables were used, with the smaller placed in front. Fig. 14.9, for example, shows a 1607 woodblock print depicting the traditional thanks offering to the First Sericulturalist, a ceremony that took place in October when the silkworm eggs were laid out on paper for hatching. Here the ceremony takes place against a landscape screen in one of the rooms of the silkworm breeding house. The family, including two small children, offers fish, pork, chicken, and wine before the statue of a male patron saint. Curiously, book illustrations (including this one) from the late sixteenth to late seventeenth centuries always show a male divinity instead of Lady Xiling, the First Sericulturalist.[14]

Incense stands and small tables were often taken outside for private worship. In *The Story of the Western Wing,* Oriole had her maid Crimson carry an incense stand to the flower garden of the monastery every night so that she could burn incense for her parents and for her own secret hopes (fig. 14.10), saying:

With this first stick of incense I pray for my deceased father's rebirth in heaven's realm. With this second stick of incense I pray that my old mother will stay healthy. And with this third stick . . .

14.10

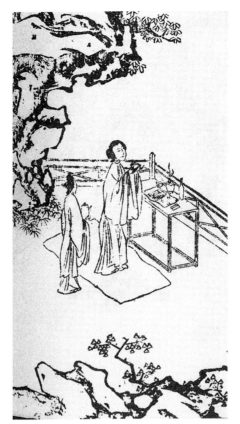

14.11

(Crimson speaks:) Sister, don't utter a prayer with this stick of incense; I'll do it for you—I pray that my sister will soon find a husband who will take Crimson along too.[15]

Wu Yueniang, Ximen Qing's first wife in the novel *The Plum in the Golden Vase,* prays for a son at a small rectangular table set up in the garden (fig. 14.11). The slender table has a continuous base stretcher and appears to be made of bamboo. In the woodblock illustrating this scene, Yueniang is about to drink some wine to wash down the unpleasant-tasting medicine she hopes will cause her to conceive a son. *The Scripture of the White-Robed Guanyin,* from which she has been reading, lies open on the table. The novel describes Yueniang's arduous ritual in detail:

> She told Xiaoyu to set out a table, and on it she placed an incense burner and burned some precious incense. Then she placed on the table a volume of the Scripture of the White-robed Guanyin. Meng

FIGURE 14.10 *Oriole Burning Nighttime Incense.* Detail of a woodblock illustration to the 1498 Honzhi ed. of *The Story of the Western Wing,* vol. 1, act 3.

FIGURE 14.11 *The Moon Lady Prays for a Son.* Ming dynasty. Detail of a woodblock illustration to *The Plum in the Golden Vase (Jin ping mei),* Chongzhen reign period (1628–44), chap. 53.

14.12

Yueniang knelt towards the west, added more incense, and opened the book. She read it once and knelt down once, and so twenty-four times, reading and kneeling time and time again.

She took the medicine from a small box, put it on the table and knelt down four times. Then she made this prayer: "The woman Wu prays to Heaven most high that, by the help of this medicine, prepared by the nuns, Xue and Wang, she may be blessed with a male child." She took the wine which Xiaoyu had warmed and knelt toward the west again. Then she swallowed the pills and the powders. When the medicine passed her throat, it tasted very fishy, and she had to gulp it down. She made reverence four times more; then went back to her own room and remained there.[16]

Small tables with drawers sometimes served as domestic shrines. In the home of Ximen's paramour Wang Liu'er, the wife of the manager of his silk store on Lion Street, such a table is visible in a room adjoining the bedroom (fig. 14.12). At the back of the table, behind a candlestick and other ritual paraphernalia, is an ancestral tablet. The servant has abandoned his bedroll and pillow to peep at the lovers in the next room.

Traditional Confucian households always had an ancestral shrine. In modest dwellings the ancestral shrine was placed along the back wall of the main hall. In larger houses the shrine was further back in the compound in a special room reserved for it. Wealthy clans kept their ancestral tablets in lineage temples built outside the city in beautiful natural settings. These temples were compounds with several courtyards and sleeping quarters for visiting family members. According to Confucian belief, after a person dies the two souls separate: the *po* soul remains in the grave and has to be appeased with offerings so that it will not become a malevolent ghost, and the *hun* soul resides in the ancestral tablet and has the power to bring good fortune or disaster to the living descendants. Therefore, the *hun* soul must be told in detail about all important family events, such as a marriage or the birth of a son. Its tablet, together with icons of other gods, remains on the altar, where descendants worship it and continually supply it with new offerings.

In 1927 Gustav Ecke photographed the sixteenth-century ancestral hall of the Zhu family in Quanzhou, Fujian (fig. 14.13). Along the back wall elegant lattice panels frame a niche containing the ancestral tablets and an ancestral portrait. A statue in front of the niche sits on a miniature yokeback armchair and holds a scepter. This small chair and the two long altar tables in the foreground are all in simple classical taste. The table in front has everted flanges, cloud-head spandrels, and legs tenoning into side foot bases; a long groove visible on the inner side of the back leg indicates that originally there were side panels.

One example of this type of side table is fashioned from *jichimu,* "chicken-wing wood," with an especially fine wavy-grained piece selected for the top (fig. 14.14). The spandrels are elegantly ornamented with back-to-back phoenixes amid clouds carved in low relief, a design derived from ancient jade motifs. The phoenix, an emblem of beauty and of the empress, is said to appear only in times of peace and prosperity. The apron is made from a single piece of wood that passes through a slot in the leg and butt joins with the spandrels. Double beading runs down the center

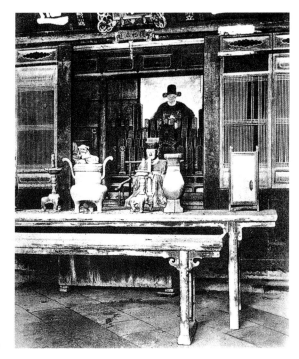

FIGURE 14.12 "Wang Liu'er's Domestic Shrine." Ming dynasty. Detail of a woodblock illustration to *The Plum in the Golden Vase* (*Jin ping mei*), Chongzhen reign period (1628–44), chap. 61.

FIGURE 14.13 Gustav Ecke. 1927. Photograph of the Zhu Family Ancestral Hall, Quanzhou, Fujian. From Ecke, *Zhongguo huali jiaju tukao,* 197.

FIGURE 14.14 Side table. Ming or Qing dynasty, seventeenth century. *Jichi* wood. Height 88 cm, length 179 cm, width 43 cm. © Christie's Images, Ltd., 1999.

14.13

14.14

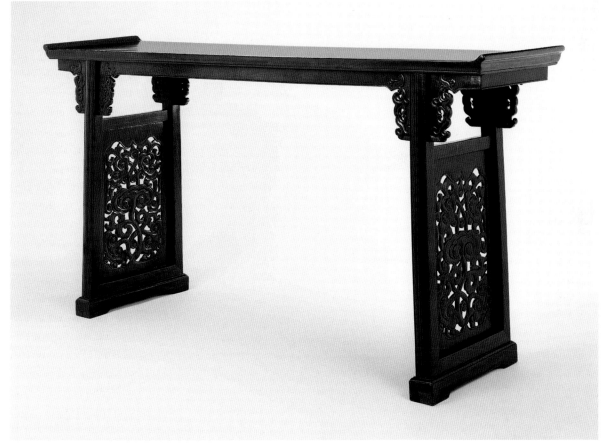

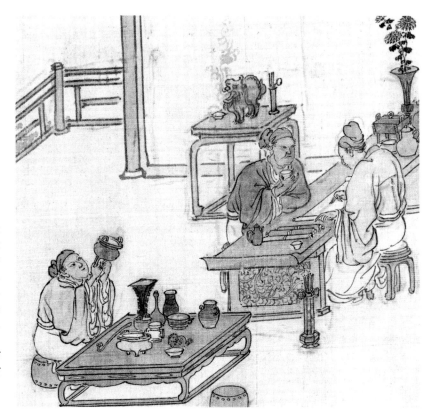

FIGURE 14.15 Zhang Hong (1577 after 1652). Qing dynasty, 1649. *Examining Antiques.* Leaf from *An Album of Figure Compositions.* Ink and color on paper. Height 28.4 cm, width 20 cm. Allen Memorial Art Museum, Oberlin College, Ohio. Gift of Carol S. Brooks in honor of her father, George J. Schlenker, and R. T. Miller Jr. Fund, 1997.

14.15

of each leg and the lower edge of the apron. Open-work carvings of *lingzhi* fungi of immortality decorate the side panels. There are no upper side panels, as there often are on tables of this type, and their absence gives a sense of space and lightness that contrasts with the dense carving of the panel.

Twentieth-century Beijing craftsmen call these tables *qiaotou an*, "recessed leg tables with everted flanges." In the seventeenth century the connoisseur Wen Zhenheng called them a kind of "wall table" (*bizhuo*) with everted flanges (*feiyun* or *qijiao*) and noted that they could be used for offerings to Buddha.[17] Although this type of table usually stood against a wall and displayed offerings or treasures, it could be pulled out into the middle of the room and used for other purposes. For instance, in *Examining Antiques,* a painting by Zhang Hong (1577–after 1652), two scholars study a scroll while seated on wooden stools

on either side of a table with everted flanges and side panels decorated with dragons (fig. 14.15). Fragrant incense emerges from the mouth of an animal-shaped censer perched—together with an incense box and a container holding incense implements—atop a separate high stand. Another scholar, seated on a porcelain drum stool, examines antique vessels collected on an elegantly fashioned low table similar to the one used on the platform in Liu Guandao's painting *Whiling Away the Summer* (see fig. 11.10).

Side tables with everted flanges sometimes have flared legs instead of a foot base. One gracefully proportioned example of this type has a solid top of richly grained *huanghuali* with a mellow patina (fig. 14.16). The openwork side panels are charmingly carved with unusual depictions of a male and female dragon sheltering a small baby dragon between them. Spirited open-mouthed baby dragons and angular scrolls with

14.16a

FIGURE 14.16 Side table, viewed from the front and the side. Ming or Qing dynasty, c. 1600–1675. *Huanghuali* wood. Height 92.75 cm, length 285 cm, depth 53 cm. The Metropolitan Museum of Art, New York. Purchase, Florence and Herbert Irving Gift and Rogers Fund, 1996 (1996.339). Photos courtesy of Ming Furniture, Ltd.

14.16b

distinctive decorative flourishes ornament the front spandrels. The scrolls extend into a wide bead edging the long straight apron. The simplified carvings on the back spandrels indicate that the table was intended to be placed against a wall.

The silhouette of the elegant dragon-family table is similar to that of the longest known side table in the classical style (fig. 14.17). The solid top of this monumental piece is 380 centimeters long and has a lustrous, richly grained, golden-hued surface. It is a luxurious table, thanks to its size, the quality of the wood, and the excellence of the carving. The spandrels are deeply carved with a remarkable variation of the ancient animal face (*taotie*) motif, which has large sensuous eyes and wispy hair. The animal face, angular spirals, and thick bead along the edge of the spandrels form a design that is at once animated and harmoniously balanced. The openwork side panels

14.17a

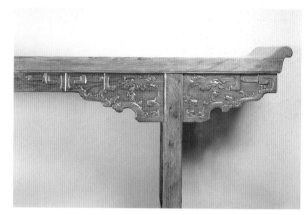

FIGURE 14.17 Long side table, with detail of one end. Ming or Qing dynasty, c. 1600–1735. *Huanghuali* wood. Height 91 cm, length 380 cm, depth 45 cm. The Minneapolis Institute of Arts. Gift of Ruth and Bruce Drayton. Photo courtesy of Ming Furniture, Ltd.

14.17b

have a large coiled dragon in the center surrounded by angular clouds. This important table has a majestic presence because of its great length, perfect proportions, and rich yet tastefully restrained decoration.

The Chinese side table with everted flanges is a surface for household treasures and occasionally for ritual offerings to the gods. Grand in dimensions, it can be religious or profane, classical or vernacular, austerely plain or elaborately carved. Although the essential function of these tables throughout history has been to display beautiful valuables to family or to gods, the displays changed with the times. Today in traditional Chinese households we can still see the Qing arrangement, where a lower square table flanked by two chairs stands in front of the long side table to create a focal point in the main room. But now the side table might hold a thermos, a clock, and a small television set, while bright New Year's posters and a photo of elderly parents hang on the wall above. These are the treasures and the auspicious objects of a modern family's world.

CABINETS AND SCREENS

15 | CABINETS AND SHELVES CONTAINING ALL THINGS IN CHINA

*D*ynastic China was a country of containment. Within the Great Wall, which protected China from the northern barbarians, were cities and towns surrounded by walls. In the cities, residences concealed behind high walls contained buildings and rooms separated by walls. And in these rooms, possessions were contained in diverse types of cabinets and boxes that often had locks to safeguard their contents. The containers, which sometimes were works of art as well as functional objects, are important documents reflecting the lifestyles, beliefs, and tastes of the time. The cabinets of China are metaphors for the great and small walls of the country.

The earliest storage containers were boxes of various sizes and shapes. A rich assortment of elaborately decorated lacquer boxes was found in the tomb of Marquis Yi of Zeng, who was buried around A.D. 433 in what is now Sui *xian*, Leigudun, Hubei province. Small boxes were round, rectangular, oval, or more fancifully shaped in the form of a duck, tortoise, or boat. They mostly held food, dishes, or toiletries, such as cosmetics and combs. The marquis's tomb also contained the first known lacquer clothes chests. Five of them, big and small, were found in the eastern chamber together with the marquis's coffin, musical instruments, and many jade, lacquer, and bronze objects. Some of the chests have inscriptions on their lids informing us that they were called 匧 匰 箮 (all variants of *gui*) and contained clothing.[1] One of the chests is rectangular with a domed lid that fits over a tenon on the body (fig. 15.1). When the lid is removed, it can stand on two convex feet at the top of the dome. Handles, at the corners of the lid and upper body, were used to lift the lid and to carry the chest. The chest is lacquered black with red decorations. In the center of the lid is a large *dou* character, referring to the Big Dipper, surrounded by smaller characters denoting the twenty-eight constellations. Flanking these characters are large depictions of the white tiger of the east and the green dragon of the west. The chest is of great importance for the study of Chinese astronomy because its decoration includes the first known listing of the constellations.[2]

15.1

15.2

FIGURE 15.1 Lacquer clothes chest. Warring States period. Found in the c. 433 B.C. tomb of Marquis Yi of Zeng, Sui county, Leigudun, Hubei. Height 40.5 cm, length 71 cm, width 47 cm. From Teng Rensheng, *Lacquer Wares of the Chu Kingdoms,* 43.

FIGURE 15.2 Coffer and box on a tombstone engraving found at Yinan, Shandong. Han dynasty, c. A.D. 75–100. Drawing from Zeng Zhaoyu et al., *Yinan gu huaxiangshi mu fajue baogao,* pl. 51.

In the second-century B.C. tomb of Lady Dai at Mawangdui, Hunan province, clothing as well as food was found packed in rectangular bamboo baskets with lids. Cosmetics and ornaments filled small rectangular lacquer boxes that had lids shaped like truncated pyramids.[3] This form of lidded box, both rectangular and square, was common at the time and came in different sizes to hold a variety of objects. Fig. 15.2 shows a tall model (standing to the right of a much larger coffer) depicted in a stone engraving on the walls of the burial chamber of a late-first-century tomb at Yinan, Shandong. Extant boxes of this type from the Han dynasty (206 B.C.–A.D. 220) are made of lacquer and painted with scrolling cloud patterns. By the Tang dynasty (618–906) they were sometimes fashioned from precious metals and even embellished with jewels; such boxes were luxurious household items or had religious functions.

In 1987 Chinese archaeologists made a discovery of great importance to the Buddhist world: the finding of four pieces of Buddha's finger bones in a crypt beneath a ruined stupa at Famen Temple in Fufeng county, Shaanxi. One of the sacred remains was enshrined in a tiny, exquisitely fashioned gold stupa-shaped reliquary encased in seven nesting caskets. The caskets were a gift to the temple from the eighteenth emperor of the Tang dynasty, Yizong (r. 859–873). The outermost sandalwood casket had rotted long before the crypt was discovered. The second, fashioned from gilded silver, has a lid of the same shape as the one in the Yinan engraving (see fig. 15.2) and is magnificently decorated with images of the Four Guardian kings, each identified by name (fig. 15.3). Its precious contents are secured by a padlock with a working key attached by a silk cord. The five caskets nested within it are identical in shape, each smaller than the one before and each with its own padlock and key. The third casket is of plain gilded silver. The fourth, also of gilded silver, has an image of Tathāgata preaching Buddhism. The fifth box is gold embellished with a six-armed Avalokiteśvara. The sixth is made of gold inlaid with pearls, and the seventh and last box is of marble adorned with pearls and gems. Thus, lay-

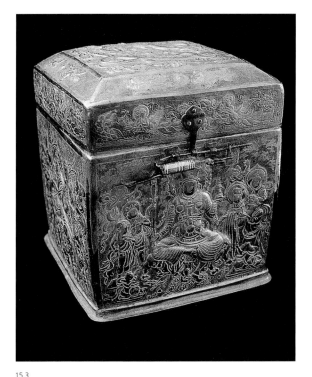

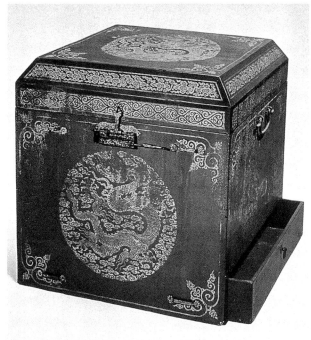

15.3

15.4

FIGURE 15.3 Gilded silver
casket. Tang dynasty, late ninth
century. Unearthed in 1987 at
Famen Temple, Fufeng county,
Shaanxi. From Han Wei,
Precious Cultural Relics, 66.

FIGURE 15.4 Lacquer clothes
box. Ming dynasty. Excavated
from the tomb of Zhu Tan
(d. 1389). Height 61.5 cm, top
58.5 cm × 58.5 cm. Shandong
Provincial Museum. From
*Wenhua dageming qijian chudu
wenwu,* 131.

ers of locked boxes fashioned of precious materials
honored and protected this most holy of relics.

This form of box was adapted to other special-
ized uses. Among Famen Temple's treasures is a sil-
ver tea sifter in the shape of a similar rectangular box
with a drawer below and a platform base with cusped
oval cutouts. In the Shōsōin in Japan, a board for the
game of *sugoroku* is stored in a box of this form that
is decorated with fine knit-bamboo matting and
stands on a platform base. This type of box never
went out of fashion. Fig. 15.4 shows a magnificent
large red lacquer one excavated from the tomb of
Zhu Tan (d. 1389), the tenth son of the emperor
Hongwu. It is ornamented with incised gilt dragon

rondels and various scroll borders. The iron lock and
handles also have gilt decorations. There is a drawer
on one side, and the interior comprises nine com-
partments. This box served as a clothes chest; when
it was found it contained a hat, robe, and boots.
Smaller hardwood boxes of this type held seals on a
scholar's desk and cosmetics on a lady's dressing table.
A plain wooden one was used to store the bullets re-
moved from animals shot by the Qianlong emperor
(1736–96).[4]

The basic form of these boxes was even adapted
for cabinets by adding doors to one side. Cabinets ap-
pear to have been rare until the chair-level mode of
living became prevalent. Perhaps some of the early

FIGURE 15.5 *Sericulture.* Attributed to the Southern Song dynasty. Detail of a handscroll. Ink and slight color on silk. Height 27.5 cm, length 513 cm. Heilongjiang Provincial Museum. From *ZGMSQJ, Huihua bian* 4: 21.

15.5

makers of cabinets simply modified a familiar box form and elevated it on a table, and only later did the fully developed high standing cabinet become common. In a detail from *Sericulture* (fig. 15.5), a handscroll attributed to the end of the Southern Song dynasty (1127–1279), we see women storing the finished silk cloth in a small cabinet with a truncated pyramid-shaped top identical to the box lids in figs. 15.2–15.4. The upper part of the wood-hinged doors has lattice panels, and one is open to reveal a central shelf. The cabinet has short feet and a standard apron. It stands on a large table. Sericulture—one of the subjects that court artists had painted since at least the Northern Song dynasty (960–1126)—symbolized peace and stability.[5] However, cabinets for storing silk were not generally depicted in the paintings or the later woodblock prints of this subject.

In paintings from the Ming dynasty (1369–1644) depicting scholarly gatherings in gardens, we see similar cabinets used to hold books and scrolls. The cabinets all stand on tables off to one side of the festivities. There is one in *The Nine Elders of the Mountain of Fragrance,* a painting by Xie Huan (active 1426–52) in the Cleveland Museum of Art. A more detailed depiction is seen in a hanging scroll belonging to the set of *Eighteen Scholars of the Tang Dynasty* in the National Palace Museum, Taipei.[6] This is a Ming Acad-

emy painting, although it has been attributed to the Song dynasty. The cabinet has a wooden frame inset with woven bamboo or reed panels, each with a central diamond ornament. Since the structure is wide, there are panels between the doors and the sides of the cabinet. One of the scholars has just opened the doors to select a work from the books and scrolls stacked on the shelves. Such a cabinet with matting panels would have been light, easy to move, and appropriate for a rustic garden setting. It would not have been as durable as hardwood furniture, and consequently there are no extant examples. This type of cabinet and the one in *Sericulture* are both shown elevated on tables, leading one to suspect that some of the medium-sized hardwood cabinets found today in collections of classical Chinese furniture were intended to be placed on tables or stands as well.

Next to the box depicted in the first-century tomb at Yinan, there is a larger rectangular coffer with four legs (see fig. 15.2). It is clearly made of wood and would have been good for storage because its legs raise it above the damp ground or floor. In form it is related to Han strongboxes, which are known from excavated green-glazed terra-cotta tomb models. The models have four short legs, a door at the back, an opening in the top, and a lock.[7] Similar strongboxes

have been found in Tang tombs, often together with figurines of seated women adorning themselves. The Southern Song painting *Returning from a Spring Outing* (see fig. 5.5) shows a coffer similar to the one in fig. 15.2, with short legs and a lid. A servant carries it on a pole, balanced by a brazier for heating wine and water. Other servants carry over their shoulders a large sun hat, a folding horseshoe armchair, and a stool. They accompany their master, who wears an official's hat, as he returns home from a day's outing. The coffer undoubtedly contains a picnic and other supplies.

We see this type of coffer again in the 1436 primer *Newly Compiled Illustrated Four-Word Glossary* under the heading *gui*. It has perpendicular boards fitted into a framework and a rectangular opening in the top. The drawing agrees with the description under *gui* in the contemporary *Classic of Lu Ban,* which describes a smaller version fashioned from heavy boards joined at the corners; sometimes wheels were added, converting the coffers to movable storage containers. Lu Ban gave precise measurements for large and small coffers:

> Large coffers with framed panels are 2 *chi* 5 *cun* high, 6 *chi* 6 *cun* 4 *fen* long, and 3 *chi* 3 *cun* wide. The legs are 7 *cun* high. Sometimes wheels are fitted under the legs, so that the coffer can be moved. Each of the four stiles is 3 *cun* wide, 2 *cun* thick. The panels should be hammered down into the frame, only then are they tight. Small coffers are made by assembling boards. They are 2 *chi* 4 *cun* high, 2 *chi* 8 *cun* wide, and 5 *chi* 2 *cun* long. The boards are 1 *cun* thick. Every item, up to the measuring peck and the traces of the stars, has been carefully noted down here.[8]

Gui might have been the word used to designate the Yinan coffer; according to Bernhard Karlgren it refers to a box in the third-century B.C. *Book of Master Han Fei (Han Fei zi)* and the Zhou dynasty *Book of Documents (Shu jing),* where it is written without the wood radical.[9] In the Ming dynasty there seems to have been no consistent use of the term. The 1609 *Pictorial Encyclopedia of Heaven, Earth, and Man* shows a tapered cabinet (fig. 15.6) under the heading *gui* (written without the wood radical).

15.6

FIGURE 15.6 Cabinets (*gui*). Woodblock illustration to Wang Qi's 1609 *Pictorial Encyclopedia of Heaven, Earth, and Man,* Qi Yong, *juan* 12, 40a.

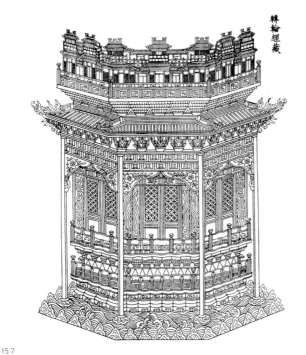

FIGURE 15.7 *Revolving Repository of the Sutras.* Northern Song dynasty. Revolving repository: height 243.84 cm, diameter 274.32 cm. Entire structure: height 609.6 cm, diameter 487.68 cm, width of each of the eight sides 198.12 cm. Drawing from Li Jie, *Yingzao fashi,* 1103, vol. 6, p. 21b.

We do not know exactly what was stored in the footed coffers—perhaps valuables, garments, or books. From literature we learn that *gui* were used to store books. The Tang poet Bo Juyi (772–846) wrote about the book box (*shugui*) that he made from cypress wood to hold his complete works:

ON A BOX CONTAINING HIS OWN WORKS
I cut cypress wood and shape a book box,
a well carved one made out of hard cypress.
Shall I keep my writings in it?
The inscription says BO LUOTIAN
I have spent all my life writing books,
from my youth till now when I'm an old man.
From beginning to end it has three thousand themes.
Of course I know they will be tossed about and lost,
but I can't stand seeing them thrown out.
I open and shut the locks with my own hand
and put the book box in front of the curtain.
I am like Deng Baidao,
but today there is no Wang Can here.
All I can do is portion them out to my daughters
who will leave them to my grandchildren.[10]

In comparing the fate of his writings to an abandoned child, Bo refers to Deng Baidao, who was obliged to abandon his only child on the roadside, and Wang Can, who rescued a foundling. He knows that eventually his books will be scattered and lost, but for the moment he has collected them in a well-made cypress wood box secured by a lock. Of course we do not know if Bo's book box really was a footed coffer or if it had some other form. A great deal of work remains to be done on furniture terminology.

When Bo Juyi was prefect of Wu, he was instrumental in the construction of a revolving bookcase for storing the Tripitaka (the Buddhist scriptures) at the Nan Chan Temple in Suzhou. It was a monumental octagonal structure. Bo describes the bookcase and the hall in which it was housed in an inscription bearing a date equivalent to March 19, 839:

The expenses for the construction of the hall amounted to 10,000 strings of cash, and for the bookcase and books 3,600 strings; in the middle of the hall there was a dais above and the bookcase below. [The dais had] a thousand niches for Buddhas disposed on nine

stages; the ornamentation was made with silk, and of colors gold and green. The bookcase had eight faces; on each side there were two doors of red lacquer reinforced with bands of copper. Around the bookcase sixty-four seats were arranged; the interior of the bookcase was made to revolve by means of a wheel which was stopped by a kind of brake. The sacred books numbered 259 cases (*han*) and 5,058 rolls.[11]

The Chinese term for this kind of revolving bookcase is *zhuanluncang,* literally, "revolving repository." Legend has it that Fu Xi, a pious layman, invented the revolving bookcase in 544, and it is occasionally mentioned in eighth- and ninth-century texts. After 972, when Emperor Taizu ordered the publishing of the whole Tripitaka in a printed edition so that all monasteries of any importance could own a copy, revolving bookcases became common even in remote village temples. One is illustrated in Li Jie's *Treatise on Architectural Methods* (*Yingzao fashi*) under the title *Revolving Repository of the Sutras* (*Zhuanlun jing cang;* fig. 15.7). It is a large architectural structure with doors, similar to the one Bo Juyi describes. Such a bookcase was practical because it made the huge Tripitaka easily accessible. That it revolved also had a ritual significance. Those wishing to acquire religious merit could, instead of reading the sutras, turn the whole structure and thus perform an act symbolic of Buddha turning the Wheel of the Law. Piet van der Loon has provided evidence that from at least the twelfth century Daoist libraries also contained revolving bookcases whose main purpose was ritualistic rather than scholarly.[12]

Revolving repositories were a specialized type of closed bookcase, or cabinet, for venerated holy scriptures. A poem by the seventh-century writer Yang Jiong mentions *shujia,* which were probably open bookcases.[13] An early depiction of an open bookcase appears in a Northern Song wall painting in Kaihua Temple, Gaoping county, Shaanxi (fig. 15.8). Here we see a thatched hut comfortably furnished with a platform (or *kang*), a footstool on which the hermit places his shoes, and a bookcase. The bookcase has three

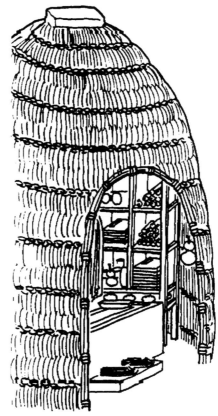

15.8

FIGURE 15.8 Thatched hut with bookcase. Northern Song dynasty. Detail from wall painting in Kaihua Temple, Gaoping county, Shaanxi. Drawing by Fu Xinian from Liu Zhiping, *Chinese Residential Architecture,* pl. 5.6.

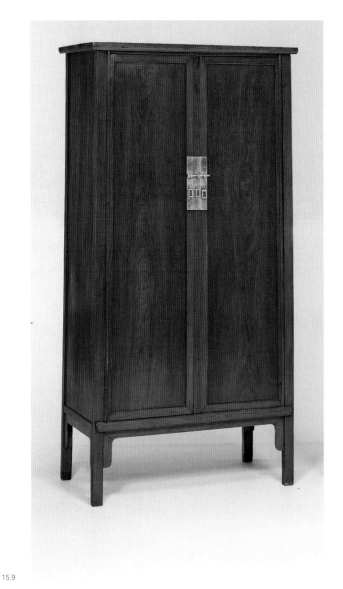

15.9

shelves, with at least one vertical member dividing them into smaller compartments. Filled with books, scrolls, and other objects, it stands above the damp ground on high legs and has solid side panels. Beneath the lowest shelf are panels with oval openings or ornaments similar to those on box-construction platforms. They may be purely decorative or may conceal drawers or storage areas.

Although the revolving repositories described by Bo Juyi and illustrated in the *Treatise on Architectural Methods* are really a kind of book cabinet, they resemble architecture more than furniture. A cabinet in the Shōsōin provides the only other clue we have to the appearance of early cabinets. Its materials and construction, however, are Japanese. The only Chinese element is the box-construction base, a feature adopted by the Japanese on many of the stands, boxes, and game tables in the Shōsōin. It is fashioned from strongly figured zelkova wood that has been stained with a purple-red extract from sappan wood and then varnished with transparent raw lacquer. Unlike Chinese cabinets, there are no floating panels between mortised and tenoned frames. Instead, bands of zelkova wood secured by silver-covered iron studs cover the edges of the cabinet. The doors open on gilt bronze hinges, and there is a gilt bronze lock. The doors are secured by something equivalent to the central removable stile of Chinese cabinets. Instead of being between the doors and mortised and tenoned into the frame, it fits over the juncture of the doors and is attached by strips of wood fitting into rings. Inside, there are three shelves that, according to the 756 inventory, contained personal belongings of Emperor Shōmu (r. 724–749), such as girdles, penknives, stained-ivory rulers, musical instruments, and handscrolls. According to the inventory, the cabinet was in an antique style and was a gift from Emperor Tenmu (r. 672–687) to Empress Jito. The same inventory mentions another cupboard, no longer extant, that was a gift from the Korean King Euja to Fujiwara-no-Kamatari.[14] Thus, perhaps this cabinet is of Korean rather than Chinese origin.

Cabinets came into popular use only after the adoption of the chair-level mode of living and may not have existed earlier in China as a type of domestic furniture. By the Ming and early Qing dynasties there were different forms of cabinets in a variety of sizes and designs. Some had specific uses and ingenious interior fittings. Previously boxes had been the principal storage containers, and they continued to be widely used. They are, however, a subject in themselves and will not be discussed here.

According to Wang Shixiang, contemporary Beijing cabinetmakers classify cabinets into two types, the round-corner tapered cabinet (*yuanjiaogui*) and the square-corner cabinet (*fang jiaogui*). Round-corner cabinets are usually splayed, with wood-hinged doors and round-edged tops that protrude beyond the side posts. Square-corner cabinets usually have metal hinges and little or no splay, and each of the four corners forms a right angle. Southerners use the term *chu* instead of *gui*.[15] Existing cabinets do not always fit neatly into these categories, however, and when writing in English, I find it less confusing to use the terms *tapered* and *square-corner*.

Tapered cabinets are among the most beautiful forms of Chinese furniture. Often the standard rectilinear shape is enlivened by the splay of the legs, which is balanced by the slight overhang of the top. On tapered cabinets, the corners of the top are usually rounded, although sometimes they are squared. When the top corners are squared, all members of the cabinet are square and the surfaces flat, except for the door pivots and the stretcher beneath the doors, which has one rounded side (fig. 15.9). The door pivots are an extension of the frame of the door panel and swing on wooden pegs fitting into holes in the top board and the stretcher. To function properly, the pivots must be round and continue their roundness down the outside edge of the frame. This cabinet, therefore, exemplifies the marriage of form and function in Chinese furniture. The door pivots form an attractive contrast to the other square members and flat surfaces. Moreover, the lock plate is made plain

and narrow, as is the apron with elongated spandrels, to visually reinforce the verticality of the cabinet. The effect is heightened by the dark shimmer of the vertical figures in the *huanghuali* wood of the tall recessed door panels. A removable central stile tenons into the top stretcher and has a mortise at the bottom, which is open on one side so that it can slide into a tenon in the bottom stretcher. The central stile prevents the top horizontal frame member from sagging when the doors open and also prevents long objects stored on the shelves from falling out. It removes quickly to provide complete access to the interior of the cabinet, which has retained most of its red over black lacquer coating. The cabinet contains two shelves and two drawers beneath the lower shelf.

This cabinet is the epitome of the elegance and restraint that characterized those pieces of classical Chinese furniture most admired by Westerners influenced by Bauhaus taste. Like the Shaker case of drawers in fig. 15.10, the tapered cabinet in fig. 15.9 has a serene, unadorned beauty thanks to the perfection of its proportions. It is this harmony of proportion that transforms each of these common objects into a work of uncommon grace. In both, the verticality is perfectly balanced and contained by the shape and overhang of the top. In the Shaker chest, the smaller drawers at the top visually lighten the rigidity of the shape, while in the Chinese cabinet the upward taper enlivens what would otherwise be a static form. Each is a functional, well-made masterpiece of the joiner's art carefully crafted from the finest materials.

Although there are no extant pre-Ming Chinese cabinets, the pivoted door construction has been used since at least the Western Zhou period (c. 1050–c. 771 B.C.). It is found on an unusual bronze *fangli* discovered during 1976–77 at Fufeng, Shaanxi (fig. 15.11). An inscription on one of the legs of this vessel contains the character *li*, and thus it is called a square (*fang*) *li*, rather than a *fangding*, as its shape suggests.[16] It is a combination cooking vessel and stove, with vents on the sides and doors on pivot hinges. On one door

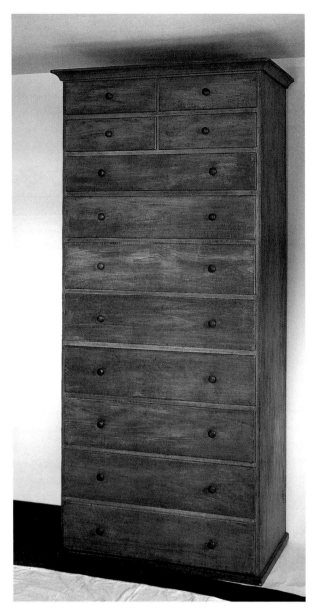

15.10

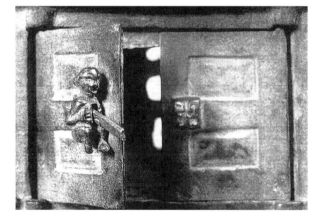

15.11

the figure of a small naked crouching man holds a bar that fits into a *taotie*-ornamented ring on the other door. The crouching man, whose left foot is amputated (amputation being one of the five punishments of ancient China) probably represents the slave responsible for stoking the stove.[17] This method of closing the doors is a precursor of that found on Ming cabinets where a padlock passes through rings on the doors and stiles. Similar figures and door fastenings appear on Western Zhou vessels of this type in the Palace Museum in Beijing, in the Sumitomo collection in Kyoto, and on a wheeled bronze carriage found in Wenxi county, Shanxi.[18] The Sumitomo vessel has small balustrades on either side of the doors, making clear the architectural origin of the construction.

Subtle variations give individual character to different tapered cabinets. A pair in the Nelson-Atkins Museum of Art (fig. 15.12) has almost the same overall dimensions as the cabinet in fig. 15.9. However, their verticality is emphasized by higher legs, the grooving and fluting of the major upright members, the long lock plates, and the upward flip of the long spandrels. Here all the frame members are rounded, rather than flat, contrasting with the plain panels and creating a different play of light along the surface of the pieces. The smooth sheen of the white brass lock plates offsets the undulating figures of the *huanghuali* wood. The openwork pulls and lock receptacles have decorations in yellow brass and copper. The interior of the cabinet has its original pale powdery-green lacquer. The two shelves and two drawers beneath the lower shelf are all constructed from *huanghuali* wood. These superb cabinets have long been known only through the publication of two details in Gustav Ecke's *Chinese Domestic Furniture*.[19] In the early 1980s the Nelson-Atkins Museum of Art found and purchased them.

By the fifteenth century tapered cabinets were so common that one, labeled *chu*, is illustrated in the 1436 primer *Newly Compiled Illustrated Four-Word Glossary* (fig. 15.13). The doors are divided horizontally into three panels, with a much smaller one just below the middle. From the fifteenth-century *Clas-*

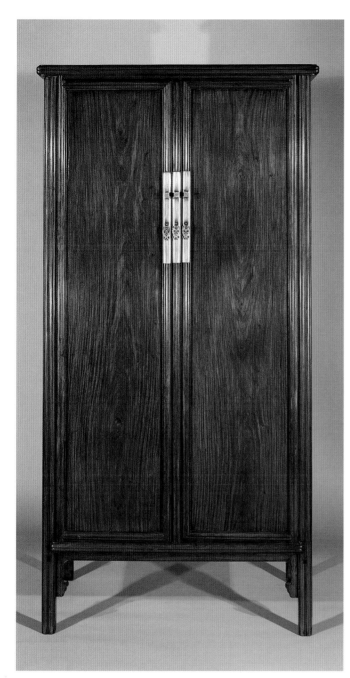

15.12

FIGURE 15.10 Grove Wright (1789–1861) and Thomas Damon (1819–80). Case of drawers. 1853. Pine, traces of yellow stain, butternut drawer fronts, walnut pulls. Height 213.36 cm, width 94.62 cm, depth 48.26 cm. Hancock Shaker Village, Pittsfield, Mass. Photograph by P. Rocheleau.

FIGURE 15.11 The doors on a *fangli* vessel discovered at Fufeng, Shaanxi. Western Zhou period. Bronze. Height 17.7 cm, length 11.9 cm, width 9.2 cm. From *ZGMSQJ, Diaosu bian* 1: 64.

FIGURE 15.12 Tapered cabinet, one of a pair. Ming dynasty, early to mid sixteenth century. *Huanghuali* wood. Height 186.7 cm, width 93 cm, depth 52.1 cm. The Nelson-Atkins Museum of Art, Kansas City, Missouri. (Purchase: The George H. and Elizabeth O. Davis Fund.)

15.13

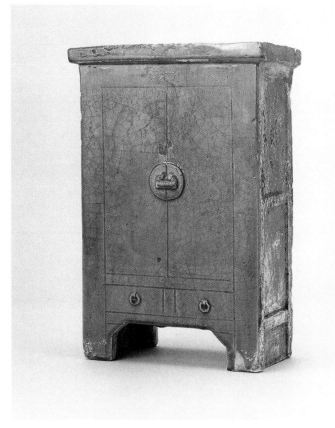

15.14

FIGURE 15.13 Illustration of a tapered cabinet (*chu*). Ming dynasty, 1436. From Goodrich, *15th Century Illustrated Chinese Primer,* n.p.

FIGURE 15.14 Miniature pottery cabinet with amber iron glaze. Ming dynasty. Height 25.2 cm, width 16 cm, depth 8.5 cm. Handler, "Cabinets and Shelves," fig. 17.

sic of Lu Ban we learn that tapered cabinets were used to store clothes. Under the heading *yichu* the text states, "The width of this cupboard is 1 *cun* 2 *fen* less at the top than at the base."[20] However, the woodblock illustration to this passage—which dates from c. 1600, some time after the original text was compiled—shows a square-corner cabinet with woodhinged doors and panels beneath the top. Tapered cabinets were also called *gui.* One illustrated under this heading in the 1609 *Pictorial Encyclopedia of Heaven, Earth, and Man* (see fig. 15.6) has three-panel doors like those in the 1436 primer (see fig. 15.13), except that the small middle panels have begonia-shaped decorations, and there is a removable central stile. A panel below the door frame probably indicates a concealed storage area, although it could be a drawer, since the motif along the top edge often appears on drawers. Some Chinese drawers are opened by lifting from underneath rather than pulling on a handle. Beneath this illustration in the *Pictorial Encyclopedia of Heaven, Earth, and Man* is another cabinet with an overhanging top that does not taper. Because this cabinet is much wider than the one above it, its doors are separated from the sides by additional panels.

It is curious that pottery tomb models show variations in the basic design of cabinets that are not found on any extant hardwood pieces. Like the wide cabinet in the *Pictorial Encyclopedia of Heaven, Earth, and Man,* the tomb models do not taper. This may reflect designs of actual furniture, or it may simply have been easier to make pottery models with straight sides. Almost all existing full-size cabinets with overhanging tops and wood-hinged doors taper. Frequently the pottery models have drawers. One with an amber iron glaze, imitating wood, has two drawers beneath the door frame and a round lock plate (fig. 15.14). George Kates suggested in 1948 that, unlike the refined hardwood pieces of the wealthy, the tomb models may reflect the furniture of ordinary people, which was fashioned from softer woods in more elaborate designs. It is rare to find a miniature cabinet in published reports of Ming excavations, and there are few among the pottery models of unknown provenance in col-

lections and antique stores. The only known wooden model was found in the tomb of Pan Yunzheng, who died in 1589 and was buried in what is now the Luwan district of Shanghai. It is a standard tapered cabinet design with rounded frame members, removable central stile, metal lock plates, and one shelf (fig. 15.15). In the tomb it stood against the wall to one side of the miniature alcove bed.[21]

With literary references to cabinets it is usually impossible, with our present knowledge, to know whether the cabinets are tapered or square-corner. In *The Plum in the Golden Vase* (*Jin ping mei*), cabinets (*chu*) are listed in the formulaic description of a bride's dowry—bed, dressing case, chests, and cabinets (*chuang lian xiang chu*)—and, therefore, were part of the furnishings of a lady's bedchamber. Her furs were stored in large cabinets (*dachu*). Ximen Qing was a silk merchant and kept rolls of silk in cabinets (*chugui*) in the front courtyard. Cabinets in his study contained his official robes and accessories, such as handkerchiefs, kerchiefs, pins, and various presents from relatives.[22]

Ximen Qing's study, described in chapter 34 of *The Plum in the Golden Vase*, had ostentatious gold-painted black lacquer book cabinets (*shuchu*) against both walls. Book cabinets are mentioned more than any other type of cabinet in Chinese literature, undoubtedly because they were of more interest to scholarly writers than were cabinets containing daily necessities. In a poem by Yang Xunji (1456–1544), "Inscribed on the Doors of My Book Cabinet" ("Shuchu shang ti"), in which he describes his advancement from bookless youth to book-loving scholar, we learn that the doors might be inscribed with poems. Ye Xie, in his *Origins of Poetry* (*Yuanshi*), completed in 1686, has a wonderful passage in which he uses book cabinets (*shuchu*) as a metaphor for memory to distinguish between the mind's capacity for storage and its ability to synthesize: "Those with no capacity for judgment in their hearts may be diligent in study the whole day through and still derive no benefit from it. In the words of the popular phrase, they are 'two-footed book cabinets.' Every day they

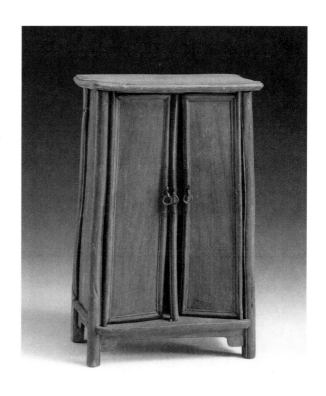

15.15

FIGURE 15.15 Miniature wooden tapered cabinet. Ming dynasty, sixteenth century. Excavated from 1589 tomb of Pan Yunzheng, Luwan district, Shanghai. Southern elm (*ju*). Height 22.86 cm, width 13.39 cm, depth 5.9 cm. Shanghai Museum.

15.16

memorize and recite more; and the more they do this, the more they become entangled in it. Then when it comes to spreading out their paper and setting their brushes to it, their hearts are as if filled with tangled threads; what comes to their minds is in such confusion that they have no way to choose."[23]

Sometimes the term *shugui* referred to book cabinets, as in a poem on carpenters by Pu Songling (1640–1715). In the study, cabinets (*chu*) would also have been used to store such things as "antique bronzes, jades, and small utensils." Each would have its own padded box—containers within containers. Scrolls were also stored in the cabinets, kept in place by the central stiles.[24]

Paintings and woodblock illustrations rarely depict cabinets. Curiously, the only representations of tapered cabinets I have found show them in shops rather than domestic settings. In an illustration of a butcher's shop in a Wanli (1573–1623) edition of *Water Margin* (*Shuihuzhuan,* also known in English as *Outlaws of the Marsh*), we see against the back wall a tapered cabinet with single-panel doors and three panels on the side (fig. 15.16). It is securely locked, suggesting that it was used to keep the day's income and other valuables. Two cabinets are visible in shops lining a busy thoroughfare in a version of *Qingming Festival on the River* attributed to Qiu Ying in the National Palace Museum, Taipei. Both have three-panel doors, and the one in a carpenter's shop seems to have decorative inlays.

Cabinets came in many different sizes, from enormous standing cabinets to small ones placed on a table. Here I will discuss only the large ones. Some, such as the *huanghuali* piece in fig. 15.17, are about 106 centimeters high, so that the top provides a convenient surface. Unlike most tapered cabinets, this one has metal hinges and no removable central stile. Inside the cabinet are a shelf and two drawers, all made from *huanghuali*. This shelf-drawer unit is unusual because it can be easily removed and the entire cabinet dismantled for transport and storage. Characters written on adjoining members make it easy to reassemble as well. The back and hardware have all been replaced.

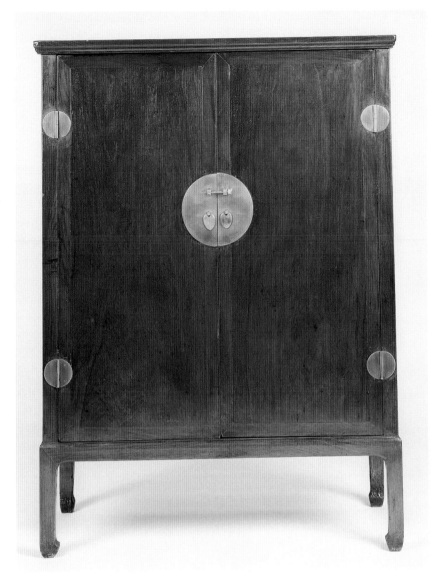

15.17

FIGURE 15.17 Low cabinet with horse-hoof feet. Ming or Qing dynasty, seventeenth century. *Huanghuali* wood. Height 106.5 cm, width 84.5 cm, depth 43.2 cm. © Christie's Images, Ltd., 1999.

The most unusual feature of this cabinet is the base with high horse-hoof feet. The base appears to be a separate structure, but in fact the vertical stiles pass through the apron to form the feet. Cabinets of this height were more convenient when elevated on high legs, some kind of base, or a table (see fig. 15.5). Usually the bases were separate, although Ernest Boerschmann's photograph (taken between 1906 and 1909) of the Imperial Library on West Lake, Hangzhou, shows the walls lined with square-corner cab-

inets with stiles extending to form the legs of bases with shelves. A rare example of a *huanghuali* cabinet on a separate stand, with drawers and a shelf, is in the Dr. S. Y. Yip Collection. Wen Zhenheng did not like cabinets with legs unless they had a separate stand (*chudian*); if the stand was open like a rack (*jia*), he considered it especially elegant.[25]

A tapered cabinet, forty centimeters taller than the single cabinet with horse-hoof feet, has a beautifully finished flat *huanghuali* top—a sure indication that the

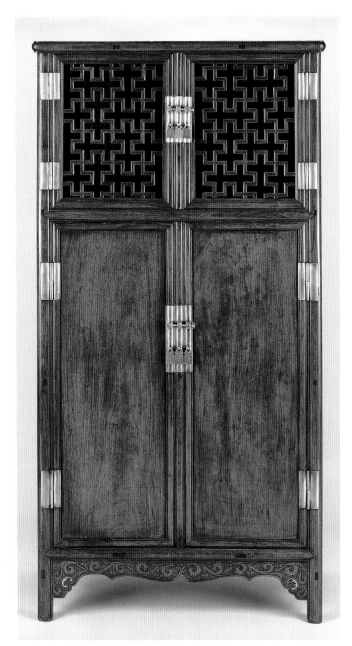

15.18

FIGURE 15.18 Tapered cabinet with lattice, one of a pair. Ming or Qing dynasty, seventeenth century. *Huanghuali* wood. Height 146 cm, width 77 cm, depth 45 cm. From Handler, "Cabinets and Shelves," fig. 22.

cabinet was never intended to be elevated on a stand (fig. 15.18). The cabinet has four doors. The larger bottom doors have solid panels; the smaller upper doors and upper side panels are lattice. Like the lattice doors on the revolving bookcase (see fig. 15.7), the ones on this cabinet derive from architectural constructions. All the doors have removable central stiles, white brass hinges, and rectangular lock plates that follow the contours of the frame members. Wood pivot hinges, which are usually found on this type of tapered cabinet, are not used here because of the separate upper and lower doors. The door pulls have cutout motifs decorated with red copper and yellow brass; the larger ones on the bottom cabinets are considerably thicker than those on the top cabinets. There is a shelf beneath the lattice doors, but no shelf in the lower part of the cabinet. Each lattice panel has a complex pattern of *wanzi* (the character for ten thousand) that is symmetrical, with one panel the mirror image of the other. The lattice is attached to frames made of wood different from the rest of the cabinet, and its continuous repeated design seems to have been cut from a larger panel. This construction suggests that the panels might have been made by specialized craftsmen and added when the cabinet was finally assembled. Since there are at least three other known cabinets with this type of lattice panel, it is unlikely that they were cut down from a larger panel originally used elsewhere.

The enclosed portion of the cabinet would have been used for storage, while the open part was appropriate for displaying a few choice objects against the beautiful *huanghuali* back panel. Looking through these panels is like looking through a lattice window in a Chinese garden; objects perceived through decorative tracery have a special allure that invites you to open the doors. The lattice side panels allow more light to enter the cabinet and permit the viewing of the contents from another angle. The lattice itself is a pleasing decorative element that is especially interesting from the side, where light shines through two superimposed panels. These cabinets were meant to be seen from the sides, not just the front, and thus the

sides have the same elaborately carved aprons as the front has. The entire surface of each apron is filled with a *lingzhi* fungus and vine pattern that is similar in its curvilinear complexity to the edge of the apron. Tapered cabinets were made in pairs to stand against the same wall or to balance each other on opposite walls. Unlike square-corner cabinets, they do not look good standing close to one another because of their taper.

A rare square-corner cabinet fully exploits the aesthetic effect of lattice panels (fig. 15.19). Here sides and doors are fashioned from single panels. The identical side panels have a random cracked-ice pattern (*bingzhanwen* or *bingliewen*)—a popular seventeenth-century decorative motif. In *The Craft of Gardens* (*Yuan ye*), published around 1631, Ji Cheng recommends the pattern for shutters, stone and broken-brick paths, and stone walls. Stone wall borders in the cracked-ice pattern were used on transitional porcelains. The pattern was admired for its pleasing asymmetry. Moreover, it evokes the lines from the *Dao de jing* that describe a sage as one who is

> shrinking,
> as ice when it melts;
> plain,
> as an unhewn log;[26]

The lattice on the doors has an unusual angular design with scrolling leaves, and this embellishment also adds strength at the fragile angular joins. All four sides of the cabinet have humpback stretchers ending in stylized dragon heads where they tenon into the legs; there are struts carved with coiling dragons on the front and back stretchers. The back of the cabinet consists of two floating panels secured by easily removable loose tenons. Similar tenons attach the frames of the side cracked-ice panels, the shelves, and the bottom panel to the frame of the cabinet. The doors, which have wood hinges instead of the metal hinges usually found on square-corner cabinets, are also easy to remove. Thus, the cabinet has been explicitly designed to disassemble quickly, like the wardrobes and display cabinets described later in this chapter. First one lifts the doors off their hinges and takes out the shelves; then one removes the side and back panels by pulling out the sliding tenons. Next, the tap of a soft mallet releases the mitered mortise-and-tenon joints at the corners of the frame. Now one can lift off the top and remove all the horizontal stretchers. The disassembled piece forms a compact bundle no more than 161 centimeters high and 61 centimeters wide.

The entire cabinet, including the back, is beautifully finished, and even the shelves and their supporting braces are fashioned from *huanghuali*. Its fine wood and interesting lattice designs would have made it an appropriate embellishment for the scholar's studio. Since the cabinet is unusually wide, it would have been useful for storing large hanging scrolls as well as books, antiques, and writing paraphernalia.

Square-corner cabinets, like tapered ones, can be plain or decorated and ingeniously fitted for specific uses. The *Classic of Lu Ban* describes a wooden square-corner medicine cabinet (*yaochu*) that is a little bit lower and wider than the clothes cupboard and has two pairs of doors placed next to each other. The doors open to reveal twenty-four drawers arranged in tiers of seven.[27] In the Forbidden City there is an elegant black lacquer medicine cabinet with gold-painted decoration (fig. 15.20). Its dimensions are similar to those of the low tapered cabinet with horse-hoof feet (see fig. 15.17). The back is inscribed, "Made in the Wanli era [1573–1620] of the Ming dynasty." It is exquisitely ornamented with dragons on the front and sides and bees and butterflies among flowers and rocks on the inside of the doors. Beneath the doors are three drawers. The interior of the cabinet has along each side a tier of ten deep drawers, each divided into three compartments. In the center there are eighty drawers, arranged in tiers of ten, attached to a revolving rod. The space is so well utilized that as many as 140 different kinds of medicines can be stored in one small cabinet. This piece is a fascinating example of how the ancient principle of the revolving bookcase—invented to store Buddhist

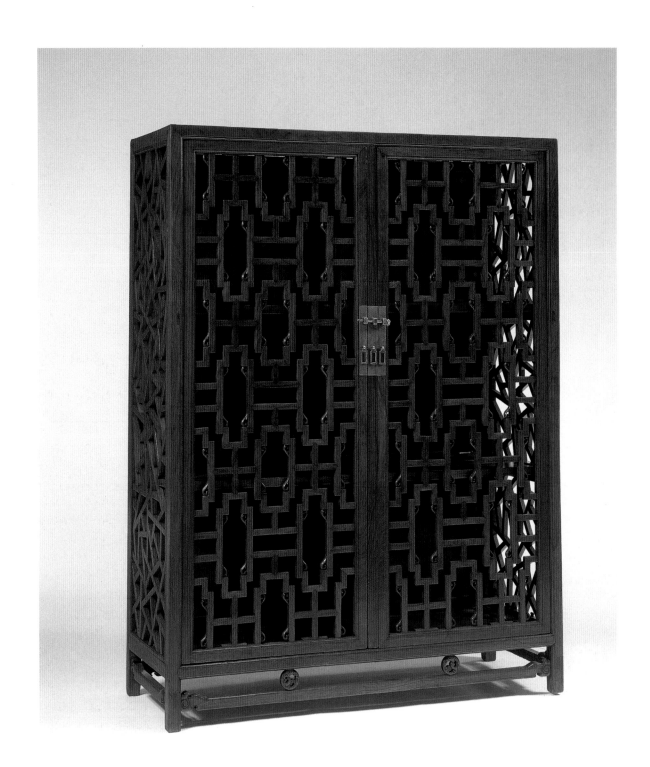

15.19

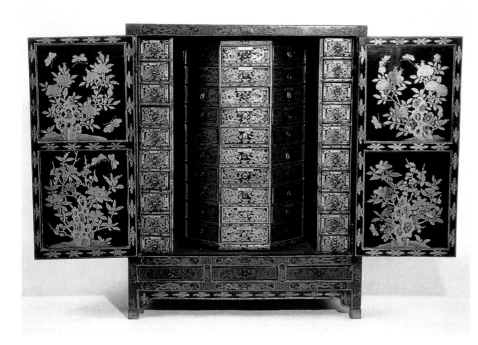

FIGURE 15.19 Square-corner cabinet. Ming or Qing dynasty, seventeenth century. *Huanghuali* wood. Height 161 cm, width 121 cm, depth 49.5 cm. © Christie's Images, Ltd., 1999.

FIGURE 15.20 Medicine cabinet. Ming dynasty, Wanli reign period (1573–1620). Gold-painted black lacquer. Height 100 cm, width 79.1 cm, depth 56.8 cm. Palace Museum, Beijing. From *Chūgoku no hakubutsukan,* 5: 186.

15.20

sutras (see fig. 15.7)—was adapted in later times for secular use.

Li Yu, who was fond of drawers to store close at hand all the small necessities of life, describes scholars' cabinets based on medicine cabinets, which he aptly calls "hundred-eye cabinets" (*baiyanchu*).[28] As Craig Clunas points out, large multidrawer cabinets have been associated with information storage since at least the Song dynasty. Zhou Mi recorded that in the thirteenth century Li Renpu, "in order to aid his writing, had made ten cabinets of wood. Each cabinet had twenty drawers, marked with the character of the sexagenary cycle. Whatever came to his attention was entered in these cabinets, arranged in good order by date and in sequence."[29] It is significant for intellectual history that Li Renpu systematically stored his knowledge in the drawers of his cabinets just as the pharmacist stored herbs in the drawers of his medicine cabinet.

Multidrawer cabinets separate objects and permit the easy retrieval of small items. Cabinets with large undivided spaces, by contrast, can contain big objects and stacks of objects, which can be further contained in boxes or coverings. When objects are stacked, retrieval is more complicated and time consuming. When spaces are high with few shelves, the upper portions tend to remain empty, leaving the space underutilized. The largest cabinets, known as four-part or compound wardrobes, are the most imposing pieces of Chinese furniture, dominating any room by virtue of their size and monumental design. In the eighteenth-century *Story of the Stone* they are called *dachu.*[30] These wardrobes were made in pairs. Beijing cabinetmakers call them *sijian gui* (four-part wardrobes) or *dingxiang ligui* (top cupboards and upright wardrobes) because each consists of two lower and two upper cabinets. Although the upper cabinets are separate structures, they are not intended to be used alone since the tops are not flush and are finished with a rough lacquer coating, like the underside of tabletops.

Fig. 15.21 shows one of a pair of exceptionally fine wardrobes fashioned from *huanghuali* wood with an orange-gold shimmer. The strongly figured wood on the doors is book matched: that is, two originally facing cuts from the same log are placed side by side so

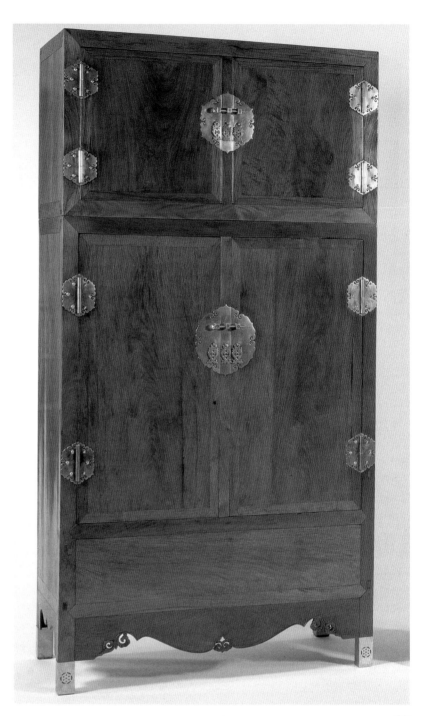

FIGURE 15.21 Compound wardrobe, one of a pair. Ming or Qing dynasty, seventeenth century. *Huanghuali* wood. Height 260 cm, width 133 cm, depth 63 cm. © Christie's Images, Ltd., 1999.

15.21

that the fibers slant in opposite directions, giving a contrasting light and dark effect. An unusual horizontal emphasis has been obtained by using darker wood for the aprons, the stretchers beneath the doors, and the upper frame members of the lower cabinets. This design creates an especially pleasing effect where the two mitered frame members of the cabinets come together to give the appearance of an elegant double miter. The natural beauty of the wood decorates the large flat surfaces of the wardrobe; only the deeply curved beaded-edged aprons are carved with *ruyi* in the center and variants of the same motif at the cusps.

The functional metal hinges, lock plate, and pulls all enhance the richness of the wood. These important decorative elements are carefully sized and spaced to complement the proportions of the wardrobe. The hardware is surface-mounted and secured with brass pins, which are almost invisible against the burnished surface of the metal. All the hardware is made from *paktong,* or white brass, composed mainly of nickel mixed with copper and zinc. The lock plates are persimmon-shaped. The openwork pulls in the shape of double fish, symbolizing abundance and wealth, have red brass eyes, and red brass is also used to outline the circular geometric design on the lock receptacles. The hinges on the lower cabinets show signs of extensive wear on the tubular sections, which have small additions, and six round-headed pins have been applied to each. Since the top cabinets are much less accessible than those at the bottom, they were opened infrequently and thus do not exhibit the same signs of wear. The wardrobes have original white-brass feet with openwork stylized chrysanthemum patterns, symbols of autumn and longevity.

Today metal pins hold the doors of the wardrobes shut. Originally the doors would have been secured by large brass padlocks, which were usually plain or simply engraved, although those for important pieces might be intricately decorated. The padlock would have passed through the three lock receptacles on the wardrobe and locked with a long key. In the *Pictorial Encyclopedia of Heaven, Earth, and Man* padlocks are called *suo* and the keys *yao*.[31] Cabinets and boxes used in Chinese households always seem to have had locks, perhaps because large extended families lived together with many servants in relatively accessible rooms.

Inside the top cabinets of the wardrobes is one shelf. The bottom cabinets have two shelves, with two drawers beneath the lower shelf. Beneath the bottom panel on the front of the cabinet is a concealed storage area covered by two framed panels, which are fitted with metal rings so that they can be lifted out. The support between the two panels tenons into the front and back stretchers. Since the mortise into which it tenons in the front stretcher is long, the support quickly slides out. The Chinese did not consider this arrangement awkward and also used it in coffers.

At the corners of each cabinet is a compound miter joint with double tenons (fig. 15.22). Structurally this is one of the most stable methods of joining three pieces of wood at right angles. In Chinese furniture it is also one of the most difficult joints to visualize. The horizontal frame members are connected by mitered double-mortise-and-tenon joints. The vertical frame member then double-lock tenons into and half-lap miters over the horizontal frame. This construction means that one and a half of the exposed double tenons of each horizontal frame member are visible on the outer surface. When the compound miter joints with double tenons are undone with the tap of a soft mallet, the entire top and bottom frames can be removed. The whole wardrobe then easily disassembles into pieces no larger than one side of a single lower cabinet (186.5 cm high, 69 cm wide). Compact deconstruction is possible because, like the square-corner cabinet with full-length lattice doors and sides (see fig. 15.19), the backs of the lower cabinets are divided vertically into two framed panels, beautifully finished on both sides, and secured by sliding tenons that release quickly.

The Chinese wardrobe was used to store garments folded vertically and then horizontally into flat rectangles. The symmetrical creases were not considered unsightly. Smaller items would have been kept in the top cupboards, which are so high that people needed

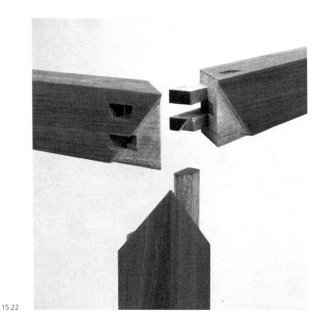

15.22

FIGURE 15.22 Model of a compound miter joint with double tenons.

ladders to reach them. In the *Story of the Stone* Granny Liu, an old country woman patronized by Grandmother Jia, is astonished by the size of the furniture in the Jia family's mansion:

"They say that 'great families live in great houses,'" said Granny Liu, "and truly when I first went into Your Ladyship's apartment yesterday and saw those great chests and cupboards [*dachu*] and tables and beds, the size of everything fairly took my breath away. That great wardrobe of yours is higher and wider than one of our rooms back home. I'm not surprised you keep a ladder in the back court-yard. When I first saw it, I thought to myself, 'Now what can they need a ladder for? They don't ripen things on the roofs as we do, so it can't be for that.' And then of course I realized: it must be for getting things out of the compartment on top of that wardrobe of yours, for you could never reach it else."[32]

In great houses like the Jia family's, wardrobes were used both in the inner women's apartments and in the reception rooms to which male visitors were invited. If the master of the house was an official, the wardrobes might contain his court robes, with the hats stored in the upper cupboards. The Portuguese Dominican Gaspar da Cruz notes, in what is the first Western mention of Chinese hardwood furniture, the dominant positions of wardrobes in the reception rooms of a Cantonese house he visited in 1556: "Entering in the first of these houses (which is large) it has therein some huge cupboards very well wrought and carved, but the work is more for strength and durability than for show."[33]

The two parts of four-part wardrobes can be placed side by side, opposite each other across a room, or symmetrically along a wall separated by a door or small coffer. According to *A Complete Collection of Necessary Matters Ordered for the Householder* (*Jujia biyong shilei quanji*), published around 1600, wardrobes should be placed against the side walls of a room and never against the back wall, where they would face a person entering the room.[34] This rule, however, may not always have been followed. In a seventeenth-century woodblock illustration to *The Plum in the Golden Vase* (*Jin ping mei*) we catch a glimpse

of the side of what is probably a wardrobe (fig. 15.23). It stands against the screening wall that masks the back entrance of a reception hall. Thus, it would have faced someone entering the hall from the back. The scene depicts Aunt Yang angrily cursing Chang the Fourth, who is trying to prevent Meng Yulou's trousseau from being taken to Ximen Qing's. Men hastily carry away the trousseau, which is packed in a large chest, a tiered box, and various small boxes. In the lady's bedroom the boxes would have been stacked with the smallest on top, or a box would have sat on top of a small cabinet (see fig. 10.18).

It is unusual to find cabinets with the special construction features of the four-part wardrobe (see fig. 15.21), which make it so easy to dismantle. Yet the same features appear in a pair of square-corner *huanghuali* display cabinets (fig. 15.24). Cabinets of this type, which Beijing cabinetmakers call *lianggegui,* have a high open shelf to display antiques and other precious objects and a storage cupboard below. They would have been used in a scholar's studio, where the display of antiques and books was essential to the refined ambiance. As Wen Zhenheng wrote, "There should be fine trees and interesting plants, a display of antiquities and books, so that those who live there should forget about age, the guest forget to leave, the visitor to the grounds forget about fatigue."[35]

Decorative moldings and low ornamental railings frame the objects placed on the shelf, which is open on three sides. To emphasize the display, the carving on the cabinet is concentrated around the shelf. The crisp beading, with an incised line along its inner edge, outlines the frame and forms elegantly detailed scrolling patterns at the arches, cusps, and corners. The front railings (fig. 15.25) have lotus bud finials energetically carved at each corner and openwork panels with striding *baize* (a mythical beast that appears when a virtuous ruler reigns) amid dragon-cloud scrolls. On the sides the continuous railings are embellished with two lively *baize,* one chasing the other. All the carving is of exceptional grace and quality.

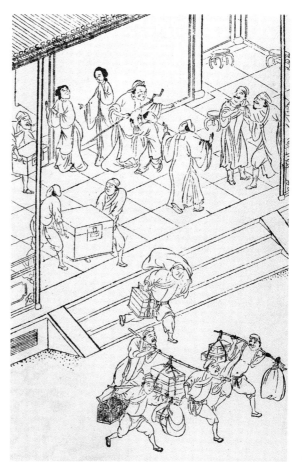

15.23

FIGURE 15.23 *Aunt Yang Angrily Curses Chang the Fourth.* Ming dynasty. Woodblock illustration to *The Plum in the Golden Vase* (*Jin ping mei*), Chongzhen reign period (1628–44), chap. 7.

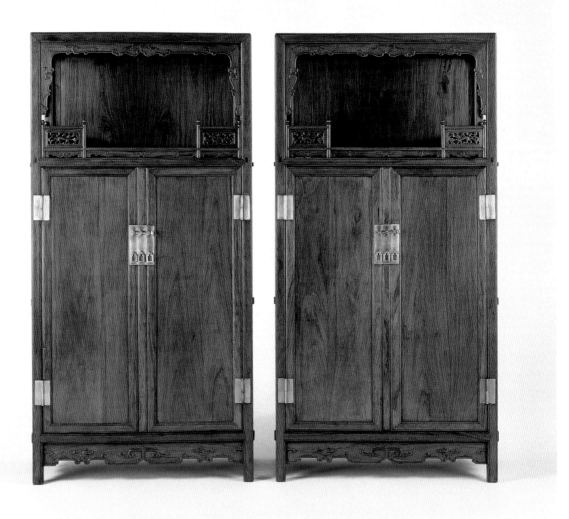

15.24

FIGURE 15.24 Display
cabinets. Qing dynasty, late
seventeenth/early eighteenth
century. *Huanghuali* wood.
Height 184 cm, width 97.5 cm,
depth 49 cm. © Christie's
Images, Ltd., 1999.

FIGURE 15.25 Detail of
carving on fig. 15.24.
© Christie's Images, Ltd., 1999.

Inside the cupboard is a shelf with two drawers un-
derneath for storing objects not currently on display;
in China such displays change according to the sea-
son and occasion. The cupboard might hold books,
and, since the central stile is removable, long scrolls
or other large objects. Beneath the cupboard is an
apron with beading that becomes dragon's heads at
the cusps and scrolls at the center.

Other decoration comes from the recessed bead-
ing along the edges of the main framing members and
the contrast between the mellow beauty of the grain

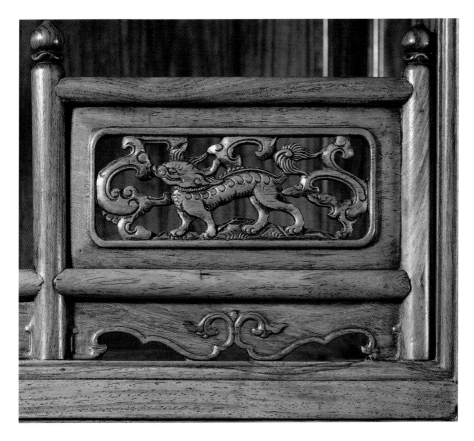

15.25

on the slightly recessed doors and the white brass rectangular lock and hinge plates. The joinery is clearly visible and used to decorative effect in the miters at the corners of the frames, the double miters of the railing and top stretchers, and the exposed tenons in the front posts just below the display shelf. On each side of the posts are three unusual protruding tenons, graduated in size with the smallest at the top. Similar conventions, such as the tapering and splay of a chair's vertical members and the gradual reduction in proportion of the hardware on wardrobes, give classical Chinese furniture the effect of stability below and lightness above.

The protruding tenons indicate that the cabinet is easy to dismantle into pieces no bigger than the side panels (49 cm by 184 cm). The back of the cabinet consists of three framed panels, beautifully finished on both sides and secured by sliding tenons that can be quickly released. The shelves, bottom of the cabinet, stretchers, and doors all lift out. Once the compound miter joints at the top corners of the cabinet have been taken apart, the horizontal members are easily removed: since the tenons of the supporting horizontal members protrude, a light tap is all that is necessary to release them. Because the cabinets are paired, the pieces of each are marked with a different character—*he* (join) and its homonym *he* (peace)—to prevent any confusion when they are reassembled. There are also directional characters for left, right, above, middle, and below.

Books and scrolls could be stored in cabinets or on open shelves. Scrolls would be placed horizontally on the shelves and books stored flat on their sides with their covers facing up (see, e.g., figs. 13.9 and 15.8). Chinese bookshelves often have drawers, which, since traditional desks do not have any drawers, are convenient places for storing writing implements,

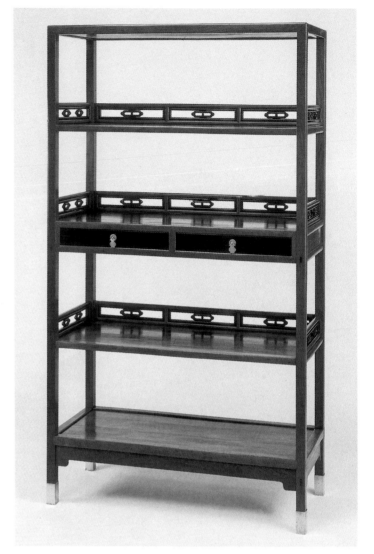

FIGURE 15.26 Bookcase. Qing dynasty, late seventeenth/early eighteenth century. *Huanghuali* wood and ebony (*wu*). Height 196 cm, width 110 cm, depth 48 cm. The Minneapolis Institute of Arts. Gift of Ruth and Bruce Drayton. Photo © Christie's Images, Ltd., 1999.

FIGURE 15.27 Chen Hongshou (1599–1652). *Landscape with Figures*. Ming dynasty, seventeenth century. Detail of a hanging scroll. Ink and color on silk. Height 171 cm, width 48.4 cm. Palace Museum, Beijing. From *Paintings of the Ming Dynasty*, 270.

15.26

notes, and anything not immediately wanted on the desk. Chinese drawers do not fit tightly into their framework and are really "pullable trays," as the common term for them, *chouti,* implies.[36] Thus it is easy to pull out the drawer and carry it to the desk. On one elegant *huanghuali* bookcase the drawer fronts and inset panels on the railings are fashioned from ebony (*wumu;* fig. 15.26). The black close-grained ebony offsets the lighter, orange-hued *huanghuali* and creates a rich decorative effect. The tall bookcase is made from square members and has four shelves with

two drawers beneath the second shelf from the top. The bottom shelf is recessed into its frame. All but the bottom shelf have low railings along the back and sides that are ornamented with ebony panels. Each railing has one slide tenon that passes through the ebony and *huanghuali* railing members to tenon into the legs. This design made the construction of the bookshelves easier because it allowed the railings to be quickly inserted after the rest of the bookcase was assembled. The ebony panels are open, with begonia-shaped motifs. There are white brass vase-shaped

drawer pulls. Since the back legs have lost some height, white brass feet were added. The back of the bookcase is finely finished, and there are standard aprons on all four sides.

Shelves were used not only for storing books in the home, but also for holding all sorts of things in shops. A rare depiction of shelves with drawers appears in the painting *Emperor Kangxi's Tour of the South*.[37] In a shop on Three Hills Street in the Fanhua district of Jiangning (modern Nanjing), a set of shelves is visible behind the counter. It is made of dark wood, with another lighter wood used for the drawers.

Shelves could also be high and wide, like the set in a hermit-scholar's thatched studio in a painting by Chen Hongshou (1599–1652; fig. 15.27). Here the shelves are completely filled with books and scrolls. Wen Zhenheng talks about bookcases (*shujia*) of this type that are as large as seven *chi* high and fourteen *chi* wide (where one *chi* is about a third of a meter). He advises keeping the bottom shelf empty so that the books will not be damaged by the damp.[38] In Chen's painting a hermit-scholar sits on a gnarled tree root, an appropriately rustic bench for a life in the mountains. Beside him incense burns in a pot on a tall stand. Chen Hongshou loved city life, wine, and women, but like many literati, he longed at times to escape to a simple life in the country. This wavering between urbanity and eremitic seclusion has a long history in China. The great Tang poet-official Wang Wei, for example, often describes the pleasures of being a hermit in the mountains:

> With a cricket's cry autumn abruptly falls
> on my thatched hall.
> The thin haze of evening is saddened with the whine
> of cicadas.
> No one calls. My cane gate is desolate.
> Alone in the empty forest, I have an appointment
> with white clouds.[39]

15.27

Whether in a mountain hermitage, a grand mansion, or a shop, storage containers were essential items for comfortable and practical living. These shelves, cabinets, and boxes were ingeniously designed to hold all kinds of objects. Utilitarian as well as aesthetic, they could be among the most beautiful and monumental pieces of Chinese furniture. In China the practical and social need to contain things inspired the creation of splendid great walls crossing half a continent, enduring and aesthetically designed walls to hold in cities and towns, well-proportioned walls to protect and house families in their compounds, and a myriad of household containers, usually of wood, to hold clothing, scrolls, books, treasures, and all objects that are stored. "To put things away" requires an ordering device. In literature words are stored in a sentence, sentences in a paragraph, paragraphs in a book, and finally books on a shelf. Ultimately everything from words to fans to dishes requires a miniature great wall. Out of this need to order and store came the inventive Chinese art of containers.

16 | THE SCREEN
A Movable Wall to Divide, Enhance, and Beautify

The screen is a movable partition that creates or erases a space and is thus the most architectural type of furniture. Unlike other furniture, which holds or supports, Chinese screens protect, divide, enhance, and beautify. In China, where screens have a long history, they are an essential part of the furnishings of homes and palaces, temples and offices. In Europe they were not introduced until the Middle Ages, when they were used in vast halls for protection against drafts, observation, and the heat from huge open fireplaces. We know that they were in English palaces from the time of Edward II (1239–1307), and an inventory of the possessions of Henry VIII (1491–1547) lists "scrynes of purple taphata frynged with purple silke, standing uppon feete of tymbre guilte silvered and painted."[1] In the late seventeenth and early eighteenth centuries Oriental screens were the rage in Europe, and large folding Coromandel lacquer screens, often elaborately decorated with exotic palace scenes, were imported from China.

The Chinese have been making profusely ornamented screens since at least the Warring States period (475–221 B.C.), when six were buried in Chu tombs in what is now Jiangling, Hubei province.[2] One of them, excavated in 1965 from tomb 1 at Wangshan (fig. 16.1), is a remarkable early example of carved interlacery in painted lacquer. Long and low, it has a complex design of fifty-five intertwining animals. An openwork panel is set into a base covered with coiling snakes, some of which creep up to attack frogs on the lower frame of the panel. On the panel, snakes threaten deer and are in turn menaced by birds in a lively yet stylized composition.

More restrained decoration appears on a solid panel screen, higher and narrower in its proportions than the Wangshan screen, that was discovered in the second-century tomb of the Marquess of Dai (fig. 16.2). This lacquered screen was found in the northern storage area together with other bedroom furnishings, including toilet boxes, an embroidered pillow, and incense containers. The screen is set into two recessed feet and has black borders with a vermilion rhombic design. One side is red and has in the center a green jade *bi* disk

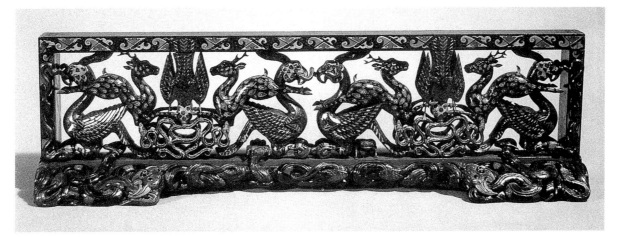

surrounded by an interlocking geometric pattern. The
other side has a black lacquer ground with a dragon
rising through clouds painted in red, green, and gray
oils. The relatively crude construction and small size
of the piece suggest that it might have been made ex-
pressly as a burial object. Early Shandong stone tomb
carvings, however, show similar small screens: one of
the reliefs in the funerary shrine (erected in A.D. 151)
of the Confucian scholar Wu Liang shows Duke Ling
of Wei seated before a screen with a diaper pattern;
in a second-century engraving in a tomb in Yinan,
Shandong, there is a screen with a plain panel and a
scroll-patterned border. A painted basket from a
tomb in Lelang, Korea (dated first century B.C. to first
century A.D.), depicts a figure sitting in front of a
screen decorated with bold scrolls in red and black
outlined in gold. There were also higher, narrower
screens, such as those found in Eastern Han tombs
(A.D. 25–220) at Wuwei, Gansu province, and Luo-
yang, Henan province.[3]

Painted lacquer screens—like the one excavated in
1983 in Xianggang, Guangzhou, Guangdong province,
from the tomb of Zhao Mo (d. c. 122 B.C.)—were
sometimes embellished with elaborately carved gilt
bronze supports and mounts. Zhao Mo ruled the
Nanyue kingdom (203–111 B.C.), an independent

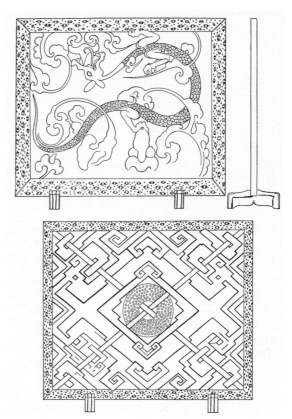

FIGURE 16.1 Painted lacquer
screen. Not later than 334 B.C.
Excavated at Wangshan,
Jiangling, Hubei. Height
15 cm, length 51.8 cm. Hubei
Provincial Museum. From
Teng, *Lacquer Wares of the
Chu Kingdoms*, 54.

FIGURE 16.2 Drawings of a
screen from tomb 1, Mawang-
dui, Hunan. Western Han
dynasty, c. 168 B.C. Lacquered
wood and oil paint. Height
62 cm, length 72 cm. From
Hunan Sheng Bowuguan,
*Changsha Mawangdui yihao
Han mu*, 1: 94.

THE SCREEN **269**

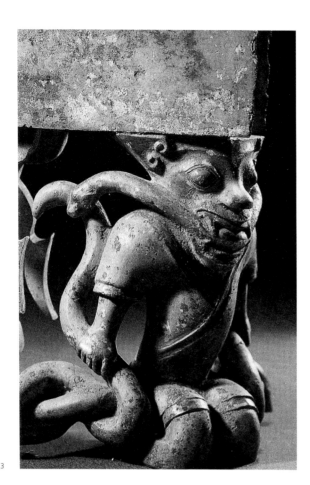

FIGURE 16.3 Detail of screen
support. Western Han dynasty.
Excavated in Xianggang,
Guangzhou, Guangdong, from
the tomb of Zhao Mo, king
of Nanyue (d. c. 122 B.C.).
Gilt bronze. Height 32 cm.
From Guangzhoushi Wenwu
Guanliweiyuanhui, *Xi Han
Nanyue wang mu*, 2: 28.

state in southern China. Unlike other screens found
in early tombs, Zhao Mo's was large. The layout of
the tomb resembles that of a palace, and the screen
was found in the main chamber of the tomb in front
of the door leading to the women's quarters. Al-
though it would have blocked the entrance, a clev-
erly concealed door in the center of the screen pre-
sumably gave the king access to his ladies. Only the
metal fittings and fragments remain, but these are
sufficient to reconstruct the dimensions and general
form of the screen, which consisted of three sections,
each 1 meter wide and about 1.85 meters high. The
well-preserved bronze supports and ornaments are
beautiful examples of the caster's art. The screen had
three pairs of supports. One pair are ornamented with
intertwining snakes. The second consist of coiled
horned beasts standing on the backs of froglike crea-
tures. The third have kneeling barefoot men grasping
and biting snakes (fig. 16.3); their flat heads hold up
the metal corner mounts into which the lacquered
screen panel was fitted. These lively three-dimensional
sculptures gracefully incorporate the snake imagery
prevalent in southern cultures. Ornamenting the top
of the back of the screen was a bronze animal mask
in the center and a pair of birds with outstretched
wings. This magnificent large screen would have de-
lighted, protected, and honored the king in his grave
by reminding him of the good things he had enjoyed
during his life.[4]

Stone engravings found in tombs often depict
people sitting on low platforms (small enough to ac-
commodate a single person or long enough for many
people) with a long screen standing behind the plat-
form and a short side wing along one end of the seat.
We see this arrangement, for instance, in a tomb in
Anqiu, Shandong (see fig. 9.1), and in the large ban-
quet scenes in the Wu Liang shrine. Sometimes there
is a three-sided screen, as in an homage scene en-
graved on a stone slab from a second-century B.C.
tomb in Qianliangtai, Shandong (fig. 16.4). Here the
screen has an honorific function, isolating and en-
hancing the person to whom homage is being paid.
This screen has four panels: two along the back and

one on each side. Wu Hung hypothesizes that this type of homage scene derives iconographically from the portrait of the first Han emperor and symbolizes sovereignty.[5] Beautifully painted screens protected and ennobled a ruler. Here, in an ode written for Prince Xiao, Yang Sheng (d. 148 B.C.) describes his patron surrounded by gorgeous screens with decorations like those found on the screen at Mawangdui (see fig. 16.2):

ODE TO SCREENS
Standing in a circle,
the screens protect my prince.
On them abound flowers,
embroideries and more embroideries,
tons of brocades,
and chains of jade rings and squares.
The screens are fully decorated
and gracefully painted.
Ancient heroes have their noble and loyal demeanor.
The screens fit my lord perfectly
and I wish him longevity.[6]

Screens in the Han dynasty imperial palace were painted with historical scenes intended as warnings to the emperor and his ladies against improper behavior and as models of good conduct. Ban Gu (d. A.D. 92), in his *History of the Former Han Dynasty* (*Han shu*), records that Emperor Wu (r. 140–87 B.C.) had a painted screen (*hua pingfeng*) showing King Zhou of the Shang and his evil concubine Daji engaged in drunken nighttime revelries. The depiction served as a warning against excessive drinking and consequent licentious and disastrous behavior. The imperial librarian Liu Xiang wrote that his famous compilation, *Biographies of Exemplary Women* (*Lienü zhuan*), was illustrated on a four-panel screen to provide moral edification: "The *Lienü Zhuan,* which was compiled by [my son], the *huangmen shilang* [the gentleman attendant at the palace gate] Liu Xin and myself, consists of [biographies of outstanding women] classified in seven volumes. The purpose [of this work] is to demonstrate the effects of disaster, fortune, glory, and humiliation, and to differentiate right from wrong, and success from failure. It was painted on the four panels of a screen."[7]

16.4

FIGURE 16.4 Engraved stone slab from a tomb in Qianliang-tai, Zhucheng, Shandong. Western Han dynasty, second century B.C. Drawing from Ren Rixin, "Shandong Zhucheng Han mu huaxiang shi," 20.

Although screens could have a didactic function and an honorific function, their primary purpose has always been to protect and conceal. A free-standing screen wall datable to the second millennium B.C. was found in front of the main gate of a royal house excavated in 1976 near Fengchu, Qishan, Shaanxi.[8] Such walls, whether constructed from rammed earth or wood, were called *fousi*. They are the prototypes of screen walls standing directly inside the front gates of Ming and Qing courtyard houses. Not only do these walls provide privacy, but they also, according to a later tradition, keep evil spirits out, for in China evil spirits can walk only in straight lines. Ma Yuan, a famous general who invaded Tonkin in A.D. 49, advised two of his relatives: "You should live [isolated by] a screen (*ping*) and preserve yourself."[9]

In everyday life, screens stood next to the head at night to protect from drafts, according to a statement in the

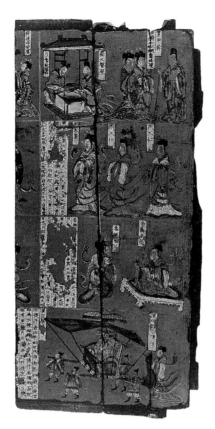

16.5

History of the Former Han. Screens were also used for concealment. Sima Qian (c. 145–c. 86 B.C.) notes that when Meng Changjun entertained guests, his attendant historian hid behind a screen (*pingfeng*) to record the conversation.[10]

Women were often hidden behind screens, because according to the strict Confucian code of ethics no man could see them except for their immediate relatives. Consequently, women watched dances and musical performances, observed their husband's friends and guests, and even took part in discussions from behind a screen. An unusual story from 540 B.C. tells of a princess of Zheng whose brother asked her to choose which of two men she preferred for her husband. Standing behind a screen, she observed the two suitors entering the mansion, one in his best clothes, the other dressed in armor and shooting arrows. She selected the one in armor because he was not only handsome but virile.[11] Screens also concealed the seductive charms of beautiful women, as we learn from the sixth-century poet Xiao Gang's description of a palace lady:

BEAUTIFUL WOMAN

This young woman passionate
and notoriously romantic
cuts yellow silk to make a moon
and shrewdly snips gold cloth into stars.
Light of her make-up better than jade,
her dress thin as a cicada's wing.
She stands cooly shifting like her face
and her voice is soft song.
When her cheeks are scarlet with wine,
her smile hides behind a scented screen.[12]

FIGURE 16.5 Panel from a wooden screen painted in lacquer. Northern Wei dynasty. Excavated from the 484 tomb of Sima Jinlong, Datong, Shanxi. Height 80 cm, width 20 cm, depth 2.5 cm. From *Wenhua dageming qijian chudu wenwu,* 143.

Fig. 16.5 shows the earliest extant remains of a paneled screen, which was excavated in 1965 in Datong, Shanxi, from the A.D. 484 tomb of Sima Jinlong, a high-ranking general of the Northern Wei period (386–535). Five wooden panels were found together with four stone bases, suggesting that the screen was stationary and perhaps had two side wings, as on the screen depicted in the Qianliangtai tomb (see fig. 16.4). The panels are lacquered red and painted with illustrations of stories of virtuous men

and women.[13] To increase the didactic efficacy of the scenes, the text of each episode is written out and the main characters identified by names next to their images. The panel illustrated in fig. 16.5 contains the following exemplary women (from top to bottom): two concubines of the sage-king Shun, three ancestors of the Zhou dynasty, a lady from the state of Lu, and Lady Pan, the concubine who refused to go out with the Han emperor Cheng in his litter lest she distract him from affairs of state.

By the Northern Wei, the long screen with side wings behind Han platforms had evolved into a multipaneled screen with hinged front panels that could enclose a canopy bed. At night the screen was closed and the curtains let down, creating a completely private space. During the day the screen was opened and the curtains drawn up, providing several people with comfortable seating protected from drafts. Such a scene appears in a stone engraving from the tomb of a nobleman, who is depicted on the right holding a cup and facing his lady (fig. 16.6). The screen is attached to the top of a rectangular boxlike base with side panels that have oval cutouts with cusped upper edges. Usually, as here, a low table or bench with multiple curved legs on each side stands in front of the seat.

Famous artists painted on screens (*pingfeng,* lit., "to shield from the wind"), and their work is recorded in treatises, such as the *Record of Famous Painters of All the Dynasties* (*Lidai minghua ji*), by Zhang Yanyuan (active 847). Gu Kaizhi (c. 344–c. 406) is said to have painted six pictures on silk for a screen: a landscape, ancient worthies, Rong Qiqi, the Master, the Yuan and Xiang rivers, and water birds. Fan Huaizhen of the Southern Qi (479–502) painted filial sons, and Yang Zihua of the Northern Qi (550–577) depicted figures in a palace garden. These paintings were sometimes so lifelike that they were mistaken for the real thing. Once Sun Quan (d. 252) asked Cao Buxing, a painter known for his dragons and Buddhist subjects, to paint on a screen. Cao accidentally dropped his brush, causing a blot on the clean silk, which he promptly transformed into a fly. Sun, mistaking it for a real one, tried to brush the fly away.[14]

16.6

FIGURE 16.6 Rubbing of a stone engraving from a Northern Wei tomb. Tenri University, Sankokan Museum.

Screen painting was an important occupation at this time. In the 570s, according to the *Southern and Northern Qi History (Nan Bei Qi shu)*, Xiao Fang "was appointed palace inspector of books and of recent poetry, and of screens done by professional painters." Poetry and screen painting were considered related, and the same history says of the last Qi ruler: "As an adult he kept some interest in poetry. He began to make use of painted screens in this regard, and so ordered . . . Xiao Fang and . . . Wang Xiaoshi to make lists of poems by the celebrated worthies and gallant gentlemen of the past, as well as of the gay verse of modern times, to serve for paintings. These he greatly admired." Fei Chang of Liang (502–557) wrote two poems on painted screens, and Yu Xin (513–581) wrote a long poem in twenty-four stanzas on multi-paneled screen paintings.[15] Whether these poems are inspirations for screen paintings or rhapsodies on screen paintings is unclear. They are, nonetheless, early evidence of the connection between poetry and painting that later became so important and is one of China's great contributions to world art. Thus furniture, specifically the screen, testifies to this early union between poetry and painting.

In the Tang dynasty (618–906) many artists, instead of painting directly on wooden panels, painted on silk or paper, which was then mounted on the screen. At this time the art of mounting was fully developed, and in the mid ninth century we find the first complete description of the process in Zhang Yanyuan's *Record of Famous Painters of All the Dynasties*. The thin paper or silk used for painting is wrinkled, fragile, and unattractive after the ink dries and so must be pasted onto sheets of backing paper. Monochrome silk or paper borders are applied to the front, and the painting is then stretched over a wooden lattice, which is fitted into the screen's frame.[16] Mounting is an important art that requires great skill and aesthetic judgment. The mounter must also be able to repair and remount old paintings that have been damaged, and it is this aspect of the art that concerned Zhang Yanyuan. He made the following specific remarks about the re-

mounting of folding screen panels, which, like a traditional Chinese book, read from right to left:

> In all things concerning pictures and manuscripts the main thing is perfection from start to finish. For famous works of art are not in a realm wherein one may lightly speak of cutting them up and altering them. If it be thought necessary to arrange together in a series . . . (on a screen of) three panels or five panels . . . then it will certainly be best to place the best part at the beginning, the worst parts next, and the middling parts last of all. Why should this be so?
>
> Because whenever people look at paintings they are of course keen when the scroll is first opened, and grow indolent and tired about half way through, but then if they come to things of middling quality they go on and on without realizing it until they come to the end of the scroll.[17]

Since screens were objects of daily use—unlike scrolls, which were kept rolled up and were opened only on special occasions—their paintings often became damaged and were remounted in a scroll format. Conversely, scroll paintings might be transferred to screens. The Tang writer Pei Xiaoyuan says that in his day two paintings on a folding screen by the sixth-century artist Zheng Fashi were removed from a screen and mounted as handscrolls.[18] Such practices continue today.

Unfortunately, however, not all screen paintings were remounted and carefully preserved. One of the great Tang landscape painters, Zhang Zao, created many vigorous ink paintings of pine trees for screens. When the owner of one of his screens died, a collector who went to purchase it discovered that the owner's widow was using the painted silk to make a dress lining and only two panels remained. Screen paintings by famous masters could command high prices. Zhang Yanyuan tells us that a single panel by one of the best painters fetched as much as twenty thousand ounces of gold, while slightly inferior ones sold for fifteen thousand each. To have a screen painted by a famous artist was an important status symbol. Du Fu, in his poem "On Seeing a Horse Painting by Cao Ba in the House of the Recorder Wei Feng," wrote that after the emperor Xuanzong had

commissioned Cao Ba to paint his favorite horse, Shining Light of Night, the best families felt that only Cao Ba's brushstrokes could give their screens (*ping-zhang*) luster. A famous painting of Shining Light of Night is now in the Metropolitan Museum in New York.[19]

Tang literature contains many references to screens. Li He (790–816), for instance, wrote a poem about the painted folding screen (*pingfeng*) surrounding the bed of a newly married couple. It had silver hinges resembling glass coins and twelve panels decorated with butterflies alighting on flowers, a symbol of lovers.

SONG OF THE SCREEN

A butterfly lights on a China pink
And turns into a silver hinge,
Some frozen water and glass coins
The color of duck-head green.
The butterfly's six wings
Around a lamp
That is burning with orchid oil.
The young woman before the mirror
Lets her tresses collapse
Sheds her gold cicadas,
And lets her face be bathed in the perfume
Of aloes from a warm fire
Spreading the smoke of dogwood.
Their wine goblets are tied with a sash,
The young bride is ecstatic
In the moonwind blowing the dew.
Outside her screen it is cold
And crows cry from the city walls;
But in Chu she dreams and dreams.[20]

In other poems Li He tells us of screens painted with golden-tailed peacocks or a river and water weeds; of others inset with glass, tortoise shell, or jade patterned like tortoise shell.[21] A marriage bed surrounded by a screen was not solely the prerogative of noble families, but was also used by ordinary officials and common people. In the popular literature found at Dunhuang are marriage songs thought to date from the seventh or eighth century. One verse says:

The hall gate is fenced on its four sides;
Within there is a four-box couch,
Surrounded by a twelve-fold screen [*pingfeng*];
The brocade coverlet is decorated with patterns.[22]

The "four-box couch" (*sihechuang*) might refer to the common box-construction platform with four panels, each with a decorative opening (see fig. 8.6).

For depictions of such beds we have to turn to illustrations to the *Vimalakīrti Sūtra,* where the ailing Vimalakīrti is shown seated on a canopy bed enclosed by a paneled screen. The bed is modeled on actual Tang beds but is greatly elevated, and the canopy is embellished to give it a thronelike aura. Sometimes the screens in these scenes are decorated with texts in fine calligraphy, as in cave 103 at Dunhuang, where they are written on light and dark pieces of paper arranged in an alternating checkered pattern (see fig. 10.4). Zhang Yanyuan describes a similar depiction in the Dingshuisi in Chang'an: "within the hall on the east wall is Vimalakīrti by Sun Shang-tze. The screen [*pingfeng*] at the back (of the hall is decorated) with copies from model-books based on ancient works. They are very fine too."[23]

In ordinary houses favorite poems might be written on the screens. The Tang dynasty poet Hanshan wrote:

Do Hanshan's poems live in your house?
You will like them more than reading sutras.
Copy them and paste them on a screen
where you can see them when you care to.[24]

Poems also served as subjects for screen paintings. Verses by Li Yi (d. 827) were especially popular, and some lines appear over and over, such as:

Before Huiluo Mountain the sands are snow;
outside Shoujiang, the moonlight is hoarfrost.[25]

Tang dynasty wall paintings at Dunhuang and in some of the recently excavated tombs appear to have depictions of screens with painted panels. A charming one from Astana has panels showing a water bird in front of a flowering plant, with rocks in the foreground and in the background birds flying toward the sunset in distant mountains. Another depiction, from a tomb in Wangcui, Chang'an, Shaanxi, has six panels, each with a painting of a lady in a garden sitting or standing below a tall tree.[26] These scenes are reminiscent of the famous screen panels now in the Shō-

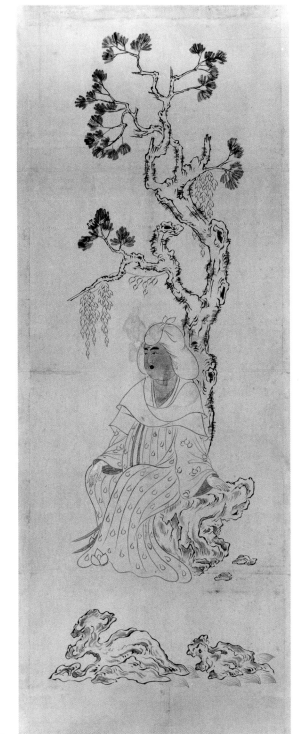

FIGURE 16.7 Sixth panel
of a folding screen, with bird
feathers decorating the painting
of a lady under a tree. Eighth
century. Ink and color on
paper. Height 136.1 cm,
width 56.4 cm. Courtesy
of the Shōsōin Treasure
House, Nara, Japan.

16.7

sōin, Nara, Japan, showing palace ladies beneath trees (fig. 16.7). Each paper panel has been mounted on ramie cloth and attached to a wooden frame. Cords passing through holes in the frames join the panels of the screen together. The faces of the ladies are carefully painted in ink and color. Their garments and hair, however, are only lightly sketched in ink because originally they were covered with pheasant feathers, a feature that must have produced a resplendent, if bizarre, effect. Previously these panels were generally considered Chinese, but inscriptions found in the backings suggest that they might have been made in Japan between 752 and 756.[27] This was a period of great Chinese influence, and the subject of beauties under trees, the plump figures, and the drawing are all typical of Tang China. Likewise, the original ornateness of the screens probably appealed to the Chinese taste. The famous poet Bo Juyi (772–846) derided the fashion for opulence; he preferred two plain paper screens on either side of his bed.

BALLAD ON AN UNADORNED SCREEN

White screen and unadorned screen,
why do you bear no calligraphy,
no decoration and no colorful paintings?
Among our contemporaries,
we have calligraphy masters
like Li Yangbin and Zhang Xu,
we have flowers and birds painted by Bian Ying
and pines and rocks by Zhang Zao.
I don't want any dot or stroke marking you.
You should keep your purity and white color.

In my thatch-roofed cottage at the foot
of the Incense Burner Mountain,
I have two screens standing by the west and east walls.
You look like the moon coming into my room at
 night
and white clouds around my bed in the morning.
I have been nurturing my inner light for years
and hope the light and the screen reflect each other.

Look at the knights' house and king's palace
where screens of brocades are decorated with pearls,
inlaid with exotic shells and mica mosaics.
Gold, silver, copper, iron, and tin are all there,
and exquisitely glamorized with diamond, sapphire,
 ruby,

opal, jade, emerald, and moonstone.
Only in this opulence do they feel content
to sleep peacefully with the screens standing around.

White screen, my unadorned screen,
everything serves its own purpose,
every object has its own function.
Now that your bones are wood
and your face is paper,
where can you be but in my thatch-roofed cottage?[28]

Tang screens are all comparatively low because they stood on top of platforms and beds or around people seated on the floor. It was only later, when Chinese began to sit on high seats and use high tables, that large floor screens became popular. Then, large folding screens might stand on the floor to protect from drafts and prying eyes the guests seated on long benches in a wine shop, as in a detail from a Five Dynasties (907–960) wall painting at Dunhuang.[29] Or large single-panel screens might divide interior spaces, as in *The Night Revels of Han Xizai* (see fig. 1.8). Han's large screens are decorated with ink landscape paintings mounted on wooden panels that fit into slots in the heavy feet. Although the feet are lacquered black, they are similar in form to those on many Ming hardwood pieces with shaped bases, drum-shaped elements, and curved spandrels. A similarly constructed miniature wooden screen was excavated from the 1190 tomb of Yan Deyuan in Datong, Shanxi.[30]

The painted landscape screen reached its zenith as an art form during the Northern Song dynasty (960–1126). Northern Song screens were larger than those of previous dynasties because of the new chair-level mode of living, which heightened both furniture and architecture. Moreover, their paintings were done by the foremost artists of the time, who were not yet inhibited by the distinction between amateur and professional that was soon to prevent the most respected painters from using such large decorative formats. By the Yuan dynasty (1279–1368) the most creative artists were not the professionals but the amateur, or literati, painters, who considered painting a personal expression and private means of communication with other literati. The public display of paintings on a

screen was, for them, most unsuitable. Thus screen painting was done only by professional artists whose work was considered decorative.[31]

In the Song dynasty, however, famous painters such as Guo Xi (c. 1001–c. 1090) received commissions to paint many screens for government offices, Buddhist temples, and the imperial palace as well as screens for the emperor to give as presents. Occasionally these were collaborative efforts, with each artist painting one panel of the screen. Although no Song screens have survived, there are some paintings (such as *The Dragon Boat Festival,* attributed to Dong Yuan in the National Palace Museum, Taipei; height 160 cm, width 156 cm) that, because their dimensions are unsuitable for hanging scrolls or handscrolls, are believed to have been painted for large screens.[32] To view these screens is to wander in the mountains or float in a boat. Landscapes painted on a folding screen are especially effective. The screen's zigzag form, folding in and out, at once reveals and obscures the scenery.

PASSING THE THREE-MILE SHOALS
My boat is a floating leaf,
my two oars startle the swans.
Waters and the sky are transparent,
my shadow a crystal, the waves flat.
Fish turn on an algae mirror
while egrets dot the misty shore.
The current at Sandy Shoals is swift,
and at Frosty Shoals it is freezing;
a full moon lolls over Moon Shoals.

My boat runs wild between endless paintings.
They unfold and zigzag like long foldable screens.
After so many years I am an aged useless recluse.
The king and his ministers had the same dream:
Fame is always shallow. Think
how distant mountains stretch around the horizon
enveloped in a chaos of clouds.
These dawning mountains are forever green.[33]

Some of the screens commissioned for the imperial palace were made specifically for use behind thrones. Often they were adorned with paintings of birds, flowers, bamboo, and ornamental rocks. In 1064 Yi Yuanji was summoned to paint the imperial audience screen in the Yingli Hall of Ritual Fasting in the Jingling Mortuary Shrine: "On the center panel he depicted rocks from T'ai-hu, and sketched in the well-known pigeons of the capital and the celebrated flowers of the Lo; while on the two side panels he represented peacocks."[34]

In paintings we also see screens used honorifically behind judges, Buddhist monks, and the occupants of tombs. A wall painting from a 1099 tomb at Baisha, Henan, shows the deceased and his wife seated at a table. Behind each seated figure is a single-panel screen completely covered with a wave painting in a blue frame with gold decorations at the corners.[35]

Waves seem to have been a popular subject for Song dynasty screen paintings. In a fan painting by Su Hanchen (twelfth century), a lady sits at her dressing table in front of a large screen containing a wave painting mounted with green silk borders and set into an elegant wooden frame with butterfly corners (fig. 16.8). A vase filled with narcissus blossoms stands on the table in front of the wave screen. The narcissus, called "water immortal" (*shuixian*) or "immortal of the waves" (*lingbo xianzi*), is a symbol of the new year admired for its graceful beauty and delicate fragrance. The young lady, lonely and secluded in the inner quarters, faces her enlarged image in a mirror and gazes at her beauty, which, like the spring flowers, will soon fade. The endless wave pattern of the screen adds to the poignancy of the scene.[36] The screen also has the practical function of providing privacy and shelter as she applies her makeup. When we see how these delicate paintings on silk were permanently displayed on large screens, it is not surprising that none has survived intact.

Fan paintings and scroll paintings, as mentioned above, were sometimes remounted on screens. The renowned painter and connoisseur Mi Fu (1051–1107) had a collection of flower paintings by Liu Chang that he mounted on a screen. Mi Fu also writes that the empress Cisheng Guanxian, wife of the emperor Renzong (r. 1023–64), bought all the paintings by Li Cheng (919–967) she could find and had them mounted on a screen (*pingfeng*).[37] Thus, we know that by the Song dynasty a number of small paintings were

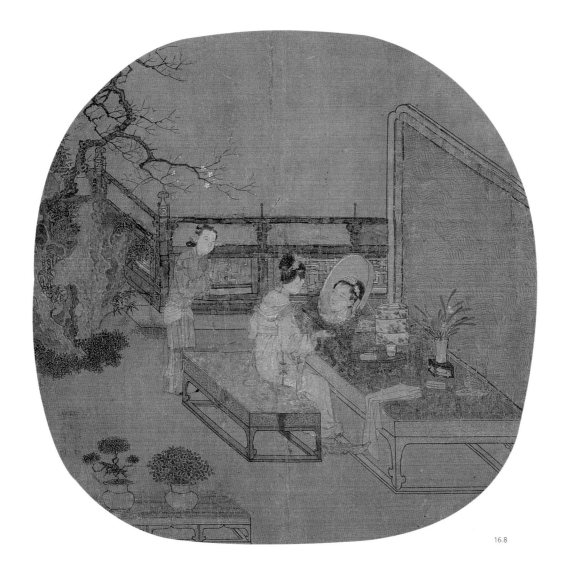

16.8

sometimes mounted together on a large screen. A brick relief carving of a screen in the 1210 tomb of Dong Ming, found at Houma, Shanxi (fig. 16.9), shows one way this mounting might have been done. The carving depicts a wooden screen in detail, with miters and double-miters, grooved surfaces, massive carved feet, and a decorative apron. The top is divided into small rectangular panels containing floral motifs, which probably represent paintings.

The new chair-level mode of living inspired not only tall floor screens, but also small single-panel

FIGURE 16.8 Su Hanchen (twelfth century). *A Lady at Her Dressing Table*. Fan painting. Ink, color, and gold on silk. Height 25.2 cm, width 26.7 cm. Denman Waldo Ross Collection. Courtesy Museum of Fine Arts, Boston.

FIGURE 16.9 Detail of a brick
relief carving. Jin dynasty.
Found on the back wall
of the 1210 tomb of Dong
Ming, Houma, Shanxi.
From *ZGMSQJ, Jianzhu
meishu bian* 2: 44.

FIGURE 16.10 Zhao Bosu
(1124–82). *Reading in the Open
Pavilion*. Southern Song dynasty.
Detail of a fan painting. Ink
and color on silk. National
Palace Museum, Taipei.

screens to place on a daybed to protect the sleeper's
head from drafts. Often they were embellished with
paintings like those on the railings of the couchbeds in
The Night Revels of Han Xizai (see fig. 1.8). We see one
depicted in an informative Southern Song fan paint-
ing attributed to Zhao Bosu (1124–82; fig. 16.10). In
a pavilion a scholar sits on a daybed with a mat seat.
An open book lies on the table, and the scholar leans
on an armrest placed in front of the small screen at
the end of the bed. Behind him is a large ink land-
scape painting mounted on a screen. Two hanging
scrolls are suspended from one side of the pavilion.
From the Song poem "Inscribed on a Pillow Screen"
("Zhenping ming"), by Zhang Shi, we know that
small screens on beds were called "pillow screens"
(*zhenping*) and sometimes had poems written on
them.[38] Poems were also written on small table screens
called "inkstone screens" (*yanping*).

According to the thirteenth-century connoisseur
Zhao Xigu, inkstone screens were invented by Su Shi
(1036–1101) and Huang Tingjian (1045–1105) to dis-
play inkstone inscriptions. Su and Huang were famous
calligraphers and early exponents of the unity of paint-
ing and poetry. Before their innovation, small stone
screens without inscriptions were used as table orna-
ments and were the subject of several poems by
Ouyang Xiu (1007–72). Zhao wrote of the new fash-
ion: "In ancient times there were no inkstone screens.
Sometimes there was an inscription on an inkstone,
usually engraved on its bottom or sides. Inkstone
screens began to be made by Tungbo [Su Shi] and
Shangu [Huang Tingjian]. Once they had carved an
inscription on the inkstone, they went on to engrave
it again on the screen in order to make it more con-
spicuous. Shangu had a screen with an inscription
from an inkstone made of raven stone. This screen is
now in the household of a scholar from Yiwu in
Yuzhou [Zhejiang]." Inkstone screens were also used
to display small paintings. When such paintings were
the work of a famous artist or were antique, Zhao
thought them particularly wonderful: "If a very small
famous painting is inserted into the screen's slot
[*qiang*], it is indeed beautiful. However, such paint-
ings are difficult to obtain. . . . Unless you have a fa-

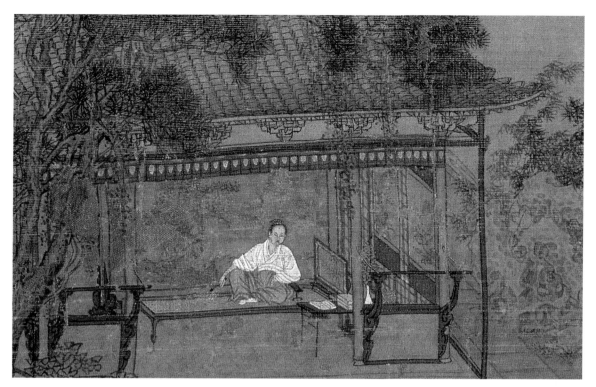

<div style="text-align: right">16.10</div>

mous painting, it cannot be done. When you use some antique brushwork it is even more marvelous."

Zhao describes how the inkstone screen consists of a stand that supports the stone or mounted painting. The stand has a horizontal member joining the two sides. On each side, a foot base holds a vertical member with a slot into which the stone or painting is inserted. Presumably the slot can go all the way through the vertical member, as in the screen depicted in *The Night Revels of Han Xizai* (see fig. 1.8), or it can be enclosed on the outside (fig. 16.11). The stand should be made of plain black lacquer or ebony: "Shuzhong [Sichuan] produces a stone which when split naturally forms the shapes of small pine trees. Sometimes thirty or fifty are lined up forming a path. It is something that cannot be produced by drawing. Moreover, since these pines are only two *cun* high, the stone is perfect for making inkstone screens. As for the shape of the screen, it is only necessary to connect the slot and the legs. The height should be one *chi* and one or two *cun* and its breadth

one *chi* and five or six *cun*; it is exactly the same size as a small ink slab. If higher and broader, it is not correct. Black lacquer or ebony (*wumu*) should be used for the slot; inlaid ornament and marbled lacquer are inappropriate."[39]

The inkstone screen that Zhao describes is similar to the seventeenth-century piece in fig. 16.11. The stand, made of *huanghuali* wood, has a simple elegance. The smooth polished surface of the wood enhances, rather than competes with, the intricate patterns on the stone panel. Between the two horizontal bars is an inset panel with a long oval beaded-edged opening. Below are simply shaped slanting aprons. On each side is a plain foot base into which is tenoned a post with shaped finial. The frame of the stone slab fits into slots on the inside of the posts, and the curved spandrels on each side strengthen the structure. The frame has rounded edges and is hollowed out slightly toward the inner edge to create a subtly raised border around the stone.

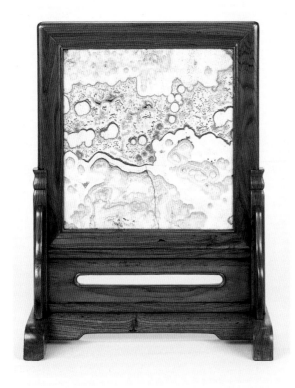

16.11

Such small screens were among the treasured objects on a scholar's desk. In Xie Huan's *Literary Gathering in the Apricot Garden* we see a table on which a small screen stands behind writing utensils—an inkstone, a water dropper, and a brush rest (see fig. 6.2). The careful representation of these objects indicates that the gentlemen, besides being important politicians, are literary scholars with aesthetic discernment. Sometimes several writing implements were ingeniously combined in a single object. A table screen/brush rest was excavated in 1966 from the Wanli period tomb of Zhu Shoucheng in Gucun township, Baoshan county, Shanghai. A miniature *zitan* table, with holes in the top for the brushes, is attached to the front of the screen, which has a marble plaque. In this case, the inkstone screen is functional as well as decorative. All inkstone screens, moreover, would have been useful to protect the writing implements from drafts and shield the scholar from prying eyes. During the Ming dynasty (1368–1644) small screens had uses beyond the scholar's desk. In woodblock illustrations we see them in shops providing privacy for the bookkeeper or a decorative backdrop for a vase of flowers; in one scene a screen partitions a long counter used for several different purposes. In the home small screens might be part of displays of treasured possessions.[40]

The smooth marble slab on the table screen in fig. 16.11 is pinkish brown with a highly textured pattern offset by the straight grain of the surrounding *huanghuali* wood. Contemplating such stones inspires lofty thoughts. Neither wholly abstract nor wholly representative, they seem endowed with evocative ever-changing cosmic movement—the Dao that pervades the universe. The French call them "dream stones" (*pierres des rêves*).[41] Marble is known for its translucency and for the unusual degree to which it both absorbs and reflects light. Ouyang Xiu, in his "Song on a Purple Stone Screen," says that moonlight is absorbed into the marble and expelled again:

The moon comes from the ocean's depth,
Traveling to the southeast of heaven.

Just as it crosses heaven's center,
It shines down into Thousand Foot Lake.
Lying in the heat of the windless lake, the moon is
motionless,
Its inverted image striking straight into Purple Rock
Cliff.
Moonlight is bright, water clear, stone shining;
Now come the Spirit of Yin to hide in the water.
From this moment, as the moon enters this stone,
Heaven has here shared its rain and sun.
Its clear glow can never be extinguished,
Heaven's most treasured cannot be hidden.
The Lord of Heaven summons the Lord of Thunder,
To bring his giant axe this night and cleave the cliff.
This one slice falls from the rocky heights;
Moonlight shining in a cold mirror, caught in a jade
casket.[42]

In this inscription Ouyang Xiu invokes mountains, water, and clouds—the essential elements of a landscape. And indeed, many dream stones resemble landscape paintings and are compared in quality to works by famous artists, especially Mi Fu and his son Mi Youren (1075–1151).[43] The Mis are associated with misty landscapes in which layers of wet ink dabs, rather than outlines, create the contours of mountains. The soft fuzzy effect is similar to the patterns often found in marble, as on the plaque displayed in the large standing screen in fig. 16.12. Images spontaneously occurring in natural materials were greatly admired and sometimes gently enhanced by the craftsman's art. Here the lapidary has maximized the potentials of the stone by careful slicing and inward carving to reach the most interesting figures. Passing your fingertips over the surface, you can feel the slight unevenness and different textures. This kind of carving, according to Zhao Xigu, existed in the thirteenth century.[44] Probably this piece of marble is part of the original screen because the rabbet in the wooden frame into which the plaque fits varies in width to accommodate the undulating marble. Since the rabbet's maximum width of one-fourth inch would have been too thick and ugly if used for the entire edge, it is unlikely that the rabbet was cut down.

The Ming connoisseur Wen Zhenheng considered single-panel screens inlaid with marble to be

the best, and those with paper or solid wood panels and folding screens inferior.[45] In the painting *Enjoying Antiques* (fig. 16.13), attributed to Du Jin (active c. 1465–c. 1509), a painting, rather than marble, has been inset into the screen. Like the screen with the marble, this one is made of wood with elaborately carved openwork panels. The carved panels have stylized cloud motifs, and the painting appears to depict waves in a misty landscape. Such screens provide a frame for the painting, containing and isolating it in a manner akin to Western frames. This effect is different from scroll mountings, which do not sharply define the boundaries of the landscape but allow it to continue beyond the edge of the painted surface. Behind and to the right of this screen is a three-panel folding screen with a landscape painting on the center panel.

Enjoying Antiques is an unusual size (126.1 cm high and 187 cm wide) and was probably meant to be mounted on a screen. It is superbly painted in a manner full of anecdotal detail. The conventional subject of a wealthy collector showing off his treasures to a friend on a garden terrace is combined with a depiction of the four arts—music, chess, calligraphy, and painting. A servant enters on the left carrying a hanging scroll and game board, the friend examines ancient bronzes spread out on a table, two women are busy arranging a zither and other acquisitions on another table, and a child chases butterflies with a fan. Because Du Jin failed to pass high enough in the official examinations to obtain an attractive post, he had to earn his living in Nanjing as a professional painter. His painting is decorative and intended to be viewed daily. It is different from the literati paintings of the time, which were intended to be viewed briefly by other literati and to give an intense and momentary experience.[46] By the Ming dynasty, screen painting was the work of professional and academy painters, rather than the more esteemed literati painters.

The screens in *Enjoying Antiques* both delineate the space on the terrace where the viewing takes place and provide protection and privacy. The artist

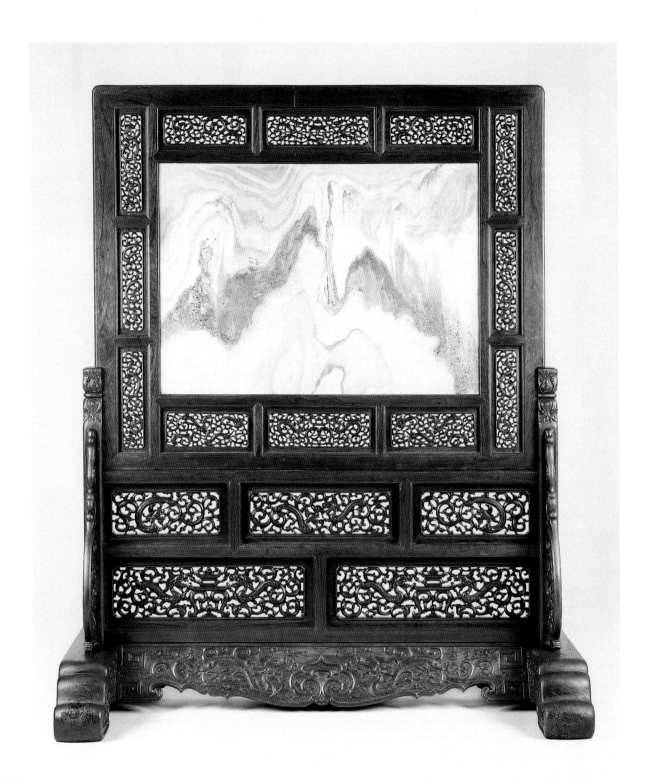

16.12

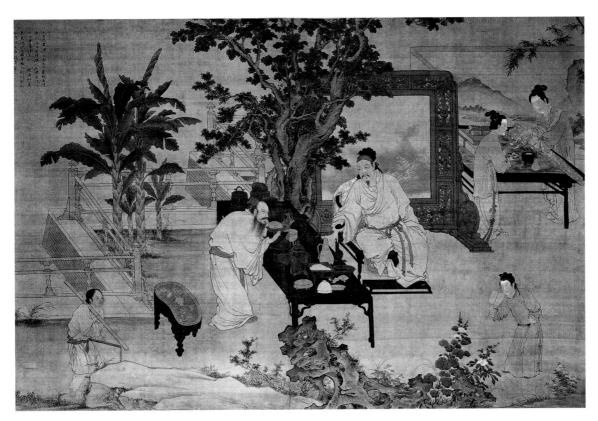

16.13

emphasized the importance of the rich collector by placing the screen behind his chair. Such large standing screens commonly appear in illustrations of the reception halls of a Ming house, where they serve as a status symbol behind the master and mistress and screen them from the doors at the back of the hall. They are essential for ceremonial occasions, such as birthdays, and for shielding ladies from the gaze of men. We find them in bedroom, study, and school-room. They stand behind chairs (see fig. 6.7), day-beds (see fig. 11.10), platforms (see fig. 8.9), desks (see fig. 13.15), and dining tables (see fig. 12.11). In short, screens were a most important and widely used piece of furniture. We know of their importance, however, only from paintings, woodblock illustrations, and literature because so few Ming and early Qing large screens have survived. There is, to my knowledge, only one Ming *huanghuali* large single-

FIGURE 16.12 Large standing screen. Ming or Qing dynasty, seventeenth century. *Huanghuali* wood, *tieli* wood feet, marble panel. Height 214 cm, length 180.9 cm, depth 104.7 cm. The Minneapolis Institute of Arts. Photo © Christie's Images, Ltd., 1999.

FIGURE 16.13 Attributed to Du Jin (active c. 1465–c. 1509). *Enjoying Antiques*. Ming dynasty. Hanging scroll. Ink and color on silk. Height 126.1 cm, width 187 cm. National Palace Museum, Taipei.

panel screen in the Palace Museum, Beijing,[47] and two unpublished examples in private Hong Kong collections.

By the Ming dynasty large single-panel screens were usually called *pingfeng,* a term that had previously been used for all types of screens. From the section on *pingfeng* in the *Classic of Lu Ban,* we learn that the small ornamental panels were called *tiaohuan* and that the dimensions of the screen depended on the size of the room.[48] The screen with the marble panel was made for a large room and, because of its weight, was probably rarely moved.

The basic form of the large standing screen in fig. 16.12 is the same as that of the table screen in fig. 16.11. However, because of its size and intricately carved openwork panels, the large screen's appearance is strikingly different. The feet are fashioned from large pieces of *tieli* wood. *Tieli* is the tallest of all hardwood trees, and so big timbers were available. The feet are massive, and yet their outlines have a graceful lilt reflecting the spirit of the relief carving. The undersides of the feet have been filled in, since they had visibly deteriorated and were resting only on their perimeters. One foot had lost about a quarter inch and was built up. Apart from these repairs, the screen was in perfect condition when the collector acquired it; he had only to clean and polish it.

Lively relief carvings of pearl-chasing dragons and scrolls fill the sides of the *tieli* foot base. Above, their *huanghuali* counterparts swoop gracefully down in the clouds to form the openwork spandrels. The posts—surmounted by exquisitely carved reversed lotus patterns—have slots for the wooden frame of the marble panel. On the aprons two dragons, surrounded by scudding clouds, run toward a central *ruyi* motif. The carving is vigorous and at the same time filled with charming details, such as the embellishments to the angular scrolls in the corners. Here on the thick apron, the carving is bolder than on the openwork base panels or the much thinner frame panels. There is, nonetheless, a remarkable consistency of conception and execution throughout the screen. Various types and combinations of dragons and clouds are the pro-

pitious theme, and they are all carved with the same energy and attention to detail.

The lowest openwork panels are extremely thick and deeply inset into their frames. They are carved in many layers and seem almost three-dimensional. Scrolling horned dragons against a cloud-scroll background flank a stylized *shou* (longevity) character and brush their bellies against the backs of coiled *chi* dragons. On the side panel above, a single dramatically scrolling dragon emerges from clouds, used here, as on all the panels, to completely fill the empty space. And on a vertical frame panel, a long dragon saunters up the side, while below a coiled dragon stands on the back of a small dragon whose head is turned. The carving on this screen is of superb quality and grace. Its beauty, combined with the monumentality and rarity of the screen, make this piece a prized possession.

The openwork carving on both the large single-panel screen and a twelve-panel screen (fig. 16.14) creates a delicate tracery pattern, giving lightness and visual interest whether viewed from afar or up close. Intended to be seen from both sides, the screens are beautifully finished on the back and front. The twelve-panel screen is identical to folding screens (*weiping*), except that it curves, rather than bends into zigzag or right-angle formations, because the panels are joined by metal hooks fitting into rings, rather than hinges. A similarly constructed screen is in the collection of Dr. S. Y. Yip.[49]

In a large hall curving screens form a striking decorative backdrop for ceremonial occasions. In front of such a screen in Canton, on October 13, 1794, the Viceroy of China received the Dutch ambassador and Andreas Everard van Braam Houckgeest, who presented a petition for audience with the Qianlong emperor (fig. 16.15). The Canton screen has solid panels decorated with large *shou* characters, rather than openwork carving, and paintings of flowers and rocks. An angular spandrel supports each side. On the right a similar screen, with landscape paintings and bordered lower panels, is partially visible.

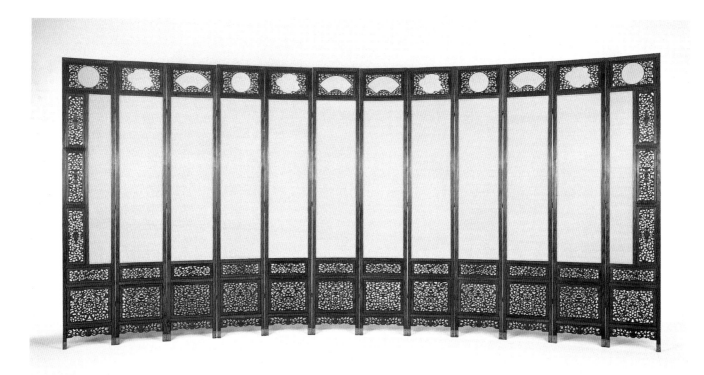

16.14

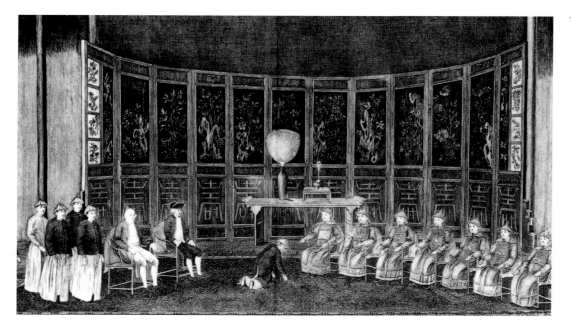

16.15

FIGURE 16.14 Twelve-panel
screen. Qing dynasty, late
seventeenth/early eighteenth
centuries. *Huanghuali* wood.
Height 320 cm, length
690 cm, depth 3 cm.
© Christie's Images,
Ltd., 1999.

FIGURE 16.15 *The Viceroy
of China Receiving the Dutch
Ambassador and Andreas Everard
van Braam Houckgeest, 13 October
1794.* Qing dynasty. Detail
of an engraving. From Braam
Houckgeest, *Voyage de l'ambas-
sade de la Compagnie des Indes
Orientales hollandaises.* American
Philosophical Society.

The twelve-panel screen in fig. 16.14 is fashioned from *huanghuali* wood and has its original metal feet. Each panel is divided vertically into five sections: The top carved openwork section has a circular, leaf-shaped, or fan-shaped opening in the center. Then there is a long empty section that probably originally contained a painting. The bottom three comprise a narrow openwork section with a mythical beast, a large openwork section with dragons flanking a *shou* character, and an openwork apron. Each end panel has three openwork sections along the outer edge and a correspondingly narrower long empty section.

The panels of the screen and the decorations are symmetrically arranged. The two center panels of the screen have fan-shaped openings in the top section and are flanked by alternating leaf, circle, and fan sections. Motifs within each carved section are likewise organized according to the same principle of reversed symmetry. Moreover, every third mythical beast section has been flipped so that the beasts face each other. Details of the motifs vary according to whether they belong to a leaf, circle, or fan panel.

The wood forming the panels of this screen is much thinner than that in the single-panel screen (see fig. 16.12), and consequently the carving is flatter. It has a pleasing linear flow and is nicely finished. The manipulation of lines and spaces is visually intriguing. The designs are not merely decorative, but are also the conventional symbols of good fortune. They were familiar formulas in seventeenth- and eighteenth-century China, and anyone seeing them would have been instinctively aware of their propitious significance.

All the openwork sections have intricate backgrounds of dragons and clouds, which are ornamental space fillers as well as auspicious patterns. Complete dragons and heads of dragons emerge from the clouds, and sometimes the dragons' bodies seem to merge with the clouds, making dragon and cloud part of the same continuous coiling motion. On the aprons, which are identical in all twelve panels, the dragons flank an upside-down *ruyi,* which in turn is flanked

by a pair of *ruyi* scepters. The *ruyi,* signifying long life and good fortune, is associated by its shape with the *lingzhi* fungus of immortality and with auspicious clouds. Many Han lacquers are decorated with stylized swirling clouds propelling immortals and real and imaginary beasts through space. On a lacquer tray from a first-century B.C. tomb at Huchang, near Yangzhou, Jiangsu, a deer leans down from his scudding cloud to nibble the fungus of immortality—a delightful scene hinting "at an angelic state in which men's desires come true."[50] By the Qing dynasty the motifs had become stiffer and more abstract, but similar undertones of meaning were still present.

Likewise, in the upper sections the motif of dragons flanking a large *shou* character has ancient antecedents. It is found on the knob of an Eastern Han jade *bi* disk excavated in 1982 from the Ma family tomb in Qingzhou City, Shandong; here the dragons flank the three characters meaning "suitable for descendants" (*yi zi sun*).[51] In this case, although the forms of the Han and Qing designs have a certain resemblance, the meanings are different.

In the next panel, the mythical beasts cavorting in the mountains among *lingzhi* fungi of immortality are the *baize* and the *qilin*. In the 1609 *Pictorial Encyclopedia of Heaven, Earth, and Man* the *baize,* which appears when a virtuous ruler reigns, has a dragon's head with horns and a mane, feline paws, and a bushy tail. The *qilin,* likewise a manifestation of an enlightened ruler, appears much more frequently in art; Shen Yue described it in the first half of the sixth century in his *History of the Liu-Song Dynasty* (*Song shu*): "Qilin are benevolent beasts. The female is called Qi and the male is called Lin. They appear when [a ruler] does not rip open pregnant animals and does not break eggs. Qilin have a deer's body, a cow's tail, a wolf's neck, and a horse's feet. They have a single horn, and their color is yellow. Qilin possess benevolence and righteousness. Their voice accords to musical scales, and their gait matches the perfect rule. They never trample upon a living insect and never damage a living plant. They never eat if it is unrighteous, never

drink from a dirty pond, and never fall in a trap or a net. Qilin appear when an enlightened ruler acts according to rules."[52]

Each of the three vertical sections of the end panels contains a depiction of a vase with a blossoming branch. The carving on this screen is for the most part identical on both sides. From the front, however, you look into the mouths of the vases, and from the less highly decorated back you have straight-on views. The motif implies a wish for tranquility and peace; *ping,* the word for vase, is a homonym of the *ping* that means "peace." The top vase contains peonies, a summer flower signifying wealth and honor. In the middle section a bronze vase holds peach flowers, spring flowers symbolizing longevity and used at the New Year as a charm against evil. The bottom section has winter plum blossoms, suggesting transient feminine beauty and purity.

When a collector bought this screen, it still retained some of the latticework fitted into the frames of the large panels to support paper or silk. The *Classic of Lu Ban* warns that when inserting this lattice "the maker should be extremely careful not to crack the frame." The silk or paper was stretched over the top of the lattice and could be left plain or ornamented with paintings or calligraphy. Since paintings on screens were fragile and easily damaged with constant exposure, few screens with original paintings remain today. Some extant paintings are known to have originally been mounted on screens. The large painting of a beautiful woman warming herself by a brazier (see fig. 19.1) is one of twelve that, according to the archives of the Qing Internal Affairs Department, were once mounted on a screen in the Reading Hall Deep Inside Weeping Willows in the Yuanmingyuan (Garden of Perfection and Light), the Yongzheng emperor's palace outside Beijing. Yongzheng's inscription indicates that the paintings were done for him between 1709 and 1723, when he was still a prince. James Cahill points out that the paintings contain sexual innuendoes, suggesting that they might have been used on a screen surrounding Yongzheng's bed.

16.16

FIGURE 16.16 Woodblock illustration to the *Imperial Edicts,* 1681, vol. 6.

An extensive study by Wu Hung reveals that these paintings of beauties wearing Chinese, rather than Manchu, dress and in a Chinese environment are idealized representations of the Other. The emperor would be both the lover and the conqueror of their beauty, space, and culture.[53]

The Kyoto National Museum has an eight-fold screen with paintings by Yuan Jiang dated 1720.[54] The paintings depict a famous summer palace and form a continuous composition. This type of paneled screen—in which only the base has wooden panels while the top forms a continuous painting—is shown in a woodblock illustration to the *Imperial Edicts* of 1681 (fig. 16.16). The screen appears to have a hard-

16.17

FIGURE 16.17 Attributed to Gu
Jianlong (1606–c. 1694). *Jingqi,
Ximen's Son-in-law, Flirts with
Golden Lotus at the Time
of the Lantern Festival.* Qing
dynasty, c. 1662–c. late 1670s.
Illustration to *The Plum in the*
Golden Vase (*Jin ping mei*),
chap. 24. Ink and color on silk.
Height 39 cm, width 31.5 cm.
The Nelson-Atkins Museum of
Art, Kansas City, Missouri.
(Acquired through the
Uhlmann Family Fund.)

wood base with metal feet. Above, the panels fit together to form a continuous wave painting. Another style used the folding screen to display album leaf and fan paintings in the manner favored by Mi Fu in the eleventh century. In an illustration to *The Plum in the Golden Vase* (fig. 16.17), each panel of the screen is mounted with exquisite small landscapes and flower paintings brushed on golden fans. The base of the screen appears to be lacquered and has metal feet and decorated panels. Other types of screens—such as stepped models used behind thrones, Coromandel lacquer, and inlaid—were also used at this time.

The Chinese screen has had essential social and decorative functions for more than two thousand years. Unlike other kinds of furniture, screens were frequently mentioned in treatises on painting and in poems. Indeed, because screens often displayed calligraphy and painting, the two highest art forms, they gained an eminent position in the realm of Chinese furniture. As a protector of privacy and a mark of social position, the screen was part of the emotional and spiritual landscape of a Chinese room. And as an indication of solitude the screen might evoke an intense sense of aloneness, as in this poem by Zhu Shuzhen (active 1095–1131):

THE OLD AGONY

Sheltered by a silver screen
from the spring wind, I dozed
cold and lonely under my quilt.
When a bird cries
my dream is gone.
The same sorrow and headache
come back. Heavy shadows of
flowers darken the lattice window.
Coiling incense smoke floats
along the pillow screen.
Don't blame the oriole
for a shattered dream
of an earlier spring. I share my old
agony with the fading night.[55]

STANDS

17 | THE INCENSE STAND AND A SCHOLAR'S MYSTICAL STATE

The aroma of fragrant incense is associated with gods, poets, and lovers. Its scent suffuses both temple and study, enticing the deities and creating a rapturous mood essential to artistic creation. Incense marked the presence of the emperor and was necessary in solemn state rituals. On informal occasions it attracted lovers with its luring perfume and spirit-altering powers. Incense was an essence of paradise and magical realms, and as early as the Western Han (206 B.C.–A.D. 9) it rose in clouds of fragrance from the peaks of censers shaped like spirit mountains (see fig. 6.6).

Because of their ceremonial status, censers were elevated on tables and later on special high stands. In Buddhist paintings of the Tang dynasty (618–906) large incense burners stand on small tables in front of the Buddha and other deities (see fig. 10.4). Especially popular for worship was the "hundred-blend aromatic" (*bohexiang*), which, according to one recipe from a Buddhist monastery in Chang'an, consisted of finely ground aloeswood, sandalwood, storax, onycha, Borneo camphor, and musk mixed with honey. In secular life, according to poetry, a hundred-blend aromatic might perfume the boudoir of a beautiful woman, while in a poet's study an incense clock told the time and created a scented ambience conducive to poetic creativity.[1]

The advent of the chair-level mode of living led to the development of specialized furniture, including the high incense stand. Such stands had both secular and religious uses. A mid-thirteenth-century painting, *Boys at Play in a Garden,* depicts a red lacquer stand on which the children place an incense burner and vases of flowers. The stand has a quatre-foil-shaped top and base stretcher, high waist, curvilinear apron, and four strongly curved cabriole legs. This stand is low—the height of a stool—but there were also taller versions, such as the one Wang Zhenpeng painted in 1308 in *Vimalakīrti and the Doctrine of Nonduality,* which depicts the famous debate between the layman Vimalakīrti and Mañjuśrī, the bodhisattva of wisdom (fig. 17.1). Here the incense stand separates the debaters in the cen-

FIGURE 17.1 Wang Zhenpeng
(c. 1280–1329). *Vimalakīrti
and the Doctrine of Nonduality.*
Yuan dynasty, 1308. Detail of a
handscroll. Ink on silk. Height
39.5 cm, length 217.7 cm. The
Metropolitan Museum of Art,
New York. Purchase, The Dillon
Fund Gift, 1980 (1980.276).

ter foreground of the handscroll; in the background
there is a goddess on the right and the disciple
Śāariputra on the left. The goddess has showered the
assembled company with sacred flowers that slide off
the bodhisattvas and cling to the disciple, indicating
that he has not yet renounced mundane desire. The
incense stand is refined, with long slender proportions
and strongly curved cabriole legs resting on a con-
tinuous base stretcher supported by small cloud-head
feet. A brocade cloth with jeweled pendants hanging
from the corners covers the stand for the ceremonial
occasion. Fragrant smoke rises from the mouth of a
mythical animal-shaped incense burner elevated on
its own lotus-form stand. Censers shaped like myth-
ical beasts were popular in the Tang dynasty and ap-
pear frequently in woodblock prints and paintings
from the Ming (1368–1644). Extant examples are
made of metal with removable or sometimes hinged
heads.[2]

The incense stand sometimes elevated other ob-
jects besides incense burners. In a scene illustrating a
Buddhist sutra carved on a temple column from the
Yuan dynasty (1279–1368), a similar stand holds a fan-
tastic rock in a bowl (fig. 17.2). Such small rocks were
treasured collector's items, magic worlds in miniature
associated with cosmic forces and paradises. The stand
shown on the pillar is like the one Wang Zhenpeng
painted, except that the legs end in cloud-head feet—
a motif typical of the Song dynasty (960–1279)—
instead of turning up and outward. We can also see
cloud-head feet on the small square stand to the right
of the seated figure. This stand holds a tripod incense
burner.

High square stands were used from at least about
1100, as we know from an example with a Tang-style
box-construction top, cutout panels, and straight
corner legs depicted in the tomb paintings at Baisha,
Henan province.[3] Paintings often depict incense burn-
ers on rustic gnarled-wood or root stands next to
deities and monks. In Zhang Shengwen's painting
Buddhist Images, the Great Master Hongren sits be-
side an incense burner placed on top of a rustic stand

17.2

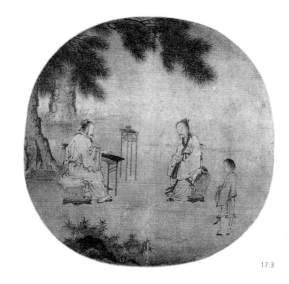

17.3

FIGURE 17.2 Detail of one of four temple columns. Yuan dynasty, fourteenth century. Wood of the verbena family. Height 2.87 m. Honolulu Academy of Arts, Honolulu, Hawaii. Gift of Mrs. C. M. Cooke, 1931.

FIGURE 17.3 Liu Songnian (c. 1150–after 1225). *Listening to the Qin*. Album leaf. Ink and slight color on silk. Width 24.6 cm. © The Cleveland Museum of Art, 1998. Leonard C. Hanna Jr. Fund.

fashioned from gnarled wood with a high shelf for the incense powder box.

We see a similar elegant wooden stand with high shelf next to the zither player seated under a pine tree in *Listening to the Qin* (fig. 17.3), by Liu Songnian (c. 1150–after 1225). The zither (*qin*), the favorite instrument of the scholar-official, was one of the symbols of the literary life. The Southern Song connoisseur Zhao Xigu, in his guidebook for the scholar of elegant taste, has a chapter on the antique zither in which he describes appropriate surroundings and also the incenses to be used when playing. Incense purified and concentrated the mind, producing that exaltation necessary for both playing and appreciating music. By the late Ming there were fixed rules for playing the zither, including the use of incense: "One should select a mountainous landscape, with trees and rivulets; borders of streams, frequented by wild geese and singing birds; a pure and secluded

abode. . . . [T]he player must don ceremonial dress, wash his hands, rinse his mouth, and purify his thoughts. After having burned incense he may take the zither from its cover, and place it on the zither table. Then he should sit down before it in a reverent mood, and regulate his breath and concentrate his mind."[4]

A popular form of incense stand was the square type illustrated under the heading "incense stand" (*xiang ji*) in the late-Ming *Pictorial Encyclopedia of Heaven, Earth, and Man.*[5] In modern collections, however, round incense stands are more common. One graceful example has an unusual solid base of exactly the same dimensions as the solid top (fig. 17.4). This feature—combined with the subdued curves of the five cabriole legs and apron and the restrained size and form of the members—gives the stand an air of calm and stability. The piece has a pronounced upward-sweeping curve; a high waist with begonia-

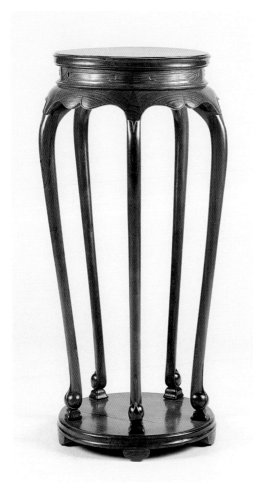

17.4

shaped cartouches adds to the sense of continuously rising elevation. Small feet elevate the base. Tapered ridged blocks elevate the legs, which expand upward to a strong molding. The molding in turn elevates the waist, which elevates the top. The ornamentation and clearly visible joinery emphasizes this series of elevations. Each long cabriole leg terminates in a ball held by a simple leaf rising up the leg in a long point. This point leads the eye upward in an unbroken line along the leg, through the point formed by the miters at the juncture of leg and apron, and along the join in the waist to the top.

Historically, the stand and the cabriole legs recall early Chinese forms found in ceremonial and religious contexts. Three and a half millennia ago, prototypes of the cabriole leg appeared on Shang (c. 1500– c. 1050 B.C.) and Western Zhou (c. 1050–771 B.C.) ritual bronze vessels (see, e.g., fig. 11.17). Another early version of the cabriole leg, sometimes animal shaped and with distinct claw feet, occurs on small low tables used to support large wine pots at ceremonial feasts in the Eastern Han dynasty (A.D. 25–220; see fig. 1.3). In the Tang, small low stands held offerings before the Buddha. These exquisitely fashioned stands are not in China, however, but in the Shōsōin

17.5

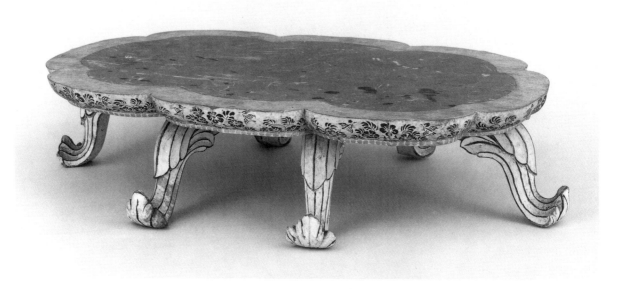

imperial treasury in Japan and were either imported from China or made under the influence of Chinese craftsmen. Many of them have cabriole legs in imaginative variations of leaf forms, such as an eight-lobed model painted white, with the legs edged in silver and the sides decorated with gold dots and small silver birds among flowers (fig. 17.5).

On later tall hardwood stands, carving replaces the painted designs, and the cabriole legs, which become long and slender, are known as "dragon-fly legs" (*qingtingtui*). An especially tall and narrow *huanghuali* stand is flamboyant with a bulging waist, flaring apron, and sharply inward-curving legs ending in vigorously upturned ends (fig. 17.6). The legs rest on small blocks supported by a circular base stretcher on low feet. The base is smaller than the top, creating an effect of soaring growth. Openwork scrolls enhance the vertical thrust of the piece by leading the eye upward in a complicated, vigorous movement along the upturned feet to the flanges, created by adding small pieces of wood to the sides of the legs. The beaded curvilinear edges of the flanges form the backs of confronting phoenixes chasing a disk. The beading continues along the legs and apron, culminating at the cusps in elaborate scrolls surmounted by a circle. And on the waist above, a curving *makara*—the water spirit of Indian mythology that came to China with Buddhism—fits neatly into an oval cartouche surrounding the disk.

As is always the case in Chinese art, ornamental carvings abound with symbolism. Here the miniature relief sculpture on wood signifies good fortune. The phoenix (*fenghuang*) is a mythical bird said to appear only in times of peace and prosperity. It is the ruler of the birds and a symbol of beauty and goodness. Depicted with the dragon, it is a symbol of the empress. Like the dragon and the *makara,* the phoenix may chase a luminous pearl or wish-granting jewel. Distinguished by its fish body attached to a tusked animal head, the *makara* symbolizes the life-giving power of water and wards off evil.

On this stand the top board and dovetailed transverse brace are removable, allowing a vase to be in-

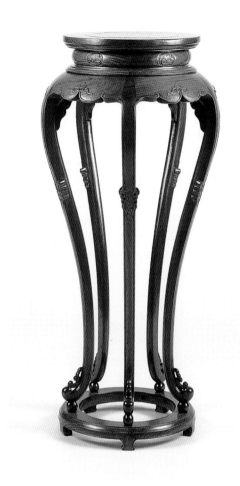

17.6

FIGURE 17.4 Incense stand. Ming dynasty, seventeenth century. *Huanghuali* wood. Height 97 cm, diameter of top 41 cm. © Christie's Images, Ltd., 1999.

FIGURE 17.5 Eight-lobed offering table decorated with gold and silver painting. No. 6. Eighth century. Hinoki (Japanese cypress wood) decorated with white, green, gold, and silver paint. Height 10.2 cm, width 44.7 cm, depth 28.8 cm. Courtesy of the Shōsōin Treasure House, Nara, Japan.

FIGURE 17.6 Incense stand. Ming or Qing dynasty, seventeenth century. *Huanghuali* wood. Height 106.5 cm, diameter 38 cm. From Handler, "Incense Stand," fig. 6.

17.7

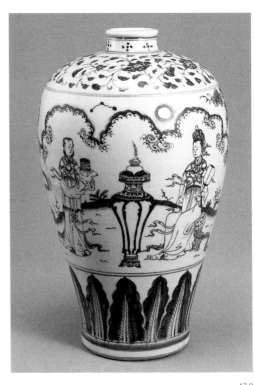

17.8

FIGURE 17.7 Drawing of
joinery at the juncture of leg,
stretchers, and foot in fig. 17.6
From Handler, "Incense
Stand," fig. 8c.

FIGURE 17.8 *Meiping* with
underglaze blue decoration.
Ming dynasty, mid fifteenth
century. Height 37 cm. Tsui
Museum of Art, Hong Kong.

serted into the frame with its base hanging down (see
the painting in fig. 12.11). Since there are five legs,
the top frame and continuous base stretcher are each
made from five pieces of wood connected by half-
lapped scarf joints. At each of these joints the pads
below the legs tenon into the base stretcher, thereby
locking the joins, and the small feet double tenon and
half-lap miter into the base stretcher (fig. 17.7).

These exaggeratedly curving stands are sometimes
called *meiping* incense stands, because of their simi-
larity in shape to a *meiping* porcelain jar. The resem-
blance of stand and jar is indeed striking when we
look at a *meiping* decorated with a scene featuring a
large incense stand in the center of the composition
(fig. 17.8). These incense stands were often carried
outside for personal prayers; here a lady burns incense
under the full moon.

Incense was also a symbol of authority, burnt when
the emperor held court and when an official con-
ducted business. A Song painting shows Zongdi, one
of the ten kings of hell, sitting formally behind his

desk, an incense burner on a tall stand by his side. In
a woodblock print illustrating *The Plum in the Golden
Vase* (*Jin ping mei*), the minister of the right, Li
Bangyan, sits in the main hall in front of a screen with
an incense burner on a stand by his side when he re-
ceives Ximen Qing's servant. The *meiping*-shaped
stand holds a tripod incense burner, a covered box for
the incense powder, and a vase containing the incense
tools (a pair of metal chopsticks and a spoon). These
"three friends of incense," frequently shown on stands
in illustrations and paintings (see, e.g., fig. 14.15), were
themselves often treasured works of art. Incense
sometimes came in sticks, but in domestic settings it
is more commonly shown in powdered form in con-
junction with chips of fragrant wood. The burner was
first filled with ash shaped into a cone with an in-
dented point. Powdered incense was placed in the in-
dentation and a chip of wood pressed down into it.
When the incense was lit, it burned down and ignited
the wood, which smoldered for a long time, giving
off fragrant smoke.[6]

Incense was burnt not only in the reception hall, but also in a woman's bedroom (see fig. 10.6), where its perfume attracted lovers and enhanced their pleasure. The incense burner could be placed on a table or a special stand. The stands could also hold a candle or a vase of flowers, as may be seen, for instance, in paintings illustrating *The Plum in the Golden Vase.*[7]

The smoke of burning incense created a fragrant ambience for social gatherings as well. In Zhang Hong's painting *Examining Antiques,* the aromatic fumes rise from an animal-shaped burner placed with an incense box and tool vase on a square stand (see fig. 14.15). Clouds of incense rise from the mouth of a similar burner just behind the edge of the screen at Meng Yulou's birthday celebration (see fig. 7.17). Ceramic burners were considered appropriate for summer and bronze ones for winter; wood and old agate or crystal could also be used.[8] For maximum effect it was necessary to move the incense stand frequently to take advantage of the air currents.[9] Because the stand was often in the middle of a room, Chinese craftsmen developed for it a three-dimensional sculptural form pleasing when viewed from any angle.

Round stands were particularly attractive. Some models had cabriole legs; others, like the one at Meng Yulou's birthday celebration, had inward-curving horse-hoof feet. A *huanghuali* example of the latter type has a satisfying solidity and grace (fig. 17.9). Its rounded forms and plain surfaces display the beauty of the wood to full advantage. The frame of the circular top has a raised outer edge, or "water-stopping" molding. The separate waist is attached to the frame and apron with dovetail wedges, while the legs double tenon into the top frame and into the continuous base stretcher.[10]

The simple, refined elegance of this incense stand is especially appropriate for a scholar's study (see fig. 15.27). In the painting *Idleness among Pines,* by Zhu Duan (active 1506–21), an incense burner is placed on this type of stand set in front of a large screen facing the entrance (fig. 17.10). A scholar is sitting at his desk by the window, about to begin his composition, while a servant grinds the ink.

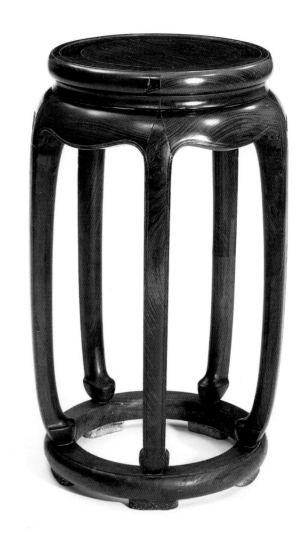

17.9

FIGURE 17.9 Incense stand. Ming dynasty, sixteenth to seventeenth century. *Huanghuali* wood. Height 78.12 cm, width 50.8 cm. Private collection. Courtesy Museum of Fine Arts, Boston.

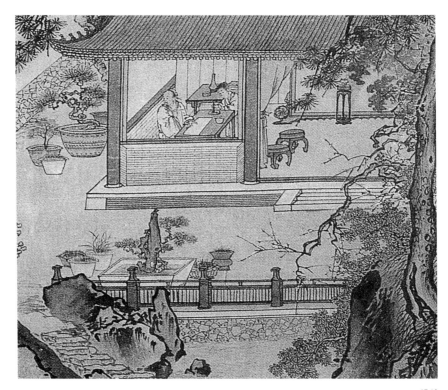

FIGURE 17.10 Zhu Duan (active 1506–21). *Idleness among Pines*. Ming dynasty. Detail of a hanging scroll. Ink and color on silk. Height 227.98 cm, width 123.2 cm. Tianjin Museum of Art. From *ZGLDHH, Tianjin Yishi Bowuguan zang huaji* 1: pl. 7.

17.10

When a scholar prepares to write a poem, paint a picture, or play the zither—activities that assume rapture—incense is indispensable. It is a spiritual stimulant that, when mixed with rare feeling and inspiration, dissipates gloom that would otherwise paralyze the artist's creativity. Because the incense stand carried the incense burner, it was a singular stimulating agent in the moment of artistic creation and in the ceremony of a scholar's way of life. In China both stand and burner are found together wherever the arts are practiced, for from the summit of the incense stand emanates that aromatic intoxicant that induces in the artist a mystical state in which "one is no longer aware of dwelling among men."[11] As the twelfth-century painter Guo Xi said:

> On leisure days I have looked through poems, ancient and modern of Jin dynasty and of Tang, and many times found a verse which expressed with perfection some striving of man's heart, or brought vividly before the mental eye some aspects of nature.
>
> But if I was not seated at leisure in a quiet room, at a bright window, with a clean table before me, with a stick of incense lighted to dissipate the gloom of care—then, even though a fine verse or a thought were before me, it would not take shape; even though a subtle feeling or rare mood presented itself, it would not fructify.[12]

he lamp has two states of being. Unlit, it is a decorative and beautiful object; when lit, it becomes a functional object as well, creating a miniature sun or moon in the house. It then becomes self-operating, continuing to produce light after you have given it the mandate and left the room. Thus, the lighted lamp acquires a life of its own—at least for a while.

Other types of furniture are functional, but they do not transform themselves when they are put to use. For instance, a chair is functional only when it supports a human body, and a cupboard functions only when objects are placed inside it. In both cases the essential state of the piece does not change. The lamp, however, transforms not only itself with its brightness, but its immediate surroundings as well.

Candle and oil lamps were practical everyday necessities in old China. Before the advent of electric lights, which enabled even the darkest corners to be brilliantly illuminated with the flick of a switch, much of human life—on cloudy days, in dim rooms, or at night—took place in dim light or darkness. Outside, people carried lanterns to light the way. Inside, they carried candles from room to room. And all sorts of lamps were used to light interiors. A single candle or simple oil lamp gave only a faint light; it took many to illumine an entire room. Each lighting device needed to be operated and maintained: it had to be lit, the wick trimmed, the candle or oil replaced, and the wax or soot cleaned away. A sudden gust of wind could plunge the room into total darkness; a careless move could set the house on fire.

Light from fire required platforms and safe vessels of wood, metal, or ceramic to support, contain, and reveal it: hence, the development of stands and lamps and of China's unique aesthetic tradition for taming flames. The lamp presents fire as an affirmative force of illumination while providing a barrier to protect people and property from danger. Firelight and its ultimate source, the sun, is associated with divinity, knowledge, and enlightenment as well as the human spirit or soul. For the interior world of the mind, light is the universal metaphor for gnosis and epiphany:

He who having used the outer-light can return
to the inner-light
Is thereby preserved from all harm.[1]

In China, accordingly, lamps have not only aesthetic
and practical functions, but a spiritual one as well. As
carriers of light, they instigate the spirit.

Lamps were an essential part of state, religious, and
family rituals. Before the most important imperial
rite, the annual sacrifice at the Altar to Heaven on the
day of the winter solstice, the emperor spent the night
fasting and meditating in the Hall of Abstinence.
Huge lanterns burned all night on the Circular
Mound, where the sacrifice would take place the next
day. Since it was a bad omen if any of the flames were
extinguished, a man stood inside each immense
lantern to make sure no candle burned out.[2] In Bud-
dhist monasteries lamps were lit at sunset as offerings
to the gods. In homes candles burned before the an-
cestral tablets to honor and placate the spirits.

Lamps were also prominent on many sacrificial and
festival days. At the time of the full moon on the
fifteenth day of the seventh month (zhongyuan),
people made sacrifices to the family's ancestors and
swept their graves. They also made offerings to the
restless "hungry souls" of those who died far from
home or had no relatives to provide for them and who
therefore might haunt the living. At night, people car-
ried lanterns—consisting of a candle stuck into the
hollow of a lotus leaf—through the streets to guide
the wandering souls or ghosts back to the underworld.
And along the riverbanks innumerable small candles
fastened to little boats were set adrift on the water to
guide the spirits of the drowned to their ultimate
domain.

The most spectacular display of lanterns occurred
during the Lantern Festival, which took place around
the fifteenth of the first month and was the climax
of the New Year's celebrations. Everyone hung up
beautifully decorated and ingeniously designed
lanterns to guide the souls of ancestors who had come
to the festivities back to the nether world. The festi-
val has been celebrated in China since at least the sixth

century A.D., when it was said that the brilliance of
the artificial lights almost outshone the light of the
full moon. The streets of the capital were lined with
candles, with "lamp towers" made of silk and hung
with gems, gold, and silver, and with lamps shaped
like dragons, phoenixes, leopards, or tigers. The Japan-
ese monk Ennin, describing the New Year's celebra-
tions in the Buddhist monasteries of Yangzhou, which
he visited in 839, tells of a "spoon-and-bamboo lamp":
a seven- or eight-foot-high bamboo tree with some
thousand spoons for burning oil tied to its branches.[3]

In Kaifeng during the Northern Song dynasty
(960–1126), lanterns were carried by dancers con-
cealed inside dragons, as in Lunar New Year's parades
today. The accounts of the celebrations at the South-
ern Song (1127–1279) capital suggest a Mardi Gras–
like scene with everyone out on the streets drinking,
eating, and enjoying music, theater, and acrobatics.
Some carried round lanterns at the end of long poles,
which from a distance looked like dancing stars. *Old
Affairs of Wulin* (*Wulin jiushi*) describes these festivi-
ties, and Jacques Gernet paraphrases the account with
particular reference to the lanterns:

> There was great competition in the manner of
> decorations and lanterns. The doorway of every
> house was draped with embroideries, bead-curtains
> and multi-colored lamps. All the shops, the squares,
> even the narrowest lanes, were lit up. The finest
> lanterns came from Suchou. Circular in shape, and
> made of glass in five different colors, they had paint-
> ings on them of landscapes, people, flowers, bamboo,
> birds and furry animals. The biggest were between
> 40 and 50 inches in diameter. The lanterns brought
> by sea from Fuchow, very fine also, took second
> place. They were of white jade, and glittered. But
> there were many other kinds as well, of all shapes
> and sizes: lanterns which turned, actuated by a thin
> trickle of water, displaying a roundabout of figures
> and small objects; lanterns with pendants of many-
> colored beads from the bottom of which hung gaudy
> ornaments made of feathers; lanterns in the shape
> of slender boats with dragon prows such as were to
> be seen on the lake at the water-festivals; lanterns in
> the form of an imperial sedan-chair; lanterns which
> turned in the heat, with horses and horsemen on
> them. . . . Some lanterns, decorated in gold and silver,
> pearls and jade, were extremely costly.[4]

Similar imaginative and lavish designs continued to be used during the Lantern Festival in the Ming (1368–1644) and Qing (1644–1911) dynasties. We have a record of lanterns among the illustrations to the novel *The Plum in the Golden Vase* (*Jin ping mei*). One painting contains a magnificent lantern in the scene where Jingji, Ximen Qing's son-in-law, flirts with Pan Jinlian at the time of the festival (see fig. 16.17). The lantern's round silk or paper shade is painted with floral sprays and has a long beaded fringe and red lotus flower suspended from its base. Above the shade is a beaded design of birds among flowering branches and rocks. From the top of its gilded frame hang beaded streamers ornamented with appropriate seven-character lines of verse. The lantern itself is a festival of extravagant color and materials.

In addition to the spectacularly ornate lanterns used on festival days, simple lamps that burned oil or wax have been used in China since antiquity. In China, as in other ancient civilizations, oil lamps consisted of wicks in simple flat pans and dome-shaped cruses. In the beginning, vegetable oil was probably the most common fuel for lamps, but whale and seal oil are known to have been burned for light since at least the fourth century B.C. In Song Yingxing's seventeenth-century treatise on technology, *Exploitation of the Works of Nature,* Song stated: "The best lamp oil is that made from the kernels of the vegetable tallow-tree seeds, followed by rape-seed oil, linseed oil . . . cotton-seed oil, and sesame oil."[5]

As for candles, beeswax was most likely already used in the Warring States period (475–221 B.C.). By the Tang (A.D. 618–906) and Song dynasties, the wax from other insects began to replace beeswax, and in the Yuan dynasty (1279–1368) tallow-tree wax was commonly employed for candles.[6] *Exploitation of the Works of Nature* contains a great deal of specific information about materials and methods:

> For making candles, the best material is the "un-mixed" vegetable-tallow fat [derived solely from the white tallow layer on the outside surface of the tallow or *Stillingia sebifera* tree seeds]; next, castor oil; next,

"mixed" vegetable tallow-seed oil solidified by the addition of [a certain amount of] white wax; next, the various clear oils solidified with the admixture of white wax; next, camphor-seed oil (it gives no less light than the others, but some people are allergic to its scent); next, holly-seed oil (used exclusively in Shao-zhou [in Guangdong,] the latter is rated low on this list because the oil yield of the holly seeds is small); the lowest in quality is beef fat, which is used widely in North China. . . .

> To make vegetable-tallow candles, a piece of bitter bamboo is split vertically into two halves which are boiled in water until they are swollen. (Otherwise, the molten vegetable tallow will stick to the bamboo.) These two halves of bamboo are then held together with rattan strips to form a pipe, into which the molten tallow is poured from a pointed iron ladle. A wick is inserted, and when the tallow is solidified the bamboo pipe is unbound and removed and the candle is lifted out. Another method of making candles consists of forming the mold by wrapping a piece of paper around a wooden stick, thus creating a paper cylinder. The molten vegetable tallow is poured into it to form a candle. This kind of candle is highly durable, not deteriorating in quality through long storage or exposure to dusty wind.[7]

Candles were often tapered toward the bottom and were colored red. The wick of the candle always projected below and was either a solid bamboo stick designed to fit into a socketed candlestick or a hollow reed made to place over a pricket.[8]

Recent excavations from the Warring States period and the Han dynasty (206 B.C.–A.D. 220) have unearthed a number of lamps that are ingenious in their practical functions and are also works of the highest artistic quality. They are really three-dimensional sculptures endowed with great vitality and ornamented with luxurious detail. Because they were made for the rulers, no expense was spared in the use of precious materials and the employment of the most skilled craftsmen. Two imaginative bronze lamps from the fourth century B.C. were found in the tombs of the Kings of Zhongshan at Pingshan, Hebei province. One consists of eight jointed sections that are easy to disassemble for convenient carrying and storage (fig. 18.1). The lamp's treelike branches hold

18.1

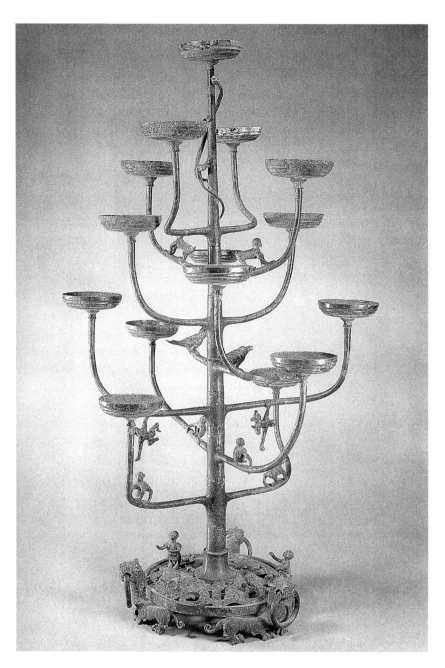

FIGURE 18.1 Bronze lamp.
Eastern Zhou dynasty.
Excavated from the late
fourth century B.C. Tombs
of the Kings of Zhongshan,
Pingshan, Hebei. Height
82.9 cm. Hebei Provincial
Museum. From *ZGMSQJ,
Diaosu bian* 1: 110.

fifteen shallow basins for oil, each with a stubby spike in the center to support the wick. Perched in the tree are a pair of singing birds; playful monkeys leap from branch to branch; and a dragon coils around the trunk as it heads for the topmost basin. Two servants standing at the base of the tree toss food up to the monkeys, while three tigers with rings in their mouths support the circular base. This lamp with its fifteen wicks would not only have provided abundant light for those times, but would also have delighted its user, who, sitting beside it on the floor, could watch the tiny animals cavort in the flickering light. The lamp most likely also had mythic significance: the trunk as a vertical axis to ascend to Paradise and the light emanating from the branches as a reference to the myth of solar trees, which were resting places for the suns.[9] Such a lamp, which is 82.9 centimeters high, is a predecessor of the tall hardwood lamp stands common some twenty-one centuries later, when people sat on chairs at high tables instead of on mats or low platforms on the floor.

Representations of animals and humans frequently supported lamps, low tables, and other small objects. Another lamp excavated at Pingshan consists of a standing man in Chinese court dress (fig. 18.2). In one hand he holds a long bamboolike pole that has a small monkey climbing up the side and ends in a basin at the top. The other hand grasps the tail of a serpent holding a ring-shaped basin on its head. Supporting this serpent is a second serpent coiling around a third ring-shaped lamp basin. Although this lamp is complicated in design, the elements relate harmoniously to one another, and the oil basins arranged at different levels diffuse the light in a pleasant way. The lamp is made of bronze decorated with red and black lacquer, except for the man's head, which is silver inlaid with black stone eyes. The lamp is only 66.4 centimeters high, yet the exuberance, bold stance, and detail of this three-dimensional sculpture of a human form remind us of the life-size terra-cotta warriors that were made about two hundred years later for the First Emperor of China's underground army. The discovery of these pieces transformed our ideas about

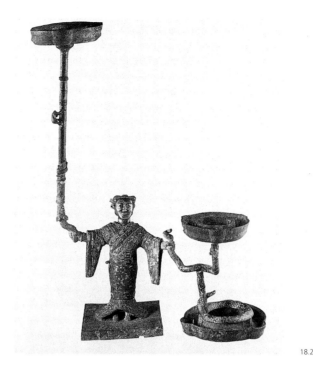

18.2

FIGURE 18.2 Lamp with male figure. Eastern Zhou dynasty. Excavated from the late fourth century B.C. Tombs of the Kings of Zhongshan, Pingshan, Hebei. Bronze inlaid with cast silver, lacquer, and black gemstone. Height 66.4 cm. Hebei Provincial Museum. From Thorp, *Son of Heaven,* 135. Photo Don Hamilton.

Chinese sculpture, showing that in early pre-Buddhist times a strong tradition of three-dimensional sculpture already existed.

Many Han dynasty lamps have the form of small three-dimensional animal sculptures. A popular model made from bronze is shaped like a kneeling ram, with a hinged back that can rest on the animal's horns to form the lamp bowl. Phoenix lamps were also common. A charming bronze lamp of this type was found in the second-century B.C. tomb of Dou Wan, Princess of Zhongshan. A phoenix perched on the back of a coiled dragon seems to sip from the shallow lamp basin held in its beak.[10]

A well-known piece from Dou Wan's dowry was found in her husband's tomb. It is an elegant gilt-

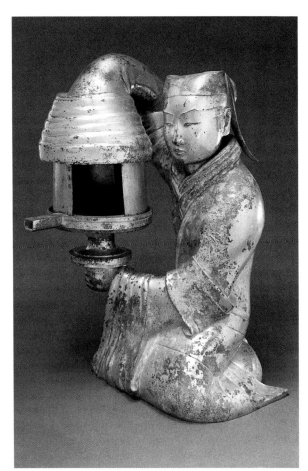

18.3

FIGURE 18.3 Subliming vessel. Western Han dynasty, first half of the second century B.C. Gilt bronze. Height 48 cm. Hebei Provincial Museum. Photograph by Wang Xugui from Wen C. Fong, *Great Bronze Age,* 94.

FIGURE 18.4 Drawing of a lamp stand from a wall painting in tomb 1, Baisha, Henan. Song dynasty, 1099. From Su Bai, *Baisha Song mu,* 26.

bronze figure of a kneeling woman holding an object that is usually called a lamp (fig. 18.3). This classification is erroneous. Recent research has shown that this type of ornamental vessel is actually a subliming vessel (called a rainbow vessel, or *deng*) used to prepare alchemical elixirs involving mercury.[11] It is distinguished by a wide tube leading from the fire chamber to the body of the vessel. This famous piece, still widely considered a major early example of an ingenious lighting device, turns out to be connected with the search for immortality rather than the more mundane function of providing light in the palace.

The Han dynasty was a particularly creative period for imaginative lamp designs and new technical inventions. In the second century B.C. Chinese invented gimbals, a series of interlocking rings joined at two opposing points so that a heavy object such as a lamp will remain upright. Gimbals had many uses: in paper lanterns that were kicked through the streets during dragon processions to symbolize the moon pearl, in perfume burners used to scent the bedclothes, in warming-stoves, and so on.

The Chinese had invented the magic lantern, an ancestor of films and slide shows, by the second century B.C. Referred to in the twelfth century as "the pacing-horse lantern" (*zoumadeng*), the magic lantern has a series of silhouette pictures through which the light shines. Propelled by the heat of the candle, the circle of pictures rotates around the flame, giving the illusion of moving figures.

Later the Chinese perfected the oil-and-wick lamp—a monumental advance. By the year 300 there were wicks made of asbestos that never needed to be replaced and would burn as long as the oil lasted. In the tenth century the Chinese developed the nearest thing to an "inexhaustible" oil lamp. Called the "economic lamp," it had a reservoir of cold water underneath the oil dish that cooled the hot oil and thus reduced the rate of useless evaporation of unburned oil by half. These inventions in China long preceded any equivalents in the West. In 1868 the Royal Society announced that Michael Faraday had invented the magic lantern in 1836. In reality, however, an early

form of this lantern was in the possession of a Chinese emperor who died in 207 B.C., and a Jesuit missionary had already described the magic lantern in the mid seventeenth century. The Victoria and Albert Museum possesses a late-eighteenth-century painting of an itinerant Chinese peep-show: a box containing a magic lantern.[12]

Besides the ingenious lanterns and elaborate lamps that the aristocracy used, there were many kinds of simple candlesticks and oil lamps made of pottery and metal. Many of the designs remained basically unchanged for centuries. Only in about the tenth century, when common people began sitting on chairs at high tables instead of on mats or low platforms, did a major change occur in lighting: the advent of the tall lamp stand. These lamp stands were much higher than previous lamps, even large ones such as the Zhongshan lamp tree (see fig. 18.1). The radical change in furniture level and consequent changes in the proportions of rooms inspired the use of tall lamp stands to illuminate high tables and higher-ceilinged interiors.

There are significant representations of lamps in paintings, reliefs, and woodblock illustrations. From the Song dynasty, a wall painting in a tomb dated 1099 at Baisha, Henan, depicts an elevated lamp stand with three small oil bowls arranged in a pyramid shape at the top of the stand (fig. 18.4). Brick reliefs in other Song dynasty tombs in Henan province show similar lamp stands with curved or straight arms, providing light for the souls of the deceased. In Hebei tomb paintings from the Liao dynasty (907–1125) there are tall lamp stands with a single oil bowl placed on a platform at the top of a long pole. On one lamp stand, depicted in Han Shixun's 1111 tomb, the pole rests on a circular base with inward curving legs. A wooden lamp stand shown in a wall painting in tomb M6 at Xuanhua has a base consisting of two crossed pieces of wood.[13] This type of base was developed and refined in later *huanghuali* pieces.

In Chinese paintings and woodblock illustrations the presence of lighted candles indicates a nighttime scene. A picture such as Qiu Ying's *Saying Farewell at*

18.4

Xunyang, in the Nelson-Atkins Museum of Art, may be brilliantly colored in jewel-like tones, yet the presence of lighted red candles immediately indicates to the viewer that it is night. Likewise, in *The Night Revels of Han Xizai* a flaming candle in an elegant tall metal stand with three cabriole legs sets the scene.[14] In a mid-thirteenth-century fan painting by Ma Lin (c. 1180–after 1256), somewhat sturdier candle stands of a similar design line the path, bordered with flowering crab apples, that leads to an open doorway in which a man sits on a roundback chair. The painting, which is in the National Palace Museum, Taipei, is usually know by the title *Waiting for Guests by Candlelight.* Recent research, however, suggests that the correct title should be *Sitting Up at Night to Gaze at Blossoming Crab Apples,* because the painting illustrates a couplet from a poem by Su Shi (1036–1101):

> Fearing that in the depth of night the blossoms will
> sleep and fall,
> He has tall candles lit to shine on their scarlet finery.[15]

Tall lamp stands made of precious hardwoods became popular in the Ming and early Qing dynasties,

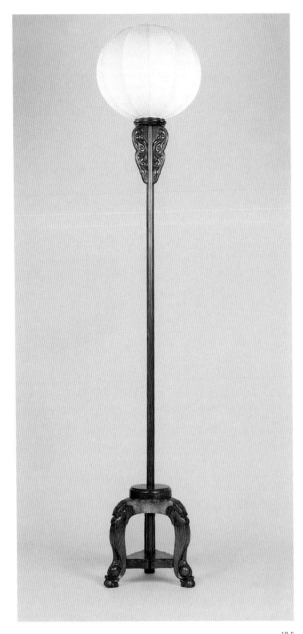

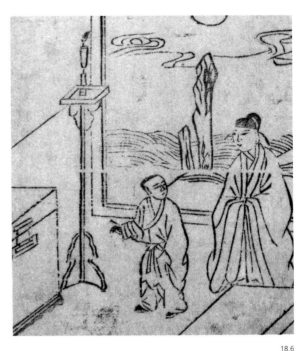

18.6

FIGURE 18.5 Lamp stand with
three legs. Ming dynasty, late
sixteenth/early seventeenth
century; modern lampshade.
Huanghuali wood. Height
162 cm, width 33 cm.
© Christie's Images,
Ltd., 1999.

FIGURE 18.6 Woodblock
illustration to the *Classic
of Lu Ban (Lu Ban jing)*.
Ming dynasty, c. 1600.

FIGURE 18.7 Qiu Ying
(c. 1494–c. 1552). *The Garden
of Peach and Pear Trees*. Ming
dynasty. Detail of a hanging
scroll. Ink and color on silk.
Length 224 cm, width 130 cm.
Chion-in, Kyoto, Japan.

18.5

when the art of fine furniture making reached its
apogee. They are called *zhutai* in the *Classic of Lu Ban*
and *dengtai* by modern craftsmen. One model with
three cabriole legs is a *huanghuali* variation of the Song
lamp stands depicted in the Baisha tomb (see fig. 18.4),
The Night Revels of Han Xizai, and *Waiting for Guests
by Candlelight.* Each leg extends from the mouth of an
animal face, imitating a form of leg found on ancient
bronze ritual vessels (see fig. 11.17), and terminates
in an upward-turning leaf clasping a ball and stand-
ing on an upside-down lotus flower (fig. 18.5). The
animal face, the mythical *taotie* associated with power

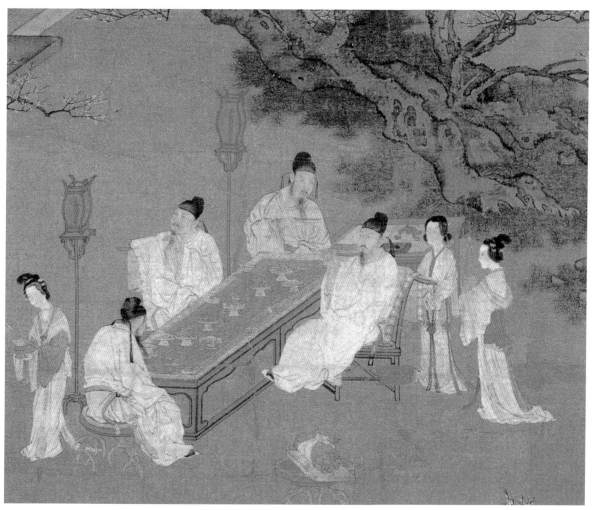

18.7

and sacrifice, and the lotus flower, the Buddhist symbol for purity, were once potent signs, but here they are simply decorative motifs giving the stand an archaistic flavor. Bronze plaques engraved with delicate swirling patterns forming the manes of the animals enhance the lamp stands' ornamental character. A triangular shelf strengthens the legs and supports the pole, which passes through a disk on the top of the legs to culminate in a circular shelf with three hanging spandrels (*guaya*) decorated with pierced curling-tendril designs. This lamp now has a modern shade.

From depictions in paintings and woodblock il-

lustrations, we know that candles, often red ones, were used on lamp stands and in lanterns in the Ming and Qing dynasties. On a wooden lamp stand a separate candlestick (fig. 18.6) or lantern stood on the shelf. Thus you could carry your lamp from another room or from outside and set it on the stand. The candle could also sit securely on a pricket. These tall lamp stands were generally used in pairs on either side of a table, seat, or screen. Since a single candle does not provide much light, they were frequently used in conjunction with table lamps and lanterns (see fig. 9.17). In *The Garden of Peach and Pear Trees* (fig. 18.7) a three-

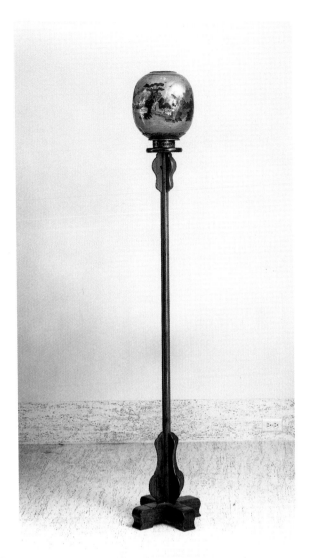

18.8

FIGURE 18.8 Lamp stand, one of a pair. Early Qing dynasty, late seventeenth to mid eighteenth century; horn shades added at a later date. *Huanghuali* wood. Height 152.4 cm. The Nelson-Atkins Museum of Art, Kansas City, Missouri. (Purchase: Nelson Trust.)

branch candelabrum stands on the small square table to the right of the main table, which is flanked by lamp stands.

Another type of lamp stand has a cross-shaped base. A simple *huanghuali* version of this type in the Nelson-Atkins Museum of Art has molded crossbars that terminate in four small feet (fig. 18.8). Four curvilinear upright spandrels (*zhanya*) tongue-and-groove into the crossbars and pole. Their design repeats, in smaller proportions and in reverse, in the hanging spandrels beneath the top shelf. The shade, dating from the eighteenth or nineteenth century, rests on a lacquered stand. It is made from slices of cow horn that were worked with the fingers under warm water until one piece fused to another without seams. Then the sheets were beaten to paper thinness, shaped into shades, and painted on the inside. From the late Ming novel *The Plum in the Golden Vase* we know that sheep's-horn lanterns or shades could originally have been used on this lamp stand.[16]

A more complicated version of the lamp stand with cross-shaped base is made from lustrous dark *zitan* wood (fig. 18.9). The satisfying bulk and curve of its members echo in the bold assurance of its decoration. The base has a flat bottom, cloud-head designs at the ends of the crossbars, and hibiscus flower medallions (called "embracing drums," *baogu*) toward the center. The yellow hibiscus (*qiukui*) flower with its swirling overlapping petals was a popular decorative motif for circular elements. This form of base also appears on small table screens, on large single-panel screens (see fig. 16.12) and screening walls, and on doors. The vigorous rounded forms of the base repeat in the large spandrels and echo in reverse in the smaller hanging spandrels beneath the round shelf. A metal spike screwed into the top of the pole, which passes through the shelf, secures a small metal dish and forms the pricket. The base of the lamp stand is fashioned from small pieces of *zitan,* a practice that became increasingly common during the eighteenth century as the precious wood became rarer.[17]

There were also adjustable lamp stands (fig. 18.10). A *huanghuali* example of this type is both decorative

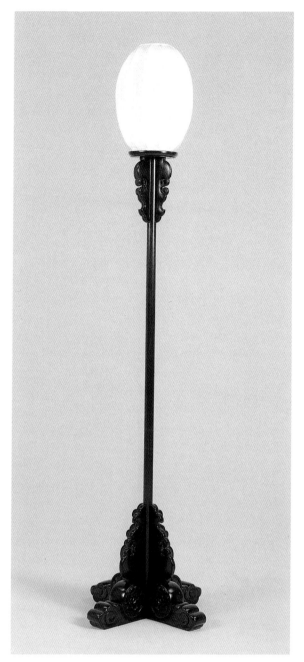

18.9

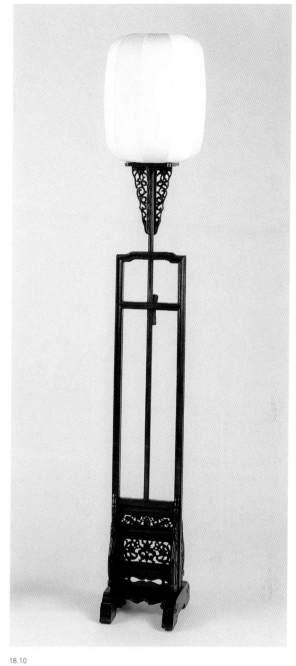

18.10

FIGURE 18.9 Lamp stand.
Early Qing dynasty, late
seventeenth/early eighteenth
century; modern lampshade.
Zitan wood. Height 155 cm,
base 50.5 cm × 50.5 cm.
© Christie's Images,
Ltd., 1999.

FIGURE 18.10 Adjustable lamp
stand, one of a pair. Early Qing
dynasty, late seventeenth/early
eighteenth century; modern
lampshade. *Huanghuali* wood.
Height 14.5 cm, base 25 cm
wide and 30.5 cm deep.
The Minneapolis Institute

of Arts. Gift of Ruth and
Bruce Drayton. Photo
© Christie's Images,
Ltd., 1999.

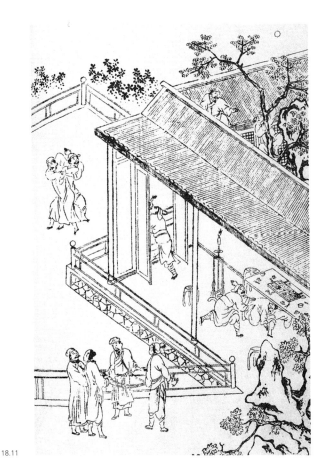

and practical because the lamp can extend from 145.5 centimeters off the floor to any height up to 201.1 centimeters—46.1 centimeters higher than the *zitan* lamp stand in fig. 18.9. It can thus provide direct light for reading or diffused light for illuminating a wide area. Such a lamp stand, with a candle on the shelf, stands by a dining table in the woodblock illustration to *The Plum in the Golden Vase* that depicts the police raid on Verdant Spring Bordello, where young master Wang and his good-for-nothing companions are carousing (fig. 18.11). The lamp stand consists of a narrow rectangular frame secured on each side by a foot base. The pole extends through the center of the frame and attaches to a horizontal bar at the bottom. Tenons at each end of the bar fit into vertical grooves on the sides of the frame, allowing the bar to move freely up and down. When the lamp reaches the desired height, the pole is secured by a wedge inserted in a horizontal bar fixed near the top of the frame. Since the wedge is loose but cannot be removed, we may conclude that when the lamp stand was assembled the wedge was first put into place; then the pole was inserted through holes in the top of the frame and the top horizontal bar and tenoned into the movable bar.

All the frame members of this stand have beaded edges and concave surfaces except for the pole and movable bar, which have beaded edges but flat sides. The corners of the square lamp shelf and the top of the frame are butterflied. Where the sides meet the top of the frame there is a full-length tenon with half-lapped miter join. This unusually strong and sophisticated join is also found on the meditation chair in fig. 2.2.

The stand is ornamented with openwork carving. The four hanging spandrels beneath the lamp shelf have curling tendril patterns. A profile depiction of a *chi* dragon—an immature hornless dragon with paws, long body, and forked curling tail—curves to form the shape of each of the four standing spandrels on the base. Three carved panels are inset between the horizontal members at the base of the stand. The lowest has simple curvilinear motifs. The large mid-

FIGURE 18.11 *Young Master Wang Fleeing the Verdant Spring Bordello.* Ming dynasty. Detail of a woodblock illustration to *The Plum in the Golden Vase* (*Jin ping mei*), Chongzhen reign period (1628–44), chap. 69.

18.12

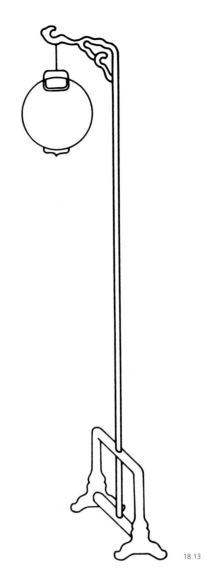

18.13

dle panel has a stylized *shou* ("longevity") character flanked by coiling *chi* dragons. This is a favorite motif on furniture, and sometimes, as here, the bottom of the character assumes the form of cabriole legs reminiscent of dragons' legs. Unlike Western dragons, which are sinister beasts, Chinese dragons are benevolent creatures, the bringers of rain and therefore of abundant harvests. Thus the combination of the wish for rain and long life is a most auspicious symbol. The symmetry of this large panel is repeated in the upper panel, where playful lions chase a luminous pearl or wish-granting jewel. Lions are not native to China but appear as guardian animals in art during the late Zhou and Han periods (that is, from the third century B.C. to the third century A.D.). Later in Buddhist art they came to symbolize religious power, as they have in many regal and religious iconographies, including ancient Greek and Christian. By at least the early tenth century, playful lions chasing a flaming pearl had became a decorative motif.[18]

The basic form of the adjustable lamp stand is ancient, appearing on Shang bronzes as an emblem (fig. 18.12) that is thought to indicate a quiver maker.[19] Fixed racks of similar design used to hold banners, musical instruments, and swords may be seen in the Forbidden City today. A more squat variant of this rack, used as a fixed lamp stand with a lantern hanging from the hooked end of a long pole, appears in several paintings illustrating *The Plum in the Golden Vase* (fig. 18.13). They are related to models with three

FIGURE 18.12 Quiver-makers' emblem found on ritual bronzes. Shang dynasty, sixteenth to eleventh century B.C. Drawing from Ecke, *Chinese Domestic Furniture*, 11.

FIGURE 18.13 Lamp stand with lantern, based on a painting illustrating *The Plum in the Golden Vase* (*Jin ping mei*). Qing dynasty, eighteenth century. Drawing from *K'ing P'ing Mei in Pictures*, 1: n.p.

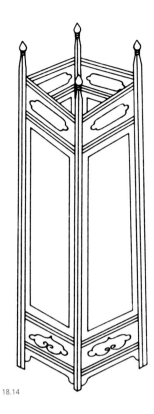

18.14

or four cabriole legs and a long pole terminating in
a dragon head–shaped hook, from which the lantern
is suspended (see figs. 12.11, 16.17). Although they
seem to have been common, no actual Ming or early
Qing examples are known to exist today. The form
is practical, allowing you to hang up the lantern that
lighted your way into the room or suspend other ob-
jects from the hook, such as a perch for a parrot or
songbird.[20] The rack and hooked pole are good ex-
amples of how the Chinese adapted one basic form
for various uses.

Yet another type of wooden lamp is the "book
lamp" (*shudeng*) illustrated in the 1609 *Pictorial Encyclo-
pedia of Heaven, Earth, and Man* (*Sancai tuhui;* fig. 18.14).
This small narrow lantern probably had paper or silk
panels to protect the lighted candle from drafts. The
small aprons, ornament on the panels, and finials are
all typical of contemporary hardwood furniture.

A simple paper lantern made of wood or bamboo
with a red candle burning inside, like the one hang-
ing from the lamp stand in Verdant Spring Bordello
(see fig. 12.11), was commonly carried hanging from
the end of a pole to light the way outside and through
the courtyards and covered porches connecting the
various parts of the house. The carrying pole some-
times ended in a dragon head–shaped hook. People
might also attach a lantern to the top of a long pole
carried in an upright position and stuck into the
ground to provide illumination for a military en-
campment. These two types are labeled *tideng* and
qingdeng, respectively, in the 1609 *Pictorial Encyclope-
dia.* In illustrations the frame of the hanging lantern
often appears to be covered with a thin silk cloth (see
fig. 19.15). Inside the house the lantern could be hung
from the rafters, from a lamp stand, or inside a bed-
stead; the *Pictorial Encyclopedia* calls this type of lantern
longdeng.[21] An illustration to *The Plum in the Golden
Vase* shows two lanterns hanging from the rafters (see
fig. 9.17). One is round and probably made of bam-
boo and paper, with painted flowers on the shade,
fringes hanging from the base, and streamers sus-

pended from the top. The other is an elegant hexagonal wooden model with floral paintings and delicate lattice-design borders on its silk or paper shade; tinkling pendants hang from the upturned ends of its roof. In another part of the room is an elaborate lamp stand with a fixed base and long pole ending in a dragon head from which hang two lotus-shaped candleholders. At first glance this depiction may appear fanciful, but when we remember the elaborate fourth-century B.C. lamp tree in fig. 18.1, it seems perfectly possible that such a lamp could exist in the Qing dynasty.

Lanterns with *zitan* frames hung from the ceilings of eighteenth-century mansions (fig. 18.15). The lanterns comprise many small pieces of wood and undoubtedly made use of precious *zitan* scraps left over from the making of larger pieces of furniture. They are ornamented with elaborately detailed pierced carving and lattice borders, which are comparable to the architectural latticework found on doors, windows, and balustrades and beneath the eaves of porches and open galleries. Translucent glass panels are tongue-and-grooved into their frames. We know that in the middle of the Qing dynasty glass replaced paper or silk in windows,[22] so it seems logical to assume that glass also began to be used in lanterns at that time. As we saw in the quotation from Jacques Gernet, *Old Affairs of Wulin* describes circular glass lanterns from the Southern Song dynasty, but glass panels set into wooden frames might well be a later innovation. Today in the Forbidden City many more elaborate versions of these lanterns, bedecked with streamers and fringes, hang from the ceilings.

Zitan lanterns like the one in fig. 18.15 are sometimes exquisitely made, with fine carving and a pleasant spacing of the design elements. Framing the glass is a flower and curling-tendril border culminating in an auspicious bat. Elegant pillars adorn the four corners. One of the sides of the lantern is hinged and has a tiny knob so that one could open the panel to insert the candle. Each night the candle was lit with a long taper.[23] The dark openwork carving would

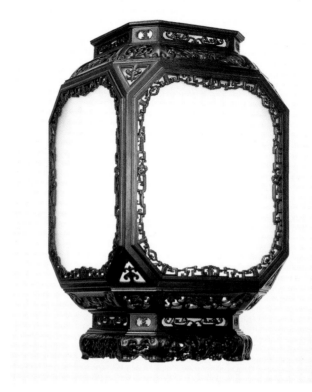

18.15

have been silhouetted against the candlelight in a pleasing pattern. And thus, glowing like stars, lanterns illumined the dark interior of the Chinese house.

The stars, the lanterns of the sky, illuminate the earth at night. The lamp, which creates an indoor star, provides practical light for human society. When stars follow their proper course and lamps are correctly illumined, there is harmony through light in the external space of the cosmos as well as in the internal space of the home and the mind. In the well-known poem "Homecoming—Late at Night," by the Tang poet Du Fu (712–770), the constellation of the Great Bear descends to its destined site in the river, while other stars still illumine the sky. Then the frightening aspects of the outdoors come under control, and one is near safety. The modest act of opening the door to one's house and lighting the lamps is enough to signify refuge and harmony:

Nightfall, I return from a
journey, slipping by tigers.
The mountains are black.
Everyone is at home asleep.
The Great Bear descends
to the river. Overhead
the stars are huge in the sky.
I hold a candle in the yard,
astonished by two burning lights.
I listen for gibbons crying
in the ravine. I hear only one.
Though white-haired and old,
I dance and sing. Leaning on my stick,
I refuse to sleep. Who cares?[24]

The lamp not only provides physical light for safety and practical comfort indoors, but also implies a higher human experience: spiritual illumination. In lines by the great Buddhist nature poet Wang Wei (699–c. 760), the metaphor for the ineffable instant of mystical gnosis includes both the sun and the lamp. But ultimately Wang chooses as his symbol for human enlightenment the warmly human device for creating light:

> They don't mourn the sinking sun
> for in them there is a burning lamp.[25]

19 | PERFUMED COALS IN PRECIOUS BRAZIERS BURN

*E*very culture and period has a different perception of comfort. In modern America we keep our houses warm in the winter, wear light clothes indoors, and put on heavy protective coats to go outside. In imperial China houses were cold, since heating was minimal, and people dressed accordingly in layers of warm garments. In everyday speech, people quantified the degree of cold by the number of jackets they wore. Since people were already so warmly dressed, heavy topcoats were unnecessary, and capes were used only as protection from rain or snow. This mode of dressing was convenient in a country where houses were built around a series of courtyards and it was necessary to step outside to move from one part of the house to another.

Poor people wore padded cotton garments while the wealthy adorned themselves in fur-lined silk robes, as may be seen in a painting of an elegantly dressed lady seated on the edge of her curtained bed (fig. 19.1). The nearly life-size painting is one of a set of twelve depictions of beautiful women that were originally mounted on a pair of six-panel screens in the Yongzheng emperor's palace (see Chap. 16). The paintings are so large and the sumptuous dress of the ladies and the splendor of the palace interiors are depicted in such detail that the emperor reclining on his bed must have had the illusion that he was actually surrounded by the twelve beauties. In the painting in fig. 19.1 we see a beauty warmly dressed in a fur cap and layers of silk garments, including a fur-lined robe. A small brazier on a stand provides a little warmth. Outside the bamboo and plum blossoms are covered with snow; indoors it is near freezing.

The scene reminds us of descriptions in contemporary novels, such as Cao Xueqin's *The Story of the Stone* (*Honglou meng,* also known in English as *A Dream of the Red Mansions*), which recalls life in the family of a well-to-do Beijing official named Jia: "Wang Xi-feng had on a little cap of red sable, which she wore about the house for warmth, fastened on with a pearl-studded bandeau. She was dressed in a sprigged peach-pink gown, with an ermine-lined skirt of dark-red foreign crepe underneath it, and a cloak of slate-blue silk

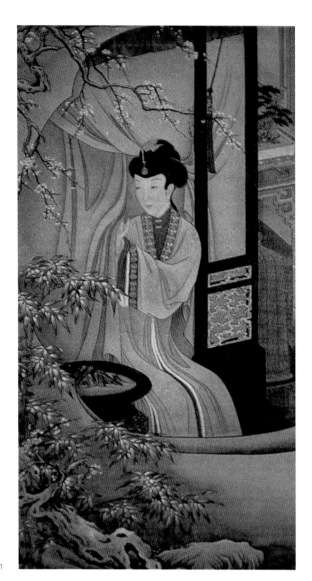

FIGURE 19.1 Zhang Zhen (active early eighteenth century) or Zhang Weibang (active mid eighteenth century). *Lady Seated on Canopy Bed*. Qing dynasty, c. 1720–23. Hanging scroll. Ink and color on silk. Height 184 cm, width 98 cm. Palace Museum, Beijing. From Palace Museum, *Court Painting of the Qing Dynasty*, 96, pl. 10.

with woven colored insets and lining of grey squirrel around her shoulders. Her face was exquisitely made-up." During the winter red felt portieres covered the doorways, and Xi-feng and the other ladies of the Jia family had plenty of wolf, fox, and squirrel fur coverlets. During the New Year's celebrations the bare wood or lacquer chairs were made warmer and more festive with fur covers on the backs and seats.[1]

Although clothing was the principal means of keeping warm in winter, various heating devices could take the chill off a room. A fire pit combined with furs for warding off the cold are mentioned in an early anecdote about Duke Wei Ling in *Master Lü's Spring and Autumn Annals* (*Lüshi chunqiu*), a third-century B.C. compilation dealing with the Spring and Autumn period (770–475 B.C.): "Your Highness does not feel cold, because you wear a fox fur coat and sit on a bear fur mattress in a room with a fire pit in the corner."[2] Recent excavations of houses from the Han dynasty (206 B.C.–A.D. 220) confirm the existence of fire pits as well as charcoal braziers, which are really portable fire pits. The earliest known brazier is from the Spring and Autumn period and was found at Xinzhen, Henan province (fig. 19.2). It is rectangular with sides sloping outward toward the top, ring handles on each side, and an inscription saying that it is "the heating stove of Prince Yingci." In the Han dynasty the design was improved by the addition of four legs (fig. 19.3).

Braziers are often round. An elegant eighth-century example in the Shōsōin consists of a marble basin supported by five gilt-bronze lions (fig. 19.4). Five double gilt-bronze rings would have enabled the brazier to be brought already lit into the room and moved from place to place. The rearing lions are lively three-dimensional sculptures exquisitely made, with their manes and fur rendered by engraved lines filled in with malachite. Since the basin is made of Dali marble, a stone common in China but rarely found in Japan, the brazier could have been imported from the mainland. Tang dynasty poets write of wine being warmed in stone braziers (*lu*) or in

metal *dang,* which are perhaps simply the metallic form of *lu*.[3]

Like the traditional Japanese hibachi, Chinese braziers were primarily devices for generating warmth; functions such as heating beverages, preparing medicines, or grilling were secondary. In paintings and woodblock illustrations we frequently see the indoor heating brazier used to warm ewers. Sometimes people took a brazier on picnics to warm beverages, as may be seen in the Southern Song painting *Returning from a Spring Outing* (see fig. 5.5). Here chains or cords from each end of a carrying pole suspend a brazier and hamper. Wine jugs have been placed among the glowing coals in the square brazier. Once the wine was warm, the jug was set in a bowl of hot water on the table and drunk from a small bowl-shaped cup on a stand (see fig. 1.8).

Braziers provided heat not only for everyday human activities but also for sericulture and other industries. The maturing silkworms in a breeding house needed to be kept at an even warm temperature, and in paintings such as the thirteenth-century handscroll *Sericulture* in the Cleveland Museum of Art we see low round braziers.[4] Chen Fu, writing in 1149, considered portable stoves (*tailu*), rather than stationary stoves, the best source of heat: "The fire should be kindled outside the room [so that the] warmth [can develop in the stove] which is covered with straw ashes so that no abrupt blaze of fire can arise." In 1313 Wang Zhen commented on this passage: "With reference to the construction of the portable stove, it has a low framework in the inside of which the portable stove is inserted. On both sides [of the stove] long handles project so that two laborers can lift it up and carry the source of heat."[5] These descriptions and the woodblock illustration published in the 1530 edition of *Nong shu* (fig. 19.5) indicate that this portable stove consisted of a metal basin set into a wooden frame. Thus the portable stove used to warm silkworms was a cruder variant of the elegant hardwood brazier stands that later graced the homes of well-to-do families.

Because the burning charcoal rested on ashes lining the metal basin of the brazier, the insulating ash

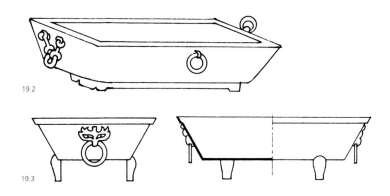

19.2

19.3

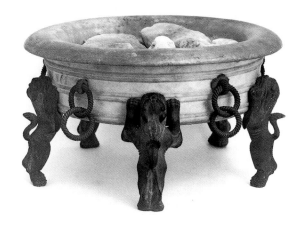

19.4

FIGURE 19.2 Bronze brazier used by Prince Yingci. Spring and Autumn period. Excavated in Xinzhen, Henan. Drawing from Institute of the History of Natural Sciences, *Ancient Chinese Architecture,* fig. 9-5-4.

FIGURE 19.3 Bronze brazier. Han dynasty. Excavated in Xujiawen, Changsha, Hunan. Drawing from Institute of the History of Natural Sciences, *Ancient Chinese Architecture,* fig. 9-5-5.

FIGURE 19.4 Marble brazier no. 2. Eighth century. Marble and gilt bronze. Height 22.6 cm, diameter 40 cm. Courtesy of the Shōsōin Treasure House, Nara, Japan.

火倉撞爐附

FIGURE 19.5 Portable stove used in sericulture. Woodblock illustration to Wang Zhen, *Nong shu,* 1530 ed., 20.

FIGURE 19.6 Attributed to Emperor Huizong (r. 1101–25). *Ladies Preparing Newly Woven Silk.* Song dynasty, early twelfth-century copy of a Tang dynasty painting by Zhang Xuan (eighth century). Detail of a handscroll. Ink, color, and gold on silk. Height 37 cm, length 145.3 cm. Courtesy Museum of Fine Arts, Boston. Chinese and Japanese Special Fund.

FIGURE 19.7 Liu Jun (fifteenth century). *Song Emperor Taizu Visiting His Prime Minister Zhao Pu on a Snowy Night.* Ming dynasty. Detail of a hanging scroll. Ink and color on silk. Height 75 cm. Palace Museum, Beijing. From *ZGLDHH, Gugong* 5: 78.

prevented the metal from becoming so hot that it would burn the wood brazier stand. Moreover, metal bosses often raised the basin slightly above the frame of the stand. Since at least the first century A.D., according to a depiction in the offering shrine of General Zhu Wei, the Chinese used fans to keep fires going and poked the coals with tongs. The tongs—long metal chopsticks linked at one end by a chain—are called *huozhu* in a fifteenth-century illustrated primer.[6]

In the home, the brazier supplied irons, hand warmers, and foot warmers with burning charcoal. In the handscroll *Ladies Preparing Newly Woven Silk* (fig. 19.6)—a twelfth-century copy attributed to the Song emperor Huizong of an eighth-century painting by Zhang Xuan—we clearly see ashes around the burning coals in a large round brazier. The brazier itself has handles and appears to be made of bronze, or gilt-bronze, with decorative cutout panels accentuated by a darker material. In this depiction of life in the imperial palace during the Tang dynasty, a court lady irons the stretched silk with a small long-handled iron while a little girl, too young to be helpful, plays underneath.

The brazier in *Ladies Preparing Newly Woven Silk* is a luxurious palace model. More common is the low metal-footed brazier, a simpler version of the Shōsōin piece, found in depictions of daily life in the Liao dynasty (907–1125) and in many paintings and woodblock illustrations from the Ming (1368–1644).[7] In the painting *Song Emperor Taizu Visiting His Prime Minister Zhao Pu on a Snowy Night,* the fifteenth-century painter Liu Jun shows the two men seated on a red carpet around a cabriole-legged brazier; a wine pot is heating in the ashes while meat grills over the glowing charcoal (fig. 19.7). A similar scene occurs in *The Story of the Stone* when, on a beautiful snowy morning before a meeting of the poetry society, the young inhabitants of the Garden decide to roast venison on an iron brazier, which is carried out for them already equipped with metal skewers and a grill.[8] On such chilly days and nights braziers provided warmth indoors, where they might be placed under the desk to warm the feet of a happy calligrapher, who, pleasantly

19.6

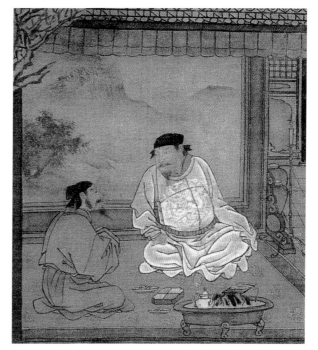

19.7

heated by the coals and a jug of wine, is inspired to write on a scroll (fig. 19.8). Or a small rectangular brazier might be placed under the table to bring comfort to the assembled diners (see fig. 7.17).

In the Ming dynasty, in addition to metal braziers that rested directly on the ground, there were also braziers that were placed on low wooden stands, which twentieth-century Beijing craftsmen call *huopenjia*. In the tomb of Pan Yunzheng, an official supervisor of the imperial kitchen who died in 1589, excavators found a miniature model consisting of a rectangular metal pan with a wide flat rim set into a waisted wooden stand with curvilinear cusped aprons, horsehoof feet, and a continuous floor stretcher (fig. 19.9). On the metal rim is a large pot, perhaps for tea, which by this time was steeped rather than boiled or powdered and mixed with hot water, as it had been in earlier times. The fifteenth-century carpenter's manual *Classic of Lu Ban* tells the craftsman how to make round and square low brazier stands with an opening in the top, a deep panel, and a continuous base stretcher. The round stand has six cabriole legs and

19.8

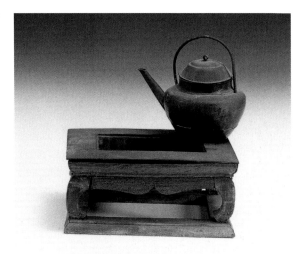

19.9

FIGURE 19.8 "A Happy Calligrapher." Detail of a woodblock illustration to Huang Fengchi's seventeenth-century *Illustrations to Tang Poems* (*Tang shi huapu*), *juan* 2, 40a.

FIGURE 19.9 Model of brazier and stand. Ming dynasty. Excavated from the 1589 tomb of Pan Yunzheng, Luwan district, Shanghai. *Ju* wood and metal. Height 4.5 cm, length 10.48 cm, width 7.94 cm. Shanghai Museum.

curvilinear aprons; the square stand has four legs. The manual also describes an unusual table with a low shelf and a round aperture for inserting a brazier.[9]

Not until the Ming dynasty were wooden brazier stands perfected. As part of the great florescence of sophisticated hardwood furniture, they became masterpieces of the joiner's art, varied in form and decoration. Elevated versions of the low brazier stand became popular. The Wanli period painter Qian Gong (active 1573–1620) depicts an elegant round model in his *Taiping Spring Colors* (fig. 19.10). The stand has horse hoof feet, curvilinear cusped aprons, clear beading, and a continuous base stretcher standing on cloud-head feet joined by scalloped aprons. It is a cold day in early spring, and the burning coals provide warmth for scholars studying a large handscroll. The coals also heat various beverages for their refreshment. Note the chopstick-shaped tongs and the way the pots are elevated above the coals. On snowy days it was pleasant to sit, wrapped in a warm rug on a fur-covered stool, around the brazier warming your hands and admiring the beauty of the garden outside. Such a scene appears in a Wanli period woodblock illustration to the drama *Embroidered Trousers* (*Xiu ku ji*), where the large bold brazier stand has six cabriole legs and arched aprons.[10] A painting depicting scholars admiring antiques in a garden shows drinks being warmed in a large rectangular brazier (fig. 19.11). It has a wide recessed waist and strongly curved cabriole legs standing on a continuous floor stretcher raised up on small feet. The undulating cusped apron flows into a cloud-head shape at the corners and down into the cusped inner edge of the leg, creating a lively silhouette.

One of the few unaltered Ming dynasty brazier stands still extant is solid in material and construction, as befits its role supporting a heavy metal basin filled with ashes and coals (fig. 19.12). Yet the strong flowing grace of its form and decoration make it visually pleasing. Made from exceptionally thick pieces of *huanghuali,* it gains further strength from having the apron and waist carved from one piece of wood and from the addition of crossed stretchers. The decora-

tive designs at the corners of the aprons are not cut all the way through, and thus the legs retain their maximum width; this unusual feature makes the stand even stronger.

Relieving the squareness of the stand are the sharp inward slant of the top moldings, the recessed waist, the inward curl of the legs at their base, and the ball feet. This basic type of leg and foot is found on small corner-leg side tables in the collections of the former Museum of Classical Chinese Furniture, the Honolulu Academy of Arts, and the Brooklyn Museum. In the brazier stand, however, the severity of the profile is enlivened by the strong curves along the inner edge of the legs, the cutout cloud heads, and the aprons. This undulation culminates in the deep cusp at the center of the apron, which echoes the sharp point on the legs. The movement of these curves is accentuated by the wide, slightly concave bead, which flows into a curl at the end of the leg. The beading continues up the outside of the leg, ending in a graceful fleur-de-lis-like motif that merges with the top corner of the leg and points upward to the brazier. The subtly modulated carving of the bead is exceptionally fine, and together with the undulating profiles unifies and enlivens the stand.

The freshness of the design, the way the miter at the join of leg and apron continues through the waist, and the manner in which the cloud heads are not cut all the way through all suggest an early date for this brazier stand. In design and function it is among the most successful examples of Ming furniture and would have been appropriate for use in the most refined interiors. We can imagine it containing a metal brazier filled with ash and burning coals to which a few aromatics have been added, warming and perfuming the air and dreams of the inhabitants of Green Delights in *The Story of the Stone:* "She took the copper cover off the brazier and damped down the glowing charcoal by shoveling some ash on to it with the fire-shovel. Before replacing the cover, she threw on a couple of pieces of agalloch to sweeten the air. Then she went behind the screen and trimmed the lamp up. After that she too went back to bed."

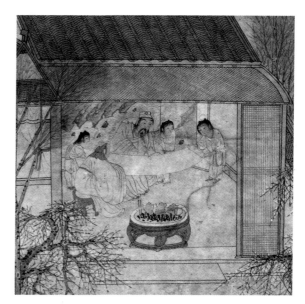

19.10

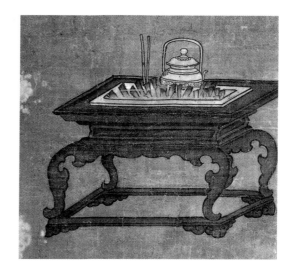

19.11

FIGURE 19.10 Qian Gong (active 1573–1620). *Taiping Spring Colors.* Ming dynasty, Wanli reign period. Detail of a hanging scroll. National Palace Museum, Taipei.

FIGURE 19.11 *Enjoying Antiques.* Attributed to the Song dynasty, but probably Ming dynasty. Detail of a hanging scroll. Ink and color on silk. Height 141.1 cm, width 100.3 cm. National Palace Museum, Taipei.

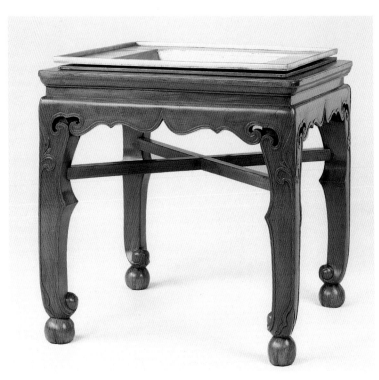

FIGURE 19.12 Brazier stand, with replacement metal pan. Ming dynasty, seventeenth century. *Huanghuali* wood. Height 60 cm, width 61 cm, depth 51 cm. © Christie's Images, Ltd., 1999.

FIGURE 19.13 Chen Mei (active 1720–40). *Pleasures of the Months for Court Ladies: Eleventh Month, Admiration for Treasures of the Past.* Qing dynasty, 1748. Album leaf. Color on silk. Height 30 cm, width 21.8 cm. Palace Museum, Beijing. From *ZGLDHH, Gugong* 7: 100.

Later, in the disturbing scene where the dying Dai-yu burns her poems, we learn that besides floor stands there were also special low stands to hold the brazier when it was used on the *kang*.[11] Sometimes low metal braziers with feet were elevated simply by setting them on a small table (see fig. 19.1). Low braziers also might have tall metal cagelike covers to prevent trailing garments from getting singed by the coals.

Braziers did not remain in a fixed place in the room but were moved around to suit the convenience of the inhabitants. When a palace lady sat down to admire a painting, a servant would place a brazier near her chair (fig. 19.13). In *The Story of the Stone* we read: "The maids moved the charcoal brazier to the back of the room and placed two tables in front of Grand-mother Jia's couch, at which the party now arranged itself for lunch. After lunch they sat once more around the brazier chatting pleasantly." The number of braziers in use depended on the weather and on the wealth of the family. As Li Yu—an outspoken dramatist, publisher, and expert on the art of living— remarks in his 1671 *Casual Expressions of Idle Feeling*

(*Xianqing ouji*): "When I am at my writing during the winter months I suffer great distress from chilled limbs and frozen ink slab. If I install more braziers so as to heat my entire study the result is not only soaring expense but the accumulation of dust on the surface of the desk, so that before the day ends I am living in a world of ashes. If I limit myself to a large stove for my feet and a small one for my hands, then my four extremities enjoy preferential treatment over the rest of my body: in my own person I house both summer and winter at once, and ears and nose and brain itself could well style themselves spurned ministers or rejected offspring."[12] Even though braziers may not have been the most satisfactory form of heating—they polluted the air, as Li Yu complains, coating surfaces and lungs with fine dust—they nonetheless made indoor human activity possible in cold weather.

The brazier is an intimate source of heat. To feel its effects you must be close to it or in direct contact. This intimacy is even truer of the hand warmer (*shoulu*) and the foot warmer (*jiaolu*), related secondary

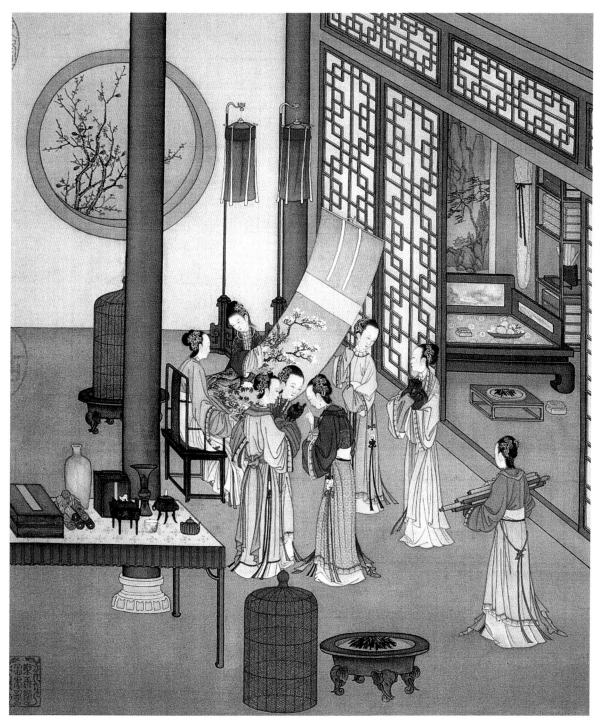

19.13

FIGURE 19.14 Zhang Mingqi (late sixteenth century). Hand warmer and inscription. Copper. Height 8.2 cm, length 13.2 cm, width 10 cm. From the Dr. Ip Yee collection, Hong Kong. Sydney L. Moss, Ltd., London.

heating devices that shared both coals and tongs with the brazier. *The Story of the Stone* describes Xi-feng using small tongs to remove coals from her hand warmer: "She was sitting on the edge of the kang, her back straight as a ramrod, with a diminutive pair of tongs in her hand, removing the spent charcoal from a portable hand-warmer. Patience stood beside her carrying a covered teacup on a tiny inlaid lacquer tray. Xi-feng appeared not to have noticed her, for she neither reached out for the cup nor raised her head, but continued picking absorbedly at her hand-warmer."

In the homes of the wealthy, hand warmers were as necessary to comfort on a cold day as fur rugs and warm wine. Once, shortly before the New Year, Grandmother Jia visited the Spring in Winter Room in the Garden to ask the young ladies to begin making lantern riddles for the Lantern Festival. The maids brought in "a big wolfskin rug and spread it out in the middle of the kang for Grandmother Jia to sit on. . . . Li Wan handed her a hand-warmer while Tan-chun fetched a winecup and a pair of chopsticks, poured out a cup of warm wine, and offered it to her with both her hands. Grandmother Jia accepted it from her and sipped the wine."

Hand warmers were treasured personal possessions, and even the maids in the Jia household had their own. When Aroma prepared to return home because of her mother's illness, Xi-feng wanted to make sure that she would make a good impression and said to the lady who would be her chaperone: "Aroma's a girl who doesn't like fuss. You'd better tell her that it's my wish that she should dress herself up in the very best things she's got. Tell her to take a good

19.14

big bundle of extra clothes with her as well. The cloth it's wrapped in is to be of the highest quality. Her hand-warmer is to be a good one, too. And tell her that before she goes I want her to come here so that I can have a look at her."[13]

In the late Ming dynasty hand warmers were valued works of art. One of the outstanding craftsmen of the time, Zhang Mingqi, specialized in their manufacture. Zhang became famous after his patron, the great collector Xiang Yuanbian (1525–90), encouraged him to move to Xiang's hometown, Jiaxing in Zhejiang province. Hand warmers were especially important for Xiang and other scholars, who led sedentary lives reading, writing, and painting at their desks. Thus, hand warmers—like the brush, ink, inkstone, water dropper, brush rest, and brush pot on the scholar's desk—became works of art, functional and at the same time beautiful and delightful objects. Unlike furniture, scholars' necessities were sometimes made in the workshops of known craftsmen who signed their work and had powerful patrons among the most famous scholars of the time.

Zhang's hand warmers, according to contemporary accounts, were made of beautifully worked even-toned copper, had strong tight-fitting lids, and were fashioned by hammering a single sheet of metal, with no cast, soldered, or inlaid details. One in the Dr. Ip Yee collection in Hong Kong has an inscription engraved on the base in seal script—"I don't know when the freezing cold arrives; I am only aware of the return of spring"—and is signed "Made by Zhang Mingqi" (fig. 19.14).[14] Such a poem might have been written by the scholar who commissioned the piece and is comparable to similar inscriptions on Yixing pottery and other objects used in the scholar's studio. The hand warmer's bulging rectangular body rests on four hollow L-shaped feet and has a domed openwork cover imitating the crisscross design of woven basketry. The warmth of the burning coals, perhaps made fragrant with aromatics, would have risen through the holes in the cover. Covers were designed to be viewed from above and are often mar-

velous examples of folk art, with beautifully wrought geometric patterns (frequently related to those found on window lattice), symbolic motifs, and landscapes or narrative scenes. A hand warmer such as the one in fig. 19.14 was an intimate personal object. Its plain smooth body and rounded corners invite you to handle it. It is only 8.2 centimeters high, 13.2 centimeters long, and 10 centimeters wide. Tiny hand warmers less than 6 centimeters high could be tucked in the clothing, medium-sized ones held in the arms (fig. 19.15), and larger ones placed on tables or couchbeds (see fig. 19.13).

Pottery was used for the simplest hand warmers. Rudolf P. Hommel illustrates a crude example he found in the Zhejiang countryside in the 1920s and describes how it was used: "The people carry these ember-bowls with them in and about the house, also when going to the fields or walking about the land, and calling on their neighbors. When they sit down, they hold the stove on their lap with their hands resting on the bamboo handle, or put it on the floor and hold their feet over it."[15]

In the Ming dynasty large metal models, more than 22 centimeters square, were used as foot warmers, as is clear from the signs of wear on their covers.[16] Chen Mei's painting (see fig. 19.13) depicts several types of heaters: a foot warmer on the floor in front of the couchbed next to a brazier in a low wooden stand, a hand warmer on the couchbed itself, and metal braziers with wire covers on the floor in the adjoining room. In *The Story of the Stone* maids also talk about hot-water bottles and clothes warmers:

> The two girls removed their hair ornaments and changed into their night-clothes. Skybright showed no disposition, after changing, to remove herself from the clothes-warmer over which she was crouched. . . .
>
> "I don't think I shall *ever* get warm," said Skybright. "And I've just remembered: I haven't brought in the hot-water bottle."
>
> "How thoughtful we are all of a sudden!" said Musk. "He never has a hot-water bottle. And *we* shan't need one tonight. It'll be much warmer in here on the clothes-warmer than it is on the kang in the other room."

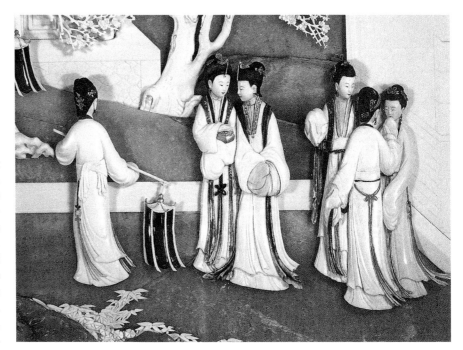

FIGURE 19.15 Chen Zuzhang et al., after drawings by Chen Mei (active 1720–40). *Pleasures of the Months for Court Ladies: First Month, Searching for Plum Blossoms on a Chilly Evening.* Qing dynasty, 1741. Detail of a plaque. Ivory, semiprecious stones. Height 34.4 cm, width 32.8 cm. Palace Museum, Beijing. From *ZGMSQJ, Gongyi meishu bian* 11: 89.

19.15

The exact form of the clothes-warmer is not known, but from a later passage in *The Story of the Stone*— "Dai-yu and her three visitors were sitting on the clothes-warmer gossiping"—we can guess that it must have had a flat surface large enough for sleeping and for several people to sit on.[17]

Space heaters—braziers, hand warmers, and foot warmers—were used in both north and south China to ward off the cold. In the north there were in addition several forms of radiant heat.[18] Already in Neolithic times fires on the ground were used to bake the earth to make it warm and dry for sitting and sleeping. Evidence of this practice has been found at Banpo and Jiangzhai, Shaanxi province, both sites from the Yangshao culture (c. 5000–c. 3000 B.C.). Today in north China Mongolian herdsmen and farmers still bake the earth in their temporary dwellings.

By the Northern Wei dynasty (A.D. 386–535) it was common practice to heat the ground underneath large public buildings and the homes of high-ranking officials. Similar in concept to the ancient Roman hypocaust, this type of heating involved a system of underground flues with an external stoke hole and smoke vent—a great improvement over the baked-ground method of heating. Underground heating was popular during the Qing dynasty in palaces and the houses of the wealthy. In *The Story of the Stone* the Crab-Flower Club met on a cold winter's day to compose poetry in the room in Snowy Rushes Retreat that had an underground heating system.[19] Yurts in Mongolia, which has very cold winters, still use this method of heating today.

The baked-ground and underground heating systems developed in China at a time when everyone sat and slept on the floor or on low platforms. Later, in about the tenth century, when it became common to sit above the ground on chairs and to sleep on high beds, the *kang* came into use (see Chap. 8). The *kang* is an elevated form of the underground heating system, with the heat-bearing flues running under a raised platform rather than under the ground. Writings from as far back as the Liao (907–1125) and Jin (1115–1234) dynasties refer to the *kang*. Archeological finds show that early *kang*s extended along two

or three sides of a room. By the Ming they were popular in both urban and rural areas of north China. Made of adobe or brick, they used straw or crop stalks for fuel in the countryside and coal or charcoal in the towns. At least in the wealthy eighteenth-century Jia household in *The Story of the Stone,* curtains could be let down at night to provide additional warmth and privacy.[20] Grandmother Jia and the most important members of the family always had a seat on the *kang,* while others sat on chairs or stools.

In the north, braziers, hand warmers, and foot warmers supplemented the radiant heating of the *kang* and the heated floor. In the south the brazier, hand warmer, and foot warmer were the only sources of indoor heat. None of these methods kept people really warm; they always needed to wear layers of padded or fur-lined garments in cold weather. An American visitor in the 1920s echoed Li Yu's seventeenth-century complaints about the cold and the inefficiency of braziers: "For if ever you were among those, who, grouped around a brazier in China, have tried to extract cheer and comfort from it, you must remember that you came nearer to swearing at than by it."[21] Unlike the Western hearth, the Chinese brazier was never the focal point of the home or a symbol of cheer and comfort. In China the dining table was the center of domestic gatherings. With layers of clothing and perhaps braziers nearby, the convivial company might even feel tolerably warm.

*I*n nature, riverbanks and shores create natural water basins. In the fields, the rice paddy is itself a basin containing the water that covers the rice seedlings. In the home, the basin becomes a miniature lake for washing when water is poured into it. Bathing has always been both a hygienic necessity and a ritual. Thus the history of the washbasin has implications far beyond the evolution of an everyday household utensil, and water itself assumes a transcendent meaning, sanctified, as we shall see, in the *Dao de jing*.

Among the ritual vessels of Bronze Age China are large flat basins (*pan*) that were used for washing the hands during ceremonies in accordance with the precepts in the *Ceremonies and Rituals* (*Yi li*). These sophisticated basins were masterpieces of the bronze-casters' art, replete with exquisitely detailed symbolic decorations. One in the Asian Art Museum of San Francisco has six small sculpted birds in procession along the rim (fig. 20.1). Around the inner sides of the basin similar birds and fish in high relief accompany incised dragons; a large turtle is incised on the bottom. These creatures suggest that the basin itself is a symbolic pond, perhaps one of the ponds at the entrance to the Yellow Springs, or land of the dead. Thus by washing in the basin, which is also a sacred pond, the supplicant would be purified and transformed. *Pan* first appear in Neolithic pottery and were made throughout the Han dynasty (206 B.C.–A.D. 220). Undoubtedly they are luxurious forms of everyday washbasins. Sumptuous basins for ritual ablutions were still produced in the Qing dynasty (1644–1911), when the emperor's personal gold washbasin was one of eight gold objects ·that became imperial emblematic objects.[1]

The bathing mores that China developed during the Eastern Zhou dynasty (770–221 B.C.) persisted until modern times. The *Record of Ritual* (*Li ji*) prescribes a schedule of ablutions for upper-class families: take a bath every fifth day, wash the hair every third day, and wash hands five times a day. Hair washing was the most important form of cleansing; indeed, by the Han dynasty officials were entitled by law to a holiday every five days for "relaxation and hair washing." Bodily purity was connected with moral purity, and this prescribed ha-

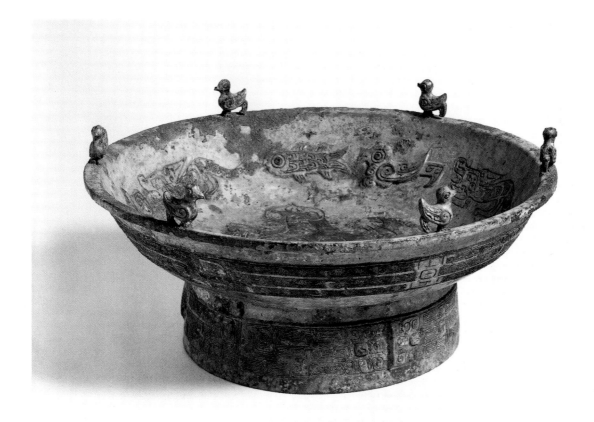

20.1

ritual washing was close to ritual purification. Before any ritual act—approaching a deity, state sacrifices, imperial audiences, marriage—it was necessary to wash away impurities.[2]

The classical ritual texts, including the *Ceremonies and Rituals* and *Record of Ritual,* were always revered in imperial China, but changing conditions made them less and less useful as practical guides. Therefore, scholars periodically wrote more up-to-date handbooks. One such handbook, by the renowned eleventh-century historian and statesman Sima Guang, contains a detailed account of domestic ancestral rites that specifies precisely when the hands should be washed and what utensils should be used:

> On the day before the ceremony, the master organizes all the male members of the family and the assistants to dust and sweep the place where the sacrifice will

FIGURE 20.1 Ceremonial water basin. Late Shang dynasty, thirteenth to eleventh century B.C. Bronze. Diameter 33.4 cm. Asian Art Museum of San Francisco. The Avery Brundage Collection.

20.2

20.3

FIGURE 20.2 Detail
of a wall painting from
a tomb in Baisha, Henan
province. Northern Song
dynasty, 1099. From Su Bai,
Baisha Song mu, pl. 27.

FIGURE 20.3 Miniature
wooden washbasin stand. Jin
dynasty. Excavated from the
1190 tomb of Yan Deyuan,
Datong, Shanxi. Drawing from
Datong Shi Bowuguan,
"Datong Jindai Yeh Deyuan
mu fajue jianbao," fig. 18.

be held, to wash and clean the utensils and containers,
and to arrange the furniture. . . .

The assistants prepare a basin with a stand for
washing hands [*guanpan you tai*] and set it on the
southeastern side of the eastern steps. To the north
of the stand is set a rack of towels for drying hands
[*shuijin you jia*]. (These are for the relatives.) Then,
on the east side of the eastern steps another basin
and some towels are set; these, however, are without
a stand or a rack. (These are for the assistants.) . . .

On the day of the ceremony, all members of the
family rise early and put on formal attire. . . .

The master and mistress now wash their hands
and carry the memorial tablets to the seats. . . .

The cook and servants have by now put the foods
for offering on a table placed on the east side of the
washing basin and towel rack. The men now wash
their hands. Then, following the example of the
master, they put down their official tablets and hold
up bowls of meat. . . .

When this first round of offerings is completed,
the deliverer of prayers and the master descend and
return to their former positions. Now the second
round of offering begins. (This is usually performed
by the mistress herself or some close relative.) The
offerer washes her hands if she has not done so
already, ascends through the western steps, pours
the wine and offers libations.[3]

Metal basins were used for washing the face, hands,
and feet. In early times the basins rested directly on
the floor. Sometimes they were slightly elevated on
low legs, like the one carried by a painted terra-cotta
female attendant found in the Sui dynasty (581–618)
tomb of Zhang Sheng at Anyang, Henan. Water for
washing was often warmed in a brazier. In one of the
Daoist wall paintings from the Yuan dynasty (1279–
1368) in the Chongyang Hall of the Yongle Gong in
Shanxi province, we see hot water being poured into
a washbasin from a jar that has just been lifted from
the low stand that supported it in the nearby brazier.
Soap at this time was a liquid made from ground-up
peas mixed with herbs.[4]

When in about the tenth century the chair-level
mode of living became prevalent, the washbasin was
elevated onto a wooden stand. The quotation from
Sima Guang's handbook on ritual makes it clear that
sometimes the stand was a status symbol used by the
master and mistress but not by the servants. Often

maids held metal basins so that their masters and mistresses could wash their hands (see fig. 9.3); perhaps these washbasins were kept in their stands and lifted out when the occasion required. The washbasin stand had various forms. A depiction of a boudoir on the walls of a tomb dated 1099 in Baisha, Henan province, shows a blue washbasin on a stand with cabriole legs (fig. 20.2). Behind, the fringed towel hangs over a narrow rack with upturned cloud-head terminals. The towel rack is a narrower version of the clothes rack, which has existed since at least the second century, when one was depicted on an engraved stone in a tomb at Yinan, Shandong.[5] Thus both the towel rack and the washbasin stand are transformations of earlier forms, used together for the first time when furniture became elevated.

During the Jin dynasty (1115–1234) washbasins were first set into round openings at the tops of stands that had six strongly curved cabriole legs and a high waist. A miniature wooden model from the 1190 tomb of Yan Deyuan in Datong, Shanxi, is decorated with a pair of *wanzi* (the character for ten thousand) in the openwork panels around the waist (fig. 20.3). *Wanzi* frequently decorate objects in the bedroom because the character represents long life and numerous offspring. This stand is in fact intended for a washbasin, as we see in a wall painting from the 1197 tomb of Yu Yin, which shows a basin inserted into a stand.[6] The wall painting depicts a dining scene. A serving maid carrying a bowl on a plate or tray approaches the basin in which, we presume, she is about to wash them.

By the Ming dynasty the washbasin stand (*mianpenjia*) had become an important piece of furniture with its own unique forms and decoration. In a kitchen and anywhere in a humble household, a simple wooden basin might be placed on a stool (fig. 20.4). But in the living quarters of a well-to-do family, sophisticated stands were the norm. Two distinct types evolved, and both are found among the miniature wooden tomb models excavated from the Pan family tombs in Shanghai. Thus, we can infer that pros-

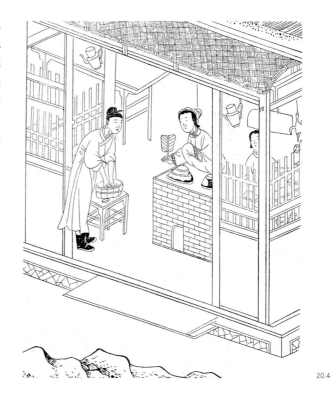

20.4

FIGURE 20.4 Detail of a woodblock illustration to *Nü sang*. Ming dynasty, 1619.

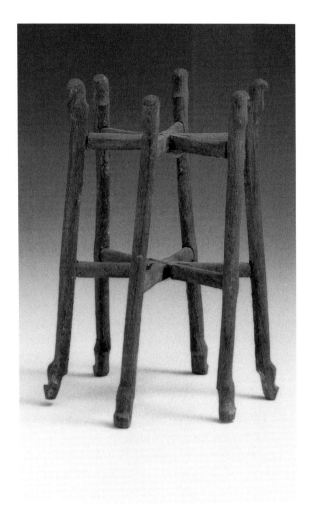

20.5a

FIGURE 20.5 Miniature
wooden washbasin stand
and separate towel rack.
Ming dynasty, sixteenth
century. Excavated from the
1589 tomb of Pan Yunzheng,
Luwan district, Shanghai. *Ju*
wood. Washbasin stand height
10.9 cm, diameter 8.1 cm;
towel rack height 24.5 cm,
width 8.79 cm. Shanghai
Museum.

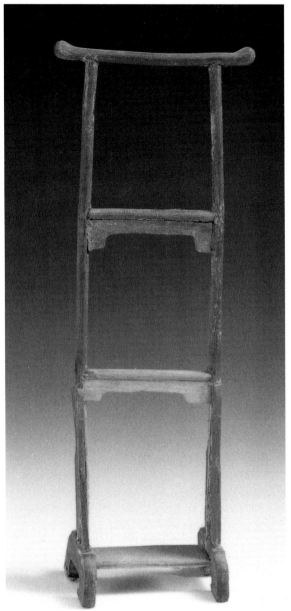

20.5b

perous households used both types simultaneously. Pan Hui (1503–87) and his second son Pan Yunzheng (1533–89) were scholar-officials who died within a few years of each other and were buried together with their wives. Pan Yunzheng's tomb contained a six-legged washbasin stand with legs that curve outward at the bottom and terminate in a bird's-head shape at the top; there was also a separate high towel rack (fig. 20.5). Pan Hui's tomb contained a six-legged washbasin stand with the two back legs extended to form the side posts of an attached towel rack (fig. 20.6).[7] The basin would have rested on the double-lotus-shapes (arranged base to base, with one lotus upright and the other upside down) at the top of each of the four front legs. Upturned *lingzhi* fungus designs carved at each end of the yoke held the towel in place.

Washbasin stands without an attached towel rack, such as the miniature one found in Pan Yunzheng's tomb, frequently have cylindrical legs that flare outward at the top and bottom. Although this shape uses more wood than straight-legged stands, it creates a pleasing form that holds the basin gracefully on the top while giving the structure greater stability on the bottom. A refined *huanghuali* example of this kind of washbasin stand is distinguished by unusual curved stretchers that double-miter into each other to create a star-shaped opening in the center (fig. 20.7). Thus the functionally necessary bracing stretchers double as a lively decorative pattern that offsets and enlivens the classical lines of the legs. This sort of decorative device must have existed in various forms given that a similar, but triangular-shaped rather than star-shaped, opening on a three-legged washbasin stand is called an "elephant's eye" (*xiang yan*) in the *Classic of Lu Ban*.[8]

The washbasin stand was so light and small that it was easy to move from place to place. In a painting by Jiao Bingzhen (active 1689–after 1726) we see a moonlit scene with a lady at her dressing table washing her hands in a basin that a maid, holding a towel, has brought to her (fig. 20.8). The stand is a later red lacquer version of the hardwood one in fig. 20.7.

Sometimes a washbasin stand with four or six legs

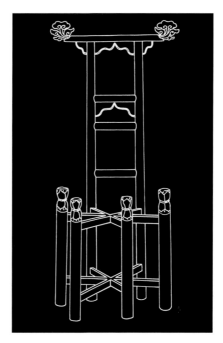

20.6

FIGURE 20.6 Miniature wooden washbasin stand with towel rack. Ming dynasty. Excavated from the 1587 tomb of Pan Hui, Shanghai. Height 32 cm. Drawing from Ellsworth, *Chinese Furniture: Hardwood Examples,* fig. 5.

FIGURE 20.7 Washbasin stand. Ming or Qing dynasty, seventeenth century. *Huanghuali* wood. Height 75 cm, diameter 38 cm. © Christie's Images, Ltd., 1999.

20.7

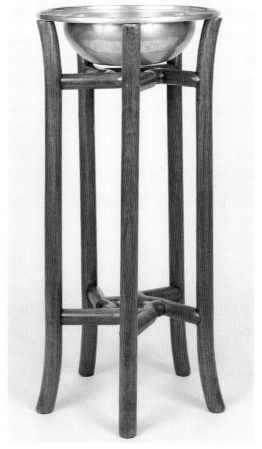

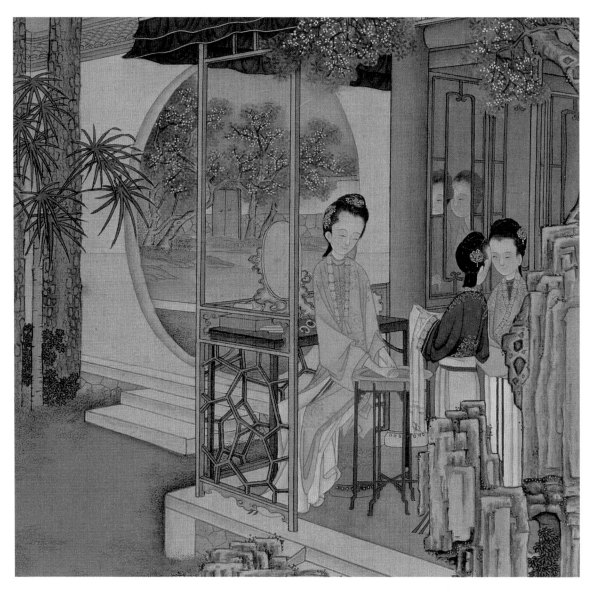

20.8

FIGURE 20.8 Jiao Bingzhen
(active 1689–after 1726).
Beautiful Women. Detail of an
album leaf, one of eight in a
series. Ink and color on silk.
Height 30.9 cm, width
20.5 cm. National Palace
Museum, Taipei.

can fold into a compact shape that is easy to move and store. One such piece is made from *huanghuali* wood and has six cylindrical legs terminating in double-lotus shapes (fig. 20.9). Fixed stretchers join two legs, and the others can be folded against this fixed frame. Each of the movable stretchers is notched over and loosely pinned to upper and lower central circular disks, allowing it to fold back when required. This same basic structure was also used for drum stands since at least about the tenth century, when a three-legged fixed version is depicted by the side of the couch in *The Night Revels of Han Xizai* (see fig. 1.8). On drum stands the drum is suspended from hooks, whereas on the washbasin stand the basin rests on the upper stretchers. This same form of stand is also sometimes used for large potted plants.[9]

Because washbasin stands are somewhat fragile structures that underwent hard daily use, few Ming dynasty examples have survived. However, because of the ritual and hygienic importance of washing, they were one of the more common items of miniature wooden and pottery tomb furniture. In excavated tombs, models of washbasin stands usually accompany models of separate towel racks. The earliest known actual hardwood towel rack, however, is an eighteenth-century piece (fig. 20.10). It is a more elaborate and richly decorated version of the simple sixteenth-century wooden tomb model in fig. 20.5. In the center of the *huanghuali* towel rack is an openwork panel of an aquatic scene with pairs of swimming and flying mandarin ducks among lotuses. As in handscroll paintings, the lotuses, shown from the viewpoint of a small animal in the water, are depicted in various stages of growth and from different angles, twisting and turning in space. Since mandarin ducks, which live in pairs and mate for life, are a symbol of marital happiness and the seed pod of the lotus a symbol of fecundity, this towel rack was undoubtedly intended for a lady's bedroom and was part of her dowry. The openwork panel is skillfully carved, even on the back, which shows a simpler version of the reverse of the scene. The *lingzhi* fungi of immortality decorating the ends of the top rail bend gracefully inward, and this line

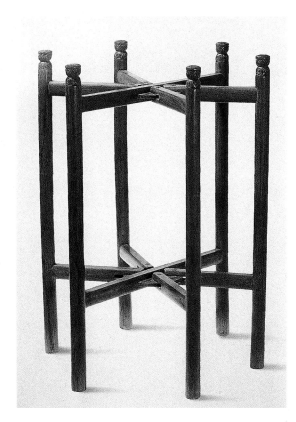

20.9

FIGURE 20.9 Folding washbasin stand. Ming dynasty. *Huanghuali* wood. Height 66.2 cm, diameter 50 cm. From Wang Shixiang, *Classic Chinese Furniture,* 250.

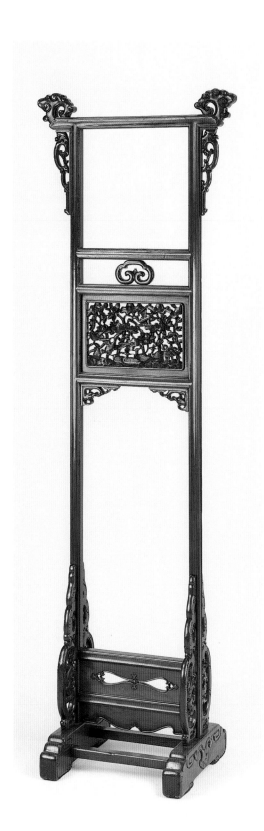

20.10

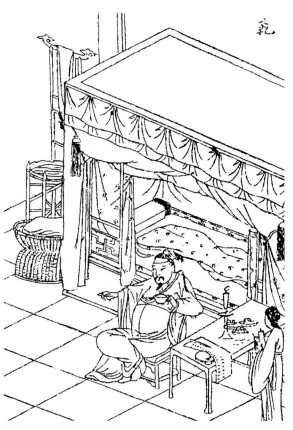

20.11

FIGURE 20.10 Towel rack.
Qing dynasty, early eighteenth
century. *Huanghuali* wood.
Height 189 cm, width 62 cm,
depth 42 cm. The Minneapolis
Institute of Arts. Gift of Ruth
and Bruce Drayton. Photo
© Christie's Images, Ltd., 1999.

FIGURE 20.11 Detail
of a woodblock illustration.
Ming or Qing dynasty.
From Zheng Zhenduo,
Zhongguo banhua shi tu lu,
vol. 15.

FIGURE 20.12 Washbasin stand
with towel rack. Ming dynasty.
Huanghuali wood. Height
16 cm, diameter 58.5 cm. Zhao
Luorui Collection, Beijing.
From Wang Shixiang, *Classic
Chinese Furniture,* 252.

continues in the dragons in the spandrels below. Spirited dragons also adorn the large spandrels at the base of the side posts, which, like the other frame members, have slightly convex surfaces with indented edges. An ornamental opening in the bottom panel is a lively variation of the standard motif.

In extant hardwood furniture it is more common to find the towel rack incorporated into the washbasin stand than as a separate piece. In this design the back legs of the stand are greatly extended to form a high towel rack, as in the miniature model from Pan Hui's tomb (see fig. 20.6). The examples of this type illustrated here all have six legs, the four front ones with lotus-shaped finials flattened on the top to support the rim of a washbasin. The ends of the top rails are strongly upturned to keep the towels in place. The racks have hanging spandrels and are divided into four sections; the second section from the top contains a panel with a lattice or pierced carving. Usually the top of the lower stretcher has a depression to hold a soap container. The elongated proportions, slender wooden members, and openwork carving give the space between and around the solid wood a special importance, making the stands most striking when silhouetted against a plain wall. And indeed they usually stood against a wall beside a dressing table or bed, as may be seen in the woodblock illustration in fig. 20.11. Here a wicker hamper for clothes stands conveniently nearby. Note, too, that the canopy bed has two sets of curtains for added warmth and privacy.

Although the washbasin stand with towel rack in the woodblock illustration is rather plain, extant hardwood examples are decorated with openwork panels and ornamental spandrels. One in the collection of Zhao Luorui, Beijing, is especially elegant because of the spaces left between the wooden decorative elements (fig. 20.12). This graceful stand once belonged to Mme Henri Vetch and was first published in 1944 in Gustav Ecke's *Chinese Domestic Furniture*.[10] The narrow verticality of the towel rack is balanced by the *lingzhi* fungi of immortality, carved from separate pieces of wood, that appear to shoot up from each

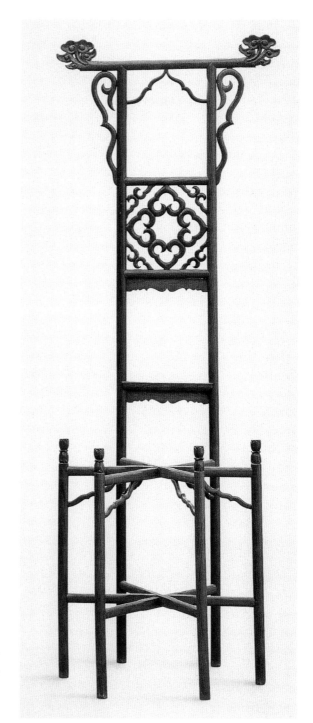

20.12

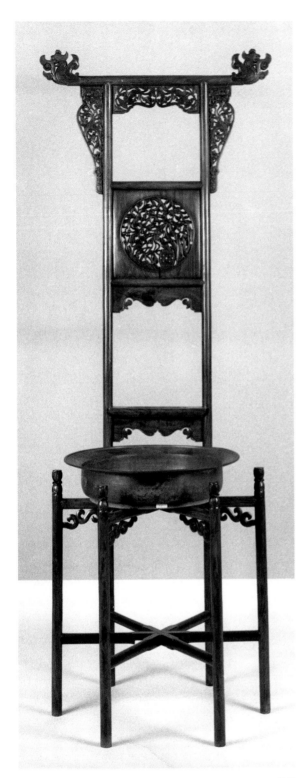

20.13

end of the top rail. Geometric cloud heads form the lattice of the main panel; delicate curving spandrels decorate the top of the rack and strengthen the stretchers that would have supported the washbasin.

Hardwood washbasin stands with towel racks are often elaborately decorated. Gazing at this ornamentation would have made washing one's hands and face an enjoyable task. Among the known examples of this type of furniture there is considerable variation in the decorative elements. One with exceptionally fine carving in the Metropolitan Museum of Art has hanging spandrels with a design of intertwined branches and leaves, a motif that echoes in the central panel (fig. 20.13). Phoenixes adorn the terminals of the crest rail. To create a strongly upturned end, the phoenixes stand on their tails between stylized clouds to create a pleasing decorative pattern. Each bird holds a large *lingzhi* fungus of immortality in its beak. In the middle of the towel rack is an inset panel that has a round pierced center carved on both sides with a charming design of birds, chime, and stool in a garden setting, probably an auspicious rebus. The mundane washbasin stand has become, in the Ming dynasty, a work of art, made from the finest hardwood and equal in beauty and importance to any other piece of furniture in the house.

Washbasin stands were often part of a bride's dowry, and stand and basin were decorated with auspicious patterns. For instance, the hands might be washed in a metal basin engraved with the character for longevity (*shou*) surrounded by five bats (symbolizing the five happinesses—long life, wealth, tranquility, virtue, natural death after achieving one's destiny) bordered by wish-granting *ruyi,* or cloud heads. On the sides of the basin butterflies, suggesting marital felicity and long life, might alternate with orchids, symbolizing "the quite unassuming manner of the true gentleman or the shy, self-effacing, delicately perfumed Chinese lady." Or an aspiring scholar washing his face might look down on a depiction of a leaping carp, suggesting that just as the carp leaps through the Dragon Gate to become a dragon, he will succeed in passing the examinations and become an

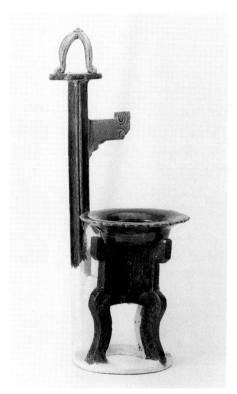

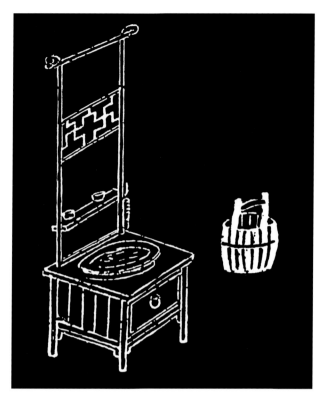

20.14 20.15

official. A fifteenth-century illustrated primer calls the washbasin *shuipen* and shows an example with a wide flat rim and tapering bowl.[11]

Washbasin stands, made of both hardwoods and softwoods, were undoubtedly more varied in design than the few remaining hardwood pieces suggest. Among the miniature pottery tomb models are ones with cabriole legs and others with four legs connected by curved stretchers on the top and bottom. Sometimes the towel rack is combined with a hat rack. One cabriole-leg example of this type has a long central pole with a hat stand on top and an arm for towels jutting out from one side (fig. 20.14). An illustration of a softwood washbasin stand in the Wanli edition of the *Classic of Lu Ban* shows the basin resting on a low square stand with a single drawer (fig. 20.15). An attached towel rack has cloud-head finials, a lattice panel with the character for ten thousand, and two small bowls, presumably for soap, on the lower stretcher. A wooden water bucket stands beside the washbasin stand.

FIGURE 20.13 Washbasin stand with towel rack. Late Ming dynasty. *Huanghuali* wood. Height 191.8 cm, greatest width 61.6 cm, diameter 54.61 cm. The Metropolitan Museum of Art, New York. Seymour Fund, 1967 (67.59).

FIGURE 20.14 Miniature tomb model of washbasin stand with towel rack and hat rack. Ming dynasty. Earthenware with *sancai* glazes. Height 36 cm, diameter of base 12.1 cm. From Handler, "Ablutions and Washing Clean," fig. 21.

FIGURE 20.15 Drawing after a woodblock illustration to the *Classic of Lu Ban* (*Lu Ban jing*). Ming dynasty, c. 1600. From Handler, "Ablutions and Washing Clean," fig. 22.

In China a vast population is sustained by the rice grown in paddies—large shallow basins of sun-mirroring water. The same element contained in basins in the home serves hygienic and ceremonial purposes. From this tradition developed the Chinese washbasin and stand. An element as pervasive, humble, and essential as water finds a place of reverence in literature and religious scripture. In the *Dao de jing*—that Chinese synthesis of literature, philosophy, and religion—water has a special place: "The goodness of water is that it benefits the ten thousand creatures; yet itself does not scramble, but is content with the places that all men disdain. It is this that makes water so near to the Way."[12]

As good water—in a washbasin or across the earth—is contained by wood or land to make it beneficial to millions and near to the Daoist way, so there is also, here examined, the long luminous way of Chinese furniture that has benefited ten thousand generations of users and observers. Its enduring objects are artistically and spiritually self-contained. The way of the sculpted wood, like austerely flat and luminous water on a still sea or in the washbasin, is of the highest good.

NOTES

Introduction

1. Laurence Sickman, "Chinese Classic Furniture" (London: Oriental Ceramic Society, 1978), 1.

2. In the West woods are classified as hardwood, which is from deciduous trees, or softwood, which is from coniferous trees. In China wood is classified as either *yingmu* ("hard wood"), which refers to precious tropical woods from deciduous trees, or *zamu* ("miscellaneous wood"), which includes deciduous woods such as walnut and elm as well as coniferous woods like pine. It should be understood that these classifications, in both China and the West, are not always based on the actual hardness or softness of the wood. Some deciduous trees have wood that is soft; some conifers have wood that is hard. In the field of Chinese furniture, it has been the practice in English to use the word *hardwood* for *yingmu* and *softwood* for *zamu*, even though *zamu* includes woods normally classified in the West as hardwood.

3. Dorothy Ko, "Pursuing Talent and Virtue: Education and Women's Culture in Seventeenth- and Eighteenth-Century China," *Late Imperial China* 13, no. 1 (June 1992): 15.

4. Robert Hatfield Ellsworth, *Chinese Furniture: One Hundred Examples from the Mimi and Raymond Hung Collection* (New York: privately published, 1996); idem, *Essence of Style: Chinese Furniture of the Late Ming and Early Qing Dynasties* (San Francisco: Asian Art Museum, 1998); *Mr. and Mrs. Robert P. Piccus Collection of Fine Classical Chinese Furniture* (New York: Christie's, 18 Sept. 1997).

5. *Classical and Vernacular Chinese Furniture in the Living Environment: Examples from the Kai-Yin Lo Collection* (Hong Kong: Yungmingtang, 1998).

6. See "The Revolution in Chinese Furniture: Moving from Mat to Chair," *Asian Art* 4, no. 3 (Summer 1991): 9–33.

Chapter 1

Adapted from Handler, "The Revolution in Chinese Furniture: Moving from Mat to Chair," *Asian Art* 4, no. 3 (Summer 1991): 9–33.

1. Nicolas Trigault, *The China That Was: China as Discovered by the Jesuits at the Close of the Sixteenth Century,* trans. L. J. Gallagher, S. J. (Milwaukee: Brace, 1942), 40–41.

2. Yu Ying-shih, "The Seating Order at the Hung Men Banquet," in *The Translation of Things Past: Chinese History and Historiography,* ed. George Kao (Hong Kong: Renditions, 1982), 49–61.

3. *Murals from the Han to the T'ang Dynasty* (Beijing: Foreign Languages Press, 1974), 39–40.

4. Henan Sheng Wenwu Yanjiusuo (Cultural Relics Institute of Henan Province), *Xinyang Chumu* (Chu tombs at Xinyang) (Beijing: Wenwu Press, 1986), pl. 31.2, 26.3.

5. A. Koidzumi and S. Sawa, *The Tomb of Painted Basket Lo-lang: Detailed Report of Archaeological Research,* vol. 1 (Keijo and Seoul: Chosen Koseki Kenkyu Kwai), 1934, pl. LXX.

6. Koidzumi and Sawa, *Tomb of Painted Basket,* pl. 71.

7. Lucy Lim, ed., *Stories from China's Past: Han Dynasty Pictorial Tomb Reliefs and Archaeological Objects from Sichuan Province, People's Republic of China* (San Francisco: Chinese Cultural Center, 1987), 105.

8. Institute of the History of Natural Sciences, Chinese Academy of Sciences, comp., *History and Development of Ancient Chinese Architecture* (Beijing: Science Press, 1986), 186, 310, 300, 302; Frances Wood, "China: Domestic Architecture," in *The Dictionary of Art* (London: Macmillan, 1996), 6: 686.

9. Henan Sheng Bowuguan (Henan Provincial Museum), "Lingbao Zhangwan Hanmu" (The Han tomb in Zhangwan, Lingbao), *Wenwu,* no. 11 (1975): 80, 87 fig. 21.

10. Lim, *Stories from China's Past,* 96–97.

11. Dunhuang Wenwu Yanjiu, *Zhongguo shiku Dunhuang Moyao ku* (Chinese cave temples: The Mogao caves at Dunhuang) (Beijing: Cultural Relics Publishing House, 1982–87), vol. 1, pl. 19; vol. 2, pl. 42.

12. See Laurence Sickman, "A Sixth-Century Buddhist Stele," *Apollo* 97, no. 133 (March 1973): 224.

13. *Ladies Playing Double Sixes,* attributed to Zhou Fang (eighth century), is in the Freer Gallery of Art, Washington, D.C. The tied cushions appear in another painting attributed to Zhou, *Tuning the Lute and Drinking Tea,* in the Nelson-Atkins Museum of Art, Kansas City.

14. Ho Zicheng, "Tang mu bihua" (Tang tomb paintings), *Wenwu,* no. 8 (1959): 33; Ennin, *Nitto guhō junrei gyōki* (The record of a pilgrimage to Tang in search of the law), ed. Adachi Kiroku (Tokyo: Zokugun Shoruito, 1970), 174, 187, 226, 246.

15. See the depictions in Dunhuang caves 12 and 360 (Dunhuang Wenwu Yanjiu, *Zhongguo shiku Dunhuang Moyao ku,* vol. 4, pls. 124, 161); see also *A Palace Consort,* National Palace Museum, Taipei, Taiwan.

16. *Xuanhe huapu* (Xuanhe painting catalog), *juan* 7, in *Yishu congshu,* 1st series, vol. 9, 193.

17. For a detailed analysis of this painting, see Wu Hung, *The Double Screen: Medium and Representation in Chinese Painting* (Chicago: University of Chicago Press, 1996), 29–71.

18. Su Bai, *Baisha Song mu* (Song tombs at Baisha) (Beijing: Wenwu, 1957), 92, 97.

19. Yang Yao, *Zhongguo Mingdai shinei zhuangshi he jiaju* (Interior decoration and furniture in Ming dynasty China) (Beijing: Beijing University Press, n.d.), 6; Chen Pin and Chen Jihua, "Jiangsu Wujin Cunqian Nan Song mu qingli jiyao" (Report on the excavation of Southern Song tombs at Cunqian, Wujin, Jiangsu province), *Kaogu,* no. 3 (1986): pl. 1; Su Bai, *Baisha Song mu,* pl. 35.

20. Institute of the History of Natural Sciences, *Ancient Chinese Architecture,* 161.

21. Valerie Hansen, "The Mystery of the Qingming Scroll and Its Subject: The Case against Kaifeng," *Journal of Sung-Yuan Studies* (1996): 183–200.

22. See Michael Freeman, "Sung," in *Food in Chinese Culture: Anthropological and Historical Perspectives,* ed. Kwang-chih Chang (New Haven: Yale University Press, 1977), 141–76; Jacques Gernet, *Daily Life in China on the Eve of the Mongol Invasion, 1250–1276,* trans. H. M. Wright (Stanford, Calif.: Stanford University Press, 1962), 49–51.

23. Valerie Hansen, *The Beijing Qingming Scroll and Its Significance for the Study of Chinese History* (Albany, N.Y.: *Journal of Sung-Yuan Studies,* 1996), section 23.

24. Nicholas Grindley, *The Bended Back Chair* (London: Barling, 1990), n.p.

25. *ZGMSQJ,* painting 12, pl. 59.

26. Institute of the History of Natural Sciences, *Ancient Chinese Architecture,* 303.

27. Fu Xinian, "Survey: Chinese Traditional Architecture," in *Chinese Traditional Architecture,* ed. Nancy Shatzman Steinhardt (New York: China Institute in America, 1984), 10–33.

28. Institute of the History of Natural Sciences, *Ancient Chinese Architecture,* 187.

29. Wang Shixiang, *Classic Chinese Furniture: Ming and Early Qing Dynasties,* trans. Sarah Handler and Wang Shixiang (Hong Kong: Joint Publishing Co., 1986), 14.

Chapter 2

Adapted from Handler, "A Ming Meditation Chair in Bauhaus Light," *Journal of the Classical Chinese Furniture Society* 3, no. 1 (Winter 1992): 26–38.

1. Christopher Wilk, *Marcel Breuer: Furniture and Interiors* (New York: Museum of Modern Art, 1981), 37–41.

2. Lao Tsu [Laozi], *Tao te ching,* trans. Feng Gia-fu and Jane English (New York: Vintage, 1989), 13.

3. Klaus-Jürgen Sembach, Gabriele Leuthäuser, and Peter Gössel, *Twentieth-Century Furniture Design* (Cologne: Taschen, n.d.), 97.

4. Ibid.

5. See Laurence Sickman, "A Sixth-Century Buddhist Stele," *Apollo* 97, no. 133 (March 1973): 224.

6. Donald Holzman, "A propos de l'origine de la chaise en Chine," *T'oung-pao* 53, nos. 4–5 (1967): 285–86.

7. W. J. F. Jenner, *Memories of Loyang, Yang Hsüan-chih and the Lost Capital, 493–534* (Oxford: Clarendon Press, 1981), 173.

8. *Quan Tang shi,* juan 446, 5010, trans. Chou Ping and Willis Barnstone.

9. Ennin, *Nittō guhō junrei gyōki* (The record of a pilgrimage to Tang in search of the law), ed. Adachi Kiroku (Tokyo: Zokugun Shoruito, 1970), 174, 187, 226, 246.

10. Taiyuan Shi Wenwu Quanli Weiyuanhui (Official Cultural Relics Committee for Taiyuan City) and Shanxi Jinci Wenwu Baoguan Suo (Institute for the Preservation of Cultural Relics in Jinci, Shanxi), eds., *Jinci* (Beijing: Wenwu, 1981), 1–9; Amy McNair, "On the Date of the Shengmudian Sculptures at Jinci," *Artibus Asiae* 49, no. 3/4 (1988): 238–43.

11. *Lu Ban jing jiang jia ching* (The classic of Lu Ban, a mirror for craftsmen), comp. Sicheng Wurong, Chongzhen (1628–44) ed., Harvard-Yenching Library, *juan* 2, 14b; Gao Lian, *Zun sheng ba jian* (Eight discourses on the art of living), Qinding Siku Quanshu ed. (Taipei: Commercial Press, 1983), *juan* 8, 16b.

12. Wen Zhenheng, *Zhang wu zu jiao zhu* (Treatise on superfluous things, annotated), ed. Yang Zhaobo, annotated by Chen Zhi (Nanjing: Jiangsu Kexue Jishu Chubanshe, 1984), 230; *Jin ping mei cihua: Ming wanli dingsi ke ben* (Story of the Plum in the Golden Vase: Edition from the *dingsi* year of the Wanli reign period of the Ming dynasty [1617]), 20 vols. (Taipei: Lian Jing Chubanshe Yegongsi, 1978).

13. Zhou Hui, *Jinling suo shi* (Details of Nanjing) (1610; reprint, Shanghai: Wenxue Guji Kanxing Chubanshe, 1955), 1:187. See Nancy Berliner, *Beyond the Screen: Chinese Furniture of the Sixteenth and Seventeenth Centuries* (Boston: Museum of Fine Arts, 1996), 127n3.

14. Mette Siggstedt, "Chinese Root Furniture," *Bulletin of the Museum of Far Eastern Antiquities* 63 (1991): 155.

15. Tu Long, *Kao pan yu shi* (Desultory remarks on furnishing the abode of the retired scholar), *Yishu congbian* (Taipei: Shijie Shuju Yinhang, 1962), vol. 28, no. 249, p. 71.

16. Gao Lian, *Zun sheng ba jian, juan* 8, 14a.

Chapter 3

Adapted from Handler, "George Kates: A Romance with Chinese Life and Chinese Furniture," *Journal of the Classical Chinese Furniture Society* 1, no. 1 (Winter 1990): 67–72.

1. George N. Kates, *The Years That Were Fat: The Last of Old China* (1952; reprint, ed. and with an introduction by John Fairbank, Cambridge, Mass.: MIT Press, 1967), 3.

2. Ibid., 12.

3. Ibid., 2–3.

4. George N. Kates, *Chinese Household Furniture* (New York: Hayes and Brothers Publishers, 1948), 4.

5. Ibid., xii.

6. Kates, *Years That Were Fat*, 267–68.

7. Fergus M. Bordewich, *Cathay: A Journey in Search of Old China* (New York: Prentice Hall, 1991), xv.

8. Ibid., xxvi.

Chapter 4

Adapted from Handler, "A Yokeback Chair for Sitting Tall," *Journal of the Classical Chinese Furniture Society* 3, no. 2 (Spring 1993): 4–23.

1. For a list of writers on this topic, see Craig Clunas, *Chinese Furniture,* Victoria and Albert Museum Far Eastern Series (London: Bamboo Publishing, 1988), 107n14.

2. John F. Haskins, "The Pazyryk Felt Screen and the Barbarian Captivity of Ts'ai Wen Chi," *Bulletin of the Museum of Far Eastern Antiquities, Stockholm* 35 (1963): 148–50.

3. Sergei I. Rudenko, *Frozen Tombs of Siberia: The Pazyryk Burials of Iron Age Horsemen,* trans. and with a preface by M. W. Thompson (Berkeley: University of California Press, 1970), 28.

4. *From the Lands of the Scythians: Ancient Treasures from the Museums of the U.S.S.R., 3000 B.C.–100 B.C.* (New York: Metropolitan Museum of Art, n.d.), pl. 23.

5. Ennin, *Nitto guhō junrei gyōki* (The record of a pilgrimage to Tang in search of the law), ed. Adachi Kiroku (Tokyo: Zokugun Shoruito, 1970), 174, 187, 226, 246.

6. Jan Fontein and Money L. Hickman, *Zen Painting and Calligraphy* (Boston: Museum of Fine Arts, 1970), 42.

7. Yu Zhuoyun et al., comp., *Palaces of the Forbidden City,* trans. Ng Mau-Sang, Chan Sinwai, and Puwen Lee (New York: Viking, 1987), 67.

8. "Ningxia Helan xian Baisikou shuangta kancewei xiujianbao" (Reconnaissance and maintenance of the twin pagodas at Baisikou in Helan county, Ningxia), *Wenwu,* no. 8 (1991): 23.

9. Laurence Sickman, personal communication. Elsewhere Sickman writes, "As George Kates describes the custom, it is Chinese furniture in its Sunday clothes" ("Chinese Classic Furniture," paper presented at the annual meeting of the Oriental Ceramic Society, London, 1978).

10. Ho Zicheng, "Tang mu bihua" (Tang tomb paintings), *Wenwu,* no. 8 (1959): 33.

11. Su Bai, *Baisha Song mu* (Song tombs at Baisha) (Beijing: Wenwu Press, 1957), 22.

12. Nancy Berliner, *Beyond the Screen: Chinese Furniture of the Sixteenth and Seventeenth Centuries* (Boston: Museum of Fine Arts, 1996), 102.

13. ZGMSQJ, *Diaosu bian* 5: *Wudai Song diaosu* (Sculpture section 5: Five Dynasties, Song sculpture) (Shanghai: Renmin Meishu Chubanshe, 1984), 183.

14. Shanxi Sheng Kaogu Yanjiusuo, "Jin mu fajue," 62.

15. Wang Qi, *Sancai tuhui* (Pictorial encyclopedia of heaven, earth, and man) (1609; reprint, Shanghai: Shanghai Guji Chubanshe, 1990), 1: 37; Rudolf P. Hommel, *China at Work: An Illustrated Record of the Primitive Industries of China's Masses, Whose Life Is Toil, and Thus an Account of Chinese Civilization* (Cambridge, Mass.: M.I.T. Press, 1969), 312.

16. Li Wai-yee, "Dream Visions of Transcendence in Chinese Literature and Painting," *Asian Art* 111, no. 4 (Fall 1990): 69–72.

17. Wang Shixiang, *Classic Chinese Furniture: Ming and Early Qing Dynasties,* trans. Sarah Handler and Wang Shixiang (Hong Kong: Joint Publishing Co., 1986), 24.

18. *Quanben Jin ping mei cihua* (Complete edition of the story of the plum in the golden vase) (Hong Kong: Taiping Shuju, 1982), vol. 6, *juan* 89, 13b.

19. Thomas Lawton, *Chinese Figure Painting* (Washington, D.C.: Freer Gallery of Art, 1973), 99.

20. One of the arms of the chair has been replaced—an old repair.

21. Wang Qi, *Sancai tuhui,* 2: 1329.

22. Gianni Guadalupi, ed., *China: Arts and Daily Life as Seen by Father Matteo Ricci and Other Jesuit Missionaries* (Milan: Franco Maria Ricci, 1984), 47–48.

23. Song Yingxing, *T'ien-kung k'ai-wu: Chinese Technology in the Seventeenth Century,* trans. E-tu Zen Sun and Shio-chuan Sun (University Park: Pennsylvania State University Press, 1966), 151.

24. Klaas Ruitenbeek, *Carpentry and Building in Late Imperial China: A Study of the Fifteenth-Century Carpenter's Manual "Lu Ban jing"* (Leiden: E. J. Brill, 1993), 230.

25. Gao Lian, *Zun sheng ba jian* (Eight discourses on the art of living), Qinding Siku Quanshu ed. (Taipei: Commercial Press, 1983), vol. 871, *juan* 8, 16b. Translation from Craig Clunas, *Chinese Furniture,* 19.

26. Curtis Evarts, "The Nature and Characteristics of Wood and Related Observations of Chinese Hardwood Furniture," *Journal of the Classical Chinese Furniture Society* 2, no. 2 (Spring 1992): 36.

27. Grace Wu Bruce, *Dreams of Chu Tan Chamber and the Romance with Huanghuali Wood: The Dr. S. Y. Yip Collection of Classic Chinese Furniture,* with an introduction by Shing Yiu Yip (Hong Kong: n.p., 1991), 5.

28. Wu Tung, *Tales from the Land of Dragons: 1,000 Years of Chinese Painting* (Boston: Museum of Fine Arts, 1997), 169.

29. Sarah Handler, "Classical Chinese Furniture in the Renaissance Collection," *Orientations* 22, no.1 (Jan. 1991): 48; Robert Hatfield Ellsworth, *Chinese Furniture: Hardwood Examples of the Ming and Early Ch'ing Dynasties* (New York: Random House, 1970), catalog no. 5.

30. *Zhongguo banhua xuan* (Selected Chinese woodblock prints) (Beijing: Rongbaozhai, 1952), 1: 44.

31. Wang Shixiang, *Connoisseurship of Chinese Furniture: Ming and Early Qing Dynasties,* trans. Lark E. Mason Jr. et al. (Hong Kong: Joint Publishing Co., 1990), A87, A86.

Chapter 5

Adapted from Handler, "The Elegant Vagabond: The Chinese Folding Armchair," *Orientations* 23, no. 1 (Jan. 1992): 90–96.

1. L. Carrington Goodrich, *15th Century Illustrated Chinese Primer: Hsin-pien tui-hsiang szu-yen* (Hong Kong: Hong Kong University Press, 1967), n.p.

2. R. Soame Jenyns and William Watson, *Chinese Art: The Minor Arts—Gold, Silver, Bronze, Cloisonné, Cantonese Enamel, Lacquer, Furniture, Wood* (New York: Universe Books, 1963), 92–93, 102.

3. See Giuseppe Tucci, *Transhimalaya* (Geneva: Nagel Publishers, 1973), pl. 112.

4. *Looking at Patronage: Recent Acquisitions of the Asian Art Museum* (San Francisco: Asian Art Museum, 1989), 57.

5. Heather Karmay, *Early Sino-Tibetan Buddhist Art* (Warminster: Aries & Phillips, 1975), 21–23.

6. Wu Tung, "From Imported Nomadic Seat to Chinese Folding Armchair," *Boston Museum of Fine Arts Bulletin* 71, no. 363 (1973), 48n20.

7. See Sarah Handler, "The Elegant Vagabond: The Chinese Folding Armchair," *Orientations* 23, no. 1 (Jan. 1992): fig. 11.

8. Karmay, *Early Sino-Tibetan Buddhist Art*, 76.

9. Liao Ben, "Guangyuan Nan Song mu zaju, daqu shike kao" (A study of the stone carvings of *zaju* and *daqu* performances in Southern Song tombs at Guangyuan), *Wenwu*, no. 12 (1986): 25–61.

10. Wang Qi, *Sancai tuhui* (Pictorial encyclopedia of heaven, earth, and man) (1609; reprint [3 vols.], Shanghai: Shanghai Guji Chubanshe, 1990), 2: 1329.

Chapter 6

Adapted from Handler, "Roses, Bamboo and the Low-back Armchair," *Orientations* 29, no. 7 (July/Aug. 1998): 12–18.

1. Wang Shixiang, *Connoisseurship of Chinese Furniture: Ming and Early Qing Dynasties,* trans. Lark E. Mason Jr. et al. (Hong Kong: Joint Publishing Co., 1990), 1: 39. For a different interpretation of the term *wenyi,* see Pu Anguo, "A Discussion of Ming-Style Furniture, in Two Parts," *Journal of the Classical Chinese Furniture Society* 2, no. 4 (Autumn 1992): 30–31.

2. William M. Drummond, "Chinese Furniture: The Sackler Collections," reprint of a 1969 lecture, *Journal of the Classical Chinese Furniture Society* 3, no. 3 (Summer 1993): 57; Craig Clunas, *Chinese Furniture,* Victoria and Albert Museum Far Eastern Series (London: Bamboo Publishing, 1988), 29.

3. Wang Shixiang, "Development of Furniture Design and Construction from the Song to the Ming," *Orientations* 22, no. 1 (Jan. 1991): 60.

4. James Cahill, *An Index of Early Chinese Painters and Paintings: T'ang, Sung, and Yüan* (Berkeley: University of California Press, 1980), 58, 217.

5. Translation adapted by Willis Barnstone after Helmut Brinken, *Zen in the Art of Painting,* trans. George Campbell (London: Arkana, 1987), 101.

6. Lina Lin, *Catalogue to the Special Exhibition of Furniture in Paintings* (Taipei: National Palace Museum, 1996), 90, no. 16.

7. Kiyohiko Munakata, *Sacred Mountains in Chinese Art* (Urbana: University of Illinois Press, 1990), 30–33.

8. Susan N. Erickson, "*Boshanlu*—Mountain Censers of the Western Han Period: A Typological and Iconological Analysis," *Archives of Asian Art* 45 (1992): 15; "Shaanxi Maoling yi hao wuming zhong yi yao cong zangkeng de fajue" (Excavation of satellite shaft no. 1 of unknown tomb no. 1 near Maoling mausoleum, Shaanxi province), *Wenwu,* no. 9 (1982): 3–4, 13; Yuan Anzhi, "Tan 'yangxin jia' tongqi" (Remarks on "Yangxin jia" bronze vessels), *Wenwu,* no. 9 (1982): 18.

9. Mai-mai Sze, *The Tao of Painting: A Study of the Ritual Disposition of Chinese Painting, with a Translation of the "Chieh Tzu Yan Hua Chuan," or "Mustard Seed Garden Manual of Painting," 1679–1701* (Princeton: Princeton University Press, 1967), 313.

10. Translation by Hans H. Frankel, quoted in Maggie Bickford, *Bones of Jade, Soul of Ice: The Flowering Plum in Chinese Art* (New Haven: Yale University Art Gallery, 1985), 163.

11. Terese Tse Bartholomew, *The Hundred Flowers: Botanical Motifs in Chinese Art* (San Francisco: Asian Art Museum, 1985), 47; Bickford, *Bones of Jade,* 65, 161–63.

Chapter 7

Adapted from Handler, "The Ubiquitous Stool," *Journal of the Classical Chinese Furniture Society* 4, no. 3 (Summer 1994): 4–23.

1. Dunhuang Wenwu Yanjiu, *Zhongguo shiku Dunhuang Moyao ku* (Chinese cave temples: The Mogao caves at Dunhuang) (Beijing: Cultural Relics Publishing House, 1982–87), vol. 1, pl. 19.

2. Ibid., pl. 43.

3. See Laurence Sickman, "A Sixth-Century Buddhist Stele," *Apollo* 97, no. 133. (March 1973): 224.

4. Gustav Ecke, "The Development of the Folding Chair: Notes on the History of the Form of the Eurasian Chair," trans. Martina Burkert, *Journal of the Classical Chinese Furniture Society* 1, no. 1 (Winter 1990): 11–21; C. P. Fitzgerald, *Barbarian Beds: The Origin of the Chair in China* (London: Cresset Press, 1965); Wu Tung, "From Imported Nomadic Seat to Chinese Folding Armchair," *Boston Museum of Fine Arts Bulletin* 71, no. 363 (1973): 36–50.

5. Donald Holzman, "A propos de l'origine de la chaise en Chine," *T'oung-pao* 53, nos. 4–5 (1967): 283; Ole Wanscher, *Sella Curulis: The Folding Stool, an Ancient Symbol of Dignity* (Copenhagen: Rosenkilde and Bagger, 1980), 9–190.

6. Xia Mingcai, "Yidu Bei Qi shimu xianke huaxiang" (The Northern Qi stone chambered tomb with incised portraits), *Wenwu*, no. 10 (1985): 50.

7. Susan Whitfield, *Life Along the Silk Road* (Berkeley: University of California Press, 1999), pl. 4.

8. Chang Wan-li, *Three-Colours Glaze Pottery of the T'ang Dynasty* (Hong Kong: Yiwen Chubanshe, 1977), 3: 24–27.

9. Yang Hong, "The Dunhuang Cave Paintings: A Study of Depictions of Furniture from the Tang Dynasty and the Five Dynasties Period," *Journal of the Classical Chinese Furniture Society* 2, no. 2 (Spring 1992): 63.

10. Wai-kam Ho, Sherman Lee, Laurence Sickman, and Marc Wilson, eds., *Eight Dynasties of Chinese Painting: The Collections of the Nelson Gallery—Atkins Museum, Kansas City, and the Cleveland Museum of Art* (Cleveland: Cleveland Museum of Art, 1980), xxxiii.

11. Chen Zengbi, "Mawu jiantan" (Discussion of the folding stool for mounting horses), *Wenwu*, no. 4 (1980): 82.

12. Ibid., 84.

13. Julia K. Murray, "Didactic Art for Women: The *Ladies' Classic of Filial Piety,*" in *Flowering in the Shadows: Women in the History of Chinese and Japanese Paintings,* ed. Marsha Widner (Honolulu: University of Hawaii Press, 1990), 33.

14. Ibid., 37.

15. Nancy Shatzman Steinhardt, "Yuan Period Tombs and Their Decoration: Cases at Chifeng," *Oriental Art* 36, no. 4 (1990/91): 199.

16. Wang Shixiang, *Connoisseurship of Chinese Furniture: Ming and Early Qing Dynasties*, trans. Lark E. Mason Jr. et al. (Hong Kong: Joint Publishing Co., 1990), 1: 127; Wen Zhenheng, *Zhang wu zu jiao zhu* (Treatise on superfluous things, annotated), ed. Yang Zhaobo, annotations by Chen Zhi (Nanjing: Jiangsu Kexue Jishu Chubanshe, 1984), 236; Klaas Ruitenbeek, *Carpentry and Building in Late Imperial China: A Study of the Fifteenth-Century Carpenter's Manual "Lu Ban Jing"* (Leiden: E. J. Brill, 1993), 251; Wang Qi, *Sancai tuhui* (Pictorial encyclopedia of heaven, earth, and man) (1609; reprint, 3 vols., Shanghai: Shanghai Guji Chubanshe, 1990), 2: 1331.

17. Sarah Handler, "The Ubiquitous Stool," *Journal of the Classical Chinese Furniture Society* 4, no. 3 (Summer 1994): 13.

18. George N. Kates, *Chinese Household Furniture* (New York: Hayes and Brothers, 1948), 40.

19. Wang Shixiang, *Classic Chinese Furniture: Ming and Early Qing Dynasties,* trans. Sarah Handler and Wang Shixiang (Hong Kong: Joint Publishing Co., 1986), 67.

20. Mai-mai Sze, *The Tao of Painting: A Study of the Ritual Disposition of Chinese Painting, with a Translation of the "Chieh Tzu Yan Hua Chuan," or "Mustard Seed Garden Manual of Painting," 1679–1701* (Princeton: Princeton University Press, 1967), 310.

21. Gianni Guadalupi, ed., *China: Arts and Daily Life as Seen by Father Matteo Ricci and Other Jesuit Missionaries* (Milan: Franco Maria Ricci, 1984), 80.

22. Cao Xueqin, *Honglou meng* (A dream of red mansions) (Taipei: Zhonghua Shuju, 1971), vol. 3, *juan* 71, 916; vol. 3, *juan* 85, 1100; vol. 2, *juan* 35, 421; trans. based on David Hawkes and John Minford's *The Story of the Stone,* by Cao Xueqin (Harmondsworth, Eng.: Penguin, 1976–86), 3: 407, 4: 117, 2: 184.

23. Laurence Sickman, "Chinese Classic Furniture" (paper presented at the annual meeting of the Oriental Ceramic Society, London, 1978), 10.

24. Handler, "Square Tables Where the Immortals Dine," *Journal of the Classical Chinese Furniture Society* 4, no. 4 (Autumn 1994): 17.

25. Grace Wu Bruce, *Dreams of Chu Tan Chamber and the Romance with Huanghuali Wood: The Dr. S. Y. Yip Collection of Classic Chinese Furniture,* with an introduction by Shing Yiu Yip (Hong Kong: n.p., 1991), 51.

26. Wang Shixiang, *Classic Chinese Furniture,* 68, no. 26.

27. Palace Museum, comp. and ed., *Court Painting of the Qing Dynasty* (Beijing: Wenwu Press, 1992), 31, pl. 8.

28. Danielle Elisseeff and Vadime Elisseeff, *New Discoveries in China: Encountering History through Archaeology,* trans. Larry Lockwood (Secaucus, N.J.: Chartwell Books, 1983), 33.

29. Wang Shixiang, *Connoisseurship of Chinese Furniture,* 1: 34.

30. David Tod Roy, trans., *The Plum in the Golden Vase, or Chin P'ing Mei,* vol. 1, *The Gathering* (Princeton: Princeton University Press, 1993), 171; for Chinese text see *Quanben Jin ping mei cihua* (Complete edition of the story of the plum in the golden vase) (Hong Kong: Taiping Shuju, 1982), vol. 2, chap. 9, 1b; on women and porcelain stools, see *Quanben Jin ping mei,* vol. 2, chap. 27, 6a.

31. Song Yingxing, *T'ien-kung k'ai-wu: Chinese Technology in the Seventeenth Century,* trans. E-tu Zen Sun and Shio-chuan Sun (University Park: Pennsylvania State University Press, 1966), 68, 306, 151.

32. Wu Tung, "Chinese Folding Armchair," 41.

Chapter 8

Adapted from Handler, "Life on a Platform," *Journal of the Classical Chinese Furniture Society* 3, no. 4 (Autumn 1993): 4–20.

1. Joseph Needham, *Science and Civilisation in China* (Cambridge: Cambridge University Press, 1954–), vol. 5, part 4, 15.

2. Chang Kwang-chih, *Shang Civilization* (New Haven: Yale University Press, 1980), 114–17.

3. Lucy Lim, ed., *Stories from China's Past: Han Dynasty Pictorial Tomb Reliefs and Archaeological Objects from Sichuan Province, People's Republic of China* (San Francisco: Chinese Cultural Center, 1987), 123.

4. Cao Guicen, "Henan Dancheng Han shi ta" (A Han stone platform from Dancheng, Henan), *Kaogu,* no. 5 (1965): 258.

5. Xu Jian, *Chu xue ji* (Record of early scholarship), Siku Chuanshu ed. (Taipei: Commercial Press, 1983), 890: 398.

6. Wang Zengxin, "Liaoyangshi Bangtaizi er hao bihua mu" (Wall painting in tomb no. 2, Bangtaizi, Liaoyang City), *Kaogu,* no. 1 (1960): 22.

7. Adapted from Richard B. Mather, ed. and trans., *Shih-shuo Hsin-yü: "A New Account of Tales of the World," by Liu I-ch'ing, with Commentary by Liu Chü* (Minneapolis: University of Minnesota Press, 1976), 419.

8. Wu Hung, *The Wu Liang Shrine: The Ideology of Early Chinese Pictorial Art* (Stanford: Stanford University Press, 1989), 52; *Murals from the Han to the T'ang Dynasty* (Beijing: Foreign Languages Press, 1974), 39, fig. 5.

9. Wu Hung, *Wu Liang Shrine,* 267.

10. Chen Zengbi, "Han, Wei, Jin duozhuoshi xiao ta chulun" (The first discussion of the small single-person *ta* during the Han, Wei, and Jin), *Wenwu,* no. 9 (1979): 66–71.

11. Osvald Sirén, *Chinese Painting: Leading Masters and Principles* (New York: Ronald Press, 1956–58), 1: 59.

12. Wai-kam Ho, Sherman Lee, Laurence Sickman, and Marc Wilson, eds., *Eight Dynasties of Chinese Painting: The Collections of the Nelson Gallery–Atkins Museum, Kansas City, and the Cleveland Museum of Art* (Cleveland: Cleveland Museum of Art, 1980), 6.

13. Gustav Ecke, *Chinese Domestic Furniture* (1944; reprint in reduced size, Rutland, Vt.: Charles E. Tuttle Co., 1962), 4.

14. People's Sports Publishing House, Beijing, ed., *Sports in Ancient China* (Hong Kong: Tai Dao Publishing, 1986), 114–15.

15. Dunhuang Wenwu Yanjiu, *Zhongguo shiku Dunhuang Moyao ku* (Chinese cave temples: The Mogao caves at Dunhuang) (Beijing: Cultural Relics Publishing House, 1982–87), 4: 113.

16. Roderick Whitfield, *The Art of Central Asia: The Stein Collection in the British Museum* (Tokyo: Kodansha, 1982–85), 1: 28.

17. Sima Guang, *Sima shi shu yi,* Congshu jicheng ed. (Shanghai: Commercial Press, 1935–37), 4: 8162; Edward H. Schafer, *The Golden Peaches of Samarkand: A Study of T'ang Exotics* (Berkeley: University of California Press, 1963), 138; Camille Fung and Alan Y. M. Fung, "Huanghuali," *Journal of the Classical Chinese Furniture Society* 1, no. 4 (Autumn 1991): 50.

18. Edwin O. Reischauer, trans., *Ennin's Diary: The Record of a Pilgrimage to China in Search of the Law* (New York: Ronald Press, 1955), 152.

19. The original painting is badly worn, but a copy made in 826 in Japan is reproduced in Pierre Rambach, *The Secret Message of Tantric Buddhism* (New York: Rizzoli, 1979), 20.

20. Chen Zengbi, "Qian nian gu ta" (A thousand-year-old pagoda), *Wenwu,* no. 6 (1984): 66–69.

21. Burton Watson, trans. and ed., *The Columbia Book of Chinese Poetry: From Early Times to the Thirteenth Century* (New York: Columbia University Press, 1984), 176.

22. Wang Shixiang, "Jichimu Platform-Type Daybed," *Journal of the Classical Chinese Furniture Society* 1, no. 2 (Spring 1991): 8; Marylin M. Rhie and Robert A. F. Thurman, *Wisdom and Compassion: The Sacred Art of Tibet* (New York: Harry N. Abrams, 1991), 161.

23. H. A. Giles, "Thousand Character Numerals Used by Artisans," *Journal of the Royal Asiatic Society, North China Branch* 20 (1885): 279.

24. Robert D. Jacobsen, with Nicholas Grindley, *Classical Chinese Furniture in the Minneapolis Institute of Arts* (Minneapolis: Minneapolis Institute of Arts, 1999), no. 21.

25. Wen Zhenheng, *Zhang wu zu jiao zhu* (Treatise on superfluous things, annotated), ed. Yang Zhaobo, annotations by Chen Zhi (Nanjing: Jiangsu Kexue Jishu Chubanshe, 1984), 241; Wang Shixiang *Connoisseurship of Chinese Furniture: Ming and Early Qing Dynasties,* trans. Lark E. Mason Jr. et al. (Hong Kong: Joint Publishing Co., 1990), 2: 76.

26. Peter Lai and Sandra Lai, *Classical Chinese Furniture: A Legacy of Refinement* (Hong Kong: Peter Lai Antiques, 1992), 18.

27. Curtis Evarts, "The Development of the Waisted Form and Variations in Its Joinery," *Journal of the Classical Chinese Furniture Society* 1, no. 3 (Summer 1991): 44.

Chapter 9

Adapted from Handler, "Comfort and Joy: A Couch Bed for Day and Night," *Journal of the Classical Chinese Furniture Society* 2, no. 1 (Winter 1991): 4–19.

1. Liu Xi, *Shiming* (Explanation of names), Congshu jicheng ed. (Shanghai: Commercial Press, 1939), 6: 93.

2. Wang Zengxin, "Liaoyangshi Bangtaizi er hao bihua mu" (Wall painting in tomb no. 2, Bangtaizi, Liaoyang City), *Kaogu,* no. 1 (1960): 22.

3. See fig. 8.2; see also Danielle Elisseeff and Vadime Elisseeff, *New Discoveries in China: Encountering History through Archaeology,* trans. Larry Lockwood (Secaucus, N.J.: Chartwell Books, 1983), 47.

4. Wengniute Qi Wenhuaguan, Zhaowuda Meng Wenwu Gongzuozhan (The Archaeological Station of the Zhaowuda League and the Cultural Center of the Wengniute Banner, Inner Mongolia), "Nei Menggu Jiefangyingzi Liao mu fajue jianbao" (Report on the discovery of a Liao tomb at Jiefangyingzi, Inner Mongolia), *Kaogu,* no. 4 (1979): 331.

5. Laurence Sickman, ed., *Chinese Calligraphy and Painting in the Collection of John M. Crawford, Jr.* (New York: Pierpont Morgan Library, 1962), 91.

6. Chen Zengbi, "Double Sixes," *Journal of the Classical Chinese Furniture Society* 2, no. 3 (Summer 1992): 48–53.

7. Wen Zhenheng, *Zhang wu zu jiao zhu* (Treatise on superfluous things, annotated), ed. Yang Zhaobo, annotations by Chen Zhi (Nanjing: Jiangsu Kexue Jishu Chubanshe, 1984), 333; translation based on Craig Clunas, *Superfluous Things: Material Culture and Social Status in Early Modern China* (Urbana: University of Illinois Press, 1991), 44.

8. Gao Lian, *Zun sheng ba jian* (Eight discourses on the art of living), Qinding Siku Quanshu ed. (Taipei: Commercial Press, 1983), vol. 871, *juan* 8, 9b.

9. Tu Long, *Kao pan yu shi* (Desultory remarks on furnishing the abode of the retired scholar), *Yishu congbian* (Taipei: Shijie Shuju Yinhang, 1962), vol. 28, no. 249, p. 71.

10. Wang Qi, *Sancai tuhui* (Pictorial encyclopedia of heaven, earth, and man) (1609; reprint, 3 vols., Shanghai: Shanghai Guji Chubanshe, 1990), 2: 1332.

11. Mai-mai Sze, *The Tao of Painting: A Study of the Ritual Disposition of Chinese Painting, with a Translation of the "Chieh Tzu Yan Hua Chuan," or "Mustard Seed Garden Manual of Painting," 1679–1701* (Princeton: Princeton University Press, 1967), 310.

12. L. Carrington Goodrich, *15th Century Illustrated Chinese Primer: Hsin-pien tui-hsiang szu-yen* (Hong Kong: Hong Kong University Press, 1967), n.p.

13. Wen Zhenheng, *Zhang wu zu jiao zhu,* 226.

14. Wang Shixiang, *Classic Chinese Furniture: Ming and Early Qing Dynasties,* trans. Sarah Handler and Wang Shixiang (Hong Kong: Joint Publishing Co., 1986), 193.

15. David Hawkes and John Minford, trans., *The Story of the Stone,* by Cao Xueqin, 5 vols. (Harmondsworth, Eng.: Penguin, 1976–86), 4: 208.

16. Cao Xueqin, *Honglou meng* (A dream of red mansions), 4 vols. (Taipei: Zhonghua Shuju, 1971), vol. 3, *juan* 63, 810; trans. based on Hawkes and Minford, *Story of the Stone,* 3: 231.

17. Cao Xueqin, *Honglou meng,* vol. 2, *juan* 53, 668; trans. based on Hawkes and Minford, *Story of the Stone,* 2: 578–79.

18. Cao Xueqin, *Honglou meng,* vol. 2, *juan* 40, 491; vol. 3, *juan* 71, 916; Hawkes and Minford, *Story of the Stone,* 2: 297, 3: 407.

19. Li Rihua, *Zitaoxuan zazhui* (Miscellaneous notes from Purple Peach Pavilion) (1617; reprint, Shanghai: Zhongyang Book Co., 1935), *juan* 1, 22b; trans. based on James C. Y. Watt, "The Literati Environment," in *The Chinese Scholar's Studio: Artistic Life in the Late Ming Period, an Exhibition from the Shanghai Museum,* ed. Chu-tsing Li and James C. Y. Watt (New York: Asia Society Galleries, 1987), 6.

20. Wen Zhengeng, *Zhang wu zu jiao zhu,* 225, trans. based on Clunas, *Superfluous Things,* 42.

21. Wen Zhenheng, *Zhang wu zu jiao zhu,* 354.

22. Wang Shixiang, *Classic Chinese Furniture,* 293.

23. Recent research by James Cahill has shown that these paintings were probably done by Gu Jianlong when he was painter-in-attendance at the Kangxi court from c. 1662 to some time in the mid or late 1670s. See Cahill, "The Emperor's Erotica" (*Ching Yüan Chai so-shih II*), *Kaikodo Journal* 11 (Spring 1999): 26–33.

24. Grace Wu Bruce, *Dreams of Chu Tan Chamber and the Romance with Huanghuali Wood: The Dr. S. Y. Yip Collection of Classic Chinese Furniture,* with an introduction by Shing Yiu Yip (Hong Kong: n.p., 1991), 49; Wang Shixiang, *Classic Chinese Furniture,* 60, no. 13.

25. George N. Kates, *Chinese Household Furniture* (New York: Hayes and Brothers, 1948), pl. 70.

26. Wang Shixiang, *Classic Chinese Furniture,* 186–87.

27. Clunas, *Superfluous Things,* 80–81.

28. Wen Zhenheng, *Zhang wu zu jiao zhu,* 225; trans. based on Clunas, *Superfluous Things,* 42.

Chapter 10

Adapted from Handler, "A Little World Made Cunningly: The Chinese Canopy Bed," *Journal of the Classical Chinese Furniture Society* 2, no. 2 (Spring 1992): 4–27.

1. Zhongguo Shehui Kexueyuan Kaogu Yanjiusuo and Hebei Sheng Wenwu Guanlichu (Institute of Archaeology, CASS, and the Hebei CPAM, Hebei province), *Mancheng Hanmu fajui baogu* (Excavation of the Han tombs at Mancheng) (Beijing: Wenwu Press, 1980), 1: 147, figs. 1, 2, 5.

2. Liu Xi, *Shiming* (Explanation of names), Congshu jicheng ed. (Shanghai: Commercial Press, 1939), *juan* 6, 193.

3. Harvard-Yenching Institute, *Shi Ching: A Concordance,* Sinological Index Series Supplement no. 9 (Tokyo: Japan Council for East Asian Studies, 1962), 42.

4. Translation based on James Legge, ed. and trans., *The Works of Mencius,* vol. 11 of *The Chinese Classics: With a Translation, Critical and Exegetical Notes, Prolegomena, and Copious Indexes* (London: Trübner & Co., 1861), 223.

5. Shang Yai, *Shang Jun shu* (The book of Shang Jun), quoted in *Cihai* (Sea of words) (Shanghai: Zhonghua Shuju, 1948), 865.

6. Wang Yi, *Chu ci* (The songs of the south), Congshu jicheng ed. (Taipei: Commercial Press, 1939), *juan* 9, 106; trans. David Hawkes in his *Songs of the South: An Ancient Chinese Anthology of Poems by Qu Yuan and Other Poets* (Harmondsworth, Eng.: Penguin, 1985), 227.

7. Yi Shui, "Zhang he zhangguo" (Curtains and curtain hooks), *Wenwu,* no. 4 (1980): 86.

8. *Murals from the Han to the T'ang Dynasty* (Beijing: Foreign Languages Press, 1974), 39, fig. 5.

9. *Gujin tushu jicheng* (Synthesis of books and illustrations of ancient and modern times) (1726; reprint, Taipei: Zhonghua Shuju, 1934), 250: 46a.

10. Ling Yuan, "Zhao Feiyan waijuan" (Private history of Queen Feiyan), in *Shuo fu* 17, *juan* 32, 23b.

11. *Liang Han Wei Jin shiyijia wenji* (Collection of the writings of eleven authors from the Han, Wei, and Jin dynasties) (Taipei: World Book Co., 1973), 1: 102–5; trans. based on Robert van Gulik, *Sexual Life in Ancient China: A Preliminary Survey of Chinese Sex and Society from ca. 1500 B.C. till 1644 A.D.* (Leiden: E. J. Brill, 1974), 68–69.

12. Xu Ling, *Yutai xinyong ji* (New songs from a jade terrace), Sibu Congkan ed. (Shanghai: Commercial Press, 1920–22), *juan* 1, 10b–11a; trans. based on van Gulik, *Sexual Life in Ancient China*, 73.

13. My translation of the inscription on the painting.

14. See the discussion at the beginning of Chap. 8. See also Danielle Elisseeff and Vadime Elisseeff, *New Discoveries in China: Encountering History through Archaeology,* trans. Larry Lockwood (Secaucus, N.J.: Chartwell Books, 1983), 47.

15. Xu Ling, *Yutai xinyong ji*, 2: 3a; translation by Willis Barnstone.

16. Li Yanshou, *Nan shi* (Southern history) (Beijing: Zhonghua Shuju, 1975), 1: 153.

17. Xiao Zixian, *Nan Qi shu* (Southern Qi history) (Beijing: Zhonghua Shuju, 1972), 1: 14.

18. Michel Beurdeley, *The Chinese Collector through the Centuries, from the Han to the Twentieth Century,* trans. Diana Imber (Rutland, Vt.: Charles E. Tuttle Co., 1969), 55, 59.

19. Edward H. Schafer, *The Golden Peaches of Samarkand: A Study of T'ang Exotics* (Berkeley: University of California Press, 1963), 232.

20. Chen Cangqi, quoted in Li Shizhen, *Bencao gangmu* (Materia medica), Siku Quanshu ed. (1596; reprint, Taipei: Commercial Press, 1983), *juan* 5, 774–83; Edward H. Schafer, "Rosewood, Dragon's Blood, and Lac," *Journal of the American Oriental Society* 7, no. 8 (April–June 1957): 132.

21. Jacques Gernet, *Daily Life in China on the Eve of the Mongol Invasion, 1250–1276,* trans. H. M. Wright (Stanford, Calif.: Stanford University Press, 1962), 121.

22. Nancy Berliner and Sarah Handler, *Friends of the House: Furniture from China's Towns and Villages* (Salem, Mass.: Peabody-Essex Museum, 1996), 82.

23. Klaas Ruitenbeek, *Carpentry and Building in Late Imperial China: A Study of the Fifteenth-Century Carpenter's Manual "Lu Ban Jing"* (Leiden: E. J. Brill, 1993), 227.

24. M. D. Flacks, *Classical Chinese Furniture* (New York: M. D. Flacks, 1997), 1: 6.

25. Wen Zhenheng, *Zhang wu zu jiao zhu* (Treatise on superfluous things, annotated), ed. Yang Zhaobo, annotations by Chen Zhi (Nanjing: Jiangsu Kexue Jishu Chubanshe, 1984), 333; trans. Craig Clunas in his *Superfluous Things: Material Culture and Social Status in Early Modern China* (Urbana: University of Illinois Press, 1991), 43–44.

26. Ruitenbeek, *Carpentry and Building in Late Imperial China,* 89, 226–27.

27. Li Yu, *Yijia yan jushi qiwan bu* (Independent words: The section on useful and decorative objects in the dwelling) (Beijing: Zhongguo Yingcao Xueshe, 1931), 28a–28b; trans. Patrick Hanan in his *Invention of Li Yu* (Cambridge, Mass.: Harvard University Press, 1988), 189–90.

28. Gao Lian, *Zun sheng ba jian* (Eight discourses on the art of living), Qinding Siku Quanshu ed. (Taipei: Commercial Press, 1983), vol. 871, *juan* 8, p. 8b–9a.

29. Wang Shifu, *The Moon and the Zither: The Story of the Western Wing,* ed. and trans. with an introduction by Stephen H. West and Wilt L. Idema, with a study of its woodblock illustrations by Yao Dajuin (Berkeley: University of California Press, 1991), 220.

30. Curtis Evarts, "The Development of the Waisted Form and Variations in Its Joinery," *Journal of the Classical Chinese Furniture Society* 1, no. 3 (Summer 1991): 45.

31. Wang Shixiang, *Classic Chinese Furniture: Ming and Early Qing Dynasties,* trans. Sarah Handler and Wang Shixiang (Hong Kong: Joint Publishing Co., 1986), 190–93.

32. CPAM, City of Shanghai, "Shanghaishi Luwan qu Ming Pan shi mu fajue jianbao" (Excavations of the Ming dynasty tombs belonging to the Pan family in the Luwan district, Shanghai), *Kaogu,* no. 8 (1961): 428.

33. Museum of the City of Suzhou, "Suzhou Huqiu Wang Xijue mu qingli lue" (A brief account of the tomb of Wang Xijui, Tiger Hill, Suzhou), *Wenwu,* no. 3 (1975): 53.

34. Ruitenbeek, *Carpentry and Building in Late Imperial China,* 223–27.

35. André Lévy, trans., *Fleur en fiole d'or (Jin ping mei cihua)* (Paris: Gallimard, 1985), 1: 598, 2: 1179.

36. Grace Service, *Golden Inches: The China Memoir of Grace Service,* ed. John S. Service (Berkeley: University of California Press, 1989), 197–98.

Chapter 11

Adapted from Handler, "On a New World Arose the *Kang* Table," *Journal of the Classical Chinese Furniture Society* 2, no. 3 (Summer 1992): 22–46.

1. Danielle Elisseeff and Vadime Elisseeff, *New Discoveries in China: Encountering History through Archaeology,* trans. Larry Lockwood (Secaucus, N.J.: Chartwell Books, 1983), 47.

2. Sarah Allen, *The Shape of the Turtle: Myth, Art, and Cosmos in Early China* (Albany: State University of New York Press, 1991), 130.

3. Jessica Rawson, *Western Zhou Ritual Bronzes from the Arthur M. Sackler Collection* (Washington, D.C.: Arthur M. Sackler Foundation, 1990), 2: 33.

4. Arthur Waley, trans., *The Book of Songs* (New York: Grove Press, 1960), 210; Harvard-Yenching Institute, *Shih Ching: A Concordance,* Sinological Index Series Supplement no. 9 (Tokyo: Japan Council for East Asian Studies, 1962), 51.

5. Lin Shouqin, *Zhongguo ximugong sunjie he gongyi yanjiu* (The craft of tenon making in fine woodwork during the Warring States period) (Hong Kong: Chinese University Press, 1981), pl. 5, no. 33:016.

6. David Hawkes, trans., *The Songs of the South: An Ancient Chinese Anthology of Poems by Qu Yuan and Other Poets* (Harmondsworth, Eng.: Penguin, 1985), 229.

7. Yang Lien-sheng, "A Note on the So-called TLV Mirrors and the Game, *Liu-po,*" *Harvard Journal of Asian Studies* 9, nos. 3–4 (Feb. 1947): 202–7.

8. Kenneth J. DeWoskin, "Music and Entertainment Themes in Han Funerary Sculpture," *Orientations* 18, no. 4 (April 1987): 35; Lucy Lim, ed., *Stories from China's Past: Han Dynasty Pictorial Tomb Reliefs and Archaeological Objects from Sichuan Province, People's Republic of China* (San Francisco: Chinese Culture Foundation of San Francisco, 1987), 71.

9. Henan Sheng Wenwu Yanjiusuo (Cultural Relics Institute of Henan Province), *Xinyang Chumu* (Chu tombs at Xinyang) (Beijing: Wenwu Press, 1986), pl. 27.1.

10. Wang Shixiang, "Additional Examples of Classical Chinese Furniture," *Orientations* 23, no. 1 (Jan. 1992): 43.

11. Xu Shen, *Shuo wen jie zi zhu* (Annotated edition of the analytical dictionary of characters), annotated by Duan Yucai (1735–1815) (Shanghai: Guju Chubanshe, 1981), 260–61.

12. Fan Ye, *Hou Han shu* (History of the Former Han), Bona ed. (Shanghai: Commercial Press, 1932), 83: 14a.

13. Shao Wenliang, *Sports in Ancient China,* ed. People's Sports Publishing House, Beijing (Hong Kong: Tai Dao Publishing Ltd., 1986), 114–15.

14. Craig Clunas, *Chinese Furniture,* Victoria and Albert Museum Far Eastern Series (London: Bamboo Publishing, 1988), 60; Wang Shixiang, "Additional Examples," 24–25.

15. *Quanben Jin Ping mei cihua* (Complete edition of the story of the plum in the golden vase) (Hong Kong: Taiping Shuju, 1982), vol. 3, *juan* 44, 7b; vol. 5, *juan* 78, 21a.

16. On *fanzhuo,* see Cao Xueqin, *Honglou meng* (A dream of red mansions) (Taipei: Zhonghua Shuju, 1971), vol. 2, *juan* 55, 699; David Hawkes and John Minford, trans., *The Story of the Stone,* by Cao Xueqin (Harmondsworth, Eng.: Penguin, 1976–86, 3: 60–61. On *kangzhuo,* see Cao Xueqin, *Honglou meng,* vol. 2, *juan* 53, 670; Hawkes and Minford, *Story of the Stone,* 2: 581.

17. Grace Service, *Golden Inches: The China Memoir of Grace Service,* ed. John S. Service (Berkeley: University of California Press, 1989), 112.

18. André Lévy, *Fleur en fiole d'or (Jin ping mei cihua)* (Paris: Gallimard, 1985), 2: 175; 1: 79, 89; 2: 758, 857, 885.

19. Institute of the History of Natural Sciences, Chinese Academy of Sciences, comp., *History and Development of Ancient Chinese Architecture* (Beijing: Science Press, 1986), 310.

20. Joseph Needham, *Science and Civilisation in China* (Cambridge, Eng.: Cambridge University Press, 1954–), vol. 5, part 3, 135.

21. H.-S. Ch'ên and George Kates, "Prince Kung's Palace and Its Adjoining Garden in Peking," *Monumenta Serica* 5 (1940): 33.

22. Hawkes and Minford, *Story of the Stone,* 2: 571; 4: 208.

23. "Essai sur l'architecture chinoise," MS Oe 13a, Bibliothèque nationale, Paris. See also Gustav Ecke, "A Group of Eighteenth-Century Paintings of Beijing Interiors," trans. Martina Bockert and Frank Wiegand, *Journal of the Classical Chinese Furniture Society* 4, no. 3 (Summer 1994): 61.

24. Institute of the History of Natural Sciences, Chinese Academy of Sciences, comp., *History and Development of Ancient Chinese Architecture* (Beijing: Science Press, 1986), 308.

25. Cao Xueqin, *Honglou meng,* vol. 2, *juan* 49, 605; Hawkes and Minford, *Story of the Stone,* 2: 480, 486.

26. Ecke, "A Group of Eighteenth-Century Paintings of Beijing Interiors," 66.

27. Institute of the History of Natural Sciences, *Ancient Chinese Architecture,* 308–10.

28. Tseng Yuho Ecke, "Appendix to 'Notes on Chinese Furniture,'" *Orientations* 22, no. 11 (Nov. 1991): fig. 4.

29. Clunas, *Chinese Furniture,* 60.

30. Robert Hatfield Ellsworth, *Chinese Furniture: One Hundred Examples from the Mimi and Raymond Hung Collection* (New York: privately published, 1996), no. 36; *Classical and Vernacular Chinese Furniture in the Living Environment: Examples from the Kai Yin Lo Collection* (Hong Kong: Yunmingtang, 1998), no. 18; Grace Wu Bruce, *Ming Furniture* (Hong Kong: Grace Wu Bruce Co., 1995), no. 12; *ZGMSQJ, Gongyi meishu bian* 11: *Zhu mu ya jiao qi* (Crafts section 11: Bamboo, wood, ivory, and horn objects) (Beijing: Wenwu Press, 1987), 140; Tian Jiaqing, *Classic Chinese Furniture of the Qing Dynasty* (London and Hong Kong: Philip Wilson Publishers and Joint Publishing Co. Ltd., 1996), nos. 57, 62.

31. Robert Hatfield Ellsworth reported in 1992 that it would soon enter the collection of the Palace Museum, Beijing. See his "Exhibition Review: A Profusion of Chinese Furnishings," *Orientations* 23, no. 5 (May 1992): 83.

32. Hawkes and Minford, *Story of the Stone,* 2: 578–79.

33. Wang Shixiang, *Connoisseurship of Chinese Furniture: Ming and Early Qing Dynasties,* trans. Lark E. Mason Jr. et al. (Hong Kong: Joint Publishing Co., 1990) 1: 49.

34. Hawkes and Minford, *Story of the Stone,* 3: 221–24; Cao Xueqin, *Honglou meng,* vol. 3, *juan* 63, 804.

35. Hawkes and Minford, *Story of the Stone*, 1: 59; 2: 184, 579; 3: 61.

36. Hawkes and Minford, *Story of the Stone*, 3: 65; Cao Xueqin, *Honglou meng,* vol. 2, *juan* 55, 702.

37. Wen C. Fong, ed., *The Great Bronze Age of China: An Exhibition from the People's Republic of China* (New York: Metropolitan Museum of Art, 1980), 143, 212.

38. Nanjing Bowuguan (Nanjing City Museum). "Nanjing Hujuguan Caohoucun Dong Jin mu" (Two Eastern Jin tombs at Hujuguan and Caohoucun, Nanjing). *Wenwu,* no. 1 (1988): 82; Han Wei, *Precious Cultural Relics in the Crypt of Famen Temple,* (Xi'an: Shaanxi People's Fine Arts Publishing House, 1989), 30.

39. Hollis S. Baker, *Furniture in the Ancient World: Origins and Evolution, 3100–475 B.C.* (London: Connoisseur, 1966), 21, 41, 50–51.

40. Hawkes and Minford, *Story of the Stone*, 4: 291.

41. Wang Shixiang, *Connoisseurship of Chinese Furniture,* 2: 48–51.

42. Hawkes and Minford, *Story of the Stone*, 3: 409.

43. Ibid., 4: 352.

44. *ZGMSQJ, Gongyi meishu bian* 11: 58.

45. Palace Museum, comp. and ed., *Court Painting of the Qing Dynasty* (Beijing: Wenwu Press, 1992), 74. This scroll shows the Kangxi emperor in Jiangning prefecture.

46. Wan Yi, Wang Shuqing, and Lu Yanzhen, comps., *Daily Life in the Forbidden City: The Qing Dynasty, 1644–1912,* trans. Rosemary Scott and Erica Shipley (New York: Viking, 1988), 249.

Chapter 12

Adapted from Handler, "Square Tables Where the Immortals Dine," *Journal of the Classical Chinese Furniture Society* 4, no. 4 (Autumn 1994): 4–23.

1. Jessica Rawson, *Western Zhou Ritual Bronzes from the Arthur M. Sackler Collection* (Washington, D.C.: Arthur M. Sackler Foundation, 1992), no. 40.

2. Fu Xinian, "Shaanxi Fufeng Shaochen Xi Zhou jianzhu yizhi chutan" (A preliminary inquiry into the remains of the Western Zhou buildings at Shaochen village in Fufeng county, Shaanxi), *Wenwu,* no. 3 (1981): 40.

3. Yang Lien-sheng "A Note on the So-called TLV Mirrors and the Game, *Liu-po,*" *Harvard Journal of Asian Studies* 9, nos. 3–4 (Feb. 1947): 203, 207.

4. Lucy Lim, ed., *Stories from China's Past: Han Dynasty Pictorial Tomb Reliefs and Archaeological Objects from Sichuan Province, People's Republic of China* (San Francisco: Chinese Culture Foundation of San Francisco, 1987), 125.

5. Hunan Sheng Bowuguan (Hunan Provincial Museum), *Changsha Mawangdui yihao Han mu* (Han tomb 1 at Mawangdui, Changsha) (Beijing: Wenwu Press, 1973), 1: 76–96.

6. Michèle Pirazzoli-t'Serstevens, "The Art of Dining in the Han Period: Food Vessels from Tomb No. 1 at Mawangdui," *Food and Foodways* 4 (1991): 213–14; *Chinese Ceramic Tea Vessels: The K. S. Collection, Flagstaff House Museum of Tea Wares* (Hong Kong: Urban Council, 1991), 26–27.

7. Kwang-chih Chang, ed., *Food in Chinese Culture: Anthropological and Historical Perspectives* (New Haven: Yale University Press, 1979), 63, 69.

8. David Hawkes, trans., *The Songs of the South: An Ancient Chinese Anthology of Poems by Qu Yuan and Other Poets* (Harmondsworth, Eng.: Penguin, 1985), 227–28.

9. Lim, *Stories from China's Past,* 144; Shao Wenliang, *Sports in Ancient China,* ed. People's Sports Publishing House, Beijing (Hong Kong: Tai Dao Publishing Ltd., 1986), 230–31.

10. Henan Sheng Bowuguan (Henan Provincial Museum), "Lingbao Zhangwan Hanmu" (The Han tomb in Zhangwan, Lingbao), *Wenwu*, no. 11 (1975): 80, 87 fig. 21.

11. Kwang-chih Chang, *Food in Chinese Culture*, 98–99.

12. Wang Renbo, ed., *Sui Tang wenhua* (Cultural relics of the Sui and Tang) (Hong Kong: China Publishing House, 1990), 201, 202–3; *The Chinese Exhibition: A Pictorial Record of the Exhibition of Archaeological Finds of the People's Republic of China* (Kansas City, Missouri: Nelson Gallery–Atkins Museum, 1975), nos. 260–62.

13. Kwang-chih Chang, *Food in Chinese Culture*, 87–140.

14. Kaneo Matsumoto, ed., *The Treasures of the Shōsōin: Musical Instruments, Dance Articles, Game Sets* (Tokyo: Shikosha Art Books, 1991), nos. 76–79.

15. *Sports and Games in Ancient China* (Beijing: New World Press, 1986), 74; Edward H. Schafer, *The Golden Peaches of Samarkand: A Study of T'ang Exotics* (Berkeley: University of California Press, 1963), 77.

16. Shao Wenliang, *Sports in Ancient China*, 173.

17. Ibid., 170.

18. Michael Freeman, "Sung," in Kwang-chih Chang, *Food in Chinese Culture*, 143.

19. Jacques Gernet, *Daily Life in China on the Eve of the Mongol Invasion, 1250–1276*, trans. H. M. Wright (Stanford, Calif.: Stanford University Press, 1962), 138.

20. E. N. Anderson, *The Food of China* (New Haven: Yale University Press, 1988), 69.

21. Li Fangyu and Long Baozhang, "Jindai Yu Yin mushi bihua" (Wall paintings from the Jin dynasty tomb of Yu Yin), *Wenwu*, no. 2 (1982): 149–51.

22. Su Bai, *Baisha Song mu* (Song tombs at Baisha) (Beijing: Wenwu Press, 1957), pl. 22; Suzhou Bowuguan, Jiangyin Xian Wenhua Zhongxin (Suzhou Museum and Cultural Center of Jiangyin), "Jiangyin Bei Song Ruichang xiangjun Sun si niangzi mu" (The Northern Song tomb of Fourth Lady Sun, Princess Ruichang, at Jiangyin), *Wenwu*, no. 12 (1982): pl. 1.1.

23. Gernet, *Daily Life in China*, 136–37; Anderson, *The Food of China*, 67.

24. Kwang-chih Chang, *Food in Chinese Culture*, 151.

25. *Quanben Jin ping mei cihua* (Complete edition of the story of the plum in the golden vase) (Hong Kong: Taiping Shuju, 1982), vol. 2, *juan* 35, 13a.

26. Ibid., vol. 6, *juan* 96, 3a.

27. George N. Kates, "Chinese Hardwood Furniture," *Journal of the Classical Chinese Furniture Society* 2, no. 1 (Winter 1991): 54.

28. *Quanben Jin ping mei cihua*, vol. 1, *juan* 11, 10a; L. Carrington Goodrich, *15th Century Illustrated Chinese Primer: Hsin-pien tui-hsiang szu-yen* (Hong Kong: Hong Kong University Press, 1967); Wang Qi, *Sancai tuhui* (Pictorial encyclopedia of heaven, earth, and man) (1609; reprint, 3 vols., Shanghai: Shanghai Guji Chubanshe, 1990), 2: 1330; Klaas Ruitenbeek, *Carpentry and Building in Late Imperial China: A Study of the Fifteenth-Century Carpenter's Manual "Lu Ban Jing"* (Leiden: E. J. Brill, 1993), 235.

29. Ruitenbeek, *Carpentry and Building*, 234; Wang Shixiang, *Connoisseurship of Chinese Furniture: Ming and Early Qing Dynasties*, trans. Lark E. Mason Jr. et al. (Hong Kong: Joint Publishing Co., 1990), 1: 57.

30. André Lévy, trans., *Fleur en fiole d'or (Jin ping mei cihua)* (Paris: Gallimard, 1985), 1: 1213.

31. Derk Bodde, *Annual Customs and Festivals in Peking as Recorded in the Yen-ching Sui-shih-chi by Tun Li-ch'en* (Hong Kong: Hong Kong University Press, 1987), 104.

32. Kristofer Schipper, *The Taoist Body*, trans. Karen C. Duval (Berkeley: University of California Press, 1993), 160–66.

33. Sheila Keppel, "The Well-Furnished Tomb, Part III," *Journal of the Classical Chinese Furniture Society* 4, no. 2 (Spring 1994): 46.

34. Robert van Gulik, *Chinese Pictorial Art as Viewed by the Connoisseur* (Rome: Istituto Italiano per il Medio ed Estremo Oriente, 1958), 17–20.

35. Sarah Handler, "Square Tables Where the Immortals Dine," *Journal of the Classical Chinese Furniture Society* 4, no. 4 (Autumn 1994): 17.

36. Translation adapted from Frederick W. Mote's in Kwang-chih Chang, *Food in Chinese Culture,* 246.

37. Wen Zhenheng, *Zhang wu zu jiao zhu* (Treatise on superfluous things, annotated), ed. Yang Zhaobo, annotations by Chen Zhi (Nanjing: Jiangsu Kexue Jishu Chubanshe, 1984), 234; Johan Nieuhof, *Voyages and Travels to the East Indies, 1653–1670* (Singapore: Oxford University Press, 1988), vii; Johan Nieuhof, *An Embassy from the East-India Company of the United Provinces to the Grand Tartar Cham, Emperor of China,* trans. John Ogilby, 2nd ed. (London: John Ogilby, 1673), 167.

38. C. R. Boxer, ed., *South China in the Sixteenth Century* (London: Hakluyt Society, 1953), 141.

39. André Lévy, trans., *Fleur en fiole d'or (Jin ping mei cihua)* (Paris: Gallimard, 1985), 1: 23, 468, 18, 362.

Chapter 13

Adapted from Handler, "A Clean Table by a Bright Window," *Journal of the Classical Chinese Furniture Society* 4, no. 2 (Spring 1994): 27–43.

1. Guo Xi, *Linquan gaozhi* (The lofty message of forests and streams), Yishu congbian ed. (Taipei: World Publishing Co., 1967), vol. 10, no. 67, 8–9; translated in Arthur Waley, *Introduction to the Study of Chinese Painting* (London: Ernest Benn, 1923), 192.

2. *ZGMSQJ, Huihua bian* 12: *Mushi bihua* (Painting section 12: Wall paintings in tombs) (Beijing: Wenwu Press, 1989), pl. 59.

3. Arthur Waley, trans., *The Book of Songs* (New York: Grove Press, 1960), 91.

4. Wang Shixiang, *Classic Chinese Furniture: Ming and Early Qing Dynasties,* trans. Sarah Handler and Wang Shixiang (Hong Kong: Joint Publishing Co., 1986), 288.

5. Wu Tung, *Tales from the Land of Dragons: 1,000 Years of Chinese Painting* (Boston: Museum of Fine Arts, 1997), 169.

6. Wai-kam Ho, Sherman Lee, Laurence Sickman, and Marc Wilson, eds., *Eight Dynasties of Chinese Painting: The Collections of the Nelson Gallery—Atkins Museum, Kansas City, and the Cleveland Museum of Art* (Cleveland: Cleveland Museum of Art, 1980), 66–69.

7. Yang Yao, *Zhongguo Mingdai shinei zhuangshi he jiaju* (Interior decoration and furniture in Ming dynasty China) (Beijing: Beijing University Press, n.d.), 6.

8. Richard Vinograd, *Boundaries of the Self: Chinese Portraits, 1600–1900* (Cambridge, Eng.: Cambridge University Press, 1992), 16–18.

9. Wang Shixiang, *Classic Chinese Furniture,* 290.

10. Translation based on Wang Shixiang, *Classic Chinese Furniture,* 290.

11. Wang Shixiang, *Connoisseurship of Chinese Furniture: Ming and Early Qing Dynasties,* trans. Lark E. Mason Jr. et al. (Hong Kong: Joint Publishing Co., 1990), 1: 70.

12. Ibid., B120, 1: 71.

13. *ZGMSQJ, Gongyi meishu bian* 11: *Zhu mu ya jiao qi* (Crafts section 11: Bamboo, wood, ivory, and horn objects) (Beijing: Wenwu Press, 1987), 63.

14. Wang Qi, *Sancai tuhui* (Pictorial encyclopedia of heaven, earth, and man) (1609; reprint [3 vols.], Shanghai: Shanghai Guji Chubanshe, 1990), 2: 1330; Wen Zhenheng, *Zhang wu zu jiao zhu* (Treatise on superfluous things, annotated), ed. Yang Zhaobo, annotations by Chen Zhi (Nanjing: Jiangsu Kexue Jishu Chubanshe, 1984), 231; Wang Shixiang, *Connoisseurship of Chinese Furniture,* 1: 69.

15. Wang Shixiang, *Classic Chinese Furniture,* no. 109, p. 288.

16. James Cahill, *Shadows of Mt. Huang: Chinese Painting and Printing of the Anhui School* (Berkeley: University Art Museum, 1981), 26–28; Sören Edgren, *Chinese Rare Books in American Collections* (New York: China Institute in America, 1984), 104–5.

17. L. Carrington Goodrich and Chaoying Fang, eds., *Dictionary of Ming Biography, 1368–1644* (New York: Cambridge University Press, 1976), 1: 213.

18. Sarah Handler, "Outstanding Pieces in Private Rooms: Chinese Classical Furniture in New American Collections," *Orientations* 24, no. 1 (Jan. 1993): 46.

19. Gao Lian, *Zun sheng ba jian* (Eight discourses on the art of living), Qinding Siku Quanshu ed. (Taipei: Commercial Press, 1983), vol. 871, *juan* 8, 15b; Wen Zhenheng, *Zhang wu zu jiao zhu*, 244.

20. Wang Shixiang, *Connoisseurship of Chinese Furniture,* 1: 101.

21. Ouyang Xiu, "Shih pi" (Calligraphic exercises), in Ouyang Xiu, *Ouyang Wenzhonggong ji* (The complete literary works of Ouyang Xiu), Guoxue jiben congshu ed. (Commercial Press, 1933), *juan* 14, 128.

22. Zhao Xigu, *Dongtian qinglu ji* (Paltry earnings in the immortals' service), vol. 5 of *Zhongguo gudai meishu congshu* (A collection of texts on ancient Chinese art) (Beijing: Guoji Wenhua Press, 1993), 221.

23. Trans. Wang Fangyu, in Wang Fangyu and Richard Barnhart, *Master of the Lotus Garden: The Life and Art of Bada Shanren (1626–1705)* (New Haven: Yale University Press, 1990), 81.

24. Li Rihua, *Zitaoxuan zazhui* (Miscellaneous notes from Purple Peach Pavilion) (1617; reprint, Shanghai: Zhongyang Book Co., 1935), *juan* 1, 22b.

25. Wen Zhenheng, *Zhang wu zu jiao zhu,* 347–48, 351–52, 333.

26. Wang Shixiang, *Classic Chinese Furniture,* 14.

27. Wen Zhenheng, *Zhang wu zu jiao zhu,* 351; *Quanben Jin ping mei cihua* (Complete edition of the story of the plum in the golden vase) (Hong Kong: Taiping Shuju, 1982), vol. 2, *juan* 34, 2b–3a.

28. Trans. Li Chu-tsing in *A Thousand Peaks and Myriad Ravines: Chinese Paintings in the Charles A. Drenowatz Collection* (Ascona, Switzerland: Artibus Asiae, 1974), 1: 29, 31.

29. Ibid., 29–40.

30. Robert van Gulik, *Mi Fu on Ink-Stones* (Beijing: Henri Vetch, 1938), 22.

31. Jonathan D. Spence, *Emperor of China: Self-portrait of K'ang-hsi* (New York: Vintage Books, 1975), 59.

32. Ruitenbeek facsimile II.43; André Lévy, trans., *Fleur en fiole d'or (Jin ping mei cihua)* (Paris: Gallimard, 1985), 2: 60, 242; Li Yu, *Yijia yan: Jushi qiwan bu* (Independent words: The section on useful and decorative objects in the dwelling) (Beijing: Zhongguo Yingcao Xueshe, 1931), 25b; Cao Xueqin, *Honglou meng* (A dream of red mansions) (Taipei: Zhonghua Shuju, 1971), vol. 3, *juan* 81, 1056; David Hawkes and John Minford, trans., *The Story of the Stone,* by Cao Xieqin (Harmondsworth, Eng.: Penguin, 1976–86), 4: 48.

33. Robert Hatfield Ellsworth, *Chinese Furniture: Hardwood Examples of the Ming and Early Ch'ing Dynasties* (New York: Random House, 1970), 226.

Chapter 14

Adapted from Handler, "Side Tables: A Surface for Treasures and the Gods," *Orientations* 27, no. 5 (May 1996): 32–41.

1. Colin Mackenzie, "Chu Bronze Work: A Unilinear Tradition or a Synthesis of Diverse Sources?" in *New Perspectives on Chu Culture during the Eastern Zhou Period,* ed. Thomas Lawton (Washington, D.C.: Arthur M. Sackler Gallery, Smithsonian Institution, 1991), 147.

2. Lothar von Falkenhausen, "Issues in Western Zhou Studies," *Early China* 18 (1993): 148–50.

3. Wang Shixiang, *Connoisseurship of Chinese Furniture: Ming and Early Qing Dynasties,* trans. Lark E. Mason Jr. et al. (Hong Kong: Joint Publishing Co., 1990), 1: 65.

4. David Tod Roy, trans., *The Plum in the Golden Vase, or Chin P'ing Mei,* vol. 1, *The Gathering* (Princeton: Princeton University Press, 1993), 132.

5. Chün-fang Yü, "Guanyin: The Chinese Transformation of Avalokiteshvara," in *Latter Days of the Law: Images of Chinese Buddhism, 850–1850,* ed. Marsha Weidner (Lawrence, Kans.: Spencer Museum of Art, 1994), 167.

6. Wen Zhenheng, *Zhang wu zu jiao zhu* (Treatise on superfluous things, annotated), ed. Yang Zhaobo, annotations by Chen Zhi (Nanjing: Jiangsu Kexue Jishu Chubanshe, 1984), 351.

7. Lu Shihua, *Shuhua shuo ling;* quotation translated by Robert van Gulik in his *Chinese Pictorial Art as Viewed by the Connoisseur* (Rome: Istituto Italiano per il Medio ed Estremo Oriente, 1958), 25.

8. Klaas Ruitenbeek, *Carpentry and Building in Late Imperial China: A Study of the Fifteenth-Century Carpenter's Manual "Lu Ban Jing"* (Leiden: E. J. Brill, 1993), 196.

9. Wang Shifu, *The Moon and the Zither: The Story of the Western Wing,* ed. and trans. with an introduction by Stephen H. West and Wilt L. Idema, with a study of its woodblock illustrations by Yao Dajuin (Berkeley: University of California Press, 1991), 211.

10. Ibid., 214.

11. Translation quoted in Cyril Birch, *The Peony Pavilion* (Bloomington: Indiana University Press, 1980), 150.

12. Judith T. Zeitlin, "Shared Dreams: The Story of the Three Wives' Commentary on *The Peony Pavilion,*" *Harvard Journal of Asiatic Studies* 54, no. 1 (June 1994): 146, 152.

13. Sheila Keppel, "The Well-Furnished Tomb, Part III," *Journal of the Classical Chinese Furniture Society* 4, no. 2 (Spring 1994): 48–55.

14. Joseph Needham, *Science and Civilisation in China* (Cambridge, Eng.: Cambridge University Press, 1954–), 9: 270.

15. Wang Shifu, *The Moon and the Zither,* 205.

16. Clement Egerton, trans., *The Golden Lotus: A Translation from the Chinese Original of the Novel Chin P'ing Mei* (Singapore: Graham Brash [PTE] Ltd., 1988), 2: 371.

17. Wen Zhenheng, *Zhang wu zu jiao zhu,* 233.

Chapter 15

Adapted from Handler, "Cabinets and Shelves Containing All Things in China," *Journal of the Classical Chinese Furniture Society* 4, no. 1 (Winter 1993): 4–29.

1. Hubei Sheng Bowuguan (Hubei Provincial Museum), *Zeng Hou Yi mu* (Tomb of Marquis Yi of Zeng) (Beijing: Wenwu Press, 1989), 1: 353–54.

2. Jao Tsung-i, in *New Perspectives on Chu Culture during the Eastern Zhou Period,* ed. Thomas Lawton (Washington, D.C.: Arthur M. Sackler Gallery, Smithsonian Institution, 1991), 177.

3. Hunan Sheng Bowuguan (Hunan Provincial Museum), *Changsha Mawangdui yihao Han mu* (Han tomb 1 at Mawangdui, Changsha), (Beijing: Wenwu Press, 1973), 2: 208–26, 168.

4. Han Wei, *Precious Cultural Relics in the Crypt of Famen Temple* (Xi'an: Shaanxi People's Fine Arts Publishing House, 1989), 36–37; Shōsōin Office, ed., *Treasures of the Shōsōin* (Tokyo: Asahi Shimbun Publishing Co., 1965), pl. 35; Sir Harry Garner, *Chinese Lacquer* (London: Faber & Faber, 1979), 160; Wang Shixiang, *Connoisseurship of Chinese Furniture: Ming and Early Qing Dynasties,* trans. Lark E.

Mason Jr. et al. (Hong Kong: Joint Publishing Co., 1990), 2: 94; Wan Yi, Wang Shuqing, and Lu Yanzhen, comps., *Daily Life in the Forbidden City: The Qing Dynasty, 1644–1912*, trans. Rosemary Scott and Erica Shipley (New York: Viking, 1988), 118.

5. Sheila Keppel, *China in 1700: Kangxi Porcelains at the Taft Museum* (Cincinnati: Taft Museum, 1988), 10.

6. Lina Lin, *Catalogue to the Special Exhibition of Furniture in Paintings* (Taipei: National Palace Museum, 1996), pl. 9.

7. Michèle Pirazzoli-t'Serstevens, "Le Mobilier en Chine à l'époque Han (206 av.–220 ap. J.C.)," *Journal des Savants* (Jan.–Mar. 1972): 39.

8. Translation from Klaas Ruitenbeek, *Carpentry and Building in Late Imperial China: A Study of the Fifteenth-Century Carpenter's Manual "Lu Ban Jing"* (Leiden: E. J. Brill, 1993), 264–67.

9. Bernhard Karlgren, *Grammata Serica: Script and Phonetics in Chinese and Sino-Japanese* (Taipei: Ch'eng Wen Publishing Co., 1971), 540h, 540g.

10. Translation by Willis Barnstone from *Gujin tushu jicheng* (Synthesis of books and illustrations of ancient and modern times) (1726; reprint, Taipei: Zhonghua Shuju, 1934), 797: 50b.

11. Translation adapted from L. Carrington Goodrich, "The Revolving Book-case in China," *Harvard Journal of Asiatic Studies* 7 (1942): 135.

12. Goodrich, "The Revolving Book-case"; J. Prip-Møller, *Chinese Buddhist Monasteries: Their Plan and Its Function as a Setting for Buddhist Monastic Life* (Hong Kong: Hong Kong University Press, 1982), 55–58; Piet Van der Loon, *Taoist Books in the Libraries of the Sung Period: A Critical Study and Index* (London: Ithaca Press, 1984), 40, 57.

13. Yang Jiong, *Yang Yingchuan ji* (Collected works of Yang Yingchuan) (Shanghai: Commercial Press, 1929), 1: 7a–8a.

14. Norimitsu Kimura, ed., *The Treasures of the Shōsōin: Furniture and Interior Furnishings* (Kyoto: Shikosha Art Books, 1992), 11, 51, 61.

15. Wang Shixiang, *Connoisseurship of Chinese Furniture*, 1: 82, 85.

16. Danielle Elisseeff and Vadime Elisseeff, *New Discoveries in China: Encountering History through Archaeology*, trans. Larry Lockwood (Secaucus, N.J.: Chartwell Books, 1983), 58.

17. Ibid., 58; Xiaoneng Yang, ed., *The Golden Age of Chinese Archaeology: Celebrated Discoveries from the People's Republic of China* (New Haven: Yale University Press, 1999), 246–47.

18. *Kokyō Hakubutsuin* (Palace Museum) (Tokyo: Kodansha, 1975), pl. 219; S. Umehara, *Shin-shū Senoku Sei-shō, or The Collection of Old Bronzes of Sumitomo*, rev. ed. (Kyoto: n.p., 1971), 1: pl. 6; *Gems of China's Cultural Relics, 1990* (Beijing: Wenwu Press, 1990), 52.

19. Gustav Ecke, *Chinese Domestic Furniture* (1944; reprint in reduced size, Rutland, Vt.: Charles E. Tuttle Co., 1962), 113.

20. Ruitenbeek, *Carpentry and Building in Late Imperial China*, 254.

21. Georges N. Kates, *Chinese Household Furniture* (New York: Hayes and Brothers, 1948), 29–30; Nancy Berliner, *Beyond the Screen: Chinese Furniture of the Sixteenth and Seventeenth Centuries* (Boston: Museum of Fine Arts, 1996), 82.

22. Craig Clunas, "The Novel *Jin Ping Mei* as a Source for the Study of Ming Furniture," *Orientations* 23, no. 1 (Jan. 1992): 67, 68; *Quanben Jin ping mei cihua* (Complete edition of the story of the plum in the golden vase) (Hong Kong: Taiping Shuju, 1982), vol. 2, *juan* 35, 4a; vol. 2, *juan* 31, 6b; vol. 4, *juan* 64, 4a.

23. Yoshikawa Kōjiro, *Five Hundred Years of Chinese Poetry, 1150–1650: The Chin, Yuan and Ming Dynasties*, trans. with a preface by John Timothy Wixted (Princeton: Princeton University Press, 1989),

131; Ye Xie, quoted in translation in Stephen Owen, *Readings in Chinese Literary Thought* (Cambridge, Mass.: Council on East Asian Studies, Harvard University, 1992), 518–19.

24. Pu Songling. *Pu Songling ji* (Collected works of Pu Songling) (Beijing: Zhonghua Shuju, 1962) 1: 742–43; Wen Zhenheng, *Zhang wu zu jiao zhu* (Treatise on superfluous things, annotated), ed. Yang Zhaobo, annotations by Chen Zhi (Nanjing: Jiangsu Kexue Jishu Chubanshe, 1984), 238.

25. Ernest Boerschmann, *Old China in Historic Photographs: 288 Views by Ernest Boerschmann,* with an introduction by Wan-go Weng (New York: Dover, 1982), 119; Grace Wu Bruce, *Dreams of Chu Tan Chamber and the Romance with Huanghuali Wood: The Dr. S. Y. Yip Collection of Classic Chinese Furniture,* with an introduction by Shing Yiu Yip (Hong Kong: n.p., 1991), 127; Wen Zhenheng, *Zhang wu zu jiao zhu,* 238.

26. Ji Cheng, *The Craft of Gardens,* trans. Alison Hardie (c. 1631; reprint, New Haven: Yale University Press, 1988), 85, 99, 100; Sir Michael Butler, Margaret Medley, and Stephen Little, *Seventeenth-Century Chinese Porcelain from the Butler Family Collection* (Alexandria, Virginia: International Art Service, 1990), 102; Lao Tzu, *Tao te ching: The Classic Book of Integrity and the Way,* trans., annotated, and with an afterword by Victor H. Mair (New York: Bantam Books, 1990), 76.

27. Ruitenbeek, *Carpentry and Building in Late Imperial China,* 262.

28. Li Yu, *Yijia yan jushi qiwan bu* (Independent words: The section on useful and decorative objects in the dwelling) (Beijing: Zhongguo Yingcao Xueshe, 1931), 30b.

29. Translation from Craig Clunas, *Chinese Furniture,* Victoria and Albert Museum Far Eastern Series (London: Bamboo Publishing, 1988), 80.

30. Cao Xueqin, *Honglou meng* (A dream of red mansions) (Taipei: Zhonghua Shuju, 1971), 2: 483.

31. Wang Qi, *Sancai tuhui* (Pictorial encyclopedia of heaven, earth, and man) (1609; reprint [3 vols.], Shanghai: Shanghai Guji Chubanshe, 1990), 2: 1339.

32. David Hawkes and John Minford, trans., *The Story of the Stone,* by Cao Xueqin (Harmondsworth, Eng.: Penguin, 1976–86), 2: 285; Cao Xueqin, *Honglou meng,* 2: 483.

33. Translated in C. R. Boxer, ed., *South China in the Sixteenth Century* (London: Hakluyt Society, 1953), 106.

34. *Jujia biyong shilei quanji* (A complete collection of necessary matters ordered for the householder) (c. 1600; reprint, Wanli ed., 10 *juan*), *juan* 1, 6b.

35. Translated by James Watt in Li Chu-tsing and James Watt, *The Chinese Scholar's Studio: Artistic Life in the Late Ming Period, An Exhibition from the Shanghai Museum* (New York: Asia Society Galleries, 1987), 5; see also Wen Zhenheng, *Zhang wu zu jiao zhu,* 18.

36. Kates, *Chinese Household Furniture,* 35.

37. See Wan, Wang, and Lu, *Daily Life in the Forbidden City,* 110.

38. Wen Zhenheng, *Zhang wu zu jiao zhu,* 240.

39. Wang Wei, *Laughing Lost in the Mountains: Selected Poems of Wang Wei,* trans. Tony Barnstone, Willis Barnstone, and Xu Haixin (Hanover, N.H.: University Presses of New England, 1991), 4.

Chapter 16

Adapted from Handler, "The Chinese Screen: Movable Walls to Divide, Enhance, and Beautify," *Journal of the Classical Chinese Furniture Society* 3, no. 3 (Summer 1993): 4–31.

1. Joseph Aronson, *The Encyclopedia of Furniture,* rev. 3rd ed. (New York: Crown Publishers, 1985), 363.

2. Teng Rensheng, *Lacquer Wares of the Chu Kingdoms* (Hong Kong: Woods Publishing Co., 1992), 107.

3. On the tomb of the Marquess of Dai, see Hunan Sheng Bowuguan (Hunan Provincial Museum), *Changsha Mawangdui yihao Han mu* (Han tomb 1 at Mawangdui, Changsha) (Beijing: Wenwu Press, 1973), 1: 36, 94; Yi Shui, "Manhua pingfeng—jiaju tanwang zhi yi" (Remarks on screens—Talks on furniture no. 1), *Wenwu*, no. 2 (1979): 74. On the Yinan screen, see Michael Sullivan, "Notes on Early Chinese Screen Painting," *Artibus Asiae* 27, no. 3 (1965): figs. 1, 4. On the Lelang screen, see A. Koidzumi and S. Sawa, *The Tomb of Painted Basket Lo-lang: Detailed Report of Archaeological Research* (Keijo and Seoul: Chosen Koseki Kenkyu Kwai [Society of the Study of Korean Antiquities], 1934), 1: pl. 44. On the Eastern Han screens, see Yi Shui, "Manhua pingfeng," 74–75.

4. Guangzhoushi Wenwu Guanliweiyuanhui (Guangzhou Board of Management for Cultural Relics), *Xi Han Nanyue wang mu* (Western Han tomb of a king of Nanyue) (Beijing: Cultural Relics Press, 1991), 1: 214, 433–51; Paula Swart, "The Tomb of the King of Nan Yue," *Orientations* 21, no. 6 (June 1990): 56–66.

5. Wu Hung, *The Wu Liang Shrine: The Ideology of Early Chinese Pictorial Art* (Stanford, Calif.: Stanford University Press, 1989), 52, 193–204. Wu Hung believes that actual screens were three-sided and that the two-panel screens are only a pictorial convention to allow the viewer to see the seated figures (*The Double Screen: Medium and Representation in Chinese Painting* [Chicago: University of Chicago Press, 1996], 19). The Anqiu engraving, however, shows a frontal view; depicting the other side panel would not have obstructed the view (see fig. 9.1).

6. Translated by Chou Ping and Willis Barnstone from *Guwen yuan* (Collection of ancient literature), Sibu Congkan ed. (Shanghai: Commercial Press, 1922), 3: 10a.

7. Ban Gu, *Han shu* (History of the former Han dynasty) (first century A.D.; reprint, Beijing: Zhonghua Press, 1962), 4200–4201; Liu Xiang quotation translated in Wu Hung, *The Wu Liang Shrine*, 171.

8. Kwang-chih Chang, *The Archaeology of Ancient China*, 4th rev. ed. (New Haven: Yale University Press, 1986), 355.

9. Rolf A. Stein, *The World in Miniature: Container Gardens and Dwellings in Far Eastern Religious Thought*, trans. Phyllis Brooks (Stanford, Calif.: Stanford University Press, 1990), 131, 109.

10. Ban Gu, *Han shu*, 2900; Sima Qian, *Shi ji* (Records of the grand historian) (first century B.C.; reprint, Beijing: Zhonghua Press, 1959), *juan* 75, 1b.

11. Robert van Gulik, *Sexual Life in Ancient China: A Preliminary Survey of Chinese Sex and Society from ca. 1500 B.C. till 1644 A.D.* (Leiden: E. J. Brill, 1974), 32.

12. Translated by Willis Barnstone from *Wei Jin Nan Bei chao wenxue shi cankao ziliao* (References for a literary history of the Wei, Jin, Southern, and Northern dynasties) (Beijing: Zhonghua Shuju, 1962), 678.

13. Wu Hung, *The Double Screen*, 88.

14. On Gu Kaizhi and Fang Huaizhen, see William Acker, *Some T'ang and Pre-T'ang Texts on Chinese Painting* (1954; reprint, Leiden: E. J. Brill, 1974), 2: 47, 154. On Yang Zihua and Cao Buxing, see Acker, *T'ang and Pre-T'ang Texts*, 2: 251, 4: 163.

15. Alexander Coburn Soper, *Textual Evidence for the Secular Arts of China in the Period from Liu Sung through Sui (A.D. 420–618), Excluding Treatises on Painting* (Ascona, Switz.: Artibus Asiae, 1967), 28, 29, 42–49.

16. Robert van Gulik, *Chinese Pictorial Art as Viewed by the Connoisseur* (Rome: Istituto Italiano per il Medio ed Estremo Oriente, 1958), 102, 34.

17. Trans. Acker, *Texts on Chinese Painting*, 1: 243–44.

18. Gulik, *Chinese Pictorial Art*, 159.

19. On Zhang Zao, see Michael Sullivan, "Early Chinese Screen Painting," 244. On Zhang Yanyuan, see Acker, *Texts on Chinese Painting*, 1: 200. On Du Fu, see David Hawkes, *A Little Primer of Tu Fu* (Hong Kong: Renditions Paperback, 1990), 146.

20. Translated by Willis Barnstone from *Gujin tushu jicheng* (Synthesis of books and illustrations of ancient and modern times) (1726; reprint, Taipei: Zhonghua Shuju, 1934), 799: 20.

21. J. D. Frodsham, *Goddesses, Ghosts, and Demons: The Collected Poems of Li He* (San Francisco: North Point Press, 1983), 84, 85, 124, 204.

22. Trans. Arthur Waley, *Ballads and Stories from Tun-huang: An Anthology* (London: Allen & Unwin, 1960), 198.

23. Acker, *Texts on Chinese Painting*, 1: 289.

24. Translated by Willis Barnstone from *Hanshan zi shi ji* (Hanshan's collected poems), Sibu Congkan 2nd ed. (Shanghai: Commercial Press, 1929), 489.

25. Guo Ruxu, *Tuhua jianwen zhi* (Experiences in painting), Yishu congbian ed. (Taipei: World Publishing Co., 1967), vol. 10, *juan* 5, 217.

26. Wang Renbo, ed., *Sui Tang wenhua* (Cultural relics of the Sui and Tang) (Hong Kong: China Publishing House, 1990), 85, 98–99.

27. Jirō Harada, *Treasures of the Shōsōin* (Tokyo: Asahi Shimbun-sha), 1960), 74–75.

28. Translated by Chou Ping and Willis Barnstone from *Gujin tushu jicheng*, 799: 20.

29. Dunhuang Wenwu Yanjiu, *Zhongguo shiku Dunhuang Moyao ku* (Chinese cave temples: The Mogao caves at Dunhuang) (Beijing: Cultural Relics Publishing House, 1982–87), vol. 5, pl. 11.

30. Datong Shi Bowuguan (Datong Museum), "Datong Jindai Ye Deyuan mu fajue jianbao" (Excavation of the Jin dynasty tomb of Ye Deyuan at Datong, Shanxi), *Wenwu*, no. 4 (1978): fig. 1.6.

31. Sullivan, "Early Chinese Screen Painting," 248.

32. Guo Ruxu, *Tuhua jianwen zhi*, 586–88; Sullivan, "Early Chinese Screen Painting," 251.

33. Translated by Chou Ping and Willis Barnstone from *Su ci* (Su's lyrics) (Hong Kong: Lingnan College, Chinese Department, 1992), 1020, no. 150.

34. Alexander Coburn Soper, trans. and ed., *Kuo Jo-hsü's Experience in Painting (Tu-hua chien-wen chih)* (Washington, D.C.: American Council of Learned Societies, 1951), 65.

35. Su Bai, *Baisha Song mu* (Song tombs at Baisha) (Beijing: Wenwu Press, 1957), pl. 22.

36. Wu Tung, *Tales from the Land of Dragons: 1,000 Years of Chinese Painting* (Boston: Museum of Fine Arts, 1997), 154; Wu Hung, *The Double Screen*, 22–23.

37. Sullivan, "Early Chinese Screen Painting," 247.

38. *Gujin tushu jicheng,* 799: 20a.

39. Zhao Xigu, *Dongtian qinglu ji* (Paltry earnings in the immortals' service), vol. 5 of *Zhongguo gudai meishu congshu* (A collection of ancient texts on Chinese art) (Beijing: Guoji Wenhua Press, 1993), 253–54.

40. Li Chu-tsing and James Watt, *The Chinese Scholar's Studio: Artistic Life in the Late Ming Period, An Exhibition from the Shanghai Museum* (New York: Asia Society Galleries, 1987), 69g; André Lévy, trans., *Fleur en fiole d'or (Jin ping mei cihua)* (Paris: Gallimard, 1985), 2: 242, 1: 380; Li and Watt, *Chinese Scholar's Studio,* 28c; *Guben xiju conggan chuji* (Collection of old editions of dramas) (Shanghai: Shangwu Yinshuguan, 1953), 31: 11b.

41. Pierre Rambach and Susanne Rambach, *Gardens of Longevity in China and Japan: The Art of the Stone Raisers,* trans. from the French by André Marling (New York: Rizzoli, 1987), 27.

42. Trans. John Hay, *Kernels of Energy, Bones of Earth: The Rock in Chinese Art* (New York: China Institute Gallery, 1986), 86.

43. Wen Zhenheng, *Zhang wu zu jiao zhu* (Treatise on superfluous things, annotated), ed. Yang Zhaobo, annotations by Chen Zhi (Nanjing: Jiangsu Kexue Jishu Chubanshe, 1984), 117.

44. Zhao Xigu, *Dongtian qinglu ji*, 253.

45. Wen Zhenheng, *Zhang wu zu jiao zhu*, 243–44.

46. James Cahill, *Parting at the Shore: Chinese Painting of the Early and Middle Ming Dynasty, 1368–1580* (New York: Weatherhill, 1978), 154–56.

47. Wang Shixiang, *Classic Chinese Furniture: Ming and Early Qing Dynasties,* trans. Sarah Handler and Wang Shixiang (Hong Kong: Joint Publishing Co., 1986), 226.

48. Klaas Ruitenbeek, *Carpentry and Building in Late Imperial China: A Study of the Fifteenth-Century Carpenter's Manual "Lu Ban Jing"* (Leiden: E. J. Brill, 1993), 219–22.

49. Grace Wu Bruce, *Dreams of Chu Tan Chamber and the Romance with Huanghuali Wood: The Dr. S. Y. Yip Collection of Classic Chinese Furniture,* with an introduction by Shing Yiu Yip (Hong Kong: n.p., 1991), 144.

50. Martin J. Powers, *Art and Political Expression in Early China* (New Haven: Yale University Press, 1991), 55, 79.

51. *Gems of China's Cultural Relics, 1992* (Beijing: Wenwu Press, 1992), 80.

52. Wang Qi, *Sancai tuhui* (Pictorial encyclopedia of heaven, earth, and man) (1609; reprint [3 vols.], Shanghai: Shanghai Guji Chubanshe, 1990), 3: 2223; Shen Yue quotation translated in Wu Hung, *The Wu Liang Shrine*, 236.

53. Ruitenbeek, *Carpentry and Building in Late Imperial China,* 222; James Cahill, "The Three Zhangs, Yangzhou Beauties, and the Manchu Court," *Orientations* 27, no. 9 (Oct. 1996): 63–65; Wu Hung, *The Double Screen*, 201–21.

54. Werner Speiser, Roger Goepper, and Jean Fribourg, *Chinese Art,* vol. 3, *Painting, Calligraphy, Stone Rubbing, Wood Engraving* (New York: Universe Books, 1964), pl. 80.

55. Translated by Willis Barnstone from *Zhu Shuzhen ji zhu* (Annotated collection of Zhu Shuzhen's poems) (Hangzhou: Zhejiang gu ji, 1985), 106–7.

Chapter 17

Adapted from Handler, "The Incense Stand and the Scholar's Mystical State," *Journal of the Classical Chinese Furniture Society* 1, no. 1 (Winter 1990): 4–10.

1. Edward H. Schafer, *The Golden Peaches of Samarkand: A Study of T'ang Exotics* (Berkeley: University of California Press, 1963), 159–60.

2. On *Boys at Play in a Garden,* see Roger Ward, comp. and ed., with the assistance of Eliot W. Rowlands, *A Bountiful Decade: Selected Acquisitions, 1977–1987, The Nelson-Atkins Museum of Art* (Kansas City, Mo.: The Nelson-Atkins Museum of Art, 1987), 90. On mythical beasts, see Schafer, *Golden Peaches of Samarkand,* 161. On extant stands, see Gerard Tsang and Hugh Moss, *Arts from the Scholar's Studio* (Hong Kong: Oriental Ceramic Society, 1986), 241.

3. Su Bai, *Baisha Song mu* (Song tombs at Baisha) (Beijing: Wenwu Press, 1957), 26.

4. Zhao Xigu, *Dongtian qinglu ji* (Paltry earnings in the immortals' service), vol. 5 of *Zhongguo gudai meishu congshu* (A collection of ancient texts on Chinese art) (Beijing: Guoji Wenhua Press, 1993), 234. Translation of Ming rules from Robert van Gulik, *Lore of the Chinese Lute: An Essay in the Ideology of the Ch'in* (Tokyo and Rutland, Vt.: Sophia University and Charles E. Tuttle Co., 1968), 50–55.

5. Wang Qi, *Sancai tuhui* (Pictorial encyclopedia of heaven, earth, and man) (1609; reprint [3 vols.], Shanghai: Shanghai Guji Chubanshe, 1990), 2: 1330.

6. Wu Tung, *Tales from the Land of Dragons: 1,000 Years of Chinese Painting* (Boston: Museum of Fine Arts, 1997), 169; David Tod Roy, trans., *The Plum in the Golden Vase, or Chin P'ing Mei,* vol. 1, *The Gathering* (Princeton: Princeton University Press, 1993), 361; Tsang and Moss, *Arts from the Scholar's Studio,* 238.

7. See *K'ing P'ing Mei in Pictures: Two Hundred Beauties, a Treasure of the Royal Palace* (1940; reprint [5 vols.], n.p., n.d.).

8. Wen Zhenheng, *Zhang wu zu jiao zhu* (Treatise on superfluous things, annotated), ed. Yang Zhaobo, annotations by Chen Zhi (Nanjing: Jiangsu Kexue Jishu Chubanshe, 1984), 351, 247.

9. Li Yu, *Yijia yan jushi qiwan bu* (Independent words: The section on useful and decorative objects in the dwelling) (Beijing: Zhongguo Yingcao Xueshe, 1931), 34b.

10. Nancy Berliner, *Beyond the Screen: Chinese Furniture of the Sixteenth and Seventeenth Centuries* (Boston: Museum of Fine Arts, 1996), 136.

11. Zhao Xigu, *Dongtian qinglu ji,* 221.

12. Guo Xi, *Linquan gaozhi* (The lofty message of forests and streams), Yishu congbian ed. (Taipei: World Publishing Co., 1967), vol. 10, no. 67, p. 19; translated in Arthur Waley, *Introduction to the Study of Chinese Painting* (London: Ernest Benn, 1923), 192–93.

Chapter 18

Adapted from Handler, "Carriers of Light: The Chinese Lampstand and Lantern," *Journal of the Classical Chinese Furniture Society* 1, no. 2 (Spring 1991): 19–35.

1. *Dao de jing,* chap. 52; translation from Arthur Waley, *The Way and Its Power: A Study of the Tao Tê Ching and Its Place in Chinese Thought* (New York: Grove Press, 1958), 206.

2. Nancy Shatzman Steinhardt, ed., *Chinese Traditional Architecture* (New York: China Institute in America, 1984), 144.

3. Edward H. Schafer, *The Golden Peaches of Samarkand: A Study of T'ang Exotics* (Berkeley: University of California Press, 1963), 259–60; Edwin O. Reischauer, trans., *Ennin's Diary: The Record of a Pilgrimage to China in Search of the Law* (New York: Ronald Press, 1955), 71.

4. Jacques Gernet, *Daily Life in China on the Eve of the Mongol Invasion, 1250–1276,* trans. from the French by H. M. Wright (Stanford, Calif.: Stanford University Press, 1962), 188.

5. Joseph Needham, *Science and Civilisation in China* (Cambridge, Eng.: Cambridge University Press, 1954–), vol. 4, part 1, 78–79; Song Yingxing, *T'ien-kung k'ai-wu: Chinese Technology in the Seventeenth Century,* trans. E-tu Zen Sun and Shio-chuan Sun (University Park: Pennsylvania State University Press, 1966), 216.

6. Needham, *Science and Civilisation,* 4: 78–80.

7. Song Yingxing, *T'ien-kung k'ai-wu,* 216, 220.

8. The position of the wick can be clearly seen in a seventeenth-century woodblock print in *Decorated Letter Paper from the Ten Bamboo Studio* (*Shizhuzhai jianpu*), in Zheng Zhenduo, *Zhongguo banhua shi tu lu* (An illustrated history of Chinese woodblock prints) (Shanghai: Zhongguo Banhua Shishe, 1940–42), 11: n.p. On the composition of the wick, see Rudolf P. Hommel, *China at Work: An Illustrated Record of the Primitive Industries of China's Masses, Whose Life Is Toil, and Thus an Account of Chinese Civilization* (Cambridge, Mass.: M.I.T. Press, 1969), 319.

9. Susan N. Erickson, "Money Trees of the Eastern Han Dynasty," *Bulletin of the Museum of Far Eastern Antiquities* 66 (1994): 28.

10. On the kneeling-ram lamp, see Danielle Elisseeff and Vadime Elisseeff, *New Discoveries in China:*

Encountering History through Archaeology, trans. Larry Lockwood (Secaucus, N.J.: Chartwell Books, 1983), 124. On the phoenix lamp in the tomb of Dou Wan, see Robert L. Thorp, *Son of Heaven: Imperial Arts of China* (Seattle: Son of Heaven Press, 1988), 182.

11. Robert Temple, *The Genius of China: 3,000 Years of Science, Discovery and Invention* (New York: Simon & Schuster, 1986), 130; Needham, *Science and Civilisation,* 70.

12. Temple, *The Genius of China,* 46–49, 87–88, 119–120.

13. On Song brick reliefs, see Su Bai, *Baisha Song mu* (Song tombs at Baisha) (Beijing: Wenwu Press, 1957), 26. On Liao tomb paintings, see Elisseeff and Elisseeff, *New Discoveries in China,* 75. On the wall painting at Xuanhua, see CPAM of Xuanhua District, Zhangjiakou (Zhangjiakou Shi Xuanhu Qu Wenwu Baoguan Suo), "Hebei Xuanhua Liaodai bihuamu" (A Liao dynasty tomb with mural paintings at Xuanhua, Hebei), *Wenwu,* no. 2 (1995): 25.

14. See James Cahill, *Parting at the Shore: Chinese Painting of the Early and Middle Ming Dynasty, 1368–1580* (New York: Weatherhill, 1978), color pl. 9; Weng Wan-go and Yang Boda, *The Palace Museum Peking: Treasures of the Forbidden City* (New York: Harry N. Abrams, 1982), 160.

15. Translation by James Cahill in Wen Fong and James Watt, *Possessing the Past: Treasures from the National Palace Museum, Taipei* (New York: Harry N. Abrams, 1996), 196.

16. *Jin ping mei cihua: Ming wanli dingsi ke ben* (Story of the plum in the golden vase: Edition from the *dingsi* year of the Wanli reign period of the Ming dynasty [1617]) (Taipei: Lian Jing Chubanshe Yegongsi, 1978), vol. 3, *juan* 42, 1b.

17. On the yellow hibiscus motif, see Terese Tse Bartholomew, "Botanical Motifs Relating to Chinese Furniture," *Journal of the Classical Chinese Furniture Society* 2, no. 4 (Autumn 1992): 47. On small table screens, see Wang Shixiang, *Classic Chinese Furniture: Ming and Early Qing Dynasties,* trans. Sarah Handler and Wang Shixiang (Hong Kong: Joint Publishing Co., 1986), 228. On doors, see Wang Qi, *Sancai tuhui* (Pictorial encyclopedia of heaven, earth, and man) (1609; reprint [3 vols.], Shanghai: Shanghai Guji Chubanshe, 1990), 2: 1018. On *zitan,* see Wang Shixiang and Curtis Evarts, *Masterpieces from the Museum of Classical Chinese Furniture* (Chicago: Chinese Art Foundation, 1995), 168.

18. Jessica Rawson, *Chinese Ornament: The Lotus and the Dragon* (London: British Museum, 1984), 110–14.

19. Kwang-chih Chang, *Shang Civilization* (New Haven: Yale University Press, 1980), 232; Gustav Ecke, *Chinese Domestic Furniture* (1944; reprint in reduced size, Rutland, Vt.: Charles E. Tuttle Co., 1962), 10.

20. James Cahill, *Shadows of Mt. Huang: Chinese Painting and Printing of the Anhui School* (Berkeley: University Art Museum, 1981), 31.

21. Wang Qi, *Sancai tuhui,* 2: 1345.

22. Institute of the History of Natural Sciences, Chinese Academy of Sciences, comp., *History and Development of Ancient Chinese Architecture* (Beijing: Science Press, 1986), 167.

23. Zheng Zhenduo, *Zhongguo banhua shi tu lu,* 5.

24. Translated by Willis Barnstone from Du Fu, *Du shi xiang zhu* (Annotated edition of Du's poems), annotated by Qiu Zhaoan (1638–after 1717) (Beijing: Zhongguo Shuzhu, 1995), vol. 4, *juan* 21, 1844.

25. Wang Wei, *Laughing Lost in the Mountains: Selected Poems of Wang Wei,* trans. Tony Barnstone, Willis Barnstone, and Xu Haixin (Hanover, N.H.: University Presses of New England, 1991), 153.

Chapter 19

Adapted from Handler, "Perfumed Coals in Precious Braziers Burn," *Journal of the Classical Chinese Furniture Society* 1, no. 3 (Summer 1991): 4–19.

1. David Hawkes and John Minford, trans., *The Story of the Stone,* by Cao Xueqin (Harmondsworth, Eng.: Penguin, 1976–86), 1: 159–60, 2: 572.

2. Institute of the History of Natural Sciences, Chinese Academy of Sciences, comp., *History and Development of Ancient Chinese Architecture* (Beijing: Science Press, 1986), 307.

3. On the eighth-century brazier in the Shōsōin, see Norimitsu Kimura, ed., *The Treasures of the Shōsōin: Furniture and Interior Furnishings* (Kyoto: Shikosha Art Books, 1992), 12. On the Dali marble brazier, see Jirō Harada, *Treasures of the Shōsōin* (Tokyo: Asahi Shimbun-sha, 1960), 1: 83; Kimura, *Treasures of the Shōsōin*, 63–64; Kazuko Koizumi, *Traditional Japanese Furniture*, trans. Alfred Birnbaum (Tokyo: Kodansha International, 1986), 156. On braziers in Tang poetry, see Kwang-chih Chang, ed., *Food in Chinese Culture: Anthropological and Historical Perspectives* (New Haven: Yale University Press, 1977), 124.

4. Wai-kam Ho, Sherman Lee, Laurence Sickman, and Marc Wilson, eds., *Eight Dynasties of Chinese Painting: The Collections of the Nelson Gallery–Atkins Museum, Kansas City, and the Cleveland Museum of Art* (Cleveland: Cleveland Museum of Art, 1980), 78.

5. Wang Zhen, *Nong shu, juan* 20, 11a, translated by Joseph Needham in *Science and Civilisation in China* (Cambridge, Eng.: Cambridge University Press, 1954–), vol. 5, part 9, 320–21.

6. Rudolf P. Hommel, *China at Work: An Illustrated Record of the Primitive Industries of China's Masses, Whose Life Is Toil, and Thus an Account of Chinese Civilization* (Cambridge, Mass.: M.I.T. Press, 1969), 309; Wilma Fairbank, *Adventures in Retrieval: Han Murals and Shang Bronze Molds* (Cambridge, Mass.: Harvard University Press, 1972), 126; L. Carrington Goodrich, *15th Century Illustrated Chinese Primer: Hsin-pien tui-hsiang szu-yen* (Hong Kong: Hong Kong University Press, 1967), n.p.

7. CPAM of Xuanhua District, Zhangjiakou (Zhangjiakou Shi Xuanhu Qu Wenwu Baoguan Suo), "Hebei Xuanhua Liaodai bihuamu" (A Liao dynasty tomb with mural paintings at Xuanhua, Hebei), *Wenwu*, no. 2 (1995): pl. 2.

8. Hawkes and Minford, *Story of the Stone*, 2: 484–85.

9. Klaas Ruitenbeek, *Carpentry and Building in Late Imperial China: A Study of the Fifteenth-Century Carpenter's Manual "Lu Ban Jing"* (Leiden: E. J. Brill, 1993), 258, 234.

10. Fu Xihua, *Zhongguo gudian wenxue banhua xuanji* (Selected woodblock illustrations to classical Chinese literature) (Shanghai: Renmin Meishu Chubanshe, 1981), 1: 487.

11. Hawkes and Minford, *Story of the Stone*, 2: 523, 4: 352.

12. Ibid., 4: 250; Li Yu, *Yijia yan jushi qiwan bu* (Independent words: The section on useful and decorative objects in the dwelling) (Beijing: Zhongguo Yingcao Xueshe, 1931), 26b, translated in Cyril Birch, *Anthology of Chinese Literature* (New York: Grove Press, 1972), 2: 154.

13. Hawkes and Minford, *Story of the Stone*, 1: 160, 2: 501, 516.

14. Translation from Ulrich Hausmann, "Keeping Warm in a Cold Study," in Paul Moss, *The Literati Mode: Chinese Scholar Paintings, Calligraphy and Desk Objects,* (London: Sydney L. Moss, 1986), 304.

15. Hommel, *China at Work,* 310.

16. Moss, *The Literati Mode,* 307, 314.

17. Hawkes and Minford, *Story of the Stone,* 2: 519–20, 538.

18. Institute of the History of Natural Sciences, *Ancient Chinese Architecture,* 308–11.

19. Hawkes and Minford, *Story of the Stone,* 2: 480, 486.

20. Ibid., 4: 208.

21. Hommel, *China at Work,* 310.

Chapter 20

Adapted from Handler, "Ablutions and Washing Clean: The Chinese Washbasin and Stand," *Journal of the Classical Chinese Furniture Society* 1, no. 4 (Autumn 1991): 23–36.

1. *"The I-Li,"* or *Book of Etiquette and Ceremonial,* trans. John Steele (Taipei: Ch'eng-wen Publish-

ing Co., 1966); Sarah Allen, *The Shape of the Turtle: Myth, Art, and Cosmos in Early China* (Albany: State University of New York Press, 1991), 107–11, 162; Wan Yi, Wang Shuqing, and Lu Yanzhen, comps., *Daily Life in the Forbidden City: The Qing Dynasty, 1644–1912*, trans. Rosemary Scott and Erica Shipley (New York: Viking, 1988), 31.

2. Edward H. Schafer, "The Development of Bathing Customs in Ancient and Medieval China and the History of the Floriate Clear Palace," *Journal of the American Oriental Society* 76 (1956): 59–67.

3. Sima Guang, *Sima shi shu yi*, Congshu jicheng ed. (1935–37), *juan* 10, 3a.; translated in Patricia Buckley Ebrey, ed., *Chinese Civilization and Society: A Sourcebook* (New York: Free Press, 1981), 80–81.

4. Danielle Elisseeff and Vadime Elisseeff, *New Discoveries in China: Encountering History through Archaeology*, trans. Larry Lockwood (Secaucus, N.J.: Chartwell Books, 1983), 167; *Yongle Gong* (Beijing: Renmin Meishu, 1964), 182; Jacques Gernet, *Daily Life in China on the Eve of the Mongol Invasion, 1250–1276*, trans. from the French by H. M. Wright (Stanford, Calif.: Stanford University Press, 1962), 125.

5. Laurence Sickman, "Chinese Classic Furniture" (paper presented at the annual meeting of the Oriental Ceramic Society, London, 1978), 13.

6. Li Fangyu and Long Baozhang, "Jindai Yu Yin mushi bihua" (Wall paintings from the Jin dynasty tomb of Yu Yin), *Wenwu*, no. 2 (1982): pl. 5.4.

7. CPAM, City of Shanghai, "Shanghaishi Luwan qu Ming Pan shi mu fajue jianbao (Excavations of the Ming dynasty tombs belonging to the Pan family in the Luwan district, Shanghai), *Kaogu*, no. 8 (1961): 426, 429.

8. Klaas Ruitenbeek, *Carpentry and Building in Late Imperial China: A Study of the Fifteenth-Century Carpenter's Manual "Lu Ban Jing"* (Leiden: E. J. Brill, 1993), 242.

9. Wang Qi, *Sancai tuhui* (Pictorial encyclopedia of heaven, earth, and man) (1609; reprint [3 vols.], Shanghai: Shanghai Guji Chubanshe, 1990), 2: 1123; *K'ing P'ing Mei in Pictures: Two Hundred Beauties, a Treasure of the Royal Palace* (1940; reprint [5 vols.], n.p., n.d.).

10. Gustav Ecke, *Chinese Domestic Furniture* (1944; reprint in reduced size, Rutland, Vt.: Charles E. Tuttle Co., 1962), 144.

11. Edouard Chavannes, *The Five Happinesses: Symbolism in Chinese Popular Art*, trans. Elaine Spaulding Atwood (New York: Weatherhill, 1973), 31, 118, 82; L. Carrington Goodrich, *15th Century Illustrated Chinese Primer: Hsin-pien tui-hsiang szu-yen* (Hong Kong: Hong Kong University Press, 1967), n.p.

12. Translation from the *Dao de jing* by Arthur Waley, *The Way and Its Power: A Study of the Tao Tê Ching and Its Place in Chinese Thought* (New York: Grove Press, 1958), 151.

WORKS CITED

Complete citations of the following works appear under the full title:

ZGLDHH *Zhongguo lidai huihua*
ZGMSQJ *Zhongguo meishu quanji*

Acker, William. *Some T'ang and Pre-T'ang Texts on Chinese Painting.* 1954. Reprint, Leiden: E. J. Brill, 1974.

Addis, J. M. *Chinese Ceramics from Datable Tombs and Some Other Dated Material: A Handbook.* London: Sotheby Parke Bernet, 1978.

Allen, Sarah. *The Shape of the Turtle: Myth, Art, and Cosmos in Early China.* Albany: State University of New York Press, 1991.

Anderson, E. N. *The Food of China.* New Haven: Yale University Press, 1988.

Anhui Sheng Wenwu Kaogu Yanjiusuo and Tianchang Xian Wenwu Guanlisuo (Institute of Cultural Relics of Anhui Province and CPAM, Tianchang County). "Anhui Tianchang xian Sanjiaowei Zhanguo Xi Han mu chutu" (Cultural relics unearthed from tombs of the Warring States period to the Western Han dynasty at Sanjiaowei in Tianchang county, Anhui). *Wenwu,* no. 9 (1993): 1–31.

Anyang Archaeological Team, 10 A. "Anyang Sui Zhang Sheng mu fajui ji" (Excavation of the Sui dynasty tomb of Zhang Sheng at Anyang). *Kaogu,* no. 10 (1959): 541–45.

Aronson, Joseph. *The Encyclopedia of Furniture.* Rev. 3rd ed. New York: Crown Publishers, 1985.

Baker, Hollis S. *Furniture in the Ancient World: Origins and Evolution, 3100–475 B.C.* London: Connoisseur, 1966.

Ban Gu. *Han shu* (History of the former Han dynasty). First century A.D. Reprint, Beijing: Zhonghua Press, 1962.

Barnhart, Richard M. *Painters of the Great Ming: The Imperial Court and the Zhe School.* Dallas: Dallas Museum of Art, 1993.

Bartholomew, Terese Tse. *The Hundred Flowers: Botanical Motifs in Chinese Art.* San Francisco: Asian Art Museum, 1985.

————. "Botanical Motifs Relating to Chinese Furniture." *Journal of the Classical Chinese Furniture Society* 2, no. 4 (Autumn 1992): 36–50.

Berliner, Nancy. *Beyond the Screen: Chinese Furniture of the Sixteenth and Seventeenth Centuries.* Boston: Museum of Fine Arts, 1996.

Berliner, Nancy, and Sarah Handler. *Friends of the House: Furniture from China's Towns and Villages.* Salem, Mass.: Peabody-Essex Museum, 1996.

Beurdeley, Michel. *The Chinese Collector through the Centuries, from the Han to the Twentieth Century.* Translated from the French by Diana Imber. Rutland, Vt.: Charles E. Tuttle Co., 1969.

————. *Chinese Furniture.* Translated by Katherine Watson. Tokyo: Kodansha International, 1979.

Bickford, Maggie. *Bones of Jade, Soul of Ice: The Flowering Plum in Chinese Art.* New Haven: Yale University Art Gallery, 1985.

Birch, Cyril. *Anthology of Chinese Literature.* 2 vols. New York: Grove Press, 1972.

————. *The Peony Pavilion.* Bloomington: Indiana University Press, 1980.

Bodde, Derk. *Annual Customs and Festivals in Peking as Recorded in the Yen-ching Sui-shih-chi by Tun Li-ch'en.* Hong Kong: Hong Kong University Press, 1987.

Boerschmann, Ernest. *Old China in Historic Photographs: 288 Views by Ernest Boerschmann.* With an introduction by Wan-go Weng. New York: Dover, 1982.

Bordewich, Fergus M. *Cathay: A Journey in Search of Old China.* New York: Prentice Hall, 1991.

Borges, Jorge Luis. *The Book of Imaginary Beings.* London: Cape, 1970.

Boxer, C. R., ed. *South China in the Sixteenth Century.* London: Hakluyt Society, 1953.

Braam Houckgeest, Andreas Everard van. *Voyage de l'ambassade de la Compagnie des Indes Orientales hollandaises, vers l'empéreur de la Chine, dans les années 1794 & 1795.* Philadelphia: privately published, 1797–98.

Brinken, Helmut. *Zen in the Art of Painting.* Translated by George Campbell. London: Arkana, 1987.

Bruce, Grace Wu. *Dreams of Chu Tan Chamber and the Romance with Huanghuali Wood: The Dr. S. Y. Yip Collection of Classic Chinese Furniture.* With an introduction by Shing Yiu Yip. Hong Kong: n.p., 1991.

————. "Ming Furniture: Some Examples of Fakes and Forgeries and Their Methods of Detection." *Orientations* 23 (Jan. 1992): 51–59.

————. *Ming Furniture.* Hong Kong: Grace Wu Bruce Co., 1995.

Bunker, Emma C. "Early Chinese Representations of Vimalakīrti." *Artibus Asiae* 30, no. 1 (1968): 28–52.

Butler, Sir Michael, Margaret Medley, and Stephen Little. *Seventeenth-Century Chinese Porcelain from the Butler Family Collection.* Alexandria, Virginia: Art Service International, 1990.

Cahill, James. *Chinese Painting*. New York: Rizzoli, 1977.

———. *Parting at the Shore: Chinese Painting of the Early and Middle Ming Dynasty, 1368–1580*. New York: Weatherhill, 1978.

———. *An Index of Early Chinese Painters and Paintings: T'ang, Sung, and Yüan*. Berkeley: University of California Press, 1980.

———. *Shadows of Mt. Huang: Chinese Painting and Printing of the Anhui School*. Berkeley: University Art Museum, 1981.

———. "The Three Zhangs, Yangzhou Beauties, and the Manchu Court." *Orientations* 27, no. 9 (Oct. 1996): 59–68.

———. "The Emperor's Erotica" (*Ching Yüan Chai so-shih II*). *Kaikodo Journal* 11 (Spring 1999): 24–43.

Cammann, Schuyler. "Some Strange Ming Beasts." *Oriental Art*, n.s., 3 (1956): 94–102.

Cao Guicen. "Henan Dancheng Han shi ta" (A Han stone platform from Dancheng, Henan). *Kaogu, no.* 5 (1965): 257–58.

Cao Xueqin. *Honglou meng* (A dream of red mansions). 4 vols. Taipei: Zhonghua Shuju, 1971.

Chang, Kwang-chih. *Shang Civilization*. New Haven: Yale University Press, 1980.

———. *The Archaeology of Ancient China*. 4th rev. ed. New Haven: Yale University Press, 1986.

———, ed. *Food in Chinese Culture: Anthropological and Historical Perspectives*. New Haven: Yale University Press, 1977.

Chang Renxia. *Handai yishu yanjiu* (A study of Han art). Shanghai: Shanghai Chuban Gongsi, 1955.

Chang Wan-li. *Three-Colours Glaze Pottery of the T'ang Dynasty*. 3 vols. Hong Kong: Yiwen Chubanshe, 1977.

Chapman, Helen B. *A Long Roll of Buddhist Images*. Revised by Alexander C. Soper. Ascona, Switz.: Artibus Asiae, 1971.

Chavannes, Edouard. *Mission archéologique dans la Chine septentrionale*. 13 vols. Paris: Imprimerie Nationale, 1913.

———. *The Five Happinesses: Symbolism in Chinese Popular Art*. Translated by Elaine Spaulding Atwood. New York: Weatherhill, 1973.

Ch'ên, H.-S., and George Kates. "Prince Kung's Palace and Its Adjoining Garden in Peking." *Monumenta Serica* 5 (1940): 1–85.

Chen Pin and Chen Jihua. "Jiangsu Wujin Cunqian Nan Song mu qingli jiyao" (Report on the excavation of Southern Song tombs at Cunqian, Wujin, Jiangsu province). *Kaogu*, no. 3 (1986).

Chen Zengbi. "Han, Wei, Jin duozhuoshi xiao ta chulun" (The first discussion of the small single-person *ta* during the Han, Wei, and Jin). *Wenwu*, no. 9 (1979): 66–71.

———. "Mawu jiantan" (Discussion of the folding stool for mounting horses). *Wenwu*, no. 4 (1980): 82–84.

———. "Qian nian gu ta" (A thousand-year-old pagoda). *Wenwu*, no. 6 (1984): 66–69.

———. "Shuangliu" (Double sixes). *Wenwu*, no. 4 (1982): 78–82. Translated in *Journal of the Classical Chinese Furniture Society* 2, no. 3 (Summer 1992): 48–55.

Cheng Dayue, ed. *Chengshi moyuan* (The Cheng family's ink catalog). 1606. East Asiatic Library, University of California, Berkeley.

Chinese Ceramic Tea Vessels: The K. S. Collection, Flagstaff House Museum of Tea Wares. Hong Kong: Urban Council, 1991.

The Chinese Exhibition: A Pictorial Record of the Exhibition of Archaeological Finds of the People's Republic of China. Kansas City, Mo.: Nelson Gallery–Atkins Museum, 1975.

Chūgoku no hakubutsukan (Chinese museums). Vol. 5, *Chūgoku Rekishi Hakubutsukan* (Chinese Historical Museum). Tokyo: Kodansha, 1982.

Cihai (Sea of words). Shanghai: Zhonghua Shuju, 1948.

Classical and Vernacular Chinese Furniture in the Living Environment: Examples from the Kai-Yin Lo Collection. Hong Kong: Yunmingtang, 1998.

Clunas, Craig. *Chinese Furniture*. Victoria and Albert Museum Far Eastern Series. London: Bamboo Publishing, 1988.

———. *Superfluous Things: Material Culture and Social Status in Early Modern China*. Urbana: University of Illinois Press, 1991.

———. "The Novel *Jin Ping Mei* as a Source for the Study of Ming Furniture." *Orientations* 23, no. 1 (Jan. 1992): 60–68.

Cohen, Monique, and Nathalie Monnet. *Impressions de Chine*. Paris: Bibliothèque Nationale, 1992.

CPAM, City of Shanghai. "Shanghaishi Luwan qu Ming Pan shi mu fajue jianbao" (Excavations of the Ming dynasty tombs belonging to the Pan family in the Luwan district, Shanghai). *Kaogu*, no. 8 (1961): 425–34.

CPAM, Jiangsu Province and the Nanjing Museum (Jiangsu sheng wenwu guanli wei yuan hui, Nanjing bowuguan). "Jiangsu Liuhe Chengqiao Dong Zhou mu" (Excavations of Eastern Zhou tomb at Chengqiao, Liuhe County, Jiangsu Province). *Kaogu*, no. 3 (1965): 105–15.

CPAM of Xuanhua District, Zhangjiakou (Zhangjiakou Shi Xuanhu Qu Wenwu Baoguan Suo). "Hebei Xuanhua Liaodai bihuamu" (A Liao dynasty tomb with mural paintings at Xuanhua, Hebei). *Wenwu*, no. 2 (1995): 4–28.

Dao Fuhai. "Shanxi Xiangfen xian chutu de Hongwu shiqi de lin chuang" (Hongwu era Ming wooden bed excavated at Xiangfen *xian*, Shanxi). *Wenwu*, no. 8 (1979): 25.

Datong Shi Bowuguan (Datong Museum). "Datong Jindai Ye Deyuan mu fajue jianbao" (Excavation of the Jin dynasty tomb of Ye Deyuan at Datong, Shanxi). *Wenwu*, no. 4 (1978): 1–7.

Dazu Rock Carvings Museum in Chongqing, comp. *Dazu Rock Carvings of China*. Chongqing: Wanli Book Co. and Chongqing Press, 1991.

DeWoskin, Kenneth J. "Music and Entertainment Themes in Han Funerary Sculpture." *Orientations* 18, no. 4 (April 1987): 34–40.

The Dictionary of Art. 34 vols. London: Macmillan, 1996.

Dittrich, Edith. *Das Westzimmer—Hsi-hsiang chi Chinesische Farbholzschnitte von Min Ch'i-chi 1640* (The west chamber—*Xixiang ji*: Chinese color woodcuts of Min Qiji). Cologne: Museum für Ostasiatische Kunst der Stadt Köln, 1977.

Droste, Magdalena. *Bauhaus*. Berlin: Benedik Taschen, 1990.

Drummond, William M. "Chinese Furniture: The Sackler Collections." Reprint of a
1969 lecture. *Journal of the Classical Chinese Furniture Society* 3, no. 3 (Summer 1993):
54–66.

Du Fu. *Du shi xiang zhu* (Annotated edition of Du's poems). Annotated by Qiu Zhaoan
(1638–after 1717). 5 vols. Beijing: Zhongguo Shuzhu, 1995.

Dunhuang Wenwu Yanjiu. *Zhongguo shiku Dunhuang Moyao ku* (Chinese cave temples: The
Mogao caves at Dunhuang). 5 vols. Beijing: Cultural Relics Publishing House, 1982–87.

Ebrey, Patricia Buckley. *Chinese Civilization and Society: A Sourcebook*. New York: Free
Press, 1981.

Ecke, Gustav. "Sechs Schaubilder Pekinger Innenraeume des Achtzehnten Jahrhunderts."
Bulletin of the Catholic University of Peking 9 (Nov. 1934): 155–69. Published in English
as "A Group of Eighteenth-Century Paintings of Beijing Interiors," trans. Martina
Bockert and Frank Wiegand, *Journal of the Classical Chinese Furniture Society* 4, no. 3
(Summer 1994): 60–70.

———. *Chinese Domestic Furniture*. 1944. Reprint in reduced size, Rutland, Vt.: Charles
E. Tuttle Co., 1962. Published in Chinese as *Zhongguo huali jiaju tukao* (Beijing:
Seismology Press, 1991).

———. "The Development of the Folding Chair: Notes on the History of the Form
of the Eurasian Chair." Translated by Martina Burkert. *Journal of the Classical Chinese
Furniture Society* 1, no. 1 (Winter 1990): 11–21.

———. "Notes on Chinese Furniture." *Orientations* 22, no. 11 (Nov. 1991): 69–77.

Ecke, Tseng Yuho. "Appendix to 'Notes on Chinese Furniture.'" *Orientations* 22, no. 11
(Nov. 1991): 78–83. Reprinted in *Chinese Furniture: Selected Articles from Orientations,
1984–1994* (Hong Kong: Orientations Magazine Ltd., 1990), 90–95.

Edgren, Sören. *Chinese Rare Books in American Collections*. New York: China Institute in
America, 1984.

Egerton, Clement, trans. *The Golden Lotus: A Translation from the Chinese Original of the
Novel Chin P'ing Mei*. 4 vols. Singapore: Graham Brash, 1988.

Elisseeff, Danielle. "A propos d'un cimetière Liao: Les belles dames de Xiabali." *Arts
Asiatiques* 49 (1994): 70–81.

Elisseeff, Danielle, and Vadime Elisseeff. *New Discoveries in China: Encountering History
through Archaeology*. Translated by Larry Lockwood. Secaucus, N.J.: Chartwell Books,
1983.

Ellsworth, Robert Hatfield. *Chinese Furniture: Hardwood Examples of the Ming and Early
Ch'ing Dynasties*. New York: Random House, 1970.

———. "Exhibition Review: A Profusion of Chinese Furnishings." *Orientations* 23,
no. 5 (May 1992): 82–84.

———. *Chinese Furniture: One Hundred Examples from the Mimi and Raymond Hung
Collection*. New York: privately published, 1996.

———. *Essence of Style: Chinese Furniture of the Late Ming and Early Qing Dynasties*. San
Francisco: Asian Art Museum of San Francisco, 1998.

Ennin, *Nitto guhō junrei gyōki* (The record of a pilgrimage to Tang in search of the law).
Edited by Adachi Kiroku. Tokyo: Zokugun Shoruito, 1970.

Erickson, Susan N. "*Boshanlu*—Mountain Censers of the Western Han Period: A Typological and Iconological Analysis." *Archives of Asian Art* 45 (1992): 6–28.

———. "Money Trees of the Eastern Han Dynasty." *Bulletin of the Museum of Far Eastern Antiquities* 66 (1994): 5–115.

"Essai sur l'architecture chinoise." MS Oe 13a. Bibliothèque nationale, Paris.

Evarts, Curtis. "The Development of the Waisted Form and Variations in Its Joinery." *Journal of the Classical Chinese Furniture Society* 1, no. 3 (Summer 1991): 36–45.

———. "The Nature and Characteristics of Wood and Related Observations of Chinese Hardwood Furniture." *Journal of the Classical Chinese Furniture Society* 2, no. 2 (Spring 1992): 28–40.

———. "Classical Chinese Furniture in the Piccus Collection." *Journal of the Classical Chinese Furniture Society* 2, no. 4 (Autumn 1992): 4–25.

———. "The Artistry of Chinese Furniture Joinery: A Manifold Expression." *Orientations* 24, no. 1 (Jan. 1993): 53–57.

Fairbank, Wilma. *Adventures in Retrieval: Han Murals and Shang Bronze Molds.* Cambridge, Mass.: Harvard University Press, 1972.

Falkenhausen, Lothar von. "Issues in Western Zhou Studies." *Early China* 18 (1993): 139–226.

Fan Ye. *Hou Han shu* (History of the Former Han). Bona ed. Shanghai: Commercial Press, 1932.

FitzGerald, C. P. *Barbarian Beds: The Origin of the Chair in China.* London: Cresset Press, 1965.

Flacks, M. D. *Classical Chinese Furniture.* Vol. 1. New York: M. D. Flacks, 1997.

Fong, Mary H. "The Origin of Chinese Pictorial Representation of the Human Figure." *Artibus Asiae* 49, nos. 1–2 (1988): 5–38.

Fong, Wen C., et al. *Images of the Mind: Selections from the Edward L. Elliott Family and John B. Elliott Collection of Chinese Calligraphy and Painting at the Art Museum, Princeton University.* Princeton, N.J.: The Art Museum, Princeton University, 1984.

———, ed. *The Great Bronze Age of China: An Exhibition from the People's Republic of China.* New York: Metropolitan Museum of Art, 1980.

Fong, Wen, and James Watt. *Possessing the Past: Treasures from the National Palace Museum, Taipei.* New York: Harry N. Abrams, 1996.

Fontein, Jan, and Money L. Hickman. *Zen Painting and Calligraphy.* Boston: Museum of Fine Arts, 1970.

Frodsham, J. D. *Goddesses, Ghosts, and Demons: The Collected Poems of Li He.* San Francisco: North Point Press, 1983.

From the Lands of the Scythians: Ancient Treasures from the Museums of the U.S.S.R., 3000 B.C.–100 B.C. New York: Metropolitan Museum of Art, n.d.

Fu Xihua. *Zhongguo gudian wenxue banhua xuanji* (Selected woodblock illustrations to classical Chinese literature). 2 vols. Shanghai: Renmin Meishu Chubanshe, 1981.

Fu Xinian. "Shaanxi Fufeng Shaochen Xi Zhou jianzhu yizhi chutan" (A preliminary inquiry into the remains of the Western Zhou buildings at Shaochen village in Fufeng county, Shaanxi). *Wenwu*, no. 3 (1981): 34–45.

———. "Survey: Chinese Traditional Architecture." In *Chinese Traditional Architecture,* edited by Nancy Shatzman Steinhardt, 10–33. New York: China Insitute in America, 1984.

Fung, Camille, and Alan Y. M. Fung. "Huanghuali." *Journal of the Classical Chinese Furniture Society* 1, no. 4 (Autumn 1991): 49–53.

Gao Lian. *Zun sheng ba jian* (Eight discourses on the art of living). Qinding Siku Quanshu ed. Vol. 871. Taipei: Commercial Press, 1983.

Garner, Sir Harry. *Chinese Lacquer.* London: Faber & Faber, 1979.

Gems of China's Cultural Relics, 1990. Beijing: Wenwu Press, 1990.

Gems of China's Cultural Relics, 1992. Beijing: Wenwu Press, 1992.

Gernet, Jacques. *Daily Life in China on the Eve of the Mongol Invasion, 1250–1276.* Translated from the French by H. M. Wright. Stanford, Calif.: Stanford University Press, 1962.

Giles, H. A. "Thousand Character Numerals Used by Artisans." *Journal of the Royal Asiatic Society, North China Branch* 20 (1885): 279.

Goodrich, L. Carrington. "The Revolving Book-case in China." *Harvard Journal of Asiatic Studies* 7 (1942): 130–61.

———. *15th Century Illustrated Chinese Primer: Hsin-pien tui-hsiang szu-yen.* Hong Kong: Hong Kong University Press, 1967.

Goodrich, L. Carrington, and Chaoying Fang, eds. *Dictionary of Ming Biography, 1368–1644.* 2 vols. New York: Cambridge University Press, 1976.

Grindley, Nicholas. *The Bended Back Chair.* London: Barling, 1990.

Guadalupi, Gianni, ed. *China: Arts and Daily Life as Seen by Father Matteo Ricci and Other Jesuit Missionaries.* Milan: Franco Maria Ricci, 1984.

Guangzhoushi Wenwu Guanliweiyuanhui (Guangzhou Board of Management for Cultural Relics). *Xi Han Nanyue wang mu* (Western Han tomb of a king of Nanyue). 2 vols. Beijing: Cultural Relics Press, 1991.

Guben xiju conggan chuji (Collection of old editions of dramas). Shanghai: Shangwu Yinshuguan, 1953.

Gujin tushu jicheng (Synthesis of books and illustrations of ancient and modern times). 1726. Reprint, Taipei: Zhonghua Shuju, 1934.

Gulik, Robert van. *Mi Fu on Ink-Stones.* Beijing: Henri Vetch, 1938.

———. *Chinese Pictorial Art as Viewed by the Connoisseur.* Rome: Istituto Italiano per il Medio ed Estremo Oriente, 1958.

———. *Lore of the Chinese Lute: An Essay in the Ideology of the Ch'in.* Tokyo and Rutland, Vt.: Sophia University and Charles E. Tuttle Co., 1968.

———. *Sexual Life in Ancient China: A Preliminary Survey of Chinese Sex and Society from ca. 1500 B.C. till 1644 A.D.* Leiden: E. J. Brill, 1974.

Guo Ruxu. *Tuhua jianwen zhi* (Experiences in painting). Yishu congbian ed. Vol. 10, no. 66. Taipei: World Publishing Co., 1967.

Guo Xi. *Linquan gaozhi* (The lofty message of forests and streams). Yishu congbian ed. Vol. 10, no. 67. Taipei: World Publishing Co., 1967.

Guwen yuan (Collection of ancient literature). Sibu Congkan ed. 4 vols. Shanghai: Commercial Press, 1922.

Han Wei. *Precious Cultural Relics in the Crypt of Famen Temple.* Xi'an: Shaanxi People's Fine Arts Publishing House, 1989.

Han, Zhongmin, and Hubert Delahaye. *A Journey through Ancient China.* New York: Gallery Books, 1985.

Hanan, Patrick. *The Invention of Li Yu.* Cambridge, Mass.: Harvard University Press, 1988.

Handler, Sarah. "The Korean and Chinese Furniture Tradition." *Korean Culture* 5, no. 2 (June 1984): 4–19.

———. "The Incense Stand and the Scholar's Mystical State." *Journal of the Classical Chinese Furniture Society* 1, no. 1 (Winter 1990): 4–10.

———. "Classical Chinese Furniture in the Renaissance Collection." *Orientations* 22, no. 1 (Jan. 1991): 42–51.

———. "Carriers of Light: The Chinese Lampstand and Lantern." *Journal of the Classical Chinese Furniture Society* 1, no. 2 (Spring 1991): 19–35.

———. "The Revolution in Chinese Furniture: Moving from Mat to Chair." *Asian Art* 4, no. 3 (Summer 1991): 9–33.

———. "Ablutions and Washing Clean: The Chinese Washbasin and Stand." *Journal of the Classical Chinese Furniture Society* 1, no. 4 (Autumn 1991): 23–36.

———. "The Elegant Vagabond: The Chinese Folding Armchair." *Orientations* 23, no. 1 (Jan. 1992): 90–96.

———. "A Ming Meditation Chair in Bauhaus Light." *Journal of the Classical Chinese Furniture Society* 3, no. 1 (Winter 1992): 26–38.

———. "Outstanding Pieces in Private Rooms: Chinese Classical Furniture in New American Collections." *Orientations* 24, no. 1 (Jan. 1993): 45–52.

———. "Cabinets and Shelves Containing All Things in China." *Journal of the Classical Chinese Furniture Society* 4, no. 1 (Winter 1993): 4–29.

———. "A Yokeback Chair for Sitting Tall." *Journal of the Classical Chinese Furniture Society* 3, no. 2 (Spring 1993): 4–23.

———. "Life on a Platform." *Journal of the Classical Chinese Furniture Society* 3, no. 4 (Autumn 1993): 4–20.

———. "The Ubiquitous Stool." *Journal of the Classical Chinese Furniture Society* 4, no. 3 (Summer 1994): 4–23.

———. "Square Tables Where the Immortals Dine." *Journal of the Classical Chinese Furniture Society* 4, no. 4 (Autumn 1994): 4–23.

Hansen, Valerie. *The Beijing Qingming Scroll and Its Significance for the Study of Chinese History.* Albany, N.Y.: *Journal of Sung-Yuan Studies,* 1996.

———. "The Mystery of the Qingming Scroll and Its Subject: The Case against Kaifeng." *Journal of Sung-Yuan Studies* 26 (1996): 183–200.

Hanshan. *Hanshan zi shi ji* (Hanshan's collected poems). Sibu Congkan 2nd ed. Shanghai: Commercial Press, 1929.

Harada, Jirō. *Treasures of the Shōsōin.* 18 vols. Tokyo: Asahi Shimbun-sha, 1960.

Harvard-Yenching Institute. *Shih Ching: A Concordance.* Sinological Index Series Supplement no. 9. Tokyo: Japan Council for East Asian Studies, 1962.

Haskins, John F. "The Pazyryk Felt Screen and the Barbarian Captivity of Ts'ai Wen Chi." *Bulletin of the Museum of Far Eastern Antiquities, Stockholm* 35 (1963): 141–60.

Hawkes, David. *A Little Primer of Tu Fu*. Hong Kong: Renditions Paperback, 1990.

———, trans. *The Songs of the South: An Ancient Chinese Anthology of Poems by Qu Yuan and Other Poets*. Harmondsworth, Eng.: Penguin, 1985.

Hawkes, David, and John Minford, trans. *The Story of the Stone*, by Cao Xueqin. 5 vols. Harmondsworth, Eng.: Penguin, 1976–86.

Hay, John. *Kernels of Energy, Bones of Earth: The Rock in Chinese Art*. New York: China House Gallery, 1986.

Henan Sheng Bowuguan (Henan Provincial Museum). "Lingbao Zhangwan Hanmu" (The Han tomb in Zhangwan, Lingbao). *Wenwu*, no. 11 (1975): 75–93.

Henan Sheng Wenwu Yanjiusuo (Cultural Relics Institute of Henan Province). *Xinyang Chumu* (Chu tombs at Xinyang). Beijing: Wenwu Press, 1986.

Ho, Wai-kam, Sherman Lee, Laurence Sickman, and Marc Wilson, eds. *Eight Dynasties of Chinese Painting: The Collections of the Nelson Gallery–Atkins Museum, Kansas City, and the Cleveland Museum of Art*. Cleveland: Cleveland Museum of Art, 1980.

Ho Zicheng. "Tang mu bihua" (Tang tomb paintings). *Wenwu*, no. 8 (1959): 31–33.

Holzman, Donald. "A propos de l'origine de la chaise en Chine." *T'oung-pao* 53, nos. 4–5 (1967): 279–92. Translated by Agnès Cartry under the title "On the Origin of the Chair in China." *Journal of the Classical Chinese Furniture Society* 2, no. 1 (Winter 1991): 61–68.

Hommel, Rudolf P. *China at Work: An Illustrated Record of the Primitive Industries of China's Masses, Whose Life Is Toil, and Thus an Account of Chinese Civilization*. Cambridge, Mass.: M.I.T. Press, 1969.

Huang Fengchi. *Tang shi huapu* (Illustrations to Tang poems). Seventeenth century.

Hubei Sheng Bowuguan (Hubei Provincial Museum). *Zeng Hou Yi mu* (Tomb of Marquis Yi of Zeng). 2 vols. Beijing: Wenwu Press, 1989.

Hubei Sheng Jing Sha Tielu Kaogudui (The Jingman-Shashi Railway Archaeological Team, Hubei province). *Baoshan chumu* (Chu cemetery at Baoshan). 2 vols. Beijing: Wenwu Press, 1991.

Hunan Sheng Bowuguan (Hunan Provincial Museum). *Changsha Mawangdui yihao Han mu* (Han tomb 1 at Mawangdui, Changsha). 2 vols. Beijing: Wenwu Press, 1973.

"The I-Li," or Book of Etiquette and Ceremonial. Translated by John Steele. Taipei: Ch'engwen Publishing Co., 1966.

Institute of the History of Natural Sciences, Chinese Academy of Sciences, comp. *History and Development of Ancient Chinese Architecture*. Beijing: Science Press, 1986.

Jacobsen, Robert D., with Nicholas Grindley. *Classical Chinese Furniture in the Minneapolis Institute of Arts*. Minneapolis: Minneapolis Institute of Arts, 1999.

Jenner, W. J. F. *Memories of Loyang, Yang Hsüan-chih and the Lost Capital, 493–534*. Oxford: Clarendon Press, 1981.

Jenyns, R. Soame, and William Watson. *Chinese Art: The Minor Arts—Gold, Silver, Bronze, Cloisonné, Cantonese Enamel, Lacquer, Furniture, Wood*. New York: Universe Books, 1963.

Ji Cheng. *The Craft of Gardens*. Translated by Alison Hardie. C. 1631. Reprint, New Haven: Yale University Press, 1988.

Jiangxi Sheng Wenwu Kaogu Yanjiusuo Lepingsheng Wenwu Chenlieshi (Leping Relics Exhibition Room, Jiangxi Institute of Archaeology). "Jiangxi Leping Songdai bihua mu" (Song tomb with murals at Leping, Jiangxi). *Wenwu*, no. 3 (1990): 14–18.

Jin ping mei cihua: Ming wanli dingsi ke ben (Story of the plum in the golden vase: Edition from the *dingsi* year of the Wanli reign period of the Ming dynasty [1617]). With illustrations from the Chongzhen reign period (1628–44). 20 vols. Taipei: Lian Jing Chubanshe Yegongsi, 1978.

Jinguo chutu wenwu zhenpin xuan (A selection of the treasures of archaeological finds of the People's Republic of China, 1976–1984). Beijing: Wenwu Press, 1987.

Jingzhou Museum, Hubei Province. *Jiangling Yutaishan Chu mu* (The Chu state tombs at Yutaishan, Jiangling). Beijing: Wenwu Press, 1984.

Jujia biyong shilei quanji (A complete collection of necessary matters ordered for the householder). Wanli ed., c. 1600. 10 *juan*.

Kao Ch'u-hsün, comp. *Hou Chia Chuang: The Yin-Shang Cemetery Site at Anyang, Honan*. Vol. 2, no. 1001 HPKM. Taipei: Institute of History and Philology, Academia Sinica, 1962.

Karlgren, Bernhard. *Grammata Serica: Script and Phonetics in Chinese and Sino-Japanese*. Taipei: Ch'eng-wen Publishing Co., 1971.

Karmay, Heather. *Early Sino-Tibetan Buddhist Art*. Warminster: Aries & Phillips, 1975.

Kates, George N. "A New Date for the Origins of the Forbidden City." *Harvard Journal of Asiatic Studies* 7 (Feb. 1943): 180–202.

———. *Chinese Household Furniture*. New York: Hayes and Brothers, 1948.

———. "Chinese Hardwood Furniture." *Antique Dealer and Collectors' Guide* (Sept. 1950). Reprinted in *Journal of the Classical Chinese Furniture Society* 2, no. 1 (Winter 1991): 28–60.

———. *The Years That Were Fat: The Last of Old China*. 1952. Reprint, edited and with an introduction by John Fairbank, Cambridge, Mass.: MIT Press, 1967. Reprint, with an introduction by Pamela Atwell, Oxford: Oxford University Press, 1988.

Keppel, Sheila. *China in 1700: Kangxi Porcelains at the Taft Museum*. Cincinnati: Taft Museum, 1988.

———. "The Well-Furnished Tomb, Part III." *Journal of the Classical Chinese Furniture Society* 4, no. 2 (Spring 1994): 44–56.

Kessler, Adam T. *Empires beyond the Great Wall: The Heritage of Genghis Khan*. Los Angeles: Natural History Museum of Los Angeles County, 1993.

Kimura, Norimitsu, ed. *The Treasures of the Shōsōin: Furniture and Interior Furnishings*. Kyoto: Shikosha Art Books, 1992.

K'ing P'ing Mei in Pictures: Two Hundred Beauties, a Treasure of the Royal Palace. 1940. Reprint (5 vols.), n.p., n.d.

Ko, Dorothy. "Pursuing Talent and Virtue: Education and Women's Culture in Seventeenth- and Eighteenth-Century China." *Late Imperial China* 13, no. 1 (June 1992): 9–39.

Koidzumi, A., and S. Sawa. *The Tomb of Painted Basket Lo-lang: Detailed Report of Archaeo-logical Research*. Vol. 1. Keijo: Chosen Koseki Kenkyu Kwai (Society of the Study of Korean Antiquities), 1934.

Koizumi, Kazuko. *Traditional Japanese Furniture*. Translated by Alfred Birnbaum. Tokyo: Kodansha International, 1986.

Kokyo Hakubutsuin (Palace Museum). Tokyo: Kodansha, 1975.

Lai, Peter, and Sandra Lai. *Classical Chinese Furniture: A Legacy of Refinement*. Hong Kong: Peter Lai Antiques, 1992.

Lao Tzu [Laozi, Lao Tsu]. *Tao te ching*. Translated by Feng Gia-fu and Jane English. New York: Vintage Books, 1989.

———. *Tao te ching: The Classic Book of Integrity and the Way*. Translated, annotated, and with an afterword by Victor H. Mair. New York: Bantam Books, 1990.

Lawton, Thomas. *Chinese Figure Painting*. Washington, D.C.: Freer Gallery of Art, 1973.

———, ed. *New Perspectives on Chu Culture during the Eastern Zhou Period*. Washington, D.C.: Arthur M. Sackler Gallery, Smithsonian Institution, 1991.

Legge, James, ed. and trans. *The Works of Mencius*. Vol. 11 of *The Chinese Classics: With a Translation, Critical and Exegetical Notes, Prolegomena, and Copious Indexes*. London: Trübner & Co., 1861.

Lévy, André, trans. *Fleur en fiole d'or (Jin ping mei cihua)*. 2 vols. Paris: Gallimard, 1985.

Li Chu-tsing. *A Thousand Peaks and Myriad Ravines: Chinese Paintings in the Charles A. Drenowatz Collection*. 2 vols. Ascona, Switz.: Artibus Asiae, 1974.

Li Chu-tsing and James Watt. *The Chinese Scholar's Studio: Artistic Life in the Late Ming Period, An Exhibition from the Shanghai Museum*. New York: Asia Society Galleries, 1987.

Li Fangyu and Long Baozhang. "Jindai Yu Yin mushi bihua" (Wall paintings from the Jin dynasty tomb of Yu Yin). *Wenwu*, no. 2 (1982): 149–51.

Li Jie. *Yingzao fashi* (Treatise on architectural methods). Shanghai: Commercial Press, 1954.

Li Rihua. *Zitaoxuan zazhui* (Miscellaneous notes from Purple Peach Pavilion). 1617. Reprint, Shanghai: Zhongyang Book Co., 1935.

Li Shizhen. *Bencao gangmu* (Materia medica). Siku Quanshu ed. 1596. Reprint (3 vols.), Taipei: Commercial Press, 1983.

Li Wai-yee. "Dream Visions of Transcendence in Chinese Literature and Painting." *Asian Art* 111, no. 4 (Fall 1990): 53–78.

Li Wenxin. "Liaoyang faxian di sanzuo bihua gumu" (Three ancient tombs with wall paintings discovered in Liaoyang). *Wenwu cankao ziliao*, no. 5 (1955): 15–42.

Li Xueqin. *Eastern Zhou and Qin Civilizations*. Translated by K. C. Chang. New Haven: Yale University Press, 1985.

Li Yanshou. *Nan shi* (Southern history). 3 vols. Beijing: Zhonghua Shuju, 1975.

Li Yu. *Yijia yan jushi qiwan bu* (Independent words: The section on useful and decorative objects in the dwelling). Beijing: Zhongguo Yingcao Xueshe, 1931.

———. *Li Yu quanji* (Li Yu's complete works). Vol. 12. Taipei: Zhengwen Chubanshe, 1970.

Liang Han Wei Jin shiyijia wenji (Collection of the writings of eleven authors from the Han, Wei, and Jin dynasties). 3 vols. Taipei: World Book Co., 1973.

Liao Ben. "Guangyuan Nan Song mu zaju, daqu shike kao" (A study of the stone carvings of *zaju* and *daqu* performances in Southern Song tombs at Guangyuan). *Wenwu*, no. 12 (1986): 25–61.

Liaoning Sheng Bowuguan (Liaoning Provincial Museum). *Liaoning Sheng Bowuguan* (Liaoning Provincial Museum). Vol. 3 of *Zhongguo bowuguan congshu* (The Museums of China). Beijing: Wenwu Press, 1983.

Lim, Lucy, ed. *Stories from China's Past: Han Dynasty Pictorial Tomb Reliefs and Archaeological Objects from Sichuan Province, People's Republic of China.* San Francisco: Chinese Culture Foundation of San Francisco, 1987.

Lin, Lina. *Catalogue to the Special Exhibition of Furniture in Paintings.* Taipei: National Palace Museum, 1996.

Lin Shouqin. *Zhongguo ximugong sunjie he gongyi yanjiu* (The craft of tenon making in fine woodwork during the Warring States period). Hong Kong: Chinese University Press, 1981.

Ling Yuan. "Zhao Feiyan waijuan" (Private history of Queen Feiyan). *Shuo fu* 17, *juan* 32, 20b–25b.

Liu Xi. *Shiming* (Explanation of names). Congshu jicheng ed. Shanghai: Commercial Press, 1939.

Liu Xiang. *Lienü zhuan* (Biographies of exemplary women). Illustrations attributed to Chiu Ying (c. 1495–1552). 1779 ed. Reprint, Beijing: Zhongguo Shudian, 1991.

Liu Zhiping. *A Brief History of Chinese Residential Architecture—Cities, Houses, Gardens.* Published in a single volume with *Residential Architecture of Sichuan,* by Wang Qiming. Beijing: Chinese Architecture and Building Press, 1990.

Looking at Patronage: Recent Acquisitions of the Asian Art Museum. San Francisco: Asian Art Museum, 1989.

Lu Ban jing jiang jia ching (The classic of Lu Ban, a mirror for craftsmen). Compiled by Sicheng Wurong. Chongzhen (1628–44) ed. Harvard-Yenching Library.

Mackenzie, Colin. "Chu Bronze Work: A Unilinear Tradition or a Synthesis of Diverse Sources?" In *New Perspectives on Chu Culture during the Eastern Zhou Period,* ed. Thomas Lawton, 107–58. Washington, D.C.: Arthur M. Sackler Gallery, Smithsonian Institution, 1991.

Mather, Richard B., ed. and trans. *Shih-shuo Hsin-yü: "A New Account of Tales of the World," by Liu I-ch'ing, with Commentary by Liu Chü.* Minneapolis: University of Minnesota Press, 1976.

Matsumoto, Kaneo, ed. *The Treasures of the Shōsōin: Musical Instruments, Dance Articles, Game Sets.* Tokyo: Shikosha Art Books, 1991.

McNair, Amy. "On the Date of the Shengmudian Sculptures at Jinci." *Artibus Asiae* 49, no. 3/4 (1988): 238–53.

Mi Fu. *Hua shi* (History of painting). *Yishu congbian* ed. Vol.10, no. 68. Taipei: World Publishing Co., 1967.

Min Qiji. *Xixiang ji* (Story of the western wing). 1640 edition.

Ming kan Xixiang ji quan tu (Complete illustrations to the Ming edition of the Story of the western wing). Shanghai: Renmin Meishu Chubanshe, 1983.

Moss, Paul. *The Literati Mode: Chinese Scholar Paintings, Calligraphy and Desk Objects.* With an essay by Ulrich Hausmann, "Keeping Warm in a Cold Study." London: Sydney L. Moss, 1986.

Munakata, Kiyohiko. *Sacred Mountains in Chinese Art.* Urbana: University of Illinois Press, 1990.

Murals from the Han to the Tang Dynasty. Beijing: Foreign Languages Press, 1974.

Murray, Julia K. "Didactic Art for Women: The *Ladies' Classic of Filial Piety.*" In *Flowering in the Shadows: Women in the History of Chinese and Japanese Paintings,* edited by Marsha Widner, 27–53. Honolulu: University of Hawaii Press, 1990.

Museum of the City of Suzhou. "Suzhou Huqiu Wang Xijue mu qingli lue" (A brief account of the tomb of Wang Xijui, Tiger Hill, Suzhou). *Wenwu,* no. 3 (1975): 51–56.

Nagahiro, Toshio. *Representational Art of the Six Dynasties Period.* Tokyo: Bijutsu Shuppan-sha, 1969.

Nanjing Bowuguan (Nanjing City Museum). "Nanjing Hujuguan Caohoucun Dong Jin mu" (Two Eastern Jin tombs at Hujuguan and Caohoucun, Nanjing). *Wenwu,* no. 1 (1988): 77–84.

Needham, Joseph. *Science and Civilisation in China.* 15 vols. Cambridge, Eng.: Cambridge University Press, 1954– .

———. *The Grand Titration: Science and Society in East and West.* London: Allen & Unwin, 1969.

Nei Menggu Jiefangyingzi Liao mu fajue jianbao" (Report on the discovery of a Liao tomb at Jiefangyingzi, Inner Mongolia). *Kaogu,* no. 4 (1979): 330–34.

Nei Menggu wenwu kaogu yanjiuso (Inner Mongolian Cultural Relics Research Institute), Zhelimu Meng Bowuguan (Zhelin Meng Museum). "Nei Menggu Kulun Qi qi ba hao Liao mu" (Liao tombs 7 and 8 in Kulun Banner, Inner Mongolia). *Wenwu,* no. 7 (1987): 74–84.

Nieuhof, Johan. *An Embassy from the East-India Company of the United Provinces to the Grand Tartar Cham, Emperor of China.* Translated by John Ogilby. 2nd ed. London: John Ogilby, 1673.

———. *Voyages and Travels to the East Indies, 1653–1670.* Singapore: Oxford University Press, 1988.

"Ningxia Helan xian Baisikou shuangta kancewei xiujianbao" (Reconnaissance and maintenance of the twin pagodas at Baisikou, Helan county, Ningxia). *Wenwu,* no. 8 (1991): 14–26.

Osaka Exchange Exhibition: Paintings from the Abe Collection and Other Masterpieces of Chinese Art. San Francisco: Center of Asian Art and Culture, 1970.

Ouyang Xiu. *Ouyang Wenzhonggong ji* (The complete literary works of Ouyang Xiu). Guoxue jiben congshu ed. Shanghai: Commercial Press, 1933.

Owen, Stephen. *Readings in Chinese Literary Thought.* Cambridge, Mass.: Council on East Asian Studies, Harvard University, 1992.

Paintings of the Ming Dynasty from the Palace Museum. Hong Kong: Art Gallery, Chinese University of Hong Kong, 1988.

Palace Museum, comp. and ed. *Court Painting of the Qing Dynasty.* Beijing: Wenwu Press, 1992.

People's Sports Publishing House, Beijing, ed. *Sports in Ancient China.* Hong Kong: Tai Dao Publishing, 1986.

Pirazzoli-t'Serstevens, Michèle. "The Art of Dining in the Han Period: Food Vessels from Tomb No. 1 at Mawangdui." *Food and Foodways* 4 (1991): 209–19.

———. "Le Mobilier en Chine à l'époque Han (206 av.–220 ap. J.C.)" *Journal des Savants* (Jan.–Mar. 1972): 2–42. Published in English as "Chinese Furniture of the Han Dynasty (206 B.C.–A.D. 220)," *Journal of the Classical Chinese Furniture Society* 1, no. 3 (Summer 1991): 52–63.

———, ed. *La Cina.* Vol. 1. Torino: UTET, 1996.

Powers, Martin J. *Art and Political Expression in Early China.* New Haven: Yale University Press, 1991.

Prip-Møller, J. *Chinese Buddhist Monasteries: Their Plan and Its Function as a Setting for Buddhist Monastic Life.* Hong Kong: Hong Kong University Press, 1982.

Pu Anguo. "A Discussion of Ming-Style Furniture, in Two Parts." *Journal of the Classical Chinese Furniture Society* 2, no. 4 (Autumn 1992): 26–35.

Pu Songling. *Pu Songling ji* (Collected works of Pu Songling). 2 vols. Beijing: Zhonghua Shuju, 1962.

Quan Tang shi (Complete poems of the Tang dynasty). Vol. 7. Taipei: Minglun Chuban-she, 1970.

Quanben Jin ping mei cihua (Complete edition of the story of the plum in the golden vase). 6 vols. Hong Kong: Taiping Shuju, 1982.

Rambach, Pierre. *The Secret Message of Tantric Buddhism.* New York: Rizzoli, 1979.

Rambach, Pierre, and Susanne Rambach. *Gardens of Longevity in China and Japan: The Art of the Stone Raisers.* Translated from the French by André Marling. New York: Rizzoli, 1987.

Rawson, Jessica. "Eccentric Bronzes of the Early Western Zhou." *Transactions of the Oriental Ceramic Society* 47 (1982–83): 11–23.

———. *Chinese Ornament: The Lotus and the Dragon.* London: British Museum, 1984.

———. *Western Zhou Ritual Bronzes from the Arthur M. Sackler Collection.* 2 vols. Washington, D.C.: Arthur M. Sackler Foundation, 1990.

Recent Discoveries in Chinese Archaeology: 28 Articles by Chinese Archaeologists Describing Their Excavations. Beijing: Foreign Language Press, 1984.

Reischauer, Edwin O., trans. *Ennin's Diary: The Record of a Pilgrimage to China in Search of the Law.* New York: Ronald Press, 1955.

Ren Rixin. "Shandong Zhucheng Han mu huaxiang shi" (Stone engravings from a Han dynasty tomb in Zhucheng, Shandong). *Wenwu,* no. 10 (1981): 14–24.

Rhie, Marylin M., and Robert A. F. Thurman. *Wisdom and Compassion: The Sacred Art of Tibet.* New York: Harry N. Abrams, 1991.

Roy, David Tod, trans. *The Plum in the Golden Vase, or Chin P'ing Mei*. Vol. 1, *The Gathering*. Princeton: Princeton University Press, 1993.

Rudenko, Sergei I. *Frozen Tombs of Siberia: The Pazyryk Burials of Iron Age Horsemen*. Translated and with a preface by M. W. Thompson. Berkeley: University of California Press, 1970.

Ruitenbeek, Klaas. *Carpentry and Building in Late Imperial China: A Study of the Fifteenth-Century Carpenter's Manual "Lu Ban Jing."* Leiden: E. J. Brill, 1993.

Schafer, Edward H. "The Development of Bathing Customs in Ancient and Medieval China and the History of the Floriate Clear Palace," *Journal of the American Oriental Society* 76 (1956): 57–82.

———. "Rosewood, Dragon's Blood, and Lac." *Journal of the American Oriental Society* 7, no. 8 (April–June 1957): 129–36.

———. *The Golden Peaches of Samarkand: A Study of T'ang Exotics*. Berkeley: University of California Press, 1963.

Schipper, Kristofer. *The Taoist Body*. Translated by Karen C. Duval. Berkeley: University of California Press, 1993.

Sembach, Klaus-Jürgen, Gabriele Leuthäuser, and Peter Gössel. *Twentieth-Century Furniture Design*. Cologne: Taschen, n.d.

Service, Grace. *Golden Inches: The China Memoir of Grace Service*. Edited by John S. Service. Berkeley: University of California Press, 1989.

"Shaanxi Maoling yi hao wuming zhong yi yao cong zangkeng de fajue" (Excavation of satellite shaft 1 of unknown tomb 1 near Maoling mausoleum, Shaanxi province). *Wenwu*, no. 9 (1982): 1–17.

Shanghai Bowuguan (Shanghai Museum). Vol. 8 of *Zhongguo bowuguan congshu* (The museums of China). Beijing: Wenwu Press, 1985.

———. "Chinese Painting and Calligraphy Exhibit." Shanghai: Shanghai Museum, n.d.

Shanxi Sheng Kaogu Yanjiusuo (Shanxi Institute of Archaeology). "Shanxi Jishan Jin mu fajue jiaobao" (Excavation of the Jin dynasty tomb at Jishan, Shanxi province). *Wenwu*, no. 1 (1983): 45–63.

Shanxi Sheng Wenwu guanli weiyuan hui (Shanxi Province Cultural Relics Committee Members). "Shanxi Changzhi Fengsuiling gu mu de qingli" (Excavations of ancient graves at Fengsuiling, Changzhi, Shanxi province). *Kaogu xuebao* 1 (1957): 103–10.

Shao Wenliang. *Sports in Ancient China*. Edited by People's Sports Publishing House, Beijing. Hong Kong: Tai Dao Publishing, 1986.

Shōsōin Office, ed. *Treasures of the Shōsōin*. Tokyo: Asahi Shimbun Publishing Co., 1965.

Shuihuzhuan (Water margin). Jianyang: Yu Shi Shuangfengtang, 1588–94.

Sickman, Laurence. "A Sixth-Century Buddhist Stele." *Apollo* 97, no. 133 (March 1973): 220–305.

———. "Chinese Classic Furniture." Paper presented at the annual meeting of the Oriental Ceramic Society, London, 1978.

———, ed. *Chinese Calligraphy and Painting in the Collection of John M. Crawford, Jr.* New York: Pierpont Morgan Library, 1962.

Siggstedt, Mette. "Chinese Root Furniture." *Bulletin of the Museum of Far Eastern Antiquities* 63 (1991): 143–80.

Sima Guang. *Sima shi shu yi.* Congshu jicheng ed. Shanghai: Commercial Press, 1935–37.

———. *Zi zhi tung jian* (Comprehensive mirror for aid in government). 4 vols. Hong Kong: China Book Co., 1971.

Sima Qian. *Shi ji* (Records of the grand historian). First century B.C. Reprint, Beijing: Zhonghua Press, 1959.

Sirén, Osvald. *Chinese Painting: Leading Masters and Principles.* Vol. 1. New York: Ronald Press, 1956–58.

Smith, Bradley, and Wan-go Weng. *China: A History in Art.* New York: Doubleday, n.d.

Song Yingxing. *T'ien-kung k'ai-wu: Chinese Technology in the Seventeenth Century.* Translated by E tu Zen Sun and Shio-chuan Sun. University Park: Pennsylvania State University Press, 1966.

Songren huace (Album paintings of Song artists). 10 vols. Beijing: Wenwu Press, n.d.

Soper, Alexander Coburn. *Textual Evidence for the Secular Arts of China in the Period from Liu Sung through Sui (A.D. 420–618), Excluding Treatises on Painting.* Ascona, Switz.: Artibus Asiae, 1967.

———, trans. and ed. *Kuo Jo-hsü's Experience in Painting (T'u-hua chien-wen chih).* Washington, D.C.: American Council of Learned Societies, 1951.

Speiser, Werner, Roger Goepper, and Jean Fribourg. *Chinese Art.* Vol. 3, *Painting, Calligraphy, Stone Rubbing, Wood Engraving.* New York: Universe Books, 1964.

Spence, Jonathan D. *Emperor of China: Self-portrait of K'ang-hsi.* New York: Vintage Books, 1975.

Sports and Games in Ancient China. Beijing: New World Press, 1986.

Sprigg, June. *Shaker Design.* New York: Whitney Museum of American Art, 1986.

Stein, Rolf A. *The World in Miniature: Container Gardens and Dwellings in Far Eastern Religious Thought.* Translated by Phyllis Brooks. Stanford, Calif.: Stanford University Press, 1990.

Steinhardt, Nancy Shatzman. "Yuan Period Tombs and Their Decoration: Cases at Chifeng." *Oriental Art* 36, no. 4 (1990/91): 198–218.

———, ed. *Chinese Traditional Architecture.* New York: China Institute in America, 1984.

Stone, Louise Hawley. *The Chair in China.* Toronto: Royal Ontario Museum, 1952.

Strassberg, Richard E. *Inscribed Landscapes: Travel Writing from Imperial China.* Berkeley: University of California Press, 1994.

Su Bai. *Baisha Song mu* (Song tombs at Baisha). Beijing: Wenwu Press, 1957.

Su ci (Su's lyrics). Hong Kong: Lingnan College, Chinese Department, 1992.

Sullivan, Michael. "Notes on Early Chinese Screen Painting." *Artibus Asiae* 27, no. 3 (1965): 239–64.

Suzhou Bowuguan, Jiangyin Xian Wenhua Zhongxin (Suzhou Museum and Cultural Center of Jiangyin). "Jiangyin Bei Song Ruichang Xiangjun Sun si niangzi mu" (The Northern Song tomb of Fourth Lady Sun, Princess Ruichang, at Jiangyin). *Wenwu,* no. 12 (1982): 28–35.

Swart, Paula. "The Tomb of the King of Nan Yue." *Orientations* 21, no. 6 (June 1990): 56–66.

Sze, Mai-mai. *The Tao of Painting: A Study of the Ritual Disposition of Chinese Painting, with a Translation of the "Chieh Tzu Yan Hua Chuan," or "Mustard Seed Garden Manual of Painting," 1679–1701*. Princeton: Princeton University Press, 1967.

Taiyuan Shi Wenwu Quanli Weiyuanhui (Official Cultural Relics Committee for Taiyuan City) and Shanxi Jinci Wenwu Baoguan Suo (Institute for the Preservation of Cultural Relics in Jinci, Shanxi), eds. *Jinci*. Beijing: Wenwu, 1981.

Tang Xianzu. *Mudan ting* (The peony pavilion). 1617. With woodblock illustrations carved by Huang Xifeng (b. 1583).

Temple, Robert. *The Genius of China: 3,000 Years of Science, Discovery and Invention*. New York: Simon & Schuster, 1986.

Teng Rensheng. *Lacquer Wares of the Chu Kingdoms*. Hong Kong: Woods Publishing Co., 1992.

Thorp, Robert L. *Son of Heaven: Imperial Arts of China*. Seattle: Son of Heaven Press, 1988.

Tian Jiaqing. *Classic Chinese Furniture of the Qing Dynasty*. London and Hong Kong: Philip Wilson Publishers and Joint Publishing Co., 1996.

Tokyo National Museum, comp. *Sōgen no Kaiga* (Song and Yuan painting). Kyoto: Benrido, 1962.

Trigault, Nicolas. *The China That Was: China as Discovered by the Jesuits at the Close of the Sixteenth Century*. Translated by L. J.Gallagher, S. J. Milwaukee: Brace, 1942.

Tsang, Gerard, and Hugh Moss. *Arts from the Scholar's Studio*. Hong Kong: Oriental Ceramic Society, 1986.

Tu Long. *Kao pan yu shi* (Desultory remarks on furnishing the abode of the retired scholar). *Yishu congbian* ed. Vol. 28, no. 249. Taipei: Shijie Shuju Yinhang, 1962

Tucci, Giuseppe. *Transhimalaya*. Geneva: Nagel Publishers, 1973.

Umehara, S. *Shin-shū Sen-oku Sei-sho, or The Collection of Old Bronzes of Sumitomo*. 2 vols. Rev. ed. Kyoto: n.p., 1971.

Van der Loon, Piet. *Taoist Books in the Libraries of the Sung Period: A Critical Study and Index*. London: Ithaca Press, 1984.

Vinograd, Richard. *Boundaries of the Self: Chinese Portraits, 1600–1900*. Cambridge, Eng.: Cambridge University Press, 1992.

Waley, Arthur. *Introduction to the Study of Chinese Painting*. London: Ernest Benn, 1923.

———. *The Way and Its Power: A Study of the Tao Tê Ching and Its Place in Chinese Thought*. New York: Grove Press, 1958.

———. *Ballads and Stories from Tun-huang: An Anthology*. London: Allen & Unwin, 1960.

———, trans. *The Book of Songs*. New York: Grove Press, 1960.

Wan Yi, Wang Shuqing, and Lu Yanzhen, comps. *Daily Life in the Forbidden City: The Qing Dynasty, 1644–1912*. Translated by Rosemary Scott and Erica Shipley. New York: Viking, 1988.

Wang Fangyu and Richard Barnhart. *Master of the Lotus Garden: The Life and Art of Bada Shanren (1626–1705)*. New Haven: Yale University Press, 1990.

Wang Gai, ed. *Jieziyuan huachuan* (Painting Manual of the Mustard Seed Garden). Preface by Li Yu dated 1679. Taipei: Universal Book Co., 1968.

Wang Qi. *Sancai tuhui* (Pictorial encyclopedia of heaven, earth, and man). 1609. Reprint (3 vols.), Shanghai: Shanghai Guji Chubanshe, 1990.

Wang Renbo, ed. *Sui Tang wenhua* (Cultural relics of the Sui and Tang). Hong Kong: China Publishing House, 1990.

Wang Shifu. *The Moon and the Zither: The Story of the Western Wing*. Edited and translated with an introduction by Stephen H. West and Wilt L. Idema. With a study of its woodblock illustrations by Yao Dajuin. Berkeley: University of California Press, 1991.

Wang Shixiang. *Classic Chinese Furniture: Ming and Early Qing Dynasties*. Translated by Sarah Handler and Wang Shixiang. Hong Kong: Joint Publishing Co., 1986.

————. *Connoisseurship of Chinese Furniture: Ming and Early Qing Dynasties*. Translated by Lark E. Mason Jr. et al. 2 vols. Hong Kong: Joint Publishing Co., 1990.

————. "Development of Furniture Design and Construction from the Song to the Ming." *Orientations* 22, no. 1 (Jan. 1991): 58–71.

————. "Jichimu Platform-Type Daybed." *Journal of the Classical Chinese Furniture Society* 1, no. 2 (Spring 1991): 4–13.

————. "Additional Examples of Classical Chinese Furniture." *Orientations* 23, no. 1 (Jan. 1992): 40–50.

Wang Shixiang and Curtis Evarts. *Masterpieces from the Museum of Classical Chinese Furniture*. Chicago: Chinese Art Foundation, 1995.

Wang Tingna, ed. *Renjing yangqiu* (Biographies of exemplary people). Shexian: Huancuitang, 1610.

Wang Wei. *Laughing Lost in the Mountains: Selected Poems of Wang Wei*. Trans. Tony Barnstone, Willis Barnstone, and Xu Haixin. Hanover, N.H.: University Presses of New England, 1991.

Wang Yi. *Chu ci* (The songs of the south). Congshu jicheng ed. Shanghai: Commercial Press, 1939.

Wang Zengxin. "Liaoyangshi Bangtaizi er hao bihua mu" (Wall painting in tomb no. 2, Bangtaizi, Liaoyang City). *Kaogu*, no. 1 (1960): 20–23.

Wang Zhen. *Nong shu*. 1530 ed. In *Bai bu cong shu*, vol. 27, no. 38.

Wang Zhongzhu. "Handai wuzhi wenhua lueshuo" (Remarks on Han dynasty material culture). *Kaogu tongxun*, no. 1 (1956): 57–76.

Wanscher, Ole. *Sella Curulis: The Folding Stool, an Ancient Symbol of Dignity*. Copenhagen: Rosenkilde and Bagger, 1980.

Ward, Roger, comp. and ed., with the assistance of Eliot W. Rowlands. *A Bountiful Decade: Selected Acquisitions, 1977–1987, The Nelson-Atkins Museum of Art*. Kansas City, Mo.: The Nelson-Atkins Museum of Art, 1987.

Watson, Burton, trans. and ed. *The Columbia Book of Chinese Poetry: From Early Times to the Thirteenth Century*. New York: Columbia University Press, 1984.

Watt, James C. Y. "The Literati Environment." In *The Chinese Scholar's Studio: Artistic Life in the Late Ming Period, an Exhibition from the Shanghai Museum*. Edited by Chu-tsing Li and James C. Y. Watt. New York: Asia Society Galleries, 1987.

Wei Jin Nan Bei chao wenxue shi cankao ziliao (References for a literary history of the Wei, Jin, Southern, and Northern dynasties). Beijing: Zhonghua Shuju, 1962.

Wen Zhenheng. *Zhang wu zu jiao zhu* (Treatise on superfluous things, annotated). Edited by Yang Zhaobo. Annotations by Chen Zhi. Nanjing: Jiangsu Kexue Jishu Chubanshe, 1984.

Weng Wan-go and Yang Boda. *The Palace Museum Peking: Treasures of the Forbidden City.* New York: Harry N. Abrams, 1982.

Wengniute Qi Wenhuaguan, Zhaowuda Meng Wenwu Gongzuozhan (The Archaeological Station of the Zhaowuda League and the Cultural Center of the Wengniute Banner, Inner Mongolia). "Nei Menggu Jiefangyingzi Liao mu fajue jianbao" (Report on the discovery of a Liao tomb at Jiefangyingzi, Inner Mongolia). *Kaogu,* no. 4 (1979): 330–34.

Wenhua dageming qijian chudu wenwu (Cultural relics unearthed during the period of the Great Cultural Revolution). Beijing: Wenwu Press, 1972.

Whitfield, Roderick. *The Art of Central Asia: The Stein Collection in the British Museum.* Vols. 1–3. Tokyo: Kodansha, 1982–85.

Whitfield, Susan. *Life Along the Silk Road.* Berkeley: University of California Press, 1999.

Wilk, Christopher. *Marcel Breuer: Furniture and Interiors.* New York: Museum of Modern Art, 1981.

Wu Hung. *The Wu Liang Shrine: The Ideology of Early Chinese Pictorial Art.* Stanford, Calif.: Stanford University Press, 1989.

———. "Rethinking Mawangdui." *Early China* 17 (1992): 111–44.

———. *The Double Screen: Medium and Representation in Chinese Painting.* Chicago: University of Chicago Press, 1996.

Wu Tung. "From Imported Nomadic Seat to Chinese Folding Armchair." *Boston Museum of Fine Arts Bulletin* 71, no. 363 (1973): 36–50.

———. *Tales from the Land of Dragons: 1,000 Years of Chinese Painting.* Boston: Museum of Fine Arts, 1997.

Wu Wei Zi, ed. *Bian yong xue hai qun yu* (Seas of knowledge and mines of jade: Encyclopedia for convenient use). 1607.

Xia Mingcai. "Yidu Bei Qi shimu xianke huaxiang" (The Northern Qi stone chambered tomb with incised portraits). *Wenwu,* no. 10 (1985): 49–54.

Xiao Zixian. *Nan Qi shu* (Southern Qi history). 3 vols. Beijing: Zhonghua Shuju, 1972.

Xixiang ji (The story of the western wing). 1498 Hongzhi edition.

Xu Jian. *Chu xue ji* (Record of early scholarship). Siku Chuanshu ed. Taipei: Commercial Press, 1983.

Xu Ling. *Yutai xinyong ji* (New songs from a jade terrace). Sibu Congkan ed. Shanghai: Commercial Press, 1920–22.

Xu Shen. *Shuo wen jie zi zhu* (Annotated edition of the analytical dictionary of characters). Annotated by Duan Yucai (1735–1815). Shanghai: Guju Chubanshe, 1981.

Xuanhe huapu (Xuanhe painting catalog). *Yishu congshu,* 1st series, vol. 9.

Yang Hong. "The Dunhuang Cave Paintings: A Study of Depictions of Furniture from

the Tang Dynasty and the Five Dynasties Period." *Journal of the Classical Chinese Furniture Society* 2, no. 2 (Spring 1992): 58–67.

Yang Jiong. *Yang Yingchuan ji* (Collected works of Yang Yingchuan). 2 vols. Shanghai: Commercial Press, 1929.

Yang Lien-sheng. "A Note on the So-Called TLV Mirrors and the Game *Liu-po.*" *Harvard Journal of Asian Studies* 9, nos. 3–4 (Feb. 1947): 202–7.

———. "An Additional Note on the Ancient Game *Liu-po.*" *Harvard Journal of Asian Studies* 15, nos. 1–2 (June 1952): 124–39.

Yang, Xiaoneng, ed. *The Golden Age of Chinese Archaeology: Celebrated Discoveries from the People's Republic of China.* New Haven: Yale University Press, 1999.

Yang Yao. *Zhongguo Mingdai shinei zhuangshi he jiaju* (Interior decoration and furniture in Ming dynasty China). Beijing: Beijing University Press, n.d.

Yi Shui. "Manhua pingfeng—jiaju tanwang zhi yi" (Remarks on screens—Talks on furniture no. 1). *Wenwu*, no. 2 (1979): 74–79.

———. "Zhang he zhangguo" (Curtains and curtain hooks). *Wenwu*, no. 4 (1980): 85–88.

The Yichang Area Museum. "Hubei Dangyang Zhaoxiang 4 hao Chunqiu mu fajue jianbao" (Excavation of tomb 4 of the Spring and Autumn Period at Zhaoxiang in Dangyang, Hubei). *Wenwu*, no. 10 (1990): 25–32.

Yongle Gong. Beijing: Renmin Meishu, 1964.

Yoshikawa Kojiro. *Five Hundred Years of Chinese Poetry, 1150–1650: The Chin, Yuan and Ming Dynasties.* Trans. with a preface by John Timothy Wixted. Princeton: Princeton University Press, 1989.

Yü, Chün-fang. "Guanyin: The Chinese Transformation of Avalokiteshvara." In *Latter Days of the Law: Images of Chinese Buddhism, 850–1850,* edited by Marsha Weidner, 151–81. Lawrence, Kans.: Spencer Museum of Art, 1994.

Yu Ying-shih. "The Seating Order at the Hung Men Banquet." In *The Translation of Things Past: Chinese History and Historiography,* edited by George Kao, 49–61. Hong Kong: Renditions, 1982.

Yu Zhuoyun et al., comp. *Palaces of the Forbidden City.* Translated by Ng Mau-Sang, Chan Sinwai, and Puwen Lee. New York: Viking, 1987.

Yuan Anzhi. "Tan 'yangxin jia' tongqi" (Remarks on "Yangxin jia" bronze vessels). *Wenwu*, no. 9 (1982): 18–20.

Zeitlin, Judith T. "Shared Dreams: The Story of the Three Wives' Commentary on *The Peony Pavilion.*" *Harvard Journal of Asiatic Studies* 54, no. 1 (June 1994): 127–79.

Zeng Zhaoyu et al. *Yinan gu huaxiangshi mu fajue baogao* (A report on the excavation of the decorated tomb at Yinan). Shanghai: Cultural Administrative Bureau, 1956.

Zhang Yinwu. "A Survey of Chu-Style Furniture." *Journal of the Classical Chinese Furniture Society* 4, no. 3 (Summer 1994): 48–59.

Zhang Zhongyi et al. *Huizhou Mingdai zhuzhai* (Ming dynasty houses in Huizhou). Beijing: Architectural and Engineering Publishing House, 1957.

Zhao Xigu. *Dongtian qinglu ji* (Paltry earnings in the immortals' service). Vol. 5 of *Zhongguo gudai meishu congshu* (A collection of ancient texts on Chinese art). Beijing: Guoji Wenhua Chubanshe, 1993.

Zheng Zhenduo. *Zhongguo banhua shi tu lu* (An illustrated history of Chinese woodblock prints). 20 vols. Shanghai: Zhongguo Banhua Shishe, 1940–42.

———. *Zhongguo gudai banhua congkan* (A collection of ancient Chinese woodblock illustrations). 4 vols. Shanghai: Guji Chubanshe, 1988.

Zhongguo banhua xuan (Selected Chinese woodblock prints). 2 vols. Beijing: Rong-baozhai, 1952.

Zhongguo lidai huihua [*ZGLDHH*] (Chinese painting through the ages). *Gugong Bowuyuan canghuaji* (Collection of the Palace Museum). Vols. 3–7. Beijing: Renmin Meishu Chubanshe, 1982–1991.

———. *Tianjin Yishi Bowuguan zang huaji 1: Song Yuan Ming Qing zuopin* (Collection of the Tianjin Art Museum 1: Song, Yuan, Ming, Qing). Tianjin: Renmin Meishu Chubanshe, 1985.

Zhongguo meishu quanji [*ZGMSQJ*] (The great treasury of Chinese fine arts). *Diaosu bian 1: Yuanshi shehui zhi Zhanguo diaosu* (Sculpture section 1: Sculpture from the beginnings of civilization to the Warring States period). Beijing: Wenwu Press, 1988.

———. *Diaosu bian 2: Qin Han diaosu* (Sculpture section 2: Sculpture of the Qin and Han). Beijing: Renmin Meishu Chubanshe, 1985.

———. *Diaosu bian 3: Wei Jin Nanbei Chao diaosu* (Sculpture section 3. Sculpture of the Wei, Jin, Southern and Northern dynasties). Shanghai: Renmin Meishu Chubanshe, 1984.

———. *Diaosu bian 5: Wudai Song diaosu* (Sculpture section 5: Sculpture of the Five Dynasties and Song). Shanghai: Renmin Meishu Chubanshe, 1984.

———. *Gongyi meishu bian 4: Qingtong qi 1* (Crafts section 4: Bronze vessels 1). Beijing: Wenwu Press, 1985.

———. *Gongyi meishu bian 11: Zhu mu ya jiao qi* (Crafts section 11: Bamboo, wood, ivory, and horn objects). Beijing: Wenwu Press, 1987.

———. *Huihua bian 4: Liang Song huihua* (Painting section 4: Painting of the two Song dynasties). Beijing: Wenwu Press, 1988.

———. *Huihua bian 7: Ming dai huihua, zhong* (Painting section 7: Ming dynasty painting 2). Shanghai: Renmin Meishu Chubanshe, 1989.

———. *Huihua bian 12: Mushi bihua* (Painting section 12: Wall paintings in tombs). Beijing: Wenwu Press, 1989.

———. *Huihua bian 20: Banhua* (Painting section 20: Woodblock illustrations). Shanghai: Xinhua Shudian, 1988.

———. *Jianzhu meishu bian 2: Lingmu jianzhu* (Architecture section 2: Tomb architecture). Beijing: Cultural Relics Publishing House, 1988.

Zhongguo Shehui Kexueyuan Kaogu Yanjiusuo and Hebei Sheng Wenwu Guanlichu (Institute of Archaeology, CASS, and the Hebei CPAM, Hebei province). *Mancheng Hanmu fajui baogu* (Excavation of the Han tombs at Mancheng). 2 vols. Beijing: Wenwu Press, 1980.

Zhu Shuzhen. *Zhu Shuzhen ji zhu* (Annotated collection of Zhu Shuzhen's poems). Hangzhou: Zhejiang gu ji, 1985.

GLOSSARY-INDEX

Italic page numbers denote illustrations.

326; stands for, 323–25, *324, 325,* 326; uses of, 321, *322,* 334

Breuer, Marcel, "Wassily" armchair, 25–26, *26,* 35

British Museum, 177

bronze: images, 82, *83;* lamps, 305–7, *306, 307;* mountain censers, 76–77, *77;* platforms, 105, *106;* screen supports, 270, *270;* stands, 180–81, *181;* tables, 161–62, *163, 165,* 181, *181;* water basins, 332, *333. See also* ritual bronzes

Brooklyn Museum of Art, 3, 38, 39, 325

Buck, Pearl, 37

Buddha of Healing, 109

Buddhism, 111, 242, 246–47; chairs and, 14, *14,* 31, *32, 33,* 58, 72; deities, 13–14, 31

Bunker, Mr. and Mrs. John, collection of, 222

butterflies, 154, 342

cabinets: as architecture, 2; bases of, 255; book, 248, 253–54; carvings on, 263, *265;* and chair-level mode of living, 243, 249; compound wardrobes, 259–63, *260;* decorative hinges and lockplates on, 261; display, 263–65, *264, 265;* doors of, 256; elevated on bases or tables, 244, 255; and information storage, 259; Japanese and Korean, 248; low, with horse-hoof feet, 254–55, *255,* 257; medicine, 257–59, *259;* in Ming dynasty paintings, 244; miniature wooden, 253, *253;* multidrawer, 257–59; with overhanging top, 252; in *Pictorial Encyclopedia of Heaven, Earth, and Man,* 245, *245,* 252; in *The Plum in the Golden Vase,* 253; pottery tomb models, 252–53, *252;* scholars', 259; Shaker, 249, *250;* in Southern Song handscroll *Sericulture,* 244, *244;* square-corner with lattice panels, 257, *258,* 261; tapered, 245, *245, 248,* 249, 250–53, *251, 253, 254, 254;* tapered,

with lattice, 255–56, *256;* types of, 248; in woodblock illustrations, 254, *254*

cabriole legs: with animal heads and claw feet, 175–77; emerging from animals' mouths, 228, 310; on *kang* tables, 171, *172,* 173, *174,* 175–76; in leaf forms, *298,* 299; prototypes of, 175–77, *176,* 298; terms for, 171

Cahill, James, 289, 355n23

Cai Zhuang, tomb of, *110,* 111

calligraphy, 203, 322–23, *324*

candles, 303, 305; in lanterns, 304, 317; in paintings and woodblock illustrations, 135–36, *135,* 309, 311, *311,* 314, *314;* used on lamp stands in Ming and Qing dynasties, *310,* 311, 314, *314;* wicks of, 305, 369n8

canopy beds: with alcove in front, 154–55, *155, 156, 157, 158;* as architecture, 2; auspicious symbols and decorative motifs on, 145, 146–47, 148–50, 151–52; bamboo, 150–51, *150;* in brides' dowries, 139, 143; in Buddhist contexts, 13, 143–44, *144;* ceremonial uses of, 141–42, 143; with curtains, *340,* 341; with elaborate carving, 148, *149,* 151, *152;* elevated, 6, 13, 143–44, *144;* enclosed by screens, 145, 273, *273,* 275; first pictorial representation of, in domestic context, 142–43, *142;* four- and six-post types, 144–45; and flowers, 146; frames of, 141, *141;* with geometric design created from spaces, 152–53, *153;* in Han dynasty, 141–43; highly decorated, with cabriole legs, 151, *152;* Hongwu era, from Ming tomb, 144, *144;* in men's bedrooms, 151; model from Tiger Hill tomb of Wang Xijue, 154, *155;* in *Night Revels of Han Xizai, 16–17,* 18, 144; as room within a room, 139, 143, 155–57, 158; six-post, with curtains, 148,

148; six-post, with *wanzi* patterns, 147–48, *147,* 154; with soft-mat seat, 153, 154; in Tang dynasty, 143; used as seats for painting tables, 207; and women's rooms, 2, 151, 157–58. *See also* bed curtains

Cao Ba, 274–75

Cao Buxing, 273

Cao Xueqin. See *Story of the Stone*

carpets, 51

carved panels, 80–81, *128,* 129

carving: on chairs, 79–81, *80;* on couchbeds, *128,* 129, *130;* on display cabinets, 263, *265;* on incense stands, 299; on lamp stands, *313,* 314–15; on lanterns, 317, *317;* on screens, 268, *269, 284,* 286, *287,* 288–89; on stools, 93–94; on tables, *210,* 211; on towel racks, 339–40, 342, *342. See also* latticework

Castiglione, Giuseppe, *Emperor Qianlong Enjoying the Snow,* 69, *69*

Cather, Willa, 40

cave paintings. *See* Dunhuang cave paintings

cedar, *221*

censers: elevated on tables or stands, 295; mountain, 76–77, *77,* 79, 295; shaped like mythical beasts, 296; to warm the bed, 142. *See also* incense burners

Central Academy of Arts and Design (Beijing), 4, 79, *79*

Ceremonies and Rituals (Yi li), 332, 333

Cha jing (Classic of tea; Lu Yu), 185

chair-level mode of living: cabinets and, 243, 249; and changes in architecture, 22; and Chinese cuisine, 19, 188; and development of furniture, 5, 9, 18, 21–22; effect on Chinese lives, 9, 24; and elevation of washbasin, 334; and folding armchair, 60; and high incense stands, 295; and innovations during Song dynasty, 18; in *Night Revels of Han Xizai,* 16–18,

Confucianism, 2, 234

connoisseurs, 3. *See also* Wen Zhenheng

continuous waist construction, 117

couch, U-shaped, 16, *16–17*, 123, 169

couchbeds: in Astor Court, 24; with cloud-head feet, *124–25*; compared with canopy beds, 131; decorative panels of, 129; full-size wooden model from Jiefangyingzi, 115, 124, *124*; functions of, 138; with game table on top, 126, *126*, 169; with horse-hoof feet, 129; *huanghuali*, with C-curved legs, 133, *134*; *huanghuali*, with elaborate carving, 129, *130*; *huanghuali*, with high railing and corner posts, *128*, 129; *huanghuali*, with horse-hoof feet and restrained decorations, 129–31, *130*; *huanghuali*, with later railings, 115–16, *115*; in illustrations of *The Plum in the Golden Vase*, 131, *131*, 135, *135*; influence of bamboo furniture on, 136–37; with low back and straight round legs, 136, *136*; in Ming dynasty, 127–29, 137–38; miniature wooden model from tomb of Yan Deyuan, 124, *125*; origins of, 122–23, *123*; with round legs and open panels, 137, *137*; with sides lower than back, 126, 127; and status, 96, 97; in *The Story of the Stone*, 96, 131–32; in studio, 132–33, *132*; in women's apartments, 131; wooden model from Ming tomb of Zhu Tan, 127; Yuan dynasty illustrations of, 126, *126*, *137*, 169; *zitan* wood, with lattice railings, 133–35, *134*. *See also* low platforms; *luohan chuang; ta*

court ladies. *See* palace ladies

court portraits, 46–47, *46, 47*

courtyard houses, 13, 37, 39, 133, 318

Crofts, George, 61

Cruz, Gaspar da, 198, 262

Cui Fen, tomb of, 21, 204

cultivated gentleman, 214–15

cupboards, 22, *23*

cushions, 14

dachu 大櫥 (large cupboard), 253, 259, 262. *See also* cabinets

dachuang 大床 ("great bed"), 155

Dai Jin: *Happy Events in Peaceful Times*, 95, *95*; *A Nocturnal Outing of the Demon Queller Zhong Kui*, 75, *75*; *The Puppet Show*, 197

Dai, Marquess of. *See* tombs, of Marquess of Dai

Dai hou jia 軑侯家 (household of the Marquis of Dai), 182

Daji (evil concubine), 271

Dali, kingdom of, 31

Dali marble, 35, 320, *321*

Damon, Thomas, *250*

damuzuo 大木作 ("greater woodwork"), 18

Dancheng (Henan province), 107

dang 鐺 (metal braziers), 321

Dao de jing, 27, 257, 332, 344

Dao Qian, "Life of the Master of the Five Willows," 217

Daoist motifs, 69

dating, 5

Datong (Shanxi province): coal used to heat *kang* in, 166; tomb of Feng Daozhen, 188, *189*; tomb of Yan Deyuan, *48, 49*, 124, *125*, 277, *334, 335*; wooden screens from, *123, 123, 272, 272*

daybeds, 116. *See also* canopy beds; couchbeds; *kangs*

Dazu cave temples, 45, *45*

De Stijl, 26

De-bzhin-gshegs-pa (Tibetan lama), 68

Decorated Letter Paper from the Ten Bamboo Studio (*Shizhuzhai jianpu*), 369n8

decorative motifs: astronomical, 241, *242*; back-to-back phoenixes amid clouds, 234, *235*; *baize*, 263, *265*, 288; bird-and-flower, 44, 129; chrysanthemum patterns, 261; cracked ice and plum blossom, 171; cracked-ice pattern, 257; curling vine and flower, 64; double fish, 261; dragon, 68, 76–77, *77*, 93–94, 101, 151, 162, 211, 236–37, *237*, 299; dragons and clouds, 286, 288; dragons facing vines, 97; dragons flanking large *shou* character, 288; "embracing drums," 313; hundred-butterflies design, 154; intertwining animals, 268, *269*; lions, 315; magnolia, 50, 150, 177; *makara*, 299; mandarin ducks among lotuses, 339; marital bliss, 129; moon, 145; narcissus, 278; peaches, 50; peonies, 50, 150, 289; phoenix, 299; plum blossoms, 81, 150, 289; *qilin*, 66, 288–89; sacred mountains, 69; scrolling lotus, 64; shamanist, 225; *shou* character, 151; *shou* character flanked by coiling *chi* dragons, 315; snakes, 270; vines, 94, 97; water, 145; waves, 278; yellow hibiscus, 313. *See also* auspicious symbols; bats; cloud-head motif; flowering plum; *lingzhi*; reversed symmetry; *shou* character; *taotie*; "three friends of winter" motif

deng 鐙 (subliming vessel), 308, *308*

Deng Baidao, 246

dengguayi 燈掛椅 ("lamphanger chair"), 49

dengtai 燈臺 (lamp stand), 310

Deqing county (Guangdong province), *226, 227*

desks: curved-leg, 203–4, *205*; with drawers, 221, 222, *222*; Kangxi emperor's mathematics, 177, 221, *221*; large tables used for, 21–22, 203, 205–6; made of natural stone, 216, *216*; small, 207. *See also* painting tables

Dessau Master's houses, 27–28, *29*

DeWoskin, Kenneth J., 164

di baxian 地八仙 ("eight immortals floor table"), 178

fangwu 方机 (square stool), 91

fanzhuo 飯桌 (dining table), 165

Faraday, Michael, 308

feasts: with low tables, 11–12, *11*, *164*, 184; in *Night Revels of Han Xizai*, 17, *16–17*

feathers, *276, 277*

Fei Chang of Liang, 274

feiyun 飛雲 (everted flanges), 236

Feng Daozhen, tomb of, 188, *189*

Fengchu (Shaanxi), 271

fenghuang. See phoenix

Ferguson, John C., *Survey of Chinese Art*, 29

fire pits, 320

First International Symposium of Ming Domestic Furniture (Beijing), 4

First Sericulturalist, 232

fish, 188, *189*

FitzGerald, C. P., 3

five blessings, 50

Five Dynasties: platforms, *110, 111*; wall paintings, 277

floors, 22

flowering plum, 145, 231; blossoms, 81, 150, 289

folding armchairs: black and gold lacquered wood, 68–69, *68*; carried by servant in *Returning from a Spring Outing*, 66–67, *66*, 91; decorative motifs on, 64, 66, 68–69; depicted by Tang Yin, 59; "drunken lord's chair," 69–71, *70*; footrests on, 64, 66; as gifts of state, 68; with horseshoe-shaped arms, 60, *61, 62, 63, 65, 67, 68*; Ming dynasty, 60–64, *61, 62, 63, 65*; in painting from Yuanbao Shan Tomb, 89; portraits of people sitting on, *47, 67, 67*; in *Qingming Festival on the River*, 19; spandrels on, 62–64; versatility of, 66–68

folding furniture, *139*, 140. *See also* folding armchairs; folding stools; folding tables

folding stools, 19, 60, 140; in *Asita Holding the Infant Buddha*, 14;

decorative motifs on, 101; in *Qingming Festival on the River*, 19, *19*

folding tables, 140, 164

Foniyingbu, 211

Food Canons (Shi jing), 185

Food habits: Song dynasty, 19, 187–88; Tang dynasty, 184–85

foot warmers (*jiaolu* 腳爐), 326–28, *326*

footrests, 64, 66, 101

footstools, 19, 92; with cloud-head feet, 126; roller stools, *213, 213, 214*; in Sui cave painting, 14; used with large armchairs, 31; used with painting tables, *213, 213*; used with yokeback chair of Song empress, 46

Forbidden City (Beijing): folding armchairs, 68–69, *68*; lanterns, 317; low desk for Kangxi emperor's mathematical studies, 177, 221; medicine cabinet, 257; platforms and *kangs*, 24, 167, *169*; studied by George Kates, 37–38; thrones, 45. *See also* Palace Museum (Beijing)

Fotudeng, 30

Four Guardian kings, 242, *243*

Four Landscape Scenes (attributed to Liu Songnian), 31, *33*

four treasures of the library. *See wenfang sibao*

fousi 桴(浮)思 (screen wall outside front gate), 271

Freeman, Michael, 187

Freer Gallery of Art, 53, 86, 346n13

Fu Qian, *Popular Literature*, 107

Fu Xi, 247

Fu Xinian, 181

Fufeng (Shaanxi province), 177, 242, *243*, 249–50, *250*

Fujian province, 234, *235*

Fujiwara-no-Kamatari, 248

funeral rites, 96

funerary chairs, 47, *48*

Fung, Alan, 111

Fung, Camille, 111

fur, 319–20

furniture, 2–3, 6, 18; and gender, 140

furniture making, 18

game bowls, 199–200, *200*

game tables: decorative motifs on, 185–86; double sixes, 126, *126*, 169, 199–200; *liubo*, 181–82, *182*; Warring States period, 162–64, *163*; *zitan* go board, 185–86, *185*; *zitan* wood, with silver inlay, 200–202, *201*

Gansu province. *See* Dunhuang cave paintings; Wuwei

Gao Lian, 47, 213; *Eight Discourses on the Art of Living*, 34, 35, 127

Gao Yuangui, tomb of, 15, 47

Gaoseng zhuan (Lives of eminent monks), 30

Gaotang (Shandong), tomb at, 188

Gaozong's Empress, 46, *46*

gardens, 216, *217, 219*

Gauthier, Judith, 28

geng 羹 (stew), 183

Gernet, Jacques, 304, 317

Giles, H. A., 115

gimbals, 308

gnarled wood furniture, 31, 34–35

go. See weiqi

Goedhuis, Michael, collection of, 65

gongan 供案 (altar tables), 228

gongzhuo 供桌 (altar tables), 228

gongzuoyi 公坐椅 ("lordly seat chair"; yokeback armchair), 53

Great Mosque (Xi'an), 101

Gropius, Walter, 27, 29

Gruber, John W., collection of, 53–55, *54*, 65–66, *65*

gu 古 (antique), 138

Gu Hongzhong, 15–16. *See also Night Revels of Han Xizai*

Gu Jianlong, *135, 150, 190, 194, 290*, 355n23

Gu Kaizhi, 273. *See also Admonitions of the Instructress to the Court Ladies*

Gu Qiyuan, 197

Gu Shiyan, 187

Guan Mianjun, 205

guang chuang 匡牀 (square bed), 140, *142*

Kangxi emperor: mathematics desk of, 177, 221, *221*; seated at black lacquered painting table, 219–21, *220*; second tour to the south, 179, 359n45

kangzhuo 炕桌 (wide *kang* table), 165, 166, 177

Kao pan yu shi. See Tu Long

Karlgren, Bernhard, 245

Kates, Beatrice, 38

Kates, George: *Chinese Household Furniture* by, 3, 36, 38, 39; description of chair runners, 46; early years, 36–37; later years, 40; publications and exhibitions, 38–39; set standards for collectors, 29; on tomb models of furniture, 252; years in Beijing, 37–38; *The Years That Were Fat* by, 36, 39, 40

Kazantzakis, Nikos, 37

ke'ai 可愛 (giving pleasure), 137

kesi 緙絲 (silk tapestry), 50, *52*

Kings of Hell, 58

kitchen tables, 12, *12*, 188

knockdown furniture, 139–40. *See also* dismantling

kuang chuang 匡床 (square bed), 140, 142

Kublai Khan, 38

Kukai, 111

*kurgan*s. *See* tombs

Kyoto National Museum, 289

lacquer, 2, 29, 30; beds, 144; boxes, 241–42, *242*, *243*; decoration of, 288; game tables, *182*; tables, 162, *163*, 225; screens, 268–69, *269*; trays, 288. *See also* black lacquer

Ladies' Classic of Filial Piety, 87–89, *87*, *88*

Ladies Playing Double Sixes (attributed to Zhou Fang), 14, 86, 346n13

Ladies Preparing Newly Woven Silk (attributed to Emperor Huizong), 322, *323*

Lady Seated on a Canopy Bed (Zhang Zhen or Zhang Weibang), 289, 319, *320*

Lady Xiling, 232

lamp shades, 312, *312*

lamp stands: adjustable, 312–15, *313*; chair-level mode of living and, 309; with cross-shaped base, 312, *312*, *313*; decorative motifs on, 310–11, 314–15; with hanging lantern, 315–17, *315*; with open-work carving, *313*, 314–15; in paintings, reliefs, and woodblock illustrations, 309, *309*; with three cabriole legs, 310, *310*

lamps, 304, 317–18; animal sculpture, 307; book lamp, 316, *316*; bronze, 305–7, *306*, *307*; oil-and-wick, 308; table, 311. *See also* lanterns

Laṅkāvatāra Sūtra, 184

lanshuixian 瀾水線 (water-stopping molding), 173

Lantern Festival, 183, 304–5

lanterns, 304–5, 308, 311; in Forbidden City, 317; glass, 317; hanging, *191*, *290*, 315–17, *315*; with *zitan* frames, 317, *317*

lao 醪 (unfermented beer), 183

latticework: in Astor Court, 22; on couchbeds, 133–35; doors on cabinets, 256, *256*; lowback armchairs, 79; panels, 257; on screens, 289

Lee, Jean Gordon, 3

Lelang (Korea). *See* Tomb of the Painted Basket

Lévy, André, 193

li 醴 (unfermented beer), 183

Li Ao, 72–73

Li Cheng (painter), 279

Li He, 275

Li ji (Record of Ritual), 332, 333

Li Jie, *Treatise on Architectural Methods* (*Yingzao fashi*), 247, 248

Li Renpu, 259

Li Rihua, 131–32

Li Yi, 275

Li Yu, 146, 222, 259; *Casual Expressions of Idle Feeling*, 326, 331; *Silent Operas*, 118, *119*

Li Zhen, 111

Liang Hong, 164

liangchuang 涼床 ("cool bed"), 155

lianggegui 亮格櫃 (display cabinet), 263

Liao dynasty: full-size wooden couchbed model from Jiefang-yingzi, 115, 124, *125*; funerary chair from tomb at Jiefangyingzi, 47, *48*; lamp stands, 309

Liaoning province. *See* Huaerlou; Liaoyang

Liaoning Provincial Museum, *114*, *163*

Liaoyang (Liaoning province), 107

Lidai minghua ji. See Zhang Yanyuan, *Record of Famous Painters of All the Dynasties*

Lienü zhuan (Biographies of exemplary women; Liu Xiang), 271

Life of Han Xiangzi, 153, *154*

Ling gui, 180–81, *181*, 193

Lingbao (Henan province), 13, 164, 184

lingbo xianzi 凌波仙子 (narcissus), 278

lingzhi 靈芝 (fungus of immortality), 46, 50, 66, 151, 205, 227; on towel racks, 337, *337*, 339, *340*, 341, *341*, 342, *342*

lions, 315, 320, *321*

Liu Chang, 279

Liu, dowager empress, 31

Liu Guandao, *Whiling Away the Summer*, 169, *170*, 236

Liu Jingzhi, 35

Liu Jun: *Mi Yuanzheng Listening to a Fisherman's Flute*, 78, *78*; *Song Emperor Taizhu Visiting His Prime Minister Zhao Pu on a Snowy Night*, 322, *323*

Liu Sheng, tomb of, 140, 141, *141*, 164

Liu Songnian, 31, *33*; *High Mountain and Flowing Water*, 297, *297*

Liu Xi, 122. *See also Explanation of Names*

Liu Xiang, *Biographies of Exemplary Women*, 271

Liu Xun, 143

Song Yu, poem "Zhao hun" by, 162–64

Sotheby's (New York), 94

Southern and Northern Qi History (*Nan Bei Qi shu*), 274

southern elm. See *ju*

Southern Song dynasty: album leaf *Returning from a Spring Outing*, 66–67, *66*, 91; banquets, 187–88; fan painting showing round stools with oval openings, 89, *89*; fan paintings, 280, *281*; handscrolls, 112, *112*, 125, *125*, 244, *244*; *A Lady at Her Dressing Table* by Su Hanchen, 127; large wave screen with butterflied corners, 127; painting depicting lowback armchairs, 72–73, *73*; stone carving of Jade Emperor seated on yokeback chair, 45, *45*

spandrels, 62, 162

Spring and Autumn period: braziers, 320, *321*; tables, 162, *163*

square tables: association with immortals, 180–82; bronze, inlaid with gold and silver, *181*, *181*; depicted in tombs, 188–89; design elements derived from bamboo furniture, 198–99; with double-molded top edge, leg-encircling stretchers, and inset panels, 198–99, *198*; found in tomb of Princess Ruichang, 188; with humpback stretchers and corner spandrels, 194–97, *196*, 198; with humpback stretchers and round recessed legs, 193, *194*, 198; lacquered wood dining table from tomb of Marquess of Dai, 182–83, *182*, 189; pairs of, 197; in *Qingming Festival on the River*, *186*, 187; used as game tables, 180, 199, 202; used for dining, 182, 187–93, 202; used for preparing food, 184, *184*, 188; used with side tables as altars, 193–94, *195*, 238; with waist, corner legs, horse-hoof feet, and curved braces, 189, *190*, 198

Starting Point and Basic Principle (attributed to Ma Hezhi), *87*

step stools, 97

Stone, Louise Hawley, 3

stone carvings: showing screens, 269, 270; of yokeback chairs without arms, 45, *45*

stone rubbings: of canopy bed enclosed by screen, 273, *273*; depicting Asita on folding stool, 83–84, *84*; depicting Guo Ru on limestone sarcophagus, *109*; from Wu Liang shrine, *108*

stone stelae, 83–84, *84*. See also stone rubbings

stools: with cushions, 14; cylindrical, with rounded top, 13–14; depicted on Eastern Zhou fragment of bronze vessel, 82, *83*; drum stools, 97–100, *98*, *99*; "embroidery," 98; folding, 84, 100–101, *100*; folding *zitan*, with footrest, 101, *101*; in garden, 89–91, 100; hourglass-shaped, 14, 82, 84; in illustrations of *Story of the Western Wing*, 97, *97*; large square *zitan*, 92–93, *93*, 121, 198; lobed, 97; low, 14, 91–92, *92*; for meditating bodhisattvas and monks, 82–84, *83*; model type for painters, 95; for mounting horses, *66*, 86, *86*; names for, 91, 98; with oval openings, 89–90, *89*, *90*; rectangular, with double stretchers, 91, *91*; round, 87–89, 97; round, used at Meng Yulou's birthday party, 95–96, *96*; round, waisted, with cabriole legs, 97; round, with convex legs ending in horse-hoof or cloud-head feet, 95; sitting posture on, 83; square cabriole-leg, with carving, 93–94, *94*; square recessed-leg, 85; and status in *The Story of the Stone*, 96–97; stele of Asita seated on folding stool with infant Buddha, 83–84, *84*; style derived from bamboo furniture construction, 136; support system, 102; Tang ladies seated on, 85–86, *85*; uses

of, 97; waisted, with humpback stretcher and horse-hoof feet, 92, *93*; ways of carrying, 91. *See also* folding stools; footstools

storage containers, 241, 267

The Story of the Stone (*Shitou ji* by Cao Xueqin): braziers in, 322, 325–26; description of couchbed, 131–32, 171–73; description of heating systems, 167, 330; hand warmers and clothes warmers in, 328–29, *329–30*; *kang* in, 132, 175, 331; *kang* tables in, 173–75, 177; tables described in, 165–66, 171–73, 222; wardrobes in, 259, 262

Story of the Western Wing (*Xixiang ji* by Wang Shifu): canopy bed, 145, *145*, 146; illustration of altar table in Monastery of Universal Salvation, 228–29, *229*; illustration *Oriole Burning Nighttime Incense*, 232–33, *233*; illustration *Oriole Writes a Letter*, *206*, 207; illustration showing platform beneath other furniture, 213; stools used as seats and tables, 97, *97*

stoves, 166, 249–50, *250*

stretcher-and-struts construction: used on bronze stands, 180–81; used on square table with humpback stretchers, 193

stretchers, 21, 97

strongboxes, 244–45

studios. *See* scholar's studio

su 俗 (vulgar), 137

Su Hanchen: *Children Playing in a Garden in Autumn*, 89–90, *90*; *A Lady at Her Dressing Table*, 127, 278, *279*

Su Shi, 217, 280, 309

Su Shunqin, 214

Su Xiaoxiao, 50, *51*

Śubhakarasimha, 111

subliming vessels, 308, *308*

Sui county (Hubei province), 241, *242*

Sui dynasty, 14, 109; tomb of Zhang Sheng, 84, *84*, 334